THE
POWER OF
ART

FOR
OUR
PARENTS

James Warren Ingalls

Flora Salvador Ingalls

Henry L. Lewis

and Joan Lewis

*who first opened our
eyes to the power of art*

THE
POWER OF
ART

THIRD EDITION

Richard Lewis
Marist College

Susan I. Lewis
State University of New York
at New Paltz

WADSWORTH
CENGAGE Learning·

Australia • Brazil • Canada • Mexico • Singapore • Spain • United Kingdom • United States

The Power of Art, Third Edition
Richard Lewis, Susan I. Lewis

Publisher: Clark Baxter

Senior Development Editor:
 Sharon Adams Poore

Assistant Editor: Ashley Bargende

Editorial Assistant: Marsha Kaplan

Associate Media Editor: Chad Kirchner

Brand Manager: Lydia LeStar

Market Development Manager: Joshua I. Adams

Senior Content Project Manager: Lianne Ames

Senior Art Director: Cate Rickard Barr

Manufacturing Planner: Sandee Milewski

Senior Rights Acquisition Specialist:
 Mandy Groszko

Production Service: Lachina Publishing Services

Text and Cover Designer: Chen Design
 Associates

Cover Image: © AP Photo/Tina Fineberg;
 Takashi Murakami, *Thanksgiving Day Parade
 Balloons (Kaikai and Kiki)*, 30' tall. New York
 City, 2010.

Compositor: Lachina Publishing Services

For product information and technology assistance, contact us at
Cengage Learning Customer & Sales Support, 1-800-354-9706.

For permission to use material from this text or product,
submit all requests online at **www.cengage.com/permissions**.
Further permissions questions can be emailed to
permissionrequest@cengage.com.

Library of Congress Control Number: 2012951251

ISBN-13: 978-1-133-58971-6

ISBN-10: 1-133-58971-5

Wadsworth
20 Channel Center Street
Boston, MA 02210
USA

Cengage Learning is a leading provider of customized learning solutions with office locations around the globe, including Singapore, the United Kingdom, Australia, Mexico, Brazil and Japan. Locate your local office at **international.cengage.com/region**

Cengage Learning products are represented in Canada by Nelson Education, Ltd.

For your course and learning solutions, visit **www.cengage.com**.

Purchase any of our products at your local college store or at our preferred online store **www.cengagebrain.com**.

Instructors: Please visit login.cengage.com and log in to access instructor-specific resources.

Printed in the United States of America
3 4 5 17 16 15

CONTENTS IN BRIEF

Preface *xv*

PART ONE

The Language of Art

Chapter 1
The Power of Art 2

Chapter 2
The Primary Elements 34

Chapter 3
The Principles of Design 52

PART TWO

The Artist's Materials and Tools

Chapter 4
Drawing 72

Chapter 5
Painting 84

Chapter 6
Printmaking 96

Chapter 7
Photography 112

Chapter 8
New Media: Time and Digital Arts 128

Chapter 9
Sculpture 148

Chapter 10
Architecture 168

Chapter 11
Decorative Arts, Crafts, and Design 192

PART THREE

A Global Heritage

Chapter 12
Ancient Empires, Ancient Gods 217

Chapter 13
The Age of Faith 247

Chapter 14
The Renaissance 275

Chapter 15
Drama and Light: Mannerism, the Baroque,
and Rococo 309

Chapter 16
The Battle of the Isms: Neoclassicism,
Romanticism, and Realism 343

Chapter 17
Out of the Studio and into the Light:
Impressionism and Postimpressionism 369

PART FOUR

The Modern Era

Chapter 18
The Real World on Trial: The Early
Twentieth Century 395

Chapter 19
The Invisible Made Visible: Abstract and
Nonrepresentational Art 423

Chapter 20
A Storm of Images: Art in the
Contemporary World 447

Glossary *485*

Photo Credits *495*

Index *505*

CONTENTS

Preface *xv*

PART ONE

The Language of Art

Chapter 1: The Power of Art 2

Art News:
 The Mona Lisa Has Been Stolen! 3

Looking at Art 4
 Learning How To See 4
 Methods and Materials 5
 Placing Art and Artist in Historical Context 5
 Art and Culture 6

The Powers of Art: Bringing Faith To Life 7
 Prehistoric Art and Magical Powers 7
 The Power of Art for Tribal Peoples 9
 A Global View:
 Journeys To The Spirit Worlds 10
 The Power of Religious Art 11

Art Represents Ideals 11
 Art as a Declaration of Power 13
 The Power to Convey Immortality 14
 The Power to Change Our Beliefs 14
 The Power to Shock 15
 Art News:
 Controversy Over the Vietnam Memorial 16
 The Power to Touch Our Emotions 17
 The Power to Awaken Our Senses 17
 The Power to Transform The Ordinary 18

The Power of Art for the Artist 19
 Self-Expression 19
 The Artist at Play 19
 The Artist's Memory 20

Defining Art 21
 Folk Art 22
 Craft and Decorative Art 22
 Lives of Artists:
 Nick Cave: The World Is His Palette 23
 Design 24
 Art is Beauty 27
 Art is Originality and Creativity 28
 Ways to Understand Art 28
 The Artist and the Art 29
 Art and Art History 30

When We Know More, We See More 32
 Beginning the Journey 32

Chapter 2: The Primary Elements 34

Space 34
Line 35
Shape 37
The Spirit of the Forms 39
Light, Shadow, and Value 40
Texture 41
Color 43
 Describing Color 44
 Color Wheel 45
 The Science of Color 46
 Art News:
 Augustus: In Living Color 47
 Naturalistic Versus Arbitrary Color 50
 Emotional Resonance 50

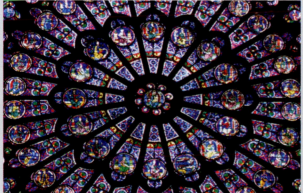

JEAN DE CHELLES, rose window of the north transept, Notre Dame Cathedral, Paris, France, 1240–1250. Stained glass, iron, and lead stone-bar tracery, diameter 43'.

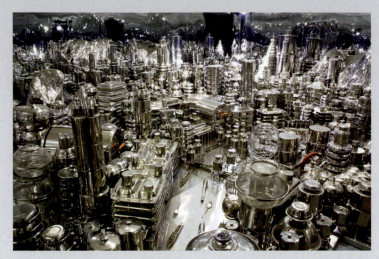

ZHAN WANG, *Urban Landscape*, 2003. Stainless steel, garden rocks, pots, pans, eating utensils, and mirror. Hayward Gallery, 2006. Photo by Stephen White, Pekin Fine Arts Co. Ltd. © Zhan Wang

Chapter 3: The Principles of Design 52

Placement 52
 Balance 54
 Symmetry and Asymmetry 55
Emphasis 57
 Unity and Variety 58
 Proportion and Scale 59
 Art News:
 Scale on Trial: The Tilted Arc Controversy 64
Designing and Organizing Space with Depth 66
Linear Perspective 68
 A Modern Way of Seeing: Cubism and Nonperspective Space 69

PART TWO

The Artist's Materials and Tools

Chapter 4: Drawing 72

Graphite 73
 Art News:
 The Lost Drawings of Michelangelo 74
Charcoal 76
Chalk And Pastel 76
Crayon 78
Pen And Ink 78

Brush And Ink 80
Wash 80
Contemporary Approaches To Drawing 81

Chapter 5: Painting 84

Encaustic 84
Fresco 86
Tempera Panel 86
Oil Painting 87
Watercolor and Gouache 90
Acrylic 91
Contemporary Approaches to Painting 92
 A Global View:
 Tibetan Sand Painting 93
Unique Materials 94

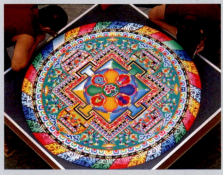

A Sand Mandala is constructed of grains of colored sand during an eight-day ritual by monks from the Drepung Loseling Monastery in India.

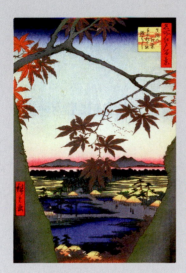

UTAGAWA (ANDO) HIRO-
SHIGE, *Maple Leaves
at the Tekona Shrine*,
Mamma, 1857. Color
woodcut, 13¾" × 9⅝".
Brooklyn Museum of Art
(Gift of Anna Ferris), New
York.

Chapter 8: New Media: Time and Digital Arts 128

Time as an Artist's Medium 128
 Moving Pictures 130
 Video Art 131
The Artist and the Computer 134
 The Pioneers of Digital Art 135
The Digital Studio 137
 Hardware 137
The Digital Media 138
 Image Editing 138
 Graphic and Type Design 139
 Digital Video 140
 Digital Animation 141
 A Global View:
 Japanese Anime 144
 Internet 145
 Interactive 145

Chapter 6: Printmaking 96

Relief Printmaking 97
 Woodcut 97
 Wood Engraving 99
Intaglio Printmaking 99
 Metal Engraving 100
 Lives of the Artists:
 June Wayne: Artist, Printmaker, Catalyst 102
 Etching 103
 Aquatint 104
Lithography 104
Silkscreen 105
 Art Issues:
 What's the Difference Between a Print and a Poster? 106
Unique Prints 109
Contemporary Approaches 110

Chapter 9: Sculpture 148

Relief Sculpture 149
Sculpture in the Round 150
Kinetic Sculpture 150
Performance Art 152
Installations 153
Earth Art 154
 A Global View:
 Eighth-Century Earth Artists 157

Chapter 7: Photography 112

Technique And Development 112
The Camera 114
Styles of Photography 115
 Straight Photography 115
 Beyond Reproduction: Fine Art Photography 118
 Photomontage 119
 Art Issues:
 Can Art Be Obscene? 121
Contemporary Approaches 123

GIUSEPPE PENONE,
Cedre de Versailles,
2002. © 2012 Artists
Rights Society (ARS), New
York/ADAGP, Paris.

Sculptural Methods 158
 Modeling 158
 Casting 158
 Wood Carving 160
 Lives of the Artists:
 The Wood Sculptures of Martin Puryear: Handmade
 Contemporary Art 162
 Stone Carving 163
Modern Sculptural Methods: Constructing and Assembling 164
Contemporary Approaches 164
 Mixed Media 165

Chapter 10: Architecture 168

The Art of Architecture 168
 The Architect as Artist and Engineer: Planning 168
 Harmony of Exterior and Interior Design 170
 Harmony with Natural Setting 171
 Art To Be Lived In 172
 A Global View:
 The Wonders of the World 173
 The Parthenon 174
 The Greek Orders 175

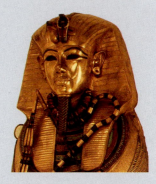

The second coffin of Tutankhamen (rule 1361–1352 BCE). Gilded wood inlaid with glass paste, 6' 7" long. Egyptian Museum, Cairo, Egypt.

Materials and Methods 176
 Earth, Clay, and Brick 176
 Stone 177
 Wood 179
 Iron and Glass 181
 Steel and Glass 181
 Reinforced Concrete 183
 Mixed Building Materials 184
Architecture Is a Product of Its Time and the Past 185
 Saint Peter's 185
 Monticello 187
Urban Planning 189
Contemporary Approaches 189

Chapter 11: Decorative Arts, Crafts, and Design 192

The Craft Media 193
 Ceramics 193
 Glass 195
 A Global View:
 Japanese Aesthetics: The Tea Ceremony
 and the Zen Garden 196
 Metalwork 198
 Fiber Arts 198
 Wood 200
The Studio Crafts Movement 201
Contemporary Approaches In Crafts 204
Design 206
 Graphic Design 207
 Industrial Design 208
 Lives of the Artists:
 Elsa Schiaparelli: Fashion As Art 209
 Interior Design 210
 Landscape Design 213

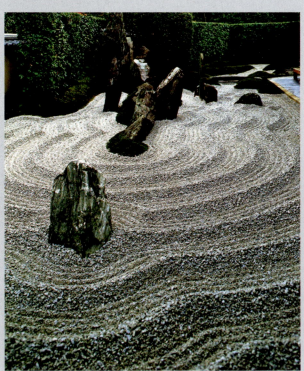

Ryoanji Zen Temple, Japanese Sand Garden, Kyoto, c. 1525. Stones, bare white sand.

PART THREE

A Global Heritage

Chapter 12: Ancient Empires, Ancient Gods 217

The First Civilizations	218
Art Issues:	
Preserving the Past: A Race Against Time	219
Egypt	220
Ancient China	223
The Classical World: Greece	224
The Classical Age	225
A Global View:	
A World Mountain For Worship	228
Art Issues:	
The Elgin Marbles Controversy	230
Classical Greek Sculpture	231
A Global View:	
Fertility Goddesses	233
Hellenistic Greece	234
The Classical World: Rome	236
Imperial Rome	236
Roman Architecture	238
Organized Conquerors	239
Roman Temples	241
Roman Painting and Mosaics	242
The Decline of Rome	243

Chapter 13: The Age of Faith 247

Religious Images or Sacrilege?	249
Early Christian and Byzantine Art	250
The Early Middle Ages	252
Islam	255
A Global View:	
A World Apart: Mesoamerica	256
Buddhism	260
Hinduism	262
The Middle Ages	264
The Romanesque Style	265
The Gothic Style	267
Art News:	
The Dimming of National Treasures	269
Medieval Art in Italy	270

Chapter 14: The Renaissance 275

The Idea of the Renaissance	276
Early Renaissance Sculpture and Architecture	277
Donatello	278
Early Renaissance Painting: Mastering Perspective	281
A Love of Learning and *Grazia*	281
Leonardo Da Vinci	282
Art News:	
The Birth of Modern Anatomy	283
The High Renaissance	284
Michelangelo	287
Art Issues:	
The Cost of Restoration: The Sistine Chapel and the Last Supper	290
Raphael	292

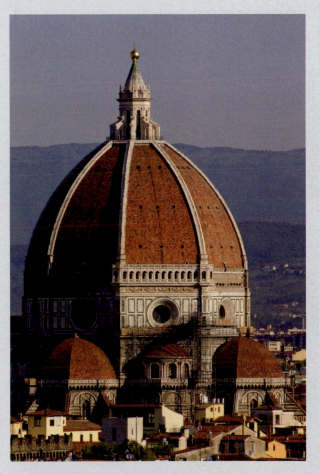

FILIPPO BRUNELLESCHI, Dome of the Florence Cathedral, 1420–1436. Florence, Italy.

The Renaissance In Venice 294
Palladio and Architecture 294
The End of the High Renaissance in Italy 295
The Beginning of the Northern Renaissance 297
Art in the Courts of the Duke of Burgundy 297
Jan Van Eyck 299
Albrecht Dürer 299
Hans Holbein and the Protestant Reformation 300
A Global View:
The Gold of the New World 301
Northern Renaissance: The Darker Side 303
Genre: Scenes From Ordinary Life 305

Chapter 15: Drama and Light: Mannerism, The Baroque, and Rococo 309

Mannerism 310
The Counter-Reformation and Tintoretto 311
The Baroque Period 313
El Greco 313
Caravaggio And Naturalism 314
Lives of the Artists:
Tumultuous and Tortured Lives:
Caravaggio and Gentileschi 316
Artemisia Gentileschi: The Spread of *Tenebroso* 318
Bernini 319
Baroque Naturalism In Spain: Velázquez 322
A Global View:
Mexican Baroque 323
The Baroque Period in the North 326
Rubens 326
The Dutch Republic 329
Art News:
Judith Leyster Rediscovered 331
Rembrandt 332
The Baroque In France 335
Louis XIV and Versailles 336
The Rococo In France: The Aristocracy at Play 338

Chapter 16: The Battle of the Isms: Neoclassicism, Romanticism, and Realism 343

The Enlightenment 344
English Art Becomes Respectable: Reynolds 344
Thomas Gainsborough 345
Neoclassicism 345
David and the French Revolution 346
Canova and Neoclassical Sculpture 348
Romanticism 350
Goya and the Romantic Reaction 350
The Birth of Romanticism 352
The English Landscape and Romanticism 352
Romanticism and Politics in France 353
Art News:
Turner, The Fire King 354
Ingres and Late Neoclassicism 357
The French Art World Divided 358
A Global View:
Orientalism 359
American Romanticism: The Hudson River School 361
Realism: Art And Politics 362
Lives of the Artists:
Rosa Bonheur Wears Pants! 364
Neoclassicism and Romanticism Merge in Academic Art 366

Chapter 17: Out of the Studio and into the Light: Impressionism and Postimpressionism 369

The Salons and Academic Art 371
Impressionism 372
The Salon Des Refusés and Manet 372
Out of the Studio and Into the Light 373
Monet, The Pure Impressionist 374
Monet in Giverny 376

WALTER GROPIUS, Bauhaus, Dessau, Germany, 1925–1926.

Renoir 377
Morisot 378
Degas And Cassatt 379
Art News:
Artist vs. Critic 380
Rodin's Touch 382
The Postimpressionists 383
Toulouse-Lautrec 384
Seurat and Pointillism 384
Gauguin and the Search For Paradise 386
Van Gogh: Father of Expressionism 387
A Global View:
Japonisme: Pictures of the Floating World 388
Cézanne's Revolution 392

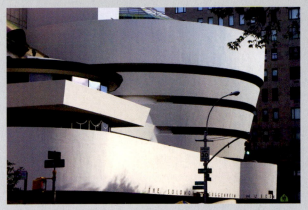

FRANK LLOYD WRIGHT, Solomon R. Guggenheim Museum, New York, 1943–1959.

PART FOUR

The Modern Era

Chapter 18: The Real World on Trial: The Early Twentieth Century 395

The Birth of a New Century 396
Munch: "Inner Pictures of the Soul" 396
German Expressionism 397
Fauvism 398
Matisse 399
Picasso And Cubism 401
A Global View:
The Living Art of Africa 402
Lives of the Artists:
The Diary of an Affair: Picasso and Marie-Thérèse 407
Abstracting Sculpture: Brancusi 408
"All Things Are Rapidly Changing": Futurism and Speed 409
Modern Warfare for a Modern World: World War I 411
Dada: To One Madness We Oppose Another 411
Art News:
Modern Art Invades America: The Armory Show 412
Marcel Duchamp And International Dada 413
The New Objectivity 415
Surrealism 417
Surrealist Juxtaposition 418
Dalí 418
Magritte: The Real World On Trial 420

Chapter 19: The Invisible Made Visible: Abstract and Nonrepresentational Art 422

Crossing the Frontier 422
The Spiritual Path to Nonrepresentation 424
Malevich and El Lissitzky: A Manifesto for Nonrepresentation 426
De Stijl 428
The International Style 428
Le Corbusier: Master of the "New Spirit" in Architecture 429
Frank Lloyd Wright 430
Abstract Art in America: O'Keeffe 431
Straight Photography 433
Art News:
The War Against Modern Art: Degenerate Art 434
The Center of Western Art Shifts 435
Abstract Expressionism: Modern Art Created In America 435
Pollock's Action Painting 436
Color-Field Painting 438
Teacher to the Next Generation 438
The New York School 439
Nonrepresentational Sculpture 440
Architecture: The Glass Box 441
Organic Abstraction 442
The Challenge of Nonrepresentational Art 444
Getting The Real World Back Into Art:
Rauschenberg and Johns 444

Chapter 20: A Storm of Images: Art in the Contemporary World 447

Pop Art	448
Venturi: Pop Architecture	450
The End of Art: Minimalism	451
Return of Representation: Superrealism	452
Architecture: Breaking Down Barriers	454
Art News:	
The Mud Angels of Florence	455
Going Beyond The Art World	457
Art Issues:	
Pilgrimages For A New Age	458
Making Room For Women: Judy Chicago	460
Changing the Nature of the Gallery Space: Performance Art	461

Art Issues:	
Why Isn't A Woman's Place in the Museum?	464
The Art World Becomes Global:	
Postmodern Art and the New Image	466
Postmodern Architecture	468
Contemporary Nonrepresentation	470
Contemporary Installations and Sculpture	471
New Electronic Media	474
Lives of the Artists:	
British Bad Boys: Hirst and Banksy	477
A Global Art World with a Rich History	479

Glossary	*485*
Photo Credits	*495*
Index	*xxx*

PREFACE

Early in the opening ceremonies of the 2008 Summer Olympics in Beijing, thousands of spectators and millions of viewers around the world were enchanted by an unexpected display of the power of art. In the middle of the Bird's Nest Stadium (see 20-25), sparkling against the night sky, a giant cylinder appeared and unrolled across the floor. What seemed to be an enormous ancient Chinese scroll painting was actually a technological marvel—a flexible LED screen one hundred sixty yards long and seventy-two feet wide. Designs from prehistoric rock paintings filled the background. Drifting across this screen, art and artifacts from five thousand years of Chinese civilization emerged and floated slowly like clouds across the sky.

At the screen's center was a pure white rectangle that looked like an empty sheet of paper. Figures dressed in black stood at the edge of this space, until one slowly stepped onto its surface and began an acrobatic dance. Viewers were amazed when he tumbled across the page, leaving what appeared to be a curving stroke of black ink. Mesmerized by the sight, a hush fell over the thousands in the stadium as he drew new lines with each long sweep of his arm. Soon, a design of curling loops emerged on the electronic canvas.

The dance was accompanied by traditional Chinese music. Other dancers entered, their bodies and sleeves acting as paintbrushes, too. As they continued to dance, the LED background around their canvas changed to one of the most famous paintings in China, "A Thousand Li of Rivers and Mountains" from the twelfth century. By their dance's finale, the movements of the athletic artists had created their own ink painting of water and mountains, too. So the giant scroll's background and center shared a theme that symbolizes harmony and balance in Chinese culture.

What was just as impressive as the performance was the silence in the stadium during it. Ninety thousand people from nations all around the world sat enthralled by the magic of seeing a work of art created before their eyes. Only when the painting and choreography were finished did the audience burst into applause.

On the other side of the globe, that same quiet can be heard every day in a small room in Berlin's Neues Museum. The room is empty except for a tall glass

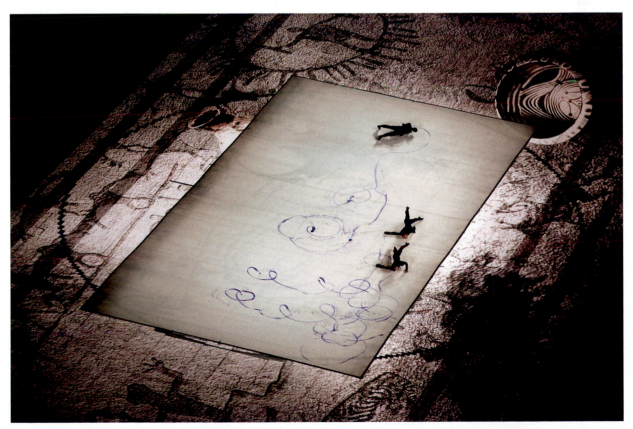

Dancers performing on giant LED screen during opening ceremonies of Beijing Summer Olympics in 2008.

cabinet at its center. In it, lit simply from above, is a bust of Nefertiti, ancient queen of Egypt (below and 12-3). Unlike the scene in the Birds Nest Stadium, technology has little place here. Cameras and cell phones are not permitted and the guards are very vigilant. Visitors see Nefertiti with only the glass of the cabinet between them and a three thousand year-old masterpiece. They circle around her slowly and typically stay for a long time staring at a woman who symbolized beauty not only in her time but for many centuries since. The museum that houses the Sun Queen is enormous, made up of three floors filled with fabulous ancient artifacts, including some of the treasures of Ancient Troy. But it is an open secret that here Nefertiti has no rivals. The crowds have come to see her. She presides over them with a small regal smile, forever patient, a queen for all time.

The atmosphere in the room is one of reverence and respect for the power of art. The intensity of the viewers' gazes and the mesmerized expressions seen in Berlin could also be seen in the stadium in Beijing. Whether ancient or twenty-first century, the power of art seems to transcend time and geography. Why else would over a billion people each year visit museums across the globe? In the United States alone, eight hundred fifty million people enter museums annually, many more than the four hundred seventy million who go to theme parks and all the major league sporting events combined. The creative urge itself appears to be primal and something that is an essential part of being a human being. Recently, prehistoric cave art made by children over thirteen thousand years ago was discovered in caves in both Europe and Australia. There appears to be no society in history that didn't make and admire art of some kind.

The writing of this third edition comes just after the end of the first decade of the twenty-first century—a good time to take stock of recent changes in the art world. We have made a special effort in this edition to reflect the increasing impact of women and non-Western painters, sculptors, architects, photographers, and designers in the art world today. We also wanted to present artists as real people, and have added a new series of boxes called "Lives of the Artists" that will give you a peek behind the curtain so you can better understand the lives they lived. The exciting convergence of artistic media and cross-pollination of artists across the globe enabled by the internet, as described in our previous edition, has only expanded. New technologies, like three-dimensional

printing, have added even more tools to the deep toolbox of today's artists. Our access to information, images, videos, and sounds is unprecedented in human history, showering us with an embarrassment of riches. This text is designed to help you navigate this flood of imagery in a clear, understandable, and enjoyable way.

We do not expect that you will rush out to see each of the works you will be introduced to in this book. That is the work of a lifetime, not a semester. These works of art are held in museums and galleries all across the world. The goal is to inspire you to look at art and to give you the tools to enjoy the experience. We hope to help you understand why the visual arts are treasured by so many people of all races and creeds. We also try to make sense of why so much money has been spent (and will continue to be spent) to preserve, conserve, and protect the most famous works of art, so the power of art can be enjoyed not only today, but tomorrow by your children and future generations.

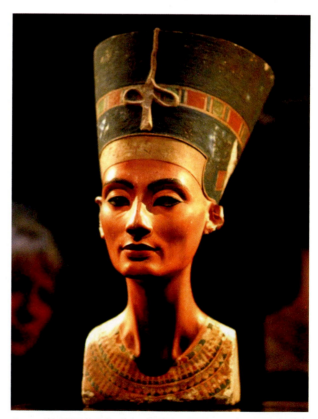

A woman looks at the bust of Queen Nefertiti, c. 1340 BCE, at the Neues Museum (New Museum) in Berlin, Germany.

CHAPTER-BY-CHAPTER CHANGES IN THE THIRD EDITION

1: The Power of Art. New discoveries of prehistoric cave art by children in South Africa and France. The art of tattoo among the Maori added. New art and artists: Michelangelo and the Medici Chapel, and a new box, "Nick Cave: The World is His Palette."

2: The Primary Elements. New discussion on the Hindu festival of Holi. New art and artists: Hokusai, *Boy Playing a Flute*; Calder, *Josephine Baker*; Caravaggio, *David with Head of Goliath*; Olaf Eliasson, *The Weather Project* at the Tate Modern; and John Constable, *The Haywain*.

3: Principles of Design. New art and artists: Matisse paper cutouts, *Jazz (The Burial of Pierrot)*; Daniel Chester French; Gabriel Orozco, *La D.S.*, modified Citroen; Andrea Dezsö's tunnel book, *Gentle Beast Hiding Among Leaves*; and George Caleb Bingham, *Card Players*.

4: Drawing. New art and artists: Ingres, *Study for portrait of Louise d'Haussonville*, graphite; Odilon Redon, *Sita*, pastel; Rembrandt, *A Sleeping Woman*, ink.

5: Painting. New art and artists: Diego Rivera, *Detroit Industry*, fresco; Raphael, *Alba Madonna*, oil; John Singer Sargent, *Venice: La Salute*, watercolor; Wangechi Mutu, *One Hundred Lavish Months of Bushwack*, mixed media.

6: Printmaking. New art and artist: Betsabeé Romero, *Always finding another cage*. New box: "June Wayne—Artist, Printmaker, Catalyst."

7: Photography and Time-Based Arts. New artists: Thomas Demand, *Junior Suite*; Laila Essaydi, *La Femmes du Maroc: La Grande Odalisque*; and Levi van Veluw, *Landscape 1*.

8: New Media. Time and Digital Arts. New art and artists: Jun Nguyen-Hatsushiba, *Vietnam-A Memorial Work;* Nina Paley, *Sita Sings the Blues;* and Julius Popp, *bit.fall.*

9: Sculpture. New discussions on the digital technique of 3D printing and an explanation of patina. New art and artists include: Sarah Sze, *Corner Plot*; Michelangelo, *Atlas Slave*; Louise Nevelson, *Tropical Garden II*; and Stephanie Lampert, *Fly Away?*, 3D printed sculpture. A New box has been added, "The Wood Sculptures of Martin Puryear: Handmade Contemporary Art."

10: Architecture. New in-depth discussion of Frank Gehry, Guggenheim Museum of Art, Bilbao, Spain. New art and artists: Zaha Hadid, *MAXXII—Museum of XXI Century Art*, Rome and Thomas Heatherwick, *Seed Cathedral*, Shanghai.

11: Crafts and Design. New art and artists: Louis Comfort Tiffany, *Autumn*, stained glass; Dale Chihuly, *Inside and Out*; Marian Bantjes, *Valentine*. New box: "Elsa Schiaparelli: Fashion as Art."

12: Ancient Empires, Ancient Gods. New art and artists: Tschumi and Photiadas, *New Acropolis Museum*, Athens; Apollonius (attr.), *The Seated Boxer*; *Gardenscape* from the Villa of Prima Porta. New box: "The Elgin Marbles Controversy."

13: The Age of Faith. New art and artists: Anthemius of Tralles and Isidorus of Miletus, Interior of Hagia Sophia and Kosho, *Portrait statue of the priest Kuya preaching*.

14: A New Perspective: The European Renaissance. New art and artist, Fra' Filippo Lippi, *Madonna with Child and Angels*.

15: Drama and Light: Mannerism, the Baroque, and Rococo. New art and artists: Jacopo Pontormo, *Deposition from the Cross*; Artemisia Gentileschi, *Judith Slaying Holofornes*, Uffizi; Rembrandt, *Self-Portrait as a Young Man*. New box: "Tumultuous and Tortured Lives: Caravaggio and Gentileschi."

16: The Battle of the -isms: Classicism, Romanticism, and Realism. New art and artists: Francisco Goya, *Saturn Devouring His Son*; J.M.W. Turner, *Burning of the Houses of Parliament*; Jean-Léon Gérôme, *Death of Caesar*. New box: "Turner, the Fire King."

17: Out of the Studio and into the Light: Impressionism and Post-Impressionism. New art and artists: Alexandre Cabanel, *The Birth of Venus*; Auguste Rodin, *The Kiss*.

18: The Real World on Trial: The Birth of Modern Art. New art and artists: Andre Derain, *London Bridge*; Henri Matisse, *Purple Robe and Anemones*; Pablo Picasso, *The Dreamer*. New box: "The Diary of an Affair: Picasso and Marie-Thérèse."

19: The Invisible Made Visible: Abstract and Non-Representational Art. New discussion on Suprematism in Russia. New art and artists: Vasily Kandinsky, *Panel for Edwin R. Campbell No. 1*; Kazimir Malevich, *Suprematist Composition: Airplane Flying*; El Lissitzky, *Beat the Whites with the Red Wedge*; Imogen Cunningham, *Leaf Pattern*; Mark Rothko, *Untitled (Painting)*, 1953-1954; Hans Hofmann, *The Golden Wall*; Mark di Suvero, *The A Train*.

20: A Storm of Images: Art in the Contemporary World. New art and artists: Roy Lichtenstein, *Drowning Girl*; Ana Mendieta, *Tree of Life*; Herzog and de Meuron, *Bird's Nest Stadium*, Beijing; Julie Mehretu, *Stadia I*; Damián Ortega, *Cosmic Thing (deconstructed Volkswagen Beetle)*; Petah Coyne, *Buddha Boy*; Nam June Paik, *Electronic*

Superhighway; Cory Arcangel, *Super Mario Clouds* (modified videogame); Damien Hirst, *For the Love of God* (diamond encrusted platinum skull); Banksy, *Cans Buffer* (street art); Takashi Murakami, *727*; Yinka Shonibare, *The Swing (after Fragonard)*; El Anatsui, *Between Earth and Heaven*; and teamLab, *Life Survives by the Power of Life* (computer animated video). Two new boxes: "The Mud Angels (of the 1966 Florence flood)" and "British Bad Boys: Hirst and Banksy."

ACKNOWLEDGMENTS

This book is the product of many years of teaching—our own as well as that we received as students. We would like to acknowledge the excellence, dedication, and influence of Abe Ajay, Rudolf Arnheim, George Bayliss, Antonio Frasconi, Al Hinton, Gerome Kamrowski, Al Mullen, and Leonard Stokes, as well as Paul Berry, Dorothea Fisher, Eugenia Janis, Kenworth Moffet, Warren Roberts, and Clara Tucker. The following colleagues at Marist College, Istituto Lorenzo de Medici, and SUNY New Paltz were especially supportive during this and previous revisions of *The Power of Art*: Artin Arslanian, Fabrizio Guarducci, Dennis Murray, Steven Poskanzer, and Thomas Wermuth.

As we revised the manuscript, many friends and colleagues offered advice, inspiration, perceptive comments, and analysis that aided us immensely. We are indebted to Lorenzo Casamenti, Stefano Casu, Donise English, Kit French, Thomas Goldpaugh, David Krikun, James Luciana, Michele Rowe-Shields, Thomas Sarrantonio, Ed Smith, Steve Vinson, Tim Watson, Jerry White, and Beth E. Wilson.

Over the years, we have been encouraged by enthusiastic readers among younger friends like Sarah and Amy Gross, Hannah Shreefter, Allison Oldehoff, and Elizabeth Moskowitz; and older art aficionados like Belle Bennett, Marjorie Brockman, Dr. Jay Levine, Edward Lewis, Ruth Page, Abby Schlossberg, and Scott Skodnek.

In developing the third edition, we responded to the recommendations of the many instructors who used the first and second ones. We would like to thank in particular the following reviewers whose perceptive comments and analysis were extremely helpful in the preparation of this book:

Nicholas Alley, Austin Peay State University; Melanie Atkinson, Hinds Community College; Rodrigo Benavides, St. Philip's College; Shawn Camp, Austin Community College; Nancy Cason, Belmont University; Claire Hampton, Volunteer State Community College; Stephen Henderson, Quinnipiac University; Katherine Jones, Central Michigan University; Jennie Klein, Ohio University; Pamela Lee, Washington State University; Cynthia Mills, Brookhaven College; Susan Mulcahy, Volunteer State Community College; Carol Norman, Jackson State Community College; Aditi Samarth, Richland College; Betty Siber, Collin College; Susana Sosa, Fresno City College; Sherry Stephens, Palm Beach Community College; Al Wildey, Central Michigan University; and Ted Wygant, Daytona State College.

Like the art world, the publishing world is in the midst of both a Digital and Global Age, too. The way this text was produced reflects these important changes. The publishing team for Cengage Learning was not located in an office building, but was spread across the United States and worked with sources all over the world. Despite the distances, we always felt a part of a talented and dedicated team. We want to thank our publisher, Clark Baxter, who contributed good spirits, a great sense of humor, and his keen judgment to the entire project; our development editor, Sharon Adams Poore, who managed to be the voice of reason, encouragement, and faith in the long process of revision and production; our project manager, Lianne Ames, who kept a steady hand on the steering wheel during the obstacle course that is publishing today; Chad Kirchner, media editor; Ashley Bargende, assistant editor; Marsha Kaplan, editorial assistant; and to Joshua Adams and Lydia LeStar for their marketing support.

We also want to thank our production manager at Lachina, Whitney Thompson, who calmly managed the complicated production process; and our ingenious and persistent photo researcher, Corey Anne Geissler at PreMediaGlobal, who surprised us with her ability to find the most challenging images so many times.

Finally, we would like to thank our students, many of whom sent us links and brought us articles and catalogs, but more importantly, who showed us the way to create a book that could transmit the power of art. The enthusiastic love for art of Erich Alejandro, Nicholas Baish, Jessica, Rachael, and Toni-Marie Chiarella, Zoe Christopher, Joe Concra, Zach Crittenden, Rich Dachtera, Matt Daly, Stefanie DeRario, Kim Dowd, Jessica Friedlander, Ryan Khoury, Jonathan Kiselik, Heather Krumm, Kevin McKiernan, Mike Milano, Joe Molloy, Danielle Morrison, Caitlin O'Hare, Matthew O'Neill, Christopher Perry, David

Restiano, Richard Santiago, Nik Sardos, Rebecca Smith, Joe Ventura, and many more students like them, is what encouraged us in the many years it took to bring this text to completion.

Last, but certainly not least, we would like to express love and appreciation to our son, Rob, for putting up with constantly busy parents and a really messy house for his entire childhood. Someday, we hope you will think it was worth it.

Richard and Susan Lewis

INSTRUCTOR RESOURCES

Powerlecture Flashdrive

This all-in-one presentation tool makes it easy to incorporate high-resolution digital images into your lectures. You can assemble, edit, and present customized lectures with the Digital Image Library that provides high-resolution images—maps, diagrams, and fine art images from the text. Use the PowerPoint presentation format or individual file formats compatible with other image-viewing software programs and even add your own images. A zoom feature enables you to magnify selected portions of an image for more detailed display in class. PowerLecture also includes a comparison-and-contrast feature, an Instructor's Manual and ExamView computerized testing with multiple-choice, matching, short-answer, and essay questions.

WebTutor™ on Blackboard® and WebCT®

Create and manage your custom course website by providing virtual office hours, syllabi, threaded discussions and track student progress with the quizzing material, and much more. Student resources include access to an interactive eBook; image flashcards that are linked to interactive content so students can review related material and test themselves, Video Study Tools, Audio Study Tools, and ArtTours. In addition, students can access the "Compare/Contrast" feature with interactive quizzes, "Foundations" modules that demonstrate art concepts and ideas, "In the Studio" video footage of interviews discussing the art-making process, "A Closer Look" section that presents web links that expand on material in the book, and more.

STUDENT RESOURCES

CourseMate

No need to make your own flashcards! Make the most of study time by accessing tools to succeed in one place. Open the interactive eBook, take notes, review image flashcards, watch videos, and take practice quizzes online with CourseMate. Additionally you will find "Foundations Interactive" modules, "In the Studio" video footage of art classes, quizzing and image flashcards which include most fine art images in the text, maps, illustrations, and more.

CHAPTER 1

THE POWER OF ART

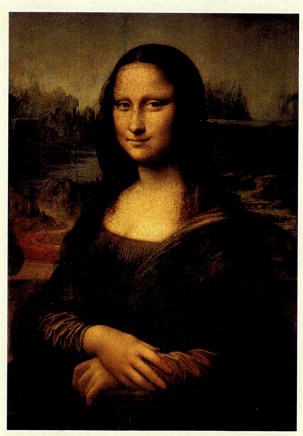

More than eight million people enter the Louvre Museum in Paris each year, making it the world's most visited museum. It is estimated that the museum generates the equivalent of nearly $1 billion in annual revenue for France. Although the huge palace contains hundreds of thousands of objects, many, if not most, visitors have come to see the most famous painting in the world, Leonardo da Vinci's *Mona Lisa* (**1-1**). Signs are posted throughout the vast museum, marking the way to its legendary masterpiece. Outside the room where the painting hangs, there is often a long line just to enter and join the crush of the crowd. Inside, there are other paintings by some of the most talented artists in history, but viewers surround only one, jostling each other, pushing toward it to get a better look. Above the crowd, one can see arms lifting cell phones and cameras and flashes going off. Tourists treat the painting like a famous landmark, posing for their pictures beside it. Guards are always nearby, and wooden barriers keep viewers at a distance. Deep within a massive case of bulletproof glass that dwarfs the small painting, the same elegant woman who has captivated generations of art lovers regards them with her inscrutable smile.

THE *MONA LISA*
HAS BEEN STOLEN!

The *Mona Lisa was* actually stolen from the Louvre in 1911, causing a national scandal. Although the complete story will never be known, it is believed that the theft was an attempt to sell not only the original *Mona Lisa* but also many forged copies. The forger's plan was that upon the shocking announcement of the painting's theft, unscrupulous wealthy collectors around the world could be easily duped into buying his forgeries of the masterpiece.

The forger contacted a former employee of the Louvre, Vincenzo Peruggia, to arrange the theft. Peruggia and his accomplices, dressed as staff members, entered the museum as it closed on Sunday afternoon, August 20, 1911. The museum would not open again until Tuesday. The thieves hid in a broom closet and slept overnight in the museum. Early the next morning, they removed the painting from its frame and carried it through the many galleries, planning to tell anyone who saw them that they were bringing the *Mona Lisa* to the staff photography lab. The only one who did see them was a plumber, who helped them open a stuck door.

No one knew the painting was missing until the next day. As the word spread, art lovers flocked to the Louvre

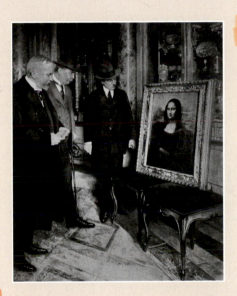

1/2 French officials examine the *Mona Lisa* after its return.

and left flowers where she had once hung. Investigators turned up few clues beyond the now-empty frame. In an ironic twist, Picasso, then a young, impoverished artist, became a suspect after two small statues from the Louvre were discovered in his studio. Meanwhile, Vincenzo Peruggia, still in Paris, hid the painting under a stove in his room.

Two years passed before Peruggia wrote to an antiques dealer in Florence, Italy, and offered the painting for sale. *Mona Lisa*'s homecoming to the city where she was painted was far from glorious. In December 1913, she traveled by train in a wooden trunk, under a false bottom, covered by old shoes and clothing. When Peruggia presented the missing masterpiece to the dealer and a museum director, he was promptly turned over to the authorities. At the trial, the thief, who was born in Italy, claimed that he had stolen Leonardo's masterpiece to return it to its rightful place in his own country. A sympathetic Italian jury sentenced Peruggia to only a few months in jail. After the trial, the *Mona Lisa* was displayed briefly in her birthplace and then was finally returned to the Louvre (1-2).

Painted at the height of the Italian Renaissance, this fascinating portrait of a woman has attracted attention for centuries. Poems and songs have been written, essays and scholarly works composed, about an oil painting that measures less than two feet by three feet. Even in our contemporary world awash in digital images, the power of da Vinci's portrait continues to transcend time. Legends have grown up around the picture—for instance, that the *Mona Lisa*'s eyes follow one around the room. Another legend suggests that the painting on display is no longer the genuine *Mona Lisa* (see "Art News" box).

What is it about this painting that has elevated it, not simply to the height of a masterpiece but to the symbolic pinnacle of Western art? How can a work of art become so valuable that it is seen as priceless? What gives the *Mona Lisa* its power over people from different centuries and cultures? Although many people have spoken of the air of mystery that surrounds the picture of the woman with the haunting smile, on first viewing it is common to find the picture a disappointment. The glass makes it difficult to see, and what we see is not exactly what Leonardo painted. The art historian Kenneth

Clark described the *Mona Lisa* as "the submarine goddess of the Louvre," a phrase that accurately reflects the dominant greenish tone of the painting as well as its aquarium-like casing. Yet the earliest known description of the portrait raves about the warmth of the colors, the rosy nostrils and red lips, as well as the overall tone of the face that "seemed not to be colored but to be living flesh." Not only has the color faded, but also at some point in its history the painting was made smaller, probably to fit into a frame, slicing off a pair of columns that once surrounded her.

LOOKING AT ART

LEARNING HOW TO SEE

Despite these ravages of time, it is possible to consider what makes the *Mona Lisa* a masterpiece. Whatever the type of art in question, the first step in learning to appreciate art is simply learning to *look*. This is more challenging than is usually believed. We often think of looking as a passive act, as in watching TV or clicking through pictures on a webpage. But studying the visual arts requires more than empty viewing; seeing can be *active* rather than passive. When primitive people looked at the world, they had to *observe* nature because they were hunters and gatherers; they depended on their eyes for survival. In their world, everything was natural and real; very little was made by humans. We, on the other hand, live among literally millions of images, not only in books or on a screen but also on almost everything we touch—from cereal boxes to printed T-shirts. As opposed to earlier periods, most of what we see and interact with is human-made. This constant bombardment by printed, video, and digital images has made us visually sophisticated, but it can also leave our eyes numb.

Artists often say that someone can really "see," as if most people cannot. What an artist means by **seeing** is difficult to explain, but it is something like the totally involved gaze of a newborn child, hungrily looking at everything as if it had never been seen before, not blinded by preconceptions. All of us like to see new things, but in the midst of a busy life our seeing becomes stale, our eyes jaded. Art can renew the pleasure of seeing and help us feel more alive. Many people have had the exhilarating experience after leaving a museum of noticing that the world outside looks much more interesting and beautiful.

Let's return to the *Mona Lisa* and look at her carefully. First, the image is beautiful. It is not simply that this is the portrait of an attractive woman—in fact, *La Gioconda* (Lisa del Giocondo) looks less than ideal to contemporary eyes. Although it is safe to assume that she was considered nice-looking by the standards of the sixteenth century, Leonardo did not give her face (see detail, **1-3**) the same perfect beauty he gave to his drawings of angels, for example. But what makes a work of art famous is less the quality of the subject than the way it is interpreted by the artist. The *Mona Lisa* is beautifully and gracefully painted. Viewers are attracted to da Vinci's work through the power of his skill as a draftsman and painter and his remarkable ability to bring his subject to life.

This lifelike quality made the *Mona Lisa* famous in its own time. According to the painter Giorgio Vasari, Leonardo's contemporary:

> Altogether this picture was painted in a manner to make the most confident artists—no matter who—despair and lose heart . . . in this painting of Leonardo's there was a smile so pleasing that it seemed divine rather than human; and those who saw it were amazed to find that it was as alive as the original.

As Vasari recognized, the *Mona Lisa* revolutionized the art of portraiture, adding movement and life in a way never seen before.

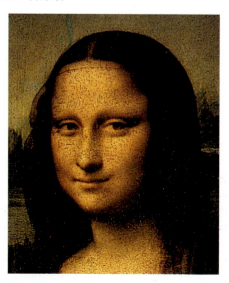

1/3 **Detail of figure 1-1: face of** *Mona Lisa.*

METHODS AND MATERIALS

Leonardo wrote in his notebooks, "moderated light will add charm to every face," as anyone who has been on a date in a candle-lit restaurant knows. Leonardo used oil paint to recreate this effect, which he called **sfumato lighting** (in Italian, "the soft mist of a fountain"), a soft light that dissolved edges and made details unclear. The *Mona Lisa*'s eyes and mouth were bathed in sfumato light by Leonardo because he knew those are the two most important areas we look at on a face. Because they are left unclear, our imagination fills them in; the lips seem to move and give the *Mona Lisa* life. Leonardo's use of sfumato lighting is responsible for the legends surrounding this painting—her inscrutable smile and the eyes that look at you and then away.

Leonardo generated a sense of movement in another way. Notice how the background does not line up on either side of the *Mona Lisa*'s shoulders. This was intentional: Leonardo wanted to create the illusion that his subject is shifting her shoulder while we are looking at her. Leonardo understood how people *see*, perhaps better than anyone who had ever lived, and he used this knowledge in subtle ways to create the illusion that his *Mona Lisa* was a real person. In fact, this is how viewers have always responded to her.

PLACING ART AND ARTIST IN HISTORICAL CONTEXT

Great art reveals the spirit of the age that produced it. Therefore, we need to know when and who made a work of art so we can begin to consider how this affected its form. The grace and beauty of Leonardo's *Mona Lisa*, for example, reflects the value placed on these qualities during the Italian Renaissance. She also illustrates the highly prized attribute of aloofness—what the Italians called *sprezzatura*, a kind of aristocratic refinement and calm.

The life of Leonardo da Vinci represents many other Renaissance values as well. Leonardo was an independent thinker, a scientific observer of nature, an imaginative inventor, and a delightful conversationalist, as well as a talented artist. He filled many notebooks (1-4) with his observations, drawings, poems, and philosophical theories. Above all, he exemplifies a crucial Renaissance idea credited with giving birth to the modern age—*individualism*. Renaissance thinkers conceived of human beings as potentially godlike creatures with immense physical, intellectual, and creative powers. Part of the mystique of Leonardo's art is that it was done by one of

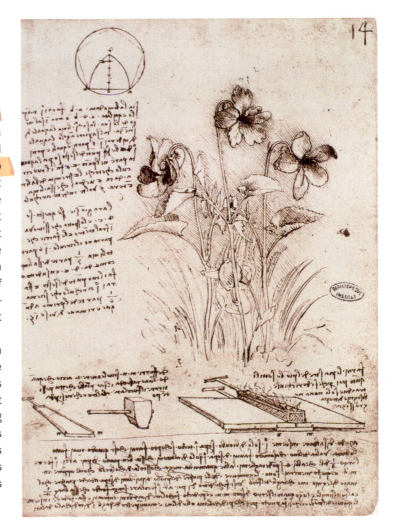

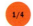 **LEONARDO DA VINCI,** *Drawing of Flowers and Diagrams.* Study from the notebooks, c. 1490–1519. Black chalk and ink, 9⅛" × 6½". Institut de France.

the first individuals to be considered a creative genius in the modern sense.

No one can really be sure why Leonardo painted this portrait of twenty-four-year-old Lisa del Giocondo, the wife of an important Florentine merchant, at the same time when the artist was refusing paid commissions from more notable persons. We do know that Leonardo worked on the *Mona Lisa* for decades and never considered it finished. Because he reworked the image over and over, carrying it with him on his travels, the painting must have exerted the same endless fascination over the artist as it has over its viewers. Leonardo died of a stroke in France, the guest of King Francis I (who moved his mother and sisters out of a chateau so da Vinci could take up residence there), so the *Mona Lisa* became part of the royal art collection. That is how it came to be in the Louvre Museum in Paris, and why it eventually became identified as not only a part of Italian culture but French culture as well.

ART AND CULTURE

Western cultures are not the only ones to see works of art as priceless. The Japanese, for example, have an elaborate system of rating works of art and their value to national heritage. The most valuable artworks are designated as Japanese **National Treasures**, while other significant works of art are categorized as Important Cultural Properties. Because of their historic and aesthetic importance, National Treasures (ranging from huge statues and painted screens to fragile decorated boxes and ceramic vessels, such as teacups) cannot be sold or taken out of the country. In Japan, even people—such as the most famous and accomplished living artists—can be given the official title of National Treasure.

One of the works of art designated as a Japanese National Treasure is the wooden statue of the *Amida Buddha* (the Buddha of the West, 1-5), carved by the sculptor Jocho in the eleventh century. This statue is part of an entire sculptured environment, a grouping of many gilded wooden figures that decorate the central hall of a Buddhist temple designed for an aristocratic family of the period. Because of their great age and the high quality of their design and carving, all of the figures in this sculptural group qualify as National Treasures, which are considered as valuable to Japanese heritage as the Statue of Liberty is to Americans.

Even if we know little about Buddhism, we can be impressed by the elaborate carving and huge scale of this sculptural group. Just a few feet inside the tall central doors, one comes face to face with the towering *Amida Buddha* on his lotus flower throne. Nearly twelve feet high, covered with gold leaf, he is surrounded by dozens of music-making angels that hang on the walls. One is also impressed by the excellent preservation of statues that will soon be a thousand years old. But try to imagine it as it first was, when all the angelic bodhisattvas were painted in bright colors, with white shrouds, blue hair, gold instruments, colorful tiaras, and necklaces. The Central Hall was painted in vivid colors—too-bright red vermillion with bits of mirrors and mother of pearl to reflect light—showing souls being welcomed to paradise. Imagine how powerful this vision of paradise must have seemed to the followers of the Pure Land Buddhist sect, who believed that when they died, their God would

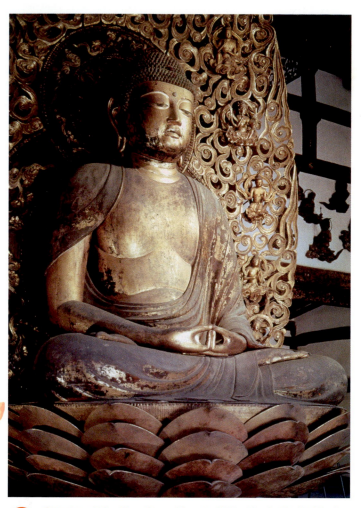

1/5 Interior of the Ho-o-do or Phoenix Hall with *Amida Buddha* by JOCHO, 1053. Gilded wood, 9' 4" high. Byodo-in Temple at Uji, Japan.

descend and lead their souls to a blissful paradise. It is this very descent, the floating of the Amida to earth, and the celestial paradise of dancing and music-making angels, that Jocho brought to life.

Just as the *Mona Lisa* reflects the ideals of Renaissance Italy, this Japanese sculptural group reflects the taste and beliefs of the world in which it was created. Eleventh-century Japan was dominated by a ruling class that valued elegance and courtly manners above all. The Amida cult appealed particularly to the upper classes because its promised paradise resembled a continuation of the luxurious life of beauty and ease they knew on earth. The Buddha, as seen by Jocho, is as refined and aloof as a prince who looks down graciously at his worshippers; the dancing angels are like so many well-bred royal attendants. The slimness and delicacy of the carvings, the richness of the bright colors and shimmering gold with which they were painted (now except for a few restored ones, see detail, 1-6, worn off), were perfectly in tune with both the subject they represented and the

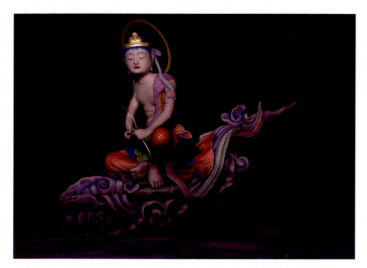

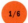 Angel on clouds with restored colors from Phoenix Hall.

patrons for whom they were made. Yet even today, in a completely changed world, embracing different religious beliefs, brought up in a different culture, we can appreciate the skill and genius that make Jocho's sculptural grouping a great work of art.

THE POWERS OF ART: BRINGING FAITH TO LIFE

Through art, the deepest and most intangible beliefs of a culture can be translated into powerful images that communicate specific spiritual messages to the people who view them as part of their religious rituals. From the beginning of humanity, people have expressed their beliefs in material form. They pictured their gods and goddesses in statues and paintings; they built places for worship and religious rites. The *Amida Buddha* is an excellent example of how art brings religious beliefs to life. In some periods, such as the Middle Ages in the Western world, most art was religious in character. So much visual art is related to human beliefs and rituals of worship that it would be easy to fill an entire library with books exploring the relationship between art and faith in different cultures.

PREHISTORIC ART AND MAGICAL POWERS

Art need not be as beautiful as the *Mona Lisa* or as elegant and sophisticated as Japanese sculpture to be considered great art. Some of the most powerful art ever made was done more than ten thousand years ago by the prehistoric hunting tribes who inhabited Europe before and during the last Ice Age. One of the very earliest known artworks of this period is a tiny (4-1/8 inch) carved

stone figurine known as the *Venus of Willendorf* (1-7): *Venus* because it is obviously female, *Willendorf* after the town in Austria where it was found. Although its exact purpose and meaning remain shrouded in the mists of time, scholars have surmised that this female fertility figure was used as some kind of magical charm. With her exaggerated breasts, belly, and buttocks, this faceless Stone-Age Venus provides a powerful visual image of the life-giving earth mother. Such fertility symbols were repeated in many different materials and locations throughout Europe and were probably connected with rituals that associated human fertility with the survival of the Ice-Age clan or tribe. For the Stone-Age people who made and used them, these were not works of art in the same sense that we understand the term. These amulets were made to be touched, held, carried, stroked, and worshipped—not to be viewed as beautiful objects in a glass cabinet, or admired as the works of individual artists.

As old as the Venus is, we now know that artmaking is much older. In 2011, a 100,000-year-old art workshop

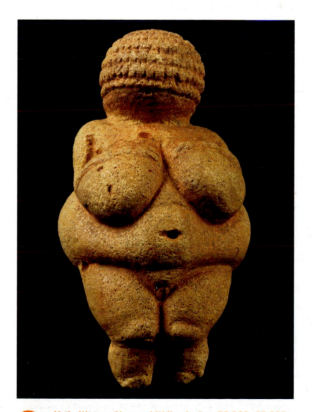

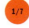 *Nude Woman (Venus of Willendorf)*, c. 30,000–25,000 BCE. Limestone, 4⅛" high. Naturhistorisches Museum, Vienna, Austria.

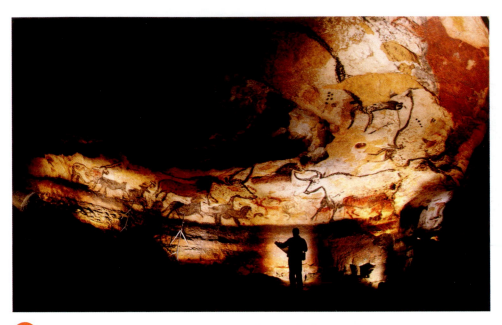

1/8 Paleolithic bulls and other animals crowd calcite walls, Lascaux, France.

was discovered in a South African cave. Inside were grinding tools, paint pots, and even traces of yellow, reddish ocher, and black charcoal pigments. Evidence revealed that the pigments were mixed with fat to make paint. Although no paintings survived, handmade beads were also found. These art materials are at least sixty thousand years older than the first-known examples of cave painting and sculpture.

Also in 2011, prehistoric art by preschool-age artists was discovered in a series of caves in France. Apparently while sitting on the shoulders of their parents, young artists made thousands of decorative **flutings,** or scraped finger tracings on the soft stone ceilings. By the size of the marks, we know some artists were as young as three years of age. The most flutings were done by a five-year-old, believed to be a girl. Wider marks reveal that the adults also joined in.

Other creations of Ice-Age tribes living in what is now France and also Spain include the earliest surviving paintings (**1-8**). Popularly known as cave paintings, these dramatic prehistoric pictures were done around 15,000 BCE. When the decorated caves at Lascaux, France, were discovered (accidentally in 1940 by some boys looking for an underground entrance to an old chateau), they caused a sensation throughout the worlds of history, archeology, and art. On these rocky walls, viewers can gaze back at the handiwork of peoples whose culture remains shrouded in mystery. Entering into the eerie, dark caves, viewers find pictures of huge Ice-Age beasts. The primary subjects of these early cave paintings are animals—most often bulls, horses, and bison, sometimes mammoths and woolly rhinoceroses. Humans were rarely shown. The depiction of these wild animals was not simplified or awkward; the cave paintings do not resemble the art of children. They are *naturalistic*, because the animals were drawn in motion, as if they were alive. Even without photographic details, contemporary viewers have no problem telling that one form is a horse, another a bull (**1-9**).

Were these images meant as records of successful hunts, or were they part of magical rituals meant to ensure success for future hunting parties? We cannot be absolutely sure of their purpose, but the most common explanation for the cave paintings is that they were used by their creators in magical rites. It is certainly unlikely

1/9 *Scene of the Hunt.* Prehistoric Cave Painting, Lascaux Caves, Perigord, Dordogne, France.

that these pictures were simply decoration for people's living quarters. Most are painted in dark, difficult-to-reach parts of the caves, portions that show no archeological evidence of having been lived in. We do know that the artists came to these special caves to paint on scaffolds by the light of oil lamps; remnants of the lamps and their palettes, along with the holes for their scaffolds, have been found. After the paintings were completed, the caves and their images seem to have been used in ceremonies for thousands of years.

THE POWER OF ART FOR TRIBAL PEOPLES

Painting and carving in rock walls, known as **rock art**, was not simply a prehistoric European phenomenon. Rock art can be found in North America, Asia, Australia, and all across Africa. These sites reveal that art played a vital role in the rituals of tribal peoples for tens of thousands of years. In fact, this role remained uninterrupted until well into the twentieth century. Not only does African rock art depict long-extinct animals, but it also includes images of European colonists and their wagons alongside tribal hunters.

Tribal art is the art of any area of the world where people lived or still live in a preindustrial state—generally without permanent buildings, written language, or modern technology. Such art is what art historians once called *primitive art*, and it was originally considered crude and uncivilized by Western Europeans and Americans who came in contact with the "undeveloped" cultures that produced it. But at the turn of the nineteenth century, their attitude changed. Tribal art was seen as new and exotic, valued by collectors and artists for its immediacy and impact. More recently there has been an attempt to appreciate and understand the arts of tribal peoples living around the world as an expression of the cultures and beliefs that produced them.

For instance, African masks have been popular with European and American art collectors for more than a century and had a dramatic impact on the development of modern art. In Western museums, these sculptural masks are usually displayed as isolated art objects (1-10), hung in tasteful arrangements on white gallery walls. Because of their strong sense of design, masks exhibited even in this static way retain their visual power, but the power of their original meaning has been lost. Within the culture and religion for which they were created, masks convey a variety of complex messages that are unknown to most museum viewers and are often obscure even to the collectors who purchase them. Masks are meant to be worn in association with elaborate

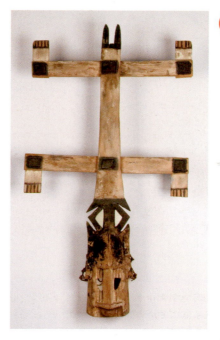

1/10 *Mask (Kanaga).* Dogon, Mali, twentieth century. Wood, polychrome, fiber, 43 1/16" high. Gift of James M. Osborn for the Linton Collection of African Art. Yale University Art Gallery, New Haven, CT.

costumes, during ceremonies where traditional songs and dances are performed (1-11). Within these ceremonies, which are scheduled according to the agricultural calendar and can last for several days, the masks have magical functions. For instance, some masks are supposed to transmit the spirits of the gods or ancestors they represent to the dancers, enabling them to dance for hours (see "Global View" box).

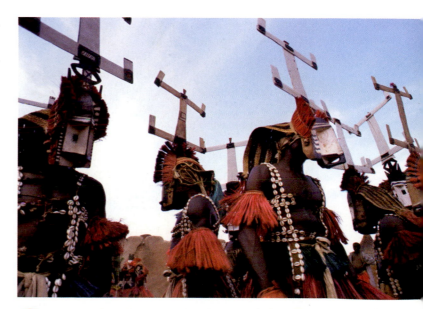

1/11 Ceremony in Dogon village of Tiogoï Republic, Mali, West Africa.

JOURNEYS TO THE
SPIRIT WORLDS

Although it is not possible to travel back in time to research the mythology of early humans, we can look at the beliefs of tribal societies today. For example, the Eskimos of the Arctic Circle live in an incredibly harsh environment, surrounded by many natural dangers. According to their beliefs, everything—animate beings such as animals and inanimate objects such as stones—has a spirit. These spirits can be contacted by a shaman, or magician/priest. Eskimos believe in an undersea kingdom of supernatural beings as well as a heavenly realm. Their gods include both helpful and destructive spirits, such as the kindly spirit of icebergs and the goddess Sedna, who controls all marine life. Shamans, besides acting as spiritual advisers and doctors to the community, intercede in times of trouble on behalf of the community with the spirits who control the Eskimo world. Illustrated here is a shaman's mask (1-12), most likely a report of a shaman's spiritual adventure. The face at the center represents the shaman's soul. Eskimo

peoples believe that these souls can fly around the world and even the universe. Shaman stories often tell of flying to distant lands, the moon, and the Land of the Dead.

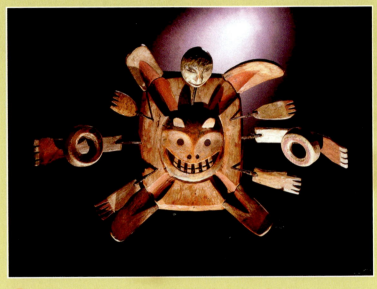

1/12 Eskimo mask depicting the spirit flight of a shaman, Alaska. Wood, metal, and paint.

The magical powers attributed to art by prehistoric peoples and "primitive" tribes are not generally accepted in our modern scientific and industrialized world. Still, even if we do not believe that works of art can cure sickness, placate dead spirits, assist us in predicting and controlling the future, or put us in direct touch with supernatural forces, we are not totally immune to the magical power in art. Imagine how you would feel if you discovered that someone had poked holes in a photograph of your grandmother's face. Would you calmly reflect that it was only a damaged piece of paper? Or would you consider it an unjustifiable attack on a dearly loved person?

Another sign that forces once called primitive are still alive today is the recent return of a prehistoric tribal art to high fashion. Tattoo, the marking of skin with designs, is an art that has been practiced around the world for thousands of years. Its name originated in Polynesia and is from the Tahitian word *tatau*. A tattoo is made by inserting permanent pigment into the skin by a variety of means, most commonly needles. Although

a tattoo can still be controversial in twenty-first-century America, it is just the opposite for the Maori tribes of New Zealand. Its creation is a sacred act, and the tattoo artist is considered a holy person. Their traditional method utilizes very sharp bone chisels to cut lines into the skin. Next, a chisel is dipped into natural pigments such as charcoal or dried caterpillars, which are shaken into the wounds to add colors. Tattooing was a coming-of-age rite for young men and women that demonstrated an adolescent's strength and courage. It was a matter of pride to never make a sound as the cuts were made. Because the chisels left grooves, a long, painful healing process followed. While the recently tattooed young people rested and fasted afterward, they were soothed by sweet flute music and numbing leaves applied to their swollen skin.

The most important Maori tattoo is the *Ta-Moko*, or facial tattoo (1-13). Although it is a mix of many traditional patterns, the design of curves and spirals for each person's ta-moko is unique. The markings are

a coded map that can be understood by other Maori and explain the status and genealogy of its wearer. For example, the sides of the face reveal one's ancestry, a father's on one side, a mother's on the other. A person's rank can be read by reading the designs on the forehead. Only Maoris of the lowest status would not have a ta-moko. One's tattoo is one's *taonga* or treasure. It is also your identity. When their signature was required on important documents, tribal chiefs would draw a picture of their ta-moko.

THE POWER OF RELIGIOUS ART

Religious art gives visual expression to inner belief and has the ability to raise people's spirits above the problems of daily life. For centuries, humans have created special places to worship with art. Such temples or churches are designed to convey particular religious messages and spiritual values. These places of devotion often share some of the magical quality of prehistoric caves. Both magical and religious art express human belief in a spiritual world. Magical art, however, supposes that images have a living power, while religious art is more often simply the visual expression of an inner belief.

Just as the Amida Buddha (1-5) embodies the beliefs of Japanese Buddhism, the Gothic cathedral of *Notre Dame* (**1-14**) in Paris is a visual expression of the Christian faith of the medieval era. With its soaring vertical lines, the cathedral seems to lift the soul heavenward, toward God. Its stained-glass windows tell biblical stories (**1-15**); its paintings and statues can instruct and even inspire the viewer. By transforming a material as dense and heavy as stone into a structure of such grace, the cathedral becomes a visual representation of the Christian belief in a spiritual existence beyond and above the limitations of physical reality. This heavenly realm is visually symbolized as the viewer's eye is drawn up the soaring lines of the gothic arches to the very top of the pointed vaults and into a space bathed in colored light. Within *Notre Dame* cathedral, we can experience the power of art to transform the physical act of viewing into the spiritual act of worshipping.

ART REPRESENTS IDEALS

Statues of gods and goddesses also have the power to express the ideals of a particular culture in physical form. The art of classical Greece, for example, expresses

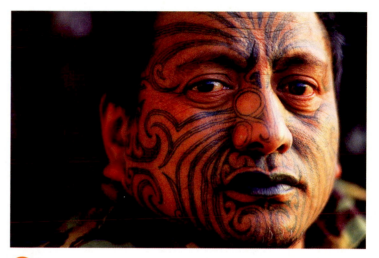

1/13 Traditional Moko Tattoo

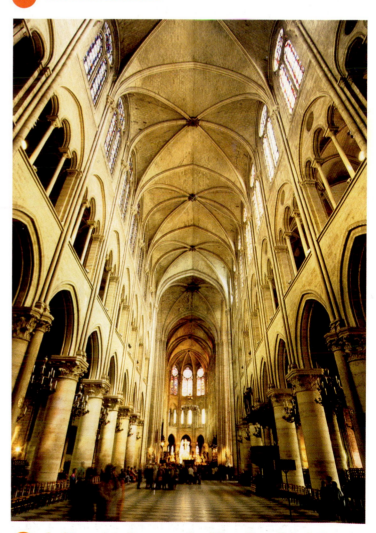

1/14 Looking up into the nave vaults of Notre Dame Cathedral, Paris, France, begun 1163, modified 1225–1250.

JEAN DE CHELLES, rose window of the north transept, Notre Dame Cathedral, Paris, France, 1240–1250. Stained glass, iron, and lead stone-bar tracery, diameter 43'.

the Greeks' cultural ideals of physical beauty and athletic strength, as in the statue *Hermes with the Infant Dionysus* by the great sculptor Praxiteles (1-16). For the Greeks, a strong and healthy body was extremely important, because physical development was considered equally as important as mental and spiritual growth. They sought a perfect balance between body and mind, a natural harmony between muscular prowess, grace, mental vigor, and physical beauty.

Greek art also aspired to another balance—between realism and idealism. Greek statues are immediately recognizable as lifelike, accurate representations of the human form. Yet, as in the figure of *Hermes* illustrated here, they idealize the human body, making it more graceful and perfect than any real person could be. Greek sculptures are not portraits of individuals but ideal types. The Western conception of great art as a fusion of the real, or truthful, with the ideal, or beautiful, is descended from the aesthetics of ancient Greece. This philosophy was expressed succinctly by the English Romantic poet John Keats in these famous lines from *Ode on a Grecian Urn*:

Beauty is truth, truth beauty—that is all
Ye know on earth, and all ye need to know.

1/16 Roman copy of PRAXITELES, *Hermes with the Infant Dionysus* (detail), from Olympia, c. 340 BCE (?). Marble, approximately 7' high. Archeological Museum, Olympia, Greece.

ART AS A DECLARATION OF POWER

Besides expressing spiritual beliefs or cultural ideals, art from the earliest times has been used to declare the power of rulers. The pharaohs of Egypt erected huge structures to declare their strength; Roman emperors constructed triumphal arches in conquered territories. For thousands of years, artists served kings and queens. During the Renaissance, royal images were not just stylized versions of majesty (as seen in Egypt) but true portraits. One of the finest of the Renaissance court painters was Hans Holbein the Younger, and our image of *Henry VIII* (1-17) is forever that of an enormous, insatiable powerhouse because of Holbein's portraits. His *Henry VIII* stands before us seeming larger than life, almost bursting the edges of the picture frame. He is dressed in stunning garments, made of the finest materials sewn with golden embroidery and jewels. Another Holbein portrait (now lost) hung over the king's throne and, according to visitors, "abashed and annihilated" them when they stood before it. That was the purpose of all the king's portraits—to glorify a man who had supreme power.

Renato Bertelli's *Head of Mussolini* (1-18) is a modern approach to paying tribute to a ruler—in this case,

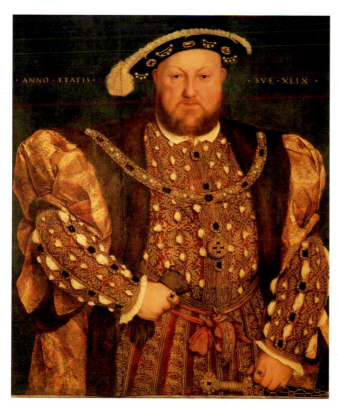

1/17 HANS HOLBEIN THE YOUNGER, *Henry VIII*, 1540. Oil on panel, 32½" × 12½". Galleria Nazionale d'Arte Antica, Rome, Italy.

1/18 RENATO BERTELLI, *Head of Mussolini (Continuous Profile)*, 1933. Painted terracotta, 19" tall. Imperial War Museum, London, Great Britain.

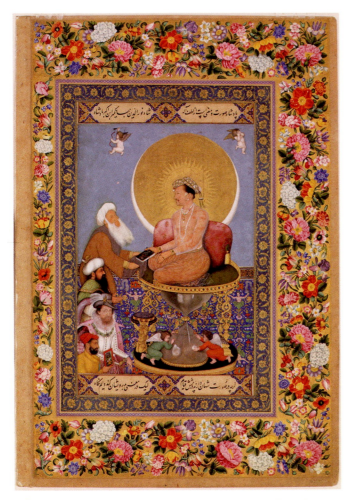

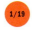 **BICHITR,** *Jahangir Preferring a Sufi Shaikh to Kings,* from the Leningrad Album, Mughal, India, early seventeenth century. Color and gold on paper, 10⅞" high. Freer Gallery of Art, Smithsonian Institution, Washington, D.C.

Benito Mussolini, the Fascist dictator who led Italy during World War II. Bertelli's sculpture is infused with the spirit of *Futurism,* a movement that celebrated progress and called on Italians to embrace a fresh approach to art, unencumbered by the past. The Futurists called for art "enriched by a new beauty: the beauty of speed" (see Chapter 18). By rotating Mussolini's profile in 360 degrees, Bertelli's "continuous profile" is meant to show the dynamism and modernity of *Il Duce*—"the Leader."

Mussolini's rise to power in the 1920s was greeted with joy by Bertelli and his fellow Futurists. In return, the Italian dictator embraced Futurism's ideals and made it the official style of his regime. This sculpture was approved by the dictator, who ordered its mass production and distribution.

THE POWER TO CONVEY IMMORTALITY

Unlike Henry VIII or Mussolini, Jahangir, the emperor of India who ruled during the height of the Mughal dynasty

in the 1600s, directed his artists to portray him as honestly as they could. Yet Jahangir did not totally renounce flattery. Although the faces are naturalistic in the painting *Jahangir Preferring a Sufi Shaikh to Kings* (1-19), the setting and events are not. The Emperor Jahangir is the source of a brilliant light, too bright even for one of the cupids. Great men have come to pay homage to Jahangir: a wise old saint (who the emperor places above all other admirers), the Sultan of the Ottoman Empire, King James I of England, and the artist Bichitr himself.

The Emperor Jahangir sits on a throne supported by an hourglass whose sand has almost run out. Yet, on the glass, cupids are painting a prayer that he might live for a thousand years. What could resolve this contradiction? It must be the act of painting itself, one of the great passions of the cultured emperor. There were many signs of Jahangir's special love during his reign. One of the greatest royal patrons of arts in history, he provided studios in the palace for his court artists and gave them the finest and most expensive materials to work with. The artists rewarded him with immortality.

THE POWER TO CHANGE OUR BELIEFS

Art also has the power to change the way we think, the way we understand the world around us. Many contemporary artists use their work to express political viewpoints, to lead their viewers to a moral lesson. In *The Liberation of Aunt Jemima* (1-20), Betye Saar comments on the stereotyping of African-American women in advertising and the media. Saar creates her work by incorporating so-called **found objects**, like the mammy doll and cutout pictures of Aunt Jemima from pancake packages. These are arranged inside a box as if the artist were creating a diorama; the doll holds a broom in one hand, and a small print of another happy mammy holding a wailing white baby is propped up in front of her. But the familiarity and friendliness of these images is radicalized by the incorporation of a black power fist in the foreground of the box, as well as a rifle and chrome pistol. Here Aunt Jemima seems to express some of the anger Saar felt, but never expressed, when she experienced discrimination as a young black woman growing up in California. (For instance, Saar won several prizes for her designs for floats in the Tournament of Roses parade before the judges realized she was an African American. After her race was disclosed, she was given only honorable mentions.) By using real mementos of contemporary culture like the advertising imagery of

Duchamp's parody was upsetting on several levels. First, he was making light of Leonardo's great masterpiece. Because the *Mona Lisa* had come to symbolize the best in Western art, he was symbolically rejecting centuries of tradition. Second, Duchamp was taking a reproduction of a painting by another artist, changing it slightly, and claiming that it was a new work of art that belonged to him—that is, he seemed to be stealing someone else's creative work and then (figuratively) spitting on it. A beautiful image was made ugly, even silly. A picture that had come to symbolize the mystery and ideal nature of all women was turned into a joke. Worst of all, he was suggesting that the *Mona Lisa* was "hot stuff."

The creation of artworks *meant* to upset the viewing public is a recent development in the history of art. In earlier times, the purpose of art was to please the person who commissioned and paid for it—the patron.

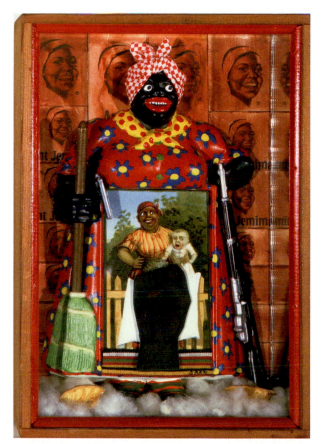

BETYE SAAR, *The Liberation of Aunt Jemima*, 1972. Mixed media, 11¾" × 2¾". University Art Museum, University of California at Berkeley, California.

Aunt Jemima, Saar creates a visual satire that shows how photographic reproductions tend to reinforce racial stereotypes in our society.

THE POWER TO SHOCK

Related to art's power to change our point of view is its power to shock us. In the early twentieth century, many artists wanted to create works that would wake viewers up and shake them out of their preconceptions about art. One such artist was Marcel Duchamp, and one of his most disturbing pictures was *L.H.O.O.Q.* (1-21), a satire of Leonardo da Vinci's *Mona Lisa*. Duchamp chose to make fun of the *Mona Lisa*, especially because it was so beloved and had become almost like a sacred image to people who cared about art. He took a postcard reproduction of the painting, added a moustache, beard, and dark pupils in pencil, and then printed a few initials at the bottom. When pronounced in French, these initials sound out the vulgar phrase, "she has a hot ass."

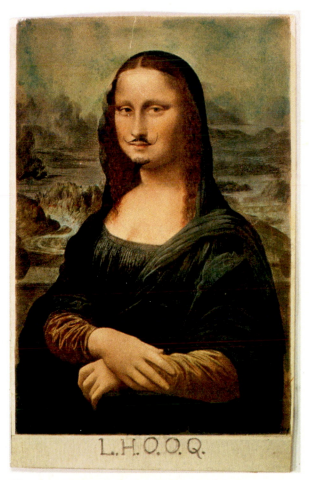

MARCEL DUCHAMP, *L.H.O.O.Q.*, 1919. Pencil on print, 7¾" × 4¾". Private collection. © 2012 Artists Rights Society (ARS), New York/ADAGP, Paris/Succession Marcel Duchamp.

CONTROVERSY OVER THE
VIETNAM MEMORIAL

The *Vietnam Veterans Memorial* was commissioned in the 1980s by the Vietnam Veterans Memorial Fund (VVMF), founded by an independent group of Vietnam veterans. Because money was raised by donations from people throughout the country, and the site on the mall in Washington, D.C., was contributed by the government of the United States, the patrons for this monument included all Vietnam veterans and in some sense all citizens of the country. The choice of the design was given to a jury of prominent artists, who looked at more than fourteen hundred entries (all reviewed anonymously, so the judges would not be influenced by the name or reputation of the artist). Surprisingly, their unanimous choice was the submission of a young architecture student, Maya Ying Lin.

Although the selection generated little negative comment at first, problems began to develop as the groundbreaking ceremony neared. Many Americans expected a realistic monument like ones seen in parks and town greens around the United States and were shocked by a design that was highly abstract. Some veterans and prominent contributors united to mount a political campaign against the monument, which was

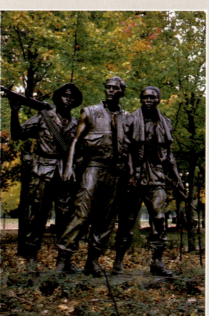

1/22 **FREDERICK HART,** *Statue for Vietnam Veterans Memorial*, Washington, D.C., 1984. Bronze, life-size.

described as a "black gash of shame." A lively, and even bitter, debate developed in the press and the halls of Congress. The official patrons—the VVMF—began to fear that the memorial would never be built at all. In the end, the detractors of Lin's winning entry managed to block government approval for a building permit unless the memorial included a realistic statue **(1-22)** and a flag.

Maya Lin was disillusioned by the pressure for these additions, which she felt would ruin the simplicity of her design and compromise the purity of the site. However, although she was the artist, because the patrons had purchased her design, she had no further control over

it. Interestingly, Lin compared the addition of a traditional statue to her monument with the disrespectful way Duchamp treated the *Mona Lisa* in *L.H.O.O.Q.*: "I can't see how anyone of integrity can go around drawing mustaches on other people's portraits," she said. To her, to place a realistic statue in the center of the wall would be a mustache, a desecration of her work. She described the statue as "trite." Frederick Hart, the sculptor of the realistic statue, showed as little respect for her memorial design, comparing it to a "blank canvas," claiming that it was "intentionally not meaningful" and "contemptuous of life."

Eventually a compromise was reached; the statue was erected in an entrance plaza a little distance away from the wall, not in front of it. For her design, Maya Lin had won $20,000 and national fame; she had also experienced criticism, rejection, and a loss of control over her own work. Frederick Hart, a professional sculptor, was paid ten times as much for his statue.

The erection of Hart's statue did not end the controversy over "The Wall's" abstract nature, however. Since then other veterans groups have lobbied for representation at the site. In 1993, a statue honoring the service of women in the Vietnam War was added. It depicts three women in uniform, one a nurse caring for a wounded soldier. Recently, after another long battle, plans were approved for a large underground Vietnam Wall Memorial Center, designed to provide pictures and films to put the war in historical context.

Despite the continuing public debate, the memorial has become one of the most popular attractions in the nation's capital. In the process, it has more than satisfied the original goals of its patrons, which were to list the name of every soldier lost in Vietnam, to honor those who fought there, to make no political statement for or against the war, and to promote reconciliation.

THE POWER TO TOUCH OUR EMOTIONS

Art can also profoundly touch the emotions of the viewer. The *Vietnam Veterans Memorial* (1-23) in Washington, D.C., was designed especially to reach out to the American people and assist in healing the wounds left by the Vietnam War. The architecture student who designed it, Maya Ying Lin, called her concept "a visual poem." When asked what effect the memorial would have on the public, she thought to herself, "They'll cry" (although she didn't say this out loud until after the project was finished). And visitors do cry at the wall, even those who did not personally know any of the soldiers whose names are listed among the dead and missing in action. No one can doubt that the *Vietnam Veterans Memorial* is the most moving monument on the mall in Washington, D.C., and perhaps the most moving war memorial ever built. What makes it so effective?

The memorial interacts with the site in a unique and powerful way. Instead of building a structure on top of the land, Maya Lin cut into it and edged the slice with a V-shaped black granite wall—one arm pointing toward the Washington Monument, the other toward the Lincoln Memorial. Into this wall more than fifty-five thousand names of all Americans who died during the Vietnam War or remain missing are incised in date order, as if on a mass gravestone. The black granite is polished to reflect its surroundings: the sky, clouds, trees, and land, as well as each person who has come to remember (see "Art News" box).

The Vietnam Memorial is the most popular site on the Mall in Washington, with nearly four million visitors visiting it each year. Many are looking for the names of specific loved ones; others are there simply to pay tribute to all of those who lost their lives. From the first, visitors have interacted with the memorial in unique ways. People reach up to touch the names and make rubbings to carry home as souvenirs. Others leave flowers, photographs, letters, and memorabilia. The memorial is a place for surviving veterans to be reunited with friends, for friends to remember the classmates who never returned, for family members to "meet" the dead father, brother, sister, or cousin who they do not remember, or perhaps never met. Lin's memorial seems to allow people to experience their loss, while comforting them at the same time. The *Vietnam Veterans Memorial* is a superb example of the power of art (even when very abstract) to reach out to the public.

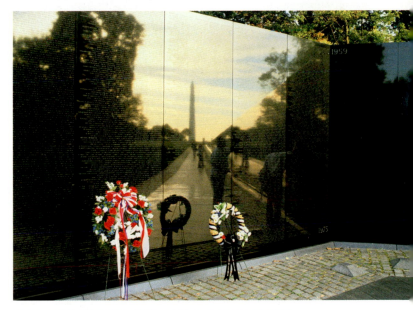

1/23 MAYA YING LIN, *Vietnam Veterans Memorial*, Washington, D.C., 1981–1983. Marble, each wing 246' long.

THE POWER TO AWAKEN OUR SENSES

Contemporary life is lived at a fast pace, and it is easy to miss what is going on around us, to have our senses dulled by overstimulation, and to literally lose focus. The great Russian writer Leo Tolstoy warned us of this danger, when he wrote "In the name of God, stop a moment, cease your work, look around you." Art has the power to awaken us to realities that we may not have recognized before, to truly open our eyes. In the modern world, the art of photography has become a medium for this kind of artistic revelation—to slow us down, to make us stop and really look.

Ansel Adams hoped his pictures would reveal eternal truths. His majestic landscape *Clearing Winter Storm* (1-24) is a superb example of the images that speak to the richness of nature or what Adams called "an austere and blazing poetry of the real." Adams was born in San Francisco and experienced its famous and terrible earthquake in the early 1900s. A weak student, he found meaning in his life when he first began hiking in Yosemite as a teenager, carrying one of the early Kodak cameras. He would explore that wilderness into his eighties and become its foremost photographer. Throughout his life, he was not only an artist, but also an important spokesperson for the environment and a leader of the Sierra Club. His images of Yosemite were meant to not only open our eyes, but also to convince us of the importance

1/24 **ANSEL ADAMS**, *Clearing Winter Storm*, Yosemite National Park, 1944. Photograph.

THE POWER TO TRANSFORM THE ORDINARY

One pleasure of looking at art is enjoying a feeling of amazement that an artist has magically transformed ordinary materials into a marvelous work of imagination. When one enters the room that houses the contemporary Chinese artist Zhan Wang's *Urban Landscape* (**1-25**), one is first struck by the sheer beauty of a shining, fabulous city. Viewers tower above it, as if seeing the glittering metropolis from a low-flying jet. But once our eyes adjust to the glare, we can see that the city was not built with brick, glass, or mortar. It was constructed with highly polished equipment from a restaurant's kitchen—the skyscrapers are stacked colanders, stainless steel pots and pans, and the boats in the river are forks, knives, and spoons.

Ultimately, Zhan hopes the viewers of his city will move beyond its visual brilliance. The artist, who was trained in traditional techniques at an academy, wants us to think about the impact that urbanization has had on Chinese culture. The sparkling, commercial environment of the modern Chinese city is also cold and mechanical, disconnected from age-old customs and nature. Even the

of preserving the wilderness in this great park. The rich range of tones and textures in *Clearing Winter Storm* testify to his technical mastery (he was the author of ten books on photographic techniques), but his skills in the darkroom were always in the service of his vision—the spirituality, beauty, and grandeur of the natural world.

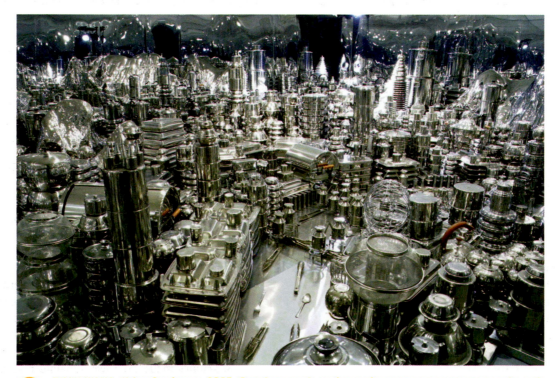

1/25 **ZHAN WANG**, *Urban Landscape*, 2003. Stainless steel, garden rocks, pots, pans, eating utensils, and mirror. Hayward Gallery, 2006. Photo by Stephen White, Pekin Fine Arts Co. Ltd. © Zhan Wang

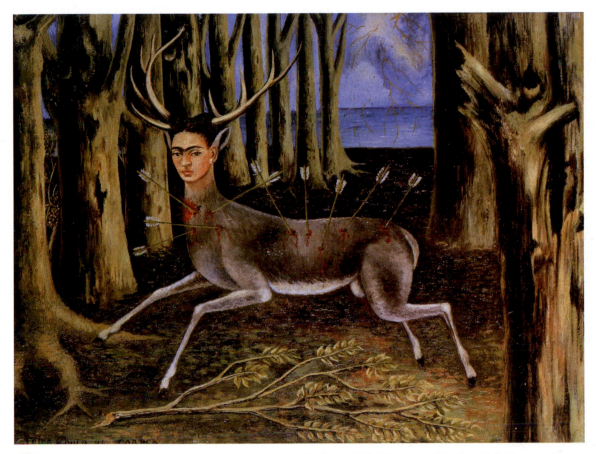

mountains that surround *Urban Landscape* are made of stainless steel, like much of modern architecture. The rapid Westernization of cities, like Zhan's native Beijing, has had spectacular results but also has meant that much has been lost.

THE POWER OF ART FOR THE ARTIST

While we have been exploring the many powerful ways that art can affect and benefit us, we have yet to consider why someone would choose to make art. A cynical observer might say artists make art to make money, but those who are knowledgeable about art know (despite the headlines about the high prices being paid for certain artworks) that few of the millions of artists at work today will ever make a living strictly from sales of their art. The satisfactions of such a difficult and often painful occupation, then, must be more substantial than dreams of wealth.

SELF-EXPRESSION

One of the most obvious and important reasons that artists make art is to satisfy the need for self-expression.

Through their art, painters, sculptors, architects, photographers, printmakers, designers, and craftspeople are all able to express their personal visions. Mexican painter Frida Kahlo used self-portraits in the style of native folk art to express her own suffering. As a teenager, she suffered a terrible injury when the bus she was riding in was smashed by a trolley. Her spine and pelvis were shattered, and she spent the rest of her life in constant pain, despite thirty-five operations. In her self-portrait, *The Little Deer* (1-26), the many insults to her body are displayed in fantastic imagery, yet there is great strength in her face. Kahlo's willingness to use art to reveal her inner life gives her work great impact. For Kahlo, the act of creating such a picture must have had a cathartic, healing power.

THE ARTIST AT PLAY

Visual art has often been used to record personal and artistic suffering, yet it can be an equally effective record of the artist's joy, such as the simple joy of being creative. A sense of spontaneous playfulness can be felt in the shaped canvasses of Elizabeth Murray. *Kitchen Painting* (1-27) is actually made from two separate pieces that project into three-dimensional space. Nearly seven feet tall, the canvasses have been shaped and beveled to

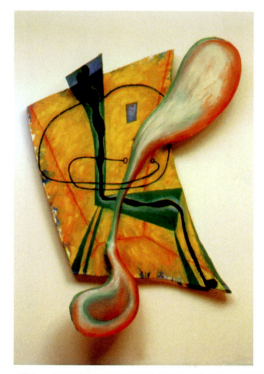

ELIZABETH MURRAY, *Kitchen Painting*, 1985.
Oil on two canvases, 58" × 81" × 14".
Private Collection, New York. Courtesy Paula
Cooper Gallery. © 2012 The Murray-Holman Family
Trust/Artists Rights Society (ARS), New York.

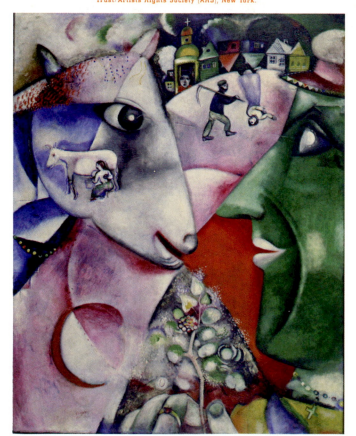

 MARC CHAGALL, *I and the Village*, 1911. Oil on canvas,
21¾" × 18¼". Philadelphia Museum of Art, Philadelphia
(given by Mr. and Mrs. Rodolphe M. de Schauensee). © 2012
Artists Rights Society (ARS), New York/ADAGP, Paris.

fit the image of a green chair on which a thin black line represents a human figure attempting to grasp an enormous pink spoon. Once the viewer deciphers the image, the visual effect is surprising and amusing. The spoon protrudes like an enormous pink tongue, the top of the green chair breaks out of the top of the painting, and the figure's arms circle like planets in the solar system. Yet, although the image is a bit nonsensical, even bizarre, the colors and shapes convey a feeling of fun rather than unease. We sense that Murray enjoyed the activity of creating this image and confusing expectations. Speaking for many artists, she said her goal in making art was to simply "respond to being alive."

THE ARTIST'S MEMORY

Visual art can also provide a vehicle for memory, a means of recording past experiences. One of the best-known artists to use art as a way of reliving the past was the Russian-born painter Marc Chagall. Chagall was influenced by the most advanced art movements of the twentieth century. As an impoverished young art student, he traveled to Paris and met daring artists like Pablo Picasso, who were experimenting with new ideas. Refusing to be bound by the limits of visual reality, artists at this time wanted to reach beyond what they saw to paint what they felt, and beyond that to what they dreamed. Yet, even though his style is modern, the work of Chagall is filled with a love for the rural scenes of his childhood in Russia.

In his pictures, time and gravity have no power; people and animals whirl through the heavens regardless of the rules of nature. Looking at *I and the Village* (1-28), we see a friendly cow and a man holding a flowering twig in his fingers, looking face to face, united visually by a red disc. The huge cow seems benign and almost as if it is about to speak to the green man, or kiss him. Smaller figures also appear: a young woman milking, a man with a scythe walking to the harvest, a woman placed upside down who seems to be gesturing him forward, a child's face peeking over the edge of a hill behind which the tiny buildings of the village appear both right-side up and upside down.

Throughout his long career (he lived to be ninety-six), Chagall used art to create a magical land of love and wonder—remarkable for a man whose life encompassed two world wars, the Russian Revolution, and the Holocaust (in the 1940s, Chagall, who was Jewish, was forced to flee from his home in France to the United States). In this sense, Chagall's work is a tribute to the power of art to transcend political realities and allow the artist to regain a lost world with memory and imagination.

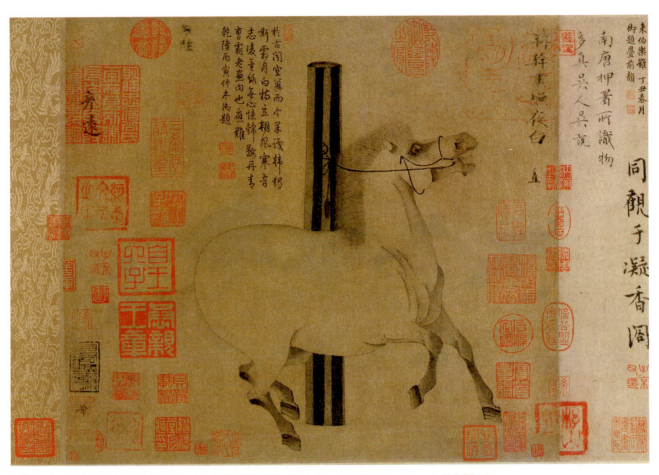

1/29 *Night Shining White*, attributed to HAN KAN, 740–756. Album leaf, ink on paper, 11¾" high. Metropolitan Museum of Art, New York.

DEFINING ART

The source of the term *art* is the Latin word *ars*, which meant "skill." Although this is the oldest meaning of **art**, it is no longer the most common meaning. For us, the realm of the arts suggests *creative* endeavors and includes an entire range of activities classified as *cultural*. These creative arts are often subdivided into the broad categories of the *performing arts* (such as theatre, music, and dance), the *literary arts* (such as poetry, essays, and novels), and the *visual arts*.

In everyday conversation, however, most people assume art means visual art, art that we experience primarily through our sense of sight. Saying that someone is an artist usually suggests that he or she draws, paints, sculpts, or designs. This is the meaning of art that this book will be using. We define the visual arts to include the artistic media of painting, sculpture, and architecture, as well as outstanding examples of drawing, printmaking, photography, design, digital art, decorative arts, and crafts. They are usually subdivided into the **fine arts** (such as painting, printmaking, and sculpture) and the **applied arts**

(such as architecture and design). For centuries, in Western art, paintings and sculptures have usually been seen as a higher form of artistic production than *applied* (or useful) arts, such as book illustration or wallpaper. However, for the last one hundred years or so, this distinction has not been as important. In Eastern art, there has never been such a division. For example, in the Chinese master Han Kan's *Night Shining White* from the eighth century (**1-29**), the calligraphy on the scroll was considered just as expressive and as much pure art as the painting of the horse.

A work of fine art is usually an original, or one-of-a-kind, creation. Each work of art is the result of the artist's personal effort, the touch of his or her hands, the fresh invention of the artist's mind, spirit, and talent. There are exceptions to this rule. Prints, whether traditional or digital, for instance, are produced in a series from an original "plate" or digital image designed by the artist. Photographs, which were once thought of as mere mechanical reproductions of reality, have also been elevated to the status of fine art. Although their artistic merit has been recognized, however, prints and photographs are usually less valued (and less expensive) than drawings, paintings, or sculptures by the same artists.

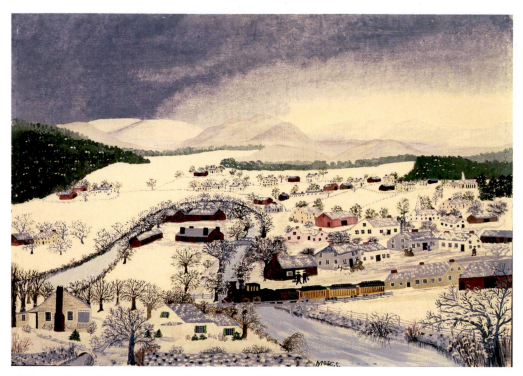

1/30 GRANDMA MOSES, *Hoosick Falls*, winter 1944. Oil on masonite, 19¾" × 23¾". The Phillips Collection, Washington, D.C. © 1987 Grandma Moses Properties Co., New York.

This reflects the fact that the work is not unique; it has been duplicated. A black-and-white print by a great photographer, however, is far more valuable than the painting of a mediocre artist.

FOLK ART

Art is generally considered to be **folk art** rather than fine art when it is the work of untrained artists working in rural areas. Folk art includes painting, sculpture, and all the decorative arts, but where a fine art chest may be made of ebony inlaid with ivory, the folk chest will be a simple wood box painted in bright colors. American folk art has become very popular in recent years and commands high prices in antique stores and galleries; whole museums and galleries are devoted to folk art collections.

A good example of a folk (sometimes called "naive") artist is Grandma Moses, who was born on a farm in New York State in 1860 but did not really begin painting until the 1930s, when she was almost eighty. Although she had no formal training, her pictures (1-30) became so popular that by the time she died in 1961, she was a household name in the United States, and her scenes were reproduced on everything from greeting cards to kitchen curtains. Although she is not as well known today as she was at the height of her popularity in the 1950s, Grandma Moses's talent transformed an elderly farm widow, suffering from arthritis, into a nationally famous personality.

The power of her art lies in its freshness and vitality. Through her pictures, Anna Mary Robertson Moses had the chance not only to recreate and in a sense relive her own past but also to share that world with her viewers. Her most popular subjects included maple sugaring, winter sleighing, scenes of old-fashioned farm life, celebrations of holidays, and the seasons. As she concludes in her autobiography:

> In my childhood days life was different, in many ways, we were slower, still we had a good and happy life, I think, people enjoyed life more in their way, at least they seemed to be happier, they don't take the time to be happy nowadays.

CRAFT AND DECORATIVE ART

When artists create useful or functional objects, such as ceramic pots, glass vases, silver bowls, woven rugs, and even wooden chairs, these are typically put in the category of *crafts* or *decorative arts*.

NICK CAVE: THE WORLD IS HIS PALETTE

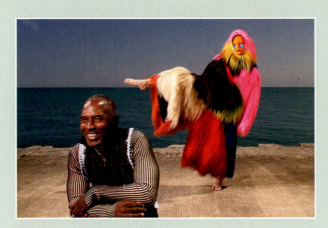

Nick Cave with Soundsuit.

We live in an era where the old distinctions between art and craft, high and low art appear to have finally dissolved. The art world freely consumes mixtures made from various times, cultures, and media. Nick Cave's *Soundsuits* (1-31) epitomize this new spirit. A soundsuit can be six or more feet tall, seen in a gallery or video, worn or danced in. Usually displayed in groups, they are not only visually exciting and surprising but also meant to make distinctive shapes and sounds as they move. Cave constructs each soundsuit from what is at hand in his workshop. One might be made entirely of discarded knitted doilies. Others have been constructed from a remarkable array of buttons (detail, **1-32**), beads, yarn, twigs, feathers, sequins, old sweaters, wire, crocheted hats and bags, synthetic hair, plastic tubes, vintage toys, masks, or even Barbie dolls. The end result is an extravagant mix of textures, colors, patterns, and sounds. One can see the influence of African ceremonies and rituals, New Orleans Mardi Gras costumes, traditional handwork, and high fashion. To reach a wider audience, Cave opened a Soundsuit Shop (www.soundsuitshop.com) in Chicago and also designed men and women's clothing lines. He says, "I love the fact that sculpture, performance, video—all of these things are layered together in my work."

Raised in the 1960s in a small Missouri town, by a single mother with six other sons, everything Cave had as a child was a hand-me-down. So he used his imagination

to transform them into his own, leading him to a life in art and design. As a young student, he couldn't afford art supplies. So he made art from what he found, finding a rich source from what was discarded or discovered. Even today, his home is a rich palette of bits and pieces found in American thrift shops, along with African statues, Asian masks, and colorful Australian fabrics from his travels. As Cave says, "I want to wake up every morning and be visually excited with every turn of my head."

In college, his imagination was not constrained by the requirements of a major. He studied art, fashion, and dance. After graduate school, he made his first soundsuit. Initially, it was meant to be a sculpture of branches and twigs, but then he wondered whether he could turn it into something that could be worn. Putting it on, he realized that his identity had been erased. Almost magically, he

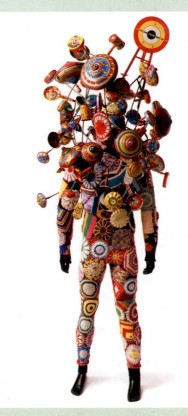

 NICK CAVE, *Soundsuit*, 2008. Mixed media, Jack Shainman Gallery, New York.

NICK CAVE: THE WORLD IS HIS PALETTE

had left himself behind. No one knew whether he was a man or woman, black or white, gay or straight. In a costume of his imagination, he could become anyone or anything.

Since then, Cave has made hundreds, perhaps thousands, of soundsuits, some meant to be shown in galleries, others designed for dancing. They can be appreciated in a performance piece, in photographs, or as video art. A single performance can include as many as ninety soundsuits at a time. He says, "Something inexplicable happens when the suits are in motion; the sounds they make give them a magical life of their own. I would love

it if everyone could put one on and feel the thrill that happens." Cave believes he has a responsibility to make the most of the transformative power of art:

The arts are our salvation—the only thing that allows us to heal and also helps us dream about what will make the world a better place. . . . I don't see myself as an artist but as a humanitarian using art to create change. If I can create an opportunity to bring people of all creeds, identities, and interests together, then I am doing my work.

A good example is a Navaho "eye-dazzler" rug (1-33). Woven and designed by Native American women in the late nineteenth century, these blankets have a strong visual impact because of their bold use of color and simple geometric designs. These weavings were named "eye-dazzlers" because of their use of new, brighter yarn

that became available to the Native Americans during this period. Although purists and collectors tended to prefer blankets made with native vegetable dyes, the weavers embraced the new colors. It is not surprising that modern artists in search of a purely visual art have been inspired by these blankets and other decorative arts, such as quilts. The decoration of useful objects has been a source of visual pleasure for viewers in many ages and cultures.

The term *crafts* is also often used to describe contemporary objects that are handmade. Craft art is perhaps the most popular way of appreciating and practicing art in our society. Many people who would be afraid to invest in an original sculpture are perfectly comfortable buying a hand-thrown pot, while individuals who insist that they "can't draw a straight line" enjoy classes on weaving or wood carving. Although some art historians and critics still think that such things as jewelry should not be considered art at all, attitudes are changing. Imaginative metal, fiber, and woodwork are now generally included in international surveys of art and design (see "Lives of the Artists" box).

DESIGN

What about functional items that are mass produced? Are they part of the world of visual arts? A broad definition of art would certainly include manufactured objects that are well designed—in fact, the Museum of Modern Art in New York devotes an entire section to outstanding examples of such objects as telephones, typewriters, and even helicopters. This field of art is known as **industrial design**.

An industrial designer must understand both art and engineering. Industrial design is the aesthetic refinement of products, making functional engineering solutions easy to use and understand, and attractive. The phrase "user-friendly" neatly conveys the goal of all industrial designers.

1/33 Germantown "eye-dazzler" rug, Navajo, 1880–1890. Split wool yarn, 2-, 3-, and 4-ply, 72" × 50". Museum of Northern Arizona, Flagstaff.

One of the most successful containers ever designed is the Coca-Cola bottle (1-34), recognized around the world and used with only modest modification for nearly a century. The bottle must not only hold soda but also dispense it easily and only on demand. The narrow opening provides a continuous but not choking flow. The wide bottom makes sure it rests easily on a table without spilling. The bottle's curvaceous shape allows it to fit comfortably in one hand, the pattern of ribs ensuring that a cold, wet piece of glass does not slip and cheat us of our refreshment.

The name "Coca-Cola" is, of course, featured prominently on the bottle. In fact, the ribs on the bottle subtly lead our eyes to the smooth center where it is displayed. This *logo* or trademark was the work of a *graphic designer*. **Graphic design**, sometimes called *commercial art*, includes two-dimensional designs that are mass-produced, such as logos, magazine layouts, decorative posters, and the cover of this book. Much thought and effort goes into every aspect of a logo, because it represents the company. The script Coca-Cola logo implies a product that has been tested by time, but the more modern typefaces that surround it make sure we know it is meant for young and old alike.

While representing a company is certainly important, graphic designers who design currency have the challenge of representing an entire nation and its people. For the arrival of a new millennium in 2000, a team of designers in New Zealand was given the task of designing a special commemorative $10 bill (1-35). Their mission was to represent the country's past and

1/34 Coca Cola.

1/35 New Zealand $10 bill, front and reverse.

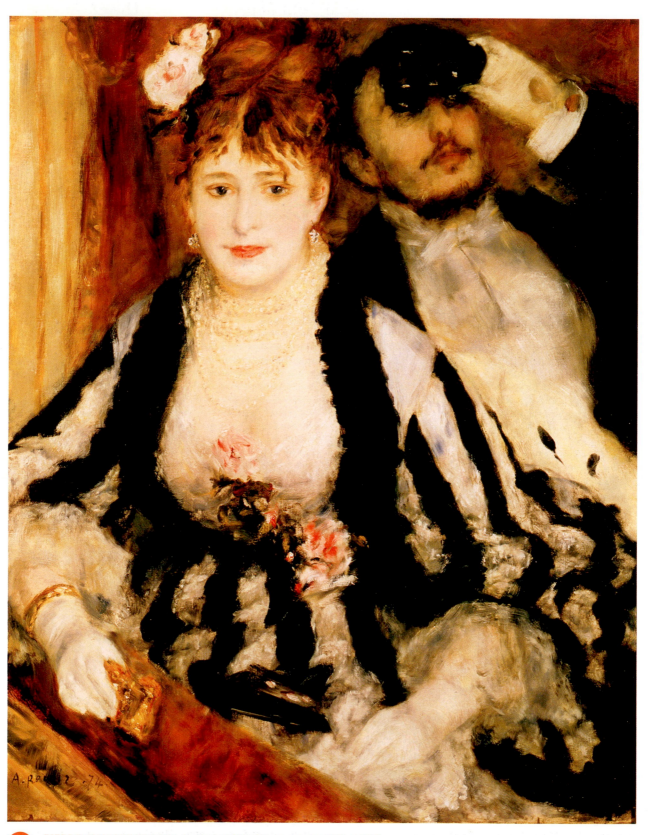

1/36 PIERRE-AUGUSTE RENOIR, *La Loge*, 1874. Oil on canvas, 31" × 25".
Courtauld Institute Galleries, London, Great Britain.

future and to capture the "kiwi spirit." In addition, they needed to integrate security measures that are essential elements in contemporary banknotes. Naturally, the bill also needed to be clear, attractive, and functional.

The designers succeeded brilliantly and in a fashion quite unlike the stale approach of many other nations. Although patterns are used in almost all currency to make counterfeiting difficult, the flowing decorations on the front of the bill are attractive and significant. They are a mix of traditional Maori art (see 1-13), Pacific shell patterns, and digital numbers symbolizing new technologies. At the center, a Maori war canoe plunges toward us—the boat that brought the first settlers to New Zealand. At the right, a satellite dish represents the latest communication media. The reverse of the bill is meant to symbolize the Kiwi spirit of adventure. Surfers, skiers, kayakers, and skydivers surround children at the center. The bill is made of polymer and incorporates the most advanced security features available. As in all aspects of the millennium note's design, this function is joined seamlessly with meaning and aesthetics. The silver ferns in the transparent window at the corner reflect rainbow light when shifted. Within the "0" of the number 10 is a watermark of a sacred Maori head that symbolizes ancestral figures and heaven.

ART IS BEAUTY

Many people think art must be beautiful to qualify as great art. For them, the primary power of visual art is its ability to delight the eye. Art that is visually pleasing seems to justify itself and needs no other reason to exist. "A feast for the eyes" is one way to describe this type of artwork. This *was* the chief criteria for fine art over several centuries, but it is no longer accepted as the only or even a vital issue today. As we begin our study of art, it is also important to keep in mind that standards of beauty are not universal. Aesthetic taste can vary with different cultures and time periods.

For example, when the Impressionists first exhibited their work in late-nineteenth-century Paris, it was rejected as hideously ugly. In fact, one critic accused them of "making war on beauty!" To the ordinary viewer of 1874, pictures like Pierre-Auguste Renoir's *La Loge* (1-36) seemed unfinished and crude. Today people flock to see the same work, which looks to the modern eye not only beautiful but also impossibly sweet, romantically ideal.

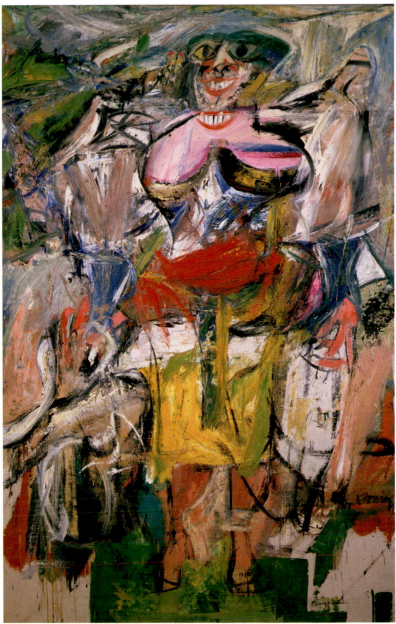

1/37 WILLEM DE KOONING, *Woman and Bicycle*, 1952–1953. Oil on canvas, 6' 4½" × 4' 1". Collection of the Whitney Museum of American Art, New York. © 2012 The Willem de Kooning Foundation/Artists Rights Society (ARS), New York.

Although many people assume that visual art should be beautiful, or at least realistic (and preferably both), you will find many artworks in museums that do not fit this mold. Some great works of art get their power from the depiction of "ugly" subjects or the distortion of forms. The subjects are not beautiful or realistically portrayed. Willem de Kooning's *Woman and Bicycle* (1-37) is a good example of the kind of painting that upsets some people today as much as the work of the Impressionists did a hundred years ago. "My child (or dog) could do a better job" is not an uncommon reaction to this type of artwork. Viewers are often upset by what they consider the gratuitous ugliness of such modern art.

1/38 Detail of figure 1-36.

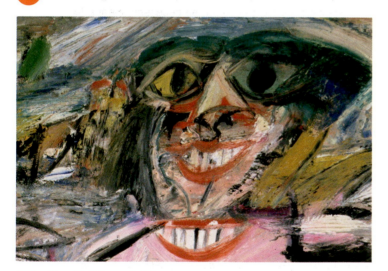

1/39 Detail of figure 1-37.

As different as they appear at first glance, upon reflection Renoir's and de Kooning's pictures of women do share certain attitudes about art. Both are committed to loose, expressive brushstrokes (details, 1-38, 1-39). Neither artist feels it is necessary to be absolutely precise and descriptive; they feel that art can hint rather than be dogmatic. Both believe in the use of colors to communicate emotion. Even though they are painting eighty years apart, the artists share a philosophy of art that stresses expressiveness. De Kooning's paintings can be seen as a more radical development of the ideas that made Renoir's approach seem unique in the nineteenth century.

ART IS ORIGINALITY AND CREATIVITY

The pictures of Renoir and de Kooning share a belief not only in expressiveness but also a belief in the value of originality. It is often said that the one thing that sets great art apart is its originality. The accepted idea is that a work of art should be a unique creation, the expression of the individuality of the artist. Those artists whom we consider greatest, like Pablo Picasso (1-40), kept developing from one successful style to another, always searching for a new mode of visual expression. The photograph (page 29) shows him experimenting with drawing with light, something only possible to see in a photograph. He is in his pottery studio, ceramics being only one of the many media he explored. This constant striving for newness and originality sets him apart from the artists of the cave paintings and the Ancient Egyptians, who repeated a similar style for centuries according to a strict set of rules or artistic formulas.

Generally, since the beginning of the twentieth century, the word *imitation* is usually associated with unoriginality rather than superior art. But in the last fifty years, even the idea of originality has been challenged by contemporary artists. As aware residents in a world of mass production, mass consumption, and mass media, some artists have created a kind of mass-produced art. Andy Warhol, for instance, became famous for his multiplication of images, as in *30 Are Better Than One (Mona Lisa)* (1-41). Using a stenciling technique, Warhol appropriated someone else's design—in this case Leonardo's *Mona Lisa*—and repeated it to create a new work of art. He created similar pictures using such popular images as Campbell's soup cans and identical photographs of Marilyn Monroe. It is rather amusing to see art collectors today attempting to sort out the "genuine" Warhols from the work of his followers and fakes. This is especially difficult since Warhol's work was created in his studio, known as "The Factory," where assistants often made art while Warhol acted out his role as a famous artist, going to parties and talking to the press.

WAYS TO UNDERSTAND ART

If our goal is to achieve a fuller knowledge and appreciation of art, we should avoid utilizing only one theory and excluding much of what might be relevant to a work of art. We have already seen that art has a variety of purposes and aspects. No single theory has yet been able to encompass them all in a useful way. To try to fence art in for the sake of any theory seems senseless. No one can determine in advance which questions or information

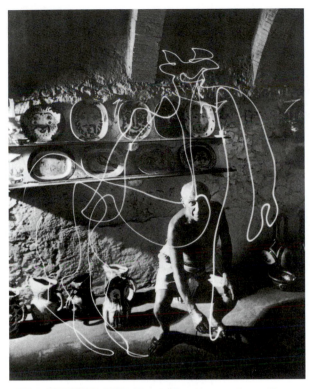

GJON MILI, *Pablo Picasso drawing a centaur with light,* 1950.

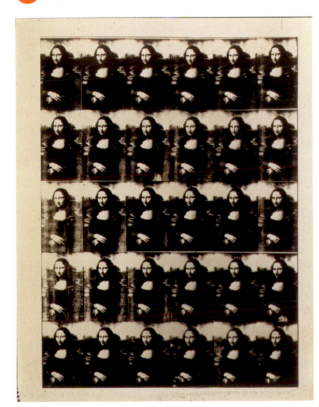

ANDY WARHOL, *30 Are Better Than One (Mona Lisa),* 1963. Silkscreen ink on synthetic polymer paint on canvas, 9' 2" × 7' 10½". © 1993 The Andy Warhol Foundation for the Visual Arts, Inc. © 2012 The Andy Warhol Foundation for the Visual Arts, Inc./Artists Rights Society (ARS), New York.

might increase our understanding of a particular work of art. To understand art, our primary question should be, *Why does it look this way?*

The viewer begins with the object itself. The main function of any work of art is to provoke aesthetic interest, but art should also be intelligible to the viewer. Integral to its success are formal concerns: its design and composition. In Chapters 2 and 3, we will study the elements of art and design to understand the structural language of art objects. Examination of the work of art should yield a sense of the artist's mastery of design principles like harmony, balance, rhythm, and pattern. No one element is essential, but if one is missing, its neglect must be justified by a special reason. For example, a chaotic effect might be explained by the artist's desire to reflect the frenzy of modern life. Or it could simply be a lack of the skill necessary to organize the subject matter. In Chapters 4 through 11, the materials and techniques used by artists are studied. One generally expects an artist to control the necessary means to reach his or her goal. However, skillful handling of materials is what a philosopher would call "a necessary but not sufficient condition." In other words, the presence of technical skills does not necessarily create a work of art, but its absence would require an explanation, such as "I am rejecting traditional concepts of skill, which I associate with a dead tradition." As we will see, it is common in the Western art of the last 150 years for artists to invent new techniques rather than follow past practices.

THE ARTIST AND THE ART

This textbook accepts the notion (not universal, but generally accepted) that the more we know about the conditions under which an artwork was produced, the better we will see it. This includes exploring aspects of an artist's biography that might be relevant. When was the artwork made? What were the artist's previous works? Can we see a progression? What ideas were current then? Was it left unfinished, or can we assume that it was meant to be seen this way? Can we determine the artist's intentions? What did the artist believe in? Even personal questions like, "Who were the artist's friends?" could have an impact on a particular work if some of an artwork's conception was influenced by discussion with a group of artists.

Few artists have been as generous in providing their influences as the nineteenth-century painter Gustave Courbet was in his huge painting *Studio of a Painter: A Real Allegory Summarizing My Seven Years of Life as an*

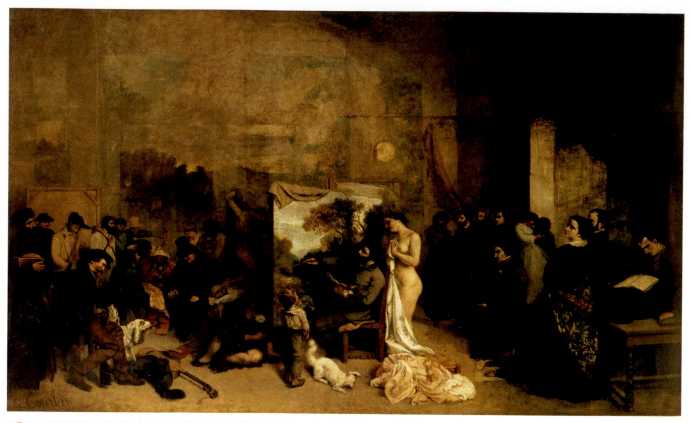

1/42 **GUSTAVE COURBET**, *Studio of a Painter: A Real Allegory Summarizing My Seven Years of Life as an Artist*, 1854–55. Oil on canvas, 11' 10" × 19' 7". Musée d'Orsay, Paris, France.

Artist (1-42). Courbet called himself a Realist painter, setting himself against the popular movements of his time in France, Neo-Classicism and Romanticism (see Chapters 16 and 17). He rejected grand historical subjects or religious images and once said, "Show me an angel and I'll paint one!" The artist believed that his work was and should be a product of his own experiences, not imagined myths or scenes from the past that he never witnessed. In his studio, we can see the artist at the center, painting a landscape of the woods near his home, with two admirers—a small boy and a nude model (perhaps his son and mistress). At either side are friends (among them well-known philosophers and writers) and local townspeople. Courbet came from a farming family, and he often depicted working-class people from all walks of life in his paintings. This upset viewers, because in his time, people from the lower classes were not considered suitable for high art—nor was an honest depiction of a nude woman. Nudes were generally given names from mythology, like Venus or Aphrodite, to justify their appearance. When his painting was rejected by an official jury, Courbet took the unusual step of exhibiting the nineteen-foot-wide picture at a pavilion he paid for himself at the Paris World's Fair of 1855.

The message of *Studio* seems to be that Courbet's approach to art cannot be fully understood without considering where he grew up and who his friends and acquaintances were. Yet Courbet's *Studio*, while designed to be a work of its time, is not only a product of his past but also the past of art history. It was clearly affected in style and subject by a past master who Courbet admired—the Spanish Baroque painter Diego Velazquez's painting of his studio in the royal palace, *Las Meninas* (see 15-16).

ART AND ART HISTORY

The relationship of an artwork to art history can be a significant matter in determining whether an artwork is significant or inconsequential. Even an artist's rejection of tradition requires an understanding of the tradition—since the artist is still conducting a dialog with it. This is why an artist is often described as "naive" if he or she is unaware of art history. Like all of us, the artist is conditioned and affected by the past. This is no weakness

or sign of lack of originality. If there could ever be an entirely original artistic genius, this individual would most likely be a sad genius indeed. The art theorist R. G. Collingwood has written eloquently on why Modern Art's love of novelty is a mistake:

> If an artist may say nothing, except what he has invented with his own sole efforts, it stands to reason he will be poor in ideas. . . . If he could take what he wants wherever he could find it, as Euripides and Dante and Michelangelo and Shakespeare and Bach were free, his larder will always be full and his cookery . . . be worth tasting. . . . Let all artists . . . plagiarize each other's works like men . . . modern artists should treat each other as Greek dramatists or Renaissance painters or Elizabethan poets did. If anyone thinks that the law of copyright has fostered better art than those barbarian times could produce, I will not try to convert them.

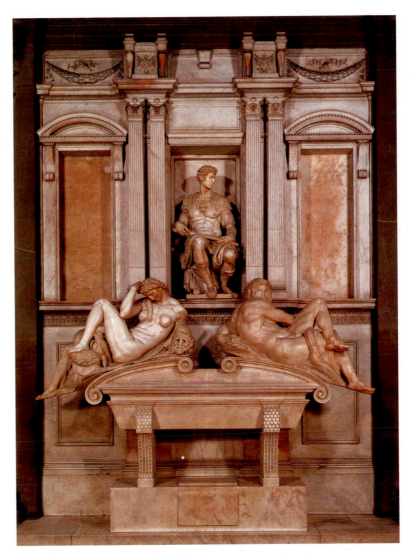

1/43 MICHELANGELO BUONARROTI, *Tomb of Guiliano de'Medici with Figures of Night and Day*, New Sacristy of the Medici Chapels, 1520–1533, Florence, Italy.

Despite Collingwood's justification, doesn't it diminish the reputation of the great Michelangelo Buonarroti when one learns he repeatedly based his work on the past? Isn't this a kind of visual theft? The Renaissance genius didn't think so. He considered it not only normal but a mark that he was well educated and understood proper artistic practice. When his patrons, the powerful Medici family of Florence, reached out to him in the 1520s to design a new family tomb, Michelangelo's thoughts turned to the past. Because the tomb was to be attached to the family chapel designed by Brunelleschi (see Chapter 14) a century earlier, Michelangelo decided to mirror its style. The basic plan and decoration pays homage to a great Florentine artist whom Michelangelo admired. Brunelleschi, a sculptor and architect, is best known for creating the most famous dome of the Early Renaissance, the Duomo of Florence (see **14-4**). Yet when it came to the new chapel's dome, Michelangelo reached much further into the past. He modeled it on one of the greatest buildings of the ancient world, the famous Pantheon in Rome (see **12-28**) from the year 120. Michelangelo had recently returned from Rome after finishing his paintings for the Sistine Ceiling (see **14-17**).

The need for a new tomb came with the untimely deaths from illness of two young Medici princes, Giuliano and Lorenzo. Michelangelo was among the mourners because he knew them himself. As a young man, he had lived in the Medici palace while being educated and was treated almost like a member of the family. In his sculpture of Giuliano (**1-43**), we can see that his dome's

reference to Ancient Rome was no accident. Giuliano is dressed and posed as a Roman emperor and looks down as if all below are his subjects. The young prince, nearly the same age as Michelangelo, achieved no such majestic status in life but is given that in his death. Atop his tomb, no mere mortals grieve for him, but the ancient mythic figures of Night and Day.

The Roman Empire was the peak of human civilization for those who lived in the Renaissance. The meaning of the word is the rebirth of ideals and art of that ancient era. By designing the Medici tomb's dome like the Roman Pantheon's and by elevating its young prince, he honors the family and the man in the highest way he knows. The art historical references are not failures of imagination but essential to the meaning of the work. Just as Renaissance artists were inspired by ancient Roman art, so have artists been in every period since then. As the twentieth-century poet T. S. Eliot put it, "Artists are in a dialog with every other artist who ever lived."

However, as a portrait, the sculpture of Giuliano de'Medici can be considered a failure. His handsome, almost godlike face bears little resemblance to the young, bearded Italian seen in a painting by Raphael. When asked by a contemporary why the sculpture didn't look like Giuliano, Michelangelo's response demonstrated that he understood the power of art. He is reputed to have confidently answered, "Don't worry, it will."

WHEN WE KNOW MORE, WE SEE MORE

This chapter presents ways to better understand and judge art. It is important to remember that an artwork need not be perfect; even a great work of art can fail in some ways and still be a masterpiece. Understanding art is similar to understanding people; the process is never finished but continually deepens as more is discovered. This is part of the power of art. The serious viewer studies the background of a work, which is far more than the white walls and polished wood floor of a gallery. The background can include the artist's biography, inner psychology, and the traditions and society

that influenced the artist. All of these elements can tell us why the artist chose to make the artwork look the way it does. No background is absolutely necessary (just as we can appreciate people without knowing everything about them), but the appreciation of a work of art is certainly increased by awareness of the context in which it was produced. It helps us see more than we could before.

BEGINNING THE JOURNEY

As you begin your study of art, think of it as you would a trip to another country. Dedicate yourself to expanding your horizons and remaining open to the many things you will be introduced to in this course. This kind of openness may be difficult to maintain when you are confronted with a work of modern art for the first time. For many viewers who are not familiar with contemporary art, their negative response is probably based on an immediate gut reaction. Nothing is wrong with having a strong, personal reaction to visual art—in fact, modern artists hope to create such reactions; most would rather have people hate their work than be bored by it. But viewers who take a quick glance and react instantly (19 seconds being the average look), without really trying to understand an artwork, are missing a rich world of visual experience. All one needs to do is invest some time and thought, and keep one's eyes and ears open to surprises.

For example, most visitors walk right by a video installation as they approach the information desk of PS 1, a contemporary art museum in New York City. Pipilotti Rist's *Selfless in the Bath of Lava* (1-44) is easy to miss because *Selfless* is just a few inches in size and is not hung on a wall. A ticket buyer with sensitive ears might be distracted by the sound of a woman's faint but desperate cries and search for its source. The hunt leads downward. The cries come from a small, jagged hole in the wooden floorboards. Just beneath the hole is a three-inch video of a nude woman (the artist) that can only be seen by squatting down. She is trapped in glowing, fiery lava. Pale and white-haired, the damned woman reaches up and screams. Pleading, she yells in several languages, "You would have done everything better. Help me. Excuse me." The scale of the video transforms each viewer, making him or her into a giant, all-powerful being with the fate of this poor woman

apparently placed in their hands. Rist wants viewers to question their attitudes about art and to change their point of view. Another of her video installations can only be found inside a handbag.

During this course, you will be treated to many surprises. You will wander around the globe and discover art from many countries and continents. Time will be no barrier as we move across the centuries. We will explore many ways of looking at and understanding art. At our journey's end, when you finish this course, you will be in a better position to say whether you think the *Mona Lisa*'s reputation is deserved, whether de Kooning had any talent, or whether Duchamp should be considered an artist. And your decision will be based on knowledge rather than prejudice or gut feelings.

After the course is over, keep in mind that you have begun a lifelong journey, one in which you will never be alone. As the French novelist Marcel Proust wrote:

> Only through art can we get outside of ourselves and know another's view of the universe which is not the same as ours and see landscapes which would otherwise have remained unknown to us like the landscapes of the moon. Thanks to art, instead of seeing a single world, our own, we see it multiply until we have before us as many worlds as there are original artists.

That is the power of art.

CHAPTER 2

THE PRIMARY ELEMENTS

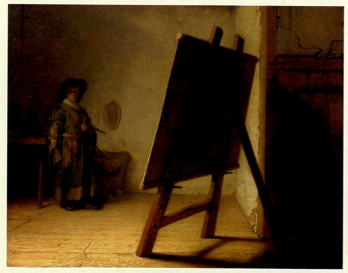

2/1 REMBRANDT VAN RIJN, *The Artist in His Studio*, c. 1628. Oil on panel, 9¾" × 12½". Museum of Fine Arts, Boston, MA (Zoe Oliver Sherman Collection.

For many viewers, one of the most frustrating aspects of art is trying to describe what they see. It is as if they were trying to explain something in a foreign language. This chapter introduces the vocabulary of the language of art, which revolves around the basic visual elements that all artists use: space, line, shape, light, texture, and color. With these elements, artists are able to create incredibly diverse images, from Egyptian pyramids to the *Mona Lisa*. The fundamentals of art and design provide a way to describe the various forms of art; they are the basis of the language in which all art is discussed.

SPACE

In the Old Testament we are told, "In the beginning . . . the earth was without form and void." Empty space is the most fundamental of the elements of art and design. Each artist has a profound sense of the void as he or she stares at the piece of paper, the canvas, the block of marble, or the empty site before beginning work. Space is the field of action on which all artists do battle. Many

artists feel as Rembrandt seems to in *The Artist in His Studio* (2-1), a little overwhelmed as they begin.

Artists work within two kinds of space. **Two-dimensional space** is flat and can only be viewed from one side. Anything that exists in this space, like the space itself, will have height and width but no real depth. However, two-dimensional art forms such as drawings or paintings often create the *illusion* of depth. **Three-dimensional space** contains objects that can be viewed from all sides, objects that have height, width, and depth. This is the kind of space we actually live in. Sculpture and architecture are examples of three-dimensional art forms.

Defining space and controlling it with the other visual elements is what making art is all about. The process begins with the artist choosing from the range of elements. In many cases, the first choice is the simplest—the line.

LINE

To a mathematician, a line is the shortest distance between two points. To an artist, a line is much more than that. It is an element of infinite potential, capable of conveying a wide variety of emotions and meanings. Vincent van Gogh's drawing *Fishing Boats at Sea* (2-2) shows the versatility of a line. By varying length and width, or by choosing various types of lines (straight, curved, or angular), the artist creates a seascape of great complexity, reflecting the many forms of nature.

All lines are the result of an artist's movement. When they particularly reveal the action of drawing, the motion of the hand and arm, they are described as *gestural*. Van Gogh's gestures are what make his drawing exciting. Notice how different kinds of lines convey

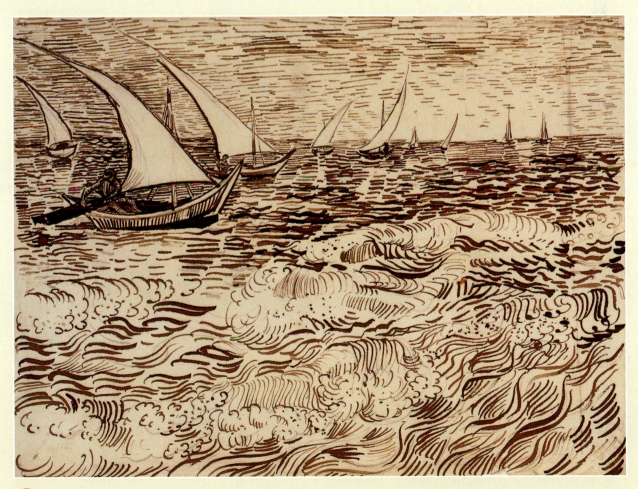

2/2 VINCENT VAN GOGH, *Fishing Boats at Sea*, 1889. Pencil, reed pen, and ink on wove paper, 9½" × 12⅝". Staatliche Museen, Berlin, Germany.

different moods. Horizontal lines seem calm, verticals inspiring, and diagonals and curves energizing. A line's texture, whether it is scratchy or smooth, for example, can imply feelings as well. The many and various lines in van Gogh's drawing almost "sound" different. One can imagine the crash of the swirling lines in the foreground as opposed to the calm, bold marks of the sea. We can hear the sails pulling taut in a stiff breeze because of the tight geometry of their lines.

By varying a line's width (or *weight*) as it is drawn, an artist can make a line seem to twist and turn as if it were moving in space. The viewer sees the line as if it has depth, as if it were curling. Artists also use this technique to create the illusion of a solid form. In *Boy Playing a Flute* (2-3), a brush and ink drawing by the Japanese artist, Hokusai, the folds of the boy's clothing are created by effective and economical shifts in each line's weight. A line that barely begins at his shoulder changes to a heavy sweep of the brush as it follows his back. What first appears to be a simple ellipse describes the top of a basket with subtle changes of width. These kinds of lines are called **contour lines**, because they describe the edge of a form.

The imaginative use of line in Japanese art and calligraphy interested many of the Abstract Expressionist artists of the 1950s. Franz Kline, a friend of de Kooning's (see Chapter 1), made expressive lines the focus of his pictures. In *New York, New York* (2-4), he used a wide brush loaded with paint to make powerful gestural lines that carved up the space of the huge canvas. Kline's title tells us he felt the result had the impact of a city crowded with skyscrapers.

Although lines are technically two-dimensional elements, three-dimensional artists like sculptors also use them. Materials that are significantly longer than they are wide—such as string, sticks, or steel bars—are considered linear elements in sculpture. For example, to capture the spirit of *Josephine Baker* (2-5), the famous Parisian cabaret singer and dancer, Alexander Calder drew playful linear forms in three-dimensional space by twisting wire. Edges or contours are also perceived as lines in sculpture. If you look at the corners of a room, you can observe that this is also true in architecture. Three lines converge at each corner in most rooms. Dramatic edges or lines on all kinds of things often elicit comments like, "Look at the lines of that boat!"

2/4 FRANZ KLINE, *New York, New York*, 1953. Oil on canvas, 79" × 51". Albright-Knox Art Gallery, Buffalo, New York. © 2012 The Franz Kline Estate/Artists Rights Society (ARS), New York.

2/3 HOKUSAI, *Boy Playing Flute*, c. 1800. Ink and brush on paper, 4½" × 6½". Freer Gallery of Art, Smithsonian Institution, Washington, D.C.

2/5 ALEXANDER CALDER, *Josephine Baker* (IV), c. 1928. Steel wire, 100.5 × 84 × 21 cm. Centre Pompidou, Musée national d'art moderne, Paris, France. © 2012 Calder Foundation, New York/Artists Rights Society (ARS), New York.

SHAPE

By their very nature, lines divide space. As a line twists along its path, you may have noticed it begins to seem as if it is tracing the border of a shape, an enclosed space. In fact, it is more common for shapes to be built from several lines, but it only takes one line that turns around and connects to its beginning to make one. A circle would be an example of a shape made with one line. In art, the word *shape* is usually used to describe two-dimensional forms. A three-dimensional shape is called a **mass**. Unlike a shape, a mass has real weight, like a block of marble. The space inside a mass, like a building's dome, is called its **volume**.

Although shapes come in all sizes and types, whether two-dimensional or three-dimensional, they are usually described in four ways: geometric, organic, abstract, and nonrepresentational.

Geometric shapes (2-6) are formed by straight lines or curved ones that progress evenly. Squares, rectangles, triangles, and circles are all examples of this kind of two-dimensional shape. The three-dimensional equivalents are the solid geometric masses called the cube, box, pyramid, and sphere.

Organic shapes (2-7) are formed by uneven curves. They are sometimes called *naturalistic* or *biomor-*

phic. Shapes that look like amoebas or treetops would be included in this category.

Abstract shapes are representational shapes that have been simplified. Even when they have been reduced to their basic underlying forms, distorted or exaggerated, the original sources of the shapes will remain recognizable. Abstract shapes can be either organic or geometric.

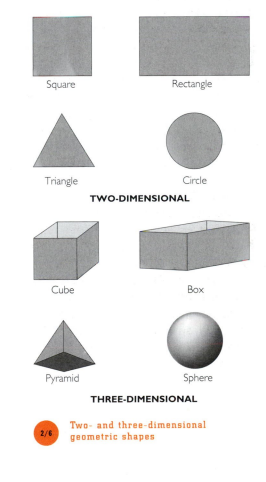

Square Rectangle

Triangle Circle

TWO-DIMENSIONAL

Cube Box

Pyramid Sphere

THREE-DIMENSIONAL

2/6 Two- and three-dimensional geometric shapes

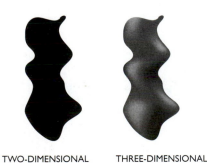

TWO-DIMENSIONAL **THREE-DIMENSIONAL**

2/7 Two- and three-dimensional organic shapes

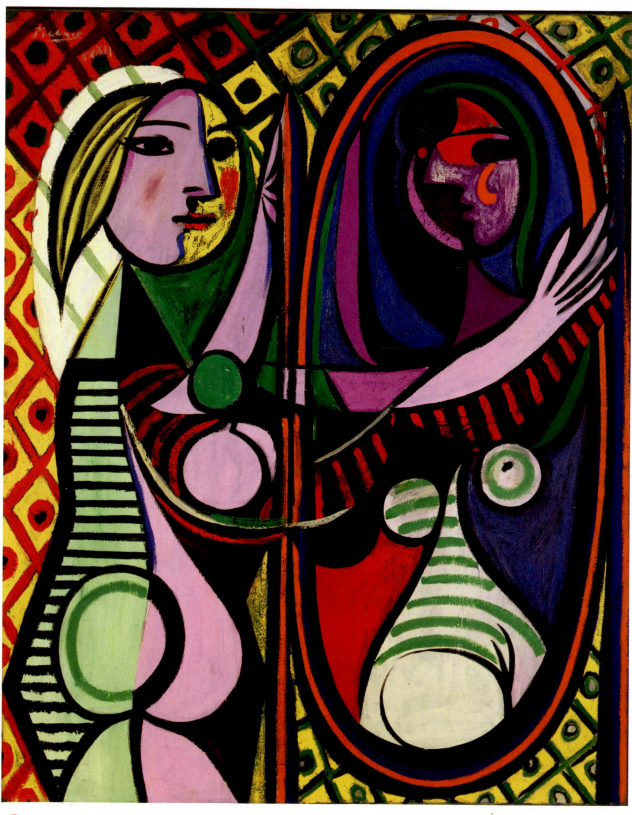

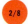

PABLO PICASSO, *Girl before a Mirror*, 1932. Oil on canvas, 63¾" × 51¼". Museum of Modern Art, New York (gift of Mrs. Simon Guggenheim). © 2012 Estate of Pablo Picasso/Artists Rights Society (ARS), New York.

Nonrepresentational shapes are those that are not meant to refer to anything we can see in the real world. They are sometimes called *nonobjective* or *totally abstract*. These shapes can also have either organic (*soft-edged*) or geometric (*hard-edged*) qualities.

In *Girl before a Mirror* (2-8), Picasso creatively employs all types of shapes and even shows how one shape may share the qualities of two different kinds. The young woman's face, for example, is recognizable but is missing many of the details. Because it has been simplified, we say it has been *abstracted*. It has also become more geometric. The curve of her belly has also become an abstract form, because it has been simplified and exaggerated. Still, it remains a naturalistic abstract shape. Behind her are nonobjective shapes (wallpaper?) that form a colorful pattern in the background. We do not have to identify them to enjoy their rhythm and bright colors.

THE SPIRIT OF THE FORMS

All geometric forms, whether two- or three-dimensional, suggest order, mathematics, and reason. Buckminster Fuller's *United States Pavilion, EXPO 67* (2-9) reflects these qualities of geometry. His building seems perfect and ideal. The absolutely consistent repetition of one basic element gives it unity and coherence. Yet it is not without a sense of movement. Most curved geometric forms, like circles and spheres, convey a feeling of motion. Squared-off geometric shapes, however, like a square or a cube, generally imply perfect calm and stability. This is why most architects prefer them for their buildings.

The sculptures of Louise Bourgeois (2-10) are more difficult to categorize. Works like *Blind Man's Buff* seem to include shapes that fit all categories at once. Each bulbous part in the center seems like a living creature, but none that we can absolutely recognize. They crowd

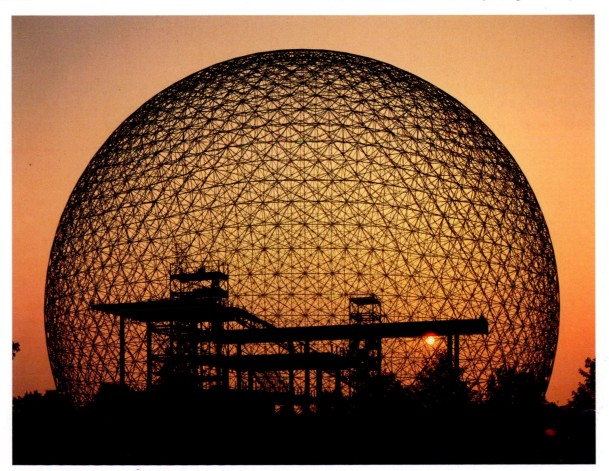

2/9 BUCKMINISTER FULLER, *United States Pavilion, EXPO 67*, Montreal, 1967. Steel and Plexiglas geodesic dome, shown under construction, 137' high, 250' diameter.

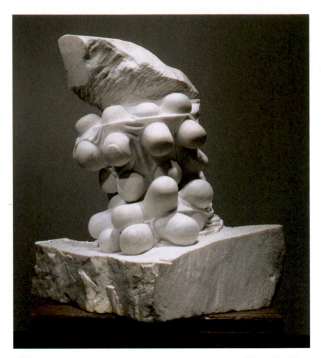

2/10 LOUISE BOURGEOIS, *Blind Man's Buff*, 1984. Marble, 36½" × 35" × 25"; 92.7 × 88.9 × 63.5 cm. Wood base: 15" × 29 3/4" × 19"; 38.1 × 75.7 × 48.2 cm. Cleveland Museum of Art © Louise Bourgeois Trust/Licensed by VAGA, New York, NY.

together, as if in a precarious huddle, and the outside forms seem on the verge of tumbling off the sculpture. Are these abstractions parts of living creatures or actually nonobjective shapes?

Compared to Fuller's dome, this sculpture's soft curves certainly appear much more naturalistic. However, compared to a realistic sculpture by Michelangelo, we would have to say that Bourgeois's work looks very geometric and much more abstract. These simple comparisons remind us that categories in art are useful for discussion, but their meaning is usually relative.

LIGHT, SHADOW, AND VALUE

Light plays a critical role in art. It is vital to the presentation of any three-dimensional art form such as Bourgeois's *Blind Man's Buff*, and a museum or gallery director will spend many hours setting up the lighting of sculptures before opening an exhibit to the public. Light obeys certain physical laws. A mass that is lit by a single source of light will be brightest where it is closest to the source, whereas other parts will be less and less bright (or more and more in shadow) in relation to their distance from the light. Sections that do not face the light at

all will be in complete darkness, as will anything directly behind the object. These are blocked from the light and in a *cast shadow*.

Highlights and shadows define the shape of a statue. For instance, in *Blind Man's Buff*, light falling on the balloon-like forms heightens our sense of their roundness. They feel soft because they are softly modeled by gradually darkening shadows. Light also accents the rough textures of the heavy masses above and below them.

Artists working in two-dimensional media (like drawing or painting) often want to create the illusion of three-dimensional masses. This can be done by recreating the effects of light and shadow as they move around a solid object.

Art students who follow a traditional course of study will spend a great deal of time learning to draw such things as drapery in light, because the illusion of three dimensions can be very powerful. A sense of volume is created by drawing the contrasting areas of lightness and darkness. The dramatic contrast between highlights and darkness in Caravaggio's *David with the Head of Goliath* (2-11) is called **chiaroscuro** (literally "light/dark"

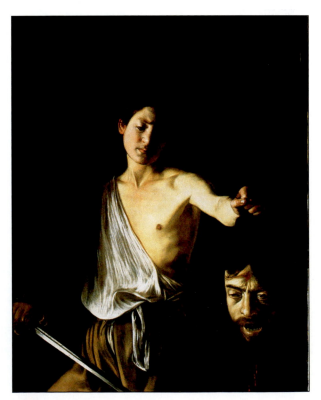

2/11 CARAVAGGIO, *David with the Head of Goliath*, c. 1610. Oil on canvas, 49" × 40". Galleria Borghese, Rome, Italy.

in Italian) and makes the figures and forms come dramatically alive. The light focuses our attention exactly where Caravaggio wants it and even controls the movements of our eyes. Thus we are drawn inescapably to the main elements of the story by following the light. First, we see David's thoughtful face, then our eyes move down his boyish chest and across his arm to Goliath's stunned expression. Next our view moves along the razor-sharp sword to return to the young hero's face. Each of these details is remarkably clear and defined, paradoxically because of the deep, obscuring shadows that surround them.

As a student's eye becomes more experienced at seeing subtle changes in lightness and darkness (or value), his or her drawings of real things will seem more convincing. Few artists were ever better than Georges-Pierre Seurat at translating the subtle aspects of the effects of light. While most artists use a combination of line and shading to model forms, his drawings use only changes in tonal values. *L'écho* (2-12), without a single line, remains a persuasive and satisfying image of a young boy calling out to produce an echo. The boy's solidity is evoked by the soft contrasts in tones.

JAMES TURRELL, *Night Passage*, 1987. Rectangle cut into partition wall, fluorescent and tungsten lamps, and fixtures, rectangle cut 82" × 191" room: 144" × 720". Solomon R. Guggenheim Museum, Panza Collection, Gift, 1991. 91.4080. Photograph by Erika Barahona © Solomon R. Guggenheim Foundation, New York. © James Turrell.

The contemporary artist James Turrell uses light itself as his medium. His installations transform simple spaces into sublime experiences. To view *Night Passage* (2-13), one walks into a dim, empty room with a simple blue rectangle apparently painted onto the back wall. As one comes closer to the painting, it grows more luminous. If you have the courage to try to touch the mysterious painting, you are in for a surprise. Your hand will pass through it into a deep, empty space. There is no painting. The rectangle is made of light. You can even stick your head into it and gaze around. Inside you experience a seemingly infinite blue space—a place with no edges or shadows, an extraordinarily peaceful, pure experience of light.

TEXTURE

Turrell's work depends not just on light, but that a powerful human instinct will be stronger than our fear of security guards. Our fingers are used from birth to understand our environment. When we "cannot believe our eyes," we will use touch to confirm or deny what our eyes have told us. We will touch something to see if it is warm or cold, soft or hard. Many textures can be pleasurable; for example, soft velvet, smooth marble, and silky water are three very different pleasing textures. Sculptors find deep satisfaction in plunging their hands into wet clay and manipulating it. Some textures are disturbing, even painful, like the coarseness of sandpaper or the jagged edge of broken glass.

GEORGES-PIERRE SEURAT, *L'écho*, 1883–1884. Conté crayon, 12" × 9¼". Yale University Art Gallery, New Haven, CT.

Artists who work in three dimensions create *tactile* textures, textures that can actually be felt. Like Turrell, most sculptors actually intend their art to be understood both visually and tactilely, and sometimes not just by people. Visitors to the estate where the sculptor Henry Moore lived for the last forty years of his life are expected to walk the grounds and to run their hands along the huge sculptures. He always thought that the barriers between art and viewers were arrogant and pretentious. At Perry Green, viewers can get a sense of works like *Sheep Piece*'s (2-14) metal surface when they touch it, its substantial weight when they lean against it, and its great size when they put their arms around it. However, when Henry Moore designed *Sheep Piece*, he wasn't thinking of people. It was inspired by and made for the sheep that graze the meadows around his home. The large metal sculpture's opening at the bottom is at a height that not only provides shelter for the sheep but is also comfortable for them to scratch their backs. The overall abstract design represents a ewe and a lamb, a kind of mother and child, where the large form protects the smaller one. Moore drew sheep often and described them as "rather shapeless balls of wool with a head and four legs," but he was always aware that "underneath all that wool was a body."

One does not need to touch all art objects to appreciate their textures. The African craftsman who made the *Oath-Taking Figure* (2-15) provided a visual feast of textures. The ritual figure mixes smooth wood, hard metal

2/15 *Oath-Taking Figure*, 1880–1920, Congo. Wood, nails, cloth, glass, paint.

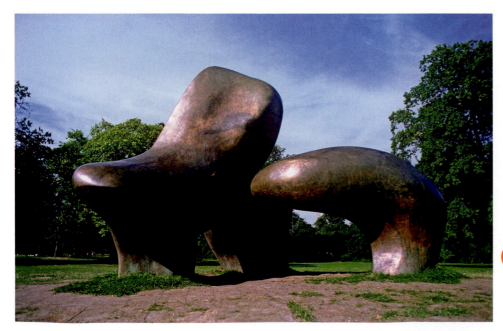

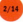 **HENRY MOORE**, *Sheep Piece*, 1971–1972. Bronze, 19' tall. Hoglands, Hertfordshire, England. The Henry Moore Foundation. © The Henry Moore Foundation. All Rights Reserved, DACS 2012/www.henry-moore.org.

nails (each nail embodies a prayer), soft animal hide, and a shiny mirror. While it may not be inviting, this strange (to Western eyes) combination of materials provides contrasts that are visually and tactilely interesting.

Creating the illusion of texture has been an interest of two-dimensional artists for centuries. For a Northern Renaissance artist like Jan van Eyck, it bordered almost on obsession. In his desire to recreate visual reality and demonstrate his accomplishments, he would crowd his pictures like *The Virgin with the Canon van der Paele* (2-16) with all sorts of textures. With the use of delicate brushstrokes, which are difficult to detect, and smooth transitions of light and dark, van Eyck shows us soft skin, curly hair, translucent glass, shiny armor made of many metals, smooth marble tile floors, an ornately carved stone throne, and fabrics of all kinds, including elaborate rugs. Van Eyck's dedication to visual truth, as seen in the lavish simulation of surfaces, shows not only his skill but also his religious devotion. He worked many hours to surround the Madonna and her child with a gorgeous and sumptuous setting.

COLOR

It is not just the textures that make Van Eyck's painting seem so dazzling. It is also the rich, vibrant colors, like the bishop's brilliant blue and gold mantle and Mary's bright red cloak at the center. The value of color was well known during the Renaissance. In fact, contracts for a commissioned painting like this would spell out not only the subject but also the colors to be used and how much money should be spent on them.

Why do we love color? Color affects us unconsciously, emotionally; we are drawn to it instinctively. No better example of the pure delight of color is the Hindu

2/16 JAN VAN EYCK, *The Virgin with the Canon van der Paele*, 1436. Tempera and oil on wood, approximately 48" × 62". Musées Communaux, Bruges, Belgium.

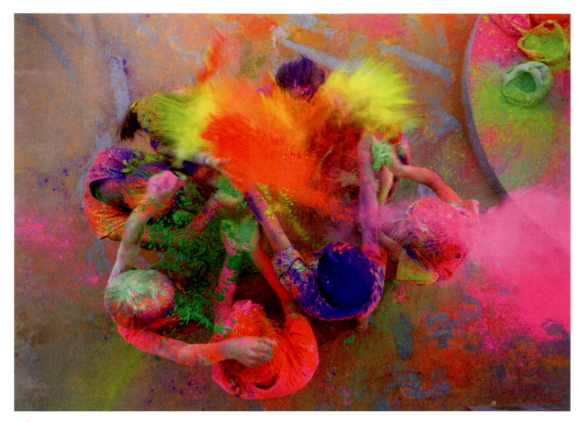

2/17 Children play with colored powder at Holi Festival in Jodhpur.

festival of *Holi* (2-17). Celebrated in late February or early March in India and other nations with large Hindu populations, it welcomes the end of winter with wild ceremonies. During this Festival of Color, men and women chase each other through the streets and throw handfuls of bright pigments or squirt colorful paint on each other. Crowds of revelers sing and dance in town squares as priests with huge hoses spray magenta, blue, or red paint from above. Young and old, rich and poor have fun together, and no one is immune from being doused with color. Even tourists who find themselves in the midst of the festivities will soon be drenched in wet paint by young children with spray bottles. By midday, the air is filled with dense clouds of color and the smell of sweet perfumes added to the pigments.

Color has been an integral part of artwork since prehistoric times. Using earth and minerals, cave artists made their pictures of bison more vivid by adding reds and browns. Small prehistoric figurines that are tens of thousands of years old show signs that they were originally decorated with colors. Even the marble statues of the Greeks, admired for centuries for their pure white surfaces, were originally colored to resemble flesh (see "Art News" box on page 47). Today, artists use new artificial colors that can glow like phosphorus. Throughout history, color has remained a constantly fascinating and important tool for artists.

DESCRIBING COLOR

Anyone who has looked at paint chips in a hardware store has been confronted with the challenge of clearly describing colors. Even white paint seems to come in countless varieties, from brilliant to snowflake to linen to eggshell and on and on. Although scientists believe that human beings with normal vision across the globe see colors in the same way, different societies have various ways of naming them. Hungarians use two words for red, a tribe in New Guinea two for green, Navajo two for black but only one word that covers both blue and green. The Welsh have a word that refers to a color that is part green, gray, and blue.

Because of the importance and complexity of color in works of art, and in order to describe colors clearly, artists have developed a specialized and sophisticated vocabulary. **Hue** refers simply to the name of a color on the color wheel or in the spectrum. For example, violet and green are two different hues. *Tints* are hues that have been lightened by white. Pink is a pale tint of red. *Shades* are hues that have been darkened by black. Navy blue is a very dark shade of blue.

The **neutral colors** are white, black, and gray. They make tints and shades but do not affect the hue of any color. For example, no matter how much black, white, or gray is mixed into blue, it could not change it into purple. Neutral colors do, however, change the value of any

hue with which they are mixed. *Value* means the relative lightness or darkness of a color. It is not the same as color **intensity**, which refers to the vividness of a particular hue. For example, when you bring up the color setting on your television, you increase the intensity of the colors. The relative values between the colors remain the same. The darks are still darks; the lights are still lights. Colors at the highest level of intensity are sometimes described as **saturated**. Any addition of a neutral color will diminish a hue's intensity. In other words, pink is lighter in value than a pure red, but not nearly as intense.

COLOR WHEEL

Artists employ a wide variety of colors that are made by mixing other colors; however, three colors cannot be made from any others. As in mathematics, where a prime number cannot be divided, in art they are called the **primary colors**: red, yellow, and blue. These are the sources for all other colors. When two primaries are mixed, they create the **secondary colors**: orange, green, and purple. The mixing of primary, secondary, and neutral colors accounts for the almost limitless range of colors in art.

Many artists have found it useful to think of primary and secondary colors arranged in a circle called the **color wheel** (2-18). On the color wheel, the primaries are placed equidistant from each other, with their secondary mixtures placed between them. Part of

the vocabulary of color is based on the color wheel. **Complementary colors** are directly across from each other on the color wheel. Red and green, yellow and purple, orange and blue are considered opposites, or *complements*. They have unique properties when they are paired: They accentuate each other's intensity, at times causing painful clashing. **Analogous colors** such as green, blue-green, and blue are adjacent on the color wheel; when paired they form more pleasant harmonies because they are more closely related.

Half of the colors on the color wheel are called **warm colors** and the other half **cool colors**. The warm colors are the family of colors based on yellow, orange, and red—colors associated with warmth, fire, and the sun. When Olafur Eliasson's installation opened at the Tate Modern (2-19) no one expected to see crowds of

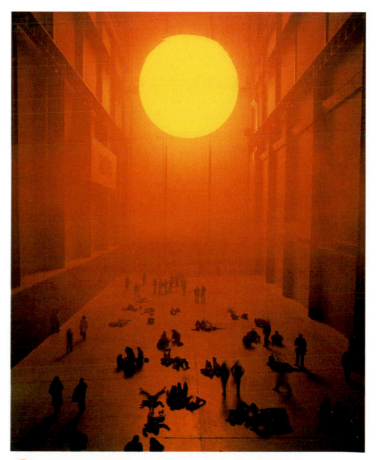

2/19 OLAFUR ELIASSON. *The Unilever Series: Olafur Eliasson, The Weather Project*, October 16, 2003–March 21, 2004, Turbine Hall, Tate Modern 29/01/2009. Installation.

green

yellow

blue

orange

purple

red

2/18 Color wheel.

Londoners lounging under its bright lights and mirrors as if they were on a beach. Clearly, our association of warm colors with temperature is very powerful. In fact, people instinctively feel a change in temperature when they walk from an orange to a blue room. The cool colors are those based on blue, purple, and green—colors that are associated with calm, the sky, and the ocean. The nineteenth-century Romantic Caspar David Friedrich's painting, *The Wreck of the Hope* (2-20), is a symphony of cool colors. It tells the story of an explorer's ship crushed by polar ice. The world is icy, cold, and silent, a vast universe to which man and his pitiful attempts to conquer nature mean nothing.

THE SCIENCE OF COLOR

Like artists, scientists have been interested in color for a long time. In the 1600s, Isaac Newton noticed how a beam of light passing through a glass of water created a rainbow on a wall. He theorized that the water, acting as a prism, refracted the light, breaking it up into its different components. These components, seen in the rainbow, are called the *color spectrum*. He discovered that white light is actually made up of all the colors.

We see a white piece of paper because when light strikes it, none of the light is absorbed; the paper reflects all of the light back to us. On the other hand, a black piece of paper absorbs all of the light cast on it. This explains why a black room is very difficult to make bright. Almost all of the light rays produced by lamps will be absorbed into the walls, leaving darkness. A piece of paper colored red seems red because it absorbs all of the colors from light *except* red, reflecting only that color back to our eyes.

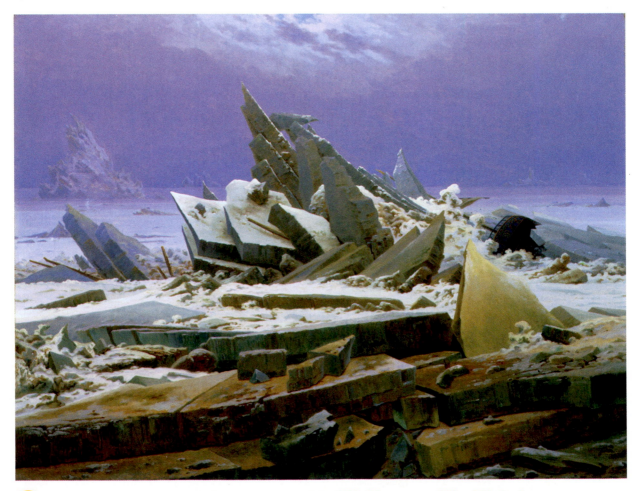

2/20 **CASPAR DAVID FRIEDRICH,** *The Wreck of the Hope,* 1823–1825. Oil on canvas, 38" × 50". Hamburger Kunsthalle, Germany.

AUGUSTUS: IN LIVING COLOR

The rediscovery of buried marble statues by ancient Greek and Roman sculptors during the early days of the Renaissance inspired Donatello, Michelangelo, and their followers. The cool white surfaces of the sculptures were believed to exemplify a long-lost rational age that needed to be reborn. Since then, white marble has been the material of choice for any sculptor who wanted to evoke the Classical ideals of calmness, rationality, and purity.

But in ancient times these sculptures actually looked quite different. Recent research has discovered traces of *polychromy* (multicolored paint) on them. As surprising as it may seem, these statues were originally clothed in brightly colored garments and their bodies painted in a flesh color. The old paints were composed of organic materials like eggs, so they simply disappeared over time.

An exhibition at a museum in Copenhagen in 2004 called "ClassiColor—the Color of Greek and Roman Sculpture" integrated recreations of well-known sculptures in their original colors with the statues we have today. Many of the recreations, such as *Augustus of Prima Porta* (2-21), would have horrified Michelangelo. If you compare it to the original (12-24), it is easy to see why. Augustus's chest armor was once decorated in garishly bright blues and reds, his head with orange hair and eyebrows, and his lips painted. As displayed in the museum, he certainly seems out of place, appearing more like a store mannequin or a socialite dressed for a costume party than an illustrious emperor. In fact,

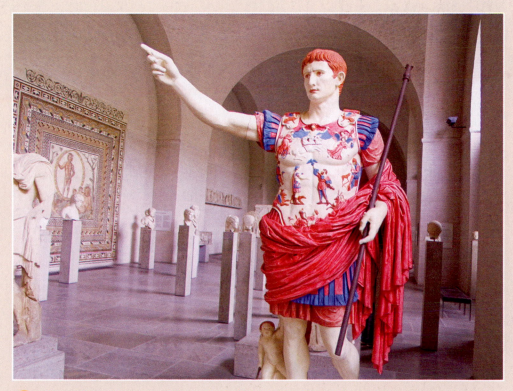

2/21 Recreation of *Augustus of Prima Porta*, 2004. Ny Carlsberg Glyptotek, Copenhagen, Denmark. Photograph by Lars Kirkegaard.

AUGUSTUS: IN LIVING COLOR

newer research reveals that the flat colors used to recreate the statues were not entirely accurate. In Ancient times, wax was applied to cover and preserve the marble statues. Combined with wax as in encaustic (see Chapter 5), the colors created a much more luminous effect, so, for example, the flesh colors were translucent and more natural looking.

Surprisingly, scientists had already discovered evidence of the colors on ancient statues in the seventeenth century. But the European artists and writers of the 1600s were in the midst of a Classical movement that believed that ancient pure white statuary was a highpoint of civilization. The "enlightened" artists of the time rejected the scientists' evidence as preposterous.

Research is showing that many more of our notions about past work will have to be revised. The Greek Parthenon, symbol of the Classical Age, was also brightly colored. So too were the great Gothic Cathedrals, which used colorful decorations to captivate, inspire, and tell biblical stories to a populace that was unable to read. Amiens Cathedral in France has embraced the new scientific evidence and now has an annual summer evening spectacular called "Cathedral in Colors." Visitors can see the architectural monument as it was centuries ago (2-22) with the aid of computer-generated lights. The Cathedral's exterior is transformed from the solemn edifice of textbooks to one that would fit well with festivals in Mexico and South America.

While it is unlikely that today's conservators will insist on repainting these cherished monuments of the past, innovative exhibitions are now helping us understand that the masters of ancient and medieval times were not austere idealists immune to the power of color. Color has been an essential element of art and design in every century.

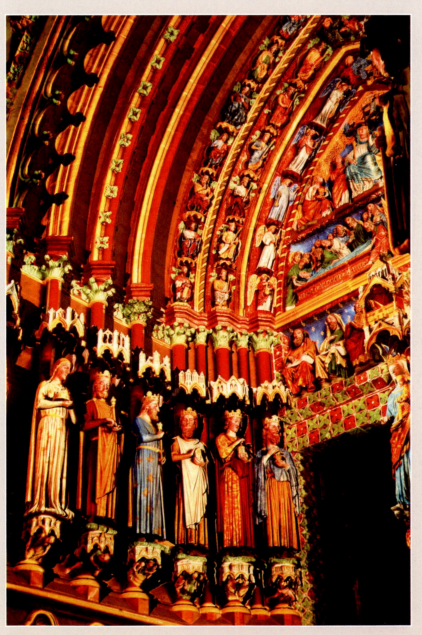

2/22 Detail of Amiens Cathedral lit with colored lights.

We begin learning the names of colors when we are very young. It begins not long after we learn to identify a cow and a pig. We are asked over and over again, "What color is this?" If our parents show us an orange circle on a white background (2-23) and we say "red!," our parents will look disappointed and tell us to try again. When we finally say "orange," they smile and tell us how smart we are.

What our parents were teaching us is how to name **local colors**. A local color is the general color nature of anything that we see. But colors in the real world are not so simple or definite. For example, if a tree is green, are all trees the same color? Is each tree always the same color? What color is it at noon? Is it still the same color at sunset? What color is it when it is wet with rain? Local color is useful for identification but is not specific enough for artists. Colors are much more variable than our parents ever told us.

In real life, we never see one color alone. Even if we enter a room painted entirely green, because of the lighting we see many different shades of green. *Color is affected by changes in the light cast on it.* An incandescent lamp would bring out the yellow in the green; a fluorescent bulb would make the green seem more blue.

A color is affected not only by light but also by what it is next to or surrounded by. For example, if we move the orange circle we saw on a white background to a red background (2-24), it will hardly seem orange at all; it will appear closer to yellow. This change is known as **simultaneous contrast**. Think of this first in black and white. A polar bear in a snowstorm is almost impossible to see, but a black bear would have a difficult time hiding. When two colors meet, they also accentuate the differences between them; their similarities will not be apparent. In fact, when that orange circle is on a yellow background (2-25), visually it is no longer orange (even though we know that is its local color). Visually, it is red. While artists need to be aware of both local colors and visual ones, they usually focus on what might be called the *visual truth*.

An analysis of Kees van Dongen's *Modjesko, Soprano Singer* (2-26) will give us an opportunity to use our new vocabulary of color. The painting combines warm and cool colors, but the warm colors dominate and make the strain of singing seem intense. That is because warm colors tend to excite, while cool colors relax the viewer. This is particularly noticeable in the singer's face—as the bright yellow changes to red, we feel the blood rush to her face as she reaches for a high soprano note. Warm colors tend to advance toward the viewer, while cool ones

2/23 Orange circle on a white square.

2/24 Orange circle on a red square.

2/25 Orange circle on a yellow square.

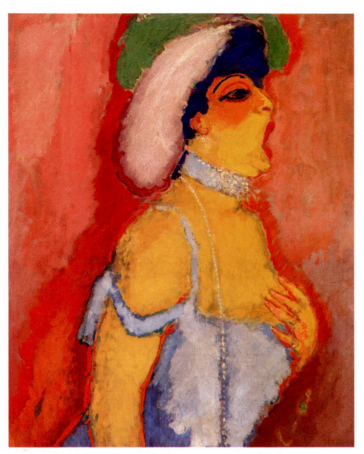

2/26 KEES VAN DONGEN, *Modjesko, Soprano Singer*, 1908. Oil on canvas, 39⅜" × 32". The Museum of Modern Art, New York. © 2012 Artists Rights Society (ARS), New York/ADAGP, Paris.

NATURALISTIC VERSUS ARBITRARY COLOR

Modjesko, Soprano Singer is an example of the deliberate use of **arbitrary colors**. The subject's skin, hair, and costume are not painted in realistic colors; these colors are the invention of the artist. Invented colors can accentuate the meaning of a picture and give it an emotional content. Arbitrary colors were also used in Picasso's *Girl before a Mirror* **(see 2-8).**

For many centuries, however, European artists rarely used arbitrary colors. From the end of the medieval period to the late 1800s, artists preferred to use colors that imitated those in the real world, or **naturalistic colors**. Although John Constable's palette for *The Haywain* **(2-27)** is limited to realistic hues, the painting also uses many of the properties of color we discussed in van Dongen's picture. Constable masterfully uses colors to direct our attention. Notice how the red marks on the horses draw us to the center of the picture to see the man and his cart. The warmth of the brown earth in the foreground helps lead us back to the reddish brown roof of the cottage. The golden trees seen in a gap take us to the distant fields. The picture's great depth is due to the faraway, pleasantly cool blue sky.

recede. Van Dongen takes advantage of these special properties. The singer's intensely yellow chest seems to expand against the pale blue dress, as does her throat, constricted by the cool ribbon around her neck.

In the background, around the figure, van Dongen uses red at its highest intensity. Shades of red become progressively lighter in value as they move away from the figure. Her hair, eyebrows, and eyes are painted in a dark tint of blue, so dark that at times they approach black. The painting's three-dimensional forms are created not by shading, as you would find in a drawing, but by changes in color value and intensity. For example, the face is shaped by shades of orange and red, with more intense colors reserved for the areas in deepest shadow. This combination of intense and pale, warm and cool colors creates the emotional, dramatic flavor of a singing performance.

EMOTIONAL RESONANCE

Throughout most of the history of art, one of color's most important uses has been to help the viewer identify subjects by use of their naturalistic colors. Since the late nineteenth century, however, many artists have explored more directly the ability of color to affect our emotions. Some modern artists have felt that if used without reference to specific objects in the real world, color could create its own visual language of emotion, an art of pure feeling, like music.

Vasily Kandinsky's *Pink Accent* **(2-28)** experiments with the expressive potential of the visual weight of different colors. This picture has its own inner life; the feelings we receive from it come from colors and shapes that do not need to refer to things we recognize in the ordinary world. Kandinsky created his own totally abstract characters, with what he called

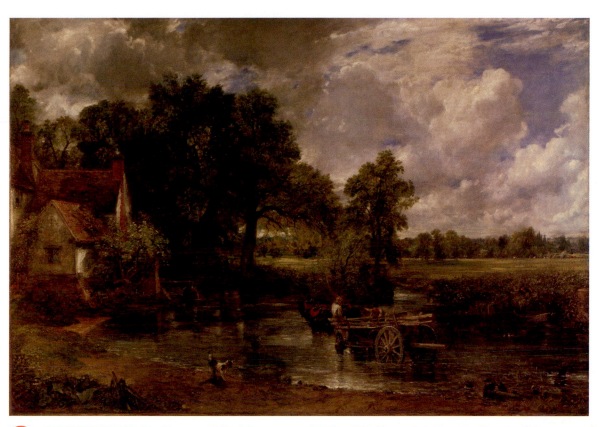

2/27 JOHN CONSTABLE, *The Haywain*, 1821. Oil on canvas, 51¼" × 73". National Gallery, London, Great Britain.

these unique beings we call colors—
each alive in and for itself, independent,
endowed with all the necessary qualities
for further independent life and ready and
willing at every moment to submit to new
combinations, to mix among themselves
and create endless series of new worlds.

Vasily Kandinsky, when he described colors mixing among themselves and creating endless series of new worlds, could also have been describing any of the other elements of art. Kandinsky thought of his elements as if they were living creatures, expressing a belief that many artists share: that in a successful work of art every point, every line, every element should be a living thing.

Kandinsky also wrote, "in art, as in nature, the wealth of forms is limitless." The challenge for an artist is to select and organize the many possible elements into a **design** that most suits the artist's intentions and is also visually satisfying. The next chapter explains the principles behind successful designs. There are just as many possible approaches as there are elements.

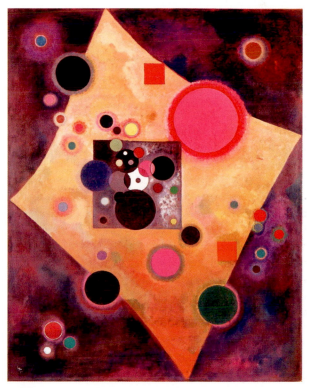

2/28 Vasily KANDINSKY, *Pink Accent.* 32" × 39½". Collection Nina Kandinsky, Neuilly sur Seine, France.

CHAPTER 3

THE PRINCIPLES OF DESIGN

Human beings prefer order, and we are made uncomfortable by chaos. Organization provides a sense of security; it is part of our desire to control our environment. We are not alone in the animal kingdom in our desire for regular meals, regular sleep, or regular hours, as anyone who owns a pet knows.

The artist reflects these basic instincts when he or she controls or **designs** the environment of a work of art. There are many possible strategies for a successful design, but almost all incorporate at least some of what can be called the *principles of design*. These have proven over time to be capable of organizing a coherent work of art from the wide range of ingredients at an artist's disposal.

As discussed in the last chapter, all artists deal first with empty space. Large, open spaces that seem endless are beautiful in nature, but most humans do not choose to make their homes in the midst of them. We like to limit an area and then populate it with buildings. For the two-dimensional artist, the first important design decision is also how to limit space and define its borders. The boundaries demarcate what is known as the **picture plane**, the playing field of the art elements. Its frame establishes a separate arena for artistic activity from the whole world that surrounds it. Its proportions will determine the effect of whatever is within its borders.

PLACEMENT

The first element put inside the picture plane has a profound effect. Now the field is no longer neutral; it is actively involved in a dialogue with what has entered it. The arrival of the first element actually produces two shapes in a picture plane. The empty space around the element becomes an important shape, too, and must be consciously dealt with. The element is called the **positive form**, and the altered space is the **negative form** or **negative space**. They are also called the **figure** and the **ground**.

Artists are particularly aware of the effect each element has on negative space. To an artist, space is never really empty; it is more like space in physics, as described by Albert Einstein, an invisible solid. By placing different elements within it, the artist manipulates space. So the arrangement of elements in the picture plane is not only a design of lines and shapes but also a design of the spaces between them—the negative spaces. The artist must control both the subjects and the spaces around them to create a successful artwork.

Ellsworth Kelly's painting *Red/Blue* (3-1) may appear at first glance to be very simple, but the placement of the orange shape on the blue ground was carefully thought

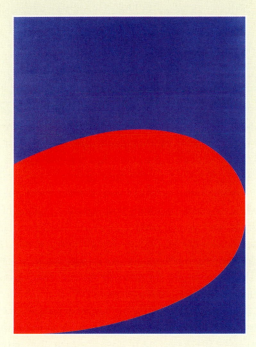

3/1

Careful placement and sensitivity to figure ground relations were always important to the French painter Henri Matisse (see chapter 18). When he was in his seventies and confined to a bed or a chair, he developed a new way of making art. Painting large pieces of paper and "drawing with scissors" as he described it, he produced some of the most popular work in his career—a portfolio of images called Jazz, later published as a book of lithographs. These pictures, like the *Burial of Pierrot* (3-2), provide a window into how artists play with figure-ground relationships and sometimes construct their subjects out of the shapes in the background. For example, the black shapes between the horses' legs are what make them appear to be prancing. The blue rectangle is the cabin of the hearse, but its white opening with a red heart at the center forms the coffin of Pierrot (in France, a well-known sad but loving clown). The white feather on the horse's head unexpectedly breaks through the pink border and joins its leaf-like companions. Matisse described his method as drawing "straight into the color" and the compositions as "improvisations in color and rhythm." Although made only of bits and pieces of paper, the whole effect is visually delightful.

out. By having that shape just touch the right border, Kelly creates two new shapes from the blue ground, one large, one small. Because the orange form sits toward the bottom of the picture plane, it conveys a sense of weight. Placed higher it would appear light like a balloon. Tilting the form upward adds a bit of liveliness to the picture. If you hold up your hand and block your view of the blue shape at the bottom, you can see what the picture would be like if the orange shape had filled the bottom half. Would it be more or less dynamic? Artists often block parts of their pictures in this way to consider changes to a composition and to see possible effects.

Designing space is a more complex task for an artist actually working in three dimensions. Part of the experience of viewing a building or most sculptures is moving around them freely. A three-dimensional form should provide a

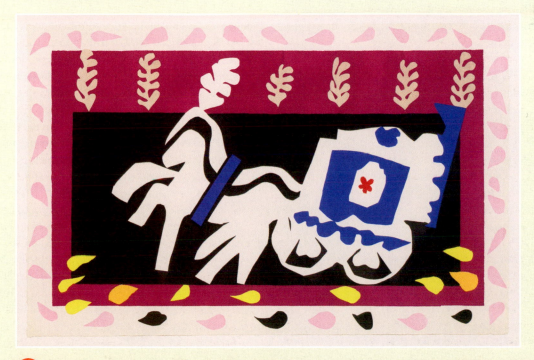

The Burial of Pierrot, stencil print, plate X from the illustrated book "Jazz" by Henri Matisse, 1947.

3/2

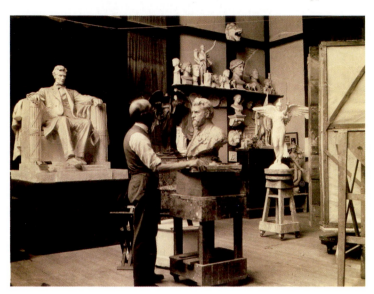

3/3 Daniel Chester French in his studio, 1922. Margaret Carson/Chapin Library, Williams College.

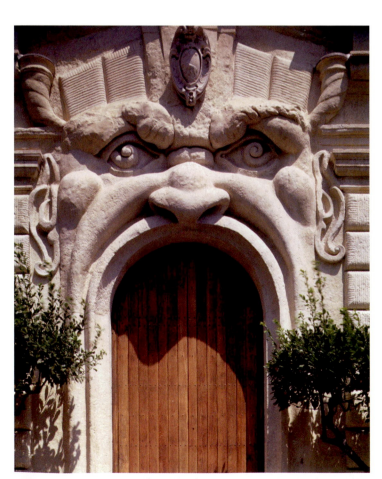

3/4 Portal of Palazetto Zuccari, Rome, Italy.

new encounter every time we shift our position. Therefore, a three-dimensional artist has to consider spatial issues from every possible vantage point. This includes not just the sculpture itself but also the many negative spaces that are being carved out by the positive forms. Planning for all of those different points of view is difficult with only flat drawings, so many sculptors build smaller studies out of materials like clay and plaster, as in the 1922 photograph of the sculptor Daniel Chester French in his studio (3-3). The walls are filled with studies for projects, and on the left we can see the model for his most famous commission—the Lincoln Memorial in Washington, D.C.

Architects also must define negative spaces, like the windows or doorways of their buildings. By decorating the portal (3-4) with a carving of a giant's face, the architect of the Palazzetto Zuccari provides an animated but rather forbidding entrance to his palace. One is forced to walk through the large mouth of a monster if one wants the privilege of entering.

Inside the "gullet" or entrance hall, one would encounter another kind of space that three-dimensional artists must design, a *confined space.* Architects must control both the exterior and interiors of their buildings. A good architect will make every room and every corridor into an aesthetic experience, even taking into account the experience of progressing from room to room (see **3-11**).

BALANCE

Balance is a natural human desire. We admire people who are well-balanced and tend to avoid those who are not. A loss of our ability to balance is disturbing, as anyone who has had an inner ear infection knows. Without it, we lose our state of well-being. Visually, we also find that achieving balance is an essential property in a satisfying work of art. The Asian symbol for yin and yang (3-5) is an example of perfect balance. It is also a good example of **figure-ground ambiguity**, where it is unclear which part should be called figure and which should be called ground. As in a

3/5 Yin/Yang symbol.

checkerboard pattern, one can see either black or white as the subject. For someone from the Eastern world, however, this is not simply an interesting illusion but a meaningful symbol of the correct way of living. The perfect balance portrayed is the balance of the life forces of yin and yang, the resolution of opposites. It is a symbol of an ideal world where night and day, work and play, emotions and logic, male and female, hot and cold, activity and rest all exist together in equivalence. One's life is out of balance when any of these things is stressed more than its opposite.

During the design process, balance is constantly changing. A mark as simple as a dot can affect the whole *equilibrium* or balance of a work of art. For example, imagine shifting one of the dots in the yin/yang symbol. It would unsettle the balance, thereby requiring a change of position or another element to be added in the field to create equilibrium. When the element enters, a new balance will need to be struck. Depending on its placement, the new shape could dominate its neighbor, be its equal, or seem overwhelmed by it.

The importance or **visual weight** of each element in a picture plane is always relative; it competes with its neighbors and is affected by the arrival of any new form. The visual weight also varies as its own position, color, size, shape, or texture changes. As the number of elements increases, the relationships become more and more complex, and maintaining equilibrium in the design is a greater challenge.

SYMMETRY AND ASYMMETRY

Art has taken many forms throughout its history, but the basic solutions to the problem of composition have remained surprisingly stable. Three basic methods of maintaining balance—symmetrical balance, radial balance, and asymmetrical balance—have proven effective. In **symmetrical balance** (sometimes known as bilateral symmetry), there is a general equivalence of shape and position on opposite sides of a central axis; if folded in half, the forms would match. With minor exceptions like the position of our hearts, all humans are designed to be bilaterally symmetrical. Ancient Cycladic idols (3-6) illustrate the special qualities of symmetrical balance. Their smooth, simplified forms and perfect symmetry provide a sense of calm and order—qualities appropriate to images of the "mother goddess."

When all elements revolve around a central point, **radial balance** is created. The whole world seems to pivot around the center in *Shamsa* (3-7), or "sunburst," which draws our attention irresistibly. The elaborate and beautiful details combined with the sumptuous use of gold

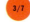 Cycladic idol, Syros, c. 2500–2000 BCE. Marble, 8½" high. National Archaeological Museum, Athens , Greece.

3/7 Ex Libris page from an album Shamsa ("sunburst" inscribed with the titles of Shah Jahan), c. 1640. Colors and gilt on paper, 15⁹/₁₆" × 10⁷/₁₆" wide. Metropolitan Museum of Art, New York.

paint creates a heavenly image, similar to the **mandalas** (see Chapter 5 "Global View" box) that Buddhists use for meditation. The titles of the Indian shah who sponsored this work (and built the Taj Mahal) are inscribed in the calligraphy at the center, along with the words, "May God make his kingdom last forever!"

In many cultures the circle is considered a perfect form. The Renaissance architect Donato Bramante's *Tempietto* (3-8) is based on a series of pure circular elements sharing the same center. From the stairs to the cylindrical columns to the dome and its cupola at the top, circular forms of countless kinds are arranged with extraordinary imagination. By utilizing radial balance to organize his building, Bramante created a sense of order and rationality. Meant to be admired as a representation of ideal forms and divine balance, the *Tempietto* is more a symbolic building than a functional one. Conducting a

church service inside is practically impossible, because the interior is actually only fifteen feet wide.

Unlike symmetrical or radial, **asymmetrical balance** is much more dependent on an intuitive balancing of visual weights. The parts do not revolve around a center or form a mirror image around an axis but can be positioned anywhere and be any size. Unlike symmetry, which is basically fixed and static, asymmetry is active. So, while it is more challenging to balance an asymmetrical artwork, when achieved, the equilibrium will be much more dynamic than in symmetrical or radial compositions. The twisting and turning forms in Pieter Paul Rubens and Frans Snyders's *Prometheus Bound* (3-9) create a sense of violent movement. This is a portrayal of the Greek mythological hero who stole fire from heaven and gave it to mankind. As a punishment, Zeus chained him to a mountaintop, where he was endlessly tortured.

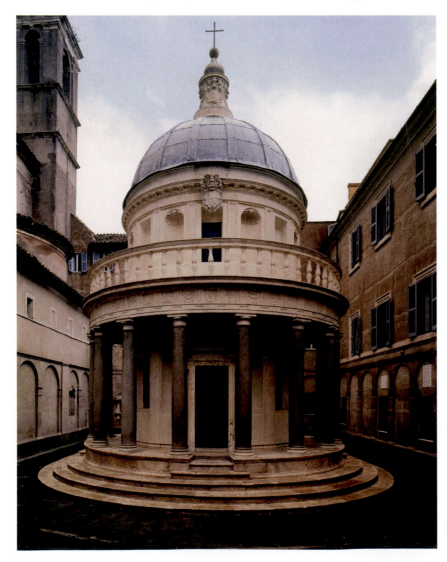

3/8 DONATO BRAMANTE, *Tempietto*, 1504 (?). San Pietro in Montorio, Rome, Italy.

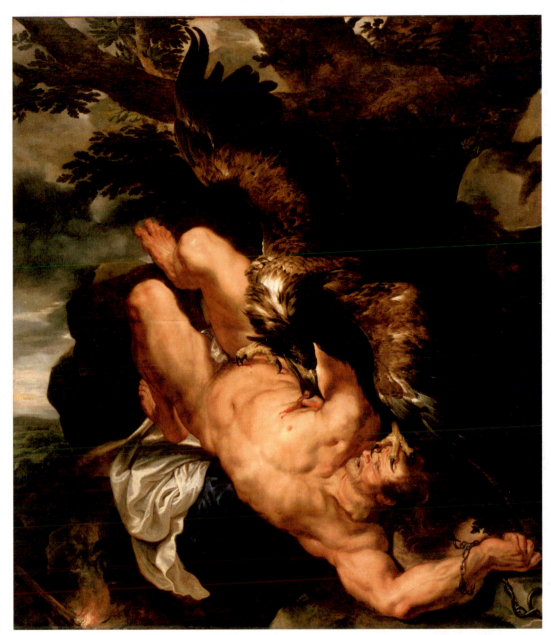

3/9 PIETER PAUL RUBENS (and FRANS SNYDERS), *Prometheus Bound*, 1611–1612. Oil on canvas, 95⅞" × 82½". Philadelphia Museum of Art.

EMPHASIS

Emphasis in a work of art is essential for its success; if every part is of equal value, either confusion or monotony will numb the viewer. *Prometheus Bound* provides a good study of ways to create emphasis: *relative size*, *lines of force*, *focal point*, and *contrast*.

 Although the picture was a collaboration, the brilliant design of the composition was by Rubens (see Chapter 15). Snyders, an expert on animal subjects, painted the magnificent eagle. The eagle and Prometheus are obviously the main characters because of their great *relative* size compared to all of the other elements. The main thrust or *line of force* in the picture is the diagonal body of Prometheus, which is falling toward the viewer. The eagle that swoops down from the right creates an opposing diagonal that crosses Prometheus at his bloody liver, which is torn out every day. The crossing lines of force *emphasize* the cruel act, making it the *focal point* of the picture. Lines that converge on one location are a powerful artist's tool. They irresistibly draw the viewer's eye. In a picture of this complexity, it is especially important for the artist to control the viewer's gaze, to choose which

parts dominate. To make doubly sure that the main subject is the center of our attention, Rubens also bathes it in a bright light that *contrasts* with the general darkness.

UNITY AND VARIETY

A radial image like the Shamsa or a symmetrical sculpture like the Cycladic idol has a strong sense of **unity** or coherence. Unity is created by repetition of shapes, textures, patterns, or colors. No work of art can succeed without it, but unity alone is unlikely to sustain the interest of a viewer. The challenge for a designer is to balance unity with variety.

In the painting *Prometheus Bound*, there is plenty of variety. We see the contrasting areas of light and dark, many different textures, and items of different sizes. Tension is created by the precarious visual balance and the violent subject. With all the variety, how did Rubens prevent total chaos and preserve a sense of unity? Although it is not readily apparent because of the complexity of the action, Rubens used *repetition*. Throughout the canvas, circular lines and shapes are repeated over and over again. The curves of Prometheus's muscles, the wings and neck of the eagle, the leaves, the rocks, the chains, and even, if we could see the original, the brushstrokes share the same form.

Unity and repetition are much more apparent in an installation by the contemporary artist Tara Donovan (3-10). Almost one hundred thousand identical Styrofoam cups are arranged by the artist to form a cloudlike shape that hovers over the gallery space. While most other sculptors use ordinary materials for planning purposes only, Donovan uses commonplace materials as her medium. She prefers stuff like pencils, paper plates, or toothpicks over expensive artist materials like marble or bronze, because they create "a very real physical connection to the work" with viewers. What could be a totally unified but terribly boring sculpture is given exceptional variety by the artist's imagination. This installation also takes different forms depending on the location. Donovan believes that each work should grow based on the specific qualities of light and space of a site, as well as the nature of the material she uses.

A more subtle use of repetition can be seen in the interior of the Pantheon in Paris (3-11), designed by the Baroque architect Jacques Germain Soufflot. One can easily see how a series of similar shapes being repeated (in this case, arches) creates a sense of **rhythm**. Rhythm is very satisfying. Our breathing, our heartbeat, the sound of waves breaking on a shore—all of these things soothe us because of their orderly repetition. Though a hiccup can be startling, in art some variation in rhythm is necessary to avoid monotony. Soufflot's design does this by interspersing domes of varying heights between the archways. He also fills open areas with different *patterns*, which are the simplest form of repetition. Patterns are created by evenly distributing a shape over a surface. They are instantly seen as a unified field; after looking at one part, one never examines the other parts separately. In the Pantheon, a sense of order because of the

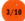 TARA DONOVAN, *Untitled*, 2003. Styrofoam cups, hot glue, size variable. ACE Gallery, New York. Photograph by Raymond Meier. Courtesy of ACE Gallery, Los Angeles.

JACQUES GERMAIN SOUFFLOT,
Pantheon (Sainte Geneviève), Paris,
France, 1755–1790.

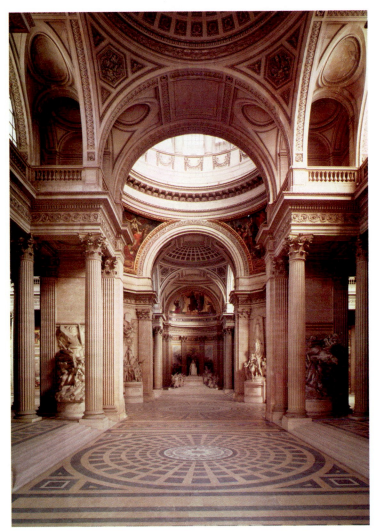

repetition of forms is combined with a sense of opulence because of a richness in surface decoration.

 Harmony is another important way to unify a composition, and *harmonious* is a good word to describe the impression made by Georgia O'Keeffe's *Two Calla Lilies on Pink* (3-12). Her painting demonstrates the two ways harmony can be created. The first is by the *sympathy of the forms*, often a byproduct of repetition. The soft, curvilinear shapes are repeated just as often as the curves in the Rubens, but here they seem to almost nuzzle each other. That is because there are very few hard contrasts; all shading is done gradually and gently. Colors also can create harmony. Red and green colors usually clash, but notice how O'Keeffe harmonizes those colors by adding white to them, using pastel versions. The most intense color is yellow-orange, a color that works well with the others but is still strong enough to provide the two focal points of the picture. Their verticality against the generally horizontal elements elsewhere also helps draw our attention to them.

PROPORTION AND SCALE

O'Keeffe's painting is more than three feet high, much bigger than any calla lily flower. By enlarging the blossoms, or changing their **scale**, we see them in a new

GEORGIA O'KEEFFE, *Two Calla Lilies on Pink*, 1928. Oil on canvas, 40" × 30". Bequest of Georgia O'Keeffe for the Alfred Stieglitz Collection, 1987. Philadelphia Museum of Art. © 2012 Georgia O'Keeffe Museum/Artists Rights Society (ARS), New York.

light and can understand the abstract beauty of their structure. **Proportion** and scale are related because they both refer to size, but they do not mean the same thing. Proportion compares the parts of one thing to each other. Scale has to do with the relation between something and a constant—for example, the size of an average person.

 The quest for ideal proportions has been pursued for centuries. Many societies have believed that these proportions would be a window into divine order. The Roman architect Vitruvius believed that the proportions of human beings were such a window and that all buildings should be built with those proportions in mind. He came to this conclusion after observing that a man with his arms and hands extended would fit into the two most perfect geometrical shapes—the circle and the square. Leonardo da Vinci shared Vitruvius's belief and also believed that scientific study of the functions of our bodies would ultimately reveal the workings of the whole universe. He wrote, "Man is the model of the world." In one of his notebooks, he drew the famous image of "Vitruvian

Man" (3-13), which updated Vitruvius's theory. Unlike the Roman architect, da Vinci had actually done measurements of human beings and learned that the square and circle would not be able to share the same center. Notice how da Vinci shifts the square down from the circle's center.

Vitruvius was preceded in the search for ideal proportions by the Ancient Greeks. Their concept of the *Golden Mean* (sometimes called the *Golden Proportion*, *Ratio*, or *Section*) was the guiding principle for the designs of their greatest buildings like the Parthenon in Athens (see Chapter 12). By tradition, Pythagoras is credited with the discovery of the ratio. Some believe this ideal preceded the Greeks and that one can see the ratio in the Pyramids of the Ancient Egyptians; others have claimed it was used in Ancient India.

This Golden Ratio can be determined in several ways, the simplest being to place a small rectangle and square together, thereby forming one big rectangle. When the proportions of the smaller rectangle equal that of the big overall rectangle, then it is the Golden Mean. The mathematical formula is $a/b = b/(a+b)$ or numerically 1:1.618. The Greeks simply referred to it by using the letter *phi*. As complicated as the formula may seem, admiration for buildings built with it has been nearly universal. Renaissance architects based their buildings on the Golden Mean. Even contemporary surveys have found that people prefer designs based on the Golden Mean compared to any other system of proportions.

For artists, however, proportions do not always have to be ideal. In fact, the impact of Gabriel Orozco's *La D.S.* (3-14) is based on its striking and unsettling contrast to the normal proportions of an automobile. To create this strange vehicle, Orozco worked in a Peugeot garage in Paris and sliced a Citroën DS into three parts. After removing the center, he reattached the two sides. Looked at from the side, it appears to be a normal automobile. Visitors can even enter it from any of the doors and open the trunk. From the front, it retains it symmetry, but its unique proportions transform it into a strange creature that confuses our expectations and seems to stare at us.

As with proportions, changes in scale are meaningful in art. The Ancient Egyptians used hierarchical scale in their works to show the relative importance of the individuals portrayed. In *Chest of Tutankhamen with Hunting and War Scenes* (3-15), a painted chest found in his tomb, the famous pharaoh is hunting both lions and his enemies. Behind him are the other members of the hunting party, but their heights are no more than one-third of his because of their lower status. The targets of his arrows—the lions and his enemies—seem even more insignificant in comparison to Tutankhamen. The use of hierarchical scaling is not unique to the Ancient Egyptians and has been used

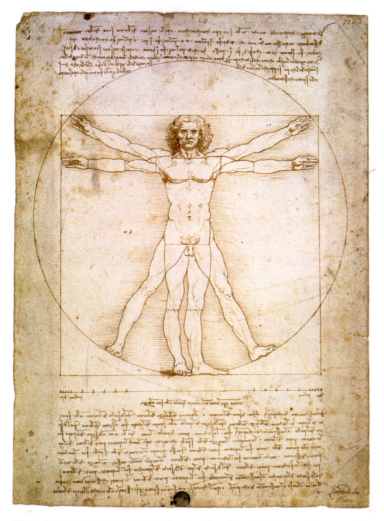

LEONARDO DA VINCI, "Vitruvian Man," c. 1490. Ink and watercolor on paper, 13½" × 9⅝". Gallerie dell'Accademia, Venice, Italy.

3/13

in cultures around the world. Examples can be found in Medieval, Assyrian, and Benin relief sculptures, as well as Renaissance altarpieces. King Tut, as he is popularly known (see Chapter 12), remains a larger-than-life figure, whose sudden death at 19 is considered mysterious. Ironically, one theory is that he died from an infection after breaking his leg in a fall off his hunting chariot.

"Larger than life" is a common expression that means someone or something is larger than an average person or *large scale*. Anything that large tends to attract our attention (see "Art News" box on page 64). Religious buildings and shrines are often built on a majestic scale, either to impress a god with the people's devotion or to impress a people with the greatness of their god. Gothic cathedrals, Greek temples, and Islamic mosques all follow this idea of the power of enormous buildings, but few temples and statues (it is both) can compare to the forty-five-foot-tall

 3/14 A work of art entitled 'La D.S 1993' by Mexican artist Gabriel Orozco is pictured during the press view of the Gabriel Orozco exhibition at the Tate Modern in London.

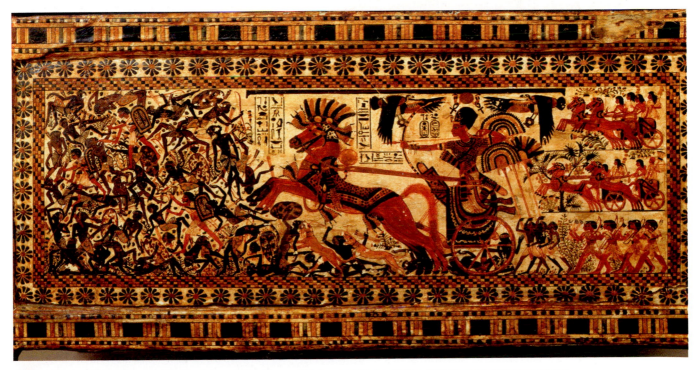

3/15 *Chest of Tutankhamen with Hunting and War Scenes* (side), c. 1323 BCE. 24" × 17". Egyptian Museum, Cairo.

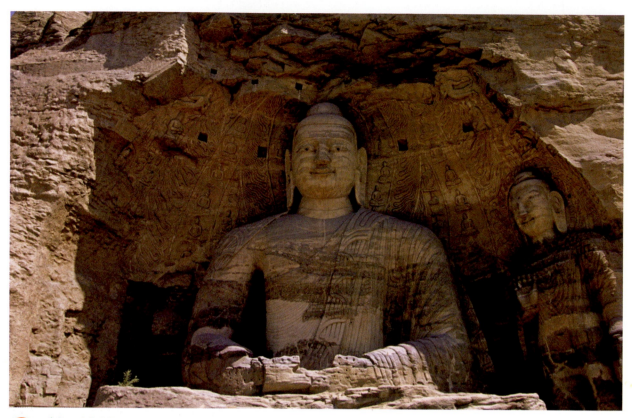

3/16 *Colossal Buddha*, Cave XX, Yungang, Shansi, China, 450–500 CE. Stone, 45' high.

Colossal Buddha of China (3-16), which was carved out of solid rock. Believers go inside the Buddha to worship at elaborate shrines at human scale, but the exterior's scale explains why viewers come away with a sense of an all-seeing and powerful god. If this statue were only three inches tall, the effect would be entirely different.

Andrea Dezsö's tunnel book, *Gentle Beast Hiding Among Leaves* (3-17), explores the effect of a miniature world on one's imagination. Her work is easy to miss in galleries or museums that are often dominated by huge paintings, installations, and sculptures. According to Dezsö, a tunnel book is "a small world that nobody has seen." Each one is constructed like a tiny stage set, with a series of cut and decorated paper panels slid into a box. Part of a series, every small diorama is no more than seven inches tall; viewers must peek into the lit interiors to discover what's "living inside." The scenes she creates are based on her childhood memories and fantasies growing up in Transylvania, in a period when Romania was under Communist rule.

3/17 ANDREA DEZSÖ, *From the Series Living Inside, "Gentle Beast Hiding Among Leaves,"* 2009. Tunnel book: hand-cut paper, thread, acrylic paint, mixed media, 7" × 5" × 6". Courtesy of the artist and Frey Norris Contemporary & Modern, San Francisco, CA.

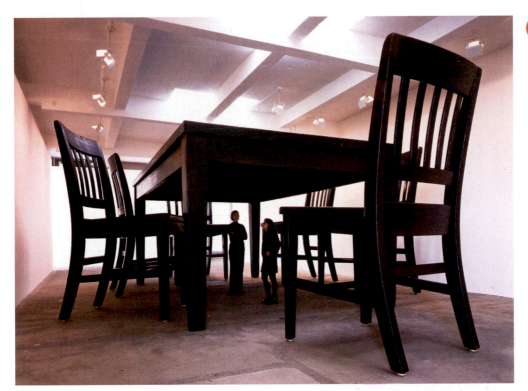

ROBERT THERRIEN, *Under the Table*, 1994. Wood and metal, 117" × 312" × 216" overall. The Broad Art Foundation, Santa Monica, CA. Photography: Douglas M. Parker Studio, Los Angeles. © 2012 Robert Therrien/Artists Rights Society (ARS), New York.

The scale of the tunnel book turns each viewer into a giant, observing the tiny, fanciful, sometimes frightening, characters within.

Quite the opposite effect is created by the scale of Robert Therrien's *Under the Table* (3-18). The sculpture depicts a completely ordinary subject—a wooden table and chairs—but their huge size takes the ordinary into the realm of fantasy. Scale, as stated earlier, is based on a frame of reference, often the size of a human being. Without the people in the illustration, we would assume it was a photograph of a dining room set taken from a low point of view. In fact, the idea for this sculpture came while Therrien was taking photographs of his own furniture. Because we can see the people, we understand that the table is gigantic, nearly ten feet tall. When visitors walk under the table, the effect is like being transported back in time—to a point-of-view we had when we were babies.

A more disturbing vision of infancy can be seen in David Siquieros's *Echo of a Scream* (3-19). Here scale and relative size is used to intensify this vision of the effect of poverty on the young. The enormous duplicate of the baby's head amplifies the power of the scream. The baby's body, however, seems weak and helpless because of its relationship to the mass of surrounding

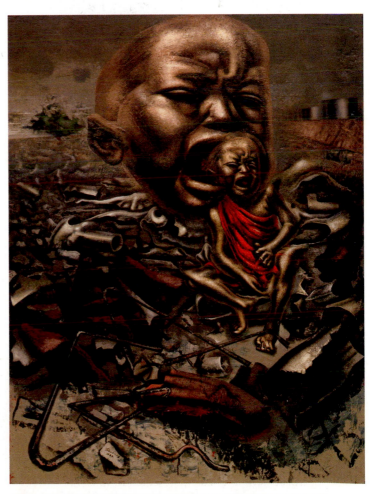

DAVID SIQUIEROS, *Echo of a Scream*, 1937. Duco on wood, 48" × 36". Museum of Modern Art, New York.

SCALE ON TRIAL:
THE *TILTED ARC* CONTROVERSY

In the 1980s, a sculpture in which no one could find any sexual, political, or even representational content became controversial just because of its scale and placement. The ultimate fate of Richard Serra's *Tilted Arc* (3-20), an outdoor sculpture commissioned by the federal government, would take nine years of bitter debate and court battles to resolve. During that time, it became a lightning rod for discussion about government-supported art and the rights of artists versus the public.

In 1979, Richard Serra, a Minimalist sculptor, was chosen by a panel of experts to design a sculpture for a plaza in front of a federal building complex in New York City. Serra is a well-known and critically acclaimed sculptor who had already designed sculpture for plazas in Berlin, St. Louis, Barcelona, and Paris. Serra's New York commission was part of the "Art in Architecture" program supervised by the General Services Administration (GSA) of the federal government. This program sets aside one-half of 1 percent of the monies allocated for new federal buildings toward the purchase of public art designed for the site. At the time of the commission, the federal buildings were already completed. The semicircular plaza in front of them already had a fountain at its center and was regularly traversed by thousands of federal employees.

After many consultations with engineers and the design review board of the GSA, the chief administrator of GSA in Washington, D.C., gave Serra the go-ahead for his design. It was completed and installed in 1981 and greeted with immediate hostility. *Tilted Arc* was both tall and menacing, graceful and impressive. Constructed of Cor-Ten steel (which is used for

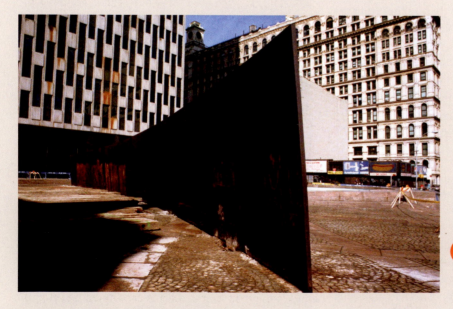

 3/20 RICHARD SERRA, *Tilted Arc*, 1981. Hot-rolled steel, 120' long. Federal Plaza, New York. © 2012 Richard Serra/Artists Rights Society (ARS), New York.

bridges), 12 feet tall and 120 feet long, it swept across almost the entire plaza between the fountain and the entrance. The sculpture formed a very gradual arc that crossed and balanced the opposing curves of the circular paving stones of the plaza. The wall of steel also tilted at a slight angle toward the central building.

Serra had decided not to embellish the fountain and buildings but to alter the whole experience of the plaza. "After the piece is created," Serra said, "the space will be understood primarily as a function of the sculpture." In other words, he wanted to make his sculpture the focus of the entire area. He succeeded in fulfilling his intention, but with a reaction he never imagined. Workers dubbed the new sculpture "the Berlin Wall of Foley Square." Instead of walking directly across the plaza as they had in the past, they were forced to walk around the sculpture. Rather than confronting and contemplating the artwork as Serra hoped they would, the workers were simply irritated by its placement. The arc made a strong abstract composition when seen from the building's windows at ground level, but it also blocked workers' view of the fountain. Angry letters flooded local newspapers and magazines, and thirteen hundred employees at the federal complex signed a petition demanding its removal.

In 1985, the head of the GSA's New York office organized three days of public hearings on the *Tilted Arc*. Testimony was heard from office workers who described the sculpture as "garbage," "an irritation," "rusted junk," and "hideous" and demanded its removal. It was clear that no one had considered consulting the occupants of the Federal Plaza before awarding Serra the commission, even though they would have to live with the sculpture every day. Museum curators, art scholars, critics, and artists testified in favor of the work. It was suggested that the GSA put some effort in "building public understanding" of the art it had commissioned. Serra attempted to explain his sculpture to the public:

Tilted Arc *was constructed to engage the public in dialogue. . . . The sculpture involved the viewer rationally and emotionally. . . . The viewer becomes aware of himself and his movement through the plaza. As he moves, the sculpture changes. Contraction and expansion of the sculpture*

results from the viewer's movement. Step by step, perception of not only the sculpture but the entire environment changes.

The judgment of the panel was that the sculpture should be removed. Shocked at first, Serra responded with a $30 million lawsuit, charging that the GSA had deprived him of his constitutionally protected rights of free speech and due process of law, along with breaching his contract. Serra argued that his contract called for a permanent sculpture. He had designed it specifically for the site, so it would not work in the same way in any other location. Its removal would destroy it. A judge ruled in 1987 that since the GSA had purchased the sculpture from Serra, he had no further rights connected with it. It was up to the government whether to keep it in the plaza, move it, or destroy it.

In March 1989, in the middle of the night, construction workers used jackhammers and cranes to disassemble the *Tilted Arc*. Broken into three pieces, the remains of the sculpture were taken to a city parking area and stacked while the GSA said it was looking for another site. Serra publicly announced that he would not cooperate with the government in its search. *Tilted Arc* was never seen again.

Because of the controversies surrounding his work, Richard Serra would likely agree that artists can no longer trust the commitment that the government makes for permanent displays of art. If an artist must fear public outrage, isn't it likely that he or she will use safe, conventional approaches to commissions rather than ambitious ones? Will caution decorate our public places instead of imagination? The judge's ruling was particularly unsettling to artists. Can the government destroy any of its thousands of artworks?

On the positive side, awareness of the need to involve the general public in decisions on public art has increased. The GSA instituted new policies that reflect the need for social responsibility in the designs it chooses. Artists are not given commissions after sites are finished but work with the architects during the planning stages. Concerned citizens are also invited into the development process. Today, education of the community is considered an integral part of any plan to bring art to civic places.

garbage. Shapes in the foreground in another context might remind us of bent paperclips, but compared to the baby, they are twisted, broken pipes.

DESIGNING AND ORGANIZING SPACE WITH DEPTH

By changing the relative size of objects, Siquieros is also able to create the illusion of the third dimension, or *depth*.

The dump where the baby was abandoned appears to go on forever, making the baby's predicament seem even more hopeless. We read the space as deep because we tend to perceive large objects as closer to us than small ones. We have all seen photographs where people in the distance are much smaller than those closer to the camera. If one of the subjects reaches out at the camera to block out the image, the size of the hand seems enormous compared to the relatively tiny figures. In Siquieros's painting, the pipelike shapes get smaller and smaller from

 SULTAN MUHAMMAD, *The Court of Gayumars,* detail of folio 20 verso of the Shahnama of Shah Tahmasp, from Tabriz, Iran, c. 1525–1535. Ink, watercolor, and gold on paper, full page approx. 1' 1" × 9". Aga Khan Trust for Culture, Geneva.

the bottom to the top of the picture. The large head at the top makes them seem even farther behind.

For many centuries and cultures, the illusion of three-dimensional space was of small importance. In Persian illuminated manuscripts, such as *The Court of Gayumars* by the Sultan Muhammad (3-21), creating a beautifully designed and meaningful picture is much more essential. Notice how most of the figures are the same size no matter how distant they are supposed to be from the viewer. Depth is implied, but in more decorative ways. We can tell which figures are meant to be behind others when they are overlapped. In the Persian

tradition, as well, closer forms are placed toward the bottom, the more distant toward the top. This particular painting shows the legendary first king of Iran with his court. Sitting on his mountain throne, the king seems to float in a lavender haze. His importance is established by his isolated position in the top center, while the members of his court are crowded together at the bottom and sides of the page. It is worth noting that this picture was painted by a sultan. Artistic accomplishment was admired by the great princes in Persia, many of whom, like Sultan Muhammad, were given formal art training.

A more convincing illusion of depth with overlapping shapes can be seen in Hiroshige's color woodcut *Maple Leaves at the Tekona Shrine* (3-22). The Japanese printmaker increases the depth with forms that diminish as they get farther from the viewer. Notice how the subject of the picture, a religious shrine, is actually one of the smallest elements. It is the tiny wooden structure positioned just left of center in the middle ground. It seems especially insignificant because of its contrast with the relatively gigantic branches and leaves across the top. The difference in their sizes helps give the illusion of great depth.

Because the branches, leaves, and cliffs are cut off by the edge of the picture, a great deal of *implied* space is also created. Because we are very familiar with photography, we are not surprised to see parts of subjects *cropped* at the border. However, Western artists of the 1800s were astonished and very excited when the first Japanese prints using this technique arrived in Europe. Before then, with the exception of portraits, all elements were neatly composed within the picture plane, rarely touching a border. Implying that forms continue past the edges is a very effective way to suggest deep space without resorting to conventional linear perspective.

To create a sense of extremely deep space, artists for thousands of years have used **atmospheric perspective**, which is based on the effect our atmosphere has on things seen at a great distance. Even the most farsighted among us have difficulty seeing

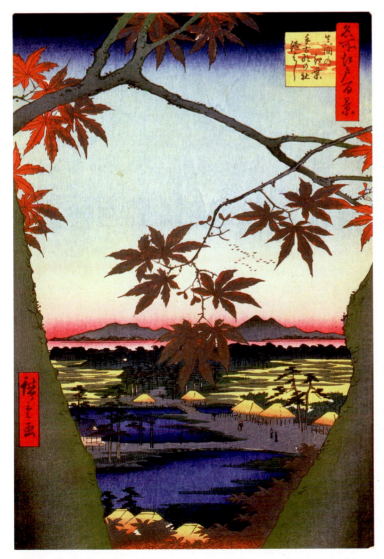

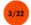 UTAGAWA (ANDO) HIROSHIGE, *Maple Leaves at the Tekona Shrine,* Mamma, 1857. Color woodcut, 13¾" × 9⅜". Brooklyn Museum of Art (Gift of Anna Ferris), New York.

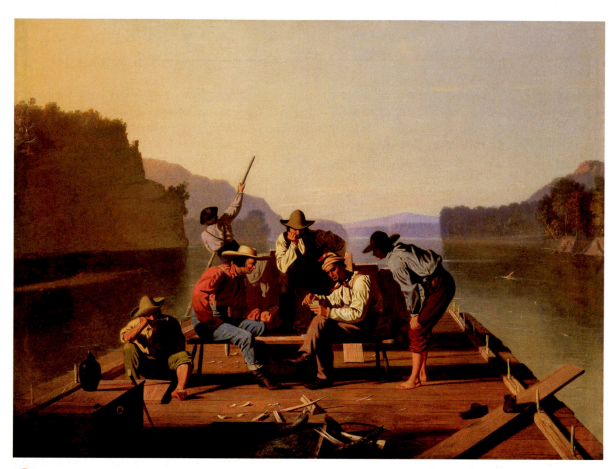

3/23 **GEORGE CALEB BINGHAM**, *Raftsmen Playing Cards*, 1847. Oil on canvas, 28" × 38". The St. Louis Museum of Art, MO, Ezra E. Linley Fund.

distant forms as clearly as those near to us, because the forms tend to get paler. Hiroshige uses this effect, too, adding red mist across the mountains.

Atmospheric perspective can also add to the beauty and enhance the mood of an image. While the card players by George Caleb Bingham (3-23) are painted with sharp outlines, the landscape around them is enveloped in the haze of a lazy day on the Missouri River. Imitating nature, Bingham created the illusion of deep space by progressively diminishing detail and blurring objects in the painting the farther they are from the foreground. The distant mountains have lost their true color and almost fade into the colors of the sky. Bingham's sensitivity to color changes in nature allowed him to take advantage of another characteristic of atmospheric perspective as well. Notice how the painting uses warmer colors in the foreground and cooler ones toward the mountains. Because distant forms become bluer or cooler, we tend to assume that warmer colors are closer to us. Bingham's use of warmer color in the foreground and cool blues in the distant mountains accentuates his picture's depth.

LINEAR PERSPECTIVE

Bingham uses another powerful technique to create depth. Notice how the diagonal lines of the raft's edges lead back to a point on the distant horizon. They demonstrate that the self-taught artist understood the rules of **linear perspective**. This more mathematically precise form of perspective was discovered in the 1400s by the Italian Renaissance sculptor and architect Filippo Brunelleschi (see Chapter 15). It has evolved over time into the principle means of creating the illusion of the third dimension.

In his experiment, Brunelleschi studied the reflection of a building behind him (the Florence baptistery—a building that would loom large in his career; see Chapter 14) on a flat mirror. He then carefully painted the mirror image on a board that had the same proportions as the mirror. By copying this image faithfully, he was able to recreate the image in perspective.

Brunelleschi had a flair for the dramatic; to reveal his new discovery, he arranged an elaborate demonstration.

A hole was drilled through the painting's center. Friends were told to look through the hole from the back and hold a mirror in front of them so they could see the picture. Brunelleschi turned them so they were facing in the direction of the original building. When he told them to lower the mirror, they could see the real building and were shocked to see it was identical to the painting.

Brunelleschi had discovered the rules of **one-point perspective**. He noticed that all parallel lines in the direction of the object being viewed converge at one point in the distance. You may have seen the same thing looking down a highway or railroad tracks. This is the rule of *convergence*. The point where the lines end is called the **vanishing point**. It is exactly at your eye level or **horizon** line. You may have noticed that at the beach, the horizon is identical to your eye level. If you look out across the water and move your head (eye level) up and down, the horizon will move up and down, too. The whole effect of a picture is determined by the choice of the eye level. As you might imagine, the view of a table is quite different for a basketball player and a toddler. Visually, they could be two different tables. Brunelleschi, aware of the impact of eye level, made sure when he drilled his peephole that those who viewed his painting were at the same eye level he had been when he painted it.

Because linear perspective can organize what we see in a logical, coherent way, its discovery was greeted with great enthusiasm by Renaissance artists. Luciano Laurana's *View of an Ideal City* (3-24) is one of many works in the 1400s that explores the new method. It is not hard to identify the central vanishing point; the artist

has the lines of the plaza and the sides of the buildings all pointing in its direction.

The sides of these buildings also demonstrate a special characteristic of linear perspective. Their size shrinks as they increase in distance from the viewer. In reality, the buildings have square corners on all sides and are rectangular, but visually we see **foreshortening** taking place, their forms diminishing as they move away from the eye. Foreshortening can produce seemingly unnatural distortions of familiar forms.

A MODERN WAY OF SEEING: CUBISM AND NONPERSPECTIVE SPACE

As realistic as linear perspective appears to be, it is actually an illusion and not truly a recreation of the way we see. Linear perspective is based on a fixed viewpoint, one eye (not two) looking in one direction only, with neither the head nor the eye moving. It is a good approximation of the view of a one-eyed cyclops who is totally paralyzed—not a bad description of a camera but unlike most human beings.

At the beginning of the twentieth century, many artists felt that in a modern world, a modern way of seeing art was needed. Linear perspective seemed limited and a hindrance to progress in art. Although more conservative artists might admit it was a lie, they could also show that, over centuries of use, it had proved to be a very useful one. The challenge for modern artists was to develop a new method of organizing space.

In Paris, two young artists, Georges Braque and Pablo Picasso, did just that. Their approach would come

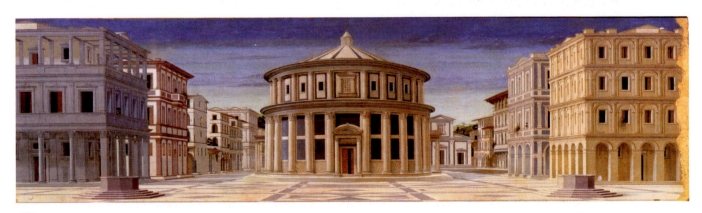

3/24 LUCIANO LAURANA, *View of an Ideal City*, c. 1470. Galleria Nazionale delle Marche, Palazzo Ducale, Urbino, Italy.

to be known as **Cubism**, although it was not, as the critic who named the movement thought, really a method based on simplifying forms into solid geometry. Cubism was a more profound change than that would have been; it was a fresh look at the world, opening up new ways to organize space.

Despite its confusing look, in some ways Braque's *Violin and Palette* (3-25) presents a truer "picture" of the way we actually see than *View of an Ideal City*. When we look at a still life, we do not stand riveted to one point, not moving a muscle, not even our eyes. We certainly do not use only one eye. Instead we look at a scene like this—bit by bit, moving our head, looking around. Our sense of the table and its objects is constructed from the many snapshots we take.

Cubism is also built from a collection of observations. In Braque's painting, the violin (like all the elements in the still life) is seen from several angles at once, revealing more than any single viewpoint could. Each part comes forward to be observed and each is equal in importance; there is no conventional foreground and background. The result is a significantly shallower space compared to linear perspective. The designer in Braque arranged the different parts into a dynamic composition of angled planes. At the top of his picture, Braque "hammered" a nail painted in conventional perspective, as if it held his painting up on the wall. It is a joke, but it is also a message that the old perspective is now just one among many perspectives available to artists.

As modern as Cubism seems, most cultures throughout history have employed an essentially flat treatment of space. Even in the West, linear perspective is a relatively recent phenomenon. Medieval, Japanese, Indian, Chinese, and even ancient Greek artists did not use linear perspective.

Our belief in mathematical perspective as a representation of the real world and the correct way to organize depictions of it can actually betray us. Used unconventionally, it can create seemingly natural worlds that are actually completely impossible. M. C. Escher, a Dutch artist, utilized apparently logical methods in many of his pictures to produce startling results. *Waterfall* (3-26) seems at first a straightforward depiction of a mill that uses a waterfall for power. On closer examination, we see that the waterfall has no source. The water is able to feed itself in a never-ending cycle, to rise after it falls and ignore the force of gravity. Escher's spatial construction takes advantage of our easy acceptance of

GEORGES BRAQUE, *Violin and Palette (Violon et palette)*, autumn 1909. Oil on canvas, 36⅛" × 16⅞". Solomon R. Guggenheim Museum, New York. © 2012 Artists Rights Society (ARS), New York/ADAGP, Paris.

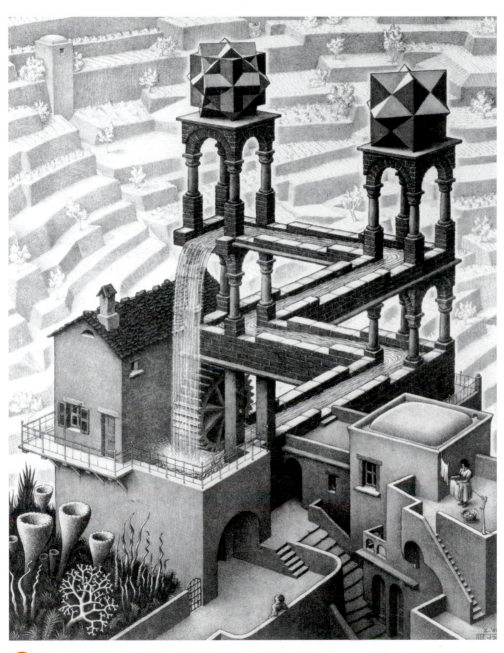

the illusion of linear perspective. The marvelous absurdity of the scene is fascinating, but perhaps ultimately disturbing because one is forced to distrust what was once taken for granted. What else do we believe in that is not true?

All artists work with the elements of art and produce works affected by art's underlying principles, but it would be a mistake to think that artists are always conscious of these rules. At times the art process is intuitive, and analysis comes later. However, all artists do make important conscious decisions when beginning works of art— what materials and techniques they will use to create them. Those materials and techniques are discussed in the next chapters.

CHAPTER 4

DRAWING

Agood craftsperson knows what materials and tools are appropriate to the job ahead, and this is also true for any artist. In fact, many of the materials and tools used by artists are also used by carpenters and construction workers. Artists use paper, paint, steel, and fabric, as well as chisels, hammers, cameras, and welding torches. Artists' materials, like oil paint or clay, are referred to as **media**. Each **medium** has its own unique characteristics, demanding the knowledge of special techniques and requiring specific tools. The tools and materials artists use can influence the creation of an artwork just as much as historical and social factors. By learning about these materials, we will discover another way to understand art.

For most of us, drawing is the way we first experienced making art. From the first scribbles of a child to the sophisticated rendering of an adult, drawing is also the most common measure of artistic talent. In many people's minds, the wildest, most abstract artworks cannot be viewed seriously without first knowing whether an artist can draw. For them, drawing means the capability of recreating objects in the visible world accurately with a pencil. Although this is a limited use of the word, many artists have shared this view. Many have also believed that drawing is the foundation for all art. For example, the great nineteenth-century draftsman, Jean-Auguste-Dominique Ingres, told the young artist Edgar Degas (see Chapter 17), "Draw lines, lots of lines, and you will become a good artist." Similarly, Michelangelo, while hard at work on the Medici Chapel, wrote on a sketch of an assistant who he felt joked around too much, "Draw Antonio, draw and don't waste time."

Drawing *is* important for just about every artist. Whether a painter, sculptor, printmaker, designer, or architect, every artist draws. Many artists cannot imagine a day passing without drawing even under the worst of circumstances (see "Art News" box on page 74). To express his love of drawing, when he was in his thirties the Japanese artist Hokusai (see Chapter 2) changed his name to Gakyojin-Hokusai, which means

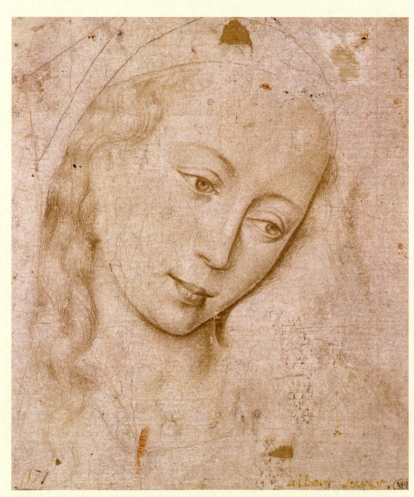

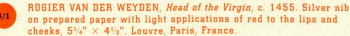

ROGIER VAN DER WEYDEN, *Head of the Virgin,* c. 1455. Silver nib on prepared paper with light applications of red to the lips and cheeks, 5¼" × 4½". Louvre, Paris, France.

4/1

"man mad about drawing." In his seventies, he changed it to Gakyo-Rojn-manji or "old man mad about drawing."

A drawing can be a way to plan a work in another media, or simply a way to play with ideas. Sketches range from studies of forms in nature to copies of another artist's work, but a drawing can also be a finished picture by itself. Drawing is not limited to using ordinary pencils on white paper. A variety of tools and materials fall under the category of drawing.

GRAPHITE

The most common instrument for drawing is a *graphite*, often inaccurately called "lead," pencil. The term "lead pencil" persists as a reminder of the drawing tool graphite replaced in the late sixteenth century. For the previous two hundred years, artists who were interested in pure, precise lines had used **metalpoint**, which was actually a thin metal wire in a holder. Although silver was the preferred metal, other metals including lead were also used. Rogier van der Weyden's *Head of the Virgin* (4-1) is an example of the delicate beauty of metalpoint drawings. Because it is made with the scrapes of light-colored metal on pale paper, a vision of the Virgin Mary appears to have materialized rather than to have been drawn.

Graphite sticks became a favored drawing tool after 1560, when the finest graphite in Europe was discovered in a mine in Cumberland, England. More and more artists were attracted to the advantages of the new material. While metalpoint produces delicate lines that are fairly light, graphite is able to make similar lines *and* bold, dark, dramatic ones. It is also more conducive to creativity, because metalpoint lines are nearly impossible to remove, but graphite lines are easily erased. Graphite permitted a less methodical and more experimental kind of drawing.

Graphite *pencils* were first created when the splendid English graphite was in short supply on the European continent during a war in the 1750s (in fact, it was considered so valuable there was concern about an invasion of graphite-deprived French artists). An inferior grade of graphite was ground into a powder and compressed into rods. The rods were slipped into wood cylinders, usually cedar. Even though the graphite deposit was mined out in the 1800s, graphite sticks continue to be used today. However, the less messy pencils have become the most popular drawing tool of artists and art students.

Few, if any, artists have ever displayed greater mastery of graphite than the nineteenth-century Frenchman Jean-Auguste-Dominique Ingres. His study for the portrait of the Comtesse d'Haussonvile (4-2) shows some of the delicacy of metalpoint drawings by the great masters he so admired, particularly in the young woman's head. But the variety of tones and widths seen in the rest of the drawing's lines are unique to graphite. Notice how one line will change its weight, beginning thin and almost invisible, gradually thickening, and then thinning again. These subtle changes appear quite effortless but require tremendous skill to produce a convincing illusion of three-dimensional form. For Ingres, as for many artists, drawn studies were an essential part of his creative process. He worked more than three years on this young aristocrat's oil portrait and made many drawings of her head, arms, and pose. If you compare this single sketch with the finished version (16-19), you can see how much thought the artist put into the arrangement of each element.

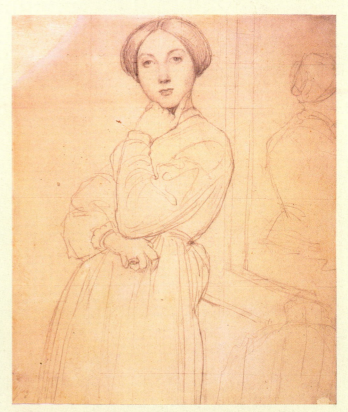

 J. A. D. INGRES, *Study for the Portrait of Louise d'Haussonville*, 1843–1845. Graphite, squared on white wove paper, 9⁵/₁₆" × 10¹¹/₁₆". Courtesy of the Fogg Art Museum, Harvard University Art Museums, Cambridge, MA.

THE LOST DRAWINGS OF
MICHELANGELO

When the team of restorers and art historians entered the small, underground room, it was filled with debris. Bags of lime and broken bricks covered the stone floor. There were even human remains, probably from one of the plagues that haunted Florence, Italy, in the fifteenth and sixteenth centuries. The walls were bare and white.

The team was hoping to solve a 450-year-old mystery. Around 1530, the artist Michelangelo Buonarroti, already famous in Italy for his sculpture of David and the Sistine Chapel's ceiling, was forced to go into hiding. Imperial troops were hunting him because he had supported the recently crushed republic in Florence. Michelangelo wrote years later that he hid in a secret room below the tombs he had designed in the Medici Chapel (see Chapter 1), but no one had ever discovered what room he meant. The irony in his selection of a hiding place was that it was the Medici who had charged Michelangelo with treason and were searching for him.

The Medici family ruled Florence for most of the Renaissance, and their generous patronage of the arts

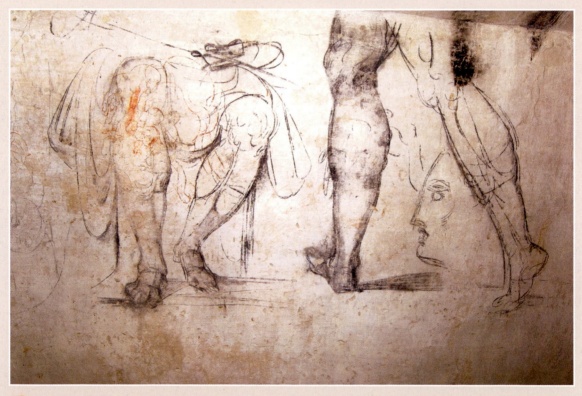

4/3 MICHELANGELO, *Medici Crypt Drawing*, c. 1530. Charcoal. Sagresti nuova, San Lorenzo, Florence, Italy. © James Luciana.

and humanities was crucial to the rebirth of Italian art and culture during this period. They had been, in fact, the most important patrons of the young Michelangelo; he had even lived for a time in their palace. They must certainly have felt betrayed when he sided with those who overthrew them to establish a republic in Florence in the 1520s. Unfortunately for Michelangelo, the republic was short-lived, and by 1530 the Medici had returned to power and considered him a traitor.

As interesting as the mystery was, why was it important to the search team to locate Michelangelo's hiding place? Because they were really looking for hidden treasure. Besides mentioning a secret room, the artist had also written, "to forget my fears, I filled the walls with drawings." Was this true? The team felt sure it was. How could Michelangelo be locked up in a room alone for six weeks and not draw?

The room they discovered lay underneath the Chapel itself. The team had found some narrow stone steps under a trapdoor in the floor of a storage room. When they first entered the underground room, they could see that the walls were totally bare, but it would not be surprising if the master's drawings had been painted over. Even huge paintings by Michelangelo and da Vinci that had decorated the goverment palace in Florence were later covered up with works by other artists. The Renaissance princes liked to redecorate, replacing one wall painting with another, much like families today change wallpaper.

One member of the team noticed that along the far wall the floor's stonework appeared to be constructed of stones half the size of the others. The team realized that the back wall must have been a later addition. After getting permission to knock the wall down, the room became twice the size it had been. But, what about the drawings? For three weeks, the team fruitlessly made tiny borings (pinholes) in the walls and ceilings. But then, in the low, curved ceiling that could be touched with an outstretched arm, one restorer made a boring that revealed some traces of charcoal. Could this be part of a charcoal drawing? Slowly, the whole group of restorers went to work.

What they exposed after meticulously cleaning that part of the ceiling was a large drawing of a horse's head—clearly in a Renaissance style. With excitement, they began to work around the room. By the time the restoration team was finished, they had uncovered about fifty drawings, most of them quite large. It was astonishing and remains so today.

Michelangelo turned his hiding place into a sketchbook. The room is covered with charcoal drawings from ceiling to floor, many drawn on top of earlier ones. There are ideas for possible future projects. Others are memories of past masterpieces, such as sketches from memory of the head of Michelangelo's David (see 14-16), figures reminiscent of the Sistine Chapel's ceiling (14-17) and a life-size Christ figure. There is even a huge self-portrait. One can see the hand of Michelangelo—literally. In one place, where he hung his lamp, part of a drawing is marred by the black soot left by the lamp (4-3). You can see swipe marks across it where he apparently tried to rub off the dirty smudge on the wall. On the ceiling just above the dirty area, he must have rested his arm, because on it you can see the black fingerprints of Michelangelo.

Tourists today wander in awe around the Medici Chapel, admiring the splendid sculpted tombs Michelangelo designed for the Renaissance princes, unaware of another marvelous experience just a few feet below them. Unfortunately, the room is not open to tourists, because the moisture in the respiration of crowds would endanger the precious drawings. But among the lucky few who have been allowed to visit the secret chamber, the sight of the idle marks of a man who died more than four hundred years ago has brought more than one of them to tears.

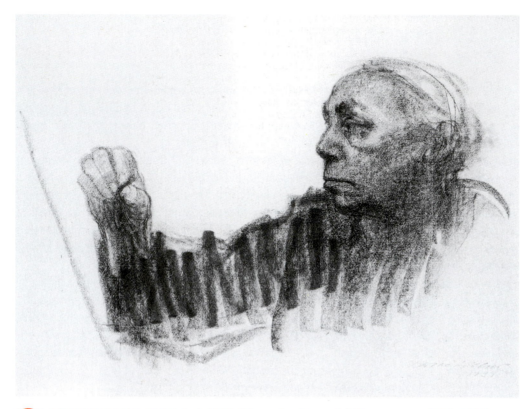

4/4 KÄTHE KOLLWITZ, *Self Portrait*, 1933. Charcoal on brown laid Ingres paper, 18¼" × 25".
© 2005 Board of Trustees, National Gallery of Art, Washington, D.C. (Rosenwald Collection). © 2012 Artists Rights Society
(ARS), New York/VG Bild-Kunst, Bonn.

CHARCOAL

After a stick tracing lines in the sand, *charcoal* is probably the oldest drawing medium. Prehistoric man used pieces of burnt wood to sketch on cave walls. Today, charcoal is manufactured in two ways. *Stick* or *vine charcoal* is made when wood is heated until only carbon remains. It is light and fragile, making lines and tones that are easily wiped away (even a good sneeze will erase parts of a stick charcoal drawing). *Compressed charcoal* is not as easy to erase and is made from ground charcoal compressed into short, squared sticks. It is better at creating rich black tones. Because of its ease of application and removal, charcoal has long been a favorite of artists and students. In the Renaissance, it was used to draw preliminary outlines for paintings. A feather or dried bread was used to erase such charcoal sketches until only a faint hint of them remained.

More recently, artists like Käthe Kollwitz, in *Self Portrait* **(4-4)**, have used charcoal for finished drawings. A dramatic range of dark and light shaded areas can be seen in her self-portrait. Fine lines made with a sharpened stick bring out the details of her face; bold ones made with its side are used to delineate her body and

help create variety. Together, they form an image of the artist at work, a combination of the discipline seen in her stare and underlying intensity evident in her body.

If one looks closely at the drawing, one can also see the *grain*, or texture, of the paper revealed by the lighter downward strokes. Surface texture is one of the distinctive characteristics of charcoal drawings and why artists who work in charcoal choose their papers carefully. We can see the grain because the raised fibers of the paper are catching and holding microscopic jagged edges of charcoal dust. To ensure a permanent bond, charcoal drawings must be sprayed with a **fixative** of shellac or plastic polymer.

CHALK AND PASTEL

Natural *chalk* is another drawing material that is soft and requires fixative to be permanently bonded to paper. It is often used along with charcoal. Like graphite, it is cut from the earth. A combination of minerals and clay, chalk was first used by artists in the Middle Ages. However, its real popularity began in the Renaissance when artists started working on large-scale projects. Metalpoint had worked beautifully on a small scale, but chalks could be

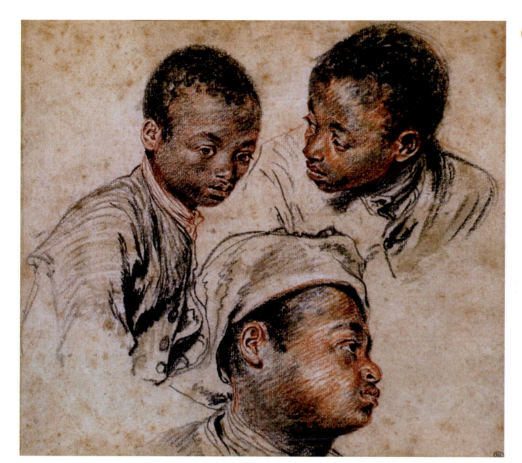

4/5 **JEAN ANTOINE WATTEAU,** *Three Studies of a Youth,* c. 1710. Sanguine, black, and white chalks and watercolor, 9½" × 10⅝". Louvre, Paris, France.

used for huge drawings. At first, red chalk (sometimes referred to as *sanguine*) was preferred, but natural chalks of black, gray, and white were also used. Because of the compressed nature of the material, neat, clear lines could be made with it.

Jean Antoine Watteau used black, red, and white chalk in combination for his drawings of a young boy's head, *Three Studies of a Youth* (4-5). By rarely blending the strokes of each color, but placing them side by side, the autonomous colors are more vivid. The drawing seems almost in full color rather than in just red, black, white, and gray. Because of the rich, bold darks of black chalk, a confident, freely executed effect is created.

It is said that Watteau kept the first modern sketchbook, because his was not a collection of preparatory plans for larger finished works but instead a collection of his current ideas and interests. Sometimes he would browse through old sketchbooks, looking for inspiration for a current project. In fact, these heads appear in several Watteau pictures painted years later.

Compared to Watteau's time, a much wider variety of colored chalks or **pastels** are available today. These fabricated chalks are a combination of loose, dry pigment and a substance that holds the pigment together, called a **binder**. Binders are used in all of the colored media and are what differentiate them. For example, oil paints are made from the same pigments as pastels, but they use oil as a binder. In the case of pastels, the pigment and binder form a paste that is rolled into a stick and then dried. A modern chemical product (methylcellulose) is used as a binder now, but in the past more ordinary materials, such as beer, milk, honey, and sugar candy, were used.

The range of colors available in pastels is as wide as in paints; in fact, pastel pictures are sometimes called "pastel paintings." However, Odilon Redon chose to work in pastels because of the special characteristics that differentiate them from painting. Control is simpler and more direct with pastels than any of the liquid media; the soft sticks of color are easily blended. Even more importantly, because pastel is a dry media, it is closest to working with pure pigments; few media can show brilliant color better. In *Sita* (4-6), Redon takes advantage of the radiance of pastels. In the Hindu epic, *Ramayana*, Sita is the wife of the god Rama. A beloved figure for Hindus, she symbolizes unfailing loyalty and represents the ideal wife. Redon described his pastel as "her head in profile, surrounded by a golden-green radiance, against a blue sky, stardust falling, a shower of gold, a sort of undersea

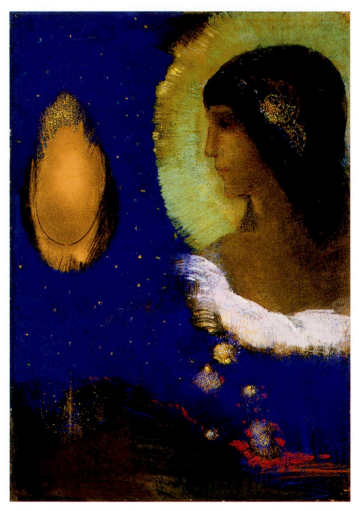

4/6 ODILON REDON, *Sita*, c. 1893. Pastel, with touches of black Conté crayon, over various charcoals, on cream wove paper altered to a golden tone, 21" × 14¾". The Art Institute of Chicago.

mountain below." The pastel medium gives a luminous quality to this imaginary portrait, where Sita seems to float in a glowing magical cloud.

CRAYON

Artist's **crayons** also provide the artist with an extensive menu of colors but do not require fixative. Like children's crayons, they have a waxy or oily binder that adheres better than charcoal or pastel to paper. This does, however, make them more difficult to erase. Unlike children's crayons, which fade quickly, artist's crayons use more permanent pigments. **Conté crayon**, developed in the late 1700s, is one of the most versatile drawing

materials. Like charcoal and pencil, it comes in a variety of degrees of hardness. Seurat's *L'écho*, seen in Chapter 2 **(2-12)**, demonstrates Conté's capacity to show subtle variations in tone. Because of the dense blacks that can be created with Conté crayons, artists often use them when they want to model forms softly.

PEN AND INK

Pens have been in use since ancient times. The oldest pens were made from tall grasses gathered along lakes and streams, reeds in the West and bamboo in the East. Because these grasses are hollow, they can hold ink. Some artists today continue to draw with such instruments, which are prepared by cutting the grass stalks at an angle. The width of the point determines the thickness of the mark.

A more flexible and finer line is available from **quill** pens. Compared to reed or bamboo pens, they glide almost effortlessly on paper. A variation in the pressure applied to the pen will smoothly change a line's width. Quill pens have been popular since the Medieval period, when monks used them to letter manuscripts. They are made from bird feathers; goose quills are the most commonly used, but crow, turkey, or even seagull quills make fine pens.

Albrecht Dürer's page of lively pillow studies **(4-7)** was most likely done with a quill pen. Dürer was only twenty-two when he made this drawing, but already one can see the skill and inventiveness that would lead to his role as leader of the Northern Renaissance (see Chapter 14). By increasing or decreasing the downward pressure on his pen, Dürer used the flexibility of quills to create many kinds of lines. To make his forms seem three-dimensional, he uses a technique called **cross-hatching**. In cross-hatching, series of parallel lines cross in a netlike fashion as they describe the contours of the subject's surface. Notice that it is not necessary to cover the whole pillow with these lines to create solidity; crucial junctures, usually where the form is in shadow, are used. By narrowing or increasing the spaces between his lines, Dürer could create differences in the relative darkness of the shadows at the same time he is creating volumetric (three-dimensional) forms. Volume is also implied by the varying width (or *weight*) of

the lines. Quick gestural lines define the pillows' shadows in the brighter light, while heavy, powerful lines form the folds of fabric in the darker areas.

The versatility of pens made from natural materials can be seen in Vincent van Gogh's drawing of the abbey of Montmajour in southern France **(4-8)**. Van Gogh would work outdoors on drawings like this, despite the strong sun, the wind, and the mosquitoes; this particular picture took a whole day to finish. Instead of concentrating on creating a sense of volume, van Gogh used his pen's ability to create a variety of marks to delineate the many textures in the landscape. The drawing's complexity is meant to reflect the infinite diversity of nature.

Manufactured steelpoint pens became available in the nineteenth century. *Nibs* with different points and angles are inserted into a holder, depending on the kind of line wanted. These pens are also responsive to variations in the pressure of an artist's hand. Because they require no skill for cutting and have uniform quality, many artists today prefer them to reed, quill, and bamboo.

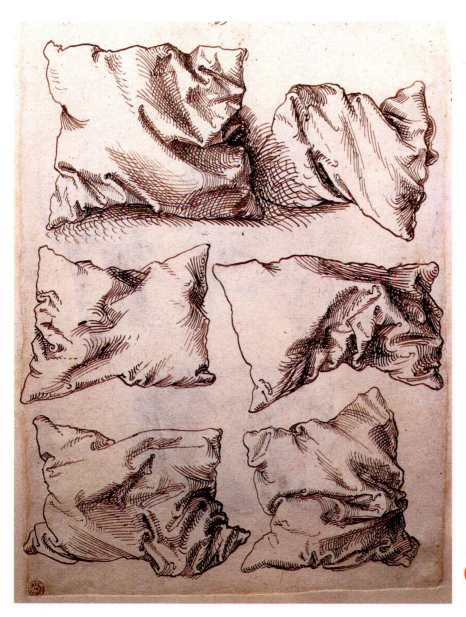

 ALBRECHT DÜRER, *Six Pillows,* 1493. Brown ink on paper, 108¾" × 79½". Metropolitan Museum of Art, New York.

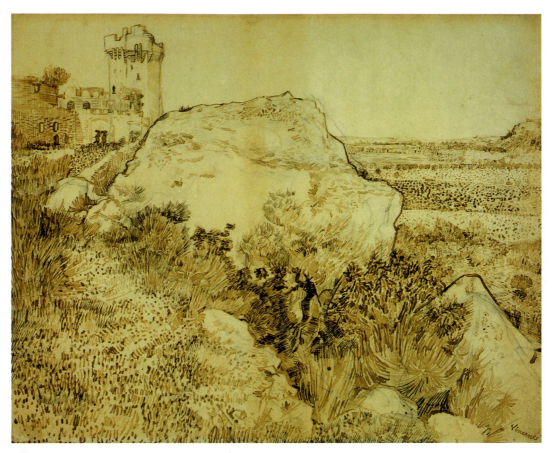

4/8 VINCENT VAN GOGH, *Hill with the Ruins of Montmajour*, 1889. Pen, 18⁷⁄₈" × 23¼". Rijksmuseum, Amsterdam, Netherlands.

BRUSH AND INK

In the West, pencils and pens are familiar to everyone because of writing. In the East, however, writing is done with brushes. Handling a brush well is a highly prized skill. In the hands of a master, one wet, pointed brush can produce a delicate, fine line or a wide, dramatic stroke quickly and elegantly. The flexibility of a line made with a brush has been seen already in a drawing by Hokusai (2-3).

Modern Chinese and Japanese artists continue to be trained in centuries-old brush techniques, requiring years of study. One of their models is the fourteenth-century master, Wu Chen. His seemingly effortless strokes for the bamboo leaves were practiced thousands of times before his teacher permitted him to attempt one in a drawing. There were two reasons for such a long training period. First, a line made with ink cannot be changed or erased—one mistake and the drawing is ruined. Second, to be convincing, a long bamboo stalk has to be brushed on quickly with confidence. Any hesitation would be revealed, but in Wu Chen's lovely *Bamboo in*

the Wind (4-9), none can be found. Wu Chen also did the beautiful calligraphy on the right; it reads, "He painted and wrote with joy." The quote demonstrates that for Chinese artists, the division between drawing and painting in Western art is meaningless.

WASH

The division between drawing and painting blurs even in the West when artists use washes—diluted ink applied with a brush to add tonal values to a drawing. Rembrandt was particularly adept at this technique. In *A Sleeping Woman* (4-10), he is able to convey her pose with a few confident and dramatic strokes of his brush. But the depth of the scene is created with layers of ink wash that he added behind her head at the top left. His handling of the brush seems as assured as Wu Chen's, and it is easy to imagine that the Dutch artist was influenced by Chinese brush painting. No specific evidence supports this theory, but Rembrandt did live in the era when the Dutch East India Company carried on a thriving trade with China.

CONTEMPORARY APPROACHES TO DRAWING

Rembrandt's dramatic gestures give viewers a vicarious sense of the act of drawing, so we can almost share the experience of him dashing it off quickly. One of the great pleasures of examining a drawing is a sense of intimacy with the artist. We can see the artist's imagination at work. Many drawings provide us with a look at the creative process, enabling us to see the early ideas, the changes, and the final decisions. This is particularly true of the work of the South African artist William Kentridge. Erasures are the essential part of his drawing process (4-11). The signs of erasing are intentionally left in, the pale memories of earlier lines and shapes giving texture and weight to the drawing. The image would be cleaner but emptier without them.

Erasing is also the active force in Kentridge's animations. The charcoal drawing is just one of hundreds for his animated film *Tide Table* (see Chapter 7). Each forms a frame that he photographs, erases and redraws, and then photographs again. Viewers witness the artist's ideas as they evolve in time, as each image dissolves into another.

Paper cutouts were called "drawing with scissors" by the French modern artist Henri Matisse (3-2). This popular folk art technique of the eighteenth and nineteenth centuries, also known as *silhouettes*, was revived in the modern era and is used by the contemporary artist Kara Walker to reexamine the past, particularly the conflict between images of slavery and romantic love in the South (4-12). She begins by laying big sheets of black paper on the floor and draws directly on them with white chalk. She then cuts her shapes out and arranges them on the wall. Walker doesn't use any photographs as sources, but creates her characters from her imagination.

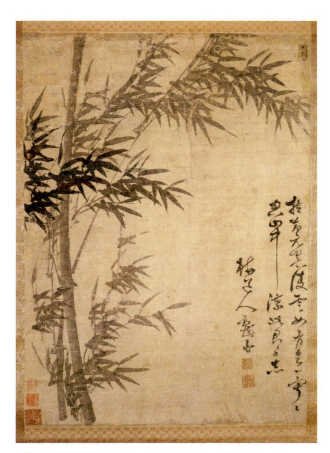

 WU CHEN, *Bamboo in the Wind,* **early fourteenth century. Hanging scroll, ink on paper. Museum of Fine Arts, Boston, MA (Chinese and Japanese Special Fund) 15.907. Photograph © 2008 Museum of Fine Arts, Boston.**

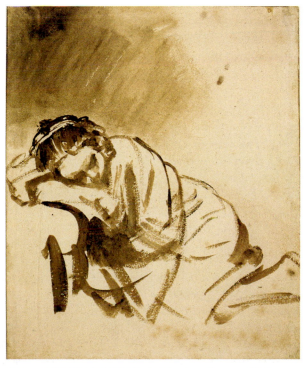

REMBRANDT VAN RIJN, *Sleeping Woman,* **1654. Pen and ink and bistre, 9¾" × 8". British Museum, London, Great Britain.**

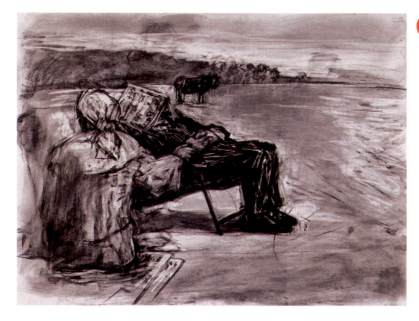

 WILLIAM KENTRIDGE, Drawing from *Tide Table*, 2003. Charcoal on paper, 31½" × 47¼". Marian Goodman Gallery, New York.

In her work *Gone, An Historical Romance of Civil War as it Occurred Between the Dusky Thighs of Young Negress and Her Heart*, she revisits the popular novel and movie *Gone with the Wind*. The novel's depiction of life in the South during the Civil War has shaped the image of that war for Americans. As a black woman who has lived in Atlanta, Walker was surprised that when she read this book, she felt herself "wanting to be the heroine and wanting to kill the heroine at the same time."

Contrast is what makes silhouettes stand out against their backgrounds. Contrast is also the method Walker uses to convey her ideas, and conflict is the result. While her black cutouts are skillfully cut and delicate, their message is raw and painful. Walker puts side-by-side both romanticized Southern aristocratic lovers and racist depictions of black women. Because her characters are portrayed in silhouette, they are not individuals but anonymous, mythic types.

Walker uses a folk art technique, traditionally used for portraits and small landscapes, but makes it wall-sized. This connects her pictures with the huge academic historical paintings that were popular during the time of the Civil War (see Chapter 16). Viewers, however, are not offered an impressive, idealized scene. Walker's elegant costume drama forces us to face the abuse and humiliation of slaves that supported the grand lifestyles of the men and women heroes in the epic novel *Gone with the Wind*.

The drawings of the artist Cai Guo-Qiang are also quite large and combine conflicting elements—fine papers with violent explosions. Cai was born in China, where gunpowder was invented (paradoxically, as an "elixir of immortality"), and was trained in stage design at the Shanghai Drama Institute. As

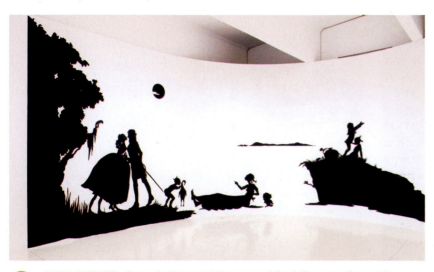

KARA WALKER, *Gone: An Historical Romance of Civil War as it Occurred Between the Dusky Thighs of Young Negress and Her Heart*, 1994. Detail of 21 paper silhouettes approximately 13' × 50' installed. Walker Art Center, Minneapolis, MN. Image courtesy of Sikkema Jenkins & Co.

a young man, he felt artists in China were too restrained by both ancient traditions and government controls. He wanted an approach that was spontaneous and imaginative.

His drawing materials—Japanese paper, loose gunpowder, and gunpowder fuses—all have long traditions but have never before been mixed. To start, he first lays long sheets of paper or panels on the ground. Then, with a dish of gunpowder in hand, he walks barefoot across the paper, tossing down clumps of gunpowder. Later, Cai spreads the powder with brooms and then artistically arranges long fuses across them. Sheets of cardboard are positioned by him and his assistants on top of the powder and fuses, with large rocks thoughtfully placed to hold the cardboard down in order for the gunpowder to be better singed into the paper and not be blown away in the explosion. Once the fuses are lit, the room is, for a moment, filled with light, smoke, and the rat-a-tat sound of loud firecracker explosions.

After the smoke clears and the rocks and the cardboard are removed, assistants put out remaining fires with balled-up wet rags on sticks. Contemplating the result, Cai may then decide to add more gunpowder and fuses to complete his work. Despite the violence of their birth, the finished drawings (4-13) are surprisingly subtle. The paper can be darkly charred in some places, with other parts barely touched by soft smudges, but every mark is filled with energy.

Cai's drawings have led him to grander spectacles. He has drawn pictures in the sky with explosions at festivals around the world, including New York (where he now lives), Edinburgh, and Venice. At an air show in San Diego, he directed the movements of airplanes, so their white vapors would make a Chinese landscape painting of mountains and a waterfall in the sky. For a project in Warsaw during 2005, he wove a giant flag out of red gunpowder fuses and cloth. He mounted it on an old Soviet-era truck and ignited it. The red flag, according to the artist, symbolized the fervor and dangers of extreme nationalism. By exploding it, he felt he was consigning that period of totalitarian rule into history.

In light of the events of September 11, 2001, in the city he now calls home, Cai has orchestrated large-scale explosion projects. After the attacks, he believes the city has more need to see hope in projects like his explosions in order to move on from the tragedy. He has said: "Because the artist, like an alchemist, has the ability to transform certain energies, using poison against poison, using dirt and getting gold." Similar healing events were staged after the terrorist Madrid bombings of 2004 and in Hiroshima.

Although Cai is able to draw realistically, sometimes even with gunpowder, he prefers not to have complete control over his materials. Cai's approach to drawing exposes the lack of imagination in the question, "Can he draw?" It ignores the possibility of not only nonrepresentational drawings but whole new forms of marking paper. Realistic rendering is only one type of drawing; even the masters of past centuries sketched abstract diagrams of planned works. Artists have always drawn for a variety of reasons and produced a wide diversity of work. As we will see in the following chapters, the limitations of every medium are far less important than the power of the artist's imagination.

4/13 CAI GUO-QIANG, *Drawing for Transient Rainbow,* 2003. Gunpowder on paper, 198¾" × 157½". Fractional and promised gift of Clarissa Alcock Bronfman. Museum of Modern Art, New York. Courtesy of Cai Studio.

CHAPTER 5

PAINTING

When most people think of art, they think of painting. This seems to be true of both the layperson and the connoisseur. Our museums devote more space to painting than any other art form. During the Renaissance, there was a great deal of discussion about whether painting was the highest of the arts. Leonardo da Vinci thought it was, placing it above sculpture and poetry. He wrote:

> if the painter wishes to see enchanting beauties, he has the power to produce them. If he wishes to see monstrosities, . . . he has the power and authority to create them . . . if in the hot season he wants cool and shady places, or in the cold season warm places, he can make them. . . . Indeed whatever exists in the universe, whether in essence, in act, or in the imagination, the painter has first in his mind and then in his hands.

There was even a questionnaire on this issue distributed to many of the important artists of the time. A painter, Pontormo, responded that the complexities of his medium were much more challenging than the others. He wrote:

> there are the various modes of working—fresco, oil, tempera . . . all of which require great practice in handling so many different pigments, to know their various results when mixed various ways, to render lights, darks, shadows, high-lights, reflections, and many other effects beyond number.

The painting media are certainly more complicated than the drawing media discussed in the last chapter. Many formulas for paint have been used over the centuries, and some artists have almost become chemists in their desire to create the perfect paint. However, all paints share a general formula that is not difficult to remember: They are a combination of powdery pigments combined with a liquid *binder*, also called a *medium*. This glue-like substance holds the paint together and attaches it to the surface (called the **ground**). What differentiates the painting media from each other, and gives each one its special qualities, is the type of medium used.

ENCAUSTIC

Encaustic is a painting medium that is at least seven thousand years old. It is created by mixing colored pigments with hot beeswax and then painting the mixture on a surface before it cools. After it hardens, the wax surface is remarkably permanent, and the painted colors can retain their brilliance for thousands of years.

We are not sure when this method was first used, but Homer describes in *The Iliad* how the ancient Greeks waterproofed and decorated the hulls of their ships with hot, colored wax. The realistic portraits on Egyptian mummy cases from the first century BCE are some of the earliest surviving examples of encaustic painting. The colors painted on ancient Greek and Roman marble statuary were usually in encaustic (probably because it also waterproofed them; see "Art News" box in Chapter 2). In the past fifty years, this ancient painting medium has experienced a revival among contemporary artists.

Jasper Johns has been one of the leaders of the encaustic renaissance. His series of encaustics, *Seasons*, from the 1980s, was done when the artist was in his late fifties and contemplating moving. By increasing the amount of wax in encaustic paint, it becomes more transparent. Johns uses this property when painting his silhouette, a projected shadow that appears in all four of these autobiographical paintings.

Encaustic also allows an artist to build up many layers of textured paint. The complexity of Johns' pictures comes from the many layers and the amount of subject matter he includes. Surrounding his silhouette are many objects that have personal meaning for the artist. In *The Seasons: Summer* (5-1), bits of his earlier works, like his early American flag series (see Chapter 20), can be seen, all held up by a rope, strung across a ladder. There are references to the discoveries of his young adult years, like the art of da Vinci, as well as a love of pottery. At the bottom are outlines of building blocks, as if to say these were the building blocks of my career. In *Fall*, the ladder snaps, the rope comes loose, and different pictures tumble down. Greens have turned to brown and the arm swings lower like a clock. By *Winter*, the hand is straight down and the scene is gray and covered with snow.

FRESCO

Traditional **fresco** is one of the most permanent of the painting media. It is a wall-painting technique that has been in use since ancient times. Beautifully preserved examples can still be seen on the walls of homes at the excavations at Pompeii and Herculaneum, Roman towns buried in volcanic ash around 79 CE (5-2). Michelangelo's paintings on the Sistine Chapel ceiling (see Chapter 14) are among the many masterpieces done in fresco. In fresco, the painter combines colored pigment with water and brushes it directly onto fresh, wet plaster (*fresco* means "fresh" in Italian). As the plaster dries, the pigment becomes bound into it and literally becomes part of the wall. This chemical process is what makes fresco painting so permanent.

Because the painting has to be done while the plaster is wet, the fresco painter must work rapidly. Much

5/2 *Herakles and Telephos*, detail, Herculaneum, c. 70 CE, after an original from the second century BCE. Wall painting, approximately 7' 2" × 6' 2". Museum Nazionale, Naples, Italy.

planning is usually necessary, and often an artist will make many sketches on paper. Large wall paintings are done in sections; a life-size figure alone might take two days to complete. Although some minor changes are possible, major revisions require lifting out whole sections of plaster and beginning again. Heavy scaffolding must usually be set up next to the wall, which makes it difficult for artists to see their work from a distance. Michelangelo was not alone among the artists who, in deep concentration, have taken one too many steps backward on the scaffolding while viewing their work. Some have even been killed.

The demands of this medium, and the availability of more flexible media like oil painting, made fresco painting rare after the Renaissance. However, in the twentieth century, in an effort to create murals that spoke to and were accessible to ordinary people, Mexican artists like Diego Rivera revived the Renaissance techniques. His *Detroit Industry* (5-3) was commissioned by the Ford Motor Company. Encompassing twenty-seven panels on four sides, it took Rivera and his assistants eight months to plan and paint these huge murals. On the north wall, he depicts the vast, complex assembly line for the first Ford V8 engines at their River Rouge factory in Dearborn, Michigan. At the center, machinery towers over the workers like ancient Mexican monoliths and a huge furnace burns behind. Workers of all races pull and push in harmony with machines. Rivera deliberately portrayed the workers as heroic, expressing his belief in the dignity of all working people. While the murals were controversial with some who knew of Rivera's Marxist beliefs, his patron, Edsel Ford, the President and son of the company's founder, was pleased and said they expressed "the spirit of Detroit." Rivera always considered them his finest work.

TEMPERA PANEL

In **tempera**, a media developed in the Early Renaissance, pigments are usually mixed with egg yolks (which is why it is sometimes called "**egg tempera**"). Yolks are a powerfully adhesive medium, as anyone who has tried to remove eggs left on a plate overnight knows. In tempera, each color must be premixed in light-, medium-, and dark-toned versions before beginning to work. Shading is done by placing small strokes of these colors side by side. Like crosshatching in drawing, the accumulation of lines

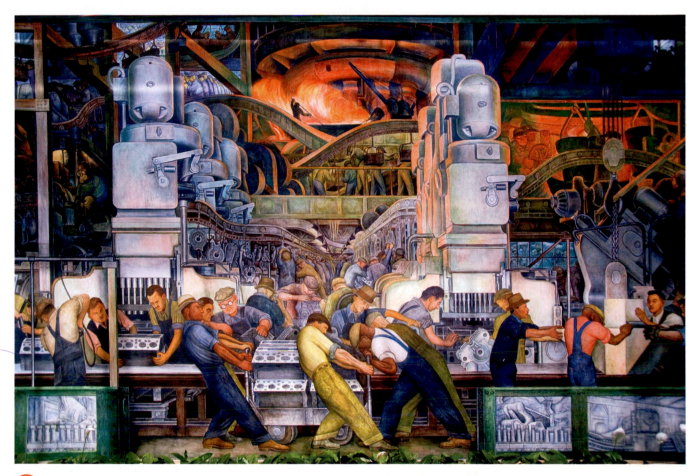

creates a modeling effect. Wood, rather than canvas, is the customary support for tempera paintings, because it is rigid and tempera has a tendency to crack if flexed. In past centuries, wood panels were prepared for the paint by adding several layers of *gesso*—a thick paste of gypsum and animal glue. Gesso produces a bright white surface that paint adheres to well.

The most famous tempera painter of the twentieth century was Andrew Wyeth, an American realist. His *Christina's World* (5-4) was painted in the traditional manner; Wyeth prepared a panel with gesso before beginning. By looking closely at the grass in the foreground, one can see many fine strokes of paint applied one over another. Tempera dries quickly, so it is sympathetic to building up painted areas in this way. Because its method of application is similar to that of drawing, many artists who have

a strong background in representational drawing skills use tempera.

OIL PAINTING

In the past, Renaissance artist Jan van Eyck (see Chapter 2) was given credit for inventing oil paint in the fifteenth century, but this is not really true. As early as the eleventh century there are records of oil-based paint. A medieval monk mentioned it in his writings but did not recommend it. He felt one of oil painting's properties—its slow drying time—made it unsuitable for most paintings. In the Renaissance, however, artists like van Eyck and da Vinci took advantage of that special property to

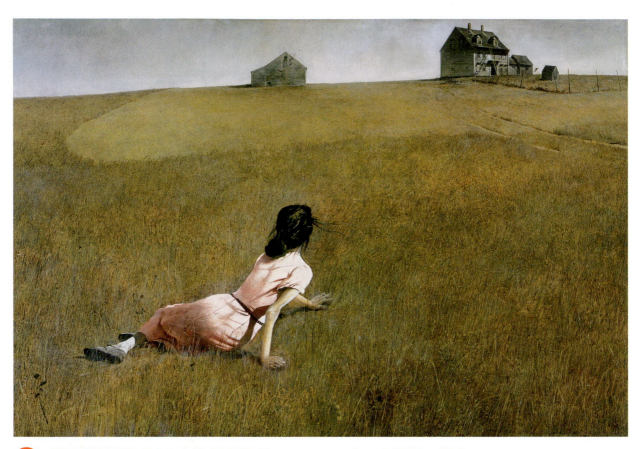

5/4 ANDREW WYETH, *Christina's World*, 1948. Tempera on gessoed panel, 32¼" × 47¾". Museum of Modern Art, New York.

create paintings of unsurpassed detail and depth. They can be given credit for showing their fellow artists the wonderful capabilities of oil painting, making it the dominant medium in Western painting since that time.

As might be assumed, oil paint is a combination of ground pigments and oil. The oil is usually linseed oil, but other kinds have been used by artists. Oil paint can be used on many different grounds: paper, wood, and one that particularly excited Renaissance artists—canvas. This was a new portable support, one that, because of its light weight, could be used for much larger paintings than those on wood panels. The flexibility of the oil medium when dry makes it even possible to roll up a large canvas for transport without cracking the paint.

Even more important to artists, oil paint allows a less methodical and freer approach to painting than fresco and tempera. Oils can be applied in layers, and an oil painting can be reworked over and over again. Because oil paint can cover up earlier versions, artists were now able to change the position of their subjects days or even months after they were initially painted.

Oil paint can also be diluted with oil medium or solvents like turpentine and made into transparent **glazes**. In his lovely *Alba Madonna* (5-5), the Italian master Raphael

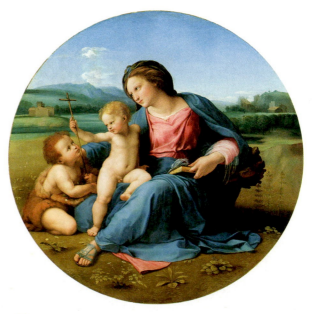

5/5 RAPHAEL, *The Alba Madonna*, c. 1510. Oil on panel, transferred to canvas, 37³⁄₁₆" diameter. National Gallery (Andrew W. Mellon Collection 1937.1.24), Washington, D.C.

began by applying opaque strokes called **underpainting** and then added transparent strokes on top to build up the softly blended illusion of three-dimensional forms. The luminosity of the Madonna's face is from the white ground that can still be seen below thin strokes of pink and other colors. While an idealized scene, the figures, their clothing, the fields, sky, and mountains demonstrate the range of oil painting to convincingly create both large and small effects. For example, touches of white paint depict detailed flower petals on the plants in the foreground, the Madonna's translucent sleeve, and wisps of soft, gentle clouds in the background. To heighten the painting's realism, Raphael eliminated most marks of his brush, hiding signs of the human gesture or act of painting on the smooth surface.

Not all artists who work in oil try to conceal their hand. One of the most daring and inventive masters of oil paint was J. M. W. Turner. His pictures, like *Snow Storm*

(5-6), are an orchestration of a variety of techniques. Thin blue washes of underpainting that established the basic composition can still be seen to the right, but in most areas, thick, textured paint, called **impasto**, has been added. Impasto paint reveals the action of brushstrokes; here it adds to the ferocity of the storm that has trapped a boat. Turner used the thickest paint for the glow of the strong central light.

The painting is not realistic in the usual sense, but it is true to a powerful, terrifying experience. Turner was on this boat when it was trapped in a storm and said "I did not paint it to be understood, but I wished to show what such a scene was like." In the midst of it, perhaps to dramatize the ship's fragility, he used thin black paint, applied with a fine brush, to delineate the threatened mast. He also scratched some of the thickest paint with the back of his brush. To create the dark, swirling shapes of the storm clouds, below the impasto Turner used a

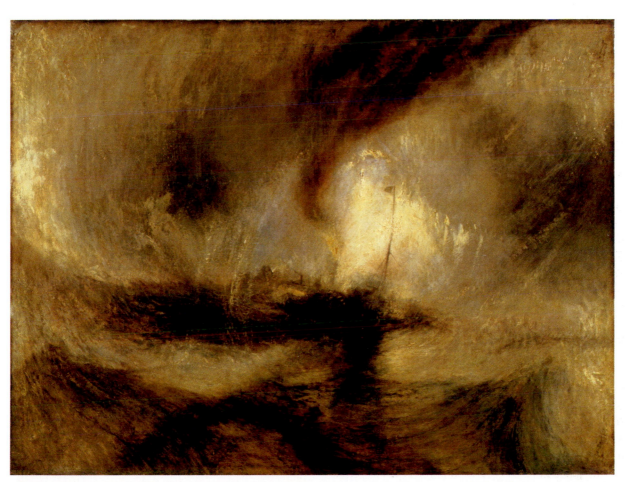

5/6 J. M. W. TURNER, *Snow Storm: Steam-Boat off a Harbour's Mouth*, 1842. Oil on canvas, 36" x 48". Tate Gallery, London, Great Britain.

technique called *wet into wet*. As the medieval monk pointed out, oil paint dries slowly. One advantage of this is that painters can mix colors directly into the wet paint on the canvas. The final effect of all these techniques is a wild, vivid surface in keeping with an exciting subject. John Ruskin, a critic of Turner's time, called it "one of the grandest statements of sea-motion, mist, and light, that has ever been put on canvas."

WATERCOLOR AND GOUACHE

Transparency is the essence of **watercolor**, a quick-drying combination of pigment and gum arabic. When diluted with water, it can be brushed smoothly onto a ground (usually paper). As with ink washes, changes are difficult in watercolor, so success depends on a direct, spontaneous application. Because watercolor paintings dry so

quickly, many artists like making sketches in watercolors as studies for works in other media. John Singer Sargent, however, considered many of his watercolors independent finished works. To keep his colors fresh in his *Venice: La Salute* (5-7), he applied them in thin washes. Successive transparent layers of color describe the complex architectural forms seemingly effortlessly.

One of the most valued characteristics of watercolors is their luminosity. The white, or in this case light cream, color of the paper is the secret behind this quality. The more of the paper that remains unpainted, the more brilliant the effect. Notice how much of the façade of the glorious church at the entrance of the Grand Canal is hardly touched by color. Sargent was a master of including just enough touches of color for a shape to emerge from the brightness of the page. As a successful society portrait painter during the Gilded Age, Venice was his refuge, a place to hide from the demands of his wealthy and

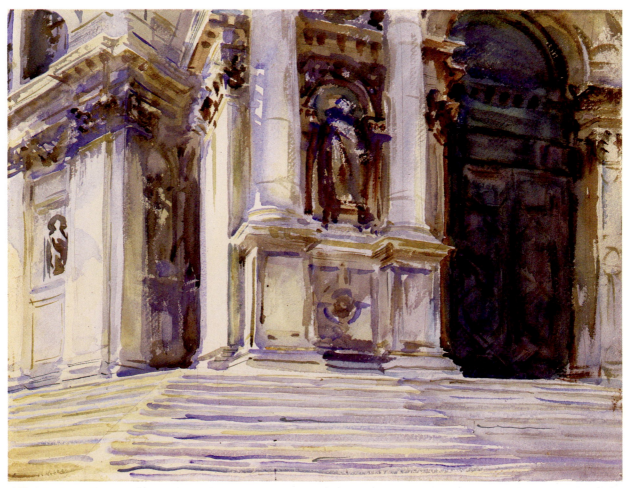

5/7 JOHN SINGER SARGENT, *Venice: La Salute*, c. 1909. Watercolor over graphite, with wax resist, on thick, rough, cream wove paper, 15¹⁵⁄₁₆" × 20¹⁵⁄₁₆". Museum of Fine Arts, Boston, MA.

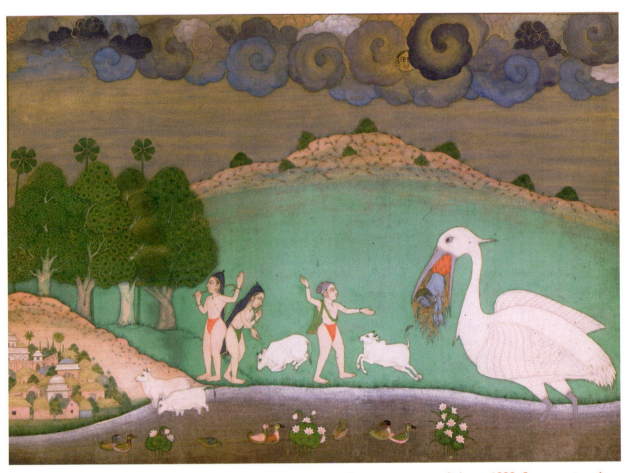

Bakasura Disgorges Krishna, page from a dispersed Bhagavata Purana manuscript, India, c. 1690. Opaque watercolor and gold on paper, 8¾" × 12" excluding border. Kronos Collection, New York.

demanding clients. He loved the city's warm, summer light and captured it in many freely painted, brilliant watercolors.

By adding chalk to pigment and gum arabic, watercolor becomes an opaque paint called **gouache**. Unlike watercolor, which cracks when applied heavily and easily gets muddy, gouache can be applied more thickly, covers well, and permits changes without losing the freshness of its colors. It can also be returned to transparency by diluting it with a high proportion of water. In India, opaque watercolor was used on paper for paintings to be bound in books of Hindu stories. These meticulous paintings were done with handmade brushes of the finest hair from kittens or baby squirrels. Artists also fabricated their own paint. The painter would work cross-legged, with a board supporting the picture in his lap. One small painting, like *Bakasura Disgorges Krishna* (5-8), might take months to complete. The picture shows the god Krishna forcing a demon in the shape of a heron to spit him out by becoming very hot. Notice the bright flames surrounding Krishna. In this painting, gold paint was used, the pigment ground from thin metal foil. It can be seen in the sky and the top of the hill. In addition, gold highlights in

the fire and the rays coming from the head of the sun were added as the last stage.

ACRYLIC

In the 1950s, an extremely flexible, new kind of paint called **acrylic** was invented. Acrylic is a water-based paint originally made for industrial use. The medium is a plastic polymer, made from resins, that dries quickly and can be applied to just about any surface, whether it has been specially prepared or not. Polymers are very adhesive and make an excellent glue. Because acrylic paint dries quickly, changes can be made almost instantaneously; or agents can be added to slow drying and permit wet-into-wet techniques.

Helen Frankenthaler was one of the first artists to explore the possibilities of this new industrial paint. Because it can be applied to unprepared, raw canvas, in *The Bay* (5-9), Frankenthaler let washes of acrylic paint soak into the fabric. With the canvas on the floor, she

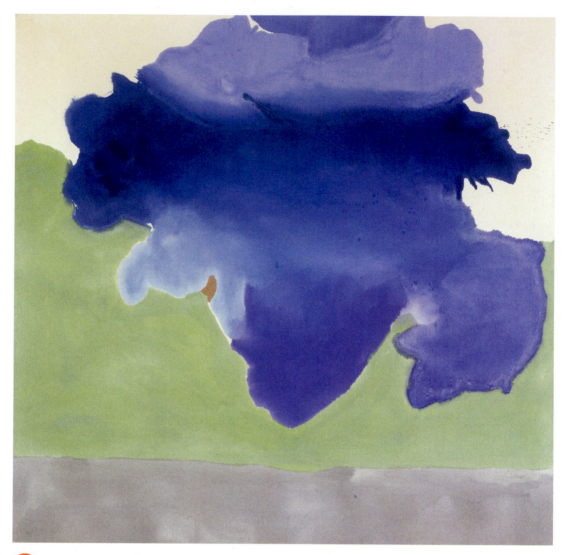

5/9 HELEN FRANKENTHALER, *The Bay*, 1963. Acrylic on canvas, 6' 8½" × 6' 9½". © The Detroit Institute of Art, MI (gift of Dr. and Mrs. Hilbert H. DeLawter). Copyright ©Helen Frankenthaler. © 2012 Estate of Helen Frankenthaler/Artists Rights Society (ARS), New York.

would pour paint onto it and then manipulate it with sponges or by tilting the canvas. This became known as the *soak and stain* method, in which sensuous, rich veils of color are created.

Applied to a surface that has been prepared with a ground, acrylic paint provides an absolute flat, pure surface. Used more thickly, impastos are possible. Acrylic is available in brilliant, as well as metallic and fluorescent, colors. In an extremely diluted state, it can be applied with an **airbrush**—a spraying device that uses an air compressor to propel a paint mist through a nozzle. There are no size limits to acrylic painting—it has been used for miniature painting and outdoor murals. In fact, because they are made of plastic polymers, acrylic paintings weather well and can even be washed with soap and water.

CONTEMPORARY APPROACHES TO PAINTING

Cutting and pasting paper, parchment, and other materials had been done for more than a thousand years before the Cubists legitimized **collage** as fine art at the beginning of the twentieth century (see Chapter 18). Previously, collage had been known as a folk art. For example, in the eighteenth century, nuns in European convents used butterfly wings to make religious pictures. With the advent of photographic reproductions in the late 1800s, almost any imaginable image became available for collage. Mixing materials, using them in unusual ways, and not respecting the borders between two- and three-dimensional media are all characteristics of a modern art form known

TIBETAN SAND
PAINTING

The well-documented permanence of fresco, oils, and acrylic is one of the factors that has attracted Western artists to those mediums. After working weeks, months, or even years on a picture, most artists would find it painful to see it disappear. Some artists have even committed suicide after fire destroyed their studios and their artworks. But Tibetan Buddhist monks deliberately work in a medium that can disappear with a sneeze—colored sand (5-10).

Delicate, detailed sand *mandalas* (an intricate circular, geometric design where deities symbolically live) are made by three or four monks sitting cross-legged under a brightly colored canopy. They work from the center and progress outward. The sand is colored with the brightest of pigments, following a circular pattern used continuously for twenty-five hundred years. Hundreds of deities are invoked by the creation of the mandala. Iron funnels are lightly stroked to create a thin line of sand and a soothing, rhythmic sound. Sand painting thereby appeals to both the eyes and the ears. Contemplation of the creation of a mandala is believed to have a healing influence and help one move toward enlightenment. According to one monk,

The sand mandala is an ancient tradition. Working on it manifests peace. And even a person who simply sees it may feel peace from deep inside.

The Tibetan monks believe the few people who see the mandala during its week of creation will increase its positive influence in the world because they have had a moment of pure peace. After it is finished, the sand painting is poured into a river to bring healing to the creatures who live in its waters.

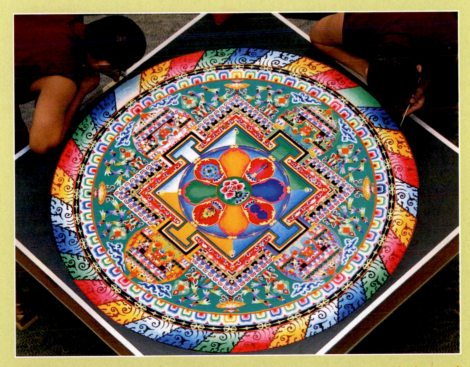

5/10 A Sand Mandala is constructed of grains of colored sand during an eight-day ritual by monks from the Drepung Loseling Monastery in India.

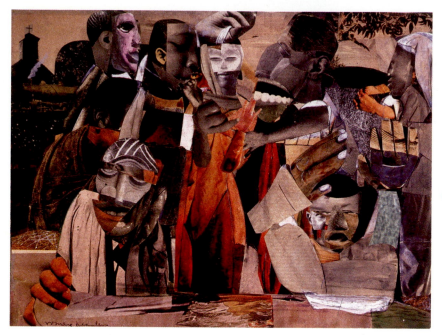

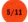 ROMARE BEARDEN, *Prevalence of Ritual: Baptism*, 1964. Photomechanical reproductions, synthetic polymer, and pencil on paperboard, 9⅛" × 12". Hirshhorn Museum and Sculpture Garden, Smithsonian Institution (gift of Joseph H. Hirshhorn, 1966). Photo: Lee Stalsworth. Art © Romare Bearden Foundation/Licensed by VAGA, New York, NY.

as **mixed media**. Mixed media can include traditional and innovative materials combined in unexpected ways, as well as manufactured and natural "found objects."

Romare Bearden's collage *Prevalence of Ritual: Baptism* (5-11) is filled with memories of his childhood in North Carolina. He pieced together magazine reproductions with areas of watercolor and sometimes fabric, making pictures related to both the fractured space of Cubism and the tradition of African-American quilting (see Harriet Powers in Chapter 11). By making each person in his collage an amalgam of several, he is able to imply a long history of baptisms in the South. The fragments in the scene create a lively syncopation throughout the picture, evoking the free improvisations of jazz.

UNIQUE MATERIALS

Contemporary artists like Wangechi Mutu continue Bearden's expansion of the range of what can be described as painting. Her pictures make the term *mixed media* seem inadequate. Painting on Mylar, a plastic film, the Kenyan artist may apply watercolor, acrylic, and spray paint, along with ink, mica, packing tape, contact paper, fake fur, glitter, and stickers.

In addition, much like a contemporary music artist, Mutu samples imagery from African art and mass media as well as cutting and pasting bits and pieces of textbooks and models from fashion magazines to form her complex creations. The life-size central figure in *One Hundred Lavish Images of Bushwack* (5-12) seems simultaneously aggressive and suffering. One foot in a vicious stiletto heel both seems to threaten and be supported

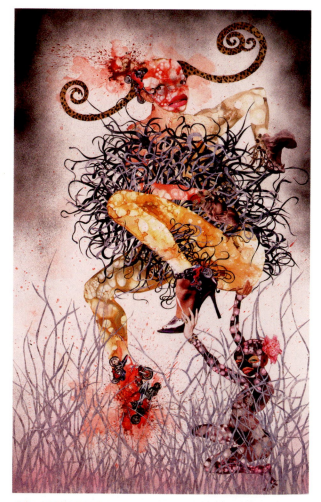

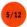 WANGECHI MUTU, *One Hundred Lavish Months of Bushwhack*, 2004. Cut-and-pasted printed paper with watercolor, synthetic polymer paint, and pressure-sensitive stickers on transparentized paper, 68½" × 42". Museum of Modern Art, New York.

by a small figure. The other foot dissolves in a blur of red spray and pasted tiny motorcycles, forming a blood-splattered, rocket-propelled skate. Her head is bleeding, too, and her skin appears diseased because of the way paint pools into blotches on plastic Mylar. Mutu has said that "females carry the marks, language and nuances of their culture more than the male." The challenges in being a contemporary African woman are perhaps the best explanation for the conflicting messages seen in this warrior woman trapped in a strange dance.

The addition of so many new materials by modern and contemporary artists inevitably raises the issue of permanence, an important one for painters for centuries. Exceptions like Tibetan sand painting (see "Global View" box) are rare, because most patrons continue to demand that the artworks they purchase or commission will last and not fade or deteriorate for a long time.

The Brazilian artist Vik Muniz has expanded the painting media by using materials that are far from permanent. In fact, some of the materials he uses would be impossible to store or even pick up without destroying the image. *Action Photo 1* (5-13) is from Muniz's series "Pictures of Chocolate." It is a copy of a well-known photograph of the Action Painter Jackson Pollock (see Chapter 19) at work on one of his drip paintings. Muniz painted his copy in chocolate syrup—an odd but not totally inappropriate choice. Like Pollock as seen in the original photograph, Muniz dripped his "paint" across his canvas (in this case paper). While Pollock would use long sticks and brushes, Muniz's gooey lines of chocolate were pushed into place using tweezers and toothbrushes.

Muniz has copied many other famous images in unusual materials. He has painted the *Mona Lisa* in peanut butter and jelly and reproduced a Caravaggio painting of Medusa in pasta and marinara sauce (see "Lives of the Artists" box in Chapter 15). While chocolate is a favorite material, Muniz has also used fake blood, ketchup, caviar, glitter, Silly Putty, nails, wire, and small, brightly colored children's soldiers. By remaking the familiar in an unfamiliar way, he hopes that viewers will look more carefully at these famous pictures. Muniz says that "What am I looking at? [is the] one question I am always trying to evoke in my work." The unusual media also reminds viewers that "a picture is always made out of something."

Because most collectors would not be interested in hanging a painting that would eventually drip down the wall and collect on the floor in a puddle, Muniz takes photographs of each of his works. These photographs are sharply focused and clearly printed in color. The brown syrup's glossy highlights shine, and the edges are crisp.

Most viewers do not realize until they see the picture's label on the wall that they are not looking at real chocolate. But in fact, the chocolate is long gone—sometimes even eaten by Muniz.

In the case of Vik Muniz's work, photography provides a permanent record of his ephemeral paintings. This is somewhat ironic, because when photography was first invented, many painters saw it as a threat to their medium. Today, a new threat has arisen—digital painting (see Chapter 8), a medium that can recreate just about all of the traditional painting media on the computer and enhances them with a wide range of digital tools. But the death of painting in the twenty-first century seems as unlikely as it was in the nineteenth century. Painting seems to be a natural impulse, and the pleasure that one gets from creating an image in paint (even if the paint is chocolate) is undeniable. It is still felt by little children as they finger paint and by retirees recreating a sunset in oils on an easel. While new media will continue being created, it is reasonable to remain confident that painting, a medium that first appeared in caves thirty thousand years ago, will continue to be a favorite of artists for years to come.

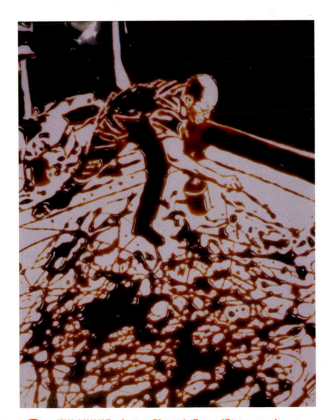

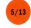 **VIK MUNIZ,** *Action Photo 1* (From "Pictures of Chocolate"), 1997. Cibachrome print, 61" × 49". Victoria & Albert Museum, London, Great Britain.

CHAPTER 6

PRINTMAKING

During the Renaissance, so many important changes took place in the Western world that it seems impossible to select the most significant development. However, the invention of the printing press in the 1450s is certainly among the greatest innovations of this period. To use just one example, Martin Luther's Protestant **Reformation** would probably never have occurred if thousands of copies of his ninety-five criticisms of the church ("95 Theses"), supplemented with printed cartoons for the illiterate, had not been circulated all over Europe. No wonder Luther said, "Print is the best of God's inventions."

In art, printing's effect was perhaps not quite as dramatic, but its contribution has been very significant. The book you hold in your hands is a product of the print revolution. The modern concept of art appreciation would not be possible without printing presses. Because of art reproductions, art—once the exclusive domain of the very wealthy and powerful—is today available to virtually everyone.

The term *print*, however, has a special meaning to the fine artist. It does not mean photographic reproductions like those in this book, but reproductions or *multiples* made directly from a block, plate, stone, or screen that an artist created. The number of prints is limited by an artist and is called the **edition**. Once the last print of an edition is "pulled," the block, plate, or other source is destroyed. Usually an artist will sign each print and also number it. For example, "23/100" means the print was the twenty-third out of an edition of one hundred. Even though an edition can number in the hundreds, each individual print is still considered an original work of art. Even before printmaking, there were other precedents for this understanding of what is an "original"—for example, limited sets of bronze casts made from a clay sculpture.

One of the most important effects of printmaking has been making fine art originals available to more people. Because they are multiples, prints are generally less expensive than other art forms. Many artists chose to be printmakers because printmaking seemed less elitist, more democratic than the other media.

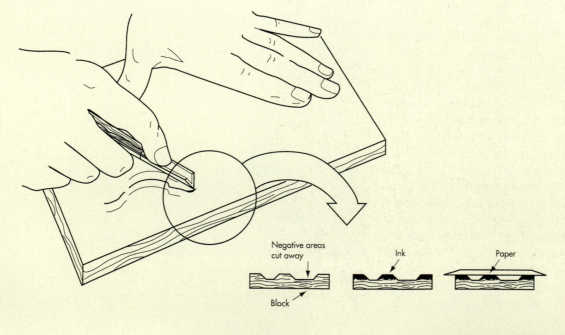

Negative areas cut away

Ink

Paper

Block

6/1 Woodcut relief process.

RELIEF PRINTMAKING

WOODCUT

In the past five hundred years, many forms of printmaking have evolved. The first in the West was the **woodcut** print, adapted from an Asian technique for printing cloth. When illuminated (handpainted) manuscripts were replaced by printed books, a way to print illustrations was also needed. Woodcut blocks were found to be the most appropriate because they fit easily into the printing press along with the type. Woodcuts are among the simplest of the print media (6-1). They are made by carving directly into a smooth piece of wood and removing any areas of the surface that are not meant to be part of the future image. In essence, the negative spaces of a design are cut away, leaving the positive areas raised up, ready to be printed. Usually a drawing is made directly on the wood, and then the background is cut out around it. The carved block is inked with a roller; the uncarved wood remaining on the surface will receive the ink and make an impression on the paper. Because the print's marks are made from inking what is left in "relief" on the block, woodcuts fall into the category of **relief printmaking**. Linoleum cuts and rubber stamps also fall into this category.

For example, in Albrecht Dürer's *The Four Horsemen* (6-2), all of the white areas had to be carved out of the block so the thin black lines in the print could appear. To make the actual print, a piece of paper is placed on top of the inked woodblock and either rubbed on the back by

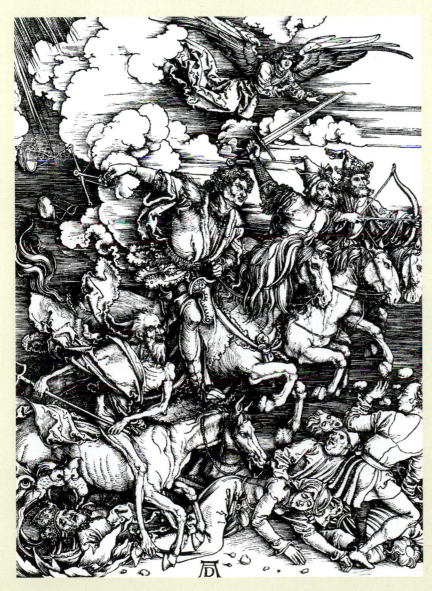

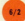 ALBRECHT DÜRER, *The Four Horsemen*, from the Apocalypse series, c. 1498. Woodcut, 15½" × 11". British Museum, London, Great Britain.

hand or passed through a printing press to transfer the image to the paper.

The first woodcut prints in Europe were decorated with crude, simple images. Purchased by ordinary people, most were either playing cards or devotional images, like saints or charms for warding off evil. Albrecht Dürer was the first Renaissance artist to show that prints could be the equal of painting or any of the other fine arts. At the time he created *The Four Horsemen*, Dürer had just returned from Italy, where he had seen the works of the great Renaissance masters for the first time. He wanted his woodcuts to have the vital force and imaginative compositions that he admired in Italian painting. The fine details in this print, the result of elaborate carving, had never been seen by Europeans in a woodcut. By recreating drawing's parallel hatching on his woodblock, he was able to model his forms and provide a sense of movement and excitement. The subject of the print is taken from Chapter 6 of the Book of Revelation and is known as the four horsemen of the Apocalypse (or end of the world). The first horseman on the right holds a bow and symbolizes conquest; the second holds a sword, symbolizing war; the third a pair of scales, symbolizing famine; and the horseman at the front left of the image is Death riding a pale horse. In the lower left-hand corner is Hades, the mouth of hell:

> And behold, a pale horse, and its rider's name was death, and Hades followed him; and they were given power over a fourth of the earth, to kill with sword and with famine and with pestilence and by wild beasts of the earth.

Dürer's print brings this fantastic scene to life, with the skeletal figure of death creating a vivid, unforgettable image of horror.

Woodcuts with fine details and elaborate design were familiar in Asia centuries before Dürer's landmark work. Paper, a necessary material for traditional printmaking, was invented in China approximately one thousand years before it first appeared in the West. So it is not surprising that the first woodblock prints also appeared earlier in the Orient, around 800 CE. Buddhist scrolls printed in China found their way to Japan, which eventually produced some of the greatest prints ever made. Even Dürer's superb woodcut seems rather crude next to Kuniyoshi Utagawa's *Various Stages of Making a Color Print* (6-3).

As seen in this print, the Japanese woodcut printing process was very different from the one Dürer followed. Dürer designed and carved his blocks himself. In Japan, a color print was the work of several artisans, each with a specialized role. Utagawa was the designer of the print,

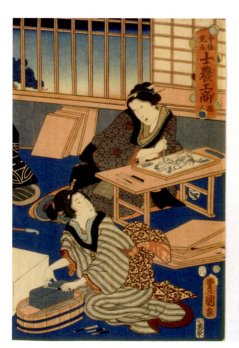
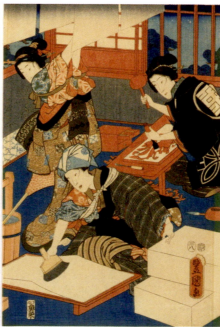
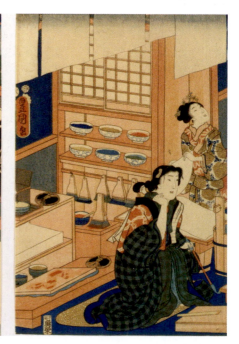

6/3 **KUNIYOSHI UTAGAWA,** *Various Stages of Making a Color Print*, 1857. Color woodcut, 9¾" × 14½". Victoria & Albert Museum, London, Great Britain.

making the drawing and planning the color scheme. Cutters would then carve the block, while printers would ink and print it. They worked as a team, with no member considered more important than another. The Japanese did not share the Western idea that the artist's unique concept is the most valuable part of an artwork. The Japanese characters at the sides of the print are the marks of the various workers, much like the credits at the end of a film.

In a color print like this one, each separate color is the product of a different carved wooden block. As in all color prints today, each color must line up correctly with the previously inked color images as it is added to the print (known as proper **registration**), or the print will be ruined—blurred or mismatched. This registration requires skill and planning by both artist and printer. We will see later in this chapter and in Chapter 17 that Japanese print design was extremely influential in the development of both modern printmaking and Modern Art.

WOOD ENGRAVING

Another relief process is **wood engraving**, first used in the 1800s. It is similar to woodcut but uses the endgrain on blocks of very hard wood, and because the endgrain is so dense and hard, tools designed to cut metal are needed. The wood's density permits very fine, precise lines to be created, and, compared to the soft wood used for woodcuts, many more prints can be made before the block begins to deteriorate. These two properties made wood engraving particularly useful for book illustration.

Gustave Doré was the preeminent French illustrator of the mid-1800s. It was his aim to illustrate all of the great books in Western literature. Figure 6-4 shows one page from his illustrated edition of the English Romantic poet Samuel Coleridge's famous poem *The Rime of the Ancient Mariner*. Doré would work on several blocks at once, first drawing directly on each block and then moving around his studio making careful cuts on one, then another, until they were all finished. The section of the poem illustrated by this engraving tells of a sailing ship sent off-course by a storm and reads:

> And now there came both mist and snow,
> And it grew wondrous cold:
>
> And ice, mast-high, came floating by,
> As green as emerald.

Notice how Doré was able to engrave delicate, almost perfect, parallel lines throughout his print. By varying their width, three-dimensional forms emerge, like the icebergs in the distance. He contrasts the precision

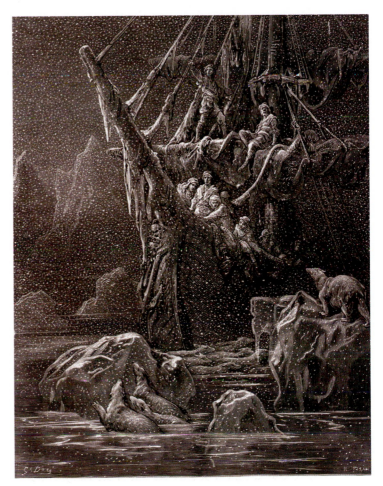

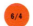 GUSTAVE DORÉ, illustration from Samuel Taylor Coleridge's *The Rime of the Ancient Mariner*, 1878. Woodcut, 9¼" × 12". Published by Harper & Brothers Publishers, New York.

of his lines with the natural effect of falling snow made freely with short stabs into the wood. Remember that the white lines, shapes, and spots represent cuts in the wood's surface; the black areas represent the surface of the wood that was left uncut.

INTAGLIO PRINTMAKING

Intaglio printmaking is the opposite of relief printing; here what is removed ends up being printed (6-5). Lines are cut into the surface of metal plates using either sharp tools or acids. The cut lines act as little channels that retain the ink after the plate has been inked by a roller and its surface wiped clean. Then a piece of moistened paper is placed over the plate. Finally, the paper and plate are run through a press, the heavy pressure of which forces the damp paper into the ink-filled grooves and thereby transfers the image. Like the letters in an engraved invitation, the lines of an intaglio print are raised, because each line on the paper was formed by being pushed into the cut channels of the metal plate.

6/5 Intaglio engraving process.

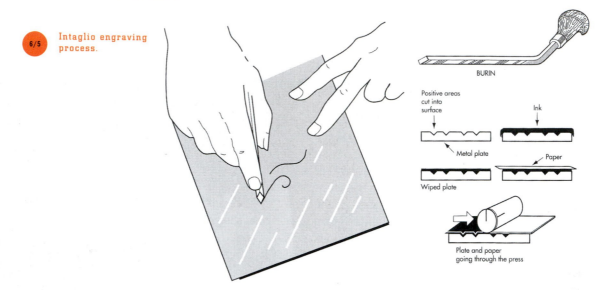

BURIN

Positive areas cut into surface

Ink

Metal plate

Paper

Wiped plate

Plate and paper going through the press

METAL ENGRAVING

During the Middle Ages, armorers and metalsmiths decorated metal by cutting into its surface, as had been done on metal weapons and objects for thousands of years.

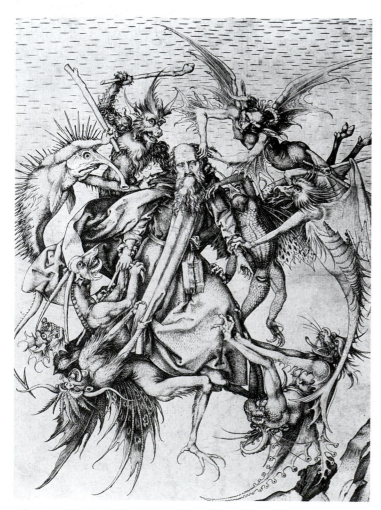

6/6 MARTIN SCHONGAUER, *Saint Anthony Tormented by Demons*, c. 1445–1491. Engraving. Fondazione Magnani Rocca, Corte di Mamiano, Italy.

They also knew that prints could be made on cloth in the same fashion. **Engraving**, the oldest form of intaglio printmaking, was developed when paper became easily available in Europe during the 1400s. In an intaglio process, cuts made on the plate print directly as lines (unlike the relief process of woodcuts or wood engravings, where the cuts remove the background). Special sharp tools called *burins* are the most common engraving tools, but any instrument sharp enough to make a mark on metal can be used. Even a needle can make a small scratch that will be reproduced.

The German artist Martin Schongauer was one of the first to utilize the capability of metal engravings to reproduce delicate, fine lines. In his *Saint Anthony Tormented by Demons* (6-6), Schongauer created a fantastic group of devils whose tails, wings, and claws are drawn in the minutest detail. The sad-faced saint is lifted off the ground and tortured in many ways—the little fingers of an ugly witch stroke his hair, while a furry devil is about to smash the side of his head with a club. From the beard of Saint Anthony to the spikes on an elephant-nosed devil, the precise hatched lines create convincing textures and solid forms.

William Hogarth, a British painter of the 1800s, began making engravings of his work and selling them cheaply because he wanted to make "art accessible to all." The purpose of his pictures, he said, was "to teach." In *Gin Lane* (6-7), the message was to warn the poor about the evils of a new, cheap liquor—gin. At the time, gin was sold unlicensed and by the barrel. A riot at a distillery can be seen to the right. If one looks closely at Hogarth's carefully constructed print, one can see many more "dreadful consequences of drinking." Hogarth was not opposed to all drinking; on his companion engraving *Beer Street*, "all is joyous and thriving," and he calls beer the "happy produce of our isle." Hogarth's efforts were not in vain; the Gin Act regulating the sale of this "deadly" liquor passed Parliament in the next year.

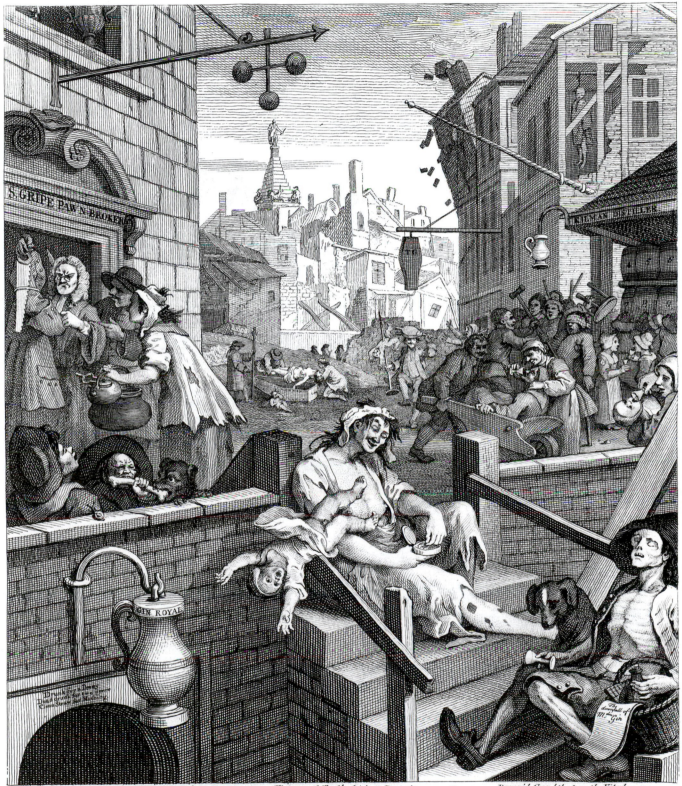

GIN LANE.

WILLIAM HOGARTH, *Gin Lane*, from *Beer Street and Gin Lane*, c. 1734.
Third state engraving, 14" × 11⅞".

JUNE WAYNE: ARTIST, PRINTMAKER, CATALYST

In 1959, June Wayne, a middle-aged artist living in California, sent a grant proposal to the Ford Foundation to start a workshop that would eventually lead to the rise of Los Angeles as an art center and ultimately to the revival of American printmaking. Wayne was from Chicago, but she had already lived in New York and France. In Paris, she had worked with a master lithographer who made prints for Picasso and Matisse. She was disturbed that in the era of postwar modernism, there were no such fine art printers in America and that in the 1950s printmaking was, as another artist said, "considered the lowest possible way of expressing yourself." Comparing the field to an endangered species, Wayne felt that "lithography was on the verge of extinction" and artists and lithographers "needed a protected environment." Her request from the Foundation was modest, but her goal was grand: to create "a pool of master printmakers in the United States." Her plan was to first familiarize local artists with lithography, to train printmakers, and then to create a market for the prints of contemporary artists.

With the three-year grant she received, Wayne set up the Tamarind Lithography Workshop in Hollywood (named for the street where it was located). At Tamarind, artists were free to explore any direction their imagination took them, but everyone had to create lithographs in an edition of thirty. The first twenty belonged to the artist; the next ten were Tamarind's. However, June Wayne wasn't interested in accumulating a stockpile of prints. She was determined to spread her passion for printmaking to the art community. From every edition, Wayne donated nine prints to different Southern California museums. The result was that enthusiasm for printmaking took off among curators and collectors in the 1960s.

The Tamarind Workshop became nationally known as an ideal place for artists to explore and innovate. It gained a reputation as a place where the printmaker had only one goal: to facilitate the artist's imagination, no matter how unique or difficult. One artist described the atmosphere as a "wonderful give and take between artist and printer which caused both to do things [neither could] have done without the other." Every print would have not only the artist's signature but the printer's and Tamarind's marks, too. The workshop developed techniques for printing on plastic, metal, and leather, and printing with unusual media like caviar and Pepto-Bismol. Tamarind worked with chemists to create new and longer-lasting inks and explored metal sheets as an alternative to traditional lithographic stones. While the editions and portfolios of art created were essential in the rise of Los Angeles as an art center, equally vital was the printer training program. Master printmakers, like Ken Tyler, learned their trade at Tamarind before going on to create their own important workshops across the country.

By the spring of 1964, Tamarind was already about to issue its one thousandth edition of lithographs. The staff decided to reserve it for June Wayne. This print (6-8) is characteristic of her style—cosmic and organic. She rarely worked with a preconceived notion, but preferred to discover the image while applying materials to a smooth lithographic stone. When she finished, the staff yelled, "At Last! A Thousand!" and the print had its name. Today, Tamarind lives on as the Tamarind Institute at the University of New Mexico. It continues Wayne's legacy of inspiring and facilitating the creativity of artists, along with the training of master printmakers.

6/8 JUNE WAYNE and JOE FUNK (Printer), *At Last a Thousand I*, 1965. Lithograph on paper sheet, 29½" × 41¾" Smithsonian American Art Museum, Washington, D.C. Art © June Wayne Trust #1/ Licensed by VAGA, New York, NY.

ETCHING

Etching is another intaglio process that uses acids rather than metal tools to cut the metal plate (6-9). First, a wax coating, or **ground**, that resists acid is applied to the plate. The printmaker then draws by cutting through the ground. The plate is then put into a tray of acid that "bites" into the metal in any places where the wax ground was removed, forming lines. After the plate is washed with water, it is inked and printed just like an engraving. Lines can be made lighter (thinner) or darker (thicker) depending on the amount of time the plate is left in acid. Because cutting wax is so much easier than scratching metal, etching allows the artist to draw lines that are more flowing and spontaneous.

Besides being a great painter and draftsman, Rembrandt van Rijn is known for his fine etchings. One of the most famous of these is his vision of Christ healing the sick, known as the *Hundred Guilder Print* (6-10). As you can see, though woodcuts and engravings depend on lines of varying width, etched prints can create large areas of velvety shadow. As he worked on this print, Rembrandt cut lines of varying widths into the metal plate by placing the plate in acid several times. When he was satisfied with the depth of the lines in each section, it would be covered in a solution that stopped the action of the acid. The areas on the left side of the print,

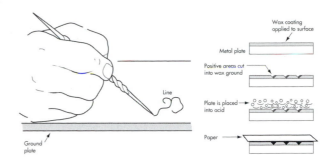

6/9 Intaglio etching process.

for example, were covered early in the process, leaving the drawing relatively light. In the darkest areas on the right side of the picture, lines were drawn close together in a tight network of crosshatching and then left in the acid bath until they became an almost solid black field. The brilliant light surrounding Christ—seeming to emanate from his figure—is set against the deep shadow of the background. Not only does this create a strong visual image, but the image also echoes the way that Rembrandt believed Christ's healing message illuminated the world. No wonder Rembrandt was able to command a high price for this print! Like Schongauer's *Saint Anthony* and Dürer's *Four Horsemen*, Rembrandt's *Christ with the Sick Around Him, Receiving the Children* spread the message of Christianity—and fine art—into the homes of many more people.

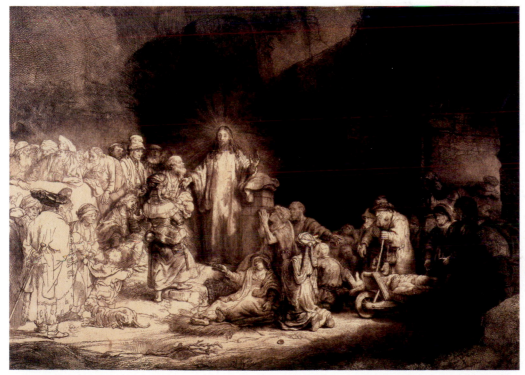

 REMBRANDT VAN RIJN, *Christ with the Sick around Him, Receiving the Children (Hundred Guilder Print)*, c. 1649. Etching, approx. 11" × 13¼". British Museum, London, Great Britain.

AQUATINT

Although the lines were etched as described in the previous section, the tonal areas in Mary Cassatt's *The Letter* (6-11) are the result of a different method than the deeply bitten line used by Rembrandt. **Aquatints** are tonal areas made by applying powdered resin to the plate and then heating it. The heat melts the resin, and each particle becomes a dot that will resist acid. As with etched lines, the longer an area of aquatint is in the acid bath, the deeper the etch and the darker the tone in the final print. Cassatt, an American who exhibited in Paris with the Impressionists (see Chapter 17), demonstrates a mastery of aquatint and color. The white of the envelope and the letter on the desk are actually the white of the paper the print was printed on. Carefully protecting these areas of the metal plate from the aquatint and the acid allows the objects to emerge from the surrounding colors. Within the small flowers that decorate the wall, we can see subtle variations of tones. Like her fellow Impressionists, Cassatt was influenced by Japanese prints. One clear sign of this is the woman's desk, which deliberately ignores mathematical perspective, as in the style of printmakers like Utagawa.

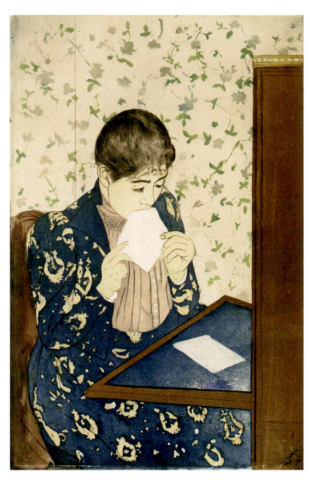

6/11 MARY CASSATT, *The Letter*, 1891. Color etching, 13⅝" × 9". Worcester Art Museum, MA.

LITHOGRAPHY

Lithography was invented as a commercial process in Bavaria in 1798 and was first used to reproduce sheets of music cheaply. Within three years, artists began using the new print medium and discovering its unique properties. In lithography, no cutting is involved. Images are drawn or painted directly in grease on a flat stone or plate (6-12). Although any substance with enough grease in it will work (such as lipstick), *litho crayons* (made of

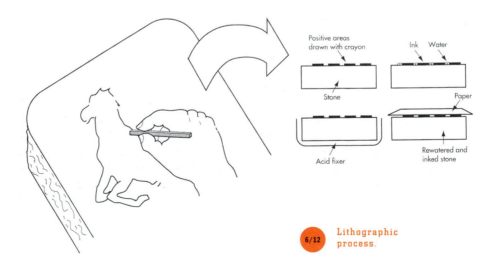

6/12 Lithographic process.

wax, soap, and black pigment) and *tusche* (a greasy liquid that can be applied with a brush or sprayed on) are the most common materials used to make images in lithography. The lithographic stone or plate is then treated with a chemical so only the areas that have grease on them will attract the ink when it is rolled on. A sheet of paper is placed on the stone or plate and run through a printing press.

Traditionally, the preferred surface for lithographs has been limestone from quarries in Bavaria. When prepared properly, it has been described as the premier drawing surface in the world. Every kind of mark made by lithographic grease crayons can be applied and reproduced exactly. Even though each stone can be used many times (by regrinding the printing surface), the intense demand for Bavarian limestone has made the stones increasingly rare. Printers around the world consider them their most valuable possessions; dropping and cracking a Bavarian stone is considered a tragedy. Because of the difficulty in obtaining such stones, specially prepared metal plates (usually zinc or aluminum) are being used more often in lithography. Metal plates are much lighter and much cheaper than stones, but they do not have the same creamy surface that makes drawing on a stone a sensual pleasure.

Many nineteenth-century artists designed lithographs, but Henri de Toulouse-Lautrec raised colored lithography to the status of fine art. *Miss Loie Fuller* (6-13) is a print designed to capture the essence of the American performer who took Paris by storm in the early 1890s. A dancer who did not dance, Fuller used huge billows of fabric and theatrical lights to create an impression of fluid motion. Here Lautrec shows Fuller suspended against a dark background, with only her small head and two tiny feet projecting beyond the exuberant, mothlike wings of her costume. You can see the curved corners of the stone block that the print was drawn on, as well as sinuous outlines of the figure drawn in tusche, and spatters of ink as well as areas of shadow created by a greasy crayon. After this drawing was made, Lautrec experimented with different color combinations as he printed. In this version, the colors of the costume blend into each other, reproducing the effect of the colored electric lights Fuller used during her performances. Lautrec published an edition (or series) of these prints, but each one is slightly different.

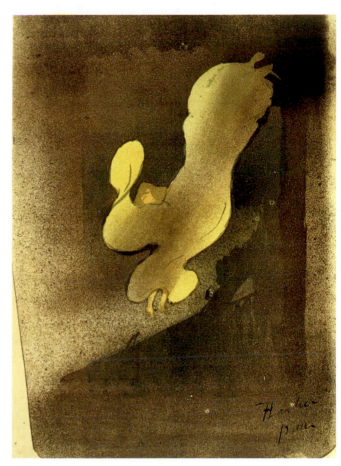

6/13 HENRI DE TOULOUSE-LAUTREC, *Miss Loie Fuller*, 1893. Lithograph, printed in color, 14½" × 10⁹⁄₁₆". British Museum, London, Great Britain.

SILKSCREEN

Silkscreen printing (or *serigraphy*) is one of the newer printmaking media, developed originally for industrial printing of patterns on fabrics. It is an inexpensive method of producing very large editions of prints and is often used for posters and T-shirts. Silkscreen is based on the ancient technique of stenciling. A stencil is attached to a screen of silk that has been tightly stretched over a

WHAT'S THE DIFFERENCE BETWEEN
A PRINT AND
A POSTER?

Do you know the difference between a fine art print and a poster? Both are printed duplicates, both are two-dimensional works of art that can be in black-and-white or color, and both can be used to decorate one's home. Both can show works by famous or unknown artists. Usually, both are printed on paper. So what's the difference?

In general, artists' prints are limited editions in which each individual print is considered an original work of art.

These types of prints are usually printed or supervised by the artist, carefully numbered, and sold to galleries, museums, or collectors. Posters are reproduced mechanically in huge print runs and can be sold by the millions in bookstores, museums, on the street, and even on the Web. There was no dramatic difference between prints and posters until the nineteenth century. Most print runs were fairly small, and the presses were operated by hand.

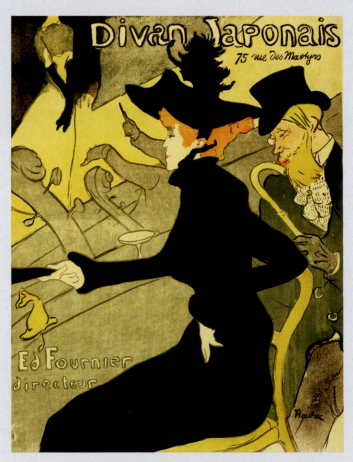

 HENRI DE TOULOUSE-LAUTREC, *Divan Japonais*, 1893. Lithographic poster, printed in color, $31^{13}/_{16}$" \times $23^{15}/_{16}$". Museum of Modern Art, New York, Abby Aldrich Rockefeller Fund, 1949.

In the 1800s, however, the industrial revolution also created a revolution in printing. Now images for a general public could be mass-produced in factories.

To understand the difference between prints and posters better, consider the work of Toulouse-Lautrec. We have already seen his print of *Miss Loie Fuller* (6-13), which appeared in a limited edition for collectors in 1893. Around the same time, Lautrec was also designing posters for events in Paris—posters to be plastered on walls around the city. Instead of being paid by art lovers and collectors, Lautrec was working for businesses—usually theatrical shows—that wanted to advertise their products and services.

In addition to Loie Fuller, turn-of-the-century Paris went wild for a series of female entertainers. One of the most famous was dancer Jane Avril, also a close friend of Toulouse-Lautrec. The artist featured her in several posters, including this one for *Divan Japonais*, a popular cabaret (6-14). Pictured behind Avril is a well-known music critic, and performing on stage (though with her head cut off by the edge of the paper) is another female celebrity, the singer Yvette Guilbert.

Although it was created as a poster, Lautrec's color lithograph has the same brilliant design as his prints and paintings (see Chapter 17). The treatment of Avril's black dress and hat with their flat, bold shapes is a result of a fascination with Japanese prints that he shared with Mary Cassatt and other Post-Impressionists (see "Global View" box on Japonisme, Chapter 17). But Japanese prints had been made with small, light blocks of wood. The colors in this lithographic print are a tribute to the dedication and imagination of Lautrec, because each color had to be printed separately using a different stone. Since Lautrec had to use several heavy stones to complete *Divan Japonais* (one black, one yellow, one green, one orange), exact registration was a challenge, yet all of the edges meet crisply. Because he was a great artist, Lautrec's posters have become valued prints over the years. This striking advertisement, once made as one of a storm of competing posters, is now in the collection of the Museum of Modern Art.

Most students purchase posters to decorate their walls, from reproductions of paintings to advertisements for movies, concerts, and rock groups. Such mass-produced decorative images, like Lautrec's posters, can increase in value over time, some even attaining a kind of cult status. This might be said of posters made for rock

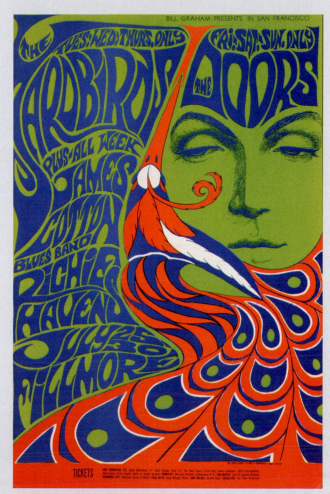

6/15 BONNIE MACLEAN, *The Yardbirds, The Doors*, 1967. Offset lithograph, 21¼" × 14". Private collection.

concerts in the 1960s. With their curving lines and pulsating electric colors, these images reflect the interchange between the counter-culture of the era and commercial mass culture. "Go with the Flow," a catchphrase of the Sixties, might be a fitting subtitle for this poster designed by Bonnie Maclean in 1967 for a concert at the Fillmore starring The Yardbirds and The Doors (6-15). The type and colored, peacock-tail pattern seem to flow down the surface of the poster, creating a message that is challenging to read, yet intriguing to decipher. Interestingly, this poster—like Lautrec's—is in the collection of the Museum of Modern Art, but as part of their design collection. Chapter 11, "Crafts and Design," will further explore the place of design in the visual arts.

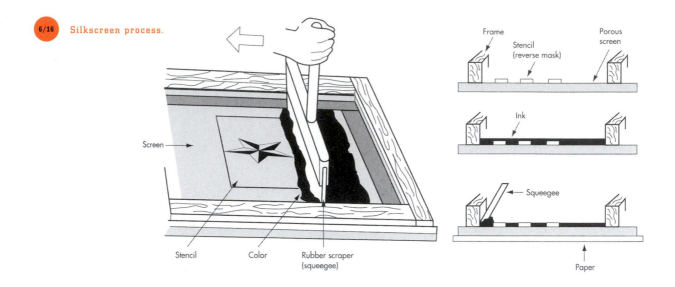

6/16 Silkscreen process.

Screen

Stencil Color Rubber scraper
(squeegee)

Frame Stencil
(reverse mask) Porous
screen

Ink

Squeegee

Paper

wooden frame (6-16). After a piece of paper is placed underneath the screen, ink is spread across the screen with a rubber blade or squeegee. The open areas of silk (those not covered with a stencil) let the ink come through and print onto the paper. As in woodcut prints, no press is necessary.

A silkscreen stencil can be created with anything that will block the ink. Heavy paper stencils produce shapes that will print with crisp edges, or glue can be painted directly onto the silk for looser effects. With the use of photosensitive chemicals, it is also possible to create stencils from photographic sources, as in Barbara Kruger's *Untitled (We don't need another hero)* (6-17). Here, Kruger combined two kinds of subjects: photographs and written words. She utilized a photostencil to borrow (or **appropriate**) imagery from another

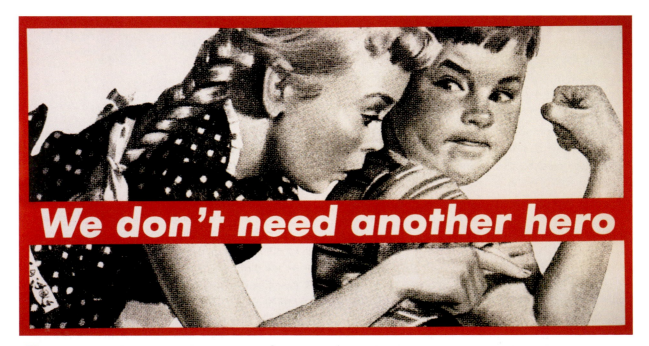

6/17 **BARBARA KRUGER,** *Untitled (We don't need another hero)*, 1987. Photograph silkscreen and vinyl, 109" × 210". Collection of Emily Fisher Landau, New York. Mary Boone Gallery, NY.

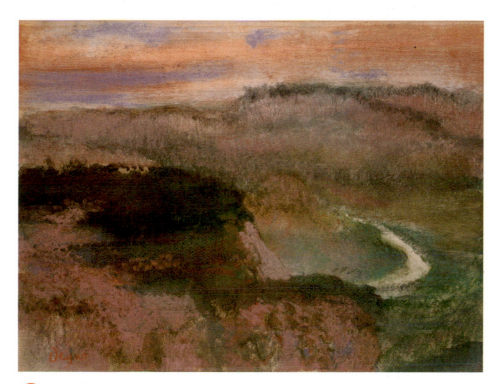

EDGAR DEGAS, *Landscape*, 1890–1893. Pastel over monotype on paper, 10½" × 14". Museum of Fine Arts, Boston, MA.

source—an illustration from the 1950s. Her statement "We don't need another hero" is a strong condemnation of the "macho" tendencies in men that the era glorified.

UNIQUE PRINTS

While it seems almost a contradiction in terms, modern artists have used the printing press to create non-multiple, or unique, one-of-a-kind prints. A **monotype** is made by applying ink or paint directly to a metal plate and then running it with paper through a press. It can also be made without the press by rubbing the back of the paper. Only one print is made (hence the name).

The Impressionist Edgar Degas was a lover of the process because it allows a quick, instinctual approach, compared to the more time-consuming and methodical approach necessary in most printmaking. Like a drawing, monotypes openly reveal the artist's hand; in fact, Degas called monotypes "drawings in greasy ink put through a press." In his *Landscape* (6-18), Degas used the *dark field* method of monotype, where ink or paint is wiped on the whole plate and then removed to build the picture. Here, Degas applied colored oil paint to the metal plate, then wiped off the curving line that suggests a road. After pulling this print, Degas enhanced his image with pastel, making this a mixed-media, original work of art, part of a series of scenes the artist described as *paysages imaginaires* or imaginary landscapes.

CONTEMPORARY APPROACHES

Contemporary printmakers continue to experiment with new techniques and to use prints in exciting ways.

Printmaking today is not necessarily displayed in frames on white walls. For example, in 1996, artist Kiki Smith (known for her work in a wide variety of media) laid a series of prints on top of each other to create a gallery installation. In *Peabody (Animal Drawings)* **(6-19)**, we see a view of this installation where the prints—all with motifs taken from nature—form a rich carpet on the gallery floor. Many of the images are repeated, as Smith explains:

> I have to make about a million proofs of everything. I don't know, it's just a repetition, like a meditation. You come back to something and then you leave it, and then you come back again and you leave it, and each time it changes.

A "proof" is a single, test print made by an artist to see what an image will look like when it is printed. Here Smith has collected a series of proofs and used them to create an artwork that takes on a three-dimensional quality. The multiple wolves, deer, and other animals emerge in delicate etched white lines, based on the meticulous nature studies of the nineteenth century, on glowing red and purple backgrounds. For Smith each of these animal images has a symbolic resonance, reminding us of the mysterious connection between humans and nature.

Both the concept of proofing and printmaking's traditional role of making art accessible to the general public are given contemporary twists in *Always finding another cage* **(6-20)** by the Mexican artist Betsabeé Romero. Romero, who calls herself a "mechanic-artist," shares the popular fascination with cars, which play an important role in most of her artworks. By carving patterns, such as native birds and flowers, into the tread of rubber tires, she can use them for printmaking. The

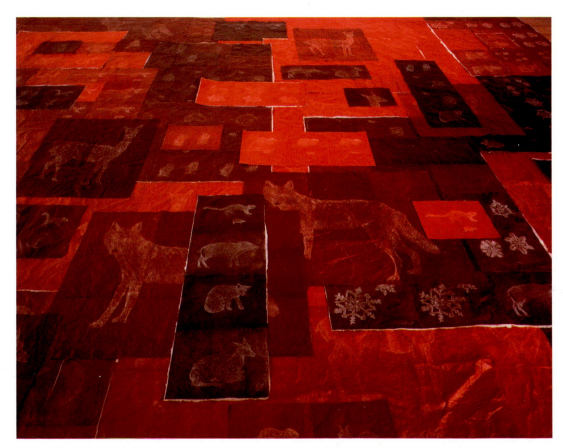

6/19 KIKI SMITH, *Peabody (Animal Drawings)*, 1996. Ink on paper, installation view. Huntington Gallery, Massachusetts College of Art, Boston, MA.

6/20 BETSABEÉ ROMERO, *Always Finding Another Cage*, 2010. Carved public transportation tires, prints on wire mesh. Courtesy the artist.

rubber of used, recycled tires is very hard, so she and her assistants use electric chisels that are normally used for industrial purposes. After inking and rolling the tires, they leave impressions just like those of a conventional print but much larger. In *Always*, Romero printed on wire mesh, but she often prints on long rolls of paper or cloth. When a similar work called *Wheeling Memory* was exhibited in Havana, Cuba, she offered to make free prints for anyone who brought her material to print on. She made prints on handkerchiefs, towels, and t-shirts. The engraved patterns on the tires were based on ceramic decorations found on Havana's buildings. After the exhibit ended, Romero put a carved tire on a car and inked it. When she drove away, she turned the city streets into an artwork.

Though the tool is rarely a car, printmaking requires the intermediary of a machine in the creative process. Still, we have seen in this chapter that printmaking is an extraordinarily flexible media. Prints can not only provide a mechanical look but also reveal a human touch. Images can be stark black and white or lavishly colored. Almost from its beginning, printmaking has been accepted as one of the fine art media with little or no controversy. But, we will see in the next chapter, this is not true of a more modern tool of the artist—the machine known as the camera.

CHAPTER 7

PHOTOGRAPHY

Since the mid-nineteenth century, the number of pictures produced and reproduced has increased explosively, largely as a result of the invention of photography. Realistic images that would have awed Michelangelo are seen every day on calendars and magazine covers. The impact of photography has been as significant as that of the printing press, and it has changed the world in a very short time. Almost from the moment of its invention in the 1830s, the photograph was greeted with enthusiasm and awareness of its historical importance. It took several decades, however, for photography to become truly accepted as one of the art media.

TECHNIQUE AND DEVELOPMENT

The long road to the photograph began around the eleventh century, when the first **camera obscura (7-1)** was developed. Literally meaning "dark room," such room-sized cameras were first used to study eclipses. By preventing all light from entering a room and then cutting a small hole in a window shade, a person could project an inverted image of the sun onto the opposite wall. However, studying an astronomical event was not the only way to use the camera. A camera obscura can also project an upside-down image of the outside world using ordinary daylight. By the 1600s, a lens helped focus images more clearly. Then in the 1700s, a table model of the camera obscura became available. With the help of a small mirror inside, it projected a right-side-up image on a screen that artists could use for tracing. The lens could be moved inward and outward depending on whether a close-up or long view was required. In fact, really only one thing separated this camera obscura from our modern camera—the lack of a light-sensitive material to record the image.

The search for a way to permanently capture a camera's image took place during the late 1700s and early 1800s, a period of intensive scientific investigation of the natural world. Botanical artists, for example, were making extremely detailed drawings of plants but were well aware that the artist's eye was technically limited. A more scientific method of observation was felt to be needed.

A series of discoveries and inventions by scientists (mostly amateur) around Europe finally resulted in the

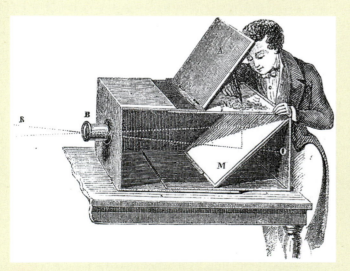

7/1 Camera obscura. Heritage Image Partnership.

first permanent photographic image—the **daguerreotype**, introduced to the world by a French painter, Louis-Jacques-Mandé Daguerre, in 1839. His pictures were produced by a complex chemical process. First, silver-coated copper plates were made light sensitive by exposure to iodine vapor. After the plate was exposed to light, the image was *developed* (made visible) by treating it with mercury vapor. The image was *fixed* (made permanent) by bathing it in a solution of salt. Daguerre's success made him famous and the toast of Paris. "Daguerreomania" soon swept Europe and the United States. His pictures were said to have defeated time.

There were, however, technical limitations to the daguerreotype. Portraits were the most popular kind of early photographs, but because an exposure of thirty minutes might be required, they tended to show very grim people trying desperately not to move. The most successful of Daguerre's images were still lifes, as in his *Collection of Fossils and Shells* (7-2). These early pictures did not use film, and only a single image could be printed. The first photographic film using the "negative–positive principle" was invented by an Englishman, William Henry Fox Talbot. His development of *negatives* made multiple prints from a single image possible and created the kind of photography that we know today.

Talbot's photograph of his *Reading Photographic Establishment* (7-3) from 1844 shows how quickly entrepreneurs realized the commercial possibilities of the new medium. Some artists, however, began to explore

the aesthetic rather than the commercial possibilities of photography. In the 1860s, Julia Margaret Cameron attempted to capture the essence of beauty through her photographic portraits. Cameron only began taking photographs at the age of forty-eight, when she received a camera as a present. As a middle-class Victorian wife and mother, she worked as an "amateur" artist, even using a former chicken coop as her studio. Nevertheless, she produced striking images that reflect both her personal vision and the ideals of the period.

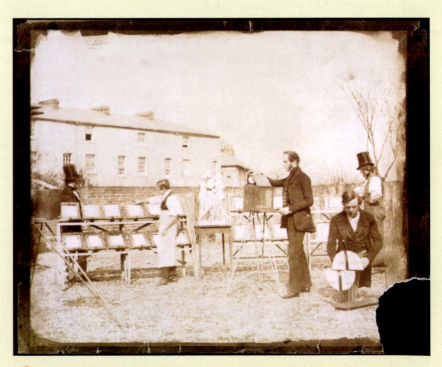

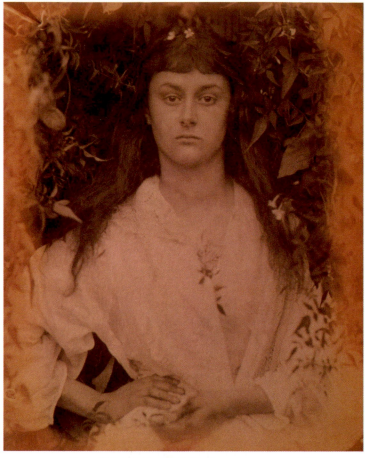

JULIA MARGARET CAMERON, *Pomona,* **1872. The Royal Photographic Society, Bath, Great Britain.**

Cameron's close-up images of her friends and family have a monumental, mythological quality, each face representing both an individual and a perfect type of beauty. In *Pomona* (7-4), Cameron presented her young sitter, Alice Liddell, as the goddess of fruit trees, dressed in an ethereal white gown and surrounded by lush vegetation. Yet the subject's face radiates intelligence and assertiveness, suggesting that our view of the ideal Victorian woman as self-effacing and demure may be inaccurate. As a child, Alice had also modeled for a true amateur

photographer—Lewis Carroll. In fact, she is the Alice who was the inspiration and model for his famous children's books, *Alice's Adventures in Wonderland* and *Through the Looking-Glass.*

As the nineteenth century progressed, scientists in Europe and the United States continued working on technical improvements. By 1880, film that needed to be exposed for only 1/1000th of a second was available. The daguerreotype had long since been eclipsed, replaced by a series of photographic media.

THE CAMERA

All cameras share five basic parts (7-5): a *light-tight box* (**camera body**), which forms the structure of the camera and prevents any unwanted light from hitting the film; a **lens**, which focuses the light onto light-sensitive material (traditionally film, but more recently a digital sensor); a **shutter**, which is triggered by the photographer and controls the time of the exposure; an **aperture** (or diaphragm), an adjustable opening that controls the amount of light entering the camera; and the **viewfinder**, which permits the photographer to see what the camera sees.

In the earlier years of photography, camera equipment was rather cumbersome and expensive, but in 1887, an American named George Eastman introduced a simple box camera called the *Kodak*. This camera would soon make taking a photograph as common as taking a train ride. Eastman's slogan was "You press the button, we do the rest." After shooting a roll of one hundred exposures on the Kodak (which reportedly got its name from the sound the shutter made), the photographer would send the entire camera to the factory in Rochester, New York. At the factory, the film would be removed and developed, and a new roll would be loaded into the camera.

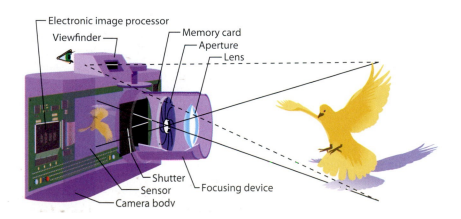

— Electronic image processor
Viewfinder —
— Memory card
— Aperture
— Lens
— Shutter
— Sensor
— Focusing device
— Camera body

A simple film camera. In a digital camera the film would be replaced by the digital sensor and related electronics.

Within twenty years of the first Kodak camera, George Eastman was in charge of the world's largest photographic manufacturing company. In the years since then, Kodak and other companies have introduced new precision lenses, electronic flashes, 35mm film, color film, instant photography, digital photography, and many other advances that make up modern photography.

STYLES OF PHOTOGRAPHY

STRAIGHT PHOTOGRAPHY

One way the new invention called *photography* (literally, "drawing with light") was first used was to make images of distant, exotic lands available to the public. Expeditionary photography, the precursor to *landscape photography*, was a field for adventurous artists. Timothy O'Sullivan, one of the pioneers of this medium, began his career as a Civil War photographer. After the war he traveled with geological survey groups throughout the Western United States. Because in his era photosensitive plates had to be developed before their wet coating dried, O'Sullivan had to bring not only his heavy camera but also a portable darkroom in an ambulance pulled by mules. Despite these handicaps and the newness of the medium, his photographs of the Canyon de Chelly in Arizona (7-6) are among the most beautiful landscape photographs ever made. The immense scale of

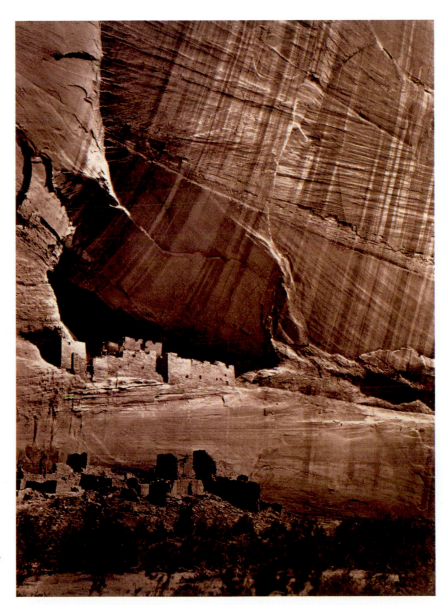

 TIMOTHY O'SULLIVAN, *Ancient Ruins in the Cañon de Chelle, N.M., in a Niche 50 Feet above the Present Cañon Bed* (now Canyon de Chelly National Monument, Arizona), 1873. Albumen print. George Eastman House, Rochester, New York.

the canyon is made apparent by seemingly tiny ruins of buildings (just one of the many clearly depicted details). Opposed to the overall feeling of great height are the many tilting horizontal parallel lines, which provide variety and help unify the whole composition.

The huge camera that O'Sullivan carried out West was similar to one used by many large-format fine art photographers today. However, the smaller-format 35mm camera—lightweight and with lenses capable of taking pictures with very fast exposures—overwhelmingly became the camera of choice for twentieth-century photographers. Its portability opened up many subjects for the photographic eye, from the top of Mount Everest to the depths of the sea.

As cameras became lighter and more portable, photographers were able to take pictures that recorded the moments of everyday life and even motion. One such photographer was Jacques-Henri Lartigue, who received his first camera when he was just seven years old. He used it to record the joys of upper-middle-class life in France before World War I. The spoiled darling of a well-off family, his life as photographed seems to have been made up of all play and no work—silly pet tricks, backyard amusements, gymnastics and sports, fashionable ladies showing off their costumes and walking their dogs, dances, fun parks, theatrical performances, and trips to the beach and the races. As a young man of the early twentieth century, Lartigue was particularly fascinated by airplanes and fast cars, and he photographed these subjects many times.

In *Delage automobile, A.C.F. Grand Prix* (**7-7**), Lartigue conveys the speed of the Automobile Age through the elliptical whirling wheel that seems to run across the print, the streaks of the roadbed, and the backward slant of figures in the background, as if left behind by the sharply focused driver on the right-hand side of the picture. Beyond his technical innovations, however, Lartigue's great strength as a photographer was his outstanding eye for a strong composition, enabling him—even as a youth—to create visually memorable images.

Another French photographer, Henri Cartier-Bresson, utilized the 35mm camera's speed to capture what he called "the decisive moment," an instant that reveals the truth. With his portable camera in hand, he said, "I prowled the streets all day . . . ready to pounce, determined to 'trap' life—to preserve life in the act of living."

His *Behind the Gare Saint-Lazare, Paris* (**7-8**) shows the unique ability of photographs to freeze a single moment in time. Forever poised above the puddle that reflects his image, a silhouetted figure is caught mid-jump as he leaves the station. Cartier-Bresson is categorized as a *straight photographer*, one who does not tamper with

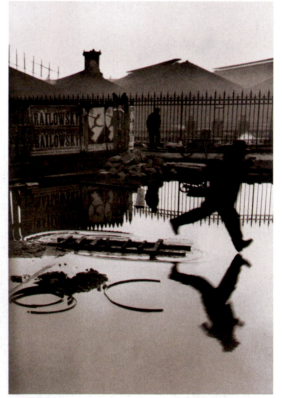

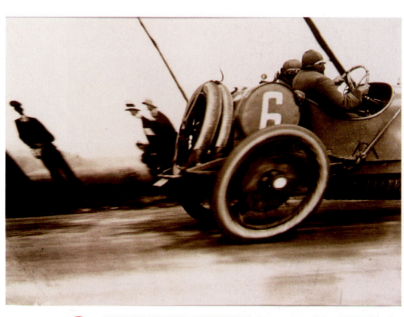

 JACQUES-HENRI LARTIGUE, *Delage automobile, A.C.F. Grand Prix, Dieppe circuit, June 26, 1912.*

 HENRI CARTIER-BRESSON, *Behind the Gare Saint-Lazare*, Paris, France, 1932. Gelatin silver print, 20" × 16".

the negative or image in any way once it has been taken (in fact, he insisted that his images could not be cropped by the magazines who employed him). Straight photographers value honesty above artistry, yet here artistry results as well from the almost-abstract design created by the visual elements masterfully framed by Bresson's camera.

A type of straight photography that became increasingly important in the twentieth century was *documentary photography*—authentic, unretouched photographs that record important social conditions and political events. One of the great strengths of photography has been its evident truthfulness, the idea that a photograph cannot lie. Many photographers have valued the medium as a tool for social reform as much as a means of

artistic expression. These goals are not mutually exclusive. Although we have seen their haunting images many times in textbooks, we may not think of these pictures as art. Yet these individuals saw themselves as social realist artists in the service of humanity.

During the Great Depression, the U.S. government hired photographers like Dorothea Lange to provide pictures illustrating the miserable living conditions of Americans who were suffering from hard times. Working for the Farm Security Administration (FSA), Lange and other professional photographers traveled the country in search of evidence to support the New Deal programs. In her famous image of a migrant mother and her children (7-9), the composition draws our attention to the

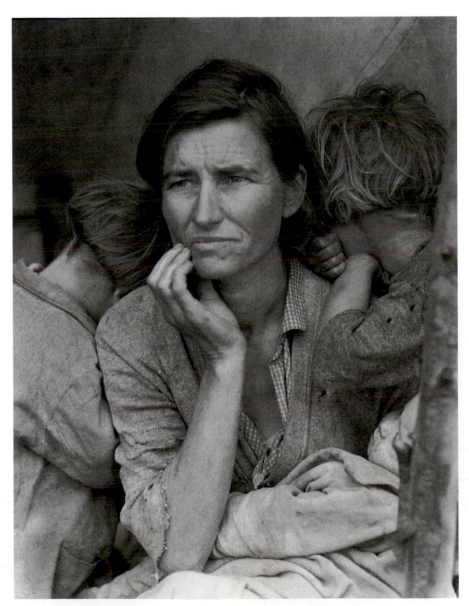

 DOROTHEA LANGE, *Migrant Mother, Nipomo Valley*, 1936. Gelatin silver print. Library of Congress, Prints and Photographs Collection.

mother's face, ensuring that we become conscious of her worry and pain. Two of her younger children press against her, hiding their faces in her sides, while she holds a baby in her lap. Lange also provided reports on her subjects. Her notes for this photograph read, in part:

> Camped on the edge of a pea field where the crop had failed in a freeze. The tires had just been sold from the car to buy food. She was thirty-two years old with seven children.

This single image has become a symbol of the dispossessed families of Depression-era America, like those described by John Steinbeck in *The Grapes of Wrath*. Often reproduced without Lange's descriptive information, the image still conveys a heartbreaking story and retains its ability to move us more than seventy-five years after it was taken.

BEYOND REPRODUCTION: FINE ART PHOTOGRAPHY

Although Europeans like Julia Margaret Cameron had experimented with the artistic potential of photography for decades, it wasn't until Alfred Stieglitz founded the *Photo-Secession* group in 1902 that American photography began to be accepted as a fine art medium. Stieglitz was a man of great energy and vision. He edited the magazine *Camera Work* to promote photography. In its first issue, he promised to show "only examples of such work as

7/10 **ALFRED STIEGLITZ,** *The Steerage*, 1907. © Artists Rights Society (ARS), New York.

gives evidence of individuality and artistic worth, regardless of school." His 291 Gallery in New York City exhibited photography alongside painting, prints, and sculpture and was one of the most advanced galleries in America. The first in this country to show modern artists like Matisse and Picasso, the 291 Gallery became a gathering place for young artists. Stieglitz believed that the photographer's eye was more important than the sophistication of his or her equipment. His own photographs, like *The Steerage* (7-10), which he called a "picture of shapes" and the first "modernist" image, reveal his ability to find design and life in unposed images. He said, "You may call this a crowd of immigrants. To me it is a study in mathematical lines, in balance, in a pattern of light and shade." His patience was legendary; he would stand for hours, no matter what the weather, waiting for the right moment.

His own eye for the work of other photographers was also of the highest quality. *Camera Work* introduced the finest and most advanced photographers to the public. One was Edward Steichen, whose long and varied career in photography began as Stieglitz's assistant. Like his mentor, Steichen believed photographers should be free to manipulate their images. His portrait of the French sculptor Rodin (7-11) pondering his famous *Thinker* (see 17-19) is actually the combination of two separate images taken in the sculptor's studios. To enhance the dramatic lighting, Steichen played with the chemistry of photography to achieve a more painterly effect.

7/11 **EDWARD STEICHEN,** *Le Penseur*, 1902. Gum print.

By the 1930s, artists had begun to approach photography as a purely artistic media. In a completely different approach to photography-as-art, the experimental artist Man Ray grasped that the supposedly realistic medium of photography was actually much more subjective than most people realized. Its images could be very deceptive. By varying position and lighting, a photographer could present a subject in many different ways and produce contradictory truths. Ray also realized that photography had the power to show worlds that were not even part of ordinary visual reality. Experimenting with the medium as a purely artistic form, Man Ray invented a new kind of photograph that did not require a camera. He called it a "rayograph," made by placing objects on photographic paper in a darkroom and then exposing the paper to light. In *Le Souffle* (7-12), mysterious waves seem to penetrate a transparent machine. The image is bizarre and otherworldly, using effects not possible in any other medium.

While Ray explored photographic innovations, Edward Weston transformed ordinary objects into abstract compositions. In *Pepper 30* (7-13), he focused on a single pepper, lighting it as if it were a precious work of art. Seen in this way, the pepper loses its normal identity as something to eat and becomes instead a voluptuous series of curving lines and undulating shapes. There is something *anthropomorphic* (human-like) in its twisted form and sensuous flesh.

PHOTOMONTAGE

The widespread reproduction of photographs has given artists new materials for collages, providing an enormous palette of realistic images. The imaginative combination of photographic images is called **photomontage**. With this medium, artists can create impossible pictures that still seem connected to the real world.

Between the world wars, the German photomontage artist Hannah Höch used found images from publications like newspapers and magazines—what has been described as the debris of modern life. By connecting heads, bodies, and machines, Höch's photomontages showed how people were becoming dehumanized cogs in the industrial process. In *Cut with the Kitchen Knife* (7-14), machinery overwhelms the characters, creating confusion. Who is responsible for this world? In the upper-right corner, we see top-hatted figures of respectability along with an old general, symbolizing bankrupt authority. The artist pokes fun at this type of authority figure toward the right of the central cog by setting the head of a proper bourgeois gentleman on top of the body of a belly dancer. Höch's photomontages are satirical, even funny, but her

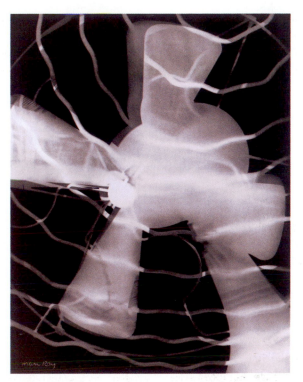

7/12 MAN RAY, *Le Souffle* (from the portfolio Electricité), 1931. Rayograph. Museum of Modern Art, New York. © 2012 Man Ray Trust/Artists Rights Society (ARS), NY/ADAGP, Paris.

7/13 EDWARD WESTON, *Pepper 30*, 1930. Gelatin silver print. Yale University Art Gallery, New Haven, Connecticut.

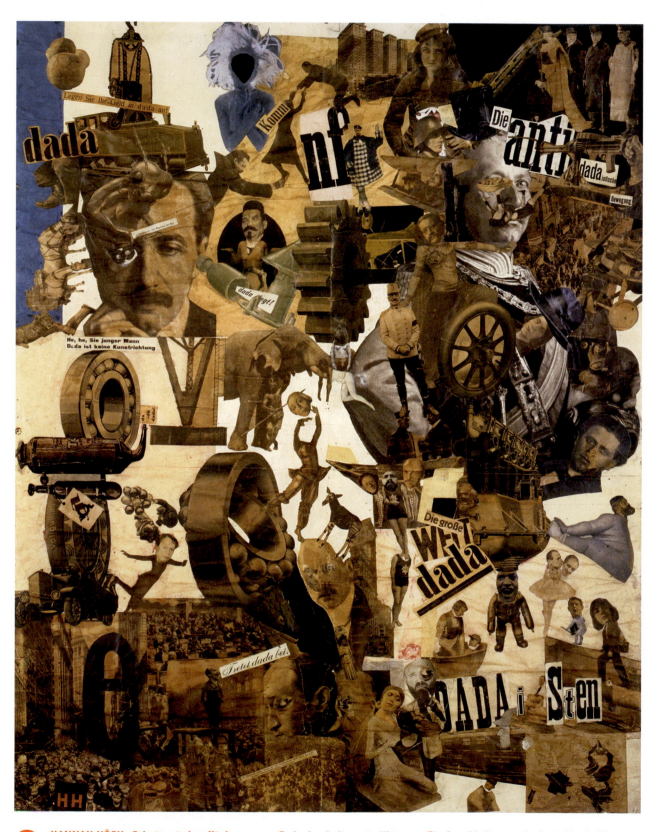

7/14 HANNAH HÖCH, *Schnitt mit dem Küchenmesser Dada durch die erste Weimarer Bierbauchkulturepoche Deutchlands (Cut with the Kitchen Knife through the Last Weimar Beer Belly Cultural Epoch)*, 1919. Staatliche Museen Preussbischer Kulturbesitz, Nationalgalerie, Berlin, Germany. © 2012 Artists Rights Society (ARS), New York/VG Bild-Kunst, Bonn.

CAN ART BE OBSCENE?

The questions of what is obscene and whether art should be banned if it is obscene have haunted modern artists for more than a century. Many important works of art that were once condemned as obscene in the past—for example, Manet's *Le Dèjeuner sur l'herbe* (17-4)—are now considered masterpieces. Even in the twentieth century, art was put on trial because of sexual content. In literature, the bannings of James Joyce's *Ulysses* and D. H. Lawrence's *Lady Chatterly's Lover* were battled in the courts and ultimately overturned. The verdicts were seen as important victories for individual civil liberties and artistic freedom. Today, the books are considered modern classics and are traditional parts of college and university curricula.

More recently, the photographs of Robert Mapplethorpe brought national attention to the conflict between artistic freedom and what community standards call obscene. Although relatively few Americans had seen his pictures,

Mapplethorpe's name became a notorious household word in 1990. Mapplethorpe was brought up in a middle-class Catholic home in suburban New York. Early in his art career, he was already exploring the limits of conventional morality by collaging sexually explicit photographs into sculptural frames that he made. As he developed as an artist, he became a successful commercial photographer. Few have questioned his marvelous technical skills. His prints brought an almost glamorous quality to whatever he portrayed, whether nudes or flowers, but it is his photographs' erotic atmosphere that has disturbed many viewers.

In *Ken Moody and Robert Sherman* (7-15), Mapplethorpe idealizes his subjects; they are living men but seem like statues. Their flesh looks as if it is carved out of the purest black and white marble. The directional lighting envelops them in a soft glowing radiance. The geometric composition is uncomplicated and dramatic, a formal progression of simple

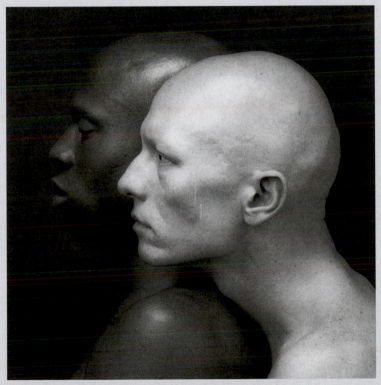

7/15 ROBERT MAPPLETHORPE, *Ken Moody and Robert Sherman*, 1984. Gelatin silver print, 7¾" × 7¾". Copyright © 1984, The Estate of Robert Mapplethorpe.

forms from white to gray to black. The image has a timeless, Classical quality.

A man and a woman, or two women posed in the same manner by Mapplethorpe, would probably not have been controversial, but Mapplethorpe shows two men who appear to be naked and who are from different races as well. Despite the serene beauty of the photograph, the sexual feeling and interracial nature of the image has aroused a great deal of hostility. Many people cannot accept a male artist's loving attitude toward other men. Even more controversial were photographs of male sadomasochistic lovers and an innocent child in a park, who seems unaware that anyone cares that she wears no underwear.

Mapplethorpe's pictures challenge the morality of his viewers. He brought the same glamorous and artful approach to whatever he portrayed, including graphic sexual acts and "kinky" paraphernalia. What many expect to remain hidden, the photographer openly exhibited as beauty, without apparent shame. One question for viewers is whether Mapplethorpe transformed his subject matter into art, or is this subject matter so taboo that it is not possible art material? What is the line between an artist's rights to explore and exhibit his or her interests and the need to protect society from what is obscene?

The controversial nature of Mapplethorpe's images became a national issue when a touring retrospective of his work was exhibited at one venue that had received funds from the National Endowment for the Arts (NEA). The exhibition traveled through many cities in the United States and became the subject of intense public scrutiny. A museum director was put on trial for allowing the exhibition to be shown in Cincinnati, Ohio. Even though the museum director was ultimately acquitted, the Mapplethorpe retrospective controversy raised important new questions: Should public funds support artists who make works that some consider obscene? Should morality enter into funding decisions? What is the proper role for taxpayer dollars in the support of the arts? After the trial ended in Cincinnati, the NEA became the next battleground over artists' rights and responsibilities.

The NEA was established by Congress in 1965 to encourage and support national progress in the arts. In the nearly fifty years since its founding, the NEA has become the largest single supporter of the arts in the United States. In the visual arts, it has distributed grants to museums, arts organizations, and individual artists in cities and small towns across America. It also supports dance, music, film, video, and public broadcasting. Its founding legislation prohibited any interference with the content of art it supports. In light of the controversy over the Mapplethorpe exhibition and others, congressional amendments were proposed to change the charter's goal of noninterference by establishing limits to the content of the art the NEA could support. Many in Congress felt they had the responsibility to determine what art would be supported by taxpayers' dollars. They said that not giving grants to controversial art was not the same as censorship. Artists would remain free to do what they wanted, just not at public expense.

In the arts community, there was widespread fear of a chilling effect on artists and art organizations similar to the McCarthy era in the 1950s. Would artists be less daring than before? Would museums show only "safe" art? Which was more dangerous, someone being offended or censoring freedom of expression? Ultimately, in the summer of 1990, the Senate and the House reached a compromise when both agreed to cut $45,000 from the NEA budget, the amount used to fund the Mapplethorpe and another controversial exhibition, and to, in effect, punish the organization for its decision to fund these exhibits (it also killed an amendment with much graver cuts). The NEA (capitulating to pressure or returning to common sense, depending on your point of view) changed its procedures, requiring anyone who was awarded a grant to sign an oath stating their work would not be obscene:

Including, but not limited to, depictions of sado-masochism, homoeroticism, the exploitation of children, or individuals engaged in sex acts.

political message was quite serious. As to who might save this corrupt world, perhaps it is the modern woman with short hair racing in on the lower left side. At the bottom right, there is a European map, which highlights the nations planning to give women the vote. Höch can be seen looking at us, marching in just above it.

CONTEMPORARY APPROACHES

Contemporary photographers continue to work in all of the styles discussed in this chapter. One who pursues the documentary tradition is Brazilian artist Sebastião Salgado, who has produced several epic series of photographs recording the plight of the poor and refugees at the turn of the twenty-first century. For instance, his series "Workers" took him to twenty-six countries over

four years, from 1986 to 1992, while his recent series "Exodus" exposes the plight of migrants around the world. Unlike Lange, however, Salgado's work is not underwritten by the government. Instead, Salgado is a successful commercial photographer, selling pictures through Amazonas Images, the photo agency he created with his wife Leila, and exhibiting his prints in museums and galleries.

Salgado's images often have a cinematic quality, as with *Gold Mine, Serra Pelada, State of Para, Brazil* (7-16). Hundreds of miners appear like a cast of thousands in a blockbuster film. Sadly, however, these are real workers, some of the fifty thousand who slave under brutal conditions in these mines for pitiful wages.

While Salgado uses his art to record devastating realities, other contemporary photographers, like Sandy Skoglund, take advantage of the commonly held faith in the truthfulness of photographs to confuse the viewer's

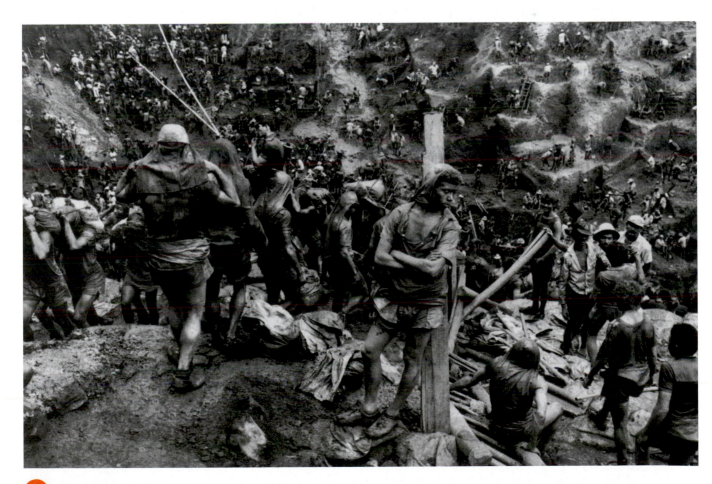

7/16 SEBASTIÃO SALGADO, *Gold Mine, Serra Pelada, State of Para, Brazil*, 1986. Iris Print, 24" × 20".

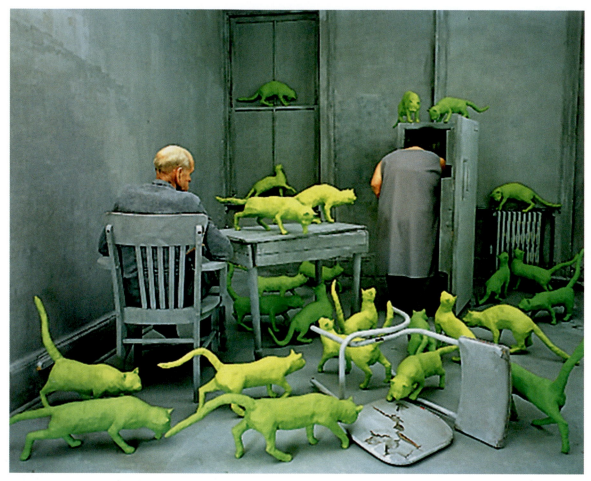

sense of reality. Her *Radioactive Cats* (7-17) is anything but a straight photograph. Every part of what we see has been carefully planned and arranged. Yet, this scene did exist and was photographed. Part of the artistic process Skoglund follows is the construction of her subject, including posing and costuming her models and applying fluorescent colors to ceramic cats she created. Following the lead of pioneer artistic photographers like Man Ray, Skoglund does not respect or believe in the neutrality of photography. Instead, she uses its power of deception for creative purposes. The result is a vivid fantasy of what the world might be like after a nuclear war.

Nothing is what it seems in *Junior Suite* (7-18), a deceptively ordinary-looking image by Thomas Demand. What appears to be a nicely arranged still life of the remains of a room service dinner is, in fact, a large-format photograph that documents a complex construction produced in paper by the artist. The scene was inspired by a crime-scene photo posted on a gossip website. It showed the pop singer Whitney Houston's last meal before her death in a Beverly Hills hotel. Demand couldn't get it out of his mind both because its posting seemed immoral

and because its composition reminded him of a Dutch old master still life. He ultimately transformed this lurid picture into a simplified and polished counterfeit. For research, he visited the hotel where Houston died and ordered a similar meal. As with all of his images, he reconstructed the scene entirely in paper and cardboard, and then photographed it. He finished by destroying the life-size fabrication, so that the faked image is the only artifact that remains. Demand's quiet image is thus the result of intricate and methodical falsification. Like many contemporary photographs, his picture is both a construction and a reproduction, calling into question the very nature of truth.

The ambitious and theatrical photographs of Cindy Sherman are equally elaborate productions that almost constitute performances. For them, Sherman stars in an endless assortment of roles, from innocent hippie to tired housewife, young girl at her first ballet recital to an autistic patient in an asylum.

Many art critics have seen her pictures as studies of women's roles in the popular media, but as her pictures have become more complex visually, they have also shown

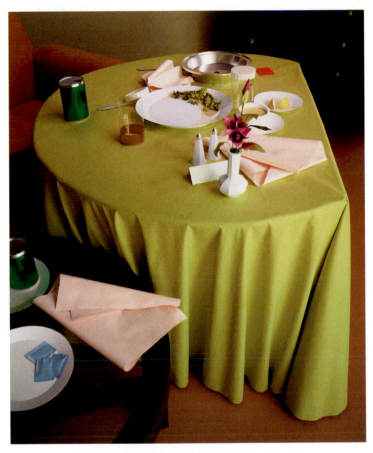

7/18 THOMAS DEMAND, *Junior Suite*, 2012. C-print mounted on Plexiglas, 55" × 45¼". Courtesy Matthew Marks Gallery, New York.

less stereotypical women and situations. *Untitled* (7-19) shows Sherman as an apparent murder victim on what appears to be an isolated forest floor. Her throat is cut, her clothing soaked and stained. Flecks of dirt on her head and neck imply that a struggle took place. Insects are hovering over her bruised face. The viewer is drawn magnetically toward the brightly lit blond-wigged head with glazed blue eyes. Notice how her head is set at the crossing point of the diagonals made by her body and the line of green moss. To produce such a carefully composed and complex image, Sherman had to become a special-effects wizard, controlling lighting, sets, makeup, and costumes. Her most successful images evoke setting and subject without making us aware of how they were constructed. In other words, while totally artificial, they seem natural.

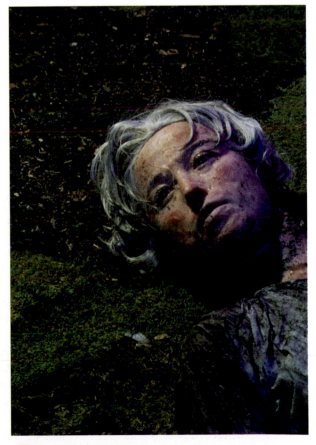

7/19 CINDY SHERMAN, *Untitled*, 1985. Color photograph, 67¼" × 49½". Courtesy Metro Pictures, New York.

Like Sherman's pictures, Lalla Essaydi's photographs also explore identity, but focus more specifically on the representation of the Arab woman. In *La Grande Odalisque*, 2008 (7-20) from the series entitled *La Femmes du Maroc* (the Women of Morocco), she explores both the customs and traditions of the culture and at the same time, how they have been typically portrayed in Orientalist painting of the 19th Century. The pose of Essaydi's figure is based closely on a painting by Ingres (see "Global View" box in Chapter 15), perhaps the most famous of many titillating paintings of the stereotypical harem girl.

Essaydi was raised in a traditional Muslim household dominated by male control, and where misbehavior was punished by being confined at home. This photograph is one of a series she took in a family-owned home in Morocco. For this series Essaydi applied Islamic calligraphy with henna to the model herself, her drapery, and all the surroundings. In employing calligraphic writing, Essaydi is practicing a sacred Islamic art that is usually inaccessible to women. To apply this writing in henna,

an adornment worn and applied only by women, adds a further subversive twist. Thus the henna/calligraphy can be seen as both a veil and as an expressive statement.

Essaydi is well aware of the complicated nature of both her imagery and herself, an artist shaped by two cultures. While she feels a part of the Islamic world, she knows she is not completely of that world any longer. "In a sense I am a Western artist, making art in a style I was unable to use in my home country." Yet she says, "In my work, I wish to present myself through multiple lenses—as an artist, as Moroccan, as traditionalist, as liberal, as Muslim."

Levi van Veluw also explores his identity and place in the world, but he does so through otherworldly landscapes in a unique form of self-portrait. Raised in a small Dutch town, he uses himself "as a blank canvas" to "construct . . . in a very small way, a different perspective on the world." Van Veluw works alone, sitting in front of a mirror, surrounded with objects he has collected. He will experiment for most of a day before he is ready to take a photograph. The construction of *Landscape 1*

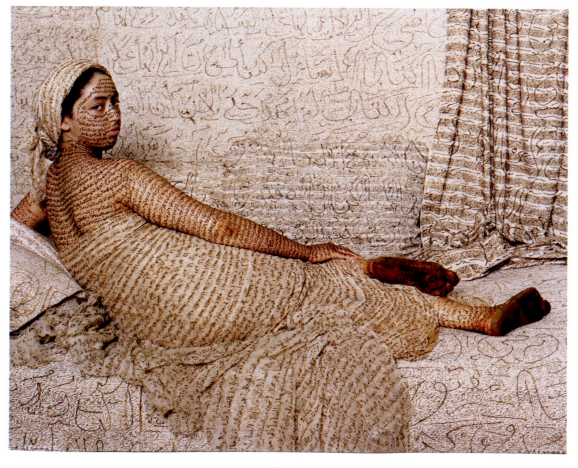

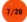 **LALLA ESSAYDI,** *La Femmes du Maroc: La Grande Odalisque,* 2008. Courtesy Edwynn Houk Gallery, New York.

(7-21) took about thirteen hours and was built by attaching materials like imitation moss, miniature cows, and trees to his face, head, and shoulders with glue, tape, and hairspray. Because he finds most landscape painting "so traditional and boring," he "kept the nice aspects of a landscape and removed the kitsch [and] glamour." Others in the Landscape series include a snow-covered scene with trees and lampposts that light up, and a video where his head is the setting for a different green countryside but with a small train that circles his forehead slowly. Each photograph is both a sculpture and "a short image of a performance."

Today, most viewers assume when they see a van Veluw photograph that it was made on a computer, but it is important to him that viewers know that he makes no use of a computer and "everything happened for real." However, van Veluw is well aware that photography, which revolutionized image-making at the beginning of the twentieth century, is now in the midst of its own revolution. The invention and acceptance of digital photography is turning out to be just as momentous as the use of computers and imaging software. Digital cameras have become so popular that traditional cameras—and the photographic methods that went with them—may soon seem as old-fashioned as the daguerreotype. Famous camera makers like Nikon and Kodak are abandoning traditional cameras for their digital counterparts. There are few remaining manufacturers of black-and-white papers for the darkroom. Although film and darkrooms may still be used by artists who are interested in historic techniques, the digital arts described in the next chapter are quickly moving to the forefront of photographic innovation. But the impact of the computer on art is much broader: It is even changing the nature of the art world itself.

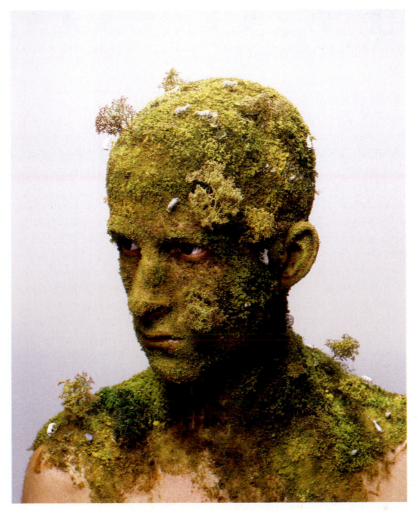

7/21 LEVI VAN VELUW, *Landscape 1* from the Landscape series, 2008. Courtesy Galerie Ron Mandos, Amsterdam/Rotterdam.

CHAPTER 8

NEW MEDIA: TIME AND DIGITAL ARTS

The story of art was transformed in the past century by new media developed from new visual technologies. As we saw in the last chapter, artists seized on photography as a new medium of expression from the moment it was invented. The marvels of motion pictures, video, and, most recently, computer technologies were also embraced by artists as new paths for exploration. While art critics, gallery owners, and museum curators were busy debating whether these new technologies could be used to create art, artists simply plunged ahead. In the twenty-first century, this pattern has continued, and if anything the pace has quickened.

TIME AS AN ARTIST'S MEDIUM

A revolution in transportation and communication began in the early nineteenth century. Stagecoaches were replaced by railroads on land and sails by steam on the seas. The new speed of travel made distant places more accessible and started an age of tourism not only for the rich, but also for the newly arrived merchant class. Messages that once took months to be delivered became

nearly instantaneous with the inventions of the telegraph and telephone and the laying of the transatlantic cable. Speed had become a mark of the age, and artists tried to portray it.

But how can you portray speed in a single image? In the early days of photography, critics celebrated the photograph as a way to defeat time. But some artists, like Eadweard Muybridge, used photography as a way to include time in their works. Muybridge was a professional photographer whose fame rests on his exhaustive studies of figures and animals in motion. His best-known series from the 1870s studied a horse galloping. Financed by a millionaire sportsman, it provided an answer to a question that had been debated by artists and the racing world for centuries: when a horse runs, is there any moment when all of his legs are off the ground? Most artists believed that such a moment was not possible, because the horse would fall to the ground. Muybridge's photographs (8-1) proved conclusively that there were such moments, and his images were printed on the cover of *Scientific American* and in European scientific journals. One journalist wrote, "Mr. Muybridge has completely exposed the fallacy of all previous ideas on the subject."

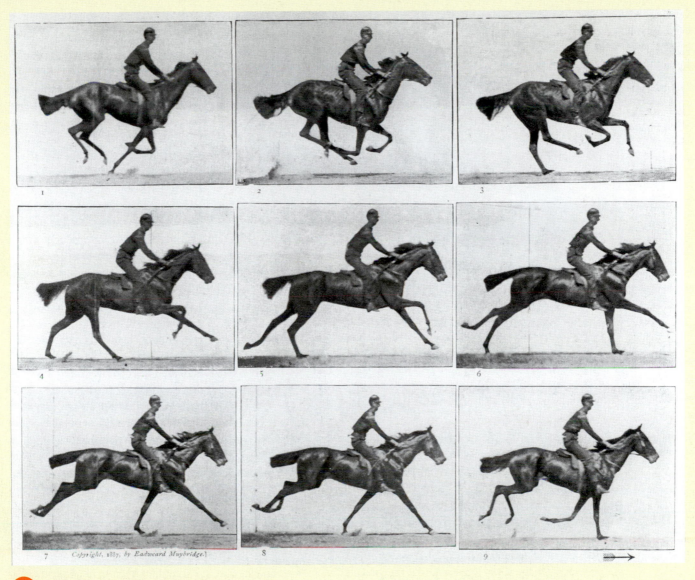

8/1 EADWEARD MUYBRIDGE, *Galloping Horse*, 1878.

Muybridge's photographs were collected in a series of books on locomotion. An encyclopedia of movement, they include women walking down stairs, men lifting heavy stones, babies toddling, and all sorts of animals in action. When these images were made available in print, artists poured over them. For example, Edgar Degas (see Chapter 17) used the famous horse photographs as the basis of his many paintings of racetracks. The modern enthusiasm for science also damaged the reputation of some older artists. The most famous and popular horse painter of the era, the Realist Rosa Bonheur (see Chapter 16), was ridiculed for the inaccuracies of her depictions after Muybridge's photographs were published. Muybridge's volumes on locomotion remain standard reference books for artists and animators even today.

The new age of transportation proceeded nonstop with the start of the twentieth century. The arrivals of the automobile and the airplane were greeted with particular enthusiasm by the Futurist artists in Italy (see Chapter 18). Feeling the heavy burden of trying to create new art surrounded by the grandeur of Roman, Renaissance, and Baroque art, the Futurists saw the new age as an opportunity to shake off this great weight and "free Italy from her numberless museums" and "useless admiration of the past." F. T. Marinetti wrote in *The Futurist Manifesto* that "the splendor of the world has been enriched with a new form of beauty, the beauty of speed."

To depict speed and movement, Futurists like Giacomo Balla looked to the motion studies of

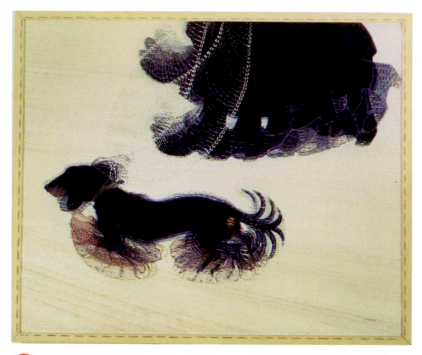

 GIACOMO BALLA, *Dynamism of a Dog on a Leash*, 1912. 35⅞" × 43⅜". Albright-Knox Art Gallery, Buffalo, New York. © 2012 Artists Rights Society (ARS), New York/SIAE, Rome.

photographers like Muybridge. Balla's *Dynamism of a Dog on a Leash* (8-2) depicts an everyday sight in the city—a woman walking a dog—in a new way. As in a multiple exposure, we can see the frenetic actions of the small dachshund trying to keep up with its owner. The chain-link leash vibrates almost musically. The range of motion of boots, paws, tail, and ears form blurred arcs of dynamic action. Although this type of view is familiar—if still amusing—today, when first painted it personified the thrill the Futurists felt for life in the new, vital modern city. It celebrated a new way of seeing and a new era for art.

MOVING PICTURES

The invention of motion pictures offered a much more direct way to represent motion. In 1888, the famous American inventor Thomas Edison met with Muybridge to discuss a revolutionary idea. Edison thought that by combining the cylinders of his phonograph with Muybridge's multiple-image photographs, he might be able to make a system that would show moving pictures. Edison eventually succeeded when he abandoned the idea of using cylinders and switched to film in long bands. In 1893, he unveiled his first motion picture camera, the *kinetoscope*. One of his first films that year showed blacksmiths at work, based on a similar series by Muybridge.

But Edison's first films could only be seen by one person at a time. In 1895, the Lumière brothers in Paris

developed a projection system. Their first films were simply scenes of ordinary events—workers leaving a factory, a train coming into a station. The fact that the pictures moved was thrilling enough for audiences. By the early 1900s, however, audiences were enjoying comedies, fantasies, and dramatic stories on film. France was the leading film producer in the world up until World War I, when the United States took over the role that it continues to have to this day.

When a medium is new, early practitioners tend to utilize the conventions of a previous one. For example, the first photographic artists tried to recreate the look of traditional painting to make their work appear more serious. It was only later that photographers understood and respected the unique qualities of photography. So it is not surprising that in the early days of film, directors shot their movies to resemble theater productions. Audiences were accustomed to the traditions of the stage. When directors began to try new techniques, the results initially shocked audiences. It has been reported that when the legendary American director D. W. Griffith first showed a close-up of an actor's head, the audience screamed. They thought that the actor had been beheaded.

By 1928, when the Surrealists Luis Buñuel and Salvador Dalí (see Chapter 18) made their short film *Un Chien Andalou (The Andalusian Dog,* 8-3) in Paris, the conventions of film techniques were well understood by audiences. But the artists had no interest in making a conventional film. Their goal was to shock and repulse their audience.

Surrealist artists believed in an art that depicted dreams and the repressed passions of the unconscious mind. Buñuel and Dalí saw film as an ideal artistic medium to construct the irrational world of a dream. In a film, like in a dream, whatever you see appears real at the time. According to the artists, the script was constructed from two of their dreams. They described their collaboration as "magical rapport." While *Un Chien Andalou* (a title that is meaningless) begins with "once upon a time," the film is no fairy tale and contains some of the most awful scenes in the history of cinema. It is a

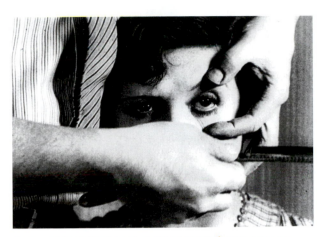

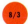

LUIS BUÑUEL and **SALVADOR DALÍ**, still from *Un Chien Andalou*, 1928. © Salvador Dali, Fundació Gala-Salvador Dali, Artists Rights Society (ARS), New York 2012.

Surrealist love story where repressed passions form an illogical nightmare.

The film begins with one of the most disturbing and unforgettable scenes in cinema history. Puffing on a cigarette, Buñuel sharpens a razor, with cheerful tango music in the background. He then calmly slices the heroine's eye with a razor as a cloud passes through the moon. In the next scene, she is unhurt. The male lead stares in fascination at his hand, drawing the interest of the woman (whom he loves). The camera slowly focuses on the hand, and the audience sees that it has a deep hole in the palm and ants are crawling out of it. The same man later moves his hand across his mouth and, when he's done, his mouth is gone. He wipes again and it is covered with the woman's armpit hair. Outside, another young woman stands in traffic pushing an amputated hand with a stick. When she is killed by a car, it arouses the man's passions, and he begins chasing his girlfriend around her room. To attract her admiration, the man drags two grand pianos into the room with great effort, each with a bleeding horse's head on top and a priest tied to it (one is Dalí).

In *Un Chien Andalou*, time is confused. Characters die and return in the next scene. Toward the end of the film, a title reads "16 years before" but appears to be on the same day. It ends with a beach scene where the film's two lovers are dead and buried in the sand up to their chests. Because of the disturbing way the artists utilized film conventions to sabotage reality (along with its capacity to shock an audience many decades later), *Un Chien Andalou* remains a landmark in film and art history.

VIDEO ART

The same year that Buñuel and Dalí completed *Un Chien Andalou* in Paris, a new technology was tested in New York City that would eventually surpass the popularity of movies. In an RCA studio, an image of a Felix the Cat doll on a rotating record turntable was sent over the airwaves. Throughout the 1930s, regular broadcasts of what were originally called "radio movies" began on the first networks. However, the audience remained very small. Even by 1945, only seven thousand homes in the United States had television sets. It wasn't until the 1950s that television took its place as the center of American cultural life.

Like photography and movies before it, artists seized upon the newly popular medium and transformed it into an art medium. Known as **video art**, it is one of the oldest of the electronic media, but it can still be said to be in its formative years. As the Korean-American artist Nam June Paik (who originated this art form) reminded his audiences, it was a long time after the invention of the printing press before there was a Shakespeare.

Paik was born in Korea in 1932, but his family was forced to leave in 1949 during the Korean War. After going to music school in Japan and Germany, he finally settled in the United States. Paik's love affair with television began in New York during the 1960s. An early work was a cello constructed with TVs that changed images when a bow was drawn across them. His collaborator, the cellist Charlotte Moorman, became "living sculpture" by performing while wearing his *TV Bra*, made of two small TV sets.

Paik became television's playful poet, an artist constantly expanding video art's vocabulary. Always interested in new technologies, he experimented with the first color synthesizers, portable video cameras, and editors. Conceptually, some of Paik's most thought-provoking (and humorous) work concerns the relationship of television imagery to reality. In *TV Buddha* **(8-4)**, a traditional sculpture of the Buddha appears to be watching his own "live" image intently on a monitor. The Buddha contemplates his electronic self, apparently mesmerized by television like any child in America. Oddly, the effect is not only comical but also peaceful; the empty setting and unchanging nature of the image is reminiscent of the Zen Buddhist goal of attaining nonbeing.

Television is rarely thought of as a spiritual medium, but like the videos of Paik, Bill Viola's art can seem mystical. While Paik's work often combines sculptural

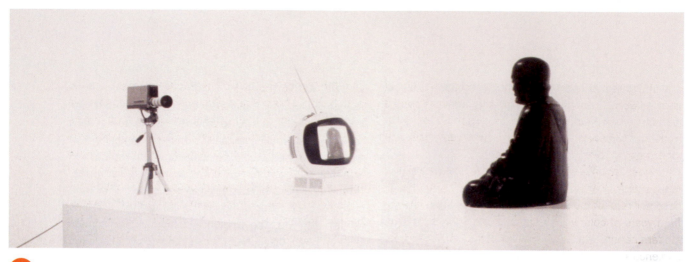

8/4 NAM JUNE PAIK, *TV Buddha*, 1974–1982. Mixed media, 55" × 115" × 36". Museum of Modern Art, New York.

installation and video, Bill Viola's are usually presented in a purer atmosphere. To see *The Crossing* (8-5, 8-6), you leave the bright white walls and lights of the gallery and enter a large dark room with black walls. Two screens hang from the ceiling, each showing a man who emerges out of the darkness. In one, he stops and stands unhurt in a mounting fire, and in the other rain begins to fall on him. Because both videos are run in a repeating loop, depending on when you enter the room, the videos can be dark and nearly silent, or bright and loud. Ultimately, the

man is engulfed in an inferno of bright yellow and orange flames, which roar around him. On the other screen, the slow drip of water turns into a deafening downpour of rain covering his body in blue and white. The figure doesn't appear to suffer, but instead seems to be transformed.

Viewers of *The Crossing* are transported into visions that relate to our experience but become intensified beyond reality. Critics have compared Viola's videos to ancient myths and biblical visions, and he has not rejected their analyses. Viola has said, "The search for

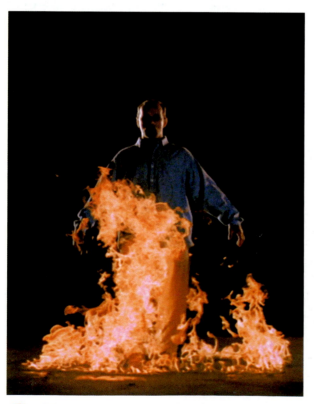

8/5 BILL VIOLA, still from *The Crossing*, 1996. Photo: Kira Perov.

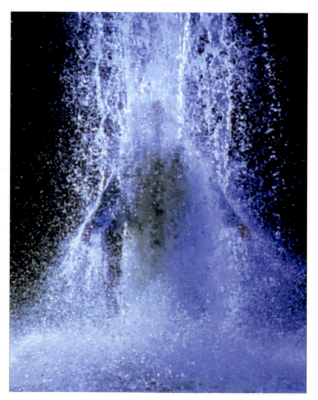

8/6 BILL VIOLA, still from *The Crossing*, 1996. Photo: Kira Perov.

something deeper than this world is a common aspect of all religions." He doesn't believe that answers can be meaningful "without connection to a process of transformation." For him, "video is a medium that deals with movement, change, and transformation."

Those themes can be found in Jun Nguyen-Hatsushiba's *Vietnam—A Memorial Work* (8-7), a symbolic portrayal of his country's painful struggle to emerge from years of colonization and war into an independent, modern nation. Filmed off Vietnam's southern coast, the audience's first view is a lovely scene from below the water to the tropical light shining above. Suddenly, the surface calm is broken by young men pushing *cyclos* (rickshaws) down under the water. Once they reach the sandy floor of the ocean, a strange race begins. They work in pairs—one dragging, the other pushing—pulling each *cyclo* along the bottom, fighting against the currents. They move in slow motion, struggling, often rushing up to get more air. The only moments of gracefulness are when they push upward and float to the surface for air. Everything else is difficult.

The *cyclos* represent Vietnam's oppressive past, and the "race" is the next generation's struggle to move past it. The film is nearly silent except for a calm New Age music soundtrack (written by Nguyen-Hatsushiba), broken by bubbling sounds. Despite the young men's struggle, the scene is beautiful. The *cyclos* travel through blue-green, hazy water past moss-covered boulders. At the end, they all swim away from the *cyclos*, and we see simple, transparent, white tented forms along the floor. The sight is a kind of underwater burial ground, ghostly, among the encrusted rocks. A bell rings, the ceremony seems to be over, and the scene fades to black.

Although *Sip My Ocean* (8-8), a video by the Swiss artist Pipilotti Rist (see 1-44), also takes place underwater, the mood is quite different and the theme not so weighty. Viewers are plunged into an underwater paradise. The camera explores a world filled with rich, saturated colors and light. Traveling with us as we look at the plants and sea life is a frolicking young woman in a bikini. The soundtrack is Rist singing.

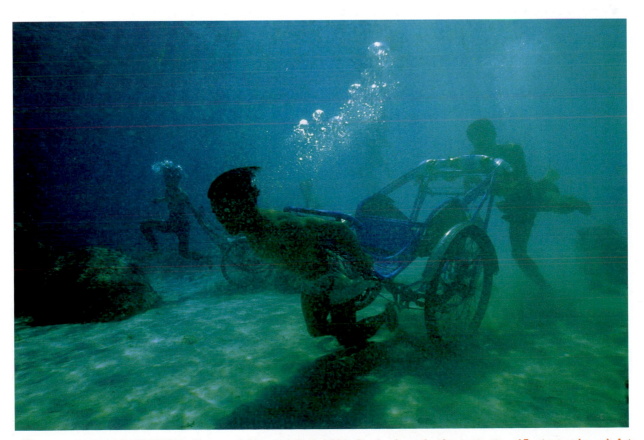

 JUN NGUYEN-HATSUSHIBA, *Vietnam—A Memorial Work*, 2001. Single-channel video projection, 13 minutes, looped. Asia Society, New York. Image courtesy of the artist and Lehmann Maupin Gallery, New York and Mizuma Art Gallery, Tokyo.

Apparently all is not well in paradise; the song is Chris Isaak's "Wicked Game," a tale of a lover's betrayal. Household objects float down from above, polluting paradise with plates and cups, records, and children's toys. The tone of Rist's voice changes from sweet singing to shrieking the lyrics ("No, I don't want to fall in love"). But unlike the works of Viola and Nguyen-Hatsushiba, Rist's video never becomes dark or frightening. Although Rist says she is "very interested in melancholy and conveying desire or longing," she "always wants to have some hope." Because everything is floating in luminous light and brilliant colors, there is a buoyant and dreamy mood. The young swimmer remains playful and never seems worried or concerned. We, too, remain enchanted, perhaps because the clear, blue ocean is bigger than any domestic issues.

Rist (who combined her name, Charlotte, with that of her childhood heroine, Pippi Longstocking) studied in Vienna, Austria, and Basel, Switzerland. After school, she directed music videos for European bands and sang in a female rock group. Water and travel are recurring themes in Rist's work. Like other video artists, she is enthusiastic about the arrival of digital video technologies. In the past, she had to supervise editors and technicians to get the results she wanted. Today, she can work directly on her videos, allowing her work to have not only more complex effects, but also a more "experimental quality." Like Rist, artists all over the world are discovering new ways of working in the new digital era.

THE ARTIST AND THE COMPUTER

The Computer Age has transformed so much in our world; it is not surprising that it has changed the art world as well. The arrival of the *digital arts* (or *digital media*), the art forms created with the aid of computer technology, is affecting just about every one of the traditional art media. Although the history of art is filled with examples of new media transforming the way artists work, it is unprecedented for artists to be given so many new techniques in so short a period and for their impact to be so pervasive. Certainly, many of the new media can be understood as digital versions of traditional tools, but some have even changed the nature of the artist's process itself.

A particularly revolutionary tool is one that seems simple—the greatest eraser in the history of art—the "undo" command. In the past, artists have had to live with the fear that any simple action (adding a new color, a chipping movement by a sculptor, or erasing a line) could in the end be a disaster and ruin a day's worth of work or even the whole work. To be a successful creative artist, one had to manage that fear and move on. Today, however, digital artists "work with a net" because they can "undo." And most digital media software allows one to undo not just the last action but five, ten, or even a hundred previous steps. Some contain a "history palette," where all changes are recorded, and a mere click

PIPILOTTI RIST, *Sip My Ocean (Schlürfe meinen Ozean)*, 1996. Audiovisual installation by Pipilotti Rist (video still). Courtesy the artist and Hauser & Wirth, Zürich/Great Britain.

can bring a picture back to a previous state from hours earlier. History can even be used as a drawing tool. By drawing with a history eraser, you can bring back a past version wherever you erase.

When an artist or designer can undo any experimental action instantly, or even move back and forth in time, he or she can work without fear of disaster and feel free to try just about anything. This is an extraordinarily liberating experience. Compare today's digital painter to a Renaissance fresco artist (see Chapter 5), who had to complete all of his or her painting before the wall dried and sealed the picture forever.

It is not just that artists have been given more tools. In an age of computers and high-speed global communication, the art world is in the process of being transformed. Because of the World Wide Web, new avenues for collaboration among artists and promoting artists' work have opened up. The gallery and museum system can even be bypassed entirely if artists choose to distribute their art around the globe via the Web.

Nevertheless, while the new digital media break new ground, they remain fundamentally connected to traditional media. This is most obvious when software is named *Illustrator* or *Painter*, but even within uniquely titled software packages, many of the most important tools bear the name of their analog parents. Digital photographers today use software to burn in or dodge parts of their images, just as traditional photographers did in a darkroom. The "onion-skin" function of animation software is named for the translucent paper that hand-drawn animators used in the time of Walt Disney to see through a series of drawings. Artists' webpages feature "galleries" and "portfolios."

Despite these connections to traditional art, the art world has not yet opened its arms to the new digital media. Gallery and museum exhibitions of digital art are still relatively rare, and many critics and even fellow artists have greeted the work of digital artists with hostility. Ours is not the first era in which artists have investigated new media and technologies in the face of resistance from traditionalists in the art world. For example, until the fifteenth century in Italy, oil paint was despised by artists. Renaissance painters then learned that the paint's biggest drawback—its slow drying time—was actually an advantage, allowing them to rework and perfect images in a way that was previously unimaginable.

Nor is the computer technology behind digital media the first time an industrial application has been appropriated for artistic use. The now-popular medium of lithography (see Chapter 6) was first used as a method for printing newspapers. The new pigments embraced by the Expressionists were formulated by German chemists for dying fabrics in the nineteenth century. In the 1950s, artists began using industrial paint made of plastic polymers and renamed it *acrylic* paint. Cheap and sold by the bucket, it became a favorite material of Abstract Expressionists like Jackson Pollock as their paintings became larger and larger (see Chapter 19).

The invention of photography in the nineteenth century and its reception by the art world parallels best that of the digital media in the twenty-first century. Like the digital media today, photography was greeted with great resistance by the art world of its time. Critics said that photography was merely a mechanical process. Many artists felt threatened by the medium, particularly those whose living depended on portraiture. Although it seems surprising now, photography was not generally accepted as a medium for fine art until the mid-twentieth century. It is not yet clear how long it will be before the digital media become fully accepted as fine art media and ultimately take their place in the history of art. However, it is certain that the history of artists and computers is just beginning.

THE PIONEERS OF DIGITAL ART

Looking at the earliest computers, it's easy to see why visual artists had no interest in them: They were machines without monitors. They were also huge. For example, the ENIAC developed at the University of Pennsylvania in the 1940s weighed fifty tons and filled a large room. More powerful than any previous computer, it completed calculations in two days that previously took a person forty years. Unfortunately, its vacuum tubes used a great deal of power. Whenever ENIAC was turned on, the lights of a whole neighborhood in Philadelphia dimmed.

In the early 1950s, the first monitors (called *vectorscopes*) were attached to computer systems at the Massachusetts Institute of Technology (MIT) in a project called "Whirlwind." Scientists created a short simulation of a ball (really a circle) bouncing. They also were able to make the huge mainframe play "Jingle Bells." This "impressive" demonstration of the potential of computer graphics and music was shown to a national audience on CBS in 1951.

Although other computer scientists found these new visions fascinating, the complexity of early computer graphics experiments made the field unattractive to artists. Typically, it would take days or months of programming before one could begin making a picture. The programs would then run for an hour or more to produce one image.

Printing that image took several hours more and required expensive *plotters* (large printers whose row of moving pens made marks on a wide roll of paper). Add in the days it would take to make changes in the program to correct an image, and one can easily see why artists did not take computer graphics seriously as a creative medium.

In 1962, a graduate student at MIT, Ivan Sutherland, truly inaugurated computer graphics as an artist's medium. His Ph.D. thesis at MIT was a hardware and software system called *Sketchpad*. It included a small nine-inch monitor and a light pen so Sutherland could draw directly on the screen (8-9). For the first time, an artist could create a work by hand rather than by writing a formula. One of the founding fathers of digital media, Sutherland's system laid the groundwork for much of today's computer graphics. With *Sketchpad*, he could draw simple lines and curves. Each line could be resized and reshaped, as well as moved to a new position. With dials, he could zoom in or out of his image. *Sketchpad* was a vector system, whereby points are placed and the computer draws the lines between them—the basis of all future vector illustration and three-dimensional software. It even included a way to save images for later viewing.

In 1965, the first exhibition of computer graphics was held at a gallery in Stuttgart, Germany, although it only displayed the work of three mathematicians. Suites of prints were generated by creating variables in the mathematical formulas. Later that year, New York City's Howard Wise Gallery held the first computer graphics exhibition in the United States. Neither exhibition was well-received by the art world. One review compared the pictures to "notch patterns on IBM [punch] cards."

But some artists and curators *were* beginning to see new possibilities. In 1966, the artist Robert Rauschenberg (see Chapter 19) and the electronic engineer Billy Kluver founded EAT (Experiments in Art and Technology). They believed that because technology was now part of life, it should be part of art, too. In 1967, they collaborated with the Museum of Modern Art in New York City on the exhibition *The Machine as Seen at the End of the Mechanical Age*. EAT called on artists to submit artworks that combined art and science. The response was so huge that the exhibition had to spill out into the nearby Brooklyn Museum.

In 1971, well-known artists like Rauschenberg, Andy Warhol, Richard Serra, and Roy Lichtenstein (see Chapter 20) participated in the exhibition *Art and Technology* at the Los Angeles County Museum of Art. Five years in development, the organizers matched twenty-two artists with corporate sponsors who paid for the high costs of computer hardware and software, technicians, and fabrication. Unfortunately, art critics largely ignored the work and focused on the sponsors, labeling the results corporate art.

Because of the still-staggering cost of computing and the complexity of computer programming, "unholy alliances" with industry would be difficult to avoid for another decade for any artist who was interested in exploring computer graphics. However, access to large mainframes and research dollars were available to faculty and graduate students at major universities. In 1968, Ivan Sutherland, who had created *Sketchpad* as a graduate student, became a professor at the University of Utah. One of the great teachers in computer science history, his graduate students became the pioneers of the next generation of computer software, for graphics, games, and general consumers. His students would later found Adobe, Netscape, and Atari. Among the methods devised by his students were the key breakthroughs in realistic three-dimensional modeling and animation of the 1970s. For example, Ed Catmull, who later founded Pixar, developed the concept of texture mapping, where an image could be wrapped around a wire-frame three-dimensional shape. Others developed *Gouraud shading*, *Phong shading*, and *bump mapping*. Even today, these methods are essential tools for computer animators and game designers.

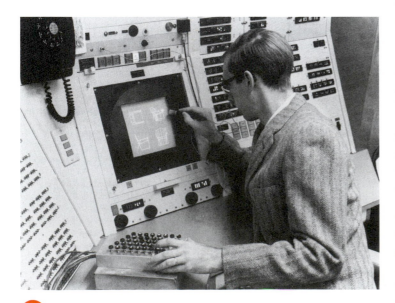

8/9 Drawing with Sketchpad, 1962.

Unfortunately, to utilize these wonderful, breakthrough techniques, you had to have access to big mainframe computers, and not too many artists did. Finally, in the 1980s, computers became available that were small enough to fit on a desk, were much more affordable, and you didn't have to be a computer scientist to use them.

For most artists and designers, the computer age began with the arrival of the Apple Macintosh in 1984—the machine that launched graphics-based computing (8-10). Known as the first user-friendly computer, the heart of its success was its Graphic User Interface (GUI, pronounced "gooey"). Earlier computers, like IBM's first PC introduced in 1981, required typing a series of coded commands with a keyboard to control them. Macintosh users moved a mouse and clicked and dragged on pictures (called *icons*). The innovative interface had many of the elements that we have since become used to—windows, pull-down menus, and file folders. The Macintosh also came with free art software like MacDraw and MacPaint. The graphics-friendly computer was instantly embraced by artists and designers, beginning a loyalty in the arts community for Apple computers that persists to this day.

THE DIGITAL STUDIO

The equipment of digital artists is not like what you would find in the studios of painters and sculptors. Instead of an easel and palette, the digital artist typically has a large desk and computer. The digital artist depends on machinery functioning smoothly to produce his or her visions. Still, the digital studio is a home for creativity and will have many similarities to all artists' spaces. The walls are often covered with clippings and postcards. Bookshelves will be filled not just with software guides, but also with many books on art. The source of the music filling the studio may be MP3 files, but the mood would not seem alien to any traditional artist who visited.

HARDWARE

Every media has its own unique equipment, and digital media is no different. Obviously, the centerpiece for digital artists is the computer. One would be hard pressed to detect any difference between the computer in a digital studio and one in a business office, but the artist's components will be of much higher quality. The digital arts

8/10 Macintosh computer advertisement, 1984.

generally demand the most powerful and fastest components. Fast processors and video cards and lots of memory are needed to be able to manage the complex computations of image or multiple image manipulation. For greater speed, digital artists, especially three-dimensional animators, often use machines with two or four processors to render their images. Digital artists also use monitors that are much larger and have *higher resolution* (able to display finer details and millions of colors). Some digital artists actually use two monitors at once—one solely for the image they are working on and the other for the toolbars and menus.

Digital still and video cameras, along with microphones, are common tools used to provide material to be manipulated by digital artists. Scanners are another way artists input imagery into computers. Flatbed scanners are the most common and are used for flat materials like photographs or drawings. There are also three-dimensional scanners that can digitize objects or sculptures.

Many digital artists who prefer to create their imagery by hand use a graphics or *digitizing tablet*, rather than a mouse. They can draw with a pen or *stylus* directly on the tablet, which can not only sense where lines are being

drawn but also the tilt of the pen and how much pressure is being applied. This allows artists to create sweeping, calligraphic lines that vary in angle and thickness. Some of the most advanced digitizing tablets are actually flat monitors. This means artists can use the stylus directly on their images and see the images change before their eyes.

Tablet computers like the iPad hold great promise as an artist's tool. As their screens become more sensitive, we are nearing the time when artists equipped with tablet computers can go out in the field and work directly from the landscape as the French Impressionists with their portable easels did in the nineteenth century (see Chapter 17). Still, the best hardware in the world will not make one a great digital artist, just as a piece of expensive marble and the finest carbide chisel does not make one a great sculptor.

THE DIGITAL MEDIA

IMAGE EDITING

Many current digital artists began their careers in the traditional media. Maggie Taylor was trained in photography and photo history. After completing her MFA in Photography, she began a successful career exhibiting still-life images taken with an old four-by-five-inch view camera. In the late 1990s, she bought a computer and a scanner, with the idea that she would use them to retouch her photographs, but she soon realized that there were much more significant possibilities in these new tools. She used the scanner like a camera by placing little objects and backgrounds on it, then combining them with image-editing software.

Taylor likes to work in series of pictures, and describes herself as "a collector of all kinds of objects at flea markets." She likes objects "with wear and tear, a past, a story to tell." Because of digital technology, rather than cutting up a precious original, as Hannah Höch (see Chapter 7) did to make her collages in the early 1900s, Taylor has available as many copies as she might need and can adjust each part for size, value, or color. Each element is put on a separate layer, making it easier to add, manipulate, or remove it; there are sometimes as many as forty different layers. A backdrop could be an old photograph or one Taylor has drawn in pastels and scanned, or both. *Boy who loves water* (8-11) combines vintage photographs, folk elements, and atmospheric backgrounds to create

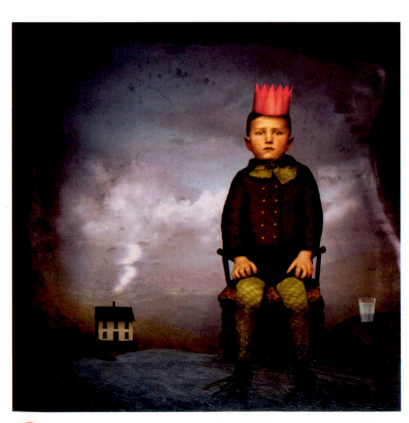

8/11 MAGGIE TAYLOR, *Boy who loves water*, 2004.

a magical image that could be from an obscure fairy tale. She describes her work as "dream-like worlds inhabited by everyday objects."

Like Maggie Taylor, Stephanie Syjuco produces digital prints that appear to be from the nineteenth century—old botanical illustrations of flora, much admired by collectors. But when one looks closely, rather than delicately painted pressed flowers, we see that the image is a carefully arranged collection of computer peripherals and cords.

Syjuco was born in the Philippines, but grew up in San Francisco, where she lives today. While working at a children's science museum, she was struck with the organic quality of computer cables and plugs. *Comparative Morphologies LIII* (8-12) was the result of her "thinking about science and technology . . . as sources of authority." She photographed each element with her digital camera and then manipulated them on her computer to accentuate their organic qualities, such as combining parts to make a stem. Objects were resized and arranged with care to finish the composition. The antique brown paper is an illusion. It is actually only one layer of the digital image. The layer was made by scanning an old botanical print and then using image-editing software to erase all of the original botanical elements.

She has said that as she worked on these prints, the parts were "growing beyond their initial function." The result is lovely and helps transcend the divide between past and present art, as well as the natural world and the digital age in which we live.

GRAPHIC AND TYPE DESIGN

The arrival of personal computers and laser printers in the 1980s created a revolution that shook the foundations of the graphic design world. For decades, designers had gone through a time-consuming process to prepare publications. Type had to be ordered from typesetters, who sent it back on long sheets. Designers then literally cut up these sheets and pasted them onto boards, which is the source of the phrase "cut and paste" in today's digital software. Any change, even a simple one in the size of a font or a spelling correction, meant a new order to the typesetter, which was costly in time and money.

The revolution began with a computer program called Aldus PageMaker, designed for the newly released Apple Macintosh. This pioneering program allowed a whole new approach to design and layout, which became known as *desktop publishing*. Suddenly, a designer could sit at a desk and manipulate text and graphics. Fonts could be resized or changed instantly, without an emergency call to the typesetter. Most important, the designer could see on the screen the layout as it would be printed—what was called *WYSIWYG* (pronounced "wizy-wig"), or "what you see is what you get."

 STEPHANIE SYJUCO, *Comparative Morphologies LIII,* 2001. Archival iris inkjet print on Somerset paper, printed by Urban Digital Color. www.stephaniesyjuco.com

Another important impact of the digital design revolution was its effect on type design. Because it was now easy to experiment with typefaces and to load additional fonts onto a computer, there was a huge demand for fresh typefaces. There was also new type design software, so that anyone who had a computer could create fonts from scratch.

The result has been thousands of new fonts for all kinds of special uses. By the 1990s, homemade typefaces, known as *garage* or *grunge fonts*, were flooding the design world. Custom fonts became part of an underground culture for young designers. One of the first leaders of this movement was House Industries. Founded in 1993 by Andy Cruz and Rich Roat, who were then in their twenties, in Wilmington, Delaware, the company continues to be known for its irreverent attitude but professional approach to type design. The first of their fonts to attract attention was "Crackhouse." *Crack House* (8-13) was a rough-edged, gritty font, unlike the clean, elegant fonts that had previously dominated graphic design. This was followed by a suite of related fonts, called "Bad Neighborhood," with new fonts like "Bad House" and "Poorhouse."

The designers of House Industries then turned their attention to themes from the past, particularly the styles of the 1950s, 1960s, and 1970s. Describing their style as "Ironic Retro," they have created collections that evoke the styles of swinging Las Vegas, Hawaiian tiki bars, and classic horror films. Instead of simply sending the fonts on a CD, they designed imaginative packaging, so a 1970s set came in a boxy van that the team from Scooby-Doo might drive. Their "House-a-Rama" fonts, inspired by the Professional Bowling Tour, were offered in a 1960s-style bowling ball bag. Today, House Industries has expanded beyond typography to more complete design services, like package design and illustration, and products like T-shirts, housewares, and other specialty items. But the real secret of their success is the time and effort spent in polishing each of their font's designs. Roat has said, "We'd like to think that we work beyond the hollowness of 'retro' through . . . exhaustive research of historical genres to produce uniquely authentic materials."

DIGITAL VIDEO

Paul Pfeiffer is an artist who works in digital images and installations, as well as video. He was born in Hawaii, but grew up in the Philippines. As a teenager, the family moved to New Mexico, and he went to a Navajo school where his parents were teachers. He began his art career as a student in San Francisco, studying printmaking.

In Pfeiffer's best-known works, he edits video of sporting events by removing the athletes, allowing the viewers to focus on the context. The viewer's experience of these events is transformed when the centers of attention—the celebrities—are removed and our attention refocuses elsewhere. In "Caryatid," the celebrations at the end of the National Hockey League finals are seen, but without any of the players who carry the victory trophy. The Stanley Cup seems to float around the rink, as the players and crowd express joy around it.

8/13 HOUSE INDUSTRIES, *Crack House*, 1993. Font design.

Pfeiffer usually presents his work on small flat screens that compel you to move close to them and ignore what's around you. In *John 3:16* (8-14), the viewer follows the progress of the ball in a professional basket-ball game. During the thirty-second video loop, the ball is in the center of the screen while it moves magically and fluidly back and forth across the court from the hands of one player to another. The ball rotates, sometimes very gradually. We can see the faces in the crowd when the ball slows, but we never see the players who handle the ball, only their hands. The effect is mesmerizing. The title's reference to the New Testament is meant to con-nect the eternal life offered spiritually to the "promise of digital images." Pfeiffer says, "they can literally last forever," because they "can always be copied endlessly. In a way, the medium itself represents a kind of promise that almost has spiritual overtones."

Many people make the mistake of thinking that com-puter art is easy because the computer does all the work. Digital artists know better. Pfeiffer's process of erasing on digital video is time consuming and painstaking. Unlike shooting with blue screens, Pfeiffer works with preexisting footage and has to erase people and then recreate the backgrounds behind them frame-by-frame. For just thirty seconds of *John 3:16*, five thousand frames had to be edited, enlarged, and repositioned. He was only able to complete a minute of video in a month. He enjoys working all day on his work and considers it "like meditation" and "a bit like painting or drawing . . . you leave your every day consciousness of the world and achieve a kind of focus."

DIGITAL ANIMATION

The effect of the digital media on animation is one that the public is probably most aware of. Few have bene-fited more from these changes than the animator John Lasseter. As a young man interested in animation in the 1970s, he was among the first students at California Institute of the Arts, a school founded by Walt and Roy Disney. While still a student there, he interned with Disney. After graduation in 1979, he was hired by them and put to work on *The Fox and the Hound*. During his time at Disney, Lasseter became enthusiastic about the possibilities of computer animation, but the studio was uninterested. Lasseter took the daring step of quitting an animator's dream job in 1984 to pursue his new interest.

He did not remain unemployed for long. Lasseter was hired by George Lucas for a new computer animation and special effects division at Lucasfilm. Unfortunately, Lucas soon decided to refocus the division on special

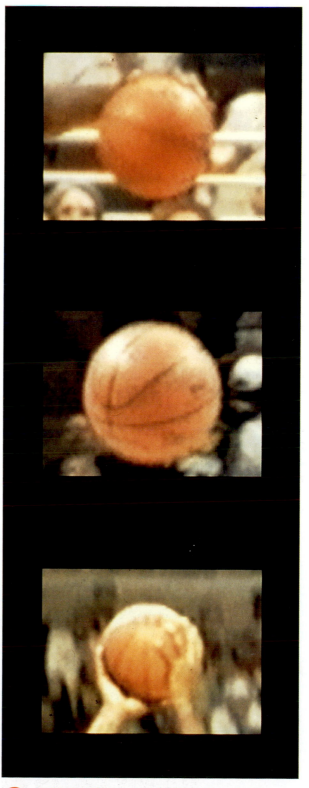

8/14 PAUL PFEIFFER, *John 3:16*, 2000. Digital video loop, LCD monitor, DVD player, and metal armature, 5½" × 6½" × 36". Courtesy the artist and The Project, New York.

effects only (renaming it Industrial Light and Magic) and sold off the computer animation portion. Luckily for Lasseter, the buyer was Steve Jobs, who had founded Apple. Jobs invested millions into the new company, hired the best minds and talents in computer animation technology, and called his company Pixar.

Lasseter's first fully computer-animated film at Pixar was called *Luxo Jr.* (8-15). It tells the story of a child lamp who loves to bounce a ball under the watchful eyes of his parent. Only a few minutes long, it was the first computer-animated film to be nominated for an Academy Award. Lasseter won his first Oscar two years later, for the short film *Tin Toy*.

The three-dimensional animation process to create such a film is quite complex. It begins with modeling, where each element is drawn first in *wireframes*—a kind of digital sculpting where the three-dimensional form looks like it is covered in a web of netting. Colors and textures for each object are chosen. Then lights are positioned on the scene. After all of the modeling and lighting is completed, animators get to work. They decide on the movements of every part of every character and place virtual cameras to track the movements. Finally, the objects, backgrounds, lights, and movements are all *rendered* (the computer generation of each scene that adds all of the planned colors, shading, texture, lighting, and movements to the wireframe forms).

Ironically, as a result of Pixar's early successes, Disney finally became interested in Lasseter's computer animation skills. Pixar and Disney agreed to collaborate on the first full-length and completely computer-animated film. The project took four years to complete, but *Toy Story* became one of the highest-grossing animations in history. An incredibly complex undertaking, it required a room full of computers, stacked like pizza boxes, just to render one frame at a time. Despite all of the computing power available, each frame took hours to render.

In the years since, Lasseter was the creative force at Pixar behind films like *Monsters Inc.*, *The Incredibles*, *Wall-E*, and other great successes. After the purchase of Pixar by Disney in 2006, Lasseter returned to his former employer as one of the leaders of their revitalized animation division. Lasseter would attribute his success, however, not to amazing technology but to his mastery of traditional animation skills. Story and an understanding of the fundamentals of animation are what he considers most important. The technology is just the tool.

One only has to look at the long lists of names at the end of any of Pixar's movies to realize that the animators at Pixar have extraordinary resources at their command. However, one great result of the digital age is that powerful tools have been put in the hands of individual artists. Nina Paley was a comic strip artist when she moved to India after her husband took a job there.

 JOHN LASSETER, BILL REEVES, EBEN OSTBY, SAM LEFFLER, and DON CONWAY, *Luxo Jr.*, **1986. Frame from film.**

While she was on a short trip to New York, her husband emailed her not to return and that their marriage was finished. Suddenly homeless and in "grief, agony, and shock," Paley over the next three years turned her anguish into a feature-length animated film as a one-woman production company. *Sita Sings the Blues* (8-16) was done on a computer using a mix of various animation techniques. Some sequences were made from collaged cut-outs, photographs, and hand-painted backgrounds that were scanned later. Others are pure 2-D Flash computer animation. The film mixes the story of her failing marriage in a jittery comic strip style, the 3,000-year-old Indian epic *Ramayana* drawn in a style reminiscent of Betty Boop cartoons, and commentary by three contemporary Indians (portrayed as shadow puppets) struggling to remember the story of the myth they learned as children. In the ancient Hindu legend, the god Rama betrays his faithful wife Sita after she is kidnapped by a demon king.

Paley was attracted to the story because it seemed to be a mirror of her own. "Why did Rama reject Sita? Why did my husband reject me? We don't know why, and we didn't know 3,000 years ago. I like that there's really no way to answer the question, that you have to accept that this is something that happens to a lot of humans." According to Paley, the film is "a tale of truth, justice, and a woman's cry for equal treatment." When the film premiered in 2008 at a film festival, it was enthusiastically received. Critics were amazed at Paley's accomplishment, particularly because her longest animation before making *Sita* was only four minutes long.

The soundtrack is an unusual blend of traditional Indian music and early Jazz Age recordings like "Mean to Me." Unfortunately for Paley, while the songs gave her inspiration, they were still under copyright protection. After learning of Paley's success, the owners demanded more than $200,000 in payment for the rights. At that point, Paley was already in debt for more than $20,000 from producing her film. It seemed that three years' work was about to be stifled.

Paley took the unusual tactic of releasing the film free on the Web. It can be downloaded in high definition. Because of a special clause in copyright rules, she has also been able to broadcast the film on public television. A year after the film was finished, the copyright owners finally agreed to let Paley make a limited-edition DVD after she paid them $50,000. Even with those limited rights, Paley continues to believe in a copyright-free society. On her website, she encourages her audience to "Please distribute, copy, share, archive, and show *Sita Sings the Blues*. From the shared culture it came, and back into the shared culture it goes."

8/16 NINA PALEY, still from *Sita Sings the Blues*, 2008. Animated film. © Nina Paley 2008.

JAPANESE ANIME

Animation from Japan is becoming a cultural force around the globe. Known as *anime* (pronounced "annie-may"), it has a distinct style as well as a wider range of subjects compared to animation in the United States. In Japan, it is not only for children, but enjoyed by all ages.

Visually, anime's distinct style evolved from nineteenth-century drawings like those of Hokusai (see Chapters 2 and 17) called *manga*. Manga means "easy, silly pictures"; they were printed sketchbooks that purported to show everyday life in Japan. Although they did show many ordinary scenes like fat men taking a bath, they also included fantastic images, like men and women smoking who have long necks like curling snakes.

In the twentieth century, manga evolved into comic books. More visually sophisticated than their American counterparts, they included close-ups, unusual angles, and imaginative page layouts. In the late 1950s, Tezuka Okama, who was called in Japan "the god of manga," began the *anime* movement when he turned his manga character *Tetsuma Atomu* (Mighty Atom) into an animated cartoon for television. Atomu was a crimefighting boy robot with jets in his feet. When his cartoons finally came to the United States, he was renamed *Astro Boy* (the name change was necessary to avoid reminding Americans about Hiroshima).

Tezuka's drawing style influenced Japanese manga and animation profoundly. It is a style viewers raised on Pokemon would recognize. His human characters have big eyes and sweet, rounded faces. Strong emotional reactions are shown by close-ups of faces with mouths wide open and holding a still image.

Today, the most influential anime director is Hayao Miyazaki, the director of *Spirited Away* (8-17), *Princess Mononoke*, and other classic films. His stories are adventures, but not ones where there are battles with swords. In *Spirited Away*, a girl whose family is moving finds herself alone in a mysterious town. There are ghosts, gods, and monsters, and she must try to figure out which ones to trust and what to do in order to save her parents. The fairy-tale atmosphere is enhanced by lovely, subtle colors, beautiful hand-drawn characters, and elaborate, decorative computer-animated backgrounds.

Miyazaki is an extraordinarily meticulous animator. Unlike most directors, he checks every drawing and redraws ones that are not to his satisfaction. He founded Studio Ghibili in Japan to produce high-quality animated films and support other talented Japanese animators. His animation has also influenced directors worldwide. *Spirited Away* was not only the most successful film in Japanese cinema history, but it also won many awards, including the Oscar for Best Animated Film. The style of recent Disney films have shown anime's influence. John Lasseter, the greatest American animator of our generation (see the Digital Animation section), helped bring *Spirited Away* to American audiences and describes Miyazaki as one of his heroes. In fact, when the Pixar staff is having trouble with one of their films, Lasseter makes them watch films by Miyazaki.

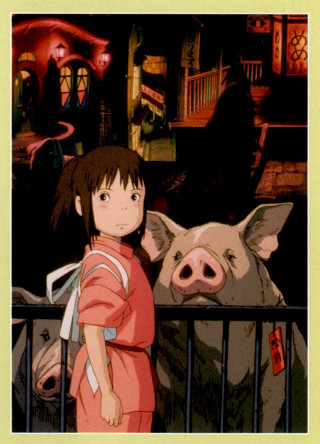

8/17 HAYAO MIYAZAKI, still from *Spirited Away*, 2001. Animated film.

INTERNET

The World Wide Web not only has provided new ways of distributing and publicizing art, but it also has provided a new way to create it—as a worldwide group project. Collaborating on an artwork is not without precedents in art history. *Prometheus Bound* (see Chapter 3) was painted by the partnership of Pieter Paul Rubens and Frans Snyders. Many successful artists (like Rubens) have had assistants to help them finish their work. The Surrealists (see Chapter 18) made collective drawings in a process they called "The Exquisite Corpse." Each artist would draw a body part without knowing what the others had done, but generally, these artists were in the same room or at least the same city.

SwarmSketch is a web project by Peter Edmunds begun in 2005 and designed to reveal "the collective consciousness" of the world on a weekly basis (8-18). Each week, hundreds of people around the world go to Edmund's website and work on a drawing. The week's theme is selected from a current popular search term from major search engines. Past drawing titles include "World's Ugliest Dog," "Smoking Gun," and "Unclaimed Baggage." Each time visitors come to the site, they can only contribute one line, but they can also vote to lighten or erase many other people's lines. As you vote on a line you can adjust its value, see the change, and also learn what country the contributor was from. Although the highest percentage of Swarm artists come from the United States, many others are from Europe and Asia.

INTERACTIVE

Lynn Hershman Leeson has been making interactive art for decades, as well as films, videos, sculptures, photography, performances, and installations. With these diverse art forms, her focus has remained on female identity and how it is conditioned by society. Her most recent work includes several attempts to create a female artificial intelligence robot that can interact either with her environment or viewers.

The overall form of *Synthia* from 2000 was modeled on an old-fashioned stock market ticker tape. Under a glass globe was a small screen that displayed a woman. Connected to the actual stock market, the woman reacted to the performance of the market on that day. For example, if the market was doing well, she might dance or go shopping. If it was really hot, she burst into flames. A down market could lead to chain smoking or shopping at a used clothing store.

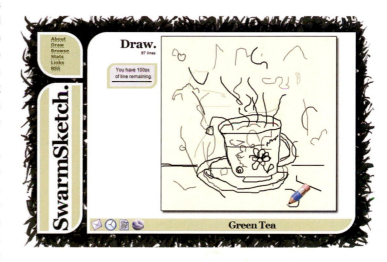

 PETER EDMUNDS, *Swarm Sketch*, 2005. Interactive website. Peter Edmunds, Unclaimed Baggage, 05/12/2005, online collaborative drawing from swarmsketch.com.

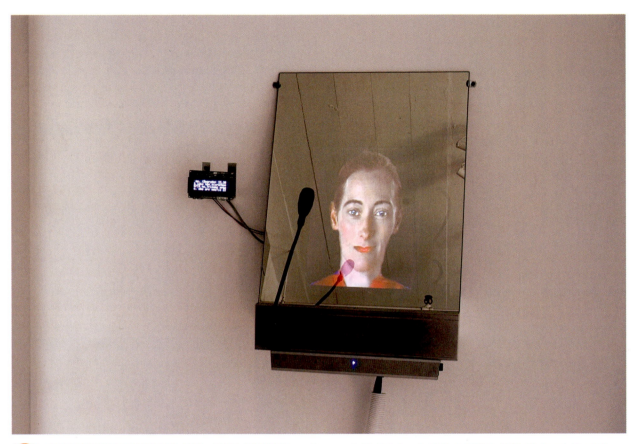

8/19 LYNN HERSHMAN LEESON, *DiNa*, 2004–2005. Dimensions variable (pictured: 10" × 10" × 10"). Networked artificially intelligent agent with Pulse 3D Veepers, Alicebot, and Natural Voices Software, edition of 3. bitforms gallery, New York.

DiNa is a step forward in artificial intelligence (8-19). With the help of a programmer using artificial intelligence and speech recognition software, *DiNa* can learn, express emotions, and carry on a sensible dialogue with a viewer. Her face is modeled in three-dimensional software and is animated to be synchronized with her speech. Her features are based on the actress Tilda Swinton, who has acted in Leeson's films. Because *DiNa* is connected to the Internet, she is aware of contemporary events and can search for information. She even ran for President in 2004 and had a campaign website. Her slogan was "Artificial Intelligence is Better then No Intelligence."

Although interacting with *DiNa* is fun, Leeson believes that the issues she raises are very serious. "Our relationship to computer based virtual life forms that are autonomous and self replicating will shape the fate of our species and seem to me to be a critical issue of our time." Leeson knows that these kinds of life forms are still in the

future and that her goals for *DiNa* cannot be completely achieved with current technologies. Like most artists, she has always overreached, but when one follows the progress of her robots, one can see that there will be a time not so far in the future when her goals will be realized.

Like Leeson's *DiNa*, Julius Popp's *bit.fall* (8-20) is at the intersection of art and science. As viewers approach the installation, it first appears to be a pleasant fountain with thin streams of water falling from above. At the front of the waterfall one also sees a downpour of data. Brightly lit words appear and then dissolve; they hang in the air for just a moment before they drop into the pool below. The effect is created by theatrical lighting and a series of water valves controlled by a computer. The words are chosen from a live feed of popular search terms on Google News. The German artist describes his work as a "metaphor for the incessant flood of information we are exposed to." When *bit.fall* is installed

outdoors, viewers can run through it and get drenched in our culture's constant stream of data.

Although the Digital Era of art is just getting underway, we can already see that every artist's medium is being affected. Artists have been handed tools that would have thrilled the Futurists at the beginning of the twentieth century. This chapter provided just a sample of the many ways artists are utilizing the new media.

But the impact does not stop there. These new tools are becoming increasingly inexpensive and available to anyone. Just as, in the early 1900s, Kodak's first cameras put photography into the hands of the general public, today people young and old have digital cameras.

They can edit images and videos on their computers and send them instantly thousands of miles away. Phone apps allow almost anyone to draw and share their art with the world as they are walking down a street. Videogames are causing a shift in consciousness. A generation has grown up moving in imaginary three-dimensional spaces of ever-increasing complexity. Online game play has made virtual collaboration ordinary; players not only take part in video games and converse with other players anywhere in the world, but they can also create their own levels and even "sell" elements they designed. How all of these developments will affect the history of art and the planet remains to be seen, but we can be sure that they will.

8/20 JULIUS POPP, *bit.fall*, 2001–2006. Stainless steel, custom electronics, computer, custom software, water. Dimensions variable, courtesy of artist.

CHAPTER 9

SCULPTURE

The art of sculpture is believed to be as old as human culture. Carved charms, amulets, and fertility figures such as the *Venus of Willendorf* (1-7) were created by Ice-Age tribes described in the first chapter. Most of these magical objects were relatively small and easily carried from place to place by nomadic hunters. At the other end of the scale, some prehistoric civilizations sculpted huge stones that have stood in the same place for centuries. For example, the Colossal Olmec head (9-1) is one of four found at an ancient temple-pyramid plaza in Mexico. How a stone weighing approximately ten tons could have been moved by a people without domesticated animals or the wheel remains a mystery, because the nearest source of this type of rock is more than fifty miles away. Volcanic basalt

is an extremely hard stone, yet this boulder was carved only with stone tools, since the Olmec civilization that created it did not use metal tools. The face is thought to be that of a ruler, but it might also be the portrait of a god. More than nine feet tall, its large, symmetrical features and stern expression seem designed to strike the viewer with fear and awe.

Sculptural decorations and statues were also part of the palaces of the Middle East, the tombs of the ancient Egyptians, and temples in India. Greek sculpture was a glory of the classical world, although little of it has survived to the present day.

Many of the techniques and tools of the sculptor have been used for centuries. When we see Edward Steichen's (see 7-11) photograph of the modern sculptor

9/1 Colossal head, Olmec, La Venta, Mexico, 900–400 BCE. Basalt, 9' 4" high. Museo-Parque La Venta, Villahermosa.

Constantin Brancusi in his studio wielding a heavy axe and surrounded by rough-hewn stones (9-2), we are reminded of the ancient, even prehistoric, lineage of sculpting. Sculpture has traditionally been divided into two major categories—what is called *relief sculpture* and *freestanding sculpture* (sculpture *in the round*). In the twentieth century, new categories were introduced—*kinetic sculpture* (art that moves), *performance art*, *installations*, and *earth art*.

RELIEF SCULPTURE

A **relief sculpture** grows out of a flat, two-dimensional background, and its projection into three-dimensional space is relatively shallow. The back of a relief sculpture is not meant to be seen; the entire design can be understood from a frontal view. Relief sculptures are often used in conjunction with architecture, as wall decorations. For instance, the stone walls of Assyrian palaces were carved with designs that protrude only slightly into three-dimensional space (9-3). The outlines of the figures are sharply cut, rather than modeled, so they appear almost like decorative cookies stuck onto the backing of the wall.

9/2 EDWARD STEICHEN, *Constantin Brancusi in His Studio*, 1925. Photogravure from plates by John Goodman and Richard Benson, 10³/₁₆" × 8". Private collection.

9/3 *Ashurnasirpal II Hunting Lions*, (detail) Nimrud, c. 875 BCE. Limestone, approximately 39" high. British Museum, London, Great Britain.

The linear quality of these low reliefs—the rhythm and pattern of the lines—is their most striking aesthetic feature. If we look closely, however, we can see sculptural effects in the curve of a cheek or the muscle on a thigh.

Most Assyrian reliefs commemorate the military victories and hunting expeditions of the kings who ruled some twenty-eight hundred years ago in what is now Iraq. Carved in limestone, these sculptured pictures lined the walls of royal habitations. Words praising the king and his accomplishments were generally carved over the figures.

The plaque showing a king mounted on a horse with attendants (9-4) from the Court of Benin, Nigeria, also decorated a royal palace. It is one of nearly a thousand that covered pillars in the many courtyards and galleries. When these plaques were made in the sixteenth century, Benin was a vast empire in West Africa and was trading with Europe. On the brass plaques, size signifies power (see hierarchical scale, Chapter 3); ornaments identify status. The central warrior chief is in *high relief* (or almost in the round); he seems about to ride out of the plaque. His warriors carry shields held out in high relief to protect him from the sun. His two small attendants in shallow relief are there simply to support the king's hands.

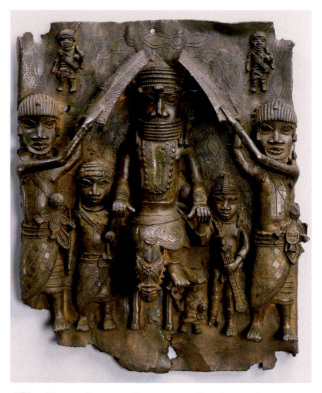

 Plaque showing a king mounted with attendants, Benin, Nigeria. Bronze, 19½" × 16½". Metropolitan Museum of Art, New York (gift of Nelson A. Rockefeller, 1965).

SCULPTURE IN THE ROUND

In contrast to sculptural reliefs, **freestanding** sculpture inhabits three-dimensional space in the same way that living things do. Sculpture in the round cannot be appreciated from only a single viewpoint but must be circled and explored. As the poet Donald Hall has written, "If there can be one best picture of a sculpture, the sculptor has failed." *Apollo and Daphne* by the Italian Baroque sculptor Gianlorenzo Bernini (9-5, 9-6) is a powerful example of sculpture in the round. The figures seem not only like living creatures, but they also seem to be moving. In the ancient myth on which the statue is based, the god Apollo fell in love with the lovely nymph Daphne. As he was chasing and just about to overtake her, Daphne called out to the Earth goddess to save her from Apollo's unwanted advances. Gaia heard her cries and came to her rescue: The instant Apollo touched her, Daphne was transformed into a laurel tree.

As the viewer moves around the life-sized figures of the young Apollo and the nymph Daphne, the twists and turns of their bodies in space create not only new visual discoveries but also changing patterns of positive and negative space in three dimensions. In contrast to relief sculptures, there is no predominant view. The figures, draperies, and setting flow into each other as you walk around the sculpture. Closer up, Bernini provides the viewer with many exceptional details, too (see 9-23). As was common in late sixteenth-century Italy (see Chapter 15), the statue was intended to impress his fellow artists as a *tour de force* of artistic skill.

KINETIC SCULPTURE

In the 1930s, while in Paris, the American sculptor Alexander Calder had begun working nonrepresentationally, making organic, simple forms out of metal. Because he wanted to see these forms float and turn in space, Calder invented the **kinetic sculpture** or **mobile** (a name given to his work by Marcel Duchamp). The first mobiles had a base and used motors to move the shapes that hung from wires. Soon, however, Calder came to the happy idea of using the wind to move his dangling shapes, as in the dramatic mobile—twenty-nine by seventy-six feet long—hanging in the National Gallery of Art in Washington (9-7). Set in motion by air currents, these works feel absolutely natural, although they are made of totally abstract shapes. Their delicate balance makes each part seem weightless. Because the wind resistance

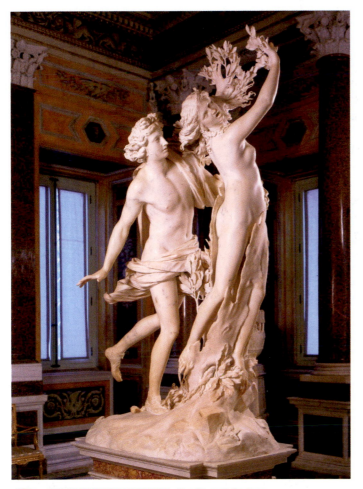

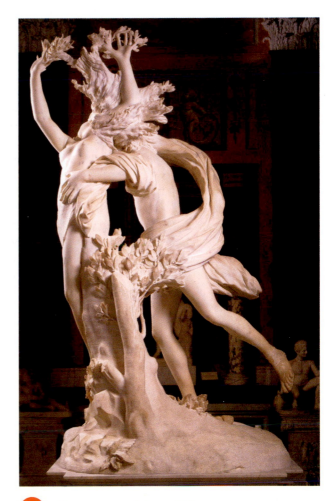

9/5 GIANLORENZO BERNINI, *Apollo and Daphne*, 1622–1625. Marble, life-size. Galleria Borghese, Rome, Italy.

9/6 Alternate view of figure 9-5.

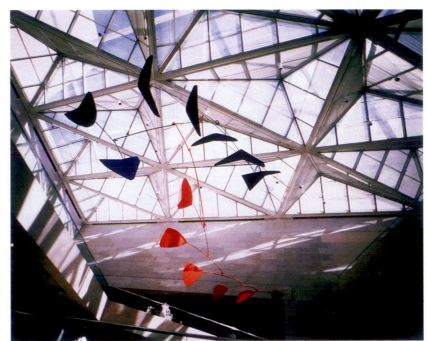

9/7 ALEXANDER CALDER, *Untitled*, 1976. Painted aluminum and tempered steel. 29' 10½" × 76". Gift of the Collectors Committee, Photograph © 2001 Board of Trustees, National Gallery of Art, Washington, D.C. © 2012 Calder Foundation, New York/Artists Rights Society (ARS), New York.

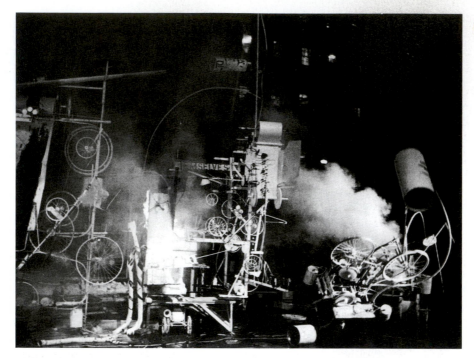

JEAN TINGUELY, *Homage to New York*, 1960, just prior to its self-destruction in the garden of Museum of Modern Art, New York.

and weight of each piece varies, different parts will move at different speeds. Therefore, the relationship of the parts is constantly changing. No photograph can do justice to these moving sculptures.

Jean Tinguely's kinetic sculptures of the 1960s were not nearly as pleasant. His infamous *Homage to New York* (9-8) was a mass of junk, including bicycle wheels, fans, many motors, and metal tubes. A comment on modern life and the machine age, it was a machine designed to destroy itself. Turned on at night before private guests (including the governor of New York) in the sculpture garden of the Museum of Modern Art in New York City, the sculpture made horrible noises, smoked, and, after several malfunctions, burned to a heap in a half hour. Besides being a kinetic sculpture, *Homage to New York* could also be described as a staged event and thus included under another new category of sculpture, performance art.

PERFORMANCE ART

Beginning around the 1960s, artists began to challenge the whole concept of art being the production of lasting physical objects. A movement called **performance art** created living sculptural events that were ephemeral, art experiences made for the moment, intended only to last in memory. Few contemporary performance artists have *not* been influenced by the German artist Joseph Beuys. His performances were always an unpredictable kind of gallery experience. In a 1965 performance *How to Explain Pictures to a Dead Hare* (9-9), for example, Beuys entered

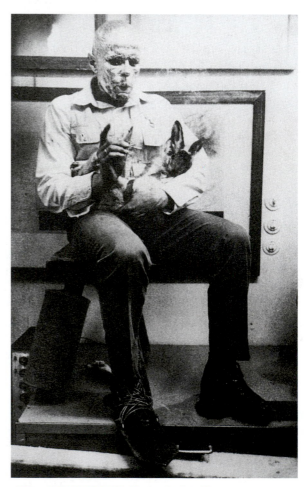

JOSEPH BEUYS, *How to Explain Pictures to a Dead Hare*, 1965. Performance at the Galerie Schmela, Dusseldorf, Germany. Photograph © 1986 Walter Vogel. © 2012 Artists Rights Society (ARS), New York/VG Bild-Kunst, Bonn.

an exhibition of his drawings and paintings with his head covered in honey and gold leaf. Carrying a dead hare in his arms, he walked from picture to picture and touched the rabbit's paw to each one. Then he sat down in a corner of the gallery and proceeded to discuss the meaning of his pictures with the rabbit. He said that he did this "because I do not really like explaining them to people" since "even in death a hare has more sensitivity and instinctive understanding than some men with their stubborn rationality."

Laurie Anderson has been a leading innovator in combining electronics, music, and performance art. Her work is autobiographical and complex. *United States Part II* **(9-10)** was developed in performances over six years and gave Anderson a celebrity status that is without precedent in performance art. In front of a huge screen, Anderson played a synthesizer keyboard that controlled her music and voice. The screen's images constantly changed during the eight-hour piece, a fluid stream of a map of the United States, photographs, drawings, and the video game "Space Invaders." Her voice changed constantly, too, gliding between various personae from a clichéd mother to a corporate executive. There are both instrumentals and songs in *United States*; one song, "O Superman," contains the chilling lines: "Well, you don't know me but I know you, and I've got a message to give

you. Here come the planes." At that moment, the theater is filled with the roar of aircraft. This message, from a performance of the 1980s, seems almost to foreshadow the terrifying events of 9/11.

After *United States Part II*, Anderson was signed to a recording contract; in fact, "O Superman" rose to number two on the British pop charts. Although most performance art is meant to be seen only once, *United States* was booked for scheduled runs like a play. Theatre critics even began reviewing Anderson's work. Some have said that Anderson has left the arena of fine art and crossed the line into entertainment. However, the goal of performance art has always been to break down the traditional boundaries of art and to confront viewers as directly as possible. Anderson's mesmerizing cross-disciplinary works have reached people who rarely see avant-garde art and has influenced the worlds of popular music, opera, film, and theater.

INSTALLATIONS

One of the newest art forms is the mixed-media **installation** or **environment**, which can be constructed in galleries, museums, or even public spaces. This large-scale art

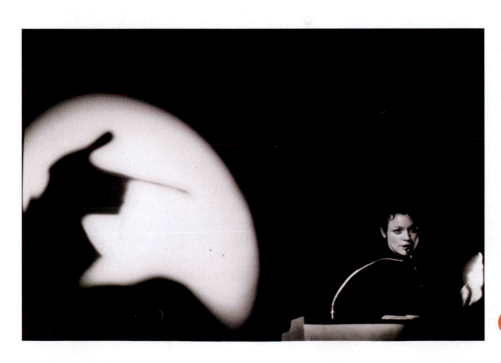

9/10 Laurie Anderson, Vancouver debut of *United States*, 1981. Photo: Cornelia Wyngaarden.

takes over a space and provides a complete and unique artistic experience for anyone who enters or comes upon it. For example, Kenny Scharf was selected in 1985 to create an installation for the Biennial Exhibition at the Whitney Museum in New York City, one of the most important exhibitions of contemporary art. For this project, Scharf chose to decorate the passageway to the restrooms with a combination of painting and sculpture (9-11). He moved into the museum, sleeping overnight on a couch in the women's restroom, and covered the walls in Day-Glo paints (later lit by black-light lamps), mixing cartoon characters like Fred Flintstone with wild patterns. Many objects (which he called "trash") were stuck to the walls and hung from the ceiling, including portable tape players that blasted loud music. The installation included decorating the phone booths at the end of the corridor with paint, glitter, and fake fur, as well as the restrooms themselves. Scharf transformed a minor hallway in a major museum into a Postmodern, raucous funhouse.

Scharf's hallway, like many installations, was designed as a temporary art experience rather than meant to be left in the museum permanently. This allowed the museum to grant the artist much more freedom to experiment. Because of its lack of restrictions, many artists chose to focus on such temporary installations (also known as *site-specific* art). Their work is designed to alter an ordinary space in a unique way and transform the viewer's experience of it.

This kind of surprise awaited pedestrians walking by a busy corner in midtown Manhattan in 2006. While New Yorkers pride themselves on being unimpressed by anything city life confronts them with, those who stopped were amazed to see what appeared to be a piece of a typical city building that had either fallen to the ground or had begun emerging from underneath the pavement (9-12). Those who took the time to peek into it were rewarded with a view of an interior of a miniature artist's studio, although one that looked as if it had been hit by an earthquake. Extending below street level was an arrangement of many ordinary items, such as a drafting table, lamps, stacks of paper towels, an iPod, pencils, and a small spiral staircase. The more inquisitive who looked up and around noticed that the strange construction (actually a temporary installation by the artist Sarah Sze) was modeled on a building across the street. According to Sze, her goal for *Corner Plot* was that it would be "a surprise . . . a point of discovery," and so it was for any busy New Yorker who took the time to simply look.

EARTH ART

Earth Art is an outgrowth and expansion of installation art—art that not only provides an environment but also leaves the gallery and interacts directly with nature. Robert Smithson was the foremost theoretician of Earth Art, where the landscape is reshaped by the artist's vision. Smithson was one of a group of artists who had become disillusioned with the world of contemporary art, which he felt had become proudly isolated and cut off from ordinary people's concerns. He wrote:

Museums, like asylums and jails, have wards and cells . . . neutral rooms called "galleries." A work of art when placed in a gallery loses its charge and becomes a portable object or surface disengaged from the outside world. . . . Once the work of art is neutralized, ineffective, abstracted, safe and politically lobotomized, it is ready to be consumed by society.

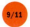
KENNY SCHARF, installation view of *Closet, No. 7*, 1985. Mixed media. From the 1985 Biennial Exhibition at the Whitney Museum of American Art, New York, March 13–June 9, 1985. Courtesy of Scharf Studio, photography by Tseng Kwong Chi. © 2012 Kenny Scharf/Artists Rights Society (ARS), New York.

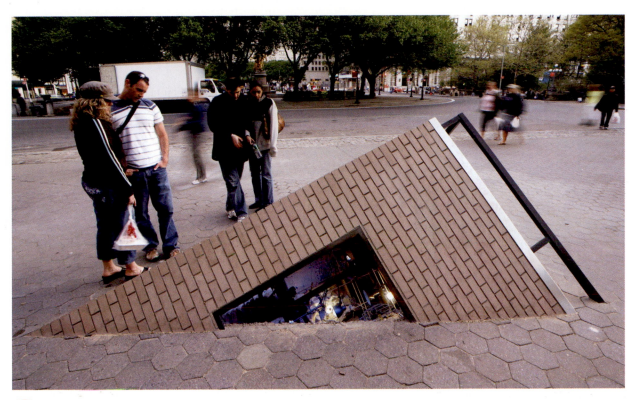

9/12 SARAH SZE, *Corner Plot*, 2006. Outdoor mixed-media installation, New York.

Smithson's answer to this problem was to create a new kind of art. His *Spiral Jetty* (9-13), constructed in 1970, remains the most famous and archetypal earthwork. Attracted to the Great Salt Lake in Utah because of its pink coloration (caused by microorganisms that live in the salt flats), Smithson was looking for a site along the shore when he had a vision while walking in the hot sun. He imagined a "rotary that enclosed itself in an immense roundness." Thus was born the idea of an enormous spiral ramp extending out into the lake. With the financial

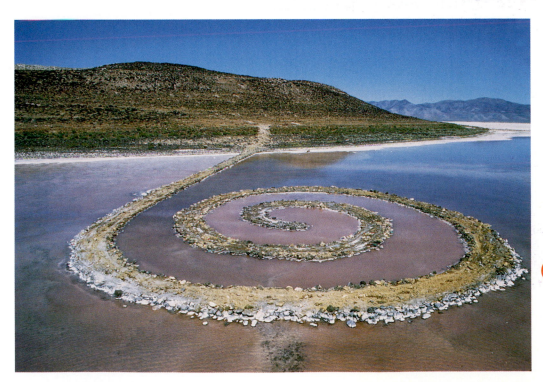

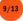 ROBERT SMITHSON, *Spiral Jetty*, April 1970. Black rocks, salt crystal, earth, red water, algae, 1,500' long × 15' wide. Great Salt Lake, Utah. Art © Estate of Robert Smithson/Licensed by VAGA, New York, NY.

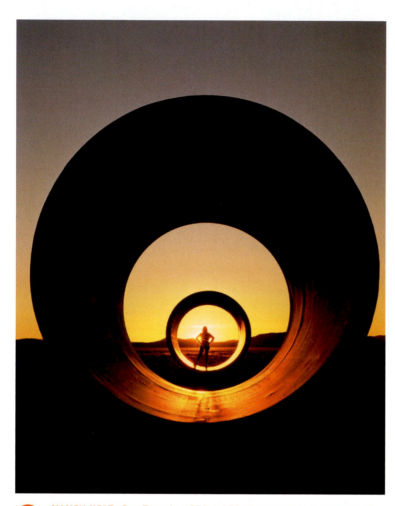

9/14 NANCY HOLT, *Sun Tunnels*, 1973–1976. Four concrete pipes, each 18' long, 9½" diameter; "X" configuration, 86' from end to end across axis. The tunnels are aligned with the sun on the horizon (sunrises and sunsets) on the solstices. Sunset at the summer solstice viewed through one of the tunnels. Near Lucin, Utah, in the Great Salt Lake Desert. Art © Nancy Holt/Licensed by VAGA, New York, NY.

of ancient monuments, Earth Art is admirable as a feat of engineering and art that is impossible to ignore. Unlike most art, no earthwork has to compete with the storm of images in ordinary life; most are placed in isolated sites, so they can be contemplated without distraction. Part of Earth Art's beauty is that its visual impact is constantly changed by nature. One's impression will be completely different depending on the light, weather, and seasons. Earthworks are also rarely permanent. Nature ultimately recycles the materials.

For instance, because the waters of the Great Salt Lake rose after 1970, for many years the *Spiral Jetty* was only visible in photographs and film. Recently, however, the water level has fallen, and Smithson's earth sculpture has once more, unexpectedly, emerged. Tragically, Smithson did not have the opportunity to see the *Spiral Jetty* sink and rise, or to fulfill his many plans for further projects. In 1973, the thirty-five-year-old artist was killed in a plane crash while scouting a possible site in Texas.

His widow, Nancy Holt, is an important Earth Artist in her own right. Like many contemporary Earth Artists, Holt is interested in restoring humanity's connection to nature and the heavens. Her *Sun Tunnels* (9-14) are four concrete tubes, each eighteen feet long and about nine feet in diameter. They were positioned carefully in the Great Salt Lake Desert in Utah so visitors inside them can see sunrises and sunsets at both summer and winter solstice. The human-made tubes provide both shelter from the desert's hot sun and beautiful views of the desert landscape through their circular openings. From inside, small discs of light in the shape of constellations can be seen. These are the result of holes cut into the concrete tubes. *Sun Tunnels*, Holt says, are meant to "focus our perception" and to get a firmer sense of our own relationship with the universe.

help of a gallery owner, and a crew of men, a tractor, and dump trucks, Smithson built his *Spiral Jetty*. It was fifteen feet wide and fifteen hundred feet long. Like most earthworks, it is horizontal in character and constructed from materials found at the site—in this case, basalt, limestone, and earth.

Smithson was pleased to learn that salt crystals also have a spiral shape, so as he says, "The *Spiral Jetty* could be considered one layer within the spiraling crystal lattice magnified trillions of times." Although that concept is intellectually satisfying, it was the colossal scale of *Spiral Jetty* that assured the sculpture's impact. Reminiscent

Many contemporary Earth Artists have actually carved the earth with bulldozers, treating it as a material for enormous sculptural works. Others have built up huge constructions of stone. Earthworks utilize the subtractive and additive methods of sculpture on the grandest scale.

EIGHTH-CENTURY
EARTH ARTISTS

Earth Art is not just a contemporary phenomenon. In India, long before modern machinery was developed, temples were carved directly out of mountainsides, creating both human-made caves and freestanding monuments. This is the subtractive method of sculpture taken to the ultimate degree. Southern India is famous for caves hollowed out of rock. By placing their temples in the earth itself, the Indians established a deep bond with nature, sheltering in the womblike shape of the human-made cave. Yet these caves were not the most impressive of Indian sculptural accomplishments.

Majestic and elaborate, both sculptural and architectural, the Kailasa Temple at Ellora (9-15) was carved top-down from solid rock 120 feet high. The courtyard is almost the length of a football field, 300 feet long and more than 150 feet wide. Within that space the temple includes a series of elements, including sixty-foot-high columns, and a tower of ninety-six feet, as well as a gateway, porches, and many shrines. Each of these structures is decorated with detailed sculptures that would once have been covered with white plaster and painted in bright colors, like Greek and Roman sculpture.

Built in the 700s by Hindu ruler Krishna II, the Kailasa Temple reportedly impressed even the man for whom it was made so much that he said, "How is it possible that I have built this other than by magic?" (Of course, the labor was done by thousands of workers and ultimately took more than a hundred years.)

As in other Hindu temples, there is a strong contrast between the bright light outside and the cooler light within, because the mountain from which the temple was carved casts deep shadows across the sculptured buildings. The design of the central shrine echoes the shape of Mount Kailasa, one of the peaks of the Himalayan mountains, believed to be the home of the Hindu God Shiva. The fusing of nature with sculpture and architecture makes this religious city-of-rock unique.

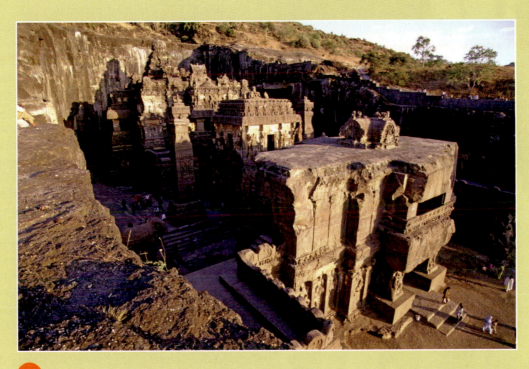

9/15 Kailasa Temple, eighth century. 96' high. Ellora, India.

SCULPTURAL METHODS

To discuss the sculptural media, it is most important to understand the two basic sculptural methods: **additive** and **subtractive**. In additive methods, the sculpture is *built up*, such as modeling a flexible material like clay or plaster or building an installation; in subtractive methods, it is *carved out* of hard materials such as wood or stone.

MODELING

Most of our childhood experience in making sculpture was with modeling statuettes out of the familiar material of clay (or clay substitutes, such as Play-Doh). Sculptors may also use clay to make sculpture, but they often build the clay form around a metal skeleton, or *armature*, for added strength.

Modeling materials, like clay or wax, sometimes perform the same function for sculptors that drawing media

do for painters, enabling them to sketch out their ideas quickly in three dimensions. Such a model is called a **maquette**. Auguste Rodin's *Walking Man* (9-16) was originally made in clay as a study for a figure of John the Baptist. In its textured surface, we can see the marks of the sculptor's strong hands modeling clay, pushing in below the ribs and adding a clump to form a muscle. Although they are a crucial stage in the design process, few clay studies survive. Left alone, clay will dry and become brittle; any contact with water will cause it to disintegrate. However, if baked or *fired* in a kiln, clay hardens to a rich red-earth tone and is called **terra-cotta**. For his *Walking Man*, Rodin utilized another, more permanent, way of preserving clay studies called **casting**.

CASTING

The centuries-old method of casting is an important, if complicated, sculptural process that allows the sculptor to make a lasting copy of his work or to create multiple copies of one design. Since ancient times, the most common material for casting has been the metal bronze, although other metals or plaster may be used.

Casting sculpture requires a series of steps in contrast to the more direct method of modeling. Most cast metal sculptures are made to be hollow, by what is called the **lost wax method** of casting (9-17). Once the original sculpture is created, a plaster or rubber mold is then made that can fit snugly around it and retain all the details of its shape and surface texture. After it is made, the original sculpture is removed from the mold, and a thin layer of wax is applied inside the mold, of exactly the thickness desired for the final metal sculpture. This layer of wax is, in essence, a hollow wax model of the original sculpture. The inside of the wax model is next filled with a material like plaster, while an outer covering of plaster is placed around the wax maquette's exterior. The whole plaster/wax arrangement is then baked in a kiln. During the baking, the plaster becomes hard and the wax melts out. That is why this is referred to as the "lost wax" method of casting. The hollow area that had contained wax is now open to hold the molten bronze, which is poured in and allowed to dry. When the bronze is hard and cool, the mold is broken off. A hollow metal version of the original sculpture can finally be seen.

Because of the complexity of the process, many large bronze sculptures are cast in pieces and then screwed together. The screws are filed down and bronze plugs are inserted over them and polished. Despite its difficulties and expense, bronze is particularly prized by sculptors because of its permanence and the **patina** it gains over

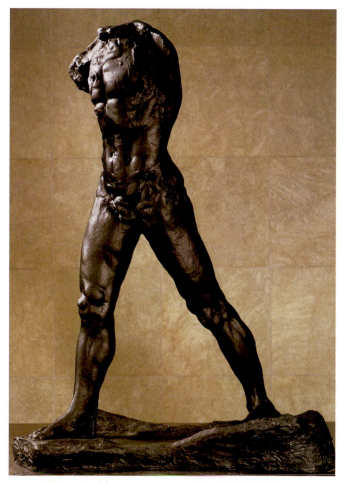

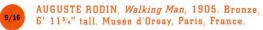
AUGUSTE RODIN, *Walking Man*, 1905. Bronze, 6' 11¾" tall. Musée d'Orsay, Paris, France.

a
Clay or plaster
original

b
Synthetic rubber mold creating
negative impression of original

c
Negative mold in two parts
coated with wax layer

Pins to
hold core Wax rods

Wax walls

Plaster core

Sand Metal

Plaster mold

d
Cutaway view of wax figure
showing walls and plaster core

e
Pouring molten metal into the mold
to replace the "lost" wax

f
Completed figure as metal rods
are being removed

9/17 Lost wax method.

time. Patina is the color a metal takes on as it chemically oxidizes and is believed to give a sculpture character. It also protects the underlying metal from additional corrosion. The Statue of Liberty's green color, for example, is due to the patina of its copper skin. Bronze is a mixture of metals, but is usually about 90% copper. Artists who work with it often have favorite chemical recipes for controlling the colors of their work's patina, rather than letting nature take its course. Bronze patina varies from black, greens, blue-black, dark or reddish brown, depending on the environment (for example, sea air) or technique used. As unpleasant as it sounds, traditionally, bronze sculptures were left in manure or dipped in urine to achieve an attractive patina. Rodin was known to respect such time-honored methods and often asked his assistants to go outdoors to urinate on his newly cast bronzes.

WOOD CARVING

If our first experience in creating sculpture was with an additive technique such as modeling, many of us have also experimented with primitive forms of the subtractive technique of carving—as in carving a shape out of a bar of soap or learning to whittle. If so, we discovered the difficulty of trying to shape materials by this method. In carving, as in preparing a woodcut, the background—the negative space—is removed or peeled away, allowing the form to emerge. The tools used usually mirror the wood-cutting tools of one's society and include saws, mallets, and chisels. Once the wood has been shaped, abrasives such as sandpaper can be used to finish and polish the surface.

Wood carving is the most important sculptural art of Africa. African carvings range from highly polished to rough-cut pieces; some depend on the natural beauty of the wood, some are painted, and some are decorated with shells, feathers, and beads. Most African sculpture in wood is carved from a single piece of a tree, chosen while it is still living, so the shape of the sculpture is limited by the shape of the trunk. The vertical, cylindrical shape of the original tree is then reflected in the outlines of the final work. This can easily be seen in the West African figures of a *Mother and Child* (9-18) and *Man with a Lance* (9-19). The ideal woman is mature, her full breasts suggesting that she has already born and nursed many children, including the baby on her lap.

In contrast, the ideal man exhibits the warrior's attributes of strength and prowess in hunting. Three to four feet high, both figures radiate a dignified presence.

When used in the initiation ceremonies and fertility rituals for which they were made, however, they would have been oiled, then decorated in bright beads and cloth. Just as Greek and Roman statues were more colorful than we realize (see 2-21), so African sculpture was not as austere when used in its original context, as with the African mask illustrated in the first chapter (see 1-10). It is extremely difficult to date African wooden sculptures; experts estimate that these figures may have been carved anytime between the fifteenth and the twentieth centuries by artists of the Bamana people (from present-day Mali).

Unlike African sculptors who carve from living trees, most sculptors do not usually limit themselves in this way and may join several pieces of wood together to create the effect they want (see Lives of the Artists box), as in the *Kongorikishi*, a guardian figure that stands at the entrance of a Buddhist temple in Nara,

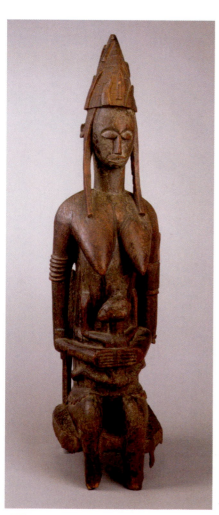

 Mother and Child, fifteenth to twentieth centuries, Mali; Bamana peoples. Wood, 48⅜" high. Metropolitan Museum of Art, NY.

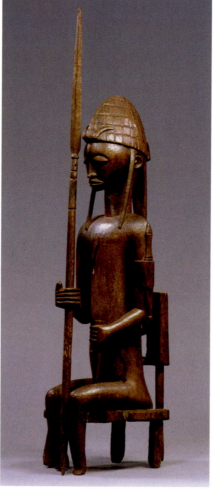

9/19 *Seated Male with a Lance*, fifteenth to twentieth centuries, Mali; Bamana peoples. Wood, 35⅜". Metropolitan Museum of Art, NY.

Japan (9-20). It almost bursts into the space it inhabits; one of a pair, it was meant to drive away evil spirits by its fierceness. This dramatic "Guardian King" stands 27-1/2 feet or nearly three stories tall and was made in 1203 by Unkei, the most famous Japanese sculptor of his age, with the help of many assistants. The guardian's furious expression and violent pose seem threatening to us but were reassuring to the worshippers who entered the Buddhist temple he protected. It is as if the Buddhist artist attempted to capture the frightening, demonic forces in the universe and turn them to a positive end.

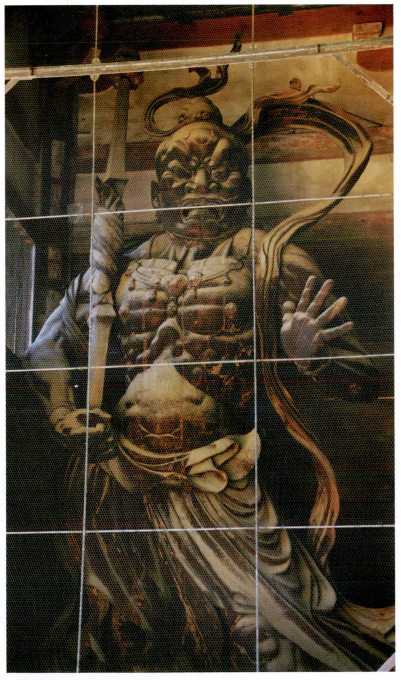

9/20 UNKEI, *Kongorikishi* (guardian figure), 1203. Wood, 27½' high. Todaiji Temple, Nara, Japan.

THE WOOD SCULPTURES OF
MARTIN PURYEAR:
HANDMADE CONTEMPORARY ART

A combination of sincerity and a sense of peace characterizes the abstract wooden sculptures of Martin Puryear. While recognition was slow to come to him (he did not have a solo show in New York City until he was forty-six years old), his selection to represent the United States at the São Paulo Bienal in 1989, and his first-prize award, mark him as one of the most important contemporary sculptors. Puryear grew up in Washington, D.C., but he has had a truly international education. After graduating from college in 1963, he joined the Peace Corps. His African assignment in Sierra Leone had a profound effect on the young black artist. Even though he was there primarily as a teacher, he learned a great deal about art, too. He experienced tribal image-making firsthand, studied the methods of the traditional wood carvers, and saw, he said, "a level beyond" realism. Puryear found that abstraction could be more alive than representational art; it could have a magic quality. After his term was over, he went to Stockholm and researched Scandinavian woodworking methods. He has since studied traditional Japanese and Mongolian crafts. He likes working in wood because "if you've got the right tools, you can do it all using your own physical body power."

Puryear's sculpture has been compared to the purity and clean lines of Minimalism (see Chapter 20) because of the simple nature of his forms, but he dislikes the label. "I was never interested in making cool, distilled pure objects. Although idea and form are ultimately paramount in my work, so are chance, accident, and rawness." For *Plenty's Boast* (9-21), Puryear appears to have drawn inspiration from brass horns and a Thanksgiving cornucopia. It also resembles a domestic animal curled up on the floor, letting out a big yawn. At a distance, the sculpture seems carefully refined and sanded, while up close one can see that Puryear does not cover up the signs of the process he used to construct his art. These are clearly handcrafted sculptures. Puryear says, "I enjoy and need to work with my hands." The marks of the staples that held the wood together during gluing are still there. He never sands his woodwork, but planes it, leaving a rougher surface.

Each of Puryear's sculptures seems to change personality as you walk around it. From one angle, it might look like a bent megaphone, from another, a collection of hooped hat boxes. Like much contemporary art, Puryear's work carries many associations from different artists and cultures, but he has also managed to fuse these diverse sources into coherent, whole, earthbound sculptures. This may explain why his organic abstractions have a gentle, calming effect on the viewer.

9/21 MARTIN PURYEAR, *Plenty's Boast*, 1994–1995. Red cedar and pine, 68" × 83" × 118". The Nelson-Atkins Museum of Art, Kansas City, MO.

STONE CARVING

The most famous sculptures in the Western tradition, like the *Venus de Milo* (12-19) or Michelangelo's *David* (14-16), are examples of master carving in stone. Sculptors working on stone use metal tools of three types: the *point*, the *claw*, and the *chisel*. The point is used to cut into the stone block, the claw to continue shaping the form, and the chisel to add detail and finish to the stone surface. Because Michelangelo's *Atlas Slave* (9-22) was never finished, we can be grateful for a rare view of the Renaissance master at work. Originally intended as one of forty figures for the tomb of Pope Julius II (see Chapter 14), the sculpture exemplifies Michelangelo's unique view of the sculptural process. He might take months to select a stone because he believed if he chose it properly, his sculpture was already in the marble block. His task was simply to remove the excess and release the figure within.

The slave does appear to be struggling to emerge from the stone. Because some parts were hardly touched, we can see the rough outlines of the original stone. A closer look reveals the different stages of carving. If we look at the prisoner's left foot, we can see the rough scrapes of the master's claw and the increasing polish as we follow up his leg. Some parts have already been smoothed by sanding, but much work remains to be done. We can easily imagine the artist at work, carefully pounding his wooden mallet onto a chisel as chips of stone fall to the floor.

Although Michelangelo's artistic ability is legendary, few other artists have equaled the skill of the Italian Baroque sculptor Gianlorenzo Bernini. He had the ability not only to unlock complex figural groups from huge blocks of stone but also to finish the stone surface so beautifully that the illusion of texture, such as skin or hair, is created. In his *Apollo and Daphne* (see 9-5, 9-6), Bernini captures the miraculous moment when Daphne is transformed from a young woman into a tree. Although Apollo's hand grasps her side, he is soon to be disappointed. Daphne's toes are taking root; her fingers are sprouting branches and leaves (9-23). The fine details of this statue are miraculous, too. Marble is very brittle at this scale; one slip of a chisel and a branch would be lost. Notice how the smooth perfection of Bernini's carving contrasts with Michelangelo's muscular forms and Rodin's more robust modeling. In choosing this subject for his work, Bernini is deliberately demonstrating his own godlike power to transform marble into flesh, bark, and hair—just as the Goddess Gaia changed Daphne into a tree.

9/22 MICHELANGELO, *Atlas Slave*, c. 1513–1520. Marble, 9' 2". Galleria dell'Accademia, Florence, Italy.

9/23 GIANLORENZO BERNINI, detail of *Apollo and Daphne*, 1622–1625. Marble, life-size. Galleria Borghese, Rome, Italy.

MODERN SCULPTURAL METHODS: CONSTRUCTING AND ASSEMBLING

Like modern painters, modern sculptors have explored new media and techniques, some of which have been borrowed from industrial technology. Sculptor David Smith used methods of *welding* and *soldering* he learned while working as a young man in automobile and locomotive factories to build large stainless-steel structures where simple geometric forms are balanced against each other. (He remained a proud member of Local 2054 of the United Steel Workers of America his entire life.) The strength of welded-steel connections allowed Smith to use forms of enormous weight in an almost light-handed way. The steel rectangles, cylinders, and bars are arranged so the open areas between them become part of the design. Smith felt strongly that his work should be seen outside, in bright sunlight. He often added color by painting or texture by burnishing the surface of his finished composition, as with the swirling silvery lines that glint from the surface of *Cubi XII* (9-24), one of a series of twenty-eight similar sculptures made of hollow stainless-steel blocks.

9/24 DAVID SMITH, *Cubi XII*, April 7, 1963. Stainless steel, 109⅝" × 49¼" × 32¼". Gift of the Joseph H. Hirshhorn Foundation, 1972, Hirshhorn Museum and Sculpture Garden. Art © Estate of David Smith/Licensed by VAGA, New York, NY.

Like Smith's sculpture, Louise Nevelson's work is geometric and carefully constructed, but instead of being built from steel, her constructions are assembled from found wooden objects—scraps of wood with nail holes, pieces of furniture, anything that struck her fancy. Unlike Smith, Nevelson was never interested in the craft of sculpting: "I wanted the form, but I didn't care for the carving. I wanted something more immediate because my creativity was faster."

Trained in modern dance, Nevelson knew that she wanted to be an artist but spent decades searching for the form her artistic expression would take. In the 1950s (when she was already in her fifties), a cardboard box gave her the idea of arranging her wooden shapes within a box-frame. Soon she began to stack her boxes together to build larger sculptures, painting them a single color (usually black, white, or gold) in order to unify the whole. Later she created sculptural installations with her sculptures lining the walls of a gallery. Her method of working was intuitive; she was building wooden collages in three

dimensions, and she would try different arrangements until she was satisfied with the final composition. Note the wonderful variety of shapes within *Tropical Garden II* (9-25), and the precision with which Nevelson achieved a harmonious balance among these diverse visual elements. Here, a coat of black paint pulls everything together. The use of black also enhanced Nevelson's lighting; she compared herself to "an architect that's building through shadow and light and dark," creating a mysterious new world.

CONTEMPORARY APPROACHES

We have seen in this chapter that sculpture is a dynamic field, retaining methods used in the Ice Age but also developing new media and approaches. It is not hard to be swept up in the excitement over the possibilities for contemporary artists. Unexpected materials abound

as artists mix media, blur the line between freestanding sculpture and earth art, art and craft, sculpture and architecture. Some works, like *Kiss of Death* (9-26), even combine elements of two- and three-dimensional media.

MIXED MEDIA

As discussed in Chapter 5, mixed media, not surprisingly, refers to art that combines more than one of the media. It is most often used in reference to art that combines both two- and three-dimensional media. *Kiss of Death* is an unconventional mixed-media project created by the British team Tim Noble and Sue Webster. The sculptors shaped two constructions out of taxidermic birds and rodents: carrion crows, jackdaws, rooks, minks, and rats, combined with bones. These rather gruesome—though

 TIM NOBLE and SUE WEBSTER, *Kiss of Death*, 2003. Taxidermic animals (carrion crows, jackdaws, rooks, minks, and brown rats), various bones, light projector, and metal stand; overall: 70⅞" × 31½" × 19¹¹⁄₁₆". Solomon R. Guggenheim Museum, New York.

9/27 TONY OURSLER, *Woo*, 2003. Fiberglass sculpture, Sony VPL CS5 projector, DVD, DVD player, 33" × 35" × 16". Courtesy of the Artist and Metro Pictures.

combination of the familiar and the alien. The face mutters, sometimes seductively. When Oursler first exhibited these sculptures, he set up a room full of creatures varying in form, color, and human characteristics. One was clownlike, one wept constantly, while another had four eyes. Each was named like a character in a science fiction novel—Cyc, Sug, and Coo. Their eyes seemed to be seeking out the visitors. One said, "dreamy, dreamy, come here." Although these forms are three-dimensional, their combination with two-dimensional video images and sound brings them to life.

The latest technologies are put in the service of storytelling and memories in Stephanie Lempert's sculptures. Lempert has long been interested in what makes an object important to us. She believes meaning comes from the memories linked with it, its connection to our past. After interviewing one hundred people about their most cherished objects and the stories associated with them, she had them write their stories. She then photographed both the object and the handwritten story. After scanning these images into her computer's 3D modeling software (see Chapter 8), she bent the handwriting so it wrapped around the object. With the aid of newly developed three-dimensional prototypers, she *printed* sculptures that are the mementos themselves but constructed out of the stories—in the storyteller's own handwriting. For example, *Fly Away?* (9-28), appears to be simply a birdcage with its door left open. However, the cage is actually built out of a string of words, which tell the story of a little boy's visit to his Aunt's house after seeing a magician make a bird disappear.

strangely fascinating—assemblages were set on poles, then lights were positioned so that they cast silhouette portraits of the artists. The shadow portrait of Noble seems to show a crow pecking out one of his eyes. The entire effect is rather bizarre, horrible, yet humorous.

Tony Oursler's art combines sculpture, video projection, and installation. The sculpture *Woo* (9-27) from 2003 is a simple biomorphic shape made of painted white fiberglass, but it comes to life when a disturbing video of bulbous eyes and a mouth in constant motion is projected onto the form. The result is a strange

9/28 STEPHANIE LEMPERT, *Fly Away?*, 2011. Rapid prototype plastic sculpture, 18" × 9" × 9". Courtesy of Claire Oliver Gallery, New York.

9/29 PATRICK DOUGHERTY, *A Cappella*, 2003–2005. Willow and bay laurel saplings, 35' × 25' × 25'. Photo: Rod Johnson.

Despite its genesis in computer software and machinery, the plastic sculpture that results is far from mechanical. The handwritten text makes delicate strands more reminiscent of lace than plastic. Words and phrases like *birdcage*, *watched with amazement*, and *canary* can be read along its edges. Just a few years ago, three-dimensional printing was a very expensive and experimental process. However, in 2011, printers became available that cost $1,000 or less, making this new, exciting technology affordable for many artists and sculptors. Who knows what's ahead for sculpture as another new digital technology adds fresh possibilities to our most ancient art form?

Nonetheless, contemporary sculptors continue to investigate some of the oldest materials known to us. Patrick Dougherty explores the boundaries between installation and Earth Art by building temporary site-specific pieces using age-old, natural materials. He designs a unique construction for each site, using local materials such as tree saplings and sticks. For his *A Cappella* (9-29), built at an arts center in California, Dougherty created a "private sanctuary":

> I could see a baroque folly in the wild wood made from branches and serving as a kind of forest confessional where the lore of trees might unfold. It could be an elegantly domed nest with an arched doorway that beckoned to morning walkers.

In fact, viewers are welcome to enter Dougherty's constructions, passing in and out of the sculpted space, truly experiencing both the inside and outside of this magical sculpture in the round. Depending on where one stands, one's experience of both the space and the texture of the walls is ever-changing. In some ways, his works are more like architecture, while their temporary life span and natural materials and settings tie them to installations and Earth Art. Once built, they are meant to last only a few seasons until they collapse, disintegrate, and ultimately disappear back into the earth (though many, like this one, are eventually dismantled). Dougherty was delighted by the reaction to his "pantheistic hideaway," as he heard comments like: "Honey, we could live here. No, honestly, we could."

As we have seen with each of the media explored so far, contemporary approaches have led to a blurring of the lines between all of the media, much like the current blurring of the lines between journalism, history, and fiction in literature; documentary and fantasy in film; or reality and performance on television. In the next chapter we explore the ways in which architecture is a distinct three-dimensional medium, and again how contemporary architects are breaking through barriers to create innovative and exciting art forms.

CHAPTER 10

ARCHITECTURE

Architecture has been called both the greatest and the least of the arts. The architect Walter Gropius called it "the most public of arts." Because important buildings often incorporate sculpture, paintings, murals, frescos, or mosaics, as well as decorative objects, architecture is also known as the Queen of the Arts, uniting and ruling over a kingdom of different media. Architecture is also simply the largest art form, with pyramids, fortresses, and skyscrapers rivaling the drama of mountains and other natural wonders. A city like New York, Tokyo, Paris, or Rome—a collection of structures designed and built by humans—is as much a "wonder of the world" as the Grand Canyon.

Yet architecture is sometimes considered less pure than the arts of painting and sculpture because, like the decorative arts and design, it is meant to be *useful*. We do not put buildings or bridges on pedestals or hang them on gallery walls; we live in them, we move through them, and often we do not see them as art at all. But architecture is the most omnipresent form of art. Because it is experienced by nearly everyone on our planet, architecture can be said to be a universal art form. Instead of

FRANK GEHRY, Sketch for Guggenheim Museum of Art, Bilbao, Spain, 1997. Drawing courtesy Gehry Partners, LLP.

needing to search it out, all we need to do is open our eyes, because architecture of some kind surrounds us wherever we live.

Like sculpture, architecture is a three-dimensional art form; it cannot be comprehended in a single glance or understood by standing in only one spot. Yet architecture seems to exist in more than three dimensions. Because most structures are designed to have both an outside and an inside, to really appreciate a work of architecture, we must walk not only around it but also *through* it. As we relate interior to exterior views in our minds, structures exist in memory as well as space and therefore acquire the fourth dimension of *time*.

THE ARCHITECT AS ARTIST AND ENGINEER: PLANNING

The architect must be a cross between a pure artist and an engineer, because a building is not meant only to be seen; it must also be functional. Buildings have to match the purpose for which they are constructed. A train station must funnel thousands of people in and out; a home should be comfortable and hospitable. Floors must support each other; walls should not fall in or out. Skyscrapers should be able to withstand high winds and even earthquakes. In modern buildings, the architect must also plan for services such as heating, cooling, electricity, and air circulation. Besides aesthetics and engineering, there is also a business side to architecture. As in all commissioned art, the architect must consider the needs of the patron and the cost of materials in any design decision. Yet the truly great architecture has combined those practical needs with imagination.

For centuries, architects have explored ideas by making drawings, just like other artists. Frank Gehry's early sketch for his iconic *Guggenheim Museum* in Bilbao, Spain (10-1) seems very unlikely to result in a finished building. It appears more like a scribble than a structure, but Gehry was determined to construct a monumental museum that had "movement and feeling." This imaginative musing ultimately led to a design process

that is followed by all architects, which demands more precise formal drawings. These include *floor plans*, or flat views from above; **elevations**, or views from the sides (10-2); and **perspectives**, views that give a three-dimensional impression of the new building in its setting. Three-dimensional models are also an important part of the process. Usually built from cardboard, Styrofoam, and wood, these models allow architects to study the forms and spaces as the building's plans proceed. The planning process is complex and can take years before actual construction begins. Yet, by comparing a photograph of the finished building (10-3) to the first sketch, you can see how close it is to Gehry's original conception.

The digital age has had a huge impact on architecture, just as it has had on many of the other artistic media. It has changed not only the planning process but also the methods that all architects use for designing and engineering buildings. In the past, working with metals and glass required a fundamentally box-like approach for the necessary structural strength to hold

10/2 FRANK GEHRY, Guggenheim Museum of Art, Bilbao, Spain, 1997. Drawing of the north elevation. Drawing courtesy Gehry Partners, LLP.

10/3 FRANK GEHRY, Guggenheim Museum of Art, Bilbao, Spain, 1997.

the great weight of a building. Frank Gehry's design for the *Guggenheim Museum* in Bilbao is in part a reaction to such structures. He said, "most of our cities built since the war [World War II] are bland. They are modernist and cold." **Computer-aided design (CAD)** allowed Gehry to utilize metal construction and also to move beyond straight lines and right angles, freeing him to use voluptuous curves and unusual slants. He took advantage of these new techniques to create architecture that would have been, if not unimaginable, certainly impossible to build thirty years ago. Bilbao appears more like a huge abstract sculpture than a building. Its steel forms clad in titanium swell and flow in sensuous shapes that come to a dynamic, asymmetrical balance. Heavy forms seem to blow in the wind.

One might guess that the complexity of the building was a construction crew's nightmare. Few joints meet at right angles and little is predictable, so detailed three-dimensional drawings were required for every location in the huge 250,000-square-foot building. The blueprints for buildings by Gehry are thicker than the last Harry Potter book and filled with intricate computer illustrations. But the people of Bilbao knew the effort was worth it. In the 1980s, their once-rich industrial city had fallen on hard times. The regional government commissioned Gehry in the hope that the museum would help revitalize the city. Nothing could have prepared them for the impact the Guggenheim Museum has had. Bilbao has become one of the most visited museums in Spain (on most days the curves of the museum are reflected in the long curves of people waiting to enter), and the city is now an important cultural center. The museum is a renowned work of art, and the success of its design has become the measure for all new museums.

HARMONY OF EXTERIOR AND INTERIOR DESIGN

Unlike other art forms, architecture has both an outside and an inside to be experienced, and the design of both aspects should be in harmony. Such harmony can be seen in the façade (the outward face of a building) and interior of the majestic *Dome of the Rock* (10-4) in Jerusalem. This early mosque was built in the seventh century—only a little more than fifty years after the death of the Prophet Muhammad—to commemorate the victory of Islam in capturing Jerusalem from the Byzantine Empire (see Chapter 13 for the history of Islam). The setting is the Temple Mount, a sacred space to three religions. It is believed to be the location where God tested Abraham by asking for the sacrifice of his son Isaac (Judaism), as well as the place from which Muhammad was taken to view both heaven and hell (Islam). The Temple Mount is also located next to the shrine of the Holy Sepulcher, where Jesus was thought to have been buried (Christianity). Because it is set on a hill, the *Dome* is visible throughout the city.

The octagonal shape of the mosque was probably inspired by early Christian sites in Jerusalem, similar

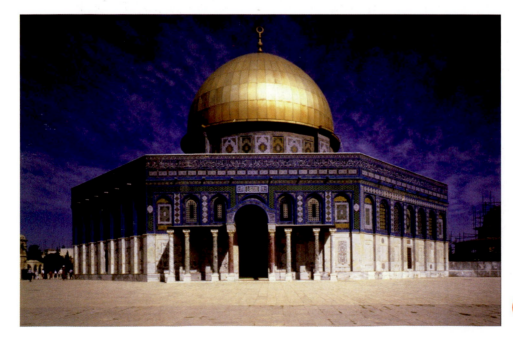

10/4 Dome of the Rock, Jerusalem, 687–692.

to St. Vitale in Ravenna (see Chapter 13), but here the wooden dome is much larger and more imposing than Roman and Byzantine domes. The combination of white and turquoise tiles and gold sparkles in the Middle Eastern sun, and is typical of many Islamic shrines. Inside the Dome of the Rock (10-5), the original mosaics (those on the outside were later replaced by tiles) glow with a golden light and impress us with their elaborate patterns of vines. Because the early Moslem religion rejected any attempt at realistic images as idolatrous, artists created decorative patterns to enrich the space that Christian houses of worship would fill with Bible stories. Both inside and outside, the lowest level of the mosque is made of beautiful marble pillars (taken from older Roman monuments), the upper levels with bands of mosaic or tile designs. At the center of the interior space is the sacred rock from which Muhammad rose to heaven, encircled by a low decorative wall.

HARMONY WITH NATURAL SETTING

The natural setting of each building also affects its appearance and often influences the way it is designed. To plan a successful building, an architect must consider local climate, available building materials, the building site, and its surroundings. The architect must also consider how to orient a building to take advantage of natural light, attractive views, and prevailing wind patterns. In certain climates, the design of exterior spaces, such as

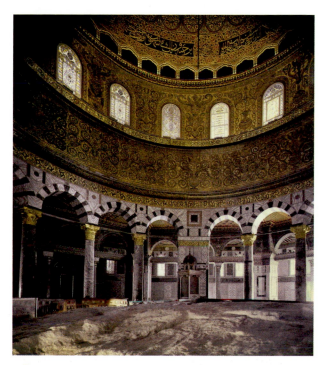

 Interior, Dome of the Rock, Jerusalem.

patios, courtyards, and **arcades** (covered walkways), can be just as important as that of the buildings. A beautiful example of the power of these spaces is the fourteenth-century *Court of the Lions* in the Alhambra palace in Spain (10-6). While light pours into the center of the king's private courtyard, the covered walkways provide both cool shelter from the hot sun of Spain and a glorious visual spectacle of pattern and rhythm through the

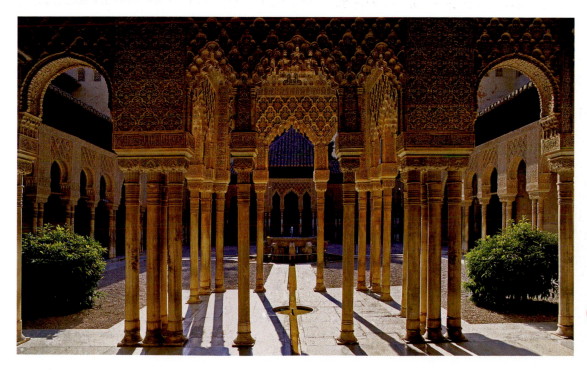

 Court of the Lions, Alhambra, Granada, Spain, 1354–1391.

harmony between the latticed light and the decoration of the columns and ceilings.

ART TO BE LIVED IN

Architecture is different from the other arts because it is lived in. Although some people might think of painting or printmaking as a luxury—pleasant but peripheral to our struggle for existence—a shelter is considered one of the necessities of life. Like a womb, architecture protects and encloses us from the hostile forces of the outer world.

Early humans found shelter in caves, made simple tents from animal hides, or built huts from locally available materials such as mud, sticks, grass, bamboo, and the bones of large animals. Even today some people live in traditional, handmade dwellings. Such indigenous shelters are rarely given the name of architecture, although they often reflect a sensitivity to the artistic principles of proportion, rhythm, and harmony. These types of buildings might be called "primitive," but they are often ideally suited to the climate and materials of a particular location. Developed over centuries, they are the result of communal efforts. That result can be both practical and

aesthetically satisfying, as can be seen in the rounded and symmetrical forms of a traditional Dogon village in Africa (10-7), as well as the pleasing geometric repetition of Pueblo villages in the American Southwest (see 10-16).

One name for the architecture of ordinary living is *vernacular* architecture, a term that refers to buildings built in a traditional, local style, without the assistance of a professional architect. There are as many styles of vernacular architecture as there are cultures in the world. In the United States, many regions have their own vernacular styles of housing, such as the log cabins of the American frontier, the Spanish-style haciendas of California, or the New England saltbox homes known as Cape Cods. Homesteaders on the prairies built their dwellings from sod, or blocks of earth, while the architecture of Native Americans ranged from longhouses to tepees to cliff dwellings.

Around the world, styles of vernacular architecture vary dramatically, as even today humans live in tents, homes on stilts, houseboats, and igloos, as well as simple houses of wood, stone, and clay, all decorated in the local style. From ranch houses to Victorian cottages, most of the architecture we live in is vernacular.

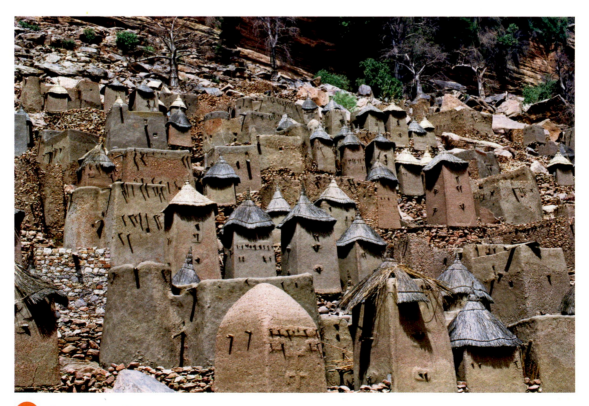

10/7 Dogon village, Mali.

A GLOBAL VIEW

THE WONDERS OF
THE WORLD

The concept of the Wonders of the World began in the ancient world. These seven wonders included the Great Pyramid of Giza in Egypt; the Hanging Gardens of Babylon; the Statue of Zeus at Olympia in Greece; the Temple of Artemis at Ephesus, Turkey; the Mausoleum (or tomb of King Maussollos) at Halicarnassus, Persia; The Colossus of Rhodes (a huge statue that spanned the harbor of Rhodes, in Greece); and the Lighthouse of Alexandria in Egypt. Only one—the Great Pyramid—still exists. Contemporary scholars point out that all of these ancient wonders were from a very small area of the world—from the Eastern Mediterranean to present-day Iran. Equally spectacular wonders that Europeans had no knowledge of, such as the Great Wall of China, never made the list.

Today, a similar but worldwide list of wonders has been compiled by the United Nations Educational, Scientific, and Cultural Organization (UNESCO). Currently, there are nearly a thousand sites on their World Heritage list, more than seven hundred of which are cultural sites. Not only does the United Nations select and identify these sites, but UNESCO works to target areas that are in danger and undertakes safeguarding and restoration efforts.

According to their philosophy, World Heritage sites are "irreplaceable sources of life and inspiration" that truly "belong to all the peoples of the world, irrespective of the territory on which they are located." That is, these cultural treasures are the heritage of all humankind, transcending political boundaries.

Many cultural World Heritage sites, like the original list of wonders, include monuments of architectural importance. At Borobudur on Java, in present-day Indonesia (10-8), a safeguarding campaign begun in 1972 had completed restoration by 1983. Estimated to have been constructed around 800 CE, Borobudur is a Buddhist site, about four hundred feet long on each side and almost one hundred feet tall, including hundreds of life-size statues of the Buddha and more than a thousand relief sculptures. Built on top of a hill, Borobudur is a *stupa* (see 12-12 and discussion of The Great Stupa), a place of worship that is not entered, but *circumambulated* (walked around). Here, one is meant to start at the lowest level and follow the walkways until one reaches the highest, circular level and a final stupa at the pinnacle of the hill. Along the way are relief sculptures showing the previous lives of Buddha, then scenes from

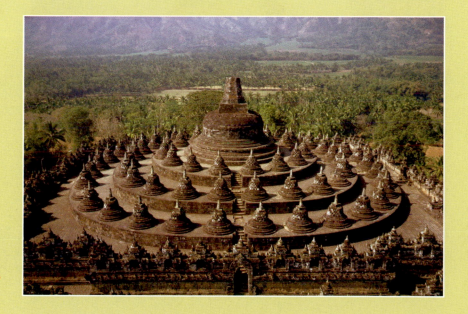

10/8 Borobudur, Java, Indonesia, c. 800.

THE WONDERS OF
THE WORLD

Buddha's life, and visions of heaven toward the top. If these reliefs were laid out in a row, they would be ten miles long!

Another successful restoration campaign took place in the Angkor Archeological Park of Cambodia, between 1993 and 2004. The most famous site in this area is the Hindu temple complex of Angkor Wat (10-9). Built by Suryavarman II, a King of the Khmer Empire, in the twelfth century, the temple had been overrun by vegetation, which is not surprising, because the Angkor Park is in the middle of a jungle. Angkor Wat is constructed in the shape of the symbolic "world mountain," with five peaks rising higher and higher toward the center.

Originally, it was surrounded by a moat of four thousand by five thousand feet, fed by a huge irrigation system. As at Borobudur, the stone walls are covered with beautiful relief sculptures—in this case, representing either the King or the Hindu God Vishnu in his various forms.

It would take hundreds of pictures to explore the glories of Borobudur and Angkor Wat, which are now preserved for humanity through the efforts of the United Nations. Other cultural wonders on the World Heritage list include Machu Picchu in Peru, the entire city of Venice, Italy, and the pyramids at Giza—the only original remaining wonder of the ancient world.

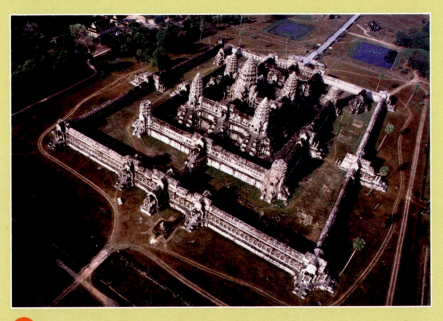

10/9 Angkor Wat, Ankor, Cambodia, first half of twelfth century.

THE PARTHENON

When historians look back to the beginnings of architecture as an art, they usually think of the magnificent structures of the great civilizations of the past. In the ancient world, temples, palaces, monuments, and tombs were the most important art forms. Also, because they are the most visible and lasting remnants of their era, their importance has actually been magnified by the passage of time. No examples of Greek mural painting remain; many statues of the golden age of Greece exist only in later Roman copies. But the architecture of the Athenian *Acropolis* (10-10) lives on as a symbol of Greek culture, equivalent to the *Iliad*, the *Odyssey*, and the works of the

great Greek dramatists and philosophers. The Greeks built edifices that speak of human intellect separate and above earthly concerns.

The word *acropolis* means simply "high place," and the Greeks chose such a hill in Athens as a setting for their most important religious center. In 480 BCE, during the Persian Wars, the original buildings and statues were destroyed, but the Athenians decided to rebuild the temples to be even more magnificent. The centerpiece of the new design was the famous *Parthenon* (seen at the top of 10-10 and 10-11), a temple devoted to Athena, the patron goddess of the city. Its marble exterior enclosed a magnificent forty-foot statue of the goddess in ivory and

gold created by Phidias, the most famous sculptor of the day. The fame of the temple's architects has lasted, too. Almost twenty-five hundred years later, we still know their names—Iktinos and Kallikrates.

Like any building with a long history, the Parthenon has had many different occupants and functions over the centuries. It became a Christian church during the era of the Holy Roman Empire and an Islamic mosque in later centuries. For two thousand years, it remained largely intact, not the ruin we see today. Then, in 1687, while being used by the Ottoman Turks to store gunpowder, it suffered a direct rocket hit from the forces of the warring Venetians, and much of the interior was blown up. In 1801, a British aristocrat found many of the priceless marble statues lying about in a state of disrepair. According to one's viewpoint, Lord Elgin either saved or stole these statues by shipping them off to England, where they remain today, known as The Elgin Marbles in the British Museum (see Art Issues box in Chapter 12). Despite all its troubles, the Parthenon is probably the most famous, and most studied, human-made structure in the world.

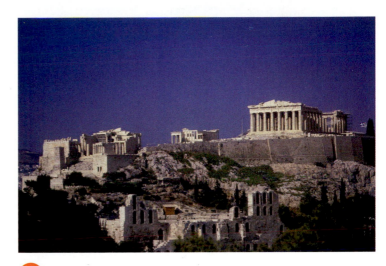

10/10 Acropolis, Athens, Greece.

THE GREEK ORDERS

The *Doric* column used in the design of the Parthenon **(10-12)** was the earliest and simplest of the *Greek orders* (column style). Doric columns were unornamented, almost severe in their plainness. This purity was characteristic of early Greek art. For the Greeks, beauty was to be found in perfection of line, shape, and proportion, not excess decoration. This simplicity, this harmony and repose, gives the Parthenon its universal appeal. Because of the abstract geometric beauty of their designs, Greek

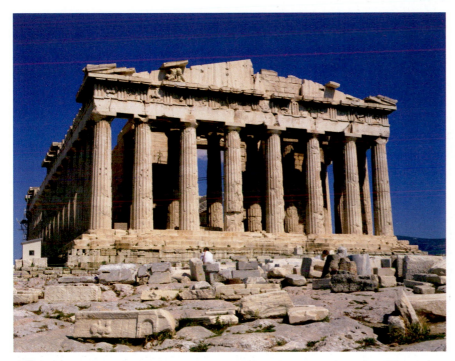

10/11 IKTINOS and KALLIKRATES, rear view of the Parthenon, Acropolis, Athens, Greece, 448–432 BCE.

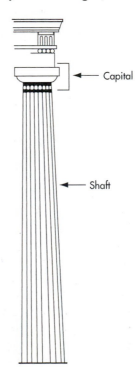

Capital

Shaft

10/12 Doric

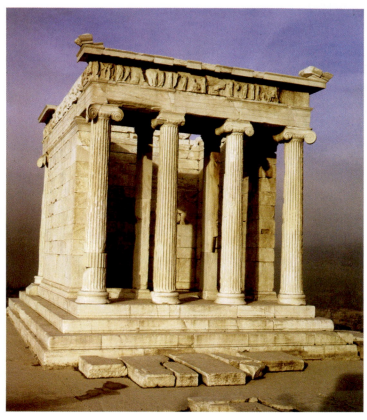

10/13 KALLIKRATES, the Temple of Athena Nike, Acropolis, Athens, Greece, 427–424 BCE.

10/14 Ionic **10/15** Corinthian

temples have been compared by many art historians to works of sculpture. This is certainly demonstrated by the exquisite design of the *Temple of Athena Nike* (10-13), also on the Acropolis. In this little temple, slim *Ionic* columns (10-14), their **capitals** (tops) adorned with graceful **volutes** (spirals), harmonize with the delicate proportions of the structure. A more decorative order, the *Corinthian* column (10-15) was rarely used by the Greeks. It was more consistent with later Roman tastes; the famous *Pantheon* (see 12-27) uses Corinthian columns both outside and inside.

MATERIALS AND METHODS

Architectural structures have been categorized and described in many different ways. Just as two- and three-dimensional art forms can be discussed in terms of both their materials (or media) and techniques, so various types of architecture can be organized by building matter—such as stone, wood, clay, brick, glass, and steel—and their method of construction. Each material has different visual, tactile, and tensile qualities; each produces a different impression; and each is capable of being used to construct structures of different sizes and shapes.

EARTH, CLAY, AND BRICK

One way to build is simply to pile up dirt, mud, or clay to form walls. **Adobe** is a kind of sun-dried brick, made of clay mixed with straw, which was used by Native American tribes in the Southwest to build their settlements. In Taos, New Mexico, traditional adobe *pueblos* (10-16), first constructed about five hundred years ago, are still in use and utilize the **bearing wall** method, where the walls support the weight of the roof and floors above. The sun-dried mud bricks are stacked to form thick walls, which are stuck together with a mortar of wet mud. Each building is topped with logs that protrude from the outer wall. Branches and grass are laid over these logs to form a roof, which is then covered with another thick layer of mud. Finally, the outlines of the bricks are hidden by a hand-smoothed coating of mud, or adobe plaster, which can be refreshed every year.

In adobe construction, the window openings must necessarily be small, since the walls are what hold these structures up. This is actually an advantage in a desert climate, where it is beneficial to keep light, and heat, out of the buildings. The massive mud walls act

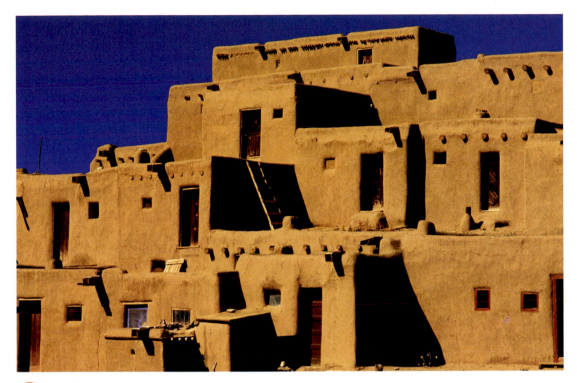

10/16 Taos Pueblo, Taos, New Mexico.

as natural temperature regulators, providing shade and coolness during the heat of the day as the walls absorb the sun's energy. At night, as the environment cools, these same walls release their heat slowly and keep interior temperatures relatively stable and comfortable. The same process keeps the clay buildings in a Dogon village (10-7) relatively cool even in the heat of Mali, Africa. Long before air-conditioning, and with optimal energy efficiency, these peoples on opposite sides of the world used natural materials to construct attractive and comfortable dwellings.

Bricks are blocks made of clay, usually hardened by being baked in ovens or kilns. Kiln-fired bricks can be glazed in different colors and arranged in interesting patterns. During the early years of the American republic, or what is called the *Federal period* in architecture, many attractive American mansions, such as Thomas Jefferson's *Monticello* (see 10-37), were constructed of brick.

STONE

Buildings made of brick are sometimes referred to as being constructed of *masonry*, but that term is more commonly used when talking about structures built of blocks of stone, such as marble or granite. Stone or masonry construction has historically been associated with strength. Castles, fortresses, and the protective walls around settlements were typically built out of stone.

Masonry construction was preferred for buildings that were meant to last.

The history of stone buildings is also a story of efforts to create larger openings and wider interior spaces. The Greeks perfected a form of construction called **post-and-lintel** (10-17), where posts or columns support horizontal lintels or cross beams. The Parthenon (10-11) provides a clear example of this method. The heavy weight of stone lintels keeps the columns steady. This method permits more open buildings than those constructed by bearing-wall methods and is just as permanent. Temples built of stone thousands of years ago, like those on the Acropolis, are still standing.

10/17 Post-and-lintel

Keystone

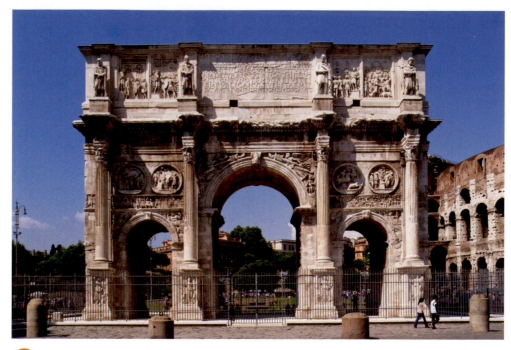

A later development in stone construction was the **round arch** (10-18), which was used extensively for the first time during the Roman Empire. The arch allowed far wider spaces between columns than did post-and-lintel construction. The huge entrances into the Colosseum in Rome (Chapter 12) are rounded arches. Triumphal arches like the *Arch of Constantine* (10-19) are excellent examples of the huge openings permitted by arches.

Such triumphal arches were constructed by the Romans throughout the Mediterranean world, as symbols of victory to mark their territory and reminders of their governing authority. Carved into the arches were relief sculptures illustrating military scenes and inscriptions that hailed the conquering heroes. The great size of the arches was necessary because of their part in

one of the most popular Roman events—the triumphal march. In these parades, trumpets would announce the arrival of their victorious generals on chariot, followed by Roman legions, slaves, conquered treasures, and humiliated enemies.

The use of the arch was expanded during the Middle Ages. **Barrel vaults** (10-20), as seen in the nave of the *Church of Sainte-Madeleine* at Vézelay in France (10-21), opened up large and long public spaces in stone buildings, particularly cathedrals. **Groin vaults** (10-20) are made by crossing two barrel vaults at right angles. Buildings made with barrel and groin vaults were, however, limited in height by the width of each arch. Only small windows were possible without weakening the stability of the arches. The awe-inspiring impression

BARREL VAULT

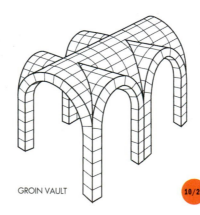

GROIN VAULT

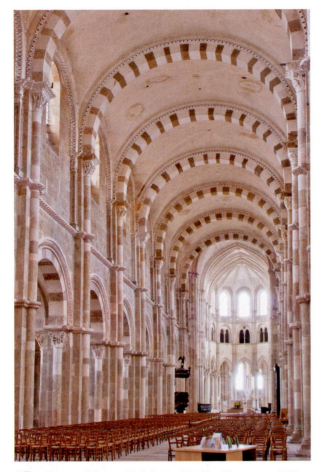

10/21 Nave of Sainte-Madeleine, Vézelay, France, twelfth century.

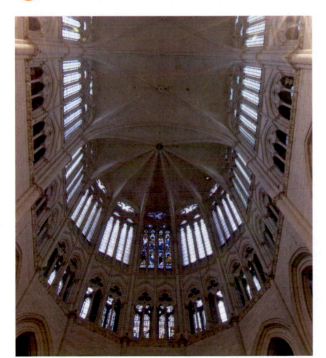

10/22 ROBERT DE LAZARCHES, THOMAS DE CORMONT, and RENAUD DE CORMONT, view of vaults, clerestory, and triforium of the Choir of Amiens Cathedral, France, begun 1220.

of Gothic cathedrals, like *Amiens Cathedral* in France (10-22), is a direct result of the desire to let more light into cathedrals, which led to the invention of the **pointed arch** (10-23). This allowed higher ceilings in the interior and large openings in the outer wall that were filled with glorious stained glass.

Stone has remained a popular and enduring material for building. Great mansions and palaces, as well as important public and religious buildings such as museums, churches, schools, and centers of government, were usually built of stone well into the twentieth century. Even today, when large buildings have skeletons of steel, architects often add stone facings in order to echo the architecture of the past, with its associations of stability, permanence, and grandeur.

WOOD

Because of our vast forests, Americans have traditionally made more buildings of wood than any other material. From the rustic log cabin to the suburban ranch, wood has been the common material for houses people live in, or what is known as *domestic* architecture. Typical dwellings in colonial New England were built from vertical wooden supports and sturdy horizontal wooden beams,

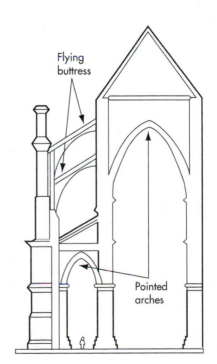

Flying buttress

Pointed arches

10/23 Pointed arches in the Gothic style

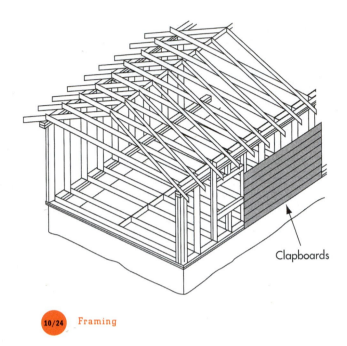

Clapboards

10/24 Framing

called **frame construction** (10-24), variations of which are still used today for most homes. The sides of the buildings were enclosed in clapboard, boards split or sawed so one edge was thinner than the other. These boards were then laid horizontally, overlapping so the thin edge was under the board above it in order to close out the harsh elements of a New England winter.

The American use of wood seems to have dictated primarily by convenience, rather than aesthetic preference. In Russia and Scandinavia, however, plentiful forests inspired a distinct architectural style that takes advantage of wood's natural beauty and versatility. Traditional Russian churches were constructed of unadorned axe-cut pine logs, joined completely without nails. The simple walls below contrast with elaborate wooden domes above, domes covered with multiple wooden shingles made of aspen. The Cathedral of the Transfiguration on Kizhi Island (10–25), built in 1714, sprouts twenty-two of these onion cupolas. Depending on the light, they sparkle like silver or glow like gold. Unfortunately, many such architectural wonders have fallen into ruin; in 1990, Kizhi was named a UNESCO world heritage site.

The Greene brothers were two California architects who valued the beauty of wood. Influenced by American traditions and a love of nature, developed a style of domestic housing that exploited the warmth of natural wood for both interiors and exteriors. Their *Gamble House* (10-26, 11-27) is an elaborate "bungalow" of more than eight thousand square feet built for an heir of the Procter & Gamble fortune. The outside of the building features large redwood timbers and overhanging eaves that protect the home from the California sun. Its open-air sleeping porches, believed to improve health through fresh air, were very popular at the turn of the twentieth century.

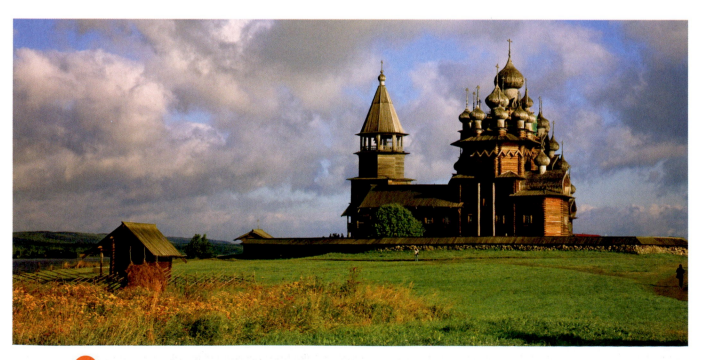

10/25 Cathedral of Transfiguration, 1714, Kihzi Island, Russia.

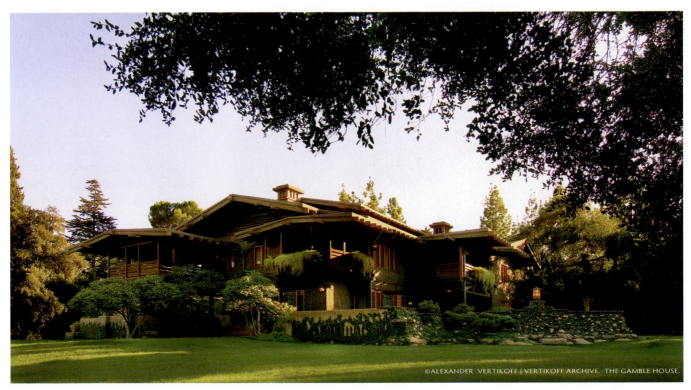

10/26 GREENE BROTHERS, Gamble House, Pasadena, California, 1908. Photo ©Alex Vertikoff. All rights reserved. For reproduction information, email info@vertikoff.com.

IRON AND GLASS

Until the nineteenth century, almost all buildings were made of clay, brick, stone, or wood. The industrial revolution created new techniques that made innovative building materials available. With the advent of coal furnaces and mass production, iron became one of the important new materials of the industrial age. This modern building material was often preferred for new types of buildings, such as factories, warehouses, railroad sheds, and large exhibition halls. Because iron was stronger than wood and lighter than stone, the pillars could be thinner and spaced farther apart than wood or stone posts. Cast-iron columns were combined with large panels of glass to make dramatic, airy exhibition halls, such as the famous *Crystal Palace*, built for the Great Exhibition of 1851 in London. The most famous and dramatic structure ever built of iron is the *Eiffel Tower* in Paris (10-27). At the time it was built, and for more than twenty-five years afterward, the Eiffel Tower was the tallest building in the world at one thousand feet high. The tower was built not by an architect but by an engineer and builder of bridges, Gustave Eiffel, who had previously designed the metal skeleton for the Statue of Liberty. Eiffel's tower was constructed as the focal point for the Paris Exhibition of 1889, one of the many popular international trade exhibits of the second half of the nineteenth century.

The Eiffel Tower was largely an experiment for the potential of iron as a building material. In fact, it was built over the objections of many of the successful artists and writers of the time, who considered its design to be hideously ugly. Later, however, modern artists became fascinated by the tower as a symbol of advanced technology, the machine age, and modern life.

STEEL AND GLASS

Despite its advantages, cast iron enjoyed a relatively brief period of popularity. Although it had been touted as fireproof, the dramatic Chicago fire of 1871 (and, ultimately, the burning of the Crystal Palace in 1936) proved otherwise. Iron actually melted at high temperatures, totally destroying the building it was meant to support. Yet something like iron was needed to hold up the new, taller buildings being constructed in large American cities.

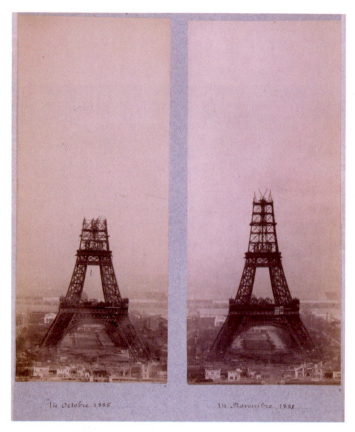
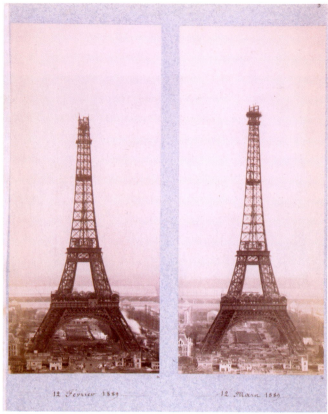

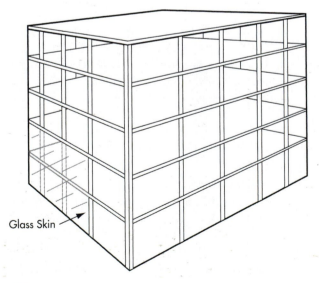

10/27 Construction of the Eiffel Tower, 1888–1889. Musée d'Orsay, Paris, France.

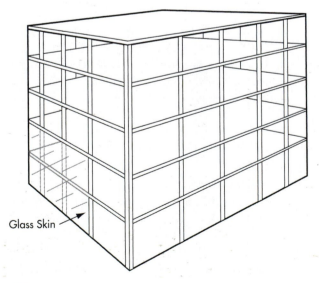

Glass Skin

10/28 Steel-frame construction

Luckily, a better material was available for the support of the new tall buildings—*steel*. Steel is both stronger and lighter than iron, and with the development of the steel industry in the 1890s, it became affordable for builders. With a new kind of construction, **steel frame** or **cage** (10-28), which employs an interior skeleton for the structure, neither stone walls nor wooden beams are needed for support. Therefore, what we see as the exterior "walls" of a steel frame building are often simply a "skin" of glass. This dramatic innovation in structural design is reputed to have been invented when an architect noticed his bird cage could support a heavy stack of books.

With a better material and a new building method, the way was cleared for an American invention—the *skyscraper*. The best of these tall steel-and-glass towers, or skyscrapers, convey a strong impression of lightness, refinement, and elegance. Such buildings were often used as giant symbols of corporate money, power, efficiency, and modernity during their heyday in the mid-twentieth century. Companies vied with each other as they commissioned new headquarters by the foremost architects of the period, attempting to outdo their neighbors in sheer size. One of the most notable, and well-designed, commercial structures was the *Seagram Building* (10-29) in New York by architects Ludwig Mies van der Rohe and Philip Johnson. Built from 1954 to 1958, its exterior is

Seagram Bldg
stepped back from
Street to Allow
skyline

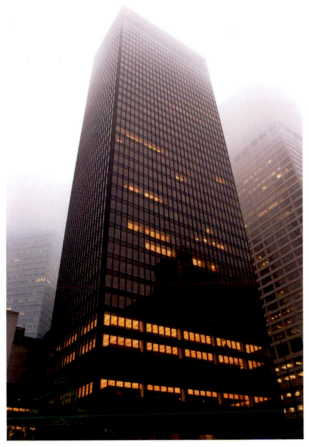

10/29 LUDWIG MIES VAN DER ROHE and PHILIP JOHNSON, Seagram Building, New York, 1956–1958.

made of amber-colored glass with bronze frames, or *mullions*. Because of this sensitive and unusual combination of materials, the building at night has been described as a giant "golden crystal."

REINFORCED CONCRETE

Reinforced concrete (or **ferroconcrete**) became another exciting new building material in the twentieth century. Although concrete (a mixture of cement, sand, and gravel) was a favorite material of the ancient Romans, reinforcing that material with small iron rods enabled architects to make structures that were not only strong but also shaped in dramatic new ways. Most buildings in the past were designed of intersecting geometric forms, such as boxes, cubes, and half-spheres. Buildings of reinforced concrete can be shaped organically as well as geometrically, with walls and roofs like swelling waves instead of straight lines. The *Trans World Airlines (TWA) Terminal* at Kennedy Airport in New York (10-30, 10-31), designed by Eero Saarinen in the late 1950s, is an excellent example of the radical potential of reinforced concrete. The building's lines, both interior and exterior, suggest dynamic motion. Looking at its swooping silhouette, one can imagine that the entire terminal has just landed and is almost ready to take off again. Interior features, such as ticket and information booths, signboards, and stairways, resemble organically shaped abstract sculptures.

Travelers were treated to a fascinating experience as they walked through the terminal. It seemed more like

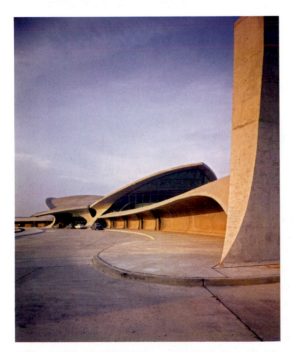

10/30 EERO SAARINEN, Trans World Airlines Terminal, Kennedy Airport, New York, 1956.

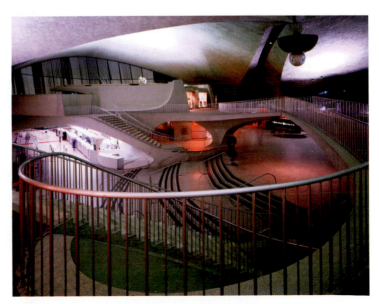

10/31 Interior of Trans World Airlines Terminal.

a living creature than an anonymous and prosaic box. Far more than most structures, Saarinen's Trans World Airlines Terminal exploits the symbolic possibilities of architecture as a three-dimensional art form. Every aspect of the building is meant to be "all of one thing," speaking of movement, flight, and escaping the bonds of gravity. Going beyond the idea of "form follows function," Saarinen's buildings are functional not merely in a practical sense but in a spiritual one as well.

Sadly, the terminal closed in 2001, when TWA went out of business after the events of September 11th. However, its architectural importance saved it from destruction. In 2008, JetBlue opened a new terminal next door and made the decision to preserve the old TWA building, which has since been restored. Today, planning continues to try to identify a way to allow travelers to once again experience this endangered landmark.

MIXED BUILDING MATERIALS

In the twentieth century, the mixing of materials became a common practice for architects, just as it did for other artists, and architects became freer to respond to their imagination. In 1936, the great American architect Frank Lloyd Wright made a preliminary visit to a site for a client's new home in the woods of Bear Run, Pennsylvania. After seeing a mountain stream with a waterfall, he came up with the inspired idea of placing the house over the cliff and letting the water pass underneath it. He utilized the relatively new *cantilevered* construction, where only one end of a beam is supported, while the other extends into space. This structure allowed the balconies of the house to seem to float above the waterfall. The result was a modern masterpiece, the Kaufman House (Fallingwater) **(10-32)**.

Fallingwater was constructed with a combination of sandstone, reinforced concrete, steel, and glass. Although these materials are more commonly used for building in cities, Wright's modern but organic approach integrated the home into its natural setting. The house rests on a rocky ledge, which forms its foundation. Fallingwater's bold shapes echo the ledge's forms. All of the building's stones are taken from a nearby quarry, a source of local

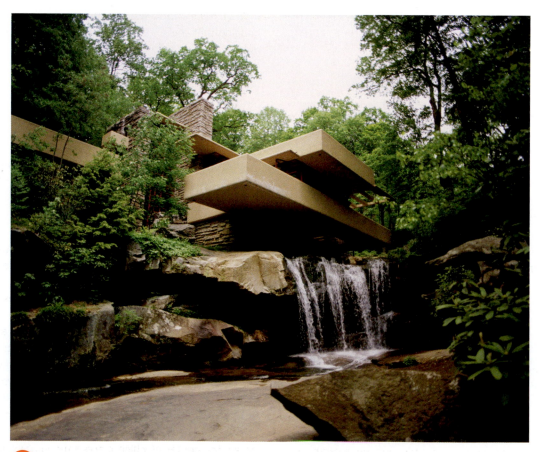

10/32 FRANK LLOYD WRIGHT, *Kaufman House (Fallingwater)*, *Bear Run, Pennsylvania, 1936–1939*.

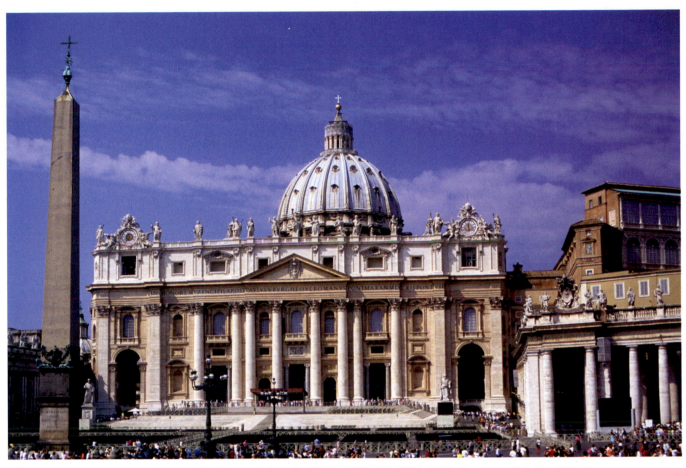

Saint Peter's Basilica, Rome, Italy. Apse and dome by MICHELANGELO, 1547–1564; dome completed by DELLA PORTA, 1588–1592; nave and façade by CARLO MADERNO, 1601–1626.

materials opened by Wright himself. The color of the concrete matches the back of a dry, fallen leaf found outside.

Surrounded by trees, the long glass walls keep the view of nature ever present inside Fallingwater. The sounds of the waterfall fill the house. The building is an imaginative blending of materials, organic and geometric forms, the seen and heard, interior and exterior, and the union of art and nature. Its brilliant design is famous throughout the world, and in 1991, the American Institute of Architects voted it the "best all-time work of American architecture."

ARCHITECTURE IS A PRODUCT OF ITS TIME AND THE PAST

Great architecture is a combination of many things. *Like all art, it reflects the needs and ideals of its time.* It is a powerful marriage of materials and structure, a dialogue with its natural setting, a solution to practical considerations, and an expression of ideals. It is built on a knowledge of contemporary methods and an awareness of forms of the past. Like all art, architecture is the tangible expression of the needs and ideals of the time period in which it was created. Let us focus on two closer studies of buildings. One, Saint Peter's Basilica in Rome, was the work of several architects over one hundred fifty years. The second was the personal vision of one man, Thomas Jefferson's home at Monticello.

SAINT PETER'S

Some of the greatest monuments of the past are the result of many years, several generations, or even centuries of work. *Saint Peter's Basilica* in Rome (10-33), the center of Catholicism and for centuries the largest church in the world, was constructed by four major (and several minor) architects over a period of a century and a half. In the early Renaissance, Pope Julius II decided to rebuild the decrepit and very ancient Saint Peter's Basilica. The pope wanted to create a new monument that would rival in size and splendor the Roman ruins that remained in the city. In 1506 the project was given to Donato Bramante, who designed a large church in the form of a cross, the center of which marked the spot where Saint Peter (an apostle of Christ and the first bishop, or pope,

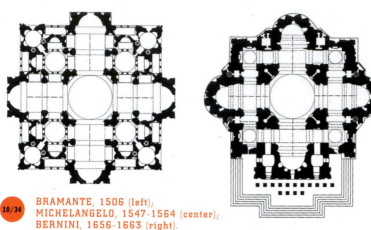

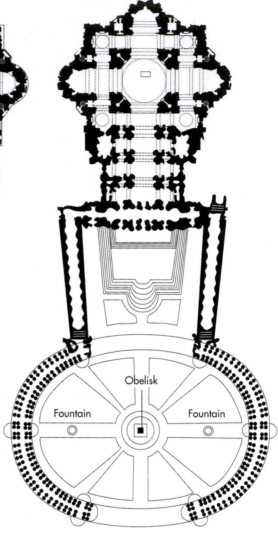

10/34 BRAMANTE, 1506 (left); MICHELANGELO, 1547-1564 (center); BERNINI, 1656-1663 (right).

of Rome) was supposed to have been buried. The ambitious interior *floor plan* (10-34, left) was actually based on a complex pattern of nine intersecting crosses, eight small domes, and one huge dome. Because of the mammoth scale of his plan, when Bramante died in 1514, very little of the building had been finished.

Michelangelo took charge of the project thirty-two years later. He criticized much of the work that had been done since Bramante's death and tried to return to the overall original plan, although with some simplifications. For example, he changed the interior space from many crosses into a single cross intersecting with a square (10-34, center). He redesigned the exterior, adding colossal columns. Michelangelo also planned a high central dome but later changed his mind in favor of a lower dome, more like Bramante's. But Michelangelo, too, did not live to see Saint Peter's completed. After his death an architect named Giacomo della Porta was given the job of building the dome, and he chose Michelangelo's earlier conception, probably because the higher dome was easier to build (10-35).

In 1603, almost one hundred years after work on Saint Peter's had begun, Carlo Maderno was given the job of enlarging and finishing the basilica. Maderno was directed to add a nave, or rectangular-shaped room, to the front of Michelangelo's Saint Peter's. He broke into the main façade of the building and projected out, changing the shape of the structure and bringing it forward into Saint Peter's square. This new façade (see 10-33) destroyed the perfectly symmetrical proportions of the Renaissance building and obscured the dome.

The last major architect to contribute to Saint Peter's was Gianlorenzo Bernini, the most famous sculptor of his time (see Chapters 9 and 15). Once surrounded by noisy, narrow streets with wandering animals, Saint Peter's was given a more appropriate environment by Bernini. He sculpted the space in front of the building by means of a **colonnade**, or row of columns, and the addition of a **piazza**, or courtyard (10-34, right;

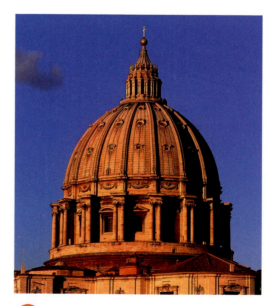

10/35 Dome of Saint Peter's Basilica, Rome, Italy.

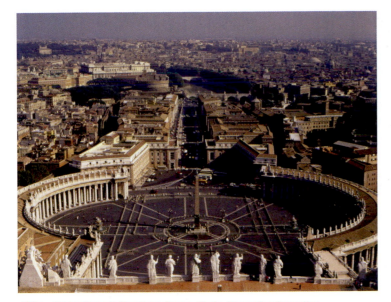

10/36 Saint Peter's Basilica, Rome, Italy. View of colonnades by BERNINI, 1656–1663.

10-36). His colonnade is like a pair of great arms that shelter a quiet, orderly courtyard from the distractions of everyday life and draw pilgrims into the entrance. Thus the building's surroundings became self-contained and harmonious.

MONTICELLO

Thomas Jefferson was a man of diverse talents and interests—a farmer, statesman, and scholar as well as an inventor and architect. Heir to a comfortable Virginia estate, he can be described as a gentleman-amateur architect, a type common in the eighteenth century. While serving as the American ambassador to France, he had visited Italy and had seen the ancient ruins. But even before visiting Europe, Jefferson had studied classical architecture through English books. Jefferson was attracted to Greek and Roman architecture because of its historical associations with good government, as well as its style and simplicity. Now that America was independent, he was eager to replace the British-influenced colonial style.

In *Monticello* (10-37), Jefferson had the chance to design his own dream house. The home took more than thirty years to complete to his satisfaction. Set on top

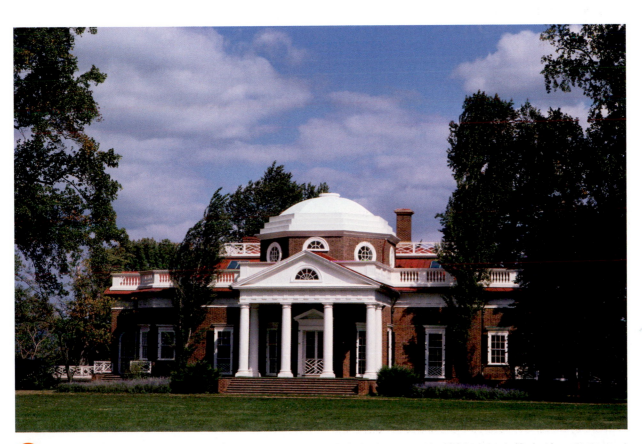

10/37 THOMAS JEFFERSON, Monticello, Charlottesville, Virginia, 1770–1806.

of a mountain (unlike other Southern plantation manors of the period), Monticello reveals an eighteenth-century taste for combining classical architectural elements, like columns, domes, and simple geometric shapes, with a natural, romantic setting. As a classical scholar, Jefferson was particularly fond of Roman poets, who described the delights of country life in a villa, and Jefferson wrote about the view from his home:

> Where has nature spread so rich a mantel under the eye? mountains, forests, rocks, rivers. With what majesty do we there ride above the storms! How sublime to look down into the house of nature, to see her clouds, hail, snow, rain, thunder, all fabricated at our feet! and the glorious sun, when rising as if out of a distant water, just gilding the tops of the mountains, and giving life to all nature!

Stripped of excess ornament and conveying a sense of purity, Monticello is harmonious and calm. Its beauty can be appreciated at first glance; carefully designed in human scale, the

10/39 BENJAMIN LATROBE, United States Capitol, Washington, D.C., designed c. 1815.

building does not overwhelm or awe the visitor. Monticello looks like what it is: a building meant to encourage a mood of speculation and intellectual pursuits, as well as gracious family living. The simple, empty room under the dome is particularly lovely, like a material representation of the human intellect, or Jefferson's extraordinary mind **(10-38)**.

But Jefferson's pursuit of ideal beauty and idyllic lifestyle had a darker side. Both the money and labor he used to create his dream house and the life he lived there were produced by slave labor. (Of course, this was also true of the Greek and Roman civilizations that he admired, although their slavery was not based on race.) Jefferson's *Monticello* reflects the ideals of individualism and respect for private property embraced by the founding fathers of the United States.

The powerful expression of ideals in architecture can influence building for decades, even centuries, to come. Monticello—itself a reflection of the endurance of classical Greek and Roman architectural ideals—had a profound and powerful effect on American architecture. Saint Peter's has also influenced countless buildings throughout the Western world. The style of our own *United States Capitol* building **(10-39)** owes as much to Michelangelo's

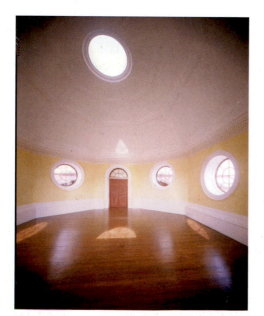

10/38 THOMAS JEFFERSON, interior of dome at Monticello.

dome as to Jefferson's promotion of neoclassicism for the government buildings of the new republic. It is just one example of the power of architecture to both express and transmit cultural values.

URBAN PLANNING

Beyond the design of individual buildings and their settings, contemporary architects are also concerned with *urban design* or *planning*. The question of how a city of the future should look is a fascinating one that has been answered in many ways during the past fifty years. This question has taken on special importance because many people find today's cities—with their crowding, traffic, crime, pollution, and lack of greenery—an unlivable nightmare.

When the Modern movement in architecture was at its height in the mid-twentieth century, a standard kind of plan was devised to reform the design of cities. One of the major innovators and creators of the new urban planning was Le Corbusier (10-40), a Swiss-born Frenchman who worked around the world. Le Corbusier designed any number of new neighborhoods and housing projects for cities from Paris to Pakistan; most were never built, but some were, and the ideas behind them became quite influential. The idea of these plans was to house people

in highrise apartment complexes, surrounded by parks and recreational areas. It was hoped that such developments would allow for both living and leisure. Pedestrian walkways would be separated from roadways, so people could walk without being bothered by cars, and vice versa.

The designs of Le Corbusier and others looked good on paper, but they rarely fit the tastes or needs of ordinary people. Human beings, it seems, prefer smaller, more separate residences and what might be called semiprivate space—like yards and gardens—to huge apartment dwellings surrounded by large, communal parks. One housing complex built on the modern plan, the Pruitt Igoe Housing Project in St. Louis, won an architect's award the year it was built but proved to be such a failure (because of crime and vandalism) that it was demolished about twenty-five years later. In 1960, a brand-new capital was opened in Brazil, called Brasilia. Built from scratch in an uninhabited portion of the country by followers of Le Corbusier, it was a "perfect" city, planned for the modern world. Today, it seems very dated; its concrete is crumbling, and its inhabitants are attempting to find ways to make the city livable.

CONTEMPORARY APPROACHES

As you might imagine from previous chapters, contemporary approaches to architecture both blur boundaries between different artistic media and make use of new technologies. Within the past decade, architecture has more than broken out of the glass-and-steel box (and variations thereof) that dominated twentieth-century modernist design, and has exploded in all directions, materially, visually, technologically, and conceptually.

Architect Zaha Hadid, born in Iraq but educated in London and practicing architecture around the world, began by attracting international attention for her innovative designs, yet most of her larger projects were never built. It is as if society had to enter the twenty-first century to have not just the capability but the courage to construct her dramatic, and dramatically different, museums, factories, bridges, and stations. Instead of rigid, geometric shapes, Hadid—like Frank Gehry (see 10-3)—prefers swooping lines and fluid spaces, designed using digital architectural design programs.

Her *MAXXI Museum* in Rome (10-41) is not just a neutral home for contemporary art, but a work of art in

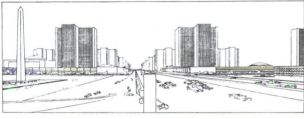

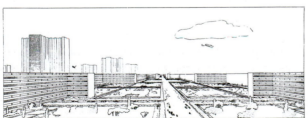

10/40 LE CORBUSIER, plan for a contemporary city for three million inhabitants, 1922.

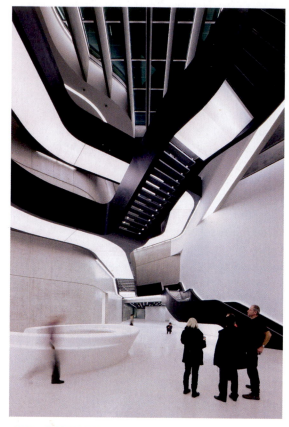

10/41 ZAHA HADID, MAXXII: Museum of XXI Century Art, interior, Rome, Italy, 2009. Courtesy Zaha Hadid Architects.

itself. In fact, when the museum first opened in 2009 no art was displayed for the first few months, so the building could be experienced without distraction. The MAXXI Museum's ramps, tunnels, and staircases suggest the energy of contemporary life, wrapping the visitors in sweeping architectural forms as they progress through the museum. For Hadid, the walls are not just for displaying art; they are "streams" forming galleries, connections, and bridges.

In 2004, Hadid became the first woman to win the prestigious Pritzker Architecture Prize. According to a member of the jury that made the award: "Hadid's fragmented geometry and fluid mobility do more than create an abstract, dynamic beauty; this is a body of work that explores and expresses the world that we live in."

As pioneering and novel as Hadid's works appear, and however challenging to construct, they can still be recognized as buildings. The same cannot be said for Diller & Scofidio's *Blur Building* (10-42), a pavilion designed for the Swiss National Expo in 2002. The husband-and-wife architects Elizabeth Diller and Ricardo Scofidio created a platform surrounded by a human-made mist, suspended over Lake Neuchâtel. Reached by

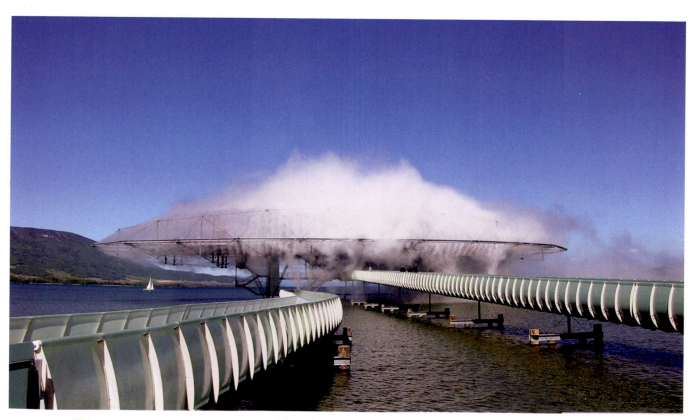

10/42 DILLER & SCOFIDIO, Blur Building, 2002.

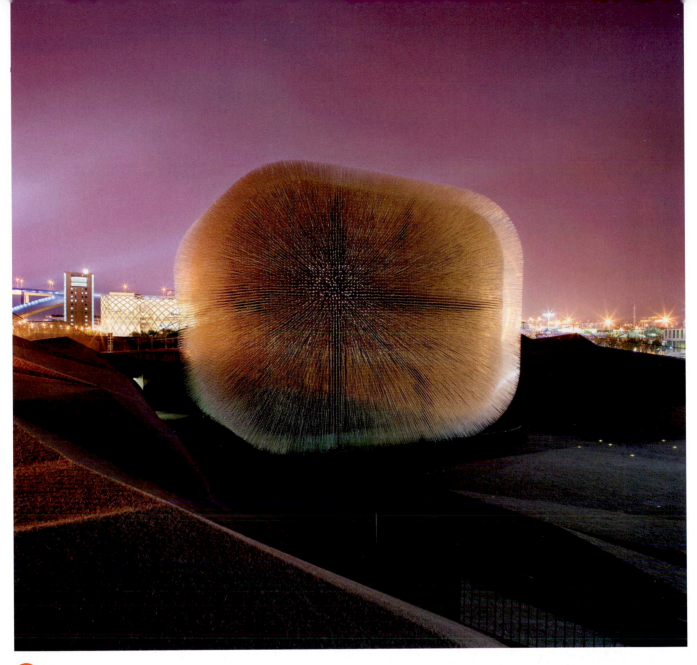

THOMAS HEATHERWICK, Seed Cathedral [UK Pavilion] at Shanghai Expo 2010.

a long ramp, the pavilion appeared like a cloud from the distance. Here the building material was neither stone, wood, steel, glass, nor any solid material, but water vapor sprayed by more than thirty-five thousand high-pressure nozzles. Visitors wore raincoats, like tourists at Niagara Falls. Once inside, they were immersed in white noise because of the roar of the nozzles and a visual white-out from the mist.

Architecture that is temporary, like the Blur Building, seems like a contradiction in terms, but it allows architects the freedom to experiment with new forms and materials without some of the traditional engineering concerns. Thomas Heatherwick's *United Kingdom* or *Seed Cathedral* (10-43) for the 2010 Shanghai Exposition was designed to be taken apart after five months. It was made of sixty thousand fiber-optic glass rods. In the daytime, sunlight moved down the rods toward the center

to illuminate the pavilion. At night, the glass rods were lit and became a glowing, breathing sculpture as they moved in the wind.

Each rod held some seeds at its tip, one of six thousand native Chinese plants. After the exhibition ended, the seeds were distributed to schools in China and the United Kingdom as part of a project to preserve threatened global plant life for future generations.

Contemporary architecture, like that of Heatherwick, Hadid, Diller, and Scofidio, is meant to be experienced and to challenge both our preconceptions about buildings and our ways of viewing the world. In that sense, they are as typical of contemporary fine artists as they are of architects. Our next chapter explores the various crafts media from which humans have made both useful and beautiful objects to decorate the inside and outside of architectural spaces.

DECORATIVE ARTS, CRAFTS, AND DESIGN

Everyday, useful objects—either handcrafted or designed to be mass-produced—are an immediate, accessible way for most of us to enjoy the power of art. Just as architecture is an art form we can experience directly, even live in, so *crafts* and other *applied* or *decorative arts* are things we live with. Attractive and functional, such ornamental items can be made of almost any material. Ceramics, glass, wood, metal, and fiber are some of the most common craft media, while the *design arts* can be reproduced in materials ranging from paper to steel. Because both crafts and design interact with us in our normal lives, they occupy a special place in people's hearts, giving pleasure that is both aesthetic and nostalgic.

What is the difference between fine art, decorative arts, crafts, and design? We posed this question in the first chapter and answered it by suggesting that the applied arts—decorative arts, crafts, and design—were meant to be used, while fine art exists simply to be admired, as "art for art's sake." In this chapter we complicate the question. Before the Renaissance in the West, there was no clear-cut distinction between a painter and the person who created the golden frame in which a painting was set—both were artists and craftsmen. Part of the Renaissance emphasis on individual genius was

to raise artists like Leonardo da Vinci and Michelangelo above craftspeople who made furniture, clothing, jewelry, or glassware. By the mid-nineteenth century, the applied arts were sometimes described as the minor arts, versus the major arts of painting and sculpture.

As explained in the first chapter, such distinctions did not exist in other parts of the world. In Japan, a teacup can be considered a priceless work of art (see "Global View" box). In the West, luxury goods—like expensive textiles, china, and silver—have been admired both for their aesthetic qualities and for the status they conferred on their owners. Precious and beautiful objects, from silver tea sets to cigarette cases, now fill the Decorative Arts galleries of many museums.

The advent of mass production had a particularly dramatic impact on artists' attitudes toward crafts and design. Hailed as a fabulous advance in supplying human needs, the Industrial Revolution of the late eighteenth and early nineteenth centuries began spewing out vast quantities of china, tableware, glasses, textiles, and furniture. At first, consumers were delighted with this mass production of cheap, ready-made goods that could be purchased for far less than their handmade ancestors. Manufacturing also opened positions for artists as professional designers of everything from carpets to lamps. However, artists

soon reacted against this flood of machine-made stuff. Some called for a return to traditional handcrafted objects, others for better design of manufactured goods. Today, some artists continue to make their own creations in home studios and sell them at craft fairs and stores specializing in unique objects, while others design industrial products for huge corporations. Both approaches can result in beautiful, and practical, works of art.

To further complicate matters, however, many contemporary artists use craft media—such as ceramics and fiber—to create works of art that clearly cannot be used. Once again, the line between media continues to blur in today's world. Nevertheless, the same elements of art—line, color, texture, shape—and the same principles of design, such as balance and harmony, apply to all of the visual arts, whether fine or applied, handmade or mass-produced.

We have divided this chapter into two sections: crafts and design. First we explore each of the major craft media—ceramics, glass, fiber, metal, and wood—both historically and as used by contemporary artists. Then, we consider the different fields of design, including graphic arts and industrial design. We end by looking at the fusion of many different media in interior and landscape design—the ultimate in multimedia arts.

THE CRAFT MEDIA

CERAMICS

Clay, used by sculptors to model statues, is also the media used to make what is known as **ceramics**. Clays are types of earth that have the property of becoming moldable, or **plastic**, when wet, and then more rigid again as they dry. Such material is transformed into *pottery* when it is heated in a closed oven, or kiln, until it becomes permanently hard. The art of ceramics, or pottery, is the result of two distinct processes—the molding of the object and the decoration of its surface. The final color and texture of a ceramic piece is affected by the variety of clay and the type of fire used, but the most important way of coloring and decorating anything made of ceramics is by glazing. A glaze is somewhat like paint, but ordinary paint would disintegrate under the high temperatures of the kiln. Glazes melt into and actually fuse with the clay of the ceramic while being heated. Usually ceramics are fired at least twice: once to set the shape of the piece, and again to incorporate the glaze onto its surface. Over the centuries, special methods of glazing

have been discovered, each creating a different effect on the surface of the fired clay.

For instance, the Chinese, who considered ceramics to be one of the highest forms of art, experimented with both firing temperatures and glazes to achieve exquisite results. Baking at a high temperature transformed their clay objects into a material of glasslike hardness called **stoneware** or **porcelain**, or what Europeans simply called "china." Chinese porcelain pieces were prized throughout the world for their elegance, purity of design, and delicacy, which symbolized their expense. The production of fine porcelain also spread to Korea, where this *Pear-shaped Vase* (11-1) was fashioned during the Koryo period, in the thirteenth century. Although this vessel looks like a vase for flowers, it was designed to hold alcohol, like the small china bottles used to serve sake in Japanese restaurants today. The pale green color of the vase, called celadon, was highly prized for its resemblance to precious jade. The perfection of the silhouette, the thinness of the ceramic walls, and the subtle floral decorations in white and darker green (encrusted under the glaze) transform

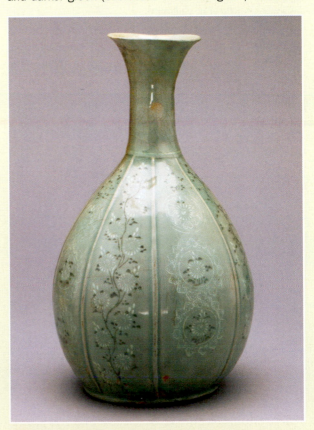

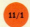 *Pear-shaped Vase for Alcohol*, 12–13th centuries. Korea, Koryo period. Celadon ceramic, with incrustations of glaze, 12¾". Musée des Arts Asiatiques-Guimet, Paris, France.

this simple clay vessel into an aristocratic status symbol, similar to those created in China during the same period.

The process of glazing is important for practical as well as decorative reasons. Not all pottery is fired at the high temperatures required to produce the glassy hardness of porcelain. More porous earthenwares require a glaze to become sealed. This is particularly important because the primary use of pottery has always been for making *vessels*, or containers. Before the development of plastic, or the manufacture of glass and metals in large quantities, ceramic vessels performed vital functions for the societies that created them. Used in such everyday activities as eating and drinking, as well as in special religious rituals and ceremonies, vessels were both a necessity of life and a means of artistic expression.

Several methods are possible for making vessels out of clay. The easiest is by simply pinching and shaping the clay into the desired shape. Another technique is to build the container by flattening clay like cookie dough and cutting out slabs that can be pressed together to form boxlike shapes. Another common way to make pottery containers is by coiling long ropes of clay and forming them into the desired shape, then smoothing out their sides by hand. This is the method used by Native Americans. Such ways of building pots by hand allow the

11/2 MARÍA MONTOYA MARTÍNEZ and JULIAN MARTÍNEZ, *Jar with feathers and an avanyu*, 1934–1943. Matte black-on-black earthenware. Museum of Fine Arts, Houston, Texas.

artist great freedom in determining the size and contours of the vessel, which can be rounded or rectangular, asymmetrical, or any shape at all.

María Martínez and her husband, Julian, were twentieth-century potters who worked in the traditional Native American methods (11-2); she built pots by hand, and he decorated them. Almost by accident, they also developed a totally new style of ceramics. During an archeological dig near their home, the San Ildefonso pueblo in New Mexico, María was approached by scholars who asked her to recreate a type of black pottery that had been found only in fragments. After studying the pieces, she reconstructed the shape of an entire pot, while Julian attempted to copy the black color by smoking the pots in a fire. When the experimental pottery was admired by visitors, the couple began to try out different methods of black-on-black decoration. The final result was a unique type of pottery in which the shiny black pot is painted with a design in **matte** (or dull) black. Julian Martínez adapted these designs from historic American Indian patterns.

The invention of what is called the potter's wheel (as long ago as 4000 BCE) was a technical advance on the laborious methods of forming ceramic vessels. The wheel is actually a horizontal disc mounted on a vertical pole; the speed at which the wheel whirls is controlled by the potter. As the wheel turns, a lump of clay can be lifted and shaped by hand into a vessel, in an action called **throwing**. There is something fascinating about watching a potter at work, live or on film, and observing the drama of the craftsperson creating a vase, cup, or bowl out of a clump of earth. The sides of the vessel actually seem to grow up from the moving wheel as if springing to life. In contrast to clay vessels made by hand building, thrown pots are always rounded and symmetrical. However, the wheel has not completely replaced methods of coiling and constructing; peoples around the world and contemporary artists still use all three methods.

The ancient Greeks used the potter's wheel to make symmetrical vessels for storing and serving both foods and liquids, like the *Exekias* amphora. Such *amphora* (vessels with two handles) were often decorated with episodes from the myths of the Greek gods and heroes. The *Exekias* amphora of the sixth century is named after an ancient artist, both potter and painter, who signed his work prominently. This painting shows a scene from Homer's epic poem the *Iliad*, the heroes Achilles and Ajax intent on a game somewhat like modern checkers (11-3). In order to achieve this black-figured decoration, the potter painted the design in a thinned clay (or *slip*) that turned black during firing. He also incised fine lines into the clay.

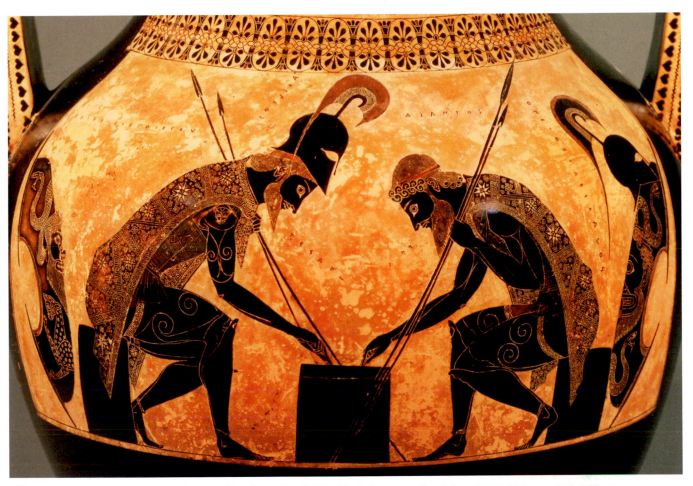

11/3 EXEKIAS, *Achilles and Ajax Playing a Dice Game* (detail Attic black-figure amphora), from Vulci, Italy, ca. 540–530 BCE. Whole vessel approx. 2' high. Vatican Museums, Rome, Italy.

GLASS

The medium of glass has a different quality than the other materials discussed in this chapter. Unlike clay, metal, wood, or fiber, glass is usually either transparent or translucent. That means that light becomes an integral part of glass objects. Glass is made primarily of silica, or a kind of sand, plus other minerals that add color. Once heated until it becomes viscous (or the consistency of jelly), glass can be shaped by blowing or molding and pressing. The glass surface can be decorated by cutting, engraving (with a tool), etching (with acid), enameling, gilding, and painting, but often the most beautiful glass is decorated by the colors and bubbles within the glass itself. Thus the pattern is an integral part of the glass object, as is seen when you look into the center of a glass paperweight. In the decorative arts, glass is used primarily in two ways: as stained glass for windows, lampshades, and screens, or as blown glass for vessels such as goblets, vases, bottles, and pitchers.

The greatest period of stained-glass artistry is considered to be medieval times, when multicolored glass paintings were used to fill the long windows of Gothic cathedrals. Of all these cathedrals, that of Chartres in France (see Chapter 13) has the most beautiful, best preserved, and complete set of original windows. Unfortunately, photographs cannot recreate the transparency and glow of the colors or the way that light passing through the windows reflects their multicolored patterns on the interior of the cathedral. The deep, brilliant blue of the windows is justly famous and has never been duplicated.

During the nineteenth century, a revival of interest in both the Gothic period and the decorative arts occurred. The American artist most associated with both stained and blown glass is Louis Comfort Tiffany. Beginning his career as a painter, Tiffany eventually became a noted interior designer and head of a company that employed more than three hundred artisans, producing a wide range of beautiful objects. He also designed jewelry for his father's business, Tiffany & Co. Today, churches and museums throughout the country still boast of their Tiffany windows.

Where medieval stained glass had been used to tell religious stories, the stained glass designed by Tiffany

A GLOBAL VIEW

JAPANESE AESTHETICS: *THE TEA CEREMONY AND THE ZEN GARDEN*

The art of ceramics is judged to have reached its highest level in Asia. Chinese porcelains are valued by collectors all over the world for their elegant shapes and glazes. The Japanese have used pottery to express a different aesthetic. While Chinese ceramics tend to look fragile and perfect, the Japanese stress a rustic simplicity in their pottery, especially vessels associated with the *tea ceremony*.

The tea ceremony is a unique and interesting part of Japanese culture. Developed during the political upheavals of the sixteenth century, the *Cha-no-yu* (*cha* is the Japanese word for tea) is a kind of ritual performance in which the audience takes part. The host, or tea master, will invite a small group of friends to a modest teahouse of unpainted wood, located in a secluded garden. The purpose is not so much to drink green tea as to contemplate art, usually a hanging scroll decorated with painting or calligraphy, and a simple flower arrangement. The utensils in which the tea is made, such as tea bowls and water jars, are considered part of the artwork to be admired. The setting, the ceremony, the artwork, and the utensils are all supposed to conform to the principles of harmony, respect, purity, and tranquility, and above all to *wabi*, the principle of quiet simplicity.

Over the centuries a certain style of pottery has come to be associated with the tea ceremony. Called **raku**, these tea utensils are made of hand-shaped earthenware, painted with a lead glaze and fired at a relatively low temperature. The shapes of the tea bowls are irregular and asymmetrical, the glazes thick and rough. Their very imperfection is prized as a mark of the masters who formed them. Just as the line of a great artist can be seen in a drawing or painting, so the spontaneous, personal touch of the potter is valued by the Japanese. Names of great potters of history are well known, and their pots are extremely valuable. Some of the ceramic vessels associated with the tea ceremony are so famous that they have individual names, like *Mellow Persimmon*, *Gold Moon*, and *Five Mountains*, and they have been designated as national treasures of Japan. This tea bowl (11-4) was created in the seventeenth century by Raku Ichinyû, one of a long line of potters (now in its fifteenth generation!), and the family after which rakuware was named.

11/4 RAKU ICHINYÚ, *Teabowl*, Japanese, Edo period, seventeenth century. British Museum, London, United Kingdom.

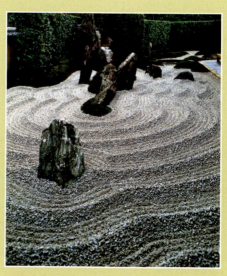

11/5 Ryoanji Zen Temple, Japanese Sand Garden, Kyoto, c. 1525. Stones, bare white sand.

To see a picture of a tea bowl is only to experience a tiny fraction of its aesthetic meaning. According to the Raku museum in Kyoto, Japan:

To hold a tea bowl is to grasp a microcosm of the universe in one's palms. It is to experience through one's fingers the delicacy and soft tactility of its form, the texture of the clay and glaze, its volume and mass, the finish of its foot and the contours of its interior.

The Japanese approach to landscape architecture is also unique. The Zen rock garden of Japan (11-5) is an approach to designing a haven of tranquility that many Westerners find mystifying. One does not walk in the garden but observes it from above on a long, porch-like platform. It appears at first as quite empty and barren. There are few plants; most of the surface is carefully raked white gravel around large stones. The Zen garden's purpose is to remove us from our insignificant worldly concerns and to stop the constant activity of everyday life.

After sitting down, one can see the pattern in the raked lines, the careful attention paid to the spaces between each rock—rocks, which were placed centuries ago. One can hear the birds, the insects, and the wind. The Zen garden offers the opportunity to regain one's focus in a place that eliminates all distractions. It is a quiet place meant to form, according to a Zen monk, "a lasting impression in your heart."

and other artists in the late nineteenth and early twentieth centuries was often used to decorate private homes. This beautiful glass window (11-6) "Autumn" was one of four season-themed panels exhibited in Europe in 1900–1902, before being installed in the living room of Tiffany's own Long Island mansion, Laurelton Hall. The actual glass is not just multicolored and translucent, but textured and three-dimensional. Tiffany developed a process that created "opalescent glass": Each piece of glass was not just one flat, transparent color, but could merge several colors and varied tones of each color. In addition, the glass could vary in depth and texture, from smooth to rough or ridged. In this panel, for example, the fruits of the season are depicted in glowing hues, surrounded by a jewel-like border of glass "pebbles" that stand in higher relief than the flatter central picture. Variations in color—from red to green for the apples, and purple to blue for the grapes—are within the glass itself, not just painted on. Tiffany painted with glass, not on glass. Though completely different in style and purpose from the stained-glass windows of Chartres, Tiffany's work was equally brilliant at exploiting the colorful luminosity of glass.

Glassblowing is a craft requiring both skill and strength. Because it is heated to a molten state, glass cannot be shaped by hand as other materials are. Instead, it is picked up in a small spherical blob at the end of a long metal pipe, then blown into bubbles of various shapes. The bubble is quickly shaped with a variety of tools, and sometimes rolled against a hard surface. If the glassblower is not pleased with the result, he or she can simply reheat the glass to a molten state and try

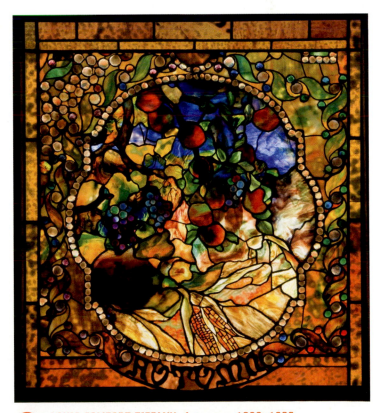

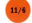 LOUIS COMFORT TIFFANY, *Autumn*, c. 1899–1900. Stained glass, 39" × 35". The Charles Hosmer Morse Museum of American Art, Winter Park, Florida.

again. When the glassblower is satisfied with the shape that has been created, the glass must be removed from the pipe to cool slowly. Thin threads of glass can be wrapped around the basic shape to add interest to the design, and smaller pieces can be added for handles.

Louis Comfort Tiffany's studio produced not only beautiful stained-glass windows, like "Autumn," but also blown-glass vessels and decorative lampshades. For instance, his glassblowers produced the delicate yet dramatic favrile glass vase illustrated here (11-7). Tiffany trademarked the term *favrile* (which means handmade) in 1894 to describe a special process for producing shimmering colored glass. The swirling iridescent patterns are actually part of the glass itself. Note the organic contours of the glass, flaring like the trumpet of a living flower. As in his stained-glass windows, you can see Tiffany's desire to interpret the beauty of nature. This dedication to handmade crafts and forms inspired by nature was a common feature of both the Arts and Crafts and Art Nouveau movements of the late nineteenth and early twentieth centuries.

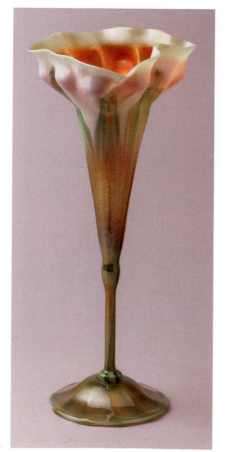

11/7 LOUIS COMFORT TIFFANY, *Vase*, 1921. Favrile glass, 13" high. Gift of Joseph H. Heil. The Museum of Modern Art, New York.

METALWORK

Humans have used many types of metal to shape beautiful decorative objects: gold, silver, iron, bronze, lead, and copper. The items made range from the giant iron gates for a palace to the most fragile jewelry. Metal can be cast or welded, but it can also be **forged** (or heated) and **wrought** (or hammered) into shape. This latter method is used by blacksmiths to make everything from horseshoes to door hinges and kitchen pots. Metal can also be hammered into sheets, which are then cut and built into the desired shapes. For jewelry, precious metals are also combined with other materials, such as stones, jewels, or enamel.

The pre-Columbian civilizations of Peru produced expert silver- and goldsmiths. The most famous of these cultures is that of the Incas. The Incas valued gold and silver for their artistic qualities rather than their monetary worth. In fact, they used no coins or money. Precious metals were reserved for the noble class because of their beauty. Gold was especially important because it symbolized the color and warmth of the sun, and the Incas considered themselves to be descendants of the sun god.

The Spanish conquistadors, led by Francisco Pizarro, found entire Incan cities decorated in gold. However, they were not particularly interested in the aesthetic value of the South American ornaments, although they admired them as curiosities. Almost all of the golden artwork collected by the Spanish in the New World was eventually melted down into gold ingots before or after it was taken to Europe.

Luckily for posterity, the pre-Columbian Peruvians had a cult of the dead somewhat like that of the ancient Egyptians (see Chapter 10). They mummified bodies, wrapped them in precious woven cloth, and buried them with golden ornaments. Long before the Incan period, sculpted golden masks were placed over the faces of the dead, who were accompanied by ceremonial golden daggers called *tumi* (11-8). Such daggers are often decorated with figures of stylized rulers or gods, shown in elaborate headdresses and jewelry. In this tumi (from the Lambayeque culture that preceded the Incas by several hundred years), the gold has been *inlaid* with turquoise stones that form the eyes and highlight headdress, jewelry, and costume.

FIBER ARTS

The fiber arts include weaving, embroidery, appliqué, quilting, knotting, beadwork, and any other forms of decorative art made with thread or textiles. Weaving,

like pottery, is a very ancient form of art; according to Homer's *Odyssey*, Penelope, the faithful wife of the hero Odysseus, spent the ten years of his absence weaving. Cloth can be woven out of fibers, such as wool, cotton, flax, and silk, into many different patterns, textures, and strengths. Most weaving is done on a **loom**, where one set of parallel threads, the **warp**, is held in a tense position. To make fabric, another set of parallel threads, the **weft** or *woof*, is arranged at right angles to the warp. The fabric is filled in by bringing these weft threads in and out, moving them back and forth, interlacing them with the warp. By using threads of different colors and textures, elaborate designs can be created. Although most cloth is used for making clothing, weaving can also provide decorative items such as carpets and wall hangings.

The most famous carpets in the world have come from the Middle East, where the geometric and organic patterns of Islamic art—also seen in tiles, calligraphy, and

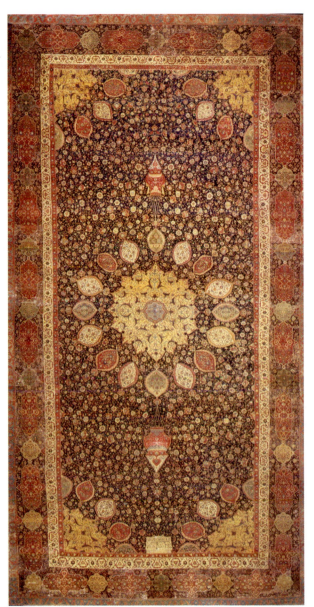

11/9 *The Ardabil Carpet*, Iran, c. 1539–1540. Hand-knotted woolen pile, on silk warp and weft; 304 knots per sq. in., 34' 6" × 17' 7". Victoria & Albert Museum, London, United Kingdom.

architectural decoration—have been translated into elaborate floor coverings. In this example, *The Ardabil Carpet* from Iran **(11-9)**, a central sunburst motif is echoed at each of the four corners, while delicate blossoms connected by scrolling lines seem to float on a dark blue background. The pattern was created by hand-knotting wool in ten colors onto a silk warp and weft—304 knots per each square inch, over the entire surface of more than thirty-four by seventeen feet! The style is typical of carpets produced in the sixteenth-century Iranian Safavid kingdom, where the art of designing Persian carpets reached its height. This particular carpet is "the world's oldest dated carpet, and one of the largest, most beautiful, and historically important in the world," according to

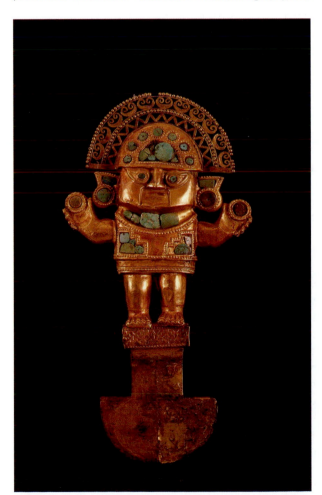

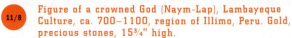

11/8 Figure of a crowned God (Naym-Lap), Lambayeque Culture, ca. 700–1100, region of Illimo, Peru. Gold, precious stones, 15¾" high.

the Victoria & Albert Museum in London, where it now hangs as the highlight of a new Islamic gallery.

In the West, quilting and embroidery have historically been done by women who did not have the freedom to become professional artists. The feminine "needle arts" provided an opportunity for women to express themselves creatively, painting their designs in thread and fabric. Such designs have ranged from pictorial and narrative, as in embroidered samplers showing people and places, to completely nonrepresentational, as in geometrically patterned quilts.

Some women have consciously used fabric and thread to make pictures that tell stories. This was the case with Harriet Powers (11-10), a former slave who designed several quilts based on biblical themes. Her method for making these quilts is one called **appliqué**, in which fabric silhouettes are cut out and stitched onto the background of another fabric. Such an appliqué technique is common in West Africa and may have been passed on to Powers by her forebears. What she did with this medium, however, was quite unusual. Instead of making attractive patterns, Powers used the squares of her quilts to vividly illustrate stories from the Bible. In this quilt she told the stories of Jonah and the whale, Adam and Eve, and the Day of Judgment, among others. While her silhouettes are simple, their arrangements demonstrate her sophisticated sense of design. Each panel is both a clear and visually interesting picture.

WOOD

Wood has been used over millennia for many objects: simple containers, tableware, utensils, and furniture. Handcrafted wooden objects and furniture were common to the most modest homes in colonial America. Most of us have seen sturdy old wooden chests and tables in antique shops that have lasted more than a hundred years. Just being handmade, however, does not automatically make an object artistic or beautiful. The craftsperson must be sensitive in shaping materials and in creating a design that is visually pleasing. Like other materials, wood can be used to create objects that are plain or extremely ornate.

The Aesthetic Movement, an arts-and-crafts movement in the last decades of the nineteenth century, established a deliberate goal of making the useful beautiful. In a reaction to poorly designed, mass-produced furniture, artists and critics in Britain and the United States began to call for more artistic and tasteful design. The elaborately detailed wood cabinet shown here (11-11) is a superb example of furniture in the aesthetic style— meant to be beautiful, but not overwhelming or aristocratic. Designed for upper-middle-class homes and lifestyles, such pieces include carving and metalwork that suggest a Gothic inspiration, because the medieval period had come to be associated with fine craftsmanship. This particular cabinet, thought to have been designed by architect Frank Furness, was executed in

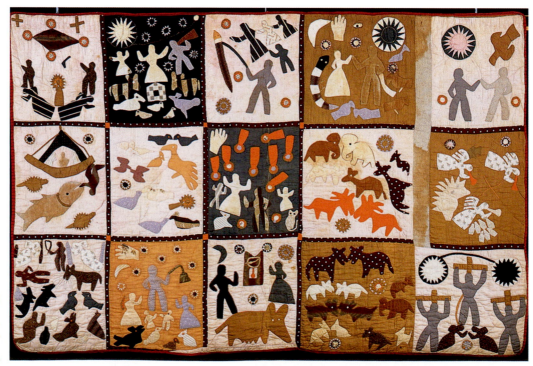

11/10 HARRIET POWERS, *Bible Quilt: The Creation of the Animals*, Georgia, c. 1895–1898. Pieced, appliquéd, and printed cotton embroidered with cotton and metallic yarns, 69" × 105". Museum of Fine Arts, Boston, Massachusetts.

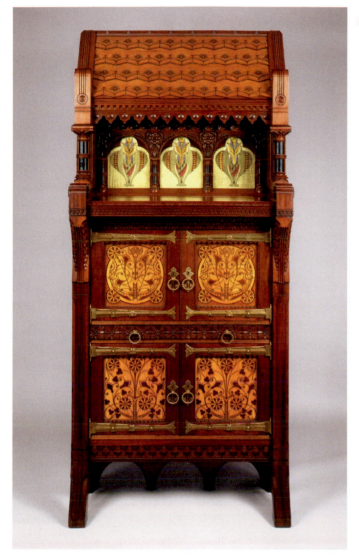

 DANIEL PABST, *Cabinet*, c. 1877–1880. Walnut, maple, white pine, glass, 96″ × 42″ × 20″. Friends of the American Wing Fund, 1985. The Metropolitan Museum of Art, New York.

their pieces, they have also moved away from making functional objects. This direction toward the fine arts and away from the practical is called the *American Studio Craft Movement*. Beginning in the 1960s, craft artists in all media began exploring a wide variety of forms that refuse the functionality that had previously been seen as central to the very identity of crafts.

A leading figure in this movement from the 1950s until his death in 2002 was the ceramicist Peter Voulkos. He influenced a whole generation with works created primarily for aesthetic interest, rather than for use. As a teacher in California, Voulkos began to make large clay objects that questioned the form of traditional vessels. For example, in his sculptured *Untitled Ice Bucket* (11-12), he took a fresh approach to the traditional bucket shape, almost as if he were simultaneously constructing and deconstructing its form. As in Japanese *raku* (see the "Global View" box), whose aesthetic influenced Voulkos, the vessel bears the rough marks of the artist's process. We can see thick slabs of clay pushed together,

the late 1870s by Daniel Pabst, a Philadelphia cabinet-maker. Combining walnut, maple, and white pine with metal hardware and painted glass, the entire surface is decorated in alternating patterns of deep relief (as in the rows of blossoms carved into the dark walnut) and shallow, inlaid panels of lighter pine incised in vine-like scrolls to reveal the reddish maple beneath. Despite the wealth of surface detail, the final effect is a harmonious melding of organic designs arranged in symmetric patterns and contained within a boxy, geometric shape.

THE STUDIO CRAFTS MOVEMENT

Although many practitioners of contemporary crafts retain their love of material and continue to handcraft

 PETER VOULKOS, *Untitled Ice Bucket*, 1986. Wood-fired stoneware, 14½″ high × 19″ diameter.

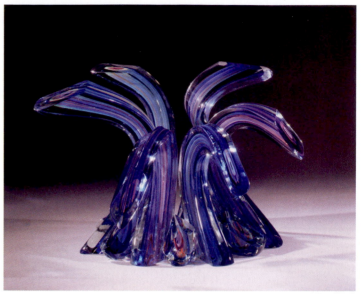

11/14 HARVEY LITTLETON, *Blue Crown*, 1988. Barium/potash glass with multiple cased color overlays. Indianapolis Museum of Art, Indiana.

11/13 ROBERT ARNESON, *California Artist*, 1982. Glazed stoneware, 68¼" × 27½" × 20¼". San Francisco Museum of Modern Art, California (gift of the Modern Art Council). Art © Estate of Robert Arneson/Licensed by VAGA, New York, NY.

the impressions of Voulkos's fingers left unsmoothed, the crude cuts of a knife. The bucket is now more like a Cubist sculpture than a container for ice.

Robert Arneson, a fellow Californian, was one of the most daring artists in breaking down the distinctions between contemporary ceramics and sculpture. His pieces are both filled with humor and totally nonfunctional, as in his self-portrait *California Artist* (11-13). Putting himself on a shabby pedestal, Arneson is casually dressed in an open blue denim shirt that reveals a hairy belly. Far from an expression of an enormous ego, Arneson's piece mocks typical comments about Californians. Beer bottles litter his monument. If one gazes past his dark tan and into his sunglasses, one can see that his head is empty.

The American Studio Craft Movement in glass began with Harvey Littleton. He did not believe that crafts should be primarily functional or merely decorative, but could in fact be the equal of abstract sculpture. *Blue Crown* (11-14) does not even pretend to be a functional vessel; it is a beautiful abstract sculpture of blown glass. Streamlined organic forms mark his work as a product of the modern era; transparent veils of color reveal its maker's love of glass.

The Studio Craft Movement affected the fiber media just as profoundly as in ceramics and glass. Imaginative new types of fiber objects have been made that cannot be categorized as wall hangings, baskets, or quilts, or any other traditional form. A fiber artist whose work has moved into the realms of sculpture, installation, and

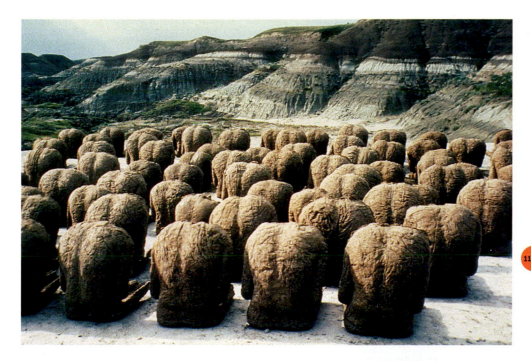

11/15 MAGDALENA ABAKANOWICZ,
Backs in a Landscape,
1976–1982. Burlap, glue.
80 pieces, three sizes:
61 cm × 50 cm × 55 cm;
69 cm × 56 cm × 66 cm;
72 cm × 59 cm × 69 cm.
© Magdalena Abakanowicz. Courtesy
of the Marlborough Gallery, New York.

Earth Art is Magdalena Abakanowicz (11-15). Her *Backs in a Landscape* hardly appears to be made of material at all, although it was constructed with burlap and glue. Instead, these headless backs seem almost to have grown up out of the earth. Bent, anonymous, and decapitated, crowded together on a windswept plain, they seem to be awaiting their fate with a fearful resignation.

As with the other media, artists working in wood have sought to stretch the boundaries of their craft. In *Ghost Clock* (11-16), furniture-artist Wendell Castle carved what appears to be a grandfather clock covered in a white sheet. Clearly, such a clock cannot be functional, or even decorative in the way that traditional clocks have been. Castle began his career as a sculptor, then moved on to create sculptural furniture. Even when his pieces are meant to be used, each is handmade and unique, carved from beautiful woods. Viewing this sculptural clock, one is immediately struck by the artist's skill. Castle's clock, a useful object that cannot really be used, creates a surreal and mysterious effect. In *Ghost Clock*, however, the effect is mysterious rather than humorous. One itches to whisk off the cloth to see the work beneath, but it remains forever out of our sight. In addition, the white cloth, shaped somewhat like a dress or an ancient toga, gives the piece an almost human (though headless) presence.

11/16 WENDELL CASTLE, *Ghost Clock*, 1985. Bleached Honduras mahogany, 86¼" × 24¼" × 15". Smithsonian American Art Museum, Washington, D.C.

11/17 ALBERT PALEY, *Portal Gates*, 1974. Forged and fabricated steel, brass, copper, and bronze. Smithsonian American Art Museum, Washington, D.C.

Although the Studio Crafts Movement has exerted a strong influence, not all craftspeople refuse to make functional objects. Some of the most talented continue to blend artistic expression with usefulness. The massive metal *Portal Gates* (11-17), created by Albert Paley for the Renwick Gallery, a division of the Smithsonian Institution devoted to American Crafts, are a remarkable example of how art and craft can be fused. Forged of steel, brass, copper, and bronze, the gates stand over seven feet tall and six feet wide, and weigh twelve hundred pounds. The heavy metals, however, have been shaped into a pattern of graceful curlicues that appears light, even fanciful. Paley was commissioned to build these gates toward the beginning of his career. In the intervening decades he has designed gates for numerous universities, museums, government buildings, zoos, homes, and even gardens, as well as freestanding metal sculptures. To honor his body of work, Paley is the only metal artist to win the Lifetime Achievement Award from the American Institute of Architects.

CONTEMPORARY APPROACHES IN CRAFTS

Since the Studio Movement that began in the 1960s, the craft media have been incorporated into the repertoire of painters and sculptors, and craftspeople have moved into the field of fine arts, until—in many cases—it is virtually impossible to tell the difference between ceramicists, woodworkers, metalsmiths, glassblowers, or fiber artists, and sculptors. Exciting new work in these media continues to challenge the distinction between art and craft.

Consider, for instance, the work of contemporary ceramicist Kathy Butterly, who creates miniature objects like *Yo* (11-18), measuring just a few inches across. Their tiny scale, bright colors, and whimsical forms (and titles) give her work a completely different feel than that of Peter Voulkos, for example. While Voulkos stressed the heavy materiality of the original clay from which all ceramics are made, Butterly's abstracted biomorphic forms seem to be created from a variety of materials. In this case, a golden base, a squishy, satiny body, a sponge-texture head, and a beak that resembles a dark seed combine to give the impression of a cartoonish toy chicken. Where Voulkos's *Untitled Ice Bucket* is rough and masculine, Butterly's *Yo* is delicate and amusing. Both artists are masters of their media while pushing its boundaries.

Dale Chihuly is the most famous and influential glassblower working in the United States—perhaps the world—today. Chihuly studied with Harvey Littleton, and then went on to experiment with multiple approaches to

11/18 KATHY BUTTERLY, *Yo*, 2004. Porcelain, earthenware and glaze, 5½" × 3½". Tibor de Nagy Gallery, New York.

glass sculpture and to train a community of younger artists. Accidents and injuries have meant that he can no longer blow glass himself, so he now maintains a more creative, supervisory role in his studio. In that sense he is much like Tiffany, who never blew glass himself.

Over more than three decades, Chihuly has created everything from personal-sized vessels to elaborate chandeliers to installations and performance pieces. His glass is noted for organic forms and vibrant colors, as in *Inside and Out* (11-19), an exuberant installation he created for the Joslyn Art Museum in Nebraska. This eight-foot-tall sculpture erupts with wild corkscrew curls and festive balloons of blown glass, assembled into an explosion of brilliant color reflected here against the deep blue of the evening sky. The work of art is not just the blown glass, but also the assembly and its placement beside a clear glass window, where its appearance changes with the light and weather. Rather than imitating the real world, Chihuly's glass sculptures seem to offer an alternate reality, a fantasy in glass where color, line, shape, and texture work together to create a unique, and powerful, aesthetic experience.

11/19 DALE CHIHULY, *Inside and Out*, 2000. Blown glass, 33" × 22" (at top) × 8'. Joslyn Art Museum, Omaha, Nebraska.

Metal artist Myra Mimlitsch-Gray also epitomizes the contemporary movement that combines exquisite crafts-manship with a sense of humor and history. Her *Melting Candelabrum* (11-20) is part of a series in which she simultaneously creates and critiques traditional domes-tic metalwork, "challenging and thwarting the viewer's expectations of familiar objects." In this piece, Mimlitsch-Gray shapes the expected metal candelabrum to imitate the melting wax of the candles it is designed to hold. Liquid silver seems to spread across the surface of the table, creating an organic shape punctuated by candle-holders, several of which seem to have melted down to their bases. According to the artist, her work "is an exploration of traditional craft practice within a contem-porary sculptural context that gives process a voice and explores gesture in rigid material."

In addition to many artists working in weaving, sew-ing, embroidery, and other textile arts, contemporary artists are also engaged in the transformation of bas-ketry. Japanese artist Nagakura Kenichi creates stunning abstract works from fibers traditionally used for baskets. Kenichi's grandfather was an artisan who made flower baskets, and his own pieces can hold flowers as well. Works like *High Flying* (11-21), however, also hold up as sculptural compositions. Note the contrast between the tightly woven basket and the loose, curling strands of fiber that surround it. After the basket is formed, clay is sluiced over the surface, then wiped off, creating a texture that is shiny on the ribbons where wiped but dusty in the corners where bands twist and overlap.

As craftspeople have moved beyond traditional forms and into the realm of abstract sculpture in a wide variety of media, their work reflects a spiritual journey and mode of self-expression closer to that of fine artists than to the artisans of the past. In the contemporary world, it is usually designers, rather than craftspeople, who create the objects that we use in our everyday life, objects that are manufactured rather than handmade.

DESIGN

The products of design—graphic design, industrial design, fashion design, interior design, and landscape design—furnish the artistic environment we live in every day. Artists, in the role of designers, have had a hand in the magazines we read, the pens we write with, the televi-sions we watch, the rooms we live in, the parks we visit, and the clothes we wear (see "Lives of the Artists" box on page 210). A design must be useful to be successful. For example, a graphic design like an advertisement must communicate its message quickly or be a failure. We are much more forgiving of a work of fine art or even crafts; we accept that true understanding may be a time-consum-ing process. Since the late eighteenth century, more and

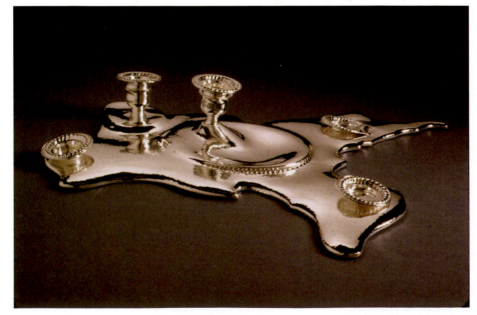

11/20 MYRA MIMLITSCH-GRAY, *Melting Candela-brum*, 2002. Rotasa Collection Trust.

more of the products we use have been mass-produced, making the artist a partner with modern industry.

GRAPHIC DESIGN

Graphic design encompasses several types of design that were once referred to rather dismissively as commercial art. Advertisements, book illustrations, the layout of magazine pages, posters, packages, logos, and signs are all examples of graphic design, as is web design. Contemporary Canadian graphic designer Marian Bantjes designs most of these and more. Her website features numerous projects, including fabric, wallpaper, wrapping paper, and temporary tattoos, as well as book design, illustrations, posters, and cards. Her work is strongly patterned and often, though not always, extremely detailed—sometimes abstract, sometimes representational. In addition to professional design jobs, every year Bantjes designs a set of valentines. In 2010 she had the clever idea of recycling Christmas cards to make her valentines, and asked friends to send her their old cards. She writes: "I created the design of the heart for laser cutting. . . . I wanted most of the card image to be cut away, but there to be enough left that some semblance of image remained; that you could tell it came from a christmas card." As you can see from the example here (11-22), Bantjes's design was traditional (with multiple hearts, curlicues, and cupids at the corners) yet contemporary (with its clean lines and open spaces). Though the laser-cut pattern is completely symmetrical, the design on the original card from which it was cut creates a slightly asymmetrical pattern of colors. Each card is cut with the same pattern, but each is unique because it was cut from a different original Christmas card. Bantjes was delighted with her experiment:

> The final result exceeded my most hopeful expectations. . . . How these cards (most of which were, in their original state, nothing special, or even downright ugly) gained so much more from the process. . . . How abstracted the designs became. . . . And how incredibly attached I became to each and every card. They were very hard to give away. I made about 500, and every single one is different.

In comparison with fine art, graphic design images are usually more direct and easy to understand. Although saying that one could look at a work of art all day is high praise, one would not want to have to stare for a long time at an advertisement or logo to guess its meaning. An

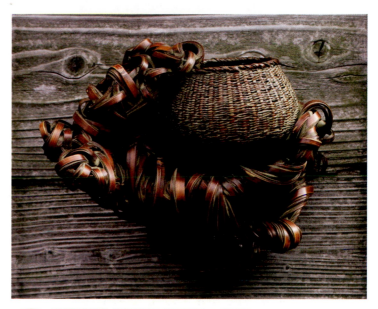

11/21 NAGAKURA KENICHI, *High Flying*, 2004. 12" × 8" × 10½". TAI Gallery, Santa Fe, New Mexico. Photographer Mochizuki Akira, Japan.

11/22 MARIAN BANTJES, *Valentine*, 2010. Laser-cut paper. Vector Art/Laser Cut.

11/23 MILTON GLASER, *I (Heart) NY More than Ever.*

image that cannot only be read quickly but has become instantly recognizable is the *I Love New York* poster, designed by Milton Glaser. After 9/11, Glaser updated his design with this new version, *I (Heart) NY More Than Ever* (11-23), featuring a dark smudge on the corner of the heart. To anyone who experienced the tragedy of the World Trade Center, or saw it on television, this graphic image conveys an instant and effective message.

INDUSTRIAL DESIGN

In 1919, with great ambition and idealism, the architect Walter Gropius founded a school devoted to the cause of integrating the arts and modern technology and transcending the boundaries among craft, design, and art. He called it the Bauhaus (the house of building). This would be a school like no other, a training ground for men and women to make them capable of meeting the challenges of the twentieth century. Gropius declared at its opening:

> Together, let us conceive and create the new building of the future, which will embrace architecture and sculpture and painting in one unity and which will one day rise toward heaven from the hands of a million workers, like the crystal symbol of a new faith.

In the new training ground of the Bauhaus, the old manner of academic education was abandoned. There were no professors and students. Those who came to study "joined" the school, and it was open to all ages, social classes, and both sexes. The academic plan was borrowed from the medieval guild system. Master artists and craftspeople, journeymen and apprentices worked together on projects in cooperation.

Gropius was a rare type of individual, a visionary who could also be pragmatic and persuasive. In the midst of hard economic times after World War I, he was able induce the German government to provide enough support so he could eliminate tuition at the Bauhaus by convincing the authorities that his goals were in line with the rebuilding of Germany. His teachers and students worked on government buildings, worker housing, furniture, and new products for industry.

The Bauhaus teaching stressed that all design must fit its purpose and contain nothing extraneous to it. Bauhaus solutions tended to reject older forms for a clean, modern, geometric, and simple style. The success of the Bauhaus formula is demonstrated by Marcel Breuer's *Club Chair B3* (11-24), whose modern design is still being manufactured, and imitated, today. Breuer

11/24 MARCEL BREUER, *Club Chair B3 (Wassily)*, 1925. Tubular steel and the textile Eisengarn, developed at the Bauhaus.

ELSA SCHIAPARELLI:
FASHION AS ART

When Elsa Schiaparelli arrived in Paris in 1922, she was in full flight from her wealthy, aristocratic, and conservative Italian family. The young Schiaparelli had escaped to London, then New York City, where she was attracted by the work of the Dada movement and became friendly with several artists, particularly Man Ray (see 7-12 and Chapter 18). When he and others of their circle left for Paris, she followed.

With the help of influential mentors, Schiaparelli set herself up as a Paris *couturier* (that is, a designer of "haute couture" or expensive, custom-made women's clothes at the forefront of fashion). Beginning with sportswear, she moved into elegant gowns and high fashion. By the mid-1930s, Elsa Schiaparelli was one of the two top Parisian fashion designers; the other was Coco Chanel. But Schiaparelli thought of herself as a true artist, not simply a designer of clothes to be worn by the rich and famous. (Her rival Chanel referred to her as "that Italian artist who makes clothes.")

Schiaparelli's friends continued to include avant-garde artists and writers, such as Salvador Dalí, Meret Oppenheim, Alberto Giacometti, and Jean Cocteau. Some of their imagery inspired her designs, while in other cases Schiaparelli worked directly with these artists to translate their motifs into fashion. For the back of one evening dress, Cocteau (a writer, artist, set designer, and filmmaker) drew the outlines of two human profiles facing each other, almost kissing. These were then embroidered onto the gown. After Man Ray photographed human hands that had been painted by Pablo Picasso to look as if they were wearing gloves, Schiaparelli designed black gloves with red lizard fingertips that resembled polished human fingernails. In a play on Réne Magritte's famous image labeled "Ceci n'est pas une pipe" (It is not a pipe) (see 18-32), Schiaparelli presented "Snuff," a cologne for men in a pipe-shaped glass container, packed in an imitation cigar box. These multiple creations (and more) reflect the values of the Surrealist manifesto written by André

ELSA SCHIAPARELLI, *Shoe Hat* (collaboration with Salvador Dali), winter 1937–38. Black wool felt, width 11". The Metropolitan Museum of Art, New York. © 2002 The Metropolitan Museum of Art.

ELSA SCHIAPARELLI:
FASHION AS ART

Breton: "The marvelous is always beautiful." But the influence was not just one-way. Photographs of "Schiap," as she preferred to be called, appeared as illustrations accompanying Surrealist poems and essays. In the work of this multitalented circle, the lines between fine art, literature, theater, design, and life were blurred.

Schiaparelli's most famous and remarkable collaborations were those she created with Surrealist Salvador Dalí. These included a suit with pockets designed to look like drawers, influenced by his painting, *The Anthropomorphic Chest of Drawers*, in which a naked female figure sprouts drawers across her chest. An evening gown, known as the Tear Dress, was printed with simulated rips, as if the fabric had been torn open at intervals to reveal a fur underlining. Perhaps their most memorable collaboration was the "shoe hat," seen here in a photograph of the period on

Gala, Dalí's wife, and a mannequin **(11-25)**. According to Schiaparelli:

> *Dalí was a constant caller. We devised together . . . the black hat in the form of a shoe with a shocking velvet heel standing up like a small column. . . . There was another hat resembling a lamb cutlet with a white frill on the bone, and this, more than anything else, contributed to [my] fame for eccentricity.*

Created in the years just before World War II, as fascism was on the rise throughout Europe, these playful designs may seem a bit frivolous to us. Schiaparelli herself explained, "In difficult times fashion is always outrageous."

began as a student at the Bauhaus, but after graduation he ran its carpentry workshop. This particular chair, the first to use tubular bent steel, is known as the "Wassily" because it was designed for painter Wassily Kandinsky, another member of the Bauhaus faculty. Breuer's chair is easily manufactured because of its simplicity. The chromed steel tubes slip into one another, so no screws and bolts are required. Even though the chair is made of hard metal and rugged fabric (designed by textile students at the Bauhaus), it is very comfortable because it flexes with the weight of the person sitting in it.

One might say that the Bauhaus created the modern field of industrial design, fabricating products that were aesthetically pleasing and capable of being mass-produced. **Industrial design** is the aesthetic refinement of products, making functional engineering solutions easy to use and attractive. An industrial designer must understand both art and engineering. Marianne Brandt, like Marcel Breuer, was a student at the Bauhaus who later headed a workshop. Her simple *Table Clock* **(11-26)** of 1930 hardly looks designed at all, yet this one is in the collection of the Museum of Modern Art. With its straight hands, the hours indicated only by short lines (no numbers), plus its total lack of ornamentation, this clock looks familiar to us but was revolutionary at the time. If you study it closely, you will see that Brandt also paid careful attention to proportion, readability, and style, rounding the edges of the square and setting the clock on a sleek chrome base. Other Brandt designs (or their descendants), like her bedside lamps, desk lights, and ceiling globes, are in homes throughout the world. Clocks

11/26 MARIANNE BRANDT, *Table Clock*, c. 1930. Painted and chrome-plated metal, 5¾" × 6⅞" × 2¾". The Museum of Modern Art, New York.

like this one are still available, for example, although the central hole that would have been used to insert a wind-up key is now gone, since today's clocks are electric.

INTERIOR DESIGN

We tend to think of *interior design* as decorating—deciding how to color and fill a room that has already been shaped—But interior design is also an integral aspect of architecture. When an architect designs any building, he or she is thinking as much of the interior as the exterior. The shape of the structure will determine the

size and shape of the rooms. Some architects are careful to design every aspect of the buildings they create, including staircases, windows, light fixtures, and even furniture, curtains, and rugs. The Greene brothers (11-27) specialized in harmonizing their interior design with their architecture (see 10-26). Their *Gamble House* in Pasadena, California, is decorated with built-in wooden cabinets, closets, and mantels, all with a beautiful hand-rubbed finish, highlighting rather than hiding the natural color and grain of the wood. Like a flowing river, the wooden banister is designed in a series of steps echoing the steps below.

The Art Nouveau interiors of Victor Horta were also inspired by nature, but European design of this period was more elegant and elaborate than that of the California Arts and Crafts movement of which the Greene brothers were part. One goal of the Art Nouveau movement was to unite all the arts, fine and applied. Horta's staircase for the Tassel House in Brussels, Belgium (11-28),

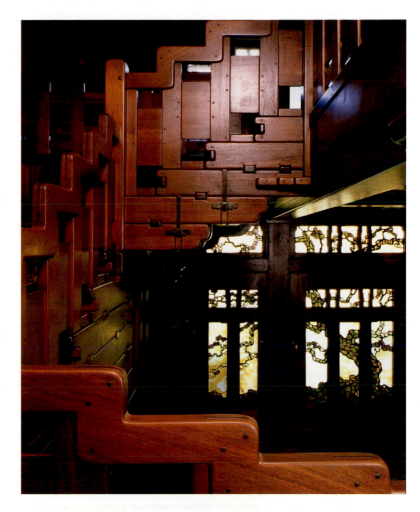

11/27 GREENE BROTHERS, *Gamble House*, staircase, 1908–1909, Pasadena, California.

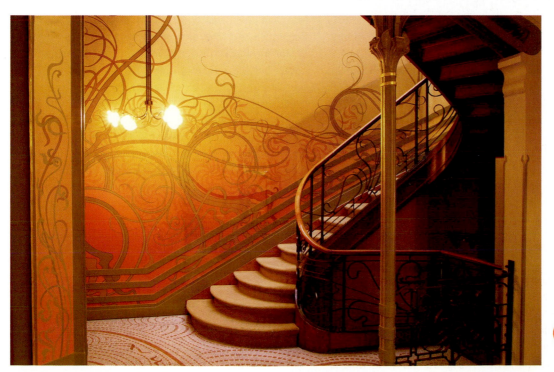

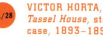 VICTOR HORTA, *Tassel House*, staircase, 1893–1894, Brussels, Belgium.

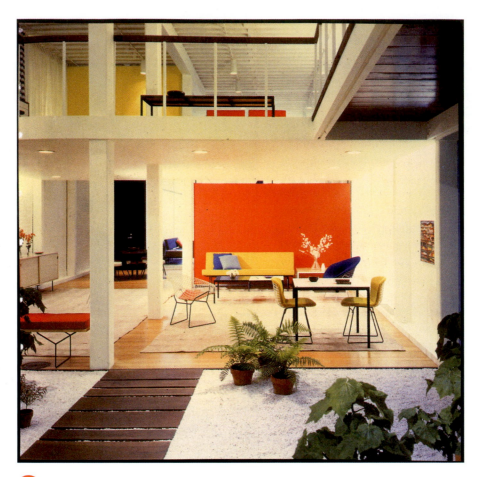

11/29 Florence Knoll showroom in San Francisco, California, 1957.

features his signature "whiplash" curves in the architectural space, wrought-iron handrails, and linear designs on the walls and floors. This house, for which Horta designed every detail down to the lighting and furniture, is considered the first true Art Nouveau building. Along with four other buildings designed by Horta, it has been named an UNESCO World Heritage Site because of its importance as a model of this revolutionary style of interior decor. While the *Gamble House* staircase seems as massive as a tree trunk, Horta's seems light and airy, like a vine reaching up to the sun. Both designs are organic and inspired by nature, but the American *Gamble House* seems simple and suburban, while the *Tassel House* reflects the cosmopolitan taste of a European capital.

The modern taste of the mid-twentieth century is revealed in the furniture showroom displayed by Knoll International in San Francisco in 1957 **(11-29)**. Designed by Florence Knoll, this brightly colored interior appears far more pared down and functional than either the Greene Brothers or the Horta interiors. The sharp lines, simple shapes, clear colors, and subtle textures reflect

the influence of modern style on items as diverse as pillows and ashtrays. Compare this room to a painting by Malevich (see Chapter 16), and the relationship between decorative and fine arts will become evident. Not only is the furniture functional (with a clear Bauhaus influence), but the space is open, the colors are bold, and the arrangement is carefully designed for comfort and traffic flow.

Florence Schust had studied with Eero Saarinen (see 10-30), then worked for Walter Gropius and Marcel Breuer briefly before meeting visionary entrepreneur Hans Knoll during World War II. They began working together, formed Knoll Associates, Inc., and were married in 1946. The Knolls imagined a revolution in interior design to coordinate with modern architecture. Hans was the salesman while Florence (known as Shu) became the brains behind the Knoll Planning Unit, working to collaborate the designers hired by the company with the manufacturing plant in order to produce "well designed 'equipment for living' within the reach of a large consumer market," according to *Arts and Architecture*. She became an innovator in

efficient office design and created the showrooms that sold their ideas—and products—to the public. After her husband's death in an auto accident in 1957, everything from the furniture to the showrooms to the letterhead and business cards was controlled by Mrs. Knoll, according to one of their designers.

LANDSCAPE DESIGN

Landscape design, the alteration of the earth for aesthetic pleasure, is an ancient art practiced all over the globe. It is mentioned in the earliest hieroglyphics of the Egyptians. Gardens and parks were planned as sources of peaceful contemplation of nature by the Greeks, Chinese, and Muslims thousands of years ago. The ancient gardens, like the famous Hanging Gardens of Babylon, are known to us in legends only, but many magnificent gardens that are centuries old can still be enjoyed today.

The gardens of Versailles, once the private treasure of the kings of France, are now open to the public. Built in the seventeenth century, during the reign of Louis XIV (see Chapter 15), they are so grand and extensive that aerial photographs are required to show their length. The gardens are built around a main central axis nine miles long. A series of *parterres* or terraces lead down to the main axis from the palace. Each level has a fountain dedicated to a classical theme. Marble statues of gods and goddesses line all of the walks. The many landscape designers were fervent followers of *classicism*, the revival of the ideals of the ancient Greeks and Romans. Their plan and the actual plantings are very orderly and geometric and are meant to be an extension of the powerful domain of the king.

The key feature of the main axis is the Grand Canal (11-30), which extends for miles beyond what your eye can see. At its head is the *Fountain of Apollo* (11-31).

11/30 Gardens of Versailles, 1669–1685, Versailles, France.

11/31 *Fountain of Apollo*, 1672–1674, Palace of Versailles, France.

The god rides on a chariot drawn by horses leaping out of the water. In Louis XIV's day, the canal had a flotilla of miniature boats that were replicas of ships in his fleet. The boats and Venetian gondolas would take members of the court on gentle romantic cruises along the canal.

Crossing the main axis are a series of secluded paths that lead to more intimate groves designed to accommodate private romantic trysts. Each has its own fountain and theme. The gardens of Versailles had an important influence on landscape design. Their classical approach is used even today in the gardens of the wealthy and is known as the French style.

Isamu Noguchi, sculptor and designer, described his life as "a crossing where inward and outer meet, East and West." Born in the United States, he was the child of a Japanese man and an American woman. He studied in Paris with the abstract sculptor Constantin Brancusi (see Chapter 15), but his trip in 1930 to China and Japan was, according to him, a "discovery of self, the

earth, the place, and my other parentage." While there he learned traditional Eastern methods of sculpting that affected his entire career. For most of his life, Noguchi had studios in both the United States and Japan. Many of his public sculptures and projects were for humanitarian causes. For example, moved by the destruction wrought by nuclear weapons, he designed two bridges for the city of Hiroshima in 1950. They lead to the Peace Park there, a memorial to the dead and a hope for the future.

His interest in the Japanese tradition of rock gardens (see the "Global View" box) is very apparent in his sculpture garden for UNESCO (the United Nations Educational, Scientific, and Cultural Organization) headquarters in Paris (11-32). It took him two years to complete. Individual sculptures made of stone (brought from Japan) exist harmoniously with plants and open spaces. A variety of textures and shapes become an appropriate symbol for the diversity of the United Nations, the mood of serenity the equivalent of its goal of peace. Noguchi

said that he turned to garden design and natural materials to free humanity "from the artificiality of the present and his dependence on industrial products."

Here we come back again to the tension between humanity and industry, fine art and mass production. As we turn to the historical sections of this book, you will see how the art of ancient times evolved into the diverse and exciting global art of today. Your knowledge of the elements and principles of art, as well as the various artistic media, will help you appreciate both the ability of artists to create satisfying work using the elements of art and design shared by all visual artists, and their mastery of the tools and materials specific to each particular work of art. This knowledge will provide a foundation on which to build your understanding of the history of art.

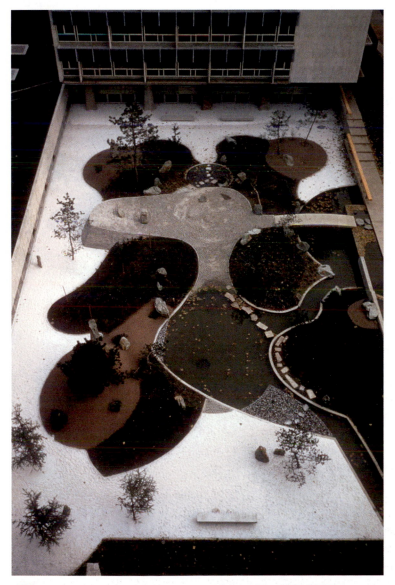

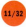 ISAMU NOGUCHI, *Gardens for UNESCO*, 1956–1958, UNESCO Headquarters, Paris, France. © 2012 The Isamu Noguchi Foundation and Garden Museum, New York/Artists Rights Society (ARS), New York.

CHAPTER 12

3000–1000 BCE

PERIOD

CYCLADIC CIVILIZATION ON GREEK ISLANDS
EGYPT: OLD KINGDOM
MIDDLE KINGDOM
NEW KINGDOM
INDUS VALLEY CIVILIZATIONS
SHANG DYNASTY IN CHINA
OLMEC CIVILIZATION IN MEZOAMERICA

HISTORICAL EVENTS

Reign of Akhenaton **1385–1358** BCE
Reign of Ramses II **1292–1225** BCE
Exodus of Moses **c. 1250** BCE
Destruction of Troy **c. 1193** BCE
King David c. **1000** BCE

ART

1

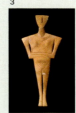

2 3

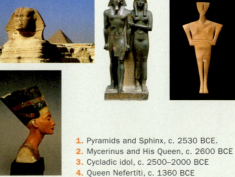

4

1. Pyramids and Sphinx, c. 2530 BCE.
2. Mycerinus and His Queen, c. 2600 BCE
3. Cycladic idol, c. 2500–2000 BCE
4. Queen Nefertiti, c. 1360 BCE

ANCIENT EMPIRES, ANCIENT GODS

In every region of the globe, art and artists have flourished within powerful empires and great civilizations. In eras when few people could read or write, art conveyed vital messages about authority and status. At times, the purpose of ancient art—like the prehistoric painting and sculpture we studied in Chapter 1—was to bridge the gap between the real world and the magical realm of the supernatural. Art gave visual form to gods and goddesses, enabling humans to express their inner beliefs and to focus their worship on specific images. Finally, ancient art attempted to satisfy a timeless human need: the hunger of each culture for visual beauty and majesty.

1000–320 BCE

ANCIENT ISRAEL: PERIOD OF THE KINGS
EGYPT: LATE PERIOD
HOMERIC AGE IN GREECE
CLASSICAL GREECE
OLMEC CIVILIZATION ENDS
ROMAN REPUBLIC
ZHOU DYNASTY IN CHINA

First Olympiad **776** BCE
Confucius **551–479** BCE
Siddhartha (Gautauma Buddha) preaches his first sermon **521** BCE
Roman Republic founded **509** BCE
Greek and Persian Wars **497–479** BCE
Age of Pericles and rebuilding of the Acropolis **460** BCE
Death of Socrates **399** BCE
Alexander the Great invades India **327** BCE

320 BCE–330 CE

HELLENISTIC GREECE
QIN DYNASTY IN CHINA
ROMAN EMPIRE

Great Wall of China built **215** BCE
Julius Caesar assassinated **44** BCE
Marc Antony and Cleopatra defeated by Augustus **31** BCE
Birth of Jesus **4** BCE
Paper invented in China **c. 100** CE
Rule of Trajan, furthest expansion of Roman Empire **98–116** CE
Emperor Hadrian **117–138** CE
Constantine issues Edict of Milan tolerating Christianity **313** CE
Constantinople becomes capital of Roman Empire **331** CE

5

6
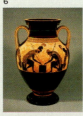

7
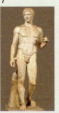

10
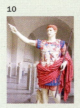

11

10. Augustus of Prima Porta, c. 20
11. Yakshi, 1st century
12. Colosseum, 70–82,
13. Arch of Constantine, c. 312–315

8
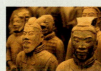

9

5. Olmec Head, c. 900–400 BCE
6. Exekias vase, 540 BCE
7. Polykleitos, Doryphous, c. 450–440 BCE
8. Parthenon, c. 448–432 BCE
9. Terra cotta army of First Emperor of Quin, c. 210 BCE

12
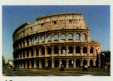

13
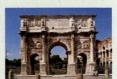

THE FIRST CIVILIZATIONS

When agriculture gradually replaced hunting as the source of human nutrition, what we call "civilization" began to develop. Fields were planted and harvested; permanent settlements grew up; and a surplus food supply allowed some members of society to take on specialized tasks as rulers, religious leaders, and artisans. Such cultures developed separately in several sites: between the Tigris and Euphrates rivers in what is now Iraq (c. 3500 BCE), in the Nile Valley of Egypt (c. 3000 BCE), in the Indus River Valley of India (c. 2500 BCE), and along the Yellow River Valley of China (c. 1700 BCE).

Culturally, what historians call civilizations are identified by having organized religion, calendars, systems for writing and recording, metalworking, and a tradition of fine and decorative arts. All of these features marked the three Mediterranean civilizations we will be discussing at length in this chapter: the empires of Egypt, Classical Greece, and Rome. The Mediterranean Sea links three

continents—Africa, Europe, and Asia—providing a cross-roads for trade and cultural interactions. The most important cultures for the development of Western art came to life in this area. At the same time, other areas of the globe were developing their own unique civilizations and cultures. Asia, Africa (below the Sahara Desert), the Pacific Islands, and the Americas each evolved their distinctive art forms—forms that had little impact on Western art before the mid-nineteenth century but had a major influence on modern art.

In the first civilizations, the artist's role changed from being a kind of priest creating magical images to a life devoted to preserving the power and recording the glory of leaders. It meant a loss of stature for artists, one that they would suffer for centuries. Once maker-magicians, they became anonymous craftspeople doing low-status manual labor. However, this does not mean their work was unimportant to the leaders they served. As Louis XIV of France said to his court artists, "I entrust to you the most precious thing on earth—my fame."

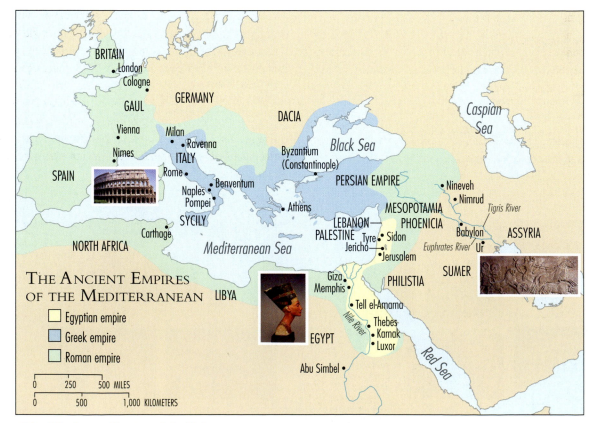

Map 12/1 The Ancient Empires of the Mediterranean

PRESERVING THE PAST:
A RACE AGAINST TIME

The early twenty-first century finds the art world in the midst of a crisis. The worldwide effects of pollution threaten our cultural heritage. Architectural monuments, outdoor sculptures, stained glass, and paintings are slowly but steadily being damaged by dangerous chemicals in the atmosphere. But it is not just our industrial world that is harming our landmarks; it is our curiosity. The prehistoric caves at Lascaux, France (1-8), were closed in 1963 because the breathing and perspiration of a constant stream of tourists (more than a million since its discovery) had resulted in mold growing on the paintings. Shocked experts watched as pictures that had been virtually undamaged for seventeen thousand years began to deteriorate quickly. (Surprisingly, when a replica of the caves opened nearby in 1983, it also became so crowded that visitors have had to be limited.) The monoliths at Stonehenge, in England, are disintegrating from air pollution caused by hundreds of tour buses. In Mexico, emissions from oil wells are causing the Mayan temples of the Yucatan to crumble. The Leaning Tower of Pisa may finally collapse in twenty to thirty years if preservationists cannot find a way to shore up its foundations.

In Egypt, the Great Sphinx (12-1) guarding the pyramids has deteriorated more in the last fifty years than in all its forty-five hundred years. A portion of its right shoulder fell off in 1988. The head is the most damaged because, for many centuries, the Sphinx had been buried up to its chest in sand that protected it. However, because it is now entirely exposed to desert winds and air pollution, the limestone of the chest has begun flaking and crumbling to an alarming extent. Tour buses are no longer allowed to run their engines near the monument because of the fumes they give off. Although there is no current danger, there has been concern that eventually the chest will be so weakened that the head may fall off. Even if the Sphinx can be saved, it is believed that Egypt has ten thousand other threatened sites.

The buildings of the Acropolis, over Athens, have had more than their fair share of troubles (see 10-10). Air pollution from the city is eating into the marble in a process that is nearly impossible to stop. Sulfur-dioxide fumes from burning heating and diesel oil combines with humidity and rainwater to form sulfuric acid. When the acid falls on marble, it bonds with it and makes gypsum. Whenever it rains, the gypsum is washed away, and another thin layer of the precious surface

of the Parthenon (see 10-11) has been lost. Planes are now forbidden to fly over the Acropolis. Athens is trying to eliminate the use of oil for heating and to replace diesel public vehicles with electric ones, but that will take time. In the meantime, the remaining relief sculptures on the buildings are being removed to the safe, controlled environment of the Acropolis Museum. Concrete casts are being put in their place.

Another problem the Parthenon faces is the rusting of steel reinforcements imbedded in its marble as part of a restoration in the early 1900s. As the steel rusts, it expands and cracks the marble. Rain gets into the cracks and freezes in winter, splitting the stone. Pieces of ancient marble are falling off. The six thousand tourists a day (four million a year) at the Acropolis have had their impact, too. The marble steps are wearing away, forcing authorities to replace them with concrete or wooden walkways. Ancient inscriptions are disappearing, along with the old pathways. The Parthenon interior is now closed to visitors to protect it. The Greek government is facing a real dilemma. Tourism is its biggest industry, but the cost of repairing the Parthenon and the Acropolis (begun in 1986 and still underway) was estimated at $15 million more than thirty years ago and is currently anticipated to cost $90 million. The 1975 study itself cost $1.6 million. UNESCO's International Council on Monuments and Sites is spearheading a worldwide effort to raise funds "to save cultural treasures, which, although they belong to the heritage of Greece, are also part of the shared inheritance of mankind."

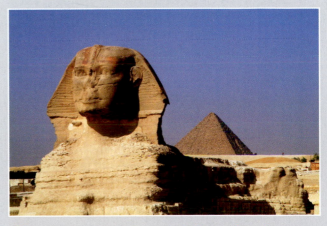

12/1 *The Great Sphinx* (Pyramid of Kafre in the right background), Gizeh, Egypt, c. 2530 BCE. Sandstone, 65' high, 240' long.

EGYPT

The new role for art and artists can be seen in the ancient Egyptian civilization that emerged along the fertile valley of the Nile River. Here artists worked in large studios near the royal palace, devoting their lives and skills to kings and queens. The studios were almost like factories, making standard images as prescribed by tradition. It was a powerful tradition; the Egyptian style remained similar for more than three thousand years. Artists preserved a continuous, recognizable tradition through thirty dynasties, showing their obedience to the long lineage of the pharaohs. The role of the artist reflected that of all members of Egyptian society—servitude to the king, who was a god. Individual creativity was restricted to working within definite parameters. Individuals fulfilled their role as inherited by virtue of family and class. Their success depended on how well they served and obeyed the pharaoh.

The Egyptian focus on death and the afterlife (the so-called cult of the dead) is so well known that most of us associate Egyptian civilization with pyramids and mummies. Pyramids were the huge tombs constructed to protect the graves of Egyptian rulers, or pharaohs. Mummies were the bodies of the dead, elaborately preserved and encased in beautiful boxes, shaped and decorated to resemble human figures. Both the pyramids and the mummy cases are excellent examples of Egyptian art, but these tombs also contained sculpted and painted wall reliefs, figurines of people involved in everyday tasks, and the personal possessions of those who were buried.

Most of the Egyptian art that remains today is from the rich tombs of the kings. Some, like the Pyramids of Giza, are among the greatest structures ever built. These tombs were directed by master-builders under the command of the pharaoh who would be entombed within. During the months that the Nile flooded its banks and made farming impossible, the people worked as a sign of faith in their king. King Chephren directed the building of the second pyramid at Giza. Also built during his reign was *The Great Sphinx* (12-1), carved out of rock found at the site, which stands guard over the city of the dead. Its face is that of Chephren himself, its body a lion. Nearly sixty-five feet tall, despite weathering over the centuries (see "Art Issues" box), it still expresses the almighty power of the god-king. No grander display of a ruler's supremacy has ever been constructed.

The Egyptians' preference for formality, even rigidity, in their portraits can be seen in the statue of the King Mycerinus and his wife Kha-Merer-Nebty (12-2). The stiffness of the poses, the symmetry of the faces and bodies, the staring eyes, and the angular outlines of the queen's elbow and the pharaoh's headdress all create a visual impression of solidity and strength. Both male and female figures represent not only individuals but also ideal male and female types. Compare the muscled torso and flat abdomen of the Pharaoh to the prominent breasts and pubic triangle of his wife (covered only by what appears to be a skintight, almost transparent shift). Such an emphasis on sexual characteristics was not meant to be pornographic, but symbolic of human fertility (see "Global View" box on Fertility Goddesses

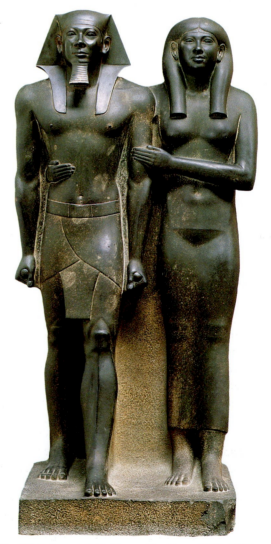

12/2 *Mycerinus and His Queen, Kha-Merer-Nebty II*, Giza, 2599–2571 BCE. Slate schist, 54½" high. Museum of Fine Arts, Boston, Massachusetts.

in this chapter and African examples of ideal male and female types, 9-18, 9-19). As in many Egyptian statues, the rulers also represent gods: the female figure's image echoes the characteristics of Hathor, the earth goddess and Egyptian equivalent of Venus. It is believed that King Mycerinus commissioned many statues identical to this one to line the way to his pyramid tomb. This example was never finished (it lacks the usual inscriptions), but traces of color prove that it was originally painted. This early example of the Egyptian style (dated about 2600 BCE) provides a typical illustration of the way Egyptians preferred to see themselves immortalized as rulers and as gods.

Although the traditions of Egyptian art and religion continued for thousands of years, a notable break developed under the pharaoh Akhenaton (1379–1362 BCE). This revolutionary king attempted to introduce *monotheism*, or the worship of a single god, to the formerly polytheistic Egyptians. For this purpose he erected an entirely new capital with many altars for the proper worship of Aton, the Sun God. The sculptural portraits of this period look quite different than what we think of as the classic Egyptian style.

Instead of the stiff, angular outlines of previous Egyptian art, the statues of Akhenaton and his family feature long, sinuous, curving silhouettes. This increased emphasis on both elegance and naturalism is seen in the beautiful portrait head of Akhenaton's wife, *Queen Nefertiti* (12-3). This piece was actually an artist's model, a kind of sculptural sketch of the Queen on which more formal, finished statues would be based. In fact, the eye on the other side of the face is missing, which has been interpreted as deliberate, because without the second eye, the image would not require worship, as a finished statue would.

Carved from limestone and painted to resemble flesh (as were most Egyptian sculptures and wall reliefs), this is undoubtedly one of the most popular examples of Egyptian art among modern viewers. In Berlin's Neues Museum, crowds circle around a glass case in the center of a dimly lit room, where the head is illuminated by a dramatic spotlight. Unlike the treatment of the *Mona Lisa* in the Louvre, photographs are forbidden, so museumgoers are forced to use their own eyes to study the work with no technology interposed. Why does this sculpture made almost 3,500 years ago attract so much attention? Perhaps it is because the queen's long neck, small head, and dramatically outlined eyes remind us of a contemporary movie star or fashion model. The sculpture is also a masterpiece of design, where wide, gentle curves

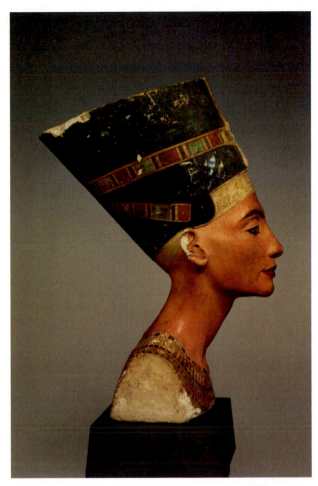

12/3 *Queen Nefertiti*, from Tell el-Amarna, c. 1360 BCE. Limestone, approximately 20" high. Staatliche Museen zu Berlin, Berlin, Germany.

flow into each other. Like a later and even more famous Egyptian queen, Cleopatra, Nefertiti has come to symbolize the idea that feminine beauty transcends time.

But the best-known example of the celebrity that art can bring to its subject and patron is that of the Egyptian pharaoh known to the contemporary world as King Tut. Tutankhamen was a young ruler who enjoyed a brief, six-year reign over the Egyptian empire following the death of the pharaoh Akhenaton, his father-in-law. King Tut won no major battles, united no kingdoms, and built no cities (although during his reign the priestly class demolished Akhenaton's new capitol when a return to polytheism was ordered). Tut lives in popular imagination primarily because his was the only pharaoh's tomb to escape grave robbers until the twentieth century. In 1922, a British team of archeologists unearthed the priceless treasure, which included the young monarch's mummified remains (encased in a triple coffin), as well as a trove of luxury objects that were buried with the pharaoh for his trip to the afterlife. When it toured the world in the 1970s, the exhibition of these objects drew huge crowds. King Tutankhamen's treasure had come to

The second coffin of Tutankhamen (rule 1361–1352 BCE). Gilded wood inlaid with glass paste, 6' 7" long. Egyptian Museum, Cairo, Egypt.

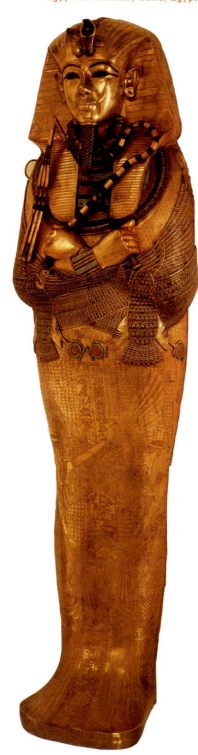

symbolize the mystery, power, and riches of the ancient Egyptian civilization.

Although viewers were fascinated by King Tut's golden throne and elaborate jewelry, the focus of the exhibit was naturally the coffin itself (12-4). The innermost chamber, which held the mummified body, is crafted of 450 pounds of gold inlaid with lapis lazuli, turquoise, and carnelian. It is not these precious materials but the exquisite workmanship, great age, and historical uniqueness that make Tutankhamen's mummy case priceless. Like the best Egyptian art, King Tut's golden portrait is formal, elegant, and reserved. The face has been simplified, or stylized, into a smooth mask of power, reminding us that the pharaoh was identified with divinity. The design of the sculpted likeness is carefully balanced, conveying a sense of grandeur and permanence—and immortality.

A hundred years after the reigns of Akhenaton and Tutankhamen, the great pharaoh Ramses II further extended the mighty Egyptian Empire, battling to enlarge its borders as far as what is now southern Syria. Traditionally identified as the pharaoh of the Exodus, Ramses demanded an even more powerful, formal style of Egyptian sculpture, as evidenced by the colossal statues of the pharaoh (sixty feet high) cut directly out of a hillside of solid rock (12-5). Dwarfed by Ramses' majesty, the workers whose labor built this monument must have felt literally crushed by its size and scale. (Although the Bible tells the story of Jewish slaves, modern historians

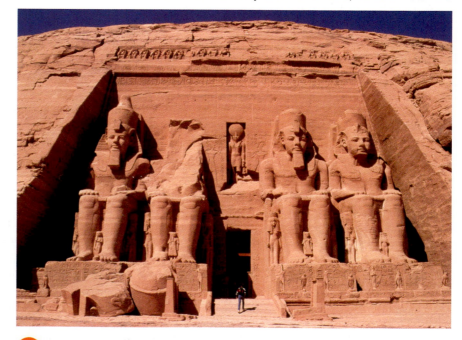
12/5 *Temple of Ramses II*, Abu Simbel, Egypt, 1257 BCE. Colossi approximately 60' high.

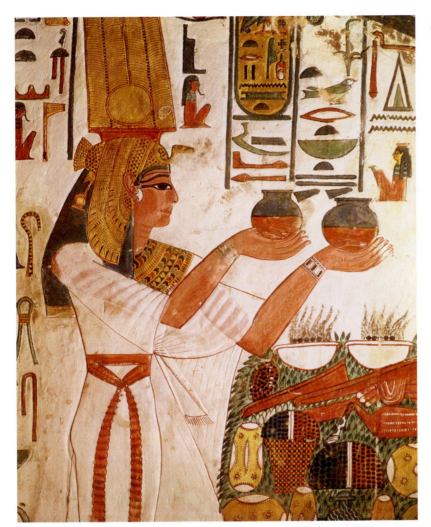

12/6 *Queen Nefertari presenting offerings,* wall painting tomb Nefertari, Egypt, c. 1250 BCE. Painting on dry plaster.

believe these monuments were created through labor and taxation required of the Egyptian people.) These gigantic statues marked the entrance to an entire temple carved from the stone cliff, including two rows of colossal statue-columns.

But Ramses appears to have had a human side as well. Besides the temple glorifying his power as a god-king, and his own tomb, the warrior pharaoh built a beautiful tribute to his favorite wife, Queen Nefertari, after her death (12-6). Although its walls were decorated more than three thousand years ago and its contents plundered, with a restoration completed in the 1990s, Nefertari's image is once again fresh and alive. Her tomb illustrates the bright colors and decorative quality of much of Egyptian art. In this painted relief of Nefertari presenting offerings to the gods, the queen almost seems to be dancing, her long fingers rhythmically curved. Like Nefertiti, Ramses' favorite wife wears an elaborate headdress and dramatic eye makeup. Earrings, a golden collar, and bracelets complete the picture of aristocratic elegance. A hieroglyphic inscription close by describes her as "the most beautiful."

ANCIENT CHINA

The ancient Egyptians were not the only people to believe that their rulers would come back to life in another world, where they would require the assistance of their followers and continue to enjoy their earthly possessions. Along the valley of the Yellow River in China, there developed a mighty civilization greatly concerned with the ceremonial burial of the dead; the earliest dynasties actually buried living servants along with their dead rulers. China is the site of one of the most remarkable tombs ever discovered—a burial on the scale of the Egyptian pyramids but completely different in artistic style.

The Qin Dynasty of China (221–206 BCE) was the first to unite a large portion of the country under a single ruler. When the Emperor Qin Shi Huang was buried, his tomb was surrounded by more than ten thousand *life-size* figures, constituting an entire sculpted army, complete with horses and chariots. This great army was even arranged in precise order, as if prepared for battle; the ranks of the soldiers can be distinguished by their costumes and weapons. The scope of the project is overwhelming, yet each of the terra-cotta figures represents

an individual portrait of a real soldier, each was originally painted, and each carried an actual weapon. This mammoth testament to a ruler's belief in an afterlife—one in which he would need an entire army—indicates the power and wealth of the emperor during this period. The figures are evidence of the high quality of Chinese earthenware sculpture (12-7, 12-8). It is possible to find some of the names of the potters who made them stamped or engraved into the clay. These potters were able to mold clay to create surprisingly realistic portraits; the army is made up of different ranks and racial types.

THE CLASSICAL WORLD: GREECE

Greek and Roman art mark the beginning and set the standard for much of the later art of the West. Although ancient civilizations in Egypt, Assyria (see 9-3), and Asia also produced great art, these styles had much less effect on later Western art than did the Mediterranean styles of Greece and its cultural descendant, Rome.

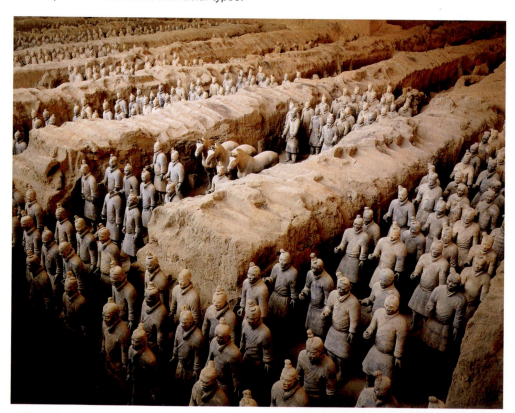

12/7 Terra-cotta army of First Emperor of Qin, Lintong, Shenxi, China, c. 210 BCE.

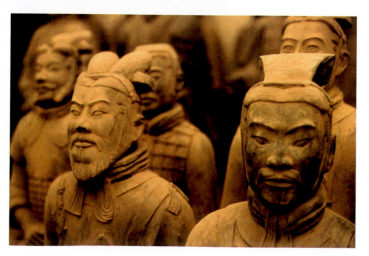

12/8 Figures from terra-cotta army of First Emperor of Qin, c. 210 BCE.

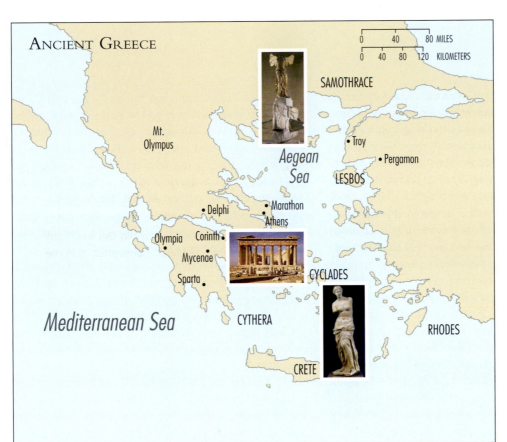

Greek civilization was not limited to the area now occupied by the modern country of Greece on the mainland of Europe. The Greeks, or "Hellenes" as they called themselves, spread from their homeland across the Aegean Sea to the coast of Turkey. The Hellenic homeland was divided into relatively small states that competed with each other economically and sometimes politically. Despite their political fragmentation, the Greeks were united by their culture: a common language and religion, a sophisticated literature and art, and a love of athletics. Whether living in one of the city-states of the mainland or in an island colony, the Greeks thought of themselves as civilized and the rest of the world as barbaric. They developed a rich mythology based on tales about gods and goddesses. According to Greek mythology, the immortal gods lived on Mount Olympus but often visited earth, interfering in human affairs and interacting with mortal men and women. Mythological and historical stories formed the basis of Greek literature and drama. The epic masterpieces of Homer, the *Iliad* and the *Odyssey*, along with the great plays of Aeschylus, Sophocles, and Euripides, attempted to understand the motivations of men and women by retelling traditional tales of Greek gods, heroes, and ancient rulers.

But the Greeks were not a blindly superstitious people. Their religion did not limit their quest for knowledge. The Western studies of mathematics, science, astronomy, history, and philosophy all began with the Greeks, who attempted to discover and understand the rules that ordered the universe. The great teacher Socrates reflected Greek attitudes in statements like "The unexamined life is not worth living" and "There is only one good, knowledge, and one evil, ignorance." His student Plato posed important philosophical questions about ideal government, truth, and beauty. Plato's student Aristotle was more practical, collecting data and formulating ideas based on his observation of natural processes. Yet he echoed Socrates' basic tenets when he said: "Educated men are as much superior to uneducated men as the living are to the dead." Greek thinkers placed a premium on logic and rationality. Their desire for clarity and order is also evident in Greek art.

THE CLASSICAL AGE

The Golden or Classical Age of Greek culture took place during the fourth and fifth centuries BCE. All of the arts—literary, theatrical, musical, and visual—flourished during this period. In open-air amphitheaters, the Greeks enjoyed the plays of great dramatists. The Western world would not see such a convergence of genius again until the Renaissance some two thousand years later. And just as the city-state of Florence was central to the development of the Italian Renaissance, so the city-state of Athens seems to have been most important

in formulating what we think of as the ideal Grecian art and architecture. The accomplishments of this period are all the more remarkable because the height of Athenian power lasted only seventy-five years—from the defeat of the Persian Empire by an alliance of Greeks in 479 BCE to the Athenians' own defeat by other Greek states, led by the rival city of Sparta in 404 BCE.

The Athenians established a new kind of state—a democracy ruled by able citizens rather than dominated by the wealthy. This was the first example in the history of the world where concerned citizens shared in public political discussion and decision making. Although the Athenian experiment in democracy was marred by their acceptance of the institution of slavery and the limitation of citizenship to males, it has served as an exciting example to later, more democratic governments. As discussed in Chapter 10, one of the major accomplishments of this era was the construction of the buildings of the Athenian Acropolis after the original temples had been destroyed by the Persians. This project was directed by the Greek leader Pericles, the leading statesman of the time.

Of all the buildings constructed under Pericles, the most important was the Parthenon (10-11, 12-9). Loosely translated, the word *Parthenon* means "to the virgin," and this temple was dedicated to the virgin Athena, patron goddess of Athens. Within its columns, the Parthenon housed a magnificent, forty-foot ivory-and-gold statue of the goddess (12-10). The Parthenon is one of the most famous architectural wonders of the world and has come to symbolize Greek art and culture. Every aspect of the structure has been measured and analyzed; generations of artists have approached it as a shrine. For instance, the view reproduced here is from a painting by the great American nineteenth-century landscape artist, Frederick Edwin Church. Church had traveled to Greece to study this monument firsthand and had written back home in a letter: "The Parthenon is certainly the culmination of the genius of man in architecture. . . . Daily I study its stones and feel its inexpressible charm of beauty growing upon my senses."

In America, we are most familiar with places of worship where ceremonies take place inside; this was not true of Greek temples. The Parthenon represents the ideal Greek temple, a religious shrine designed to face outward rather than to draw worshippers inward like a Christian church (12-11, floor plan of the Parthenon). The

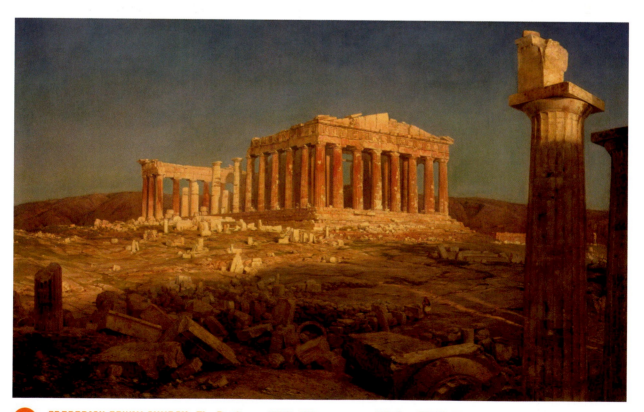

12/9 FREDERICK EDWIN CHURCH, *The Parthenon*, 1871. Oil on canvas, 44½" × 72½". The Metropolitan Museum of Art, New York.

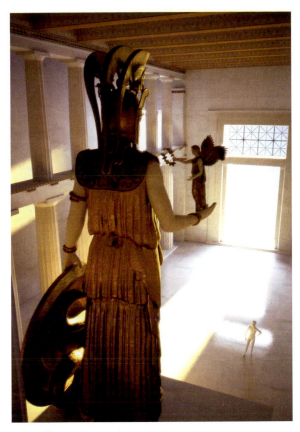

12/10 Reconstruction of statue of Athena in Parthenon. Virtual model by Paul Debevec, 2004. Cella rendering from The Parthenon Project, www.debevec.org/Parthenon, © 2004 University of Southern California.

interior chamber, where the magnificent statue of Athena was reflected in a shallow pool of water, was open only to priests and priestesses of the cult. The statue might be glimpsed from the eastern doorway, but the space where religious rituals took place was outside at an altar placed in front of the eastern entrance. There religious processions would stop. Greek worshippers would gaze on the golden marble that rose up against the clear blue sky. Brilliant sunlight cast highlights and shadows on the fluted columns and the colorful painted marble statues that decorated the triangular pediments at either end of the roof.

The temple was simple in plan. Whereas the inner chambers have been destroyed, we can still see the row of columns, or **colonnade**, a kind of open porch that completely surrounded the inner rooms. These simple vertical columns support the horizontal lintels that held up the roof. Thus the form—posts holding up lintels (see 10-17), verticals supporting horizontals—is a clear expression of function, or how the building works. The structural skeleton of the temple is immediately apparent to the viewer; nothing is mysterious, hidden, or confused. The exterior design of the Parthenon is symmetrical, perfectly balanced. The Greek values of clarity, order, and unity are simply and powerfully expressed.

Yet the lines of the building are not perfectly straight. The columns swell gradually from their bases and then taper toward their tops (see 10-12). These slightly curved lines, lines that the human eye does not

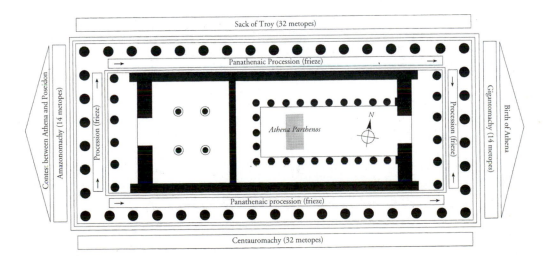

Sack of Troy (32 metopes)

Contest between Athena and Poseidon

Amazonomachy (14 metopes)

Procession (frieze)

Panathenaic Procession (frieze)

Athena Parthenos

N

Procession (frieze)

Gigantomachy (14 metopes)

Birth of Athena

Panathenaic procession (frieze)

Centauromachy (32 metopes)

12/11 Floor plan of the Parthenon

A WORLD MOUNTAIN FOR WORSHIP

Buddhism began in India and spread across Asia at the same time as the height of the Greek and Roman empires in the Mediterranean region. The founder of the Buddhist faith was a Prince, Siddhartha Gautama (believed to have lived in the sixth century BCE), who turned his back on wealth and status in order to discover the reason for human suffering. After searching for years, he experienced enlightenment. The prince then became the Buddha, and he taught that suffering is caused by desire, and that humans must free themselves from desire through meditation and right conduct in order to escape the endless cycle of pain. Instead of the self-indulgence of his early life, or the strict abstinence of his years of searching, the Buddha advocated a "middle way," in which humans attempt to let go of all attachment to the material world. Those who achieve this end attain nirvana. The Buddha lived the rest of his life as a teacher, while his closest followers became Buddhist monks and nuns.

With the spread of Buddhism in India came the development of a new religious architectural form that would greatly influence the Eastern world—the **stupa**. Jewish temples, Christian churches, and Islamic mosques are all based on a concept of worship familiar to most of us: A large, impressive building is dedicated to God, who is praised and prayed to by the people who gather within its walls. In contrast, the Parthenon was a temple whose worshippers gathered outside, in the open air. The concept behind a Buddhist stupa is even more foreign to most Westerners. A stupa is actually a mound and cannot be entered like a building. Instead, the Buddhist walks around the stupa in a clockwise direction. This walk symbolizes the Path of Life around the World Mountain, and the walking is a form of meditation and worship.

One of the earliest Indian stupas is *The Great Stupa* at Sanchi (12-12). This mound was finished in the first century CE. Originally it was covered with brick, then white stucco that was gilded. On the very top is a balustrade within which you can see a mast topped with a three-layered umbrella that symbolizes the three parts of Buddhism—the Buddha, the Buddhist Law, and the Monastic Order. Around the mound are a railing and four exquisitely carved gates. The sculptures on these gates tell stories about the Buddha or contain Buddhist symbols. Entering the gate, the pilgrim climbs stairs to a raised walkway that leads the worshipper on his or her journey. There is no statue of the Buddha at Sanchi; the burial mound itself is symbolic of the Buddha and his death.

Ironically, over the centuries, Buddhism became far stronger in the areas it spread to than it remained in India. Borobudur in Indonesia (10-8) includes fifteen hundred stupas, and the whole monument also symbolizes "The World Mountain," as do the individual stupas themselves. In some regions, however, Buddhists built temples rather than stupas, as in the Byodo-in Temple of Japan (1-5).

Today, we can get an idea of how early gilded stupas might have looked in the *Schwedagon Pagoda* of Rangoon, Myanmar (Burma) in Southeast Asia (12-13). This particular stupa (the word *pagoda* comes from the term Portuguese traders in Asia used to describe stupas) was built hundreds of years ago, but (like the Ise Shrine in Japan, 10-25) it has been rebuilt and renewed many times.

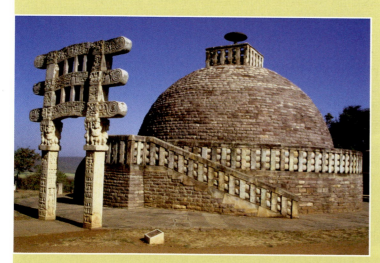

12/12 *The Great Stupa*, Sanchi, India, third century BCE to early first century CE.

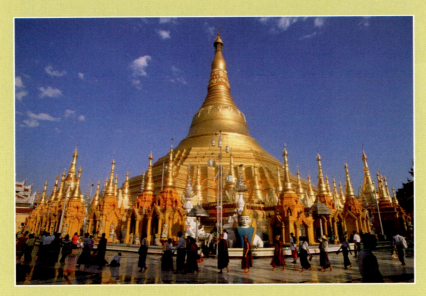

 12/13 *Schwedagon Pagoda*, Rangoon Myanmar (Burma), 14th century or earlier. Stupa, gold, silver, and jewel encrusted, approx. 344' high.

It is now covered with gold, silver, and jewels—the umbrella at the top is encrusted with thousands of diamonds. This magnificent pagoda, surrounded by a forest of shrines, each with its own miniature golden tower, is almost 350 feet high. Perhaps its grandeur seems far removed from the original Buddha, who renounced worldly pleasures in order to search for the cause of suffering, but St. Peter's Basilica (10-33) may seem equally distant from Jesus of Nazareth, the simple carpenter. As we will continue to see, each religious tradition in the world has expressed itself in beautiful art and often demonstrates its faith and devotion in rich, expensive decoration.

consciously perceive as curved, relieve the rigidity of the strict horizontal and vertical design, making it more visually pleasing and graceful. Curved lines give an organic, living quality to the structure. For instance, the swell of the columns has been compared to the muscular support of a human limb, like an arm or leg. The Parthenon is a perfect example of the melding of grace with strength, an ideal also expressed in the statues of Greek gods and heroes. Because the Greeks were great builders, they were able to construct the Parthenon with no mortar to hold the stones together. What appear to be solid marble columns are actually built out of marble drums, like round blocks, that have been fit one on top of the other.

It is interesting to note that the Parthenon as it appears today is rather different from that built and used by the ancient Greeks. Obviously, the temple is in disrepair, but other changes have taken place. The sculptures of the pediment were removed by the British Lord Elgin in the early nineteenth century (12-14)—now known as the Elgin marbles—and are housed in the British Museum (see "Art Issues" box). In addition, the sculptural elements on the temple were originally painted to look more lifelike so they could be more easily seen by viewers at the ground level.

Although we cannot see the Parthenon, or any Greek temple, exactly as the ancient Greeks meant it to be

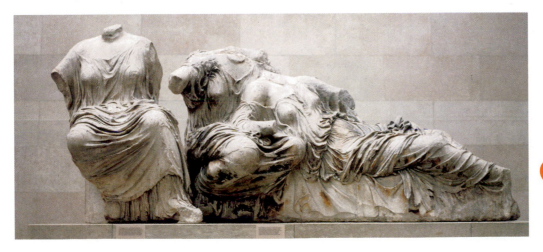

 12/14 *Three Goddesses*, from the east pediment of the Parthenon, c. 438–432 BCE. Marble, over life-size. British Museum, London, United Kingdom.

THE ELGIN MARBLES
CONTROVERSY

The Parthenon, one of the greatest architectural monuments in the world, is at the center of one of the greatest controversies in the art world. It is a battle that has pitted the Greeks against their British allies, and its resolution could affect the future of all major museums. Much is in dispute, but here are the facts.

In 1801, Thomas Bruce, the Earl of Elgin, was the English ambassador to the Ottoman Empire, of which Greece was then a part. While in Athens, Lord Elgin, concerned about the sad state of the Parthenon, received permits from the Turkish government to remove the panels that had decorated the Parthenon's exterior since it was constructed in the fifth century BCE. Seventeen figures from the pediments and more than fifty panels, nearly half the decorations, were taken off the façade and shipped to London. Lord Elgin ultimately sold them to Parliament, who gave them to the British Museum. In 1816, they were first exhibited, capturing the enthusiasm of the British people. John Keats, the great nineteenth-century Romantic poet, wrote a poem on the effect of these "wonders." There they remain and are considered British national treasures; millions of people go to see them each year at no charge.

The British contend that they are responsible for preserving these precious sculptures for more than two hundred years. They believe that Lord Elgin rescued the marbles when they were deteriorating in a ruined Acropolis for the sake of the world's cultural heritage. A man with a true love of antiquity, he was horrified when he witnessed Turkish soldiers using the statues for target practice. He also learned that some of the friezes had recently been burned to make lime for other building projects. He felt it was his mission to save them from the "barbarous Turks." He got the necessary permits, removed and shipped the panels at his own expense. Lord Elgin hoped the marbles would foster a British renaissance of art and culture by inspiring artists and artisans. The British government has stated repeatedly that "the Elgin Marbles were properly acquired, legally acquired by the British Museum."

The Greek point of view, not surprisingly, is quite different. Lord Elgin had given many gifts (which they sometimes call "bribes") to Turkish officials to acquire his permits, which were actually somewhat vague. In fact, they grant "painters" the right to erect scaffolding, make drawings, and plaster casts of the Parthenon and only say "no opposition should be made" if they also remove "some pieces of stone." The British claim of preservation is somewhat weakened by contemporary observers who witnessed the clumsiness of the marbles' removal. They were roughly sawn off, damaging the building. Some friezes were broken or destroyed when they were accidentally dropped off the Parthenon. Another British romantic poet, Lord Byron, took the Greek side when he wrote: "Dull is the eye that will not weep to see/Thy walls defaced, thy mouldering shrines removed/By British hands. . ."

More importantly, whatever Lord Elgin's claim, the Greek government says he was dealing with a conquering power, not the Greek people. The Turkish government had no right to grant permits that gave away an essential part of the Greeks' historic heritage. This is why they should be returned. As one cultural minister said, "The Parthenon itself demands its marbles back."

The English were not the first to ship home statues from Greece. That honor belongs to the ancient Romans, who collected masterpieces from across their empire. That is why there are more ancient Egyptian obelisks in Italy today than remain in Egypt. In the nineteenth century, the Turks themselves suffered at the hands of Germans, who removed archeological treasures from ancient Troy. (Ironically, the Germans now complain about how the Russians plundered these same treasures from a Berlin Museum and transported them to Moscow at the end of World War II.)

Whatever one's sympathies, the ultimate resolution of the matter is quite important. Like the British Museum, the greatest museums in the world, in Berlin, Madrid, Paris, and elsewhere, are in nations who were once among the most powerful in the world. The priceless masterpieces inside them were largely acquired through victories in war, imperial domination, and sheer wealth. If they were forced to *repatriate* or return these cultural artifacts to their original homes, it would devastate their collections.

In 2009, a new Acropolis Museum opened in Athens. Built as an answer to the strongest argument

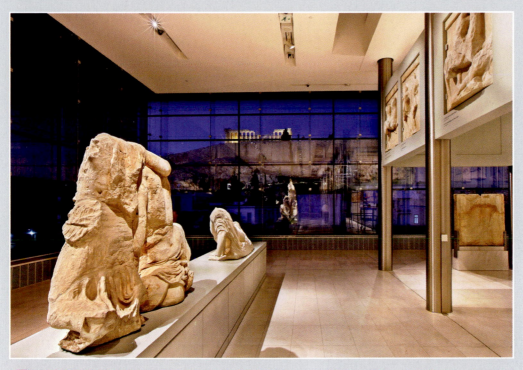

BERNARD TSCHUMI and **MICHAEL PHOTIADIS,** *Acropolis Museum, Athens,* 2009. View of Acropolis from Parthenon Gallery.

of the British—that they are better equipped to preserve these priceless treasures—it has the finest state-of-the-art climate controls available. It also is designed to withstand earthquakes. The Acropolis Museum's top floor is dedicated to the sculptural decoration of the Parthenon. Displayed in the order they were on the great ancient building are not only the few remaining sculptures and friezes from the Parthenon but also plaster casts of those in the British Museum and elsewhere. It is as if the Greeks are saying "we are ready to safeguard our heritage and are holding places for their return." Through the wide glass windows, one can see clearly the Parthenon atop the Acropolis (12-15). One can only wonder how much longer it and the Greek people will be waiting.

seen, historians, writers, critics, and tourists have all found in the remains of the Athenian Parthenon a spur to their imagination, a symbol of the very spirit of the Classical Age of Greece.

CLASSICAL GREEK SCULPTURE

The Greek concern with balance, harmony, and proportion that we saw in the architecture of the Parthenon is also evident in their sculpture. However, when Greek statues represent the ideal beauty of the human form—youth, strength, grace—they do this by appearing more lifelike, or **naturalistic**, than statues of previous cultures, such as those of the Egyptians. Greek sculpture and painting were based on a study of the human body, especially the nude athletic male. This is not surprising, because the Greeks believed that mental health should be balanced by physical exercise. The original Olympic Games were part of a sacred festival open to Greeks from every state;

in fact, the Greeks counted their history as beginning in the year of the first Olympiad (equivalent to our 776 BCE). Because the Greeks exercised and competed naked, it was natural for artists to represent them in the nude; the Greeks found nothing shocking about seeing people unclothed. In addition, for the Greeks, nudity was associated with both heroism and divinity.

The Greeks tempered their admiration for athletic strength with an equal respect for youthful grace. They sought a perfect balance between body and mind, a natural harmony among muscular prowess, mental vigor, and physical beauty. For the ancient Greeks, ideal men (even more than women) could be seen as beautiful.

Unfortunately, very few Greek statues have survived in their original form. We are left, then, to make judgments about Greek sculpture from secondhand Roman copies. Still, this is perfectly appropriate, because these copies, not the Greek originals, had a profound effect

on the artists of the Renaissance and later Western art. *Discobolos*, or Discus Thrower (12-16), is a Roman copy in marble of a famous Greek statue by Myron; the bronze original was cast around 450 BCE, at the height of Greece's Golden Age. Here we see the athletic male in the midst of competition, yet he is not grunting or sweating. This perfect young man seems capable of great physical effort without any emotional strain; his face remains perfectly calm. This depiction fits the Greek ideal of dignity and self-control, a philosophy that became known as **stoicism**. What was unusual in Myron's statue

was the dramatic motion and dynamic pose of the figure. Compare this to the rigidity of Egyptian statues, such as that of Mycerinus (12-2). The remarkable balance of the moving figure of *Discobolos* is a result of the precise moment selected by the artist—the pause between the athlete's upward and downward motion.

Another statue of this period that had a great influence on later Western art is the *Doryphoros*, or Spear Carrier (12-17). Again, what remains is a much later Roman copy of a bronze original cast by the famous artist Polykleitos. The statue has not only lost its spear,

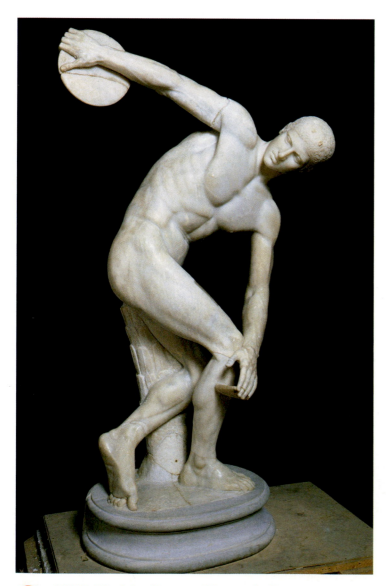

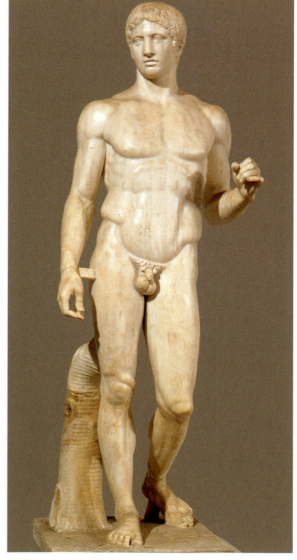

 MYRON, *Discobolos*. Roman marble copy of a bronze original of c. 450 BCE, life-size. Museo Nazionale, Naples, Italy.

12/17 **POLYKLEITOS**, *Doryphoros*. Roman marble copy of a bronze original of 450–440 BCE, 6' 6" high. Museo Nazionale, Naples, Italy.

FERTILITY
GODDESSES

In Chapter 1 we looked at the *Venus of Willendorf*, carved about twenty thousand years ago, a tiny stone figurine in which the female sexual characteristics had been greatly exaggerated. Such early sculpture reflects a natural concern for human fertility and the continuation of the tribe, just as cave paintings were meant to magically ensure a supply of animals to hunt for food. Fertility goddesses continued to be worshipped by many early civilizations. It is not surprising that women, with their power of procreation, were associated with the creative forces in the universe. Throughout the ancient Middle East and Mediterranean basin, these overtly sexual goddesses were worshipped under many names: Ishtar (in Babylon), Astarte (in Syria), Isis (in Egypt), and Aphrodite (in Greece). Modern scholars refer to all of these as manifestations of a single powerful concept: The Great Mother Goddess. Mother of the earth, she symbolized life forces and controlled the heavens, the seasons, and fertility for plants and animals as well as humans.

Today we are most familiar with the name the Romans gave to the goddess of fertility—Venus—but cultures from all over the globe have incorporated female fertility figurines into their religious art. In Indian art, the figure of a voluptuous woman is known as a *Yakshi* (12-18). Originally part of a primitive system of beliefs, these Yakshis were incorporated into the decoration of both Hindu and Buddhist religious centers. The Yakshi illustrated here, for instance, is from a gateway of the Great Buddhist Stupa at Sanchi (see the "Global View" box, "World Mountain for Worship").

In Indian as in Greek art, there is no shame in showing the nude body, and Indian artists seem to stress even more the overtly sexual nature of their goddesses. With large breasts, tiny waists, and swelling hips, these represent an exaggeration of the female form as much as the Venus of Willendorf does. Notice also how the Yakshi is shown intertwined with a tree—representing vegetation, or the fertility of earth. Although we would never expect this seductive Yakshi to come to life, still the Indian goddess has a playful quality that seems to be lacking in the Western portraits of goddesses. The attitude toward divinity seems somehow less authoritarian, more joyful.

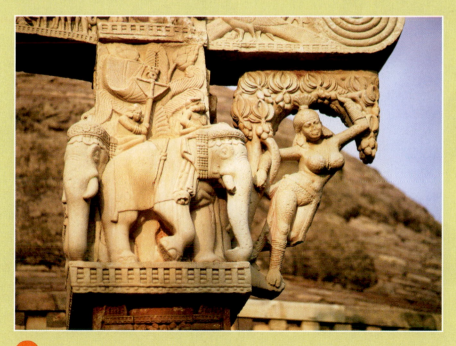

12/18 *Yakshi*, from the East Gate, *The Great Stupa*, Sanchi, India, early first century BCE.

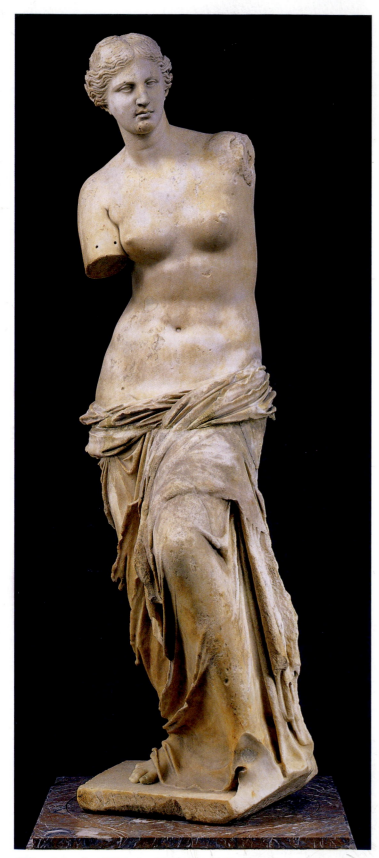

Aphrodite of Melos, c. 150–100 BCE. Marble, approximately 6' 10" high. Louvre, Paris, France.

but supports have also been added in the form of a tree trunk and a brace between the thigh and the wrist. Nevertheless, we can recognize some essential qualities of Greek sculpture: the nude, athletic male; the graceful, natural stance; the well-defined muscles and understanding of human anatomy. Despite its pose of relaxed movement, the figure is shown as balanced and unified.

This statue is particularly important because it was known as the *canon*, which means measure or model. It exemplified, according to the Greeks, the most perfect and pleasing proportions for representing the human figure. Polykleitos was one of the most famous Greek sculptors; after his death, his name even came to mean "sculptor." Artists who followed him studied his ideas and abided by his perfect proportions.

HELLENISTIC GREECE

After the classical period, Greek history and art entered what is called the Hellenistic Age. This period began with the age of Alexander the Great (356–323 BCE), when not only all of the Greek city-states were conquered and unified, but also an attempt was made to conquer the rest of the known world. Alexander, the student of Aristotle, reached as far as India, and although his empire was divided after his death, cultural connections between the subcontinent and the classical world began to flourish.

Greek sculpture became more naturalistic, more illusionistic, and more human during this period. The work of Praxiteles (1-16) and the *Aphrodite of Melos* (known commonly as the *Venus de Milo*, **12-19**) illustrate how Greek sculptors made marble resemble flesh. Although she is missing her arms, the life-size *Venus de Milo* still illustrates the voluptuous charms of the Greek goddess. Not only are her breasts bare, but also her hips and abdomen. We can imagine this Venus breathing, moving, like a real person. These sculptures appeal less to the rational mind and more to the senses than the restrained works of the classical period. Also, during the Hellenistic Age, a more elaborate style of column gained popularity—the *Corinthian* order (see Chapter 10), which was topped with a capital of sprouting leaves.

By the second century BCE, Greek sculptors had begun to sculpt ever-more complex and dramatic figures that made bolder use of space. Two examples of this more exciting, less classical or restrained sculpture are the *Nike of Samothrace* (**12-20**) and the *Laocoön* group (**12-21**).

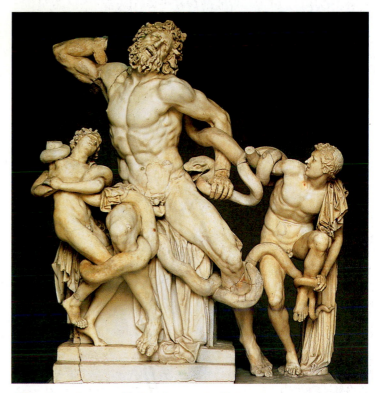

12/21 *Laocoön* group, first century BCE to first century CE. Marble, 8' high. Vatican Museums, Vatican State (partially restored).

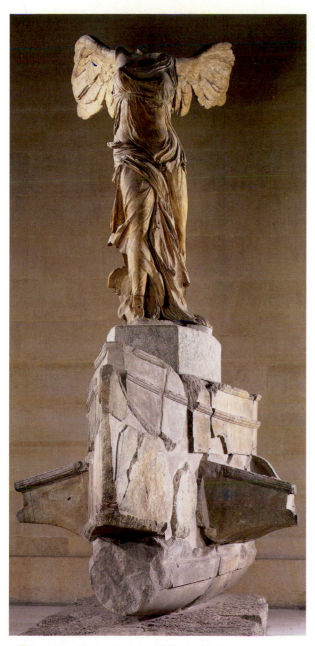

12/20 *Nike of Samothrace*, c. 190 BCE. Marble, approximately 8' high. Louvre, Paris, France.

Nike means goddess of winged victory. Like so many ancient statues, this one no longer has a head, but the spirit of the piece is still evident. It shows the victory goddess landing on the prow of a ship. This portrayal of

a moment in time, rather than a timeless universal, is one break with the classical past. Another is the sense of motion, the windswept drapery, the twisted lines of the costume, and the diagonals of the wings. The detailed rendering of the wet, clinging drapery is typical of Hellenistic sculpture, where artists attempted to make marble resemble both cloth and the flesh beneath it.

The *Nike of Samothrace* was carved about 190 BCE; the *Laocoön* group of the first century CE represents the ultimate in Hellenistic theatrics. It illustrates the story of a Trojan priest, Laocoön, who (along with his sons) was squeezed to death by sea serpents as a punishment for displeasing the gods. Compare the writhing, twisting figures of the *Laocoön* to that of the earlier *Doryphoros* (12-17)—the expression of anguish on his face to the masklike features of the Classical Age; we have come far from perfect beauty and harmony.

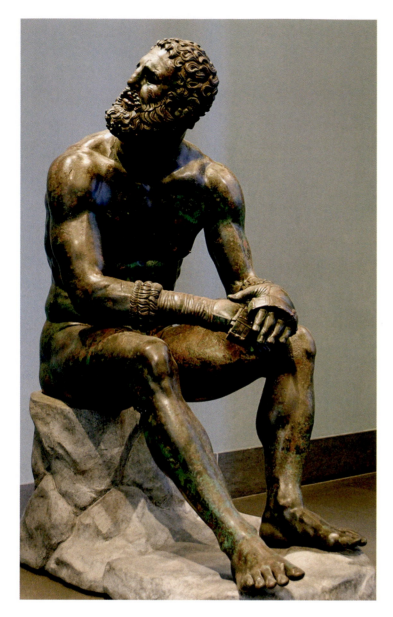

The Seated Boxer, attributed to APOLLONIUS, from the Thermae of Constantine, Rome, c. 100–50 BCE. Bronze, 4' 2" high. Museo Nazionale Romano–Palazzo Massimo alle Terme, Rome, Italy.

THE CLASSICAL WORLD: ROME

The city of Rome in Italy was the center of a second, and related, dynamic civilization that spread throughout the Mediterranean world. As early as the third century BCE, Rome had expanded and conquered Greek settlements on the boot of Italy, and by about 150 BCE, Greece had been annexed into the growing Roman Empire. In fact, the *Laocoön* was sculpted for Roman patrons after Greece had become a Roman province. During this early imperialistic period, Rome operated as a republic. The government was controlled by a small group of wealthy families by means of a senate and by officials elected from a small pool of eligible aristocrats and an electoral system heavily weighted toward the nobility.

Roman culture was modeled on that of the Greeks: Their gods were variations on the same theme; their literature imitated Greek poetry and drama; their art and architecture grew directly from Greek sources. Educated Greeks were often brought to Rome as slaves for the wealthy, working as clerks and teachers. Greek artists flocked to Rome, attracted by money and patronage, and created many of the surviving Roman copies of Greek statues. Although the Romans absorbed their artistic ideals from the Greeks, they were more realistic than idealistic, more active than philosophical, more pragmatic than creative.

The Romans also contributed something unique to the world of Western sculpture: a tradition of realistic portraits. This school of portraiture developed in response to a specific need that related to Roman religious practices. Roman religion centered around the family and home, where busts of ancestors were given a place of honor. These were realistic and descriptive of all facial features, unattractive though they might be. Compare the Roman portrait busts (12-23) with the head of Hermes by Praxiteles (1-16), and you will immediately see the contrast between Greek and Roman art. It is inconceivable that the Greeks of the Classical Age would have commissioned such an unflattering image or would have wanted to keep it in their homes. Such unsparing portraits are typical of the virtues that Romans admired during the republican period: discipline, honesty, obedience, courage, strength, and frugality.

IMPERIAL ROME

In 31 BCE, after a long period of civil wars (immortalized by William Shakespeare in Julius Caesar and by Hollywood in such epics as *Cleopatra*), Julius Caesar's great-nephew Octavius finally defeated his enemies in battle, and the Roman Empire was born. Given the title of Augustus,

Another Hellenistic statue, this one in bronze, reflects a new taste for realism versus the naturalistic idealism we associate with Classical art. Again, compare this figure of a seated boxer (12-22) to a statue from the Classical period, the *Discobolos* (12-16). The discus-thrower is a young man with a perfect physique, smooth flesh, a handsome face, and an impersonal expression. The *Seated Boxer* is a mature man, muscular yet battered, with a brutally scarred face. The sculptor used reddish copper to highlight his lips, and also the bleeding cuts on his cheeks, forehead, nose, and ears. The bout is over, and art historians speculate that this exhausted veteran is either waiting for the verdict or already named the loser of the match. Instead of a heroic man in the prime of life who moves with effortless ease, we see an aging fighter with a bent back, who strains even to lift his head. Compared with the *Nike of Samothrace* and the *Laocoön* group, this statue demonstrates the wide range of expression within Hellenistic art.

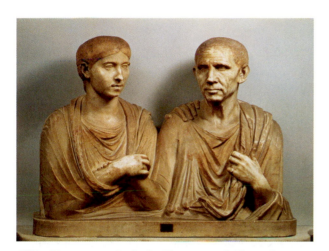

12/23 Funerary portrait of a Roman couple (formerly known as Cato and Porzia), c. first century BCE. Marble 27" high. Vatican Museums, Vatican State.

Octavius proceeded to consolidate his power. Although he never called himself emperor, he held dictatorial and imperial powers. For the next one hundred fifty years, Rome would be at peace, prospering and expanding, reaching the furthest limit of its rule. Eventually the empire would stretch completely around the Mediterranean, from Italy to Spain, through North Africa, the Near East, Turkey, and Greece, and including all of the islands in what Romans called *Mare Nostrum* or "Our Sea." Because of the **Pax Romanus**, or "Roman peace," it was possible for citizens to travel safely anywhere within the far-flung empire. Roman legions also marched northward. Having already conquered Gaul (what is now France) under Julius Caesar, Rome expanded through the island of Britain to Hadrian's Wall, near the current border of Scotland.

The statue known as *Augustus of Prima Porta* (**12-24**) stood in the courtyard of the suburban Roman estate of

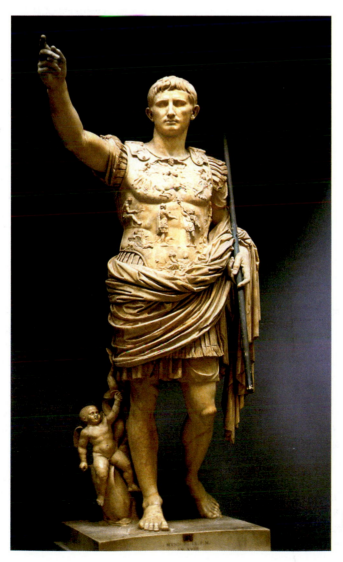

 Augustus of Prima Porta, c. 20 BCE. Marble, 6' 8" high. Vatican Museums, Vatican State.

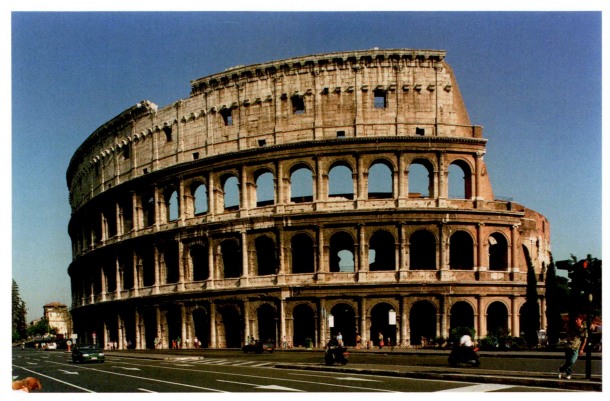

12/25 Colosseum, Rome, Italy, 70–82 CE.

Augustus's wife, Livia. The posture is that of a victorious general addressing his troops, and the emperor is shown in armor. His breastplate is sculpted with scenes of Roman military triumph and the mythological figures of gods and goddesses. The pose of the figure is clearly based on the Greek model of the *Spear Carrier* (12-17), and the face shown is that of a handsome man in the prime of life. Here Greek idealization and Roman realism combine to create a convincing portrait of a "real man" and an effective image of the perfect leader. Looking down on his people with calm concern and complete self-confidence, Augustus represents the *pater patriae*, "the father of his country." The historical scenes on his breastplate illustrate instances when his armies imposed peace on rebellious provinces. In works of art such as this, Augustus consciously attempted to identify himself with the ultimate authority of the state and the beginning of a new, golden age of Roman civilization. (A facsimile of the statue as originally painted can be seen in Chapter 2.)

ROMAN ARCHITECTURE

Pomp and glory were needed to impress the masses, Roman citizens, and rival states. It was in architecture that the Romans found a medium most suited to their message. They adopted the language of Greek architecture—the Doric, Ionic, and Corinthian orders. They also borrowed the idea of the arch from the East (where

it had been used primarily for drains) and exploited its possibilities to construct public buildings of great size, feats of ancient engineering. The emperor Augustus, who embarked on a major program of renovation in the capital, bragged that he had found Rome a city of brick and left it a city of marble. In addition, the vast imperial building program extended throughout all areas under Roman control, from Britain to the Near East. Distant provinces of the empire were supplied with defensive walls, paved roads for the transport of armies and goods, aqueducts to supply fresh water to cities, and spacious public baths.

One of the most famous structures in Rome, symbolic of the city and imperial Roman architecture, is the *Colosseum* (12-25). This huge arena (known to the Romans as the Flavian Amphitheater) is familiar to generations of American moviegoers because of its legendary association with gladiators and chariot races. To us, familiar with huge sports stadiums, the Colosseum looks almost ordinary, but in the Roman world it was a remarkable achievement. The use of the arch was key to the support of such a structure, which could not have been held up by the simple post-and-lintel system of the Greeks. Holding up to fifty thousand spectators, it was thirteen stories tall. The Colosseum was a gift of the imperial family to the people of Rome, offering free games as repayment for the fact that this area of the city had been taken from the people by the Emperor Nero (notorious for fiddling while

Rome burned). The name Colosseum referred to a colossal statue of Nero that stood on the spot.

The purpose of the Colosseum was to house popular entertainments; for its opening in 80 CE, the entire field was turned into an immense sea of water, in which three thousand participants staged a mock battle. Plenty of blood was shed here: As many as five thousand wild beasts might be slaughtered in a single day. Animals could be raised to field level from the cellars by means of a complex system of elevators. Gladiators were well-fed on a diet of red meat, which was thought to ensure that their blood would be bright red when it spurted out.

Aesthetically, the Colosseum makes a dramatic impression even in its present state of decay. It is like an illustrated essay on the three orders: the first story decorated with simple Doric columns, the second with more elegant Ionic columns, and the third by elaborate Corinthian columns. The columns and the lintels they support, however, are not integral to the structure of the theater; they are simply ornamental, because the weight of the walls is supported by round arches rather than slim columns. The arches served not only to support the structure but also as convenient exits and entrances for thousands of spectators. Whereas the beauty of Greek architecture was based on honesty and simplicity, Roman architecture was meant to provoke awe in the viewer. In imperial Rome, the human scale of buildings such as the Parthenon was sacrificed to a kind of superhuman scale.

Later, when Rome was attacked by Gothic tribes, the Colosseum became a fortress. The iron bars that held the marble were melted down for weapons, and statues were hurled down at the invaders—but that would be after it had stood for almost four hundred years.

ORGANIZED CONQUERORS

The success of the Romans was based on the military might of their highly professional armies and the brilliance of their generals, as well as their powers of organization, their centralized administration, their efficient bureaucracy, and the huge tax base from their conquered territories. Above all, the Romans showed great political finesse, an ability to absorb many different peoples, races, religions, and cultures. One of the means by which Roman imperial authority was displayed was in official, public, and triumphant monuments, such as the *Arch of Constantine* (10-19). Another famous victory symbol of imperial Rome is the *Column of Trajan* (12-26). Trajan was a great general who ruled as emperor of Rome during the second century CE, and the Roman Empire reached its greatest size during his reign. This column

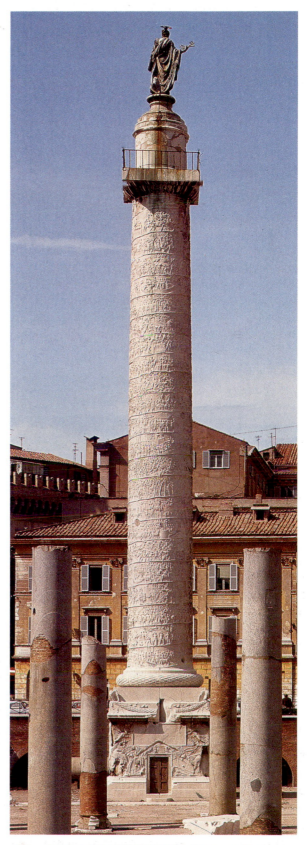

 Attributed to APOLLODORUS, *Column of Trajan*, 113 CE. Marble, 128' high. Rome, Italy.

commemorates his two campaigns against the Dacians, which culminated in the conquest of the area that today still bears the name of Rome, Romania.

Erected in Rome in 113, the column established a format that would be used for centuries. More than one hundred fifty tightly packed scenes spiral up its height, reading like the scrolls that were once stored in the two libraries on the same site. At the base (12-27), a surprised river god meant to represent the Danube has turned to see the Roman armies crossing his river on a bridge they constructed. At the next level, the soldiers, after being addressed by Trajan, proceed to build fortifications. In fact, it is not battles themselves but the world-renowned engineering and organization skills of the Romans that are accentuated in the stories described. The overall atmosphere is one of calm, methodical planning succeeding over disorganized barbarians. The Romans march in orderly patterns, while the enemy's

attacks seem confused; the Romans are clean-shaven, while the Dacians are sloppy and bearded. Trajan is always dignified and in control. Still, the Roman legions must fight long and hard as they move their way up the 125-foot column to ultimate victory.

The sculptor of this immense marble relief must have shared the Roman fascination with building, because precise details of constructions are seen throughout. Some believe that he was Apollodorus, the architect of the bridge over the Danube and other wonders of the ancient world. But even though the figures and backgrounds have many naturalistic details, real proportions are not used. Trajan is always larger than his soldiers, his armies always larger than any of the buildings. Size is related to the importance of the element in the story being told.

Inside the column, a long spiral staircase leads to a balcony at the top. In ancient times, one could walk up

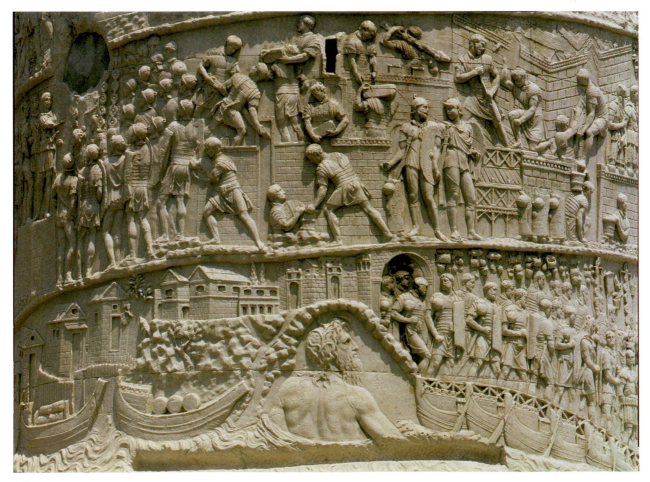

12/27 Detail of Trajan's column.

to pay homage to a bronze statue of Trajan and admire a beautiful view of the city he once ruled. Centuries later, a statue of Saint Peter was put in its place. Beneath Saint Peter's feet, in the base, are Trajan's ashes. It is, perhaps unintentionally, symbolic of the new church supplanting the once all-powerful pagan emperor and how time is the enemy that no one defeats.

ROMAN TEMPLES

In addition to their use of the arch, the Romans developed the architectural feature of the dome. A dome makes it possible to span a dramatic space without columns or supports, but with the dome, as with the arch, we see a convergence of technical means with aesthetic considerations. In other words, the dome was not merely a useful feature; it was developed to be aesthetically pleasing as well. The most beautiful domed monument from ancient times, perhaps of any age, can also be found in the city of Rome—the *Pantheon*.

The *Pantheon* (**12-28**) was a temple dedicated to the worship of all the Roman gods and goddesses, as its name (*pan* means "all," *theos* means "god") suggests. This architectural wonder was begun under the emperor Hadrian (117–138), who may well have been its designer. The size of the huge dome was never surpassed until the twentieth century. Hadrian held the empire together through hard work and strong character and was a great patron of the arts.

Looking at the Pantheon's façade, we immediately recognize Greek influence: It resembles the front of a Greek temple. Behind the rectangular porch, however, is a completely round building, or **rotunda**. The rotunda is topped by half of a sphere that, if it were continued, would just touch the floor of the building. In other words, the diameter of the rotunda is exactly equal to the height of the building at the top of its dome. Thus the space within the Pantheon is perfectly balanced, simply understood, and harmonious. At the very top of the dome is an open **oculus**, or eye, that permits a view of the heavens above (**12-29**).

The Pantheon, which has stood for almost two thousand years, is also a tribute to the engineering knowledge of Roman builders. Whereas the Greeks used solid marble to build their temples, the Romans exploited the potential of concrete as a building material. The dome of the Pantheon is designed of concrete that has been *coffered*; that is, squares have been cut into its surface. This coffering was not only part of the decorative scheme, but it also had the effect of lightening the weight of the dome itself.

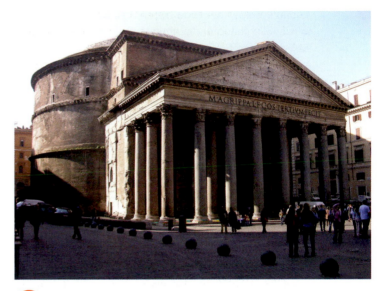

 The Pantheon, 110–125 CE, Rome, Italy.

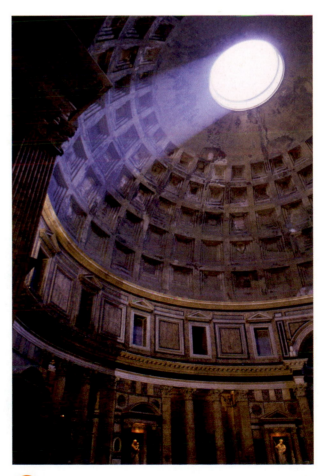

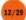 Dome with oculus of the Pantheon.

To the eye, the dome appears so light that it seems to float over the rotunda rather than press down upon the viewer. On entering the Pantheon, one is overwhelmed by a sense of peace and visual satisfaction at the contemplation of its perfectly harmonious proportions. In Roman times, the ceiling was studded with bronze rosettes that looked like stars. For generations since, its refreshing shade and cool stone have provided an escape from the hot Roman sun. Whereas the Greek temple was like a sculpture set in space, meant to be appreciated from the outside, the Pantheon is more like a frame enclosing three-dimensional space, a way of making empty space into the subject of the architecture.

ROMAN PAINTING AND MOSAICS

In addition to public buildings such as the Colosseum and the Pantheon, emperors, generals, and the upper class built expensive palaces complete with beautiful gardens and fountains. The gardens were filled with Roman copies of Greek sculpture, and the villas were decorated by wall paintings (see *Herakles* and *Telephos*, 5-2) and mosaics. One of the most beautiful and evocative fresco paintings to survive is from a villa that belonged to Livia, the wife of the Emperor Augustus **(12-30)**. The walls were from a windowless, underground room, possibly used to keep cool in the summer. The pale blue-green of the walls surround the viewer within an imaginary garden in which all flowers are in bloom at the same time, and all fruits are in season. Silvery light shimmers on pine needles; birds fly through the air or alight on branches. The whole effect is delightfully relaxing and peaceful, and reveals a very different aspect of Roman taste from the more familiar architectural and sculptural wonders designed to impress the viewer. This room was clearly meant to delight the senses.

Roman paintings in stone—**mosaics**—have stood the test of time better than the more fragile frescoes. One remarkable mosaic, made during the second century,

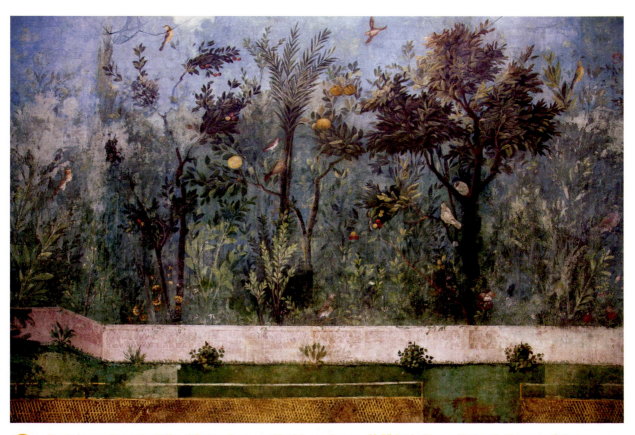

12/30 *Gardenscape,* from the Villa of Prima Porta, c. 30–20 BCE. Fresco, 6' 7" high. Museo Nationale Romano–Palazzo Massimo alle Terme, Rome, Italy.

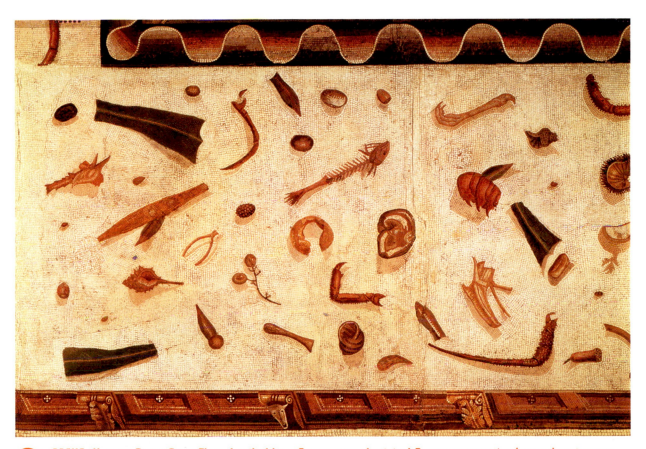

12/31 SOSUS, *Unswept Dining Room Floor*, detail of later Roman copy of original Pergamene mosaic of second century BCE. Vatican Museums, Vatican State.

is known as *Unswept Dining Room Floor* (12-31), because it represents the floor as it might have looked after a Roman banquet. The artist demonstrates complete mastery of the medium of mosaic, a medium, which like so many others, had originally been developed by Greek artists. A mosaic image is built up of tiny pieces, or *tiles*, of colored stone, ceramic, or glass, all fitted together in an intricate puzzle to form the desired pattern or picture. Here small marble tiles are used in different tones to actually *model* forms three-dimensionally; cast shadows add to the illusion of reality, as does the funny little mouse nervously gnawing on some food in a small corner. But despite the surprising realism of the individual images, all the remnants of the meal have been designed to create a pleasing pattern against the pale floor.

THE DECLINE OF ROME

Mosaic or fresco, these examples of interior decoration were obviously designed to amuse a pampered upper class. Many contemporary observers felt that such aristocratic Romans had become decadent and had lost touch with the values that had enabled them to conquer and dominate so many peoples. As the Roman Empire entered its second century, the age of confidence was replaced by a time of troubles. Historians continue to argue over the reasons for these troubles, but inflation became rampant and trade diminished. Rome was plagued with a swollen bureaucracy and urban riots. There were also military defeats at the borders of the empire, by the armies of the Persians in the east and Germanic tribes in the northwest.

12/32 *Battle of Romans and Barbarians on the Ludovisi Battle Sarcophagus,* c. 250–260 CE. Marble, approx. 5' high, Museo Nazionale Romano–Palazzo Altemps, Rome, Italy.

The violent clashes between Roman armies and invaders are preserved in the dramatic relief sculpture, *Battle of Romans and Barbarians* on the *Ludovisi Battle Sarcophagus* (12-32). (A *sarcogphagus* was a stone coffin in which Roman aristocrats buried their dead.) Note the difference between the orderly Roman soldiers of Trajan's column and the writhing, twisting figures that crowd the surface of this stone box. Although the sculptors were still able to depict human figures convincingly, both Classical restraint and Republican realism have been abandoned. The battle shown here—probably against the Germanic tribes, or Goths—is violent, with gruesome corpses interspersed with the victorious Roman armies.

Between the third and fifth centuries, Roman culture was shaken, changed, and eventually overcome by three forces: the internal crisis described previously, conversion to Christianity, and the Germanic invasions. The first two forces affected the spirit of the Romans and the other threatened the physical integrity of the empire. Christianity, an offshoot of Judaism, was originally condemned as an Eastern, mystical religion, and its followers were persecuted by the Romans. But, as

the empire continued to crumble from within and to be attacked from without, Christian ideals began to appeal to the average Roman citizen. It was almost as if the entire empire experienced a communal spiritual crisis, a crisis of confidence. Early Christianity preached renunciation of the world and concentration on the promise of an afterlife—in opposition to the Roman ideals of practicality and public service. The Christian church emphasized the spirit and condemned the desires of the body, in direct contrast to the Greco-Roman ideals of physical fitness, health, and balance between body, mind, and spirit.

The Roman style continued to change in the three centuries after the age of Augustus. The technical skill of Roman sculptors declined, as is evidenced by the *Arch of Constantine* (10-19), constructed between 312 and 315. In the traditional Roman manner, this monument was dedicated to the most famous victory of Emperor Constantine the Great. What was not traditional was that much of the decoration for the arch was actually stolen from earlier monuments to emperors. There is a dramatic contrast between the naturalism of the older sculpted reliefs and the awkwardness of those created by the artists of the Age of Constantine.

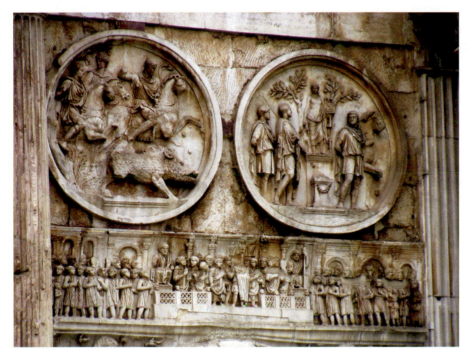

 Medallion reliefs from the Arch of Constantine, 117–138 CE, and Frieze from the Arch of Constantine, early fourth century CE. Marble, medallions approximately 80" high, frieze approximately 40" high.

The two circular medallions taken from the *Arch of Hadrian* illustrate the classical style of the height of imperial power (12-33). The figures are graceful and well-proportioned; they are shown in a variety of poses. The medallion at the left conveys the motion of a hunt, with realistic men on rearing horses, and the sculptor even suggests the texture of the wild boar's fur. On the right, an idealized, Grecian-style statue of a god stands on a classical base, and the sculptor is skilled enough to convey the difference between living figures and the immobile stone statue. Both medallions surround the sculpted forms with space and arrange shapes in a pleasing and harmonious way within the round frame.

In contrast to these reliefs, which echo much of the Greek and Roman art we have looked at so far, the horizontal relief depicting Constantine addressing the Roman Senate below them seems childlike and crude. The figures sculpted in the fourth century are squat; their heads seem too big for their bodies. The figures seem to be crowded on top of each other without enough space to move. There is nothing left here of either realistic Roman portraiture or idealistic Greek beauty.

The classical elegance of the older medallions was not to be seen again for a thousand years, until the Italian Renaissance. Yet it would be wrong to see this change in artistic style merely as the result of a loss of talent or the ability to make art look real. In fact, this period is the birth of the Byzantine and medieval styles that would come to dominate Western art in the coming centuries. The Age of Constantine marks the beginning of a period when the symbolic content of a work of art became more important than its naturalism. These fourth-century relief sculptures therefore represent a changing vision, one that had not yet reached maturity. Superb works of art would eventually be produced in both the Byzantine and medieval style—art with a different aesthetic, a different purpose, but with no less power than the masterpieces of the Greeks and Romans.

CHAPTER 13

Constantine the Great (272–337, emperor 306–337) was a uniquely important figure in the history of the late Roman Empire and Western civilization. According to legend, Constantine saw a miraculous cross in the sky before the crucial battle of the Milvian Bridge, commemorated in the triumphal arch discussed in the last chapter. After his victory, in 313 he declared Christianity legal and stopped the persecution of Christian believers; in 325 he made Christianity the official state religion of Rome. The remains of a colossal statue of the emperor from 330—its head alone is more than eight feet tall—suggest the direction that Western art will take in the centuries to come (13-1). Moving away from both the naturalism favored by the Greeks and the realism of early Roman portraits, *Constantine the Great* is presented with an awesome face. His huge, staring eyes seem all-seeing; it is an image not of a man but of absolute power.

325–500

PERIOD

DECLINE OF THE ROMAN EMPIRE
SPREAD OF CHRISTIANITY THROUGHOUT THE ROMAN
 WORLD
GUPTA DYNASTY IN INDIA
SHINTO BELIEFS IN JAPAN
GERMANIC INVASIONS OF ROMAN EMPIRE IN THE WEST
FALL OF ROMAN EMPIRE IN WESTERN EUROPE

HISTORICAL EVENTS

Constantine reunites eastern and western halves
 of Roman Empire 324–325
Constantinople becomes capital of Roman Empire 331
Emperor Theodosius declares Christianity the official
 religion of Roman Empire 391
Attila the Hun invades Italy 452
St. Patrick converts Ireland c. 475
Romulus Augustus, Emperor of the Roman Empire
 in the west, deposed 476

ART

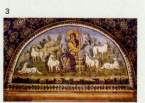

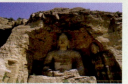

1. Colossal statue of Constantine, c. 300
2. Seated Buddha Preaching the First
 Sermon, fifth century
3. Christ as the Good Shepherd, 425–450
4. Colossal Buddha, 450–500

THE AGE OF FAITH

Approximately one thousand years divide Constantine's conversion to Christianity from the Italian Renaissance. If Constantine had been the immortal he appears to be in his statue, he would have seen in those years the destruction of the western half of his empire but also the beginning of an age of faith, with his newfound Christianity coming to dominate Western Europe. The new Middle Eastern creed spread energetically, even beyond the boundaries of the former Roman state, eventually uniting a vast region from Iceland to Russia in the north and from Spain to Turkey in the south.

At its southern and eastern borders, however, another vigorous Middle Eastern religion rose up to challenge Christian unity and dominance. Born in the desert lands of the Arabian Peninsula, and like Christianity heir to the Judaic tradition of monotheism, Islam expanded across the Middle East in the sixth and seventh centuries, sweeping westward through North Africa and

500–1000

SPREAD OF BUDDHISM TO SOUTHEAST ASIA
EARLY MIDDLE AGES AND FEUDALISM IN EUROPE
GROWTH OF CHRISTIAN MONASTERIES
WEST AFRICAN KINGDOM OF GHANA
SPREAD OF ISLAM ACROSS MIDDLE EAST AND
 NORTHERN AFRICA
ARAB-MOSLEM GOLDEN AGE OF ART AND LEARNING
CLASSIC MAYAN PERIOD IN CENTRAL AMERICA
TANG DYNASTY IN CHINA

1000–1400

MEDIEVAL PERIOD IN EUROPE
HEIAN PERIOD IN JAPAN
CRUSADES EXPOSE EUROPE TO ART AND CULTURE
 OF MIDDLE EAST
GROWTH OF TOWNS IN WESTERN EUROPE
ROMANESQUE ART
SONG DYNASTY IN CHINA
KAMAKURA PERIOD IN JAPAN
GOTHIC ART
WEST AFRICAN KINGDOM OF MALI

Justinian attempts to reunite eastern and western
 Roman Empires 527–565
Buddhism reaches Japan sixth century
Mohammed proclaims the faith of Islam 611
Islam spreads into Spain 711–718
Beowulf composed eighth century
Charlemagne crowned Holy Roman Emperor 800
Viking raids throughout Europe eighth through tenth
 centuries

Norman conquest of England 1066
First crusade 1095–99
Genghis Khan conquers vast empire in Asia 1162–1227
St. Francis of Assisi establishes Franciscan order 1209
Pope Innocent III calls the Fourth Lateran Council,
 reorganizes and reforms Latin Church 1215
The Hundred Years' War between England and
 France 1337–1453
The Black Death begins to sweep Europe 1348
Chaucer, *Canterbury Tales* c. 1390

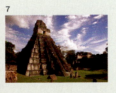
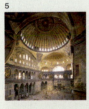

5. Hagia Sophia, 532–537
6. Book of Lindisfarne, seventh century
7. Temple I, Tikal, c. 732
8. Kailasa Temple, eighth century
9. Great Mosque, Samarra, 848–852

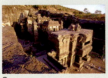
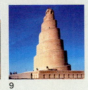

10. Warrior Columns, c. 900–1180
11. Shiva Nataraja, Lord of the Dance, c. 1100
12. Priest Kuya Preaching, thirteenth century
13. Pear-shaped vase, twelfth–thirteenth century
14. Chartres Cathedral, 1194–1260

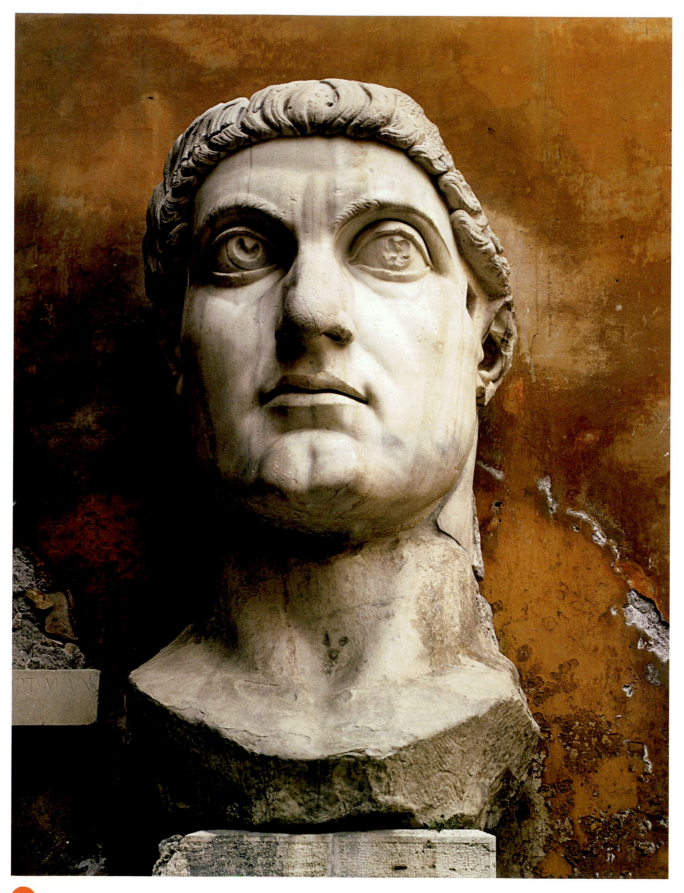

13/1 *Constantine the Great,* c. 330. Marble, approximately 8' 6" high. Palazzo dei Conservatori, Rome, Italy.

up into southern Spain. Between the eleventh and fourteenth centuries, Moslem domination of the Christian pilgrimage sites in the Middle East, particularly the city of Jerusalem, led to a series of Crusades in which European Christians attempted to win back "their" Holy Land. Finally, in 1453, Moslems captured the remnant of Constantinople, the capital of the Eastern Roman, or Byzantine, Empire founded by Constantine a thousand years earlier.

The same period also saw the Indian religion of Buddhism extend its influence throughout China, Southeast Asia, Korea, and Japan. In India itself, however, Buddhism waned due to a resurgence of the older Hindu religion. In this chapter, we explore art made in the name of all of these important faiths—Christianity, Islam, Buddhism, and Hinduism—in the years between 350 and about 1450, an era when religion replaced the political empires of ancient times as the primary unifying cultural force in most of Europe and Asia.

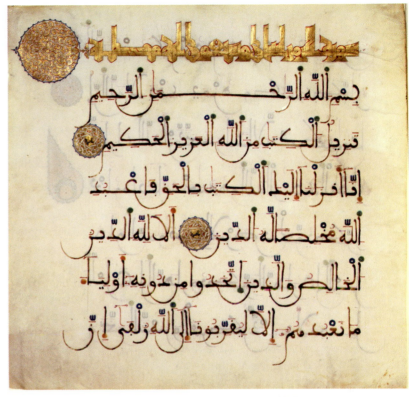

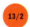 Qur'an manuscript, 13th–14th century, Nasrid (1230–1492). Attributed to Spain. The Metropolitan Museum of Art, New York, Rogers Fund.

RELIGIOUS IMAGES OR SACRILEGE?

The idea that pictures of gods were sacrilegious was common to several world religions, at least in their earliest phases. Religions that have forbidden or limited the visual depiction of their god include Judaism, Buddhism, Christianity, and Islam.

The Buddhist reluctance to give physical form to the Buddha lasted several hundred years after his death in 483 BCE. Instead, Buddhism developed a variety of ways to indicate the Buddha symbolically without actually picturing a human figure. For instance, the lion and the wheel were used to represent the Buddha's royal blood. In the second century CE, this taboo against showing the Buddha as a person was broken, and statues of the seated, cross-legged Buddha became one of the most powerful and pervasive in all of art (see 13-20).

The Moslem faith retains to this day its objection to visual representations of Allah. In fact, early Moslems went further in forbidding the use of *all* images, because they believed that the act of creation should be reserved for Allah alone. Thus, an artist who attempted to represent reality was a sinner against God and could have no hope of a heavenly reward. Much Moslem artwork, therefore, consists of decorative motifs, geometric or organic patterns (see *Shamsa*, 3-7), without any pictures or statues at all. Within these limitations their nonrepresentational decoration and calligraphy, as in this page from a medieval Qur'an (13-2), achieved a remarkable beauty.

As an outlawed religion, early Christianity produced no architectural monuments, no important sculpture or painting. But even when Christianity was established as the state religion of the Roman Empire, the early leaders of the Christian church felt that statues were too much like pagan images, and forbade their use in churches. The question of whether two-dimensional pictures, such as paintings and mosaics, should be allowed was the subject of much debate in the early church, a debate that was not settled until the sixth century, when Pope Gregory the Great finally decided in favor of the visual arts. He approved of painting and mosaic not for their beauty but for their instructional value, saying, "Painting can do for the illiterate what writing does for those who read."

EARLY CHRISTIAN AND BYZANTINE ART

Because they had no alternative artistic tradition of their own to draw from, early representations of Christ often show him as The Good Shepherd, a young man like the Greek god Apollo. A beautiful mosaic (13-3) done for the fifth-century Tomb of Galla Placidia, Empress of the West, melds late Roman style and early Christian symbolism. Christ is shown as the shepherd of his flock. In one hand he grasps a cross, more like a scepter and symbol of power than a reminder of the suffering of the crucifixion. The other hand reaches out to caress one of his sheep, suggesting his role as protector and redeemer of humankind.

The tomb of Empress Galla Placidia is in the Italian coastal city of Ravenna, rather than Rome, because her brother, the emperor, had fled there in 410 to escape a series of barbarian attacks. Since 376, the western portion of the empire had fallen prey to a continuous process of invasion, starting with the outer provinces, then Italy, and finally, even Rome itself. By the time the last western emperor was deposed by a Gothic king in 476, the act was simply a recognition that the fall of the Roman Empire had already taken place.

In the eastern half of the empire, however, Roman art and culture survived. It was richer and better organized than in the west, better able to defend its borders or buy off its attackers. In *Christ as the Good Shepherd*, we can see signs that the Roman artistic style was changing to become less naturalistic, more stylized and symbolic. The plant shapes are repeated designs, as is the pattern on the coats of the sheep. The art of the eastern half of the empire continued to develop in this direction, and the early Christian-Roman style eventually developed into a new artistic style known as **Byzantine**. Such Byzantine trends came to influence the west through the actions of Emperor Justinian, a remarkable leader and patron of the arts. In one final attempt to reunite the empire that had been divided in 395, the eastern emperor sent his armies to invade Italy in 540. Briefly successful, Justinian reestablished imperial control in Ravenna. Though he never set foot in Italy, he directed a building program that would symbolize his authority. One result of this program was the remarkable church of San Vitale.

Decorated in 547, about a hundred years after the mausoleum of Galla Placidia, San Vitale contains some of the most exquisite and famous mosaics ever created. The simple, almost naive pictures of early Christian times became more courtly, sophisticated, and stylized, flatter but more decorative. The centerpieces of the decorative scheme were, on one side of the altar, the group portrait, *Justinian and Attendants* (13-4), and on the other, the portrait of Empress Theodora, with hers (13-5). Notice

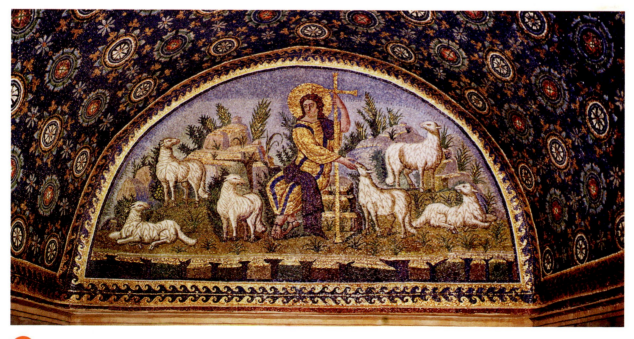

13/3 *Christ as the Good Shepherd*, mosaic from Galla Placidia, 425–450. Ravenna, Italy.

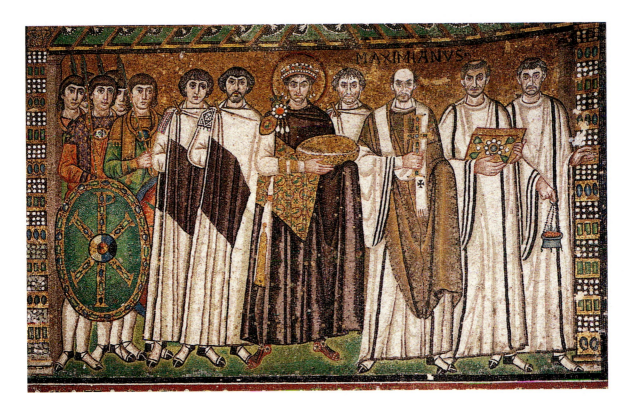

13/4 *Justinian and Attendants,* mosaic from the north wall of the apse, c. 547. San Vitale, Ravenna, Italy.

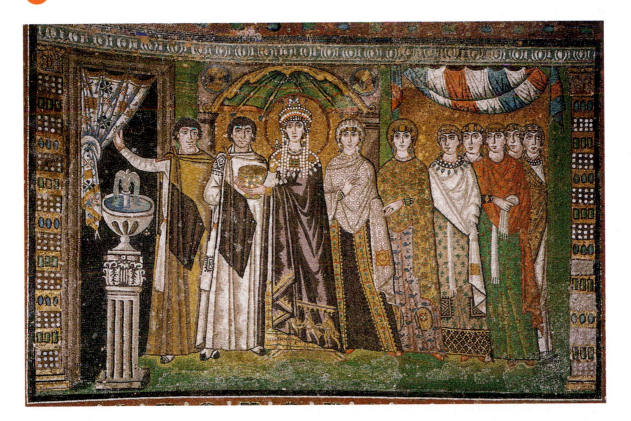

13/5 *Theodora and Attendants,* mosaic from the south wall of the apse, c. 547. San Vitale, Ravenna, Italy.

how much more two-dimensional these Byzantine-style figures appear than the late Roman-style Christ of a hundred years earlier. Like the earlier sculpted reliefs on the *Arch of Constantine* (12-33), they are arranged stiffly, facing front, their eyes locked on the viewer. Repetition with only minor variations is especially evident in the figures of Justinian and his courtiers; Theodora and her ladies appear sophisticated and elegant, with more diversity in their costumes. The artist seems to delight in the beautiful patterns of their rich robes, ignoring the anatomy of the bodies beneath them. Instead of using the medium of mosaic to give the illusion of reality, as we saw in the Roman *Unswept Dining Room Floor* (12-31), or the landscape behind *Christ as the Good Shepherd*, the Byzantine artist manipulates colored stones to create a sparkling and jewel-like effect. The liberal use of gold helps give the picture an aristocratic and royal feeling.

While Justinian's group portrait shows the two arms of his authority, the church and the military, it was truly Empress Theodora who was his co-ruler from the time he ascended the throne. The daughter of a circus entertainer and a former actress, she seems to have been a strong character and shrewd politician who was better able to make decisions and act in times of crisis than her husband. All of this—Theodora's imperious personality and personal power, the elegance and formality of the Byzantine court, the close relationship between the state and the church—is perfectly illustrated in these mosaic portraits.

The design of the building that housed these fabulous mosaics can also be used as an example of how architecture was changing. The rationality, logic, and order we saw in classical Greek and Roman architecture was not an appropriate setting for Christian ceremonies and rituals, which were meant to make the worshipper think of otherworldly mysteries. Unlike Greek religious ceremonies, which took place outside of their temples, Christian services took place inside, away from the bustle of the world, in a place where the worshipper might turn his or her mind away from everyday life. If we compare the interior and exterior views of *San Vitale* (13-6, 13-7) to those of the *Pantheon* (12-28, 12-29), we immediately grasp essential differences between the Roman and Byzantine style of religious architecture, between Roman pagan and Byzantine Christian beliefs. While the exterior of the Pantheon is symmetrical and awe-inspiring, San Vitale's is absolutely plain and somewhat confusing. The Pantheon is clearly based on geometric harmonies, clarity, and simplicity; while San Vitale's basic shape is also round and covered by a dome, the exterior is complicated and seems to sprout a variety of different-shaped appendages. The interior is also intricately divided, almost like a flower with its core surrounded by petals (13-8). Instead of a single, central source of light to illuminate the space, like the Pantheon's oculus, San Vitale's shadowed interior is lit by many small windows. Entering the Byzantine church, the worshipper senses that he or she has wandered into another realm, a world of the spirit. The interior glows with rich, multicolored marble inlays and mosaics.

While Byzantine art continued to evolve in the eastern half of the empire over the next one thousand years, profoundly affecting the art of eastern Europe—especially Greece and Russia—the rest of Europe enjoyed only a brief exposure to the rule of the Byzantine emperor before another wave of Germanic invasions cut them off from the eastern empire.

THE EARLY MIDDLE AGES

The Germanic tribes who looted Rome and swept across Europe in the fourth and fifth centuries did not bring with them a culture with elaborate sculpture and architecture, well-established literature, or even a written language. Some of their names, like Goths and Vandals, remain even today associated with barbarians and thieves. The values they stressed were the characteristics needed to win in combat: courage and ruthlessness. There was no concept of loyalty to the state or nation, which did not exist. Instead, warriors (the aristocracy) gave their loyalty to individual warlords who had proven their valor in battle.

After a period of destruction—the looting of cities, burning of libraries—some of these tribes from the borders of the old empire began to settle in distinct areas. A tribe called the Franks settled in Gaul, which would become present-day France. The Angles, Saxons, and Jutes settled in Britain; the language of the Angles developed into English and gave us the name England. The art of these Germanic tribes was dramatically different from that of the Greeks, Romans, and Byzantines. These were migratory people organized in warlike bands, not wealthy aristocrats living in cities. Instead of temples to the gods, the Germanic princes built large wooden halls where they could feast and drink with their comrades. When the Angles and Saxons saw the ruins of great stone buildings left by the Romans in Britain, they imagined they were the work of a race of giants.

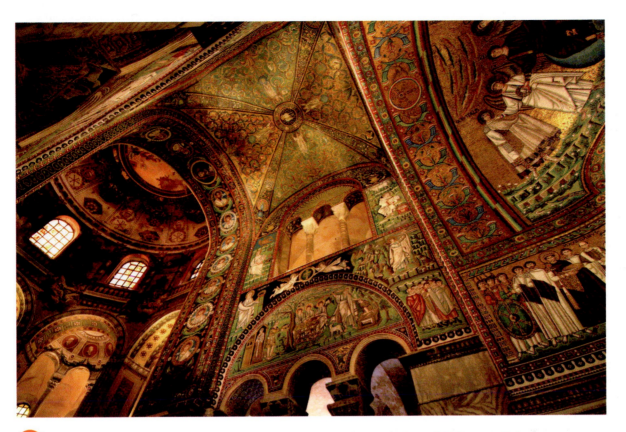

13/6 Mosaic interior of San Vitale, looking up, *Justinian and Attendants* at right, c. 547. Ravenna, Italy.

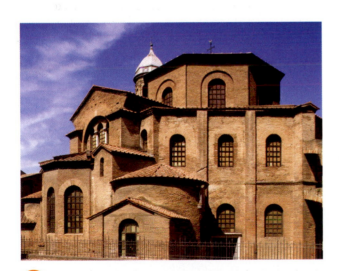

13/7 Exterior of San Vitale, 526–547. Ravenna, Italy.

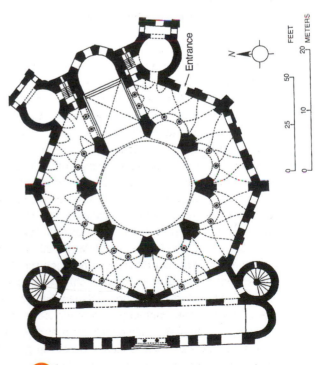

13/8 Plan of San Vitale. Ravenna, Italy.

The art of the Angles and Saxons, like other Germanic tribes, did not depict the human figure at all. It was a decorative art of small, intricately patterned golden and jeweled objects. The Germans were great metalworkers and wonderful weapons makers; they also used their skills to create elaborate jewelry. For the warrior-aristocracy, such treasure was both symbolic of their special status and prized for its own sake. The great Anglo-Saxon epic *Beowulf* tells us of their love for bright colors and precious metals, materials that gleamed and glowed. Such treasure had an almost magical fascination for them. Heroes like Beowulf wore rich golden buckles on their costumes and were buried with these ornaments as part of a pagan ritual. In the 1930s, the remains of an entire seventh-century Anglo-Saxon warship was found buried in England at a place called Sutton Hoo. The treasures unearthed there included an elaborate golden buckle (13-9) about five inches long, whose intricate patterning seems incongruous with its barbarian source. Three plain golden circles are interlaced with a fine web of serpents. The interwoven pattern and the theme of interlocking animals, especially serpents, is typical of the Germanic style.

Although Rome had ceased to be the center of the empire, it remained the center of the Christian church in the West. In 597, missionaries were sent by the pope to England to convert the heathen Anglo-Saxons. The conversion of the English to Christianity began a rich period of artistic production, especially the illustration of manuscripts. Book illustration had not been a very important artistic medium in the Roman world, but because the Christian New Testament was so central to the new faith, the decoration of the Gospels became worthy of the greatest effort. Elaborately decorated manuscripts were prepared in monasteries, where monks devoted their lives to the glorification of God.

Lindisfarne (or "Holy Island"), on the English coast, was one of the earliest sites of an especially fruitful mingling of the earlier Irish or Celtic traditions, the Anglo-Saxon artistic style, and the Roman-Byzantine. Two pages from the same book of Gospels, the *Book of Lindisfarne* of about 700, illustrate the dramatically different artistic styles being practiced at this time on the edge of what had once been the Roman world. In the page with an ornamental cross (13-10), we can immediately recognize the same interlaced decorative pattern of lines that the Anglo-Saxons used in their metalwork, in this case twisted dog-headed serpents and wild birds. Here, however, the formerly pagan design is superimposed with the shape of a cross—the most powerful symbolic shape in Christian art. Without sacrificing the amazing richness and complexity of the northern style, the artist-monk has brought order out of chaos by using the shape of the cross to organize the overall page.

The original of this artwork is only a little larger than nine by twelve inches. Think how different this is from the human scale of Greek art or the superhuman scale of Roman architecture! For centuries, people have been amazed by the delicacy, the imagination, and the fantastic detail of Irish and English manuscripts of this period. Some even thought the work must have been done by angels. For the artist, producing the illumination was probably a kind of religious discipline, like fasting. To paint with such patience demonstrated an almost obsessive devotion and love of God.

In the same book, however, we find pictures of another type. These are portraits of the four Evangelists, or authors of the four Gospels. While the border surrounding *Saint Matthew* (13-11) matches the style of the cross page, the rest is typical of a surprisingly different style. It shows the figure of the saint sitting on a bench,

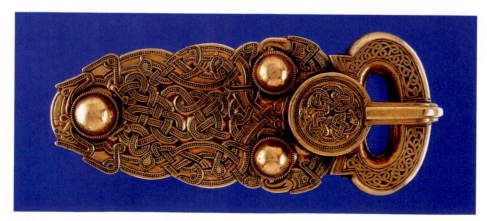

 The Golden Buckle of Sutton Hoo, Anglo Saxon, seventh century. Gold and enamel, 5¼" long. British Museum, London, United Kingdom.

writing his gospel about the life of Christ; above him is an angel. The northern tribes had no tradition of human portraiture, so what was the source of this image?

Historians suspect that visiting monks from the Mediterranean world brought to Lindisfarne a gospel book or books in the Byzantine style. Notice the similarities between the figure of Saint Matthew and the mosaics of Justinian and Theodora. Although the mediums and sizes are completely different, the sharp lines of the drapery and the long, thin bodies certainly resemble each other. Still, Saint Matthew is not exactly like a figure in a true Byzantine manuscript or mosaic. The drawing is stiff and awkward, more a collection of patterns than natural forms. This is partly because the artist is copying from another source, a source he considers sacred but does not really understand, never having drawn a human figure from life. During the early medieval period, monastic artists, like the philosophers and theologians, accepted the authority of the past. Christian monasteries attempted to preserve what was left of Roman culture by copying classical manuscripts as well as Christian works. This kind of copying from sacred texts, rather than working from nature, was the rule.

ISLAM

In the early 700s, despite the best efforts of the powerful emperor Charlemagne, Spain was conquered by Islamic invaders from North Africa. In most of the Spanish Peninsula, Moslem culture—and art—would flourish for the next seven hundred years. Islam was founded by the prophet Mohammed (570–632), who lived on the Arabian Peninsula; it spread throughout the Middle East with amazing rapidity. The teachings of Mohammed are recorded in the Qur'an, which tells of the revelations of God through the angel Gabriel. The name *Islam* means "submission to the will of God." The Moslem religion stresses five duties: (1) belief in one God and his prophet, Mohammed; (2) praying each day at appointed hours; (3) charitable giving; (4) fasting during the daylight hours in the holy month of Ramadan; and (5) making a

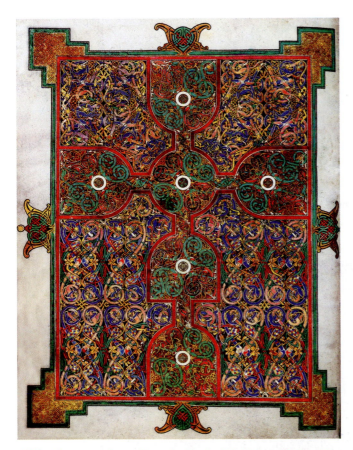

 Ornamental page from the *Book of Lindisfarne* (Cotton MS Nero D IV f 26v), from Northumberland, England, late seventh century. Illumination, approximately 13" × 10". British Library, London, United Kingdom.

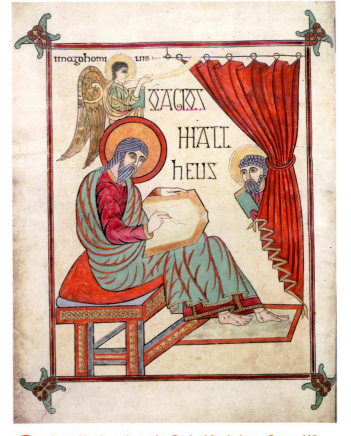

 Saint Matthew, from the *Book of Lindisfarne* (Cotton MS Nero D IV f 25v), from Northumberland, England, late seventh century. Illumination, approximately 11" × 9". British Library, London, United Kingdom.

A WORLD APART:
MESOAMERICA

On the other side of the globe from Eurasia and Africa, the Americas were evolving their own civilizations and art forms. Independent of the Old World, the New World developed agriculture, a calendar, a system of hieroglyphic writing, and a complex mythology. We have already seen one of the colossal stone heads (9-1) created by the Olmecs, an ancient American empire. The art and culture of the Americas before European contact is called Pre-Columbian (that is, before Columbus) or Pre-Hispanic (before the Spanish). During this period—lasting thousands of years—civilizations of the Americas rose and fell, conquered and were conquered in turn. Over such a vast area, spanning two continents, great variations in language, political structures, and society arose and were reflected in artwork.

Mesoamerica (present-day Mexico and Central America) became the site of the earliest known American civilizations to produce sophisticated arts, rivaling the monuments of Egypt, Greece, and Rome. The Pre-Columbian era in Mesoamerica has been divided into three periods: Preclassic (lasting from 2000 BCE to 300 CE), Classic (from 300–900), and Postclassic (from 900–1500, or the European arrival). The Olmecs were a Preclassic civilization, thought to be the mother culture for all later Mesoamerican societies. Supported by a base of agricultural labor that produced a surplus of food (American corn, or maize, was the staple of their diet), they built towns housing rulers, priests, and artisans, where the people gathered for religious ceremonies at mounds or pyramids. Although we can admire their massive sculptures, we still know little about Olmec beliefs.

The Empire of the Mayans (300–900) is considered the Classic period of Mesoamerican art. Like the ancient Egyptians, the Mayans built impressive pyramids, but with a different purpose. These were not tombs but religious sites. The dramatic pyramids at Tikal (13-12) rise out of the Guatemalan jungle; a ladder of steep stone steps leads to a small temple that tops the structure. These pyramids were originally part of a huge plan, surrounded by open spaces, where peasants would come to witness religious rites performed by priests and rulers.

Mayan wall paintings, done in a fresco technique that developed independently in the Western hemisphere, show us these rites. Figures of fierce rulers or priests in animal costumes perform human sacrifices. It was believed that human blood was demanded by the gods in exchange for

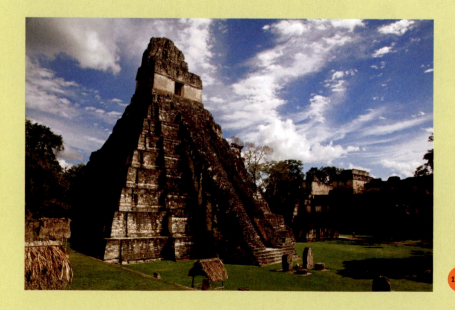

13/12 Temple I, Maya, Tikal, c. 732, Guatemala.

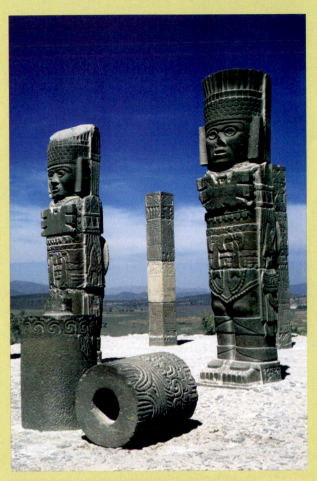

The Toltec culture flourished from about 900 to 1180, after which Tula was abandoned and then destroyed (no one knows why or how). Rival city-states warred with each other for power until a band from the North arrived and consolidated power. The Aztecs, who were still building power up to the time of the European contact and conquest, considered the Toltecs to be their ancestors. Calling themselves the "Mexica" (hence the current name for their nation), they in turn built temples and sacrificed victims (especially war captives) to the gods. They built their capital, Tenochtitlan, on islands across a lake, and its ruins remain underneath today's Mexico City (see "Global View" box in Chapter 14). Their main temple was a pyramid symbolizing a sacred mountain (somewhat like Buddhist stupas and Hindu temples). Aztecs actually had two calendars—a solar and agricultural calendar with 365 days and a religious or ritual calendar with 260 days. Every fifty-two years the calendars coincided and began a new cycle with special ceremonies. This famous stone calendar (13-14) was completed in 1479, shortly before the arrival of Columbus. Weighing twenty-four tons, it preserves a powerful image of a people who had no clue that their universe was about to be destroyed.

13/13 Warrior Columns, Toltec, c. 900–1180. Tula, Mexico.

their gift of life to human beings. These practices were common throughout Mesoamerica for centuries.

As the Mayan civilization declined, other Empires such as the Toltecs and Aztecs emerged in central Mexico. Like the Maya, the Toltecs built large pyramids, although theirs were wider and more horizontal. Atop *The Pyramid of the Morning Star* in their capital at Tula, they placed a series of fifteen-foot monoliths known as the Warrior columns (13-13). With their rigid stance and symbolic weapons (they carry darts and spear throwers), these statues both supported the original temple roof (like Greek columns) and served as guardian figures for it. Also like Greek columns, they are made of several blocks of stone set vertically, rather than carved from a single piece of rock.

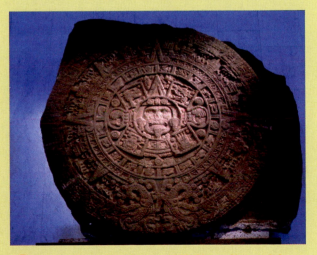

13/14 Aztec Calendar, Mexico, 1479. Museo Nacional de Antropologia e Historia, Mexico.

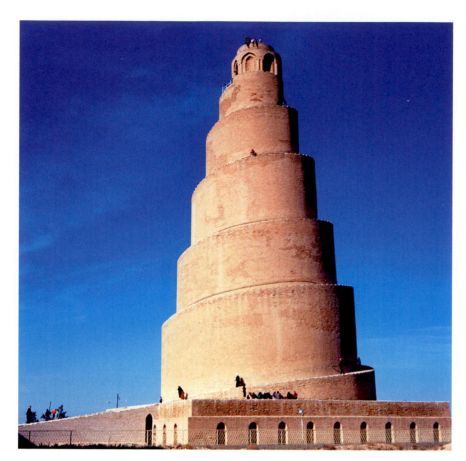

pilgrimage to Mecca, the birthplace of the prophet, once in one's lifetime.

Like the Jews, Moslem Arabs were originally a nomadic, desert people who had no permanent architecture. Eventually, Islamic architecture developed its own particular shape: a rectilinear, walled space with an open courtyard in the center. The main axis of the building was oriented to face in the direction of Mecca, the holy city, and this direction was visually emphasized by a **mihrab**, or niche. This niche, which was often elaborately decorated, fulfills a function similar to that of the altar in a Christian church, as a focal point for worship. Mosques also include distinctive towers, or minarets, from which believers are called to prayer five times a day.

Minarets, therefore, became visual symbols of the spread of Islam. In the middle of the ninth century, the caliph (local ruler) Al-Mutawakkil constructed a huge minaret as part of the Great Mosque of Samarra (located in present-day Iraq) (13-15). The unique sandstone and brick structure is designed as a 164-foot-high spiral and is known as the Malwiya Minaret. The term *malwiya* has been translated to mean "snail shell," and refers to that shell's natural whorls. One can see how large it is by the scale of the tiny figures climbing to the top. Sadly, this historic monument was damaged by a bomb blast in 2005 during the unrest that followed the U.S. overthrow of Saddam Hussein.

As discussed earlier, representational art was banned, but a love of pattern can be seen in Islamic art. This is beautifully illustrated by the *Great Mosque* (temple) in Cordoba, Spain. The interior space is marked by a rhythmic repetition of columns and arches (13-16); the

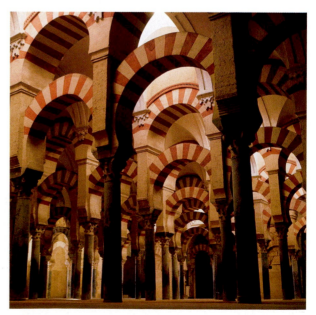

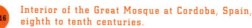
13/16 Interior of the Great Mosque at Cordoba, Spain, eighth to tenth centuries.

13/17 Dome near the mihrab, Great Mosque, 962–966. Cordoba, Spain.

original area was built in the late 700s. After three more periods of construction, ending around the year 1000, the mosque had quadrupled in size. The visual effect of these multiple columns—more than five hundred in all—is like that of a magical forest. Because the spaces above the arches are open, the effect is far more light and airy than Roman buildings. The elaborate mihrab and dome above it were completed in the late tenth century, when Cordoba had become a major Islamic city. An arched doorway marks the niche; the exquisite golden dome (13-17) is located in the chamber in front of the niche. Constructed of marble, stucco, and mosaic, all materials and patterns are fused into an incredibly rich design that is also harmonious and orderly.

The other unique architectural feature of the Islamic mosque, the **minaret**, is well-illustrated by the exterior of the *Hagia Sophia* (13-18), a remarkable Christian church that was transformed into a mosque after the capture of Constantinople by the Moslem Turks in 1453. Originally built by Justinian in the early sixth century, about the same time as San Vitale, the Hagia Sophia was the most famous and dramatic church in the capital of the eastern Roman Empire. Influenced by Roman architecture, the church was topped with a huge dome. To change the magnificent structure from a church to a mosque, the new

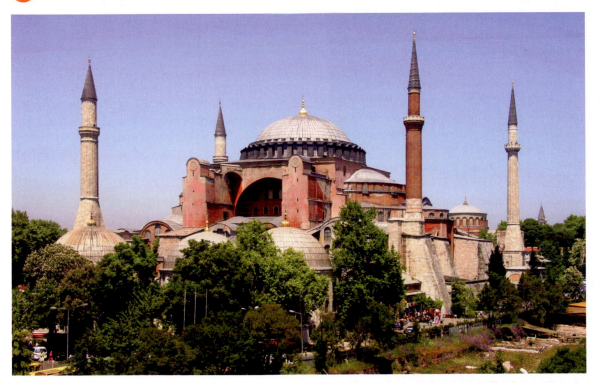

13/18 ANTHEMIUS OF TRALLES AND ISIDORUS OF MILETUS, Hagia Sophia, 532–537. Constantinople (Istanbul, Turkey).

rulers of Constantinople (which they renamed Istanbul) added four delicate minarets at the building's corners. This combined style of a central dome flanked by minarets then became a new model for Islamic architecture.

The interior of the *Hagia Sophia* **(13-19)** also demonstrates how churches were transformed into mosques. The function of the interior of the building was changed by plastering over mosaics with Christian images (though deliberately not destroying them) and by the addition of a mihrab. However, the soaring dome, which seems suspended on a circle of light, remained the most striking architectural feature. In the mid-nineteenth century the building was restored; at that time, colossal medallions painted in flowing gold calligraphy with the names of Allah, the Prophet Mohammed, and early Islamic caliphs were added. In 1931, the Hagia Sophia was converted again, from a mosque to a museum, which opened four years later. Many of the Christian mosaics have been uncovered and restored, but the Islamic medallions also remain, testifying to the varied history—Byzantine, Ottoman, and now Turkish—of this world-famous building.

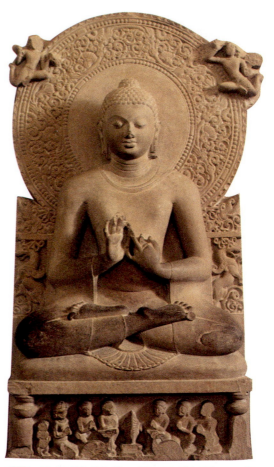

13/20 *Seated Buddha Preaching the First Sermon*, from Sarnath, India, fifth century. Stele, sandstone, 63" high. Archeological Museum, Sarnath, India.

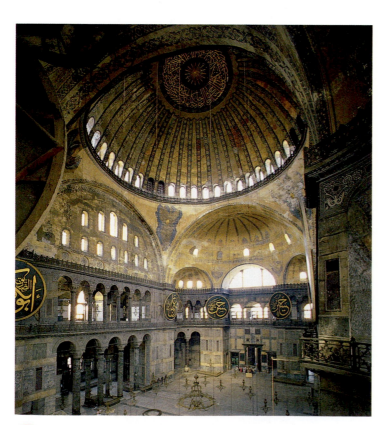

13/19 **ANTHEMIUS OF TRALLES AND ISODORUS OF MILETUS**, *Interior of Hagia Sophia*, 532–537. Constantinople (Istanbul, Turkey).

BUDDHISM

As described in Chapter 12, Buddhism was founded by Siddhartha Gautama, a prince from Nepal who lived in the sixth century BCE. In his search for the meaning of life and the reason for human suffering, the Buddha experimented with a number of paths to enlightenment and experienced many adventures and temptations. Through the revelation that all life is an illusion, and the only way to escape pain is to renounce all desires, the Buddha was able to escape what Hindus believed was the endless cycle of life, death, and rebirth and attain **nirvana**, a state of endless bliss.

One of the classic representations of the Buddha is the sculptural depiction of *Seated Buddha Preaching the First Sermon* **(13-20)** from the fifth century. Every element is symbolic. The Buddha is seated like a yogi, or Indian holy man. A beautifully carved halo is behind his head. The position of his hands is known as the teaching gesture, also called "turning the wheel of the law." Around him are the symbols we saw in the Lion Capital, the wheel of the law behind and stylized lions on either side. Certain features, such as the elongated earlobes from heavy earrings and the stylized arrangement of the hair,

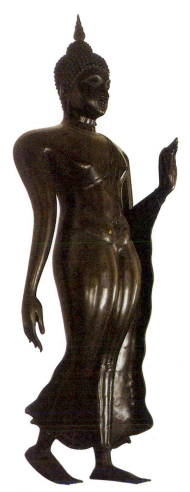

Walking Buddha, fourteenth century. Bronze, 88" high. Monastery of the Fifth King, Bangkok, Thailand.

Western art, particularly religious art, the essence of both sexes is reflected in this image of divinity.

As discussed in the first chapter, Buddhism had also spread to Japan and continued to flourish there throughout the medieval period. In the Kamakura period, as we have also seen, wood carving was highly developed and appreciated. The carving of a wandering Buddhist monk, Kuya-Shonin (Saint Kuya), was done by Koshu, a sculptor from a noted family of artists (13-22)—in fact, his father sculpted the guardian figure in Chapter 9 (9-20). Originally, this carving was painted to look more realistic, with inlaid eyes of rock crystal. Paradoxically, this "portrait" of a revered historical saint, meant to look so lifelike, was created approximately two hundred years after

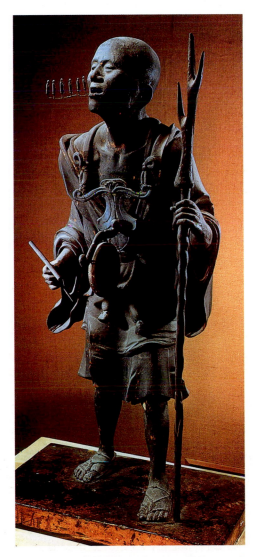

KOSHO, *Portrait statue of the priest Kuya preaching*, Kamakura period, early 13th century. Painted wood with inlaid eyes, 3' 10½" high. Rokuharamitsuji, Kyoto, Japan.

show that the Buddha was once a noble Indian prince. The statue balances such finely carved details against smooth, undecorated expanses of stone. The quiet, harmony, and idealization of the figure contribute to a sense of repose, as do the downturned eyelids and calm smile.

The classic figure of this Indian Buddha underwent many transformations as the religion spread throughout Asia. For instance, the dramatically different *Colossal Buddha* from China (3-16) was hewn out of rock at about the same time as the Indian statue. The Japanese *Amida Buddha* (1-5) is more elegant and aristocratic. Buddhism traveled not only east to China and Japan but also into Southeast Asia. The *Walking Buddha* of Thailand (13-21) was finished about a thousand years after the Indian Buddha from Sarnath. This figure represents the Buddha in his role as missionary—a fitting role, considering the vast spread of Buddhism from its original base. The bronze sculpture is more than life-size. Its utterly smooth surface and sinuous curves are typical of Thai art (compare him to Rodin's *Walking Man*, 9-16), and its ideal beauty is described by Thai Buddhists as "arms like the hanging trunk of an elephant." In a way utterly unlike

his death. The monk Kuya, known as Sage of the People, was known for constantly chanting the name of Amida Buddha as he traveled from place to place; the miniature Buddhas emerging from his mouth like little birds represent the sound of his repeated prayer. The statue is dressed in the typical costume of an itinerant preacher, one who had given up worldly possessions to spread the word of salvation through the name of Amida Buddha.

HINDUISM

Like Judaism, Christianity, and Islam, Buddhism and Hinduism are also related religions. Hinduism is an earlier system of beliefs, an ancient religion native to India.

Hindus believe that humans are fated to experience an unending cycle of birth, life, death, and rebirth, known as reincarnation. The final goal of this cycle is oneness with the absolute, or the Supreme Being, who is present in the world in innumerable forms. The concept of *karma* determines one's fate: The deeds of one lifetime influence one's status in the next. This idea is reflected in a rigid caste system, where one's social status is absolutely determined by birth into one of five castes, or classes: priestly, warrior, producer, menial, and untouchable.

Hinduism is polytheistic, incorporating many major and minor deities. However, the most important god is a threefold divinity: Brahma, the Creator; Vishnu, the

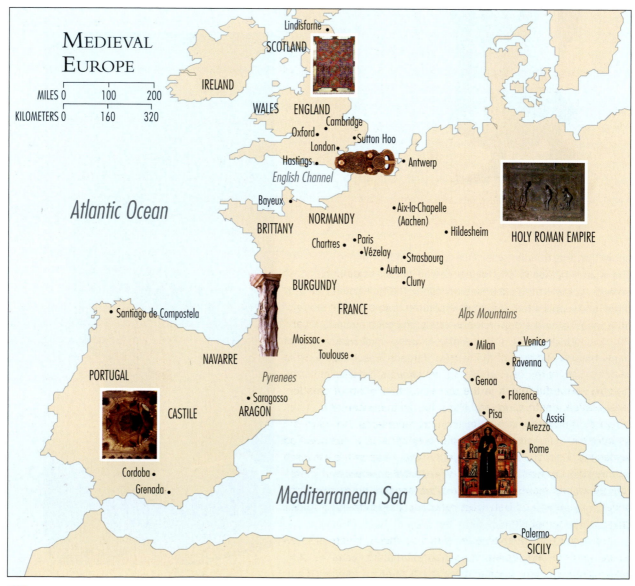

Medieval Europe

Perhaps the most startling aspect of Hindu art to Christian (or Moslem) eyes is the incorporation of the theme of sexual pleasure into places of worship. We have already seen the voluptuous Yakshi, who adorned the Buddhist stupa at Sanchi (12-18); her image was related to native Indian fertility rites. However, the exterior carvings on the Jagadambi Temple (13-24) go beyond the realm of the voluptuous and into that of the erotic. Rather than rejecting the body and sensual delights, Hinduism incorporates the worship of the youthful human body. Sexual pleasure becomes a symbol of the union of the human with the divine, not a source of guilt or shame.

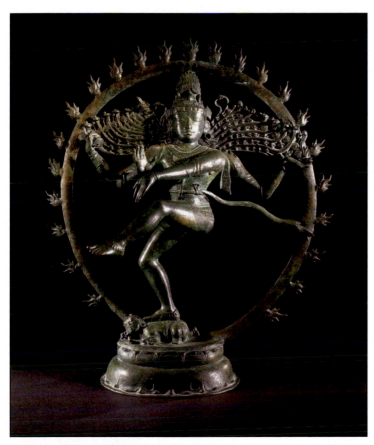

13/23 *Shiva Nataraja, Lord of the Dance,* India, c. 1100. Bronze, 35" tall. British Museum, London, United Kingdom.

Preserver; and Shiva, the Destroyer. This god includes within itself several opposing concepts: light and dark, birth and death, beauty and ugliness, good and evil, male and female. Because the idea of destruction carries within it the seeds of its opposite, rebirth and reproduction, the god Shiva has many faces, from fierce destroyer to calm and caring preserver. His most famous role is that of *Shiva Nataraja, Lord of the Dance* (13-23). The dance of Shiva symbolizes the most powerful forces in the universe, the rhythm of creation, conservation, destruction, and liberation. In this incarnation he is shown surrounded by a halo of fire that represents the universe; his long hair streams out like wings on either side of his head as he dances. This fine bronze sculpture was made in the eleventh century and demonstrates that Indian artists excelled in metalwork as well as stone carving. The figure appears both strong and graceful, dynamic and balanced, reflecting the contrasting forces typical of Hindu beliefs.

Hindu religious architecture is not so much constructed as carved, and the temples are often said to be more like huge, complex sculptures than architecture. One dramatic example is the temple at Ellora, which is completely carved out of a mountain (see 9-15). Other Hindu shrines were built to resemble mountains.

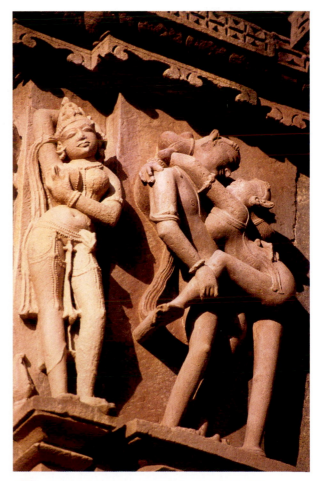

13/24 Celestial deities, c. 1000. Jagadambi Temple, Khajuraho, India.

THE MIDDLE AGES

How different was the attitude toward the human body and sexuality during the early Middle Ages in the West! The art of the early Middle Ages appears almost obsessed with the ideas of death and sin. The years between 850 and 1000 were a dark period for the arts in most of Europe. The second wave of invasions disrupted cultural and economic recovery. People found little comfort on earth and concentrated on the prospect of their heavenly reward—or the fear of eternal damnation. One work of art that seems symbolic of this period is a panel from the magnificent bronze doors of the church of Saint Michael's in Hildesheim, Germany, *Adam and Eve Reproached by the Lord* (13-25). This illustrates the Old Testament story in which God discovers that Adam and Eve have disobeyed him and eaten from the Tree of Knowledge, committing humanity's "original sin." God, on the left, seems to convict Adam with the pointed finger of condemnation. The cowering Adam passes the blame on to Eve, who tries to hide her nakedness and point to the serpent at the same time.

A comparison of Adam and Eve to any Greek or Roman nude statue immediately illuminates the change from classical to medieval artistic styles and cultural values. In the Hildesheim doors, cast in 1015, humans attempt to hide their spindly, naked bodies before God. They are ashamed to be nude. These bodies show none of the ideal beauty or athletic grace of Greek and Roman statues, and certainly none of the sensual delight of Indian carvings. This is not simply because the medieval artist is unskilled—on the contrary, the crafting of these great bronze doors was a complex project that took tremendous artistic talent. But the message of the art is anguish and guilt rather than pride and confidence, and thus calls for a new style.

The Prophet Jeremiah (or Isaiah), from Moissac, France, c. 1115–1135. Stone, life-size.

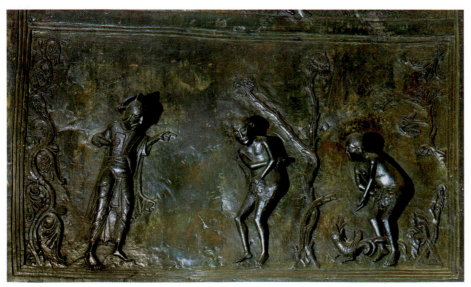

Adam and Eve Reproached by the Lord, the bronze doors, 1015. Hildesheim, Germany.

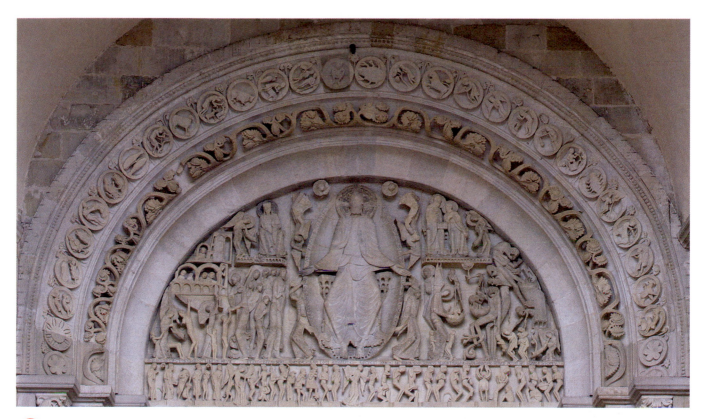

13/27 GISLEBERTUS, *Last Judgment*, tympanum of Saint Lazare, c. 1130. Marble, 21' wide at base. Autun, France.

THE ROMANESQUE STYLE

By the time the great doors at Hildesheim were made, northern Europe had begun to recover from the period of invasions. The Crusades to the Holy Land were beginning to turn the militancy of warriors away from their European neighbors. Travel within Europe became safer and easier. Pilgrims streamed across Europe from shrine to shrine, on foot, in search of salvation. In the eleventh century, a vast building program seems to have begun almost spontaneously, with monasteries erecting magnificent new churches to attract and accommodate pilgrims. One of the important stops on the pilgrimage route through southern France was the church of Saint Pierre at Moissac.

The most famous sculpture at Moissac is the figure of a prophet (13-26), completed around 1115, or about one hundred years after the Hildesheim doors. Carved into the **trumeau** (the central pillar of the main doorway) of the church is the emaciated, elongated, and extremely expressive figure of an Old Testament prophet. The body of this holy man seems to have been stretched vertically and twisted horizontally to fit it into the space of the column. It is almost as if the prophet were eternally, awkwardly trapped in a prison of stone. He is not only a man of God, but also the victim of a kind of divine energy. His gentle face and long, flowing beard, his bony feet and writhing body all give the impression of a person who has left physical concerns and material comforts far behind.

Around the year 1000, the theme of the end of the world, or the final day of judgment, became common in medieval art. Many believed this time was near. A vision of the Apocalypse, or end of time, from the New Testament Book of Revelation, was carved into the entrance of the Cathedral at Autun. Completed just a few years after the prophet from Moissac, we see the *Last Judgment* (13-27) described in grisly detail. The moment pictured is one where four angels blow their trumpets, and the dead are resurrected to be judged. The angels appear with long, curved horns in the corners of the work. The huge figure of Christ in the center dominates the composition, completely out of scale with the other figures. On the left side, the saved are allowed to enter heaven and worship God. On the right, horrible monsters join the Archangel Michael in the task of weighing souls (13-28). Under the semicircular tympanum, on the horizontal lintel of the doorway, we see the figures of the dead—on the left prepared for heaven, on the right pushed off toward hell. Beneath the earth the damned wait in terror for their punishment; one is in the process of being plucked up by a set of disembodied hands. As in the trumeau at Moissac, angular figures seem to be crammed into the space they inhabit. Classical balance and repose are totally lacking, replaced by energy and tension. As before, nude bodies are objects of shame. The overall message is truly horrifying.

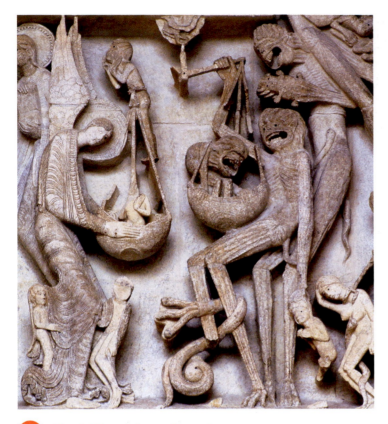

13/28 Detail of *Last Judgment*, Autun, France.

Although fairly typical of the *Romanesque* style, Autun is unusual because most of the sculpture was created by a single artist and one who has left us his name, Gislebertus. The entire sculptural program of the church is the result of his very personal vision and imagination. This is not a case of the artist copying from past models (as in the *Book of Lindisfarne*) but of an artist who is reinterpreting a story in a fresh and immediate way. The work at Autun is proof that by 1100, some medieval artists were allowed to express their individuality.

Individuality and self-expression were not, however, typical of most art done during the eleventh and early twelfth centuries. As befitted the warlike times, architecture tended to be massive, solid, and strong. This was true not only of castles and fortresses but also of churches and monasteries. The style of these buildings is called **Romanesque**, because they were based on the Roman building principle of the round arch. Medieval building techniques and engineering, however, were not as sophisticated as those of the Romans. Whereas the Romans were able to create multistoried structures like the Colosseum and huge open spaces like the Pantheon, medieval builders were more limited in their abilities. Heavy stone buildings were supported by thick walls. Few windows pierced these massive walls and towers. The interiors of the churches were dark and mysterious, lit with candles. The European feudal economy could not support elaborate marble and mosaic decorations such as those typical of the Byzantine Empire or the richly decorated mosques that filled the Islamic world. Ornament was provided simply by the sculpting of the stone itself, as seen in the trumeau and tympanum above.

There are, however, important similarities to the Classical style. As in Greek and Roman architecture, decoration was confined to certain specific parts of the structure, and the overall structure is clear to the eye and easy to understand. Buildings were made of geometric shapes, combining the rectangle, square, and circle.

By the early Middle Ages, the basic shape of Christian churches had evolved into that of a so-called Latin cross, with a long, rectangular room, or **nave**, crossed by a shorter rectangular **transept**, which ran perpendicular to the main space (13-29). The very shape was symbolic of Christianity, Christ's death, and resurrection. In large

Entrance Nave Transept

13/29 Latin Cross Plan (Chartres Cathedral).

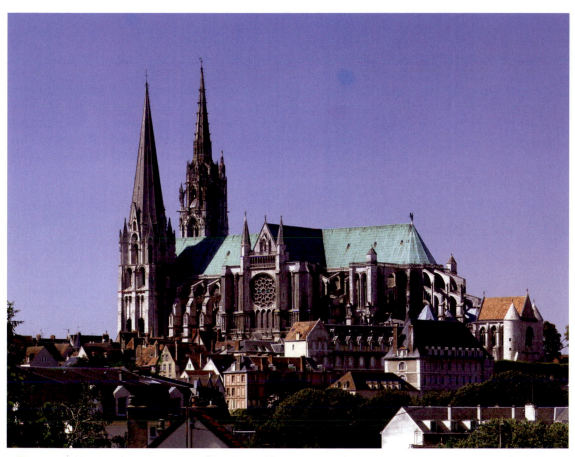

13/30 Chartres Cathedral, c. 1194–1260. Chartres, France.

churches, the central nave was flanked by two narrower *aisles*, running beside the more open space of the nave. Heavy Roman-style rounded arches with columns on either side of the nave supported the weight of the roof. The rhythmic repetition of columns and arches created a visual sense of order and stability—but not grace. There is something monumental, solid, and even rather squat and square about the design of most Romanesque churches. As with the Romanesque Sainte-Madeleine in Vézelay (10-21), rows of columns seem to march with heavy tread, like armies, toward the altar. The whole shape of the church is like a rounded tunnel, a round arch extended through space to form a **barrel vault** (see Chapter 10). There is a feeling of utter solidity. Within fifty years, this powerful style would be replaced by something completely different. Born in the region of Paris, the **Gothic** style would express a new, northern European aesthetic.

THE GOTHIC STYLE

The period of the twelfth and thirteenth centuries, when hundreds of Gothic cathedrals were erected, was one of prosperity and growth in western Europe. The Western world was becoming more cultured because of the sophistication of returning Crusaders, growing trade with

Islamic Spain, and increasing wealth. Thriving towns vied with each other to build ever-larger and more beautiful cathedrals—symbols of civic pride as well as religious devotion. Cathedrals like the one at Chartres cost many fortunes to build. *Chartres Cathedral* (**13-30**), located in a small town outside of Paris, was not the first Gothic cathedral in France, but it has been considered the most perfect representative of the Gothic style. This style developed as Chartres was being built, and the building exhibits the changing taste of several centuries. It is fitting that we view Chartres within the medieval town from which it grew. Gothic churches were most often cathedrals built in towns, rather than monasteries out in the countryside. Their worshippers were not primarily monks, nuns, and pilgrims but ordinary working people *and* noble patrons. The building of a Gothic church was a great undertaking accomplished not by the church alone, or by any single class of society, but by all of the townspeople, who took great pride in their accomplishment. At Chartres, noble patrons paid for the elaborate sculptural decoration over the doorways and competed with each other to erect ever-more-beautiful statues and stained-glass windows. Other windows were the gifts of the town guilds (see "Art News" box).

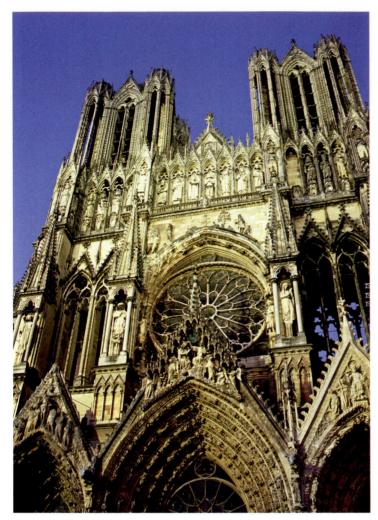

13/31 **GAUCHER DE REIMS and BERNARD DE SOISSONS**, west façade of Reims Cathedral, ca. 1225–1290. Reims, France.

The unique features of Gothic architecture were the *pointed arch*, the *ribbed vault*, *exterior buttresses*, and *stained-glass windows*. The pointed arch (see Chapter 10) made it possible for churches to become much taller than had previously been possible. The weight of these dramatically soaring arches was carried not by the walls but by reinforced ribs that created a stone skeleton for the structure. To stabilize this skeleton and keep the building from collapsing outward, supports called buttresses were constructed outside of the cathedrals—a decorative exterior scaffolding. This elaborate support system made it possible to replace large expanses of stone walls with brilliant stained-glass windows. In contrast to Greek temples, which are usually horizontal, or Romanesque churches, which often appear to be based on a square, the lines of Gothic arches and spires seem to soar toward the heavens. This is true of both the exteriors, as in Chartres and Reims (13-30, 13-31), and interiors, as in *Notre Dame* (1-14), *Amiens* (10-22), and *Sainte Chapelle* (13-32).

In contrast to Classical and Romanesque styles, Gothic decoration was organic—that is, it seemed to be alive. Gothic cathedrals were often covered with intertwined, vinelike curlicues that seemed to sprout from every surface. In cathedrals such as *Reims* (13-31), the mass of the walls is penetrated by intricate voids and lacy projections that almost dissolve the basic shape of the building. If Classical art is geometric, logical, controlled, balanced, and harmonious, Gothic art can be seen as organic, intuitive, teeming with life, free—almost the polar opposite.

The Gothic style was not simply the expression of an anti-Classical taste, however, nor the result of certain technical innovations in architecture. The outer form of a Gothic church was an expression of its spiritual function. We know something about this because one of the initiators of the Gothic style, Abbot Suger, left extensive records from the construction of the first Gothic church, Saint Denis. In these records, Suger explains exactly what he wanted from the new style of architecture. His idea was that "the wonderful and uninterrupted light of

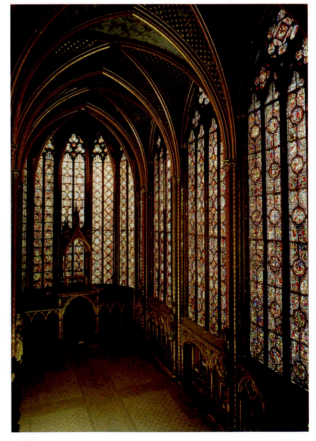

13/32 Interior of Sainte Chapelle, 1243–1248. Paris, France.

THE DIMMING OF NATIONAL TREASURES

The fifty thousand square meters of medieval stained glass in France is more than that in the rest of the world combined. The Gothic cathedrals are one of the nation's most precious treasures but, unfortunately, they are also in danger. Centuries of rain and wind have stained them, and now air pollution is having its effect, too. Controversy has surrounded a recent attempt to clean some of the windows of the cathedral at Chartres (13-33), described by the American writer Henry Adams in 1904 as "the most extraordinary creation of all the Middle Ages—a materialization of the most exalted dreams of humanity." An association of artists complained that after the famous blue glass was cleaned, it had become paler and grayer and lost its ability to reflect light. It was later revealed that one of the cleaning chemicals was a kind used by industry for bleaching. A synthetic resin applied to the exterior was impossible to remove. The government halted the restoration out of fear that more harm than good was being done. No one doubted the pressing need for restoration, but no one had a sure answer to how it could be done safely.

While restoration resumed in 1986, it has been time consuming and expensive. Restoring the 170 windows will cost more than $75,000 each, and because many of the most important windows are at a great height, the expense of scaffolding may double the cost. A fundraising campaign is underway, but time is running out for Chartres. A century ago, Henry Adams had already realized that there was too little research on stained glass and said, "The French have been shockingly negligent of their greatest artistic glory."

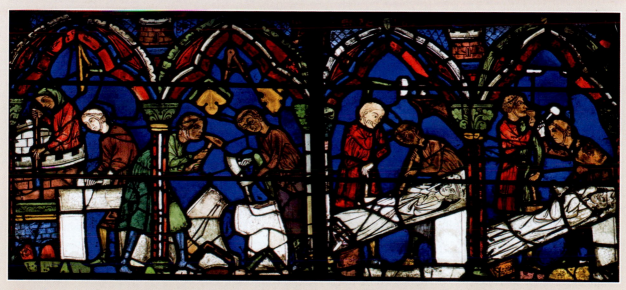

13/33 *Legend of Saint Chéron,* first north radiating chapel of the ambulatory, Chartres Cathedral, 1194–1220. Stained-glass window. Chartres, France.

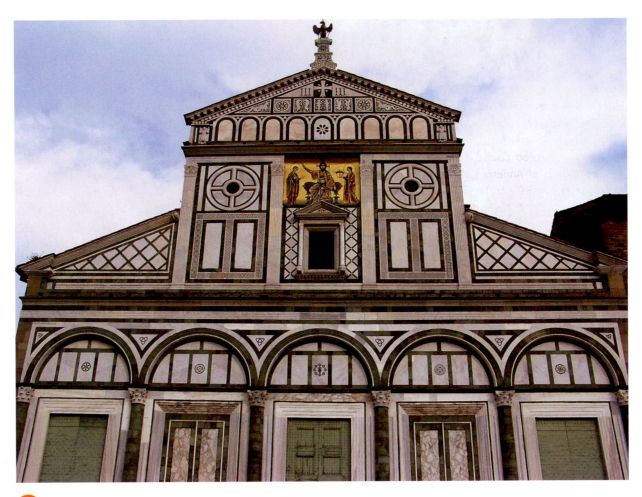

13/34 San Miniato al Monte, Florence, Italy, 1060–1150.

the most luminous windows" would assist the soul in reaching a state of transcendence, that the material beauty of the architecture would provide a bridge to a completely spiritual experience.

The idea of transcendence of the earthly realm was expressed in all the visual elements of Gothic architecture: the soaring, graceful lines of the pointed arches; the breathtaking open space above the heads of the worshippers; the replacement of heavy stone walls by panels of brilliantly colored glass. Here the spirit could fly upward, toward heaven. One of the most glittering examples of the Gothic desire for color, space, and light is the royal chapel of *Sainte Chapelle* (13-32) in Paris. Here the walls are gone; the stained-glass windows are interspersed with slim, golden ribs that are more like stems than columns. At Sainte Chapelle we see the ultimate in jewel-box-like aristocratic elegance.

MEDIEVAL ART IN ITALY

The art of Italy during the Middle Ages was not like the art of northern Europe. The Italians never really developed a taste for the more elaborate embellishments of Gothic decoration. In fact, Italy never completely turned its back on the influence of Classical art and architecture. Italian churches tended to be more geometric and solid. The walls did not dissolve into panels of stained glass. This was partly for practical reasons; in the bright light and hot climate of Italy, churches were designed as a refuge of shade and coolness. They were decorated with the Classical media of fresco and mosaic.

The design of *San Miniato* in Florence (13-34), built between 1060 and 1150, demonstrates the continuity between Italian and classical architecture as compared to the Gothic cathedrals. Sitting on a hill with a magnificent view of the city, the church is geometric and

symmetric; its exterior is covered with sheets of green and white marble arranged in a harmonious pattern of rectangles, circles, and semicircles. The only other decoration is a single, central mosaic and a series of abstract symbols traced in the same green-and-white marble. The columns are Corinthian, with none of the carved decorative figures typical of northern European architecture in this period. Compare this simple decorative scheme with the multicolored painted sculptures that crowded onto the façade of Amiens Cathedral (see "Art News" box in Chapter 2). Still, one could not mistake this building for a Classical temple, despite its glowing marble façade; we have seen nothing quite like this before. Some architectural historians believe that this style not only influenced, but actually foreshadowed, the work of Italian Renaissance architects like Brunelleschi (see Chapter 14).

During the Middle Ages, Italian sculpture also continued to be influenced by Classical models. A vivid example is the work of the sculptor Nicola Pisano, done in the mid-thirteenth century. For the baptistery in Pisa, Pisano carved an elaborate marble pulpit that included nude figures. One of the panels illustrates three events from the story of Christ's birth. On the left is a scene of the Annunciation, with the Archangel Gabriel informing the Virgin Mary that she is to have a child. In the center of the relief (13-35), Mary reclines after having given birth in the manger, with the baby Jesus wrapped in swaddling clothes behind her. The upper-right corner shows angels announcing the birth of the Messiah to shepherds in the fields. Finally, along the bottom, Mary and Joseph watch as the child is bathed. The use of many stories within the same frame is typical of Medieval art, but the style of Pisano's carving is clearly influenced by Greek and Roman sculpture. One obvious similarity is the use

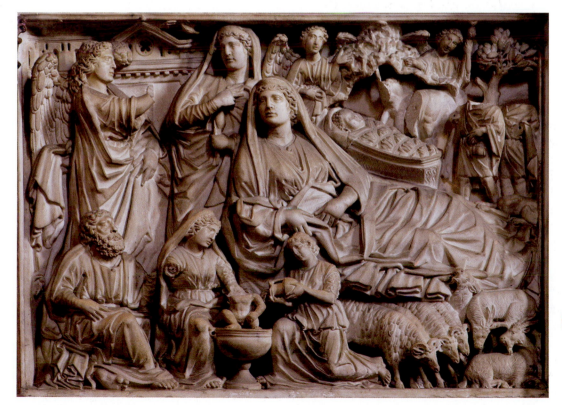

 NICOLA PISANO, *The Annunciation and the Nativity,* 1259–1260. Marble relief, approximately 34" × 45". Baptistry, Pisa, Italy.

of Classical costumes and ancient models for the faces and hairstyles, as well as nude figures. Another is the rounded carving of the figures; there is no doubt that Pisano was inspired by Roman relief sculpture, which could still be seen throughout Italy.

But while Italian architecture and sculpture showed the influence of ancient art, Italian Medieval painting was closer to the art of the Byzantine Empire. Many of the characteristics we observed in the mosaics of Justinian and Theodora in the Church of San Vitale at Ravenna in the sixth century continued to dominate the art of the Byzantine Empire: the stylization and elongation of figures, the flatness and love of color and pattern.

In the eleventh and twelfth centuries, Italian painters began to use a new art form to decorate their churches: Painted wooden panels were made to hang behind the altar. Such pictures featured the Christian subject matter of crucifixions, madonnas, and the lives of saints. The *Saint Francis Altarpiece* of 1235 (13-36) by Bonaventura Berlinghieri is typical of this kind of Italian-Byzantine painting. The center of the composition is dominated by an oversized figure of Saint Francis, the Italian saint

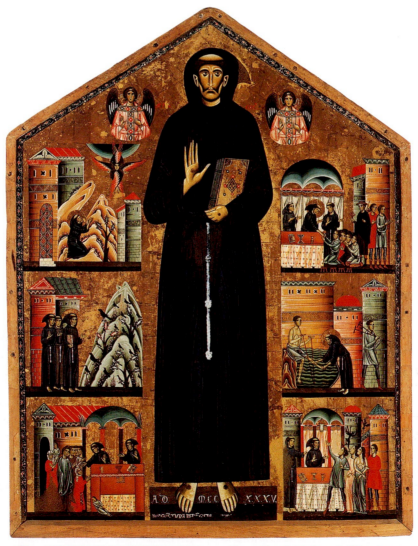

13/36 BONAVENTURA BERLINGHIERI, panel from the *Saint Francis Altarpiece*, 1235. Tempera on wood, approximately 60" × 42". San Francesco, Pescia, Italy.

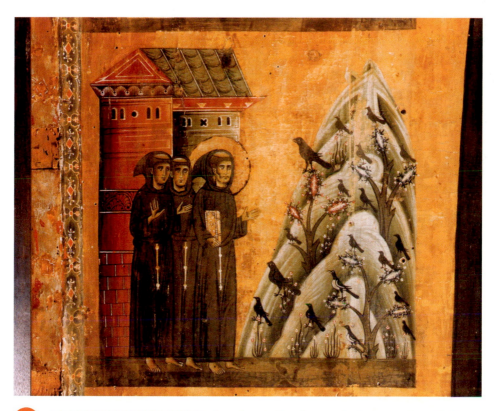

13/37 BONAVENTURA BERLINGHIERI, *Saint Francis Preaching to the Birds*, detail of 13-37.

noted for his gentleness and renunciation of all worldly goods and powers. The compassionate and human Saint Francis, however, is shown in a stiff pose, looking more like a flat pattern than a real person. This solemn figure is surrounded by smaller scenes that tell stories from the saint's life. The background of the panel is gold, and although the saint is shown in a drab costume, bright shades of blue and red enliven the little scenes. Most of these scenes show Saint Francis's miracles and stress his supernatural powers.

Close examination of one such scene, *Saint Francis Preaching to the Birds* (13-37), reveals the characteristics of the late Medieval style. Because painters in Berlinghieri's time copied the elements of their pictures from pattern books rather than basing them on studies from life, the figures are generic, with no individual qualities. Francis is nearly identical to the other monks; he

can be identified only because of his attributes: his halo, signifying his sainthood, and the stigmata (wounds of Christ) on his hands and feet. The birds are also one basic form repeated with little variation. Natural scale and proportion were not considered. The three monks could never fit into the tiny, flat monastery behind them. The space between the figures is inadequate; they seem to be attached to one another like glued paper dolls. The mountain in front of them is hardly a hill, its trees little more than decoration.

Yet it is a mistake to judge the scene by whether it is realistic or not. Berlinghieri's altarpiece is one more example of an art of faith and devotion. Correct proportions or solidity are not his concerns. The art of the altarpiece, as in art across much of the globe in the Age of Faith, is in the arrangement of the sacred stories into an imaginative and satisfying design.

CHAPTER 14

In the Italian town of Padua around the year 1300, a simple chapel was built alongside a palace. Because an ancient Roman amphitheater had once occupied that site, the chapel became known as the Arena Chapel. Its plain, unassuming exterior seems to make it an unlikely site for one of the most important achievements of Western civilization. But an extraordinary experience awaits those who enter the chapel, because the flat, unadorned walls were transformed between the years 1305 and 1310 by one of the pivotal figures in the history of art, an artist named Giotto.

Initiating a return to visual realism, Giotto almost single-handedly created the Renaissance style of painting. In *Lamentation* (14-1), one of the more than forty frescos illustrating the lives of Mary and Jesus in the Arena Chapel, we can see a sculptural solidity that had not been seen for more than one thousand years. There is weight to the figures, bulk, and flesh; they are rooted to the ground by gravity. They are solid people on a solid earth. If we compare this fresco to Berlinghieri's *Saint Francis Altarpiece* (13-36), done eighty years earlier, the change becomes very apparent. No longer are sacred stories being arranged to make a design. The many pictures on the walls of the chapel are organized in three rows and tell the stories sequentially, in chronological order.

Giotto has a new way of telling stories; rather than multiple scenes in one panel, he chooses one significant

1300–1400

PERIOD

FIRST SIGNS OF THE RENAISSANCE IN ITALY
GOTHIC PERIOD IN NORTHERN EUROPE
MOORISH RULE IN SPANISH GRANADA
YUAN DYNASTY OF THE MONGOLS OVERTHROWN BY MING IN CHINA
AZTEC EMPIRE ESTABLISHED IN MEXICO

HISTORICAL EVENTS

Dante's *Divine Comedy* c. 1310
Papal court moves to Avignon 1309
The Black Death in Europe 1348

ART

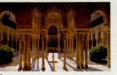
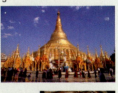

1. Giotto, *Lamentation*, 1305
2. Wu Chen, *Bamboo in the Wind*, early 14th century
3. Schwedagon Pagoda, fourteenth century
4. Court of the Lions, the Alhambra, 1354–1391
5. Sluter, *The Well of Moses*, 1395–1406

THE RENAISSANCE

moment in each. He tries to imagine how the holy scene might have really looked. The spaces between the figures seem natural. Figures are in true proportion to each other. They are placed in a natural setting. Blue sky at the top of each panel unifies the scenes. This blue background is lighter in the lower panels, but the hue becomes progressively deeper as the viewer's eye reaches the starry ceiling.

More importantly, Giotto tries to imagine how his characters felt. Real human emotion is being displayed as the Virgin Mary and Christ's followers mourn over the dead body of Jesus. The viewer can empathize with each person and understand what he or she is feeling because Giotto has created a unique pose and facial expression

for each one of them. Even the ethereal angels experience human emotions of grief and anguish, each in their own way. Giotto's characters are not generic people copied from a pattern book or people pictured by symbols of their roles in society. Now each is an individual first, a unique person. Giotto literally brought religious art down to earth.

Giotto was revolutionary in another way—he was a *famous* artist. For the past fifteen hundred years, since the Greeks, an artist was thought of as just another craftsperson, like a carpenter or a barrel-maker (Gislebertus, 13-27, being a rare exception). But Giotto's genius was recognized almost immediately; by the time he was offered this commission his services were in

1400–1492

EARLY RENAISSANCE IN EUROPE
INCA CIVILIZATION IN PERU
GOLDEN AGE OF VENETIAN EMPIRE
PRINT REVOLUTION IN EUROPE

Joan of Arc burned at the stake 1431
The Medici rule of Florence begins 1434
Ottoman Empire conquers Constantinople,
 renamed as Istanbul 1453
The Gutenberg Bible 1455
Portuguese mariners round tip of Africa 1487
Columbus sails to the Americas 1492

1492–1560

HIGH RENAISSANCE IN ITALY
THE RENAISSANCE CONTINUES IN THE REST OF
 EUROPE
EUROPEAN AGE OF EXPLORATION AND DISCOVERY
AFRICAN SLAVES TRANSPORTED TO AMERICAS
MUGHAL DYNASTY IN INDIA
HEIGHT OF OTTOMAN EMPIRE

The Protestant Reformation begins 1517
Machiavelli's *The Prince* 1517
Cortez conquers the Aztecs 1519–1521
Magellan's voyage circumnavigates the globe
 1519–1522
Henry VIII becomes Head of the Church
 of England 1531
Copernicus declares that the planets revolve
 around the sun 1543

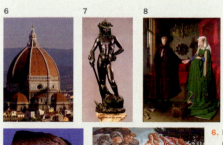

6 7 8

9 10

6. Brunelleschi, Dome of Florence Cathedral, 1420–1436
7. Donatello, *David*, c. 1428–1432
8. van Eyck, *Giovanni Arnolfini and his Bride*, 1434
9. Aztec Calendar, 1479
10. Botticelli, *The Birth of Venus*, c. 1482

11 12

11. Michelangelo, *David*, 1501–1504
12. Leonardo da Vinci, *The Mona Lisa*, c. 1503–1505
13. Raphael, *Madonna della Sedia*, 1510–1512
14. Ryoanji Zen Temple, c. 1525
15. Holbein, *Henry VIII*, 1540

13 14 15

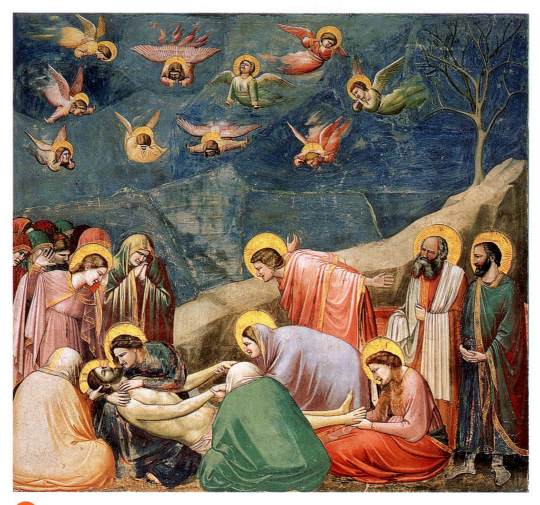

14/1 GIOTTO, *Lamentation*, c. 1305. Fresco. Arena Chapel, Padua, Italy.

great demand by the most powerful leaders of fourteenth-century Italy. Dante Alighieri, his contemporary and friend, mentions Giotto's dominance of the art world in the *Divine Comedy*, writing "now the hue and cry is for Giotto." Beginning with Giotto and the Renaissance, the history of art is the history of great and famous artists.

THE IDEA OF THE RENAISSANCE

The historical period known as the **Renaissance** is generally considered to mark the beginning of the modern world. During this period, Europe underwent significant economic, political, social, and cultural changes, changes which led to the development of world civilization today. Capitalism, the rise of the nation-state, scientific investigation, individualism, the idea of progress—all have their roots in the Renaissance. The term, which means "rebirth," was coined by the people of fifteenth-century Italy. They saw their own age as an exciting flowering of art and culture

after what they called the Middle or Dark Ages. For the leading thinkers of the fifteenth and sixteenth centuries, the medieval period was a barrier, a gloomy, uncultured period between themselves and the grandeur of ancient Rome. The poet Petrarch wrote, "After the darkness has been dispelled, our grandsons will be able to walk in the pure radiance of the past." The Renaissance view of the medieval period has colored general opinion to this day.

The possibilities of life in medieval Europe *had* been limited. People were controlled by their place within the political system of feudalism, by the rigid rules of the Christian Church, and by a rural, agricultural economy that limited mobility and tied most people to the land for their whole lives. The world of an average person—a peasant—was restricted to the distance that could be walked in a few days.

Then, beginning as early as the twelfth century, but flowering dramatically in the fourteenth century in Italy and reaching the north in the fifteenth century, western Europe experienced an economic revival. This rebirth fostered trade and the growth of cities; it also resulted in an increase in wealth, learning, and sophistication that

had not been seen since the greatest days of the Roman Empire, a thousand years earlier. This explosion of energy sparked the Age of Exploration and took Western peoples all over the world. A direct result is today's global culture (see "Global View" box on *The Gold of the New World*).

But above all, the Renaissance is famous for advances in art and architecture. In fact, it is the only historical period known primarily for its artists and only secondarily for its political and religious leaders. Leonardo da Vinci, Michelangelo, Raphael—these names are familiar to everyone. The greatest of their works, such as the portrait of *Mona Lisa* and the ceiling of the Sistine Chapel in the Vatican, have never been matched and may never be surpassed in fame. The art of the Renaissance is the starting point of all later art in the West.

EARLY RENAISSANCE SCULPTURE AND ARCHITECTURE

During the Renaissance, Italy was divided into many city-states, each ruled by a powerful and wealthy family. By the beginning of the fifteenth century, Florence was in the midst of an economic boom and had become one of the most prosperous cities in Europe. A wealthy, cultured society revolved around the ruling family, the Medici—international leaders in banking, as well as great patrons of the arts. There was a great deal of building—schools, hospitals, and especially churches. Artists from all over Italy were coming to Florence, attracted by the many commissions.

One famous competition was held to design the bronze doors of the city's baptistery. The finalists, both in their twenties, were Filippo Brunelleschi and Lorenzo Ghiberti. Each was required to execute a specific tale from the Old Testament, *Abraham's Sacrifice of Isaac* (14-2, 14-3), where the old patriarch was asked by God to prove his faith by killing his only son. The theme was chosen for the challenge of representing a variety of subjects—figures young and old, clothed and nude, as well as animals and landscape—and because it was thought to foreshadow the sacrifice of Christ by his own father. In both relief sculptures, Abraham is about to cut his son's throat when an angel of God rushes in and stops the sacrifice. Surrounding the main action are the donkey that carried Abraham and Isaac to the mountaintop, two servants, and a ram that appeared miraculously and was sacrificed as a replacement for the young man.

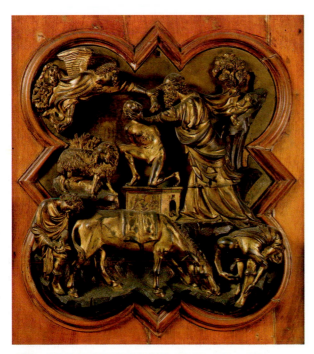

 FILIPPO BRUNELLESCHI, *The Sacrifice of Isaac*, competition panel, 1401–1402. Gilt bronze, 21" × 17½". Museo Nazionale del Bargello, Florence, Italy.

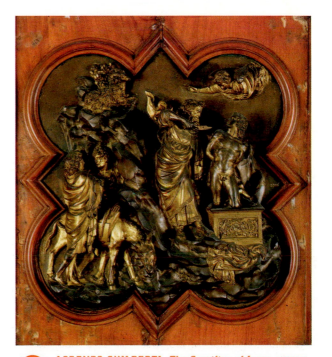

14/3 LORENZO GHILBERTI, *The Sacrifice of Isaac*, competition panel, 1402. Gilt bronze, 21" × 17½". Museo Nazionale del Bargello, Florence, Italy.

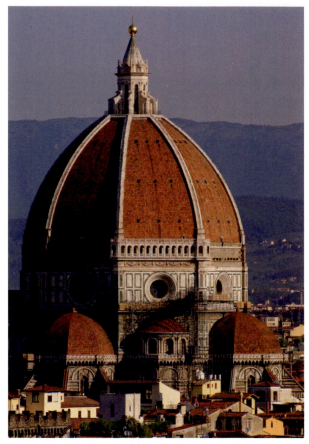

14/4 FILIPPO BRUNELLESCHI, Dome of the Florence Cathedral, 1420–1436. Florence, Italy.

Ghiberti's design was selected for a number of reasons. Brunelleschi's seemed more cluttered, with too many distractions from the main action. The figures do not seem to be in true proportion; Isaac is small and his father seems to be almost twisting his head off. Ghiberti's, on the other hand, is a masterful composition. He has separated the main action from the rest of the scene with a diagonal cliff. He draws attention to the sacrifice by having Abraham's elbow stick out of the panel, so the viewer follows his arm down to the edge of the knife and then to Isaac's neck. Ghiberti's angel enters more dramatically than Brunelleschi's. Rather than coming from the left side in profile, the angel comes hurtling toward us from deep space. What may have clinched his victory, however, was the beautiful figure of Isaac. His nude form was reminiscent of the perfectly proportioned statues of the ancient Greeks and Romans. A fascination with the Classical Age was to be one of the strongest influences on Renaissance thought.

While Brunelleschi would lose again to Ghiberti when a second set of baptistery doors was offered to competition, he would have a greater triumph—as an architect. The world-renowned *Dome of the Florence Cathedral* (14-4) is his creation. The cathedral, originally begun in 1296, with a tower designed by Giotto, was nearly

complete when Brunelleschi began work in 1420, but it had a huge hole at its center. The space for the dome—nearly 140 feet wide—remained open to the elements, much too wide for any of the known building methods.

A dome presents a unique engineering challenge—how to support a great weight (the finished dome would weigh eighty million pounds) over a great distance with support only at a roof's edges. While the Pantheon's dome (12-29) covered approximately the same expanse as the cathedral in Florence, the methods of the ancient Roman engineers had been lost during the Middle Ages. Fortunately, after his two humiliating defeats to Ghiberti, Brunelleschi had gone to Rome to study the ruins of the ancient buildings. By using the results of his studies, combining them with medieval techniques, and by inventing many new ones over fourteen years of construction, Brunelleschi was able to solve the problem that baffled all his countrymen.

While his engineering achievement was marvelous, the *beauty* of the dome was even more awe-inspiring. A herringbone pattern of red bricks was framed by eight white ribs that reached up to a lantern at the peak. The dome of the cathedral became the focal point of the city of Florence and remains so today. When Michelangelo, who was trained as a young man near the *Duomo*, designed his own dome for St. Peter's (see Chapter 10), he said, "I'll make its sister bigger, not more beautiful."

Once it was built, Brunelleschi became the most famous architect of his day. He continued to make many trips to Rome to study the classical architecture of the ruins and led the revival of interest in the culture of ancient Greece and Rome. These ruins would become an important source for Renaissance artists, and a pilgrimage to Rome would become a required part of an artist's education for centuries. Brunelleschi's use of the forms of classical architecture in an imaginative way, in order to achieve harmony and beauty, would be an example followed for the next five hundred years by almost every architect. Brunelleschi's study of the ancient monuments of the Greeks and Romans and Giotto's concern for the individual were the two main ingredients of **humanism**, the predominant philosophy of the Renaissance and catalyst for the period's great achievements.

DONATELLO

When Brunelleschi went to study the ruins of Rome, he went with his friend, Donatello, a young man who would become the greatest sculptor of his time. Donatello had been a student of Ghiberti, but his achievements far surpassed his teacher, almost single-handedly creating the

14/5 DONATELLO, *Saint Mark*, 1411–1413. Marble, 7' 9" high. Or San Michele, Florence, Italy.

Renaissance style of sculpture. *Saint Mark* (14-5) was done when he was twenty-five years old. It shows he already had a great understanding of anatomy and form. We can see how the body shifts its weight at the hips, reminiscent of Greek statues like *Doryphoros* (12-17) nearly two thousand years earlier. Donatello's advance from the medieval style is very apparent when compared to what was naturalistic in its own time, Pisano's *Annunciation* (13-36). Rather than a crowded scene with many stories, we have a freely moving individual. We can see not only Donatello's mastery of the real features of a human body but also his ability to give a sculpture personality. Unlike Greek sculpture, Donatello's is not godlike but human. Saint Mark is dignified and thoughtful, his features strong but not perfect. He is a man who has lived on our earth and seen much; his hair is thinning and his brow is wrinkled.

The statue was commissioned by the Linen Drapers Guild of Florence, whose patron saint was Saint Mark. It is therefore not surprising that Donatello paid an extraordinary amount of attention to the drapery on his statue.

The fabric seems to flow naturally with the body, as in the ancient *Venus de Milo* (12-19), and is even inscribed with detailed embroidery. The Linen Drapers Guild was not one of the wealthier ones in Florence, so *Saint Mark* was made of marble rather than the more expensive cast bronze. A more affluent patron, probably a member of the ruling Medici family, commissioned *David* (14-6). It was the first freestanding life-size bronze figure since ancient

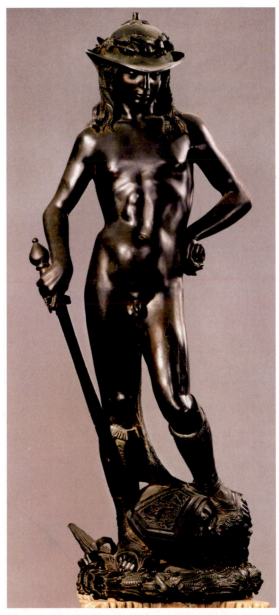

14/6 DONATELLO, *David*, c. 1428–1432. Bronze, 6¼' high. Museo Nazionale del Bargello, Florence, Italy.

times. Donatello was one of the first artists of the Renaissance to work from live models and to follow the Greek style by portraying David nude. For Donatello and other Renaissance artists, nudity was no longer shameful, as in the medieval period, but beautiful and capable of representing humanity's highest ideals.

Donatello's *David* is barely an adolescent, a boy who seems incapable of such a tremendous deed. He is almost effeminate; his muscles seem too weak to even lift Goliath's sword. Yet below him is Goliath's severed head, which the young boy is rolling around with his foot. How could this child defeat the giant Goliath? Donatello's answer to this riddle is also the meaning of the Old Testament tale: Miracles can be accomplished only with the assistance of God. If Donatello had created a muscle-bound David, the miraculous nature of the story would be lost. Yet the boy seems unaware of divine intercession; instead, he is proud of his own accomplishment. Pride would remain David's flaw even as king of the Israelites.

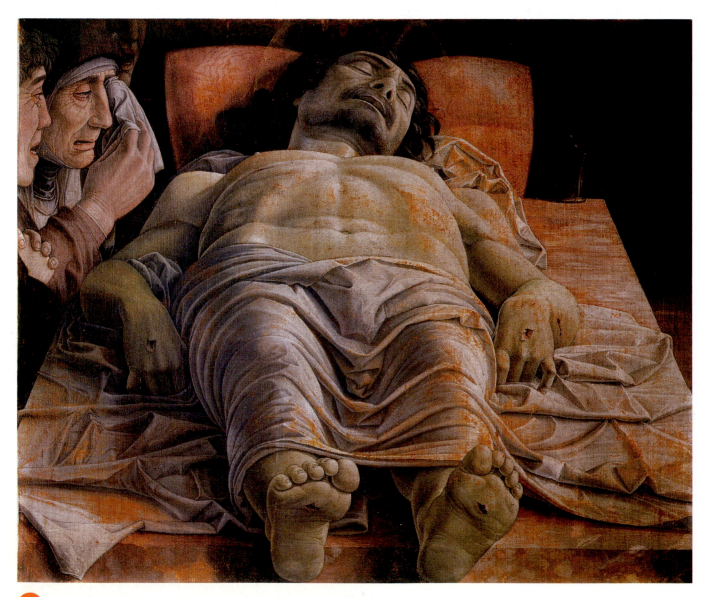

14/7 ANDREA MANTEGNA, *The Dead Christ*, c. 1501. Tempera on canvas, 26¾" × 32". Pinacoteca di Brer, Milan, Italy.

EARLY RENAISSANCE PAINTING: MASTERING PERSPECTIVE

Brunelleschi's discovery of the mathematical rules of perspective (see Chapter 3) transformed two-dimensional art. With perspective, drawing and painting were now raised to the level of science. In *The Dead Christ* (14-7), Andrea Mantegna uses perspective to place us right at the feet of Jesus. Like Giotto, his goal is to represent the events of the New Testament as realistically as possible. Unlike Giotto, however, he does not seem concerned with the inner emotion of his characters. He looks with a colder, less sympathetic eye. Mantegna's *Dead Christ* seems to be an eyewitness report. He depicts the wounds of Jesus with almost cruel accuracy; we can see into several layers of skin and flesh. On Jesus's right arm, there are dried drips of blood, remnants of his suffering during the crucifixion.

The mourners at the left are anything but idealized. Mary is not young and innocent as usually depicted but an old woman with leathery skin who cannot control her weeping. Because of our close-up perspective, we are not allowed to be emotionally disengaged. We are compelled to examine and consider the misery of Jesus's death.

A LOVE OF LEARNING AND *GRAZIA*

Mantegna, like the leading intellectuals of his time, considered the Middle Ages an era of superstitious thought. They felt it was time to see once again clearly and rationally as the Romans had. This desire to see clearly was the source of the detached, unemotional eye of Mantegna's *Dead Christ*, as well as the mathematical vision of Luciano Laurana's *View of an Ideal City* (3-24).

By the end of the fifteenth century in Florence, there was already a reaction to this coldness: a call for pictures with a sense of grace—called **grazia** by the Renaissance Italians. Fra' Filippo Lippi's *Madonna with Child and Angels* (14-8) epitomizes this opposing desire. Unlike Mantegna's harsh contrasts and grim colors, the picture has smooth, soft transitions, delicate lighting effects, a beautiful sky, and figures colored with pinks,

lemon, and apricot hues. This Mary is sweet, young and innocent. Her hair is wrapped in a diaphanous cloth, and she appears lost in thought as the angels present her with her child.

Lippi, a monk himself, was no angel. He lived an unusually adventurous life and was even kidnapped by Barbary pirates. The beautiful Madonna's face has been identified as his mistress, a nun. Their child, Filippino, would also become a successful painter in Florence and is possibly the model for the angel at the right.

But Lippi's student, Sandro Botticelli, surpassed them all in fame. His greatness was in his ability to bring beauty and harmony to pictures that also embrace scientific and classical ideals. Though his work is filled with scholarly allusions, they do not weight his pictures down. In fact, his figures float—they hardly touch the ground. Learning from the ancients was mixed with a graceful line and rhythm.

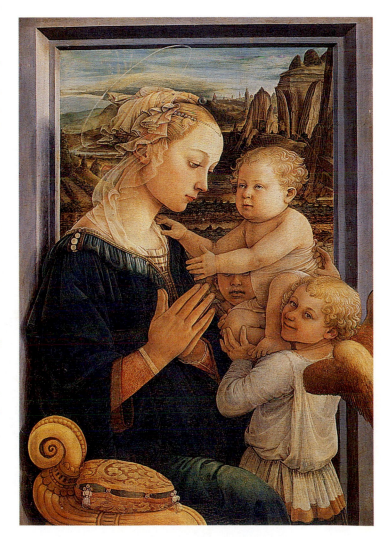

14/8 FRA' FILIPPO LIPPI, *Madonna with Child and Angels,* c. 1465. Tempera on panel, 36" × 25". Galleria degli Uffizi, Florence, Italy.

Botticelli's *The Birth of Venus* (14-9) is popular today because of its sweetness and the innocent quality of Venus as she floats in a fantasy world. Yet it is also a work of serious study, demonstrating that the artist was a scholar of ancient myths. The tale of Venus's birth is found in Hesiod's *Theogony*. When Cronus (the god of time) castrated his father Uranus (the sky god), he tossed his father's genitals to earth, which fell into the sea. From the foam of the splash, Venus was born. Botticelli's painting shows Zephyr, the god of the wind, blowing her to shore. In his arms is his wife Chloris, the goddess of spring, who blows flowers toward the newborn goddess. The symbolic meaning of the picture is that love triumphs inevitably over brutality, because out of the most brutal of acts, the goddess of love was born.

In the centuries since the fifteenth century, Botticelli's Venus has continued to symbolize ideal beauty. Yet if we look closely at her, we will see that she is not in perfect proportion. Her neck is quite long with a steep incline along the shoulder. Her left arm is also exceedingly long.

But these distortions are intentional; they do not make for a deformed goddess of love. In fact, they help create a more graceful image than any realistic picture could. Distortion can sometimes create greater beauty.

LEONARDO DA VINCI

During the Renaissance, artists joined scholars in a search for the fundamental cosmic truths of proportion, order, and harmony. At the beginning of the era, the medieval tradition of looking to the authors of the past for these truths remained (see "Art News" box on *The Birth of Modern Anatomy*). Ancient masters like Aristotle were considered to have almost sacred authority, second only to the Old and New Testaments. Leonardo da Vinci was familiar with the old texts but questioned them, too. Unlike most of his contemporaries, he wanted to find out things for himself. If he came across a problem, he would not look solely for the answer in books; he would devise experiments to solve it. Leonardo was a leader on a new path—to nature and imagination, and a scientific approach to knowledge. He

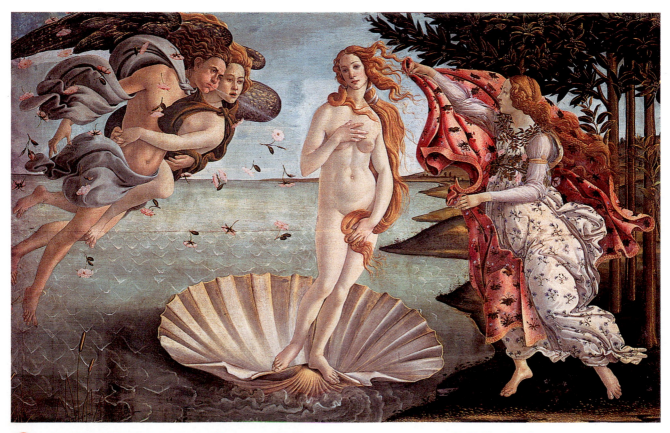

SANDRO BOTTICELLI, *The Birth of Venus*, c. 1482. Tempera on canvas, approximately 5' 8" × 9' 1". Galleria degli Uffizi, Florence, Italy.

THE BIRTH OF
MODERN ANATOMY

The medieval schematic of the muscle system (14-10) dates from the same period in which Giotto was painting. It is one of the earliest attempts to show the inner structure of the human body. Surprisingly, it is based solely on the work of Greek physicians. The art of Greece had beautiful representations of the human form, but it was truly a superficial understanding, because they did not know what lay beneath the skin. Dissections were forbidden in ancient and medieval times, so there were not many opportunities to learn the details of the human inner structure. Inner organs were revealed only after terrible accidents or wounds, which were probably not the best moments to make detailed studies.

However, in the early Renaissance, lawyers had an important role in increasing the knowledge of the human body, because they began requesting autopsies for their cases. By the end of the 1400s, dissections of cadavers were permitted, and anatomy was an officially recognized part of the university curriculum. Still, the study of anatomy made little progress, because professors would never actually touch a cadaver. Their knowledge was not based on any actual study but rather on readings of ancient medical texts. In their anatomy classes, they would sit on a throne and lecture in Latin (the traditional language of the universities). Assistants (usually a local butcher) would do the carving. Another assistant would point with a stick to the area the professor was describing; however, he knew little about anatomy and usually did not understand Latin.

It was an artist who made the first serious study of anatomy: Leonardo da Vinci (14-11) turned his incredible curiosity toward the exploration of the unknown

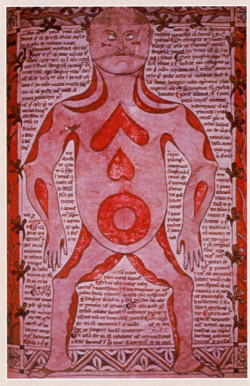

Medieval schematic of the muscle system, *Ashmolean Codex*, folio 22R, early 1300s. Bodleian Library, Oxford, United Kingdom.

14/11 LEONARDO DA VINCI, anatomical muscle studies, late fifteenth or early sixteenth century.

THE BIRTH OF
MODERN ANATOMY

territory of the body. Obsessed by detail, he believed that detail revealed God's design. He did many anatomical studies, dissecting more than thirty cadavers before Pope Leo X barred him from sneaking into the mortuaries at night. By then, da Vinci had described the circulation of the blood (one hundred years before its official discovery). He was also the first person to study the reproductive system of women.

However, Leonardo's notebooks were the private records of an artist. Vesalius was the first scholar to publish detailed studies of the human body (14-12). Vesalius was a zealous scientist (obtaining cadavers from graveyards, mortuaries, and the gallows), and his illustrations are works of art. When he became a professor at the University of Padua (the day after he earned his medical degree there), he disregarded the old traditions and did the dissections himself. His drawings are very accurate despite the serious handicaps he faced. Because the corpses he worked on were not preserved in formaldehyde, he had to work fast and have a photographic memory for details. Vesalius was a very popular lecturer and traveled to universities all over Italy to demonstrate dissections. At the University of Pisa, the outdoor theatre collapsed during one of his lectures from the weight of the huge crowds—a tragedy, but also evidence of the universal love of learning in Renaissance Italy.

Vesalius's and Leonardo's research avoided a pitfall of the unconditional admiration in the Renaissance of the ancient Greeks and Romans. Modern anatomy could only be born when the old texts were abandoned and self-reliant scientists conducted truly scientific research on their own.

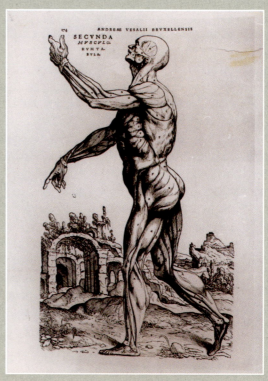

14/12 VESALIUS, "The Muscle System," *De Humani Corporis Fabrica Libri Septem*, 1543. Fratelli Fabbri, Milan, Italy.

believed in observation and analysis. For example, to learn about flying, he would watch birds, not just read books. His famous drawing of *Vitruvian Man* (3-13) is a good example of his approach. He corrects the ancient architect's theory of ideal proportions to fit the actual ones of human beings. The method Leonardo used is called **inductive reasoning**, where one observes phenomena directly and then uses information gathered to develop general rules. The medieval method is known as **deductive reasoning**, where already accepted general rules determine how you explain natural phenomena.

Leonardo da Vinci is the embodiment of the term "Renaissance man" because he worked in so many fields: anatomy, aeronautics, hydraulics, military engineering, and urban planning (see pages from his sketchbooks in figures 1-4, 14-11). During his long lifetime, he imagined helicopters, armored vehicles, air conditioning, brakes, and transmissions. Among his many discoveries are how water flows, how birds fly, and that the heart pumps blood. Yet Leonardo never thought of himself as a scientist; he was first and foremost an artist. He believed that observation and investigation of the laws of nature were necessary for an artist to have a true understanding in order to produce works of art. But, of course, it was more than that. As revealed in his notebooks full of detailed drawings, Leonardo, like many of his contemporaries, was in love with the act of seeing. He epitomized the Renaissance's enthusiastic rediscovery of the natural world.

THE HIGH RENAISSANCE

Leonardo's *The Virgin of the Rocks* (14-13) marks a new period in art—the *High Renaissance*. Compare it to a work of thirty years earlier, Mantegna's *The Dead*

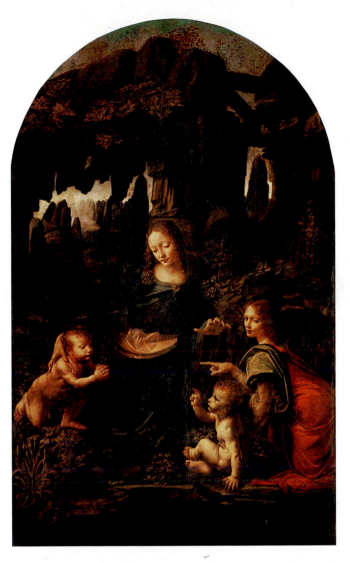

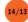

14/13 LEONARDO DA VINCI, *The Virgin of the Rocks*, c. 1485. Oil on wood (transferred to canvas), approximately 6' 3" × 3' 7". Louvre, Paris, France.

Christ (14-7). Mantegna's picture seems stiff. Its cold clarity seems impoverished when contrasted with the liquid atmosphere and subtle muted light of Leonardo's picture. In this painting, hard edges are nonexistent. While it looks real, it is more like a dream, a vision. The figures of the Virgin Mary, the infant Jesus, his cousin John the Baptist, and the angel are not entirely of our world, nor should they be.

The *Virgin of the Rocks* shows the perfect ease and accomplishment, the effortlessness—the *grazia*—that Renaissance artists were looking for. But underlying the softness is a new structural innovation, a geometric underpinning, which will be used throughout the Renaissance—the **figure triangle**. Leonardo also used a new medium that had been developed in northern Europe—oil painting. The smooth and subtle transitions between light and dark are made possible by this revolutionary medium (see Chapter 5). As seen in Chapter 1, Leonardo also revolutionized portraiture. His *Mona Lisa* has movement and life beyond any seen before.

For the dining hall of a monastery in Milan, Leonardo painted *The Last Supper* (14-14). To

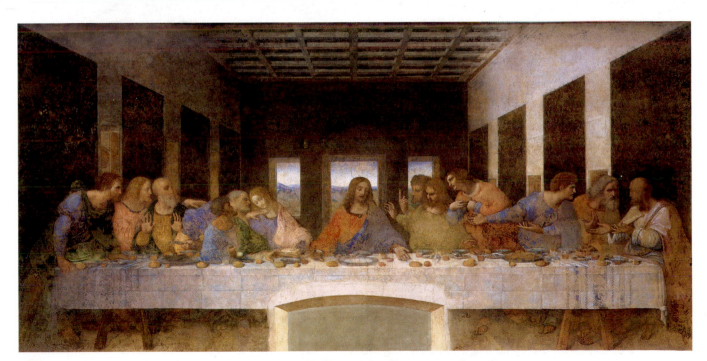

14/14 LEONARDO DA VINCI, *The Last Supper*, c. 1495–1498. Fresco (oil and tempera on plaster). Refectory, Santa Maria delle Grazie, Milan, Italy.

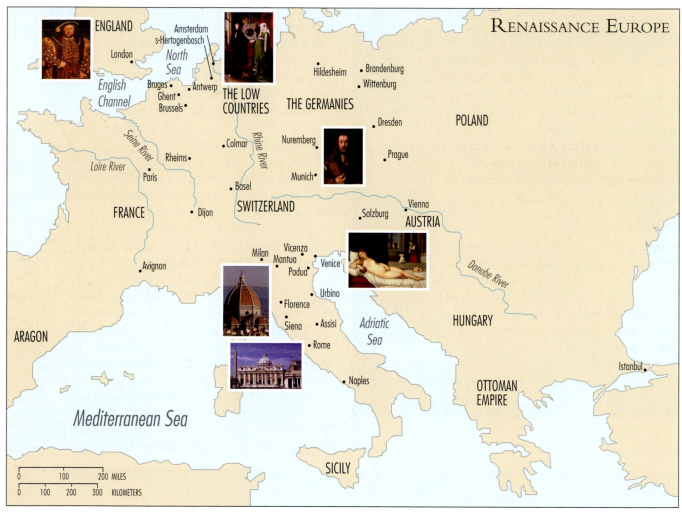

RENAISSANCE EUROPE

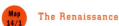

Map 14/1 **The Renaissance**

make the event vivid to the Dominican brothers, he placed Christ's table in line with the tables of the monks. All of the figures are life-size. The moment he chose to portray is when Christ discloses to his followers: "One of you will betray me." The apostles react to the announcement in different ways, according to their character. Some recoil in horror. Others discuss who could have betrayed their master. One gentle soul asks Jesus if it could have been himself. Judas, the only figure whose face is in darkness, pulls back from Jesus and clutches his bag of silver. *The Last Supper* shows a masterful use of perspective and symmetry. Leonardo used Christ's head as the vanishing point, so

all parallel lines on ceiling and walls lead directly to the center of attention. While no halo is actually painted above Christ's head, the pediment above creates one, and the light from the center window creates an aura around him.

Unfortunately, the masterpiece began to deteriorate almost immediately. Leonardo, incessant experimenter that he was, had altered the traditional chemistry of fresco (see Chapter 5) to allow more opportunities to make changes. The experiment was not a success. Even in Leonardo's own time, pieces of the paint began to fall off the wall. Today, after a time-consuming restoration to preserve what remains, some art historians estimate

that the restored picture is no more than 20 percent of the original (see "Art News" box).

Because of his genius, Leonardo, the child of a peasant, was given a high social position and became familiar with kings and queens. The king of France even threw his own mother out of her château so Leonardo could stay there and could not believe that "there was another man born in this world who knew as much" as he did. But toward the end of his life, Leonardo, acknowledged as the great artist of his time, felt the challenge of a younger man, one who would become the predominant artist of the High Renaissance.

MICHELANGELO

Giorgio Vasari, a painter, is best known for his *Lives of the Artists*, a contemporary biography of the important Renaissance artists (many of whom he knew). He introduced his chapter on Michelangelo Buonarroti with a description that seems more like the birth of a god than a man. After noting the achievements of Giotto and his followers, Vasari says:

> the great Ruler of Heaven looked down and, seeing these vain and fruitless efforts and the presumptuous opinion of man more removed from truth than light from darkness resolved, in order to rid him of these errors, sent to earth a genius universal in each art, to show single-handed the perfection of line and shadow, and who should give relief to his painting, show a sound judgment in sculpture, and in architecture. . . . He further endowed him with true moral philosophy and a sweet poetic spirit, so that the world should marvel at the singular eminence of his life and works and all his actions, seeming rather divine than earthly.

Michelangelo was a child prodigy. As a young man, it was said that no pose was too difficult for him to draw (see 4-3). Despite his great talent, his family (who believed they had noble roots) considered his vocation an embarrassment, and he was regularly beaten by his father and brothers. Apprenticed around the age of thirteen, he attracted the attention of the ruler of Florence,

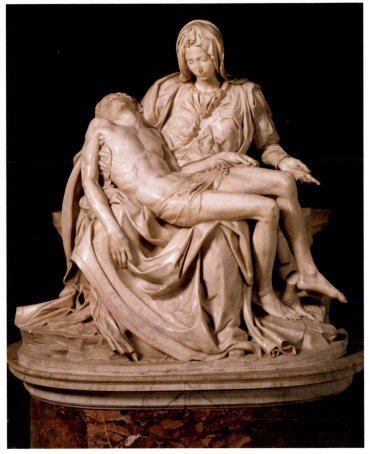

14/15 MICHELANGELO BUONARROTI, *Pietà*, 1499. Carrara marble, 69" high. Saint Peter's, Rome, Italy.

Lorenzo de' Medici, who arranged for Michelangelo to study sculpture in the private academy on the grounds of the Medici Palace. When he was only twenty-three years old, he was hired by a cardinal to sculpt the *Pietà* (14-15) for a church in Rome. The marvelous but melancholy *Pietà* shows the dead body of Christ after having been removed from the cross, lying across his mother's lap. Mary is sad but dignified, the gesture of her left hand signifying acceptance. The unusual proportions (he is smaller than she) remind us that no matter what the age of Jesus at his death, we are looking at a mother whose child has died. As in Botticelli's *The Birth of Venus*, imaginative distortion increases his art's power.

After his success in Rome, Michelangelo returned home to Florence to work on an eighteen-foot block of marble that had been prepared for Donatello but left unused for decades. When Michelangelo transformed the enormous stone into the finished statue of *David* (14-16), the city fathers decided to put it in the Piazza Vecchio, the main square, as the symbol of Florence. The statue shows David before he killed Goliath. David is tense but confident, sling across his shoulder, his right hand loosely fingering the stone. His eyes stare intensely as if he is choosing the right moment for his attack. Unlike Donatello's version (14-6), this David is not a child but a powerful young man, a worthy symbol of the youthful vitality of Florence.

When Michelangelo was thirty years old, Pope Julius II summoned him to Rome for his first papal commission: sculpting the pope's tomb. With youthful enthusiasm, Michelangelo drew up a design for an enormous tomb with forty bigger-than-life statues. He left Florence for the marble quarries of Carrera. He spent several months picking out the marble because of his singular vision of the sculptural process. Michelangelo believed that if chosen properly, his sculpture was already alive in the block of stone. He needed only remove the excess to release the figure within (see his *Slave*, 9-21).

Michelangelo returned from his months in the quarries and filled half of Saint Peter's square with a hundred tons of his stones. However, the pope was no longer interested in the tomb. He did not tell Michelangelo, but he had decided to tear down the old Saint Peter's, the most venerated building in the Christian world, and replace it with a new one, a massive undertaking (see Chapter 10). Michelangelo was furious and told Julius II (known as "the terrible pope" for his temper) he was leaving Rome, and he would never have any dealings with him again. Rather than hunting down Michelangelo and executing him, as might have been expected, emissaries of the pope began negotiations through the leaders of Florence for Michelangelo to return to Rome. The pope had a new commission for Michelangelo—to cover the ceiling of a tremendous chapel adjoining Saint Peter's (the old ceiling had developed cracks). It was 5,800 square feet, blue covered with gold stars.

Michelangelo was not interested in this new commission. First, he wanted to complete the project for the tomb he had spent so much time planning, and second, he told the pope, he was a sculptor not a painter. This was not an overstatement. The artist had only completed one painting since his apprenticeship. He finally agreed to paint the ceiling after many heated discussions because the pope promised he could finish the tomb afterward. What this "sculptor" created was the world-famous masterpiece, the ceiling of the *Sistine Chapel* (14-17).

14/16 MICHELANGELO BUONARROTI, *David*, 1501–1504. Marble, approximately 13' 5" high. Galleria dell'Accademia, Florence, Italy.

Working on scaffolding seventy feet from the floor, it took Michelangelo about four years to complete this project. At first, eager to finish quickly and begin again on the tomb, he planned to paint only the corner spaces, making portraits of the twelve apostles in each of them. However, the word "ambitious" is hardly sufficient to describe what became his ultimate plan. Michelangelo decided to represent the history of the world before Moses, from the first event in *Genesis*—the separation of light from darkness—to the story of Noah. Surrounding the main scenes are prophets who predicted the coming of Christ. Supporting every subject and scene are realistically painted architectural elements and nude figures who react to the scenes they frame. The Sistine ceiling contains more than three hundred figures, all in an incredible variety of poses and actions and all depicted as fully rounded three-dimensional forms, as one would expect from the hand of a sculptor.

A suspicious man, Michelangelo feared that other artists were conspiring against him and worried that Pope Julius II favored the more pleasant and cultivated Raphael, who was also working at the time on commissions in the Vatican. In fact, the Pope did pay Raphael significantly more for the tapestries he designed to be hung in the Sistine Chapel than for the painting of its ceiling. However, Julius II, while reputed to be impatient, cooperated with just about all of Michelangelo's requests. Special scaffolding was built to his specifications, pigments he required were imported from Turkey, and it is believed that he hired thirteen assistants (though he was notoriously difficult to work with and typically did almost everything himself). No one else was permitted in the chapel while Michelangelo was at work (see "Art Issues" box on *The Cost of Restoration*).

While it is filled with philosophical and religious references, generally, the story Michelangelo tells over the length of the ceiling is the movement to pure spirit from the physical. He began painting in reverse chronological order. The first important scene shows Noah, his spirit numbed by alcohol, naked before his children and ridiculed by them. The next scene is *The Flood*, the torrents of rain and water sweeping the earth. Michelangelo realized after this scene that he had underestimated the effect of the height of the ceiling and began

14/17 MICHELANGELO BUONARROTI, the ceiling of the Sistine Chapel, 1508–1512, Fresco. Vatican City, Vatican State.

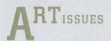

THE COST OF RESTORATION: THE
SISTINE CHAPEL
AND THE LAST SUPPER

When it is announced that beloved masterpieces are about to be restored, art lovers around the world hold their breath and hope that nothing goes wrong. History is filled with the destructive mistakes of well-meaning experts. In 1980, the Vatican announced that it had authorized four men to lead a team of restoration experts on an extraordinary mission—the cleaning of Michelangelo's Sistine ceiling frescos. By the time the team had finished nearly ten years later, they had not only removed centuries of grime but had also attracted the ire of many art experts around the world. More importantly, they forever changed the way the ceiling and its artist will be seen. In 1999, restoration was finished on another world-famous masterpiece, Leonardo's *The Last Supper*. A tedious process of twenty years, the approach taken by restorers and the ultimate result were also sources of controversy.

Before beginning the Sistine Chapel restoration, computers were used to map every single inch of the 2,732-square-foot ceiling—cracks, dirt, and all. Gammaray, infrared, and thermal photographs were entered into the computer to reveal the many layers of the fresco. A huge movable scaffold was built (with an elevator) and was attached to the same spots that Michelangelo used for his scaffold in the early years of the sixteenth century. Many tests would be made before an area was cleaned—one square foot at a time. First, the dust would be wiped off the area. Then a sponge with pure, distilled water was used. After that a gooey chemical solvent was applied with a brush, and then the miracle began. In three minutes, it loosened and mixed with four centuries of soot, varnish, and grease from candles, glues, and old restorations, leaving a soft mixture to be wiped away with a sponge and water.

Figure **14-18** illustrates the unique partnership between craftspeople and computer technicians that transformed not only the appearance of Michelangelo's masterpiece but also our understanding of it. The restorers gained an intimate knowledge of Michelangelo's working procedures and built a valuable data bank in the computers that shows his progress day by day. Except for the paintings on the sides, most of which were painted from his imagination without drawings, Michelangelo would scratch a fairly detailed sketch into the wet plaster before painting. Close up, one can almost see Michelangelo at work. One sees parts of the ceiling where the artist ignored original plans as a new idea occurred to him. Restorers even discovered hairs from Michelangelo's brushes still imbedded in the original painting.

The familiar dark and dignified Sistine ceiling studied by art historians for centuries no longer exists; it has been replaced by a brightly colored, lively display. Before the cleaning, Michelangelo was known as a master draftsman, capable of foreshortening figures in a marvelous variety of poses, but he was also considered an indifferent colorist, more concerned with creating sculptural forms in paint than making strong color statements. No longer. The vivid colors discovered in the cleaning process

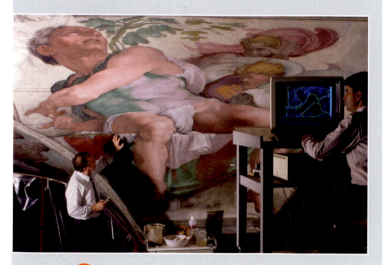

14/18 Frescoes being restored, Sistine Chapel ceiling.

provided a new picture of the genius of Michelangelo. The darkness of the painting was largely a result of animal glues used in varnishes by past restorers. The varnishes were used to brighten the painting but would inevitably deteriorate, making the painting even dimmer than before the varnish was applied. Over time, Michelangelo's fresco became darker and darker. Long before the twentieth century, the somber Sistine ceiling was the only one remembered. So it is not surprising that scholars around the world were shocked to see the new version. Many criticized the restorers, accusing them of removing not only dirt and old varnish but also a second coat of paint they believed Michelangelo had used to soften the colors. Some said the Sistine ceiling had been destroyed. Others say that the unhappy critics are having difficulty adjusting to Michelangelo's original, colorful pictures. The sooty ceiling was an aged and well-loved friend that they miss.

The process of restoring the equally beloved *Last Supper* of Leonardo da Vinci was perhaps even more challenging (14-19). It began in 1979 with the simple goal of reattaching paint that had flaked off, but soon expanded to a complete restoration. Unlike the relatively well-preserved Sistine ceiling, the *Last Supper* has had a long, unfortunate history. Its deterioration began almost as soon as Leonardo completed it in 1498, because the artist had experimented unsuccessfully with the fresco medium. In the 1600s, a door was cut at the painting's bottom, removing Christ's legs. When Napoleon invaded Italy, he used the refectory where the *Last Supper* is housed as a stable.

In the centuries since Leonardo finished the painting, many restorers tried to rehabilitate it, and some of their methods only increased the picture's problems. For example, restorers in the 1700s painted in oils directly onto the picture. When their restorations flaked off, each flake took some of Leonardo's original paint with it. Subsequent restorers decided to repaint the picture rather than restore it, some changing the artist's original vision. Their overpainting also damaged the chemicals in Leonardo's paint. Twentieth-century restorers did better work, but during World War II an Allied bombardment hit the refectory, shaking the painting and caving in the roof. The *Last Supper* was covered for years while the building awaited repairs. Mildew grew on its surface during that time.

The primary goals of the most recent restoration were to remove all previous restorations and to reattach only the remaining original parts of the masterpiece. Pinin Brambilla Barcilon devoted two decades of tedious labor to the project. When it was completed in 1999, she was in her seventies with weakened eyesight and chronic pain; she said, "Centimeter by centimeter I worked with a knife and microscope for 20 years to remove what five centuries

of restoration and dirt had left behind." A day's work might only complete an area the size of a postage stamp. The most advanced technologies available were used. Infrared and chemical analyses were used to determine which paint was original. Small borings into its surface were made and miniature cameras were inserted to examine the structural integrity of the wall. Today, the painting is protected by being exhibited only to small groups by appointment and in a completely climate-controlled environment.

Like the restoration of the Sistine Chapel, this restoration has been controversial in the art world. The decision to retain only Leonardo's original paint meant that Brambilla and her team removed much that had been familiar for centuries. For example, Christ's red beard was eliminated because it was determined to be a later addition. Many areas were left empty because they no longer had any of the original paint. While the colors in many parts are once again bright and luminous, the painting clearly reflects its substantial damage over the past five hundred years.

The restorations of the Sistine Chapel and *The Last Supper* cost many millions of dollars. Many millions of dollars will be needed to restore the Acropolis in Athens, and millions more will be spent on the damaged medieval stained glass in France (see the "Art News" box in Chapter 13). The costly and time-consuming restoration of paintings, sculptures, quilts, pottery, and buildings occupies tens of thousands of people around the world. How can such expenditures be justified in a world with so many problems, where children go to sleep hungry and families have no homes? It must be that people believe that, just as we have a responsibility to preserve our natural environment for the sake of future generations, we must preserve our cultural environment, the harvest of the best efforts of centuries of men and women.

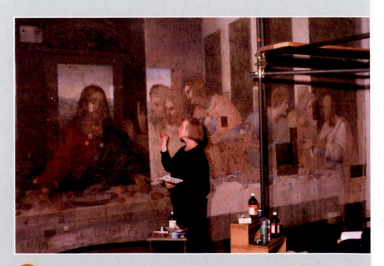

14/19 Restoration of **LEONARDO DA VINCI's** *The Last Supper.*

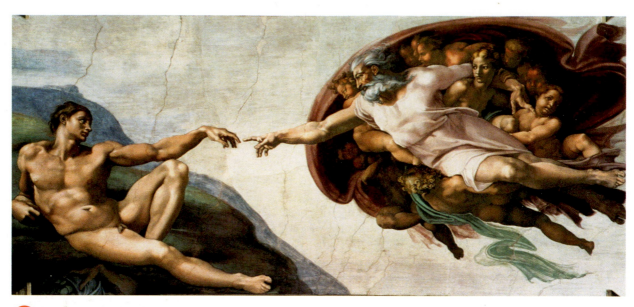

14/20 MICHELANGELO BUONARROTI, *The Creation of Adam* (detail of figure 14-17).

painting larger figures, starting with the *Expulsion from Eden*. After that comes *The Creation of Adam* **(14-20)**, the most famous of the scenes, where a powerful and compassionate God (who resembles the ancient god Zeus) brings a still-weak Adam the spark of life. *The Creation of Eve* shows her pulled from the side of a sleeping Adam by a simple gesture of God.

Moving back farther in time, we are shown God racing back and forth across the heavens in *Creating the Sun, Moon, and Planets* and *Congregating the Waters*. The climax of the ceiling is the first moment of creation—the *Separation of Light and Darkness*. With *Jonah and the Whale* (symbolizing Christ's resurrection) just over the altar, they announce the inevitable triumph of the spirit over the physical world.

RAPHAEL

As you can imagine, this masterpiece had a profound effect on the artists of the Renaissance. Perhaps the biggest effect was on the younger Raffaello Santi, the artist we call Raphael. In 1508, the pope called on Raphael, then twenty-five years old, to decorate his private library in the Vatican, now known as the "Stanza della Segnatura." Because this was his first great commission, Raphael chose a great humanistic subject. Raphael decided to sum up all learning; each of the four walls would represent one discipline: theology, law, literature, and philosophy.

While decorating these walls, he managed to see Michelangelo's unfinished work on the Sistine ceiling. Legend tells us that he bribed the guards to let him see the ceiling while Michelangelo was away. He slipped into the chapel, climbed up the scaffolding, and was stunned by the masterpiece. Raphael immediately realized that his pictures in the library seemed backward compared to Michelangelo's and quickly redesigned and repainted all of his pictures.

The School of Athens **(14-21)** is the most famous wall of the Stanza. It is a picture of a heavenly world of knowledge, the Elysian (or "delightful") Fields spoken of by the Greek poets. We see the greatest philosophers of the classical period in discussion, thinking, teaching, and arguing. In the center is Plato, pointing upward to the ideal, and Aristotle, pointing downward to reality. On the lower left, Pythagoras, a Greek philosopher and mathematician, is writing; at right, Euclid, the Greek founder of geometry, is surrounded by many students.

The connection felt between those ancient times and the Renaissance of Raphael is given visual form by the artist's choice of models for the philosophers. Plato is also a portrait of Leonardo da Vinci, for example. Euclid is the architect Bramante who designed the new Saint Peter's and whose ceilings and archways can be seen overhead. In the foreground, alone and moody, is Michelangelo as Heraclitus, known as the "weeping philosopher." At the farthest right, a sign of his modesty, is Raphael himself, posing as a student of Euclid.

Preparatory sketches were always important for Raphael, but he never made more than he did for this project. *The School of Athens* is known for its perfect composition and perspective. Unity is achieved by the repetition of arched (elliptical) shapes throughout. Even the figures form a large ellipse. As in Leonardo's *The Last Supper*, the vanishing point is placed at the center of attention—Plato and Aristotle. Notice how the seemingly casual form of the reclining Diogenes on the steps also points at the

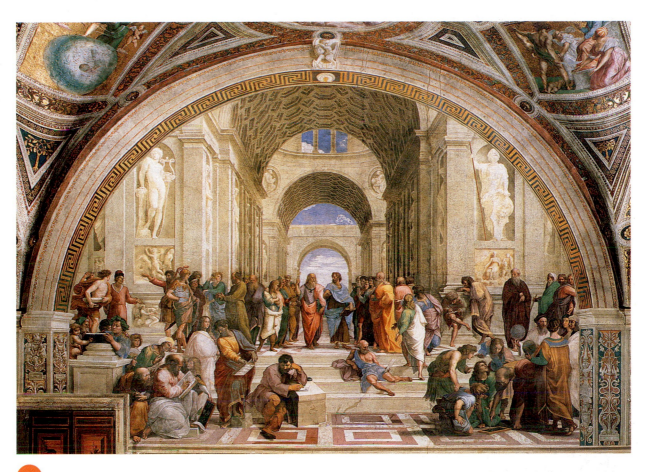

14/21 RAPHAEL, *The School of Athens*, 1509–1511. Fresco, 19' × 27', Stanza della Segnatura, Vatican Palace, Vatican State.

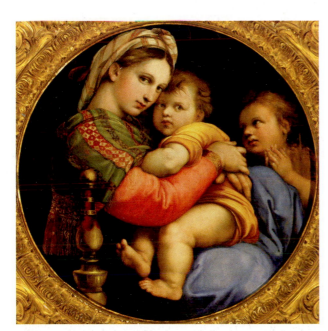

14/22 RAPHAEL, *Madonna della Sedia*, 1510–1512. Panel painting, tondo, 28" diameter. Pitti Gallery, Florence, Italy.

central figures. Even though it is more complicated than Leonardo's picture, *The School of Athens* remains a vision of order and dignity. Raphael achieves a harmonious composition of freely moving figures, something artists have admired in his work throughout the centuries.

The School of Athens shows Raphael's formal, mathematical side, but his *Madonna della Sedia* (14-22) shows his sweet and loving side. The sheer, ideal beauty of his pictures of the Madonna and Christ child made Raphael famous (see also 5-5). Over the centuries, Raphael's *Madonna della Sedia* has been seen as artistic perfection. As a modern critic said, this picture would be recognized as a masterpiece even if it were found dusty and unlabeled in an attic. It is in a circular format called a *tondo*, which means "simple" in Italian, yet it is probably the most difficult form for a painting compositionally because of a tendency to seem unbalanced and rolling. Raphael secured the scene by providing the strong vertical of the chair post, but that is merely a technical issue. The picture's lasting fame depends on the warmth, softness, and pride of Mary as she cuddles with the wriggling infant Jesus. One cannot imagine a sweeter expression of the love of a mother for her child.

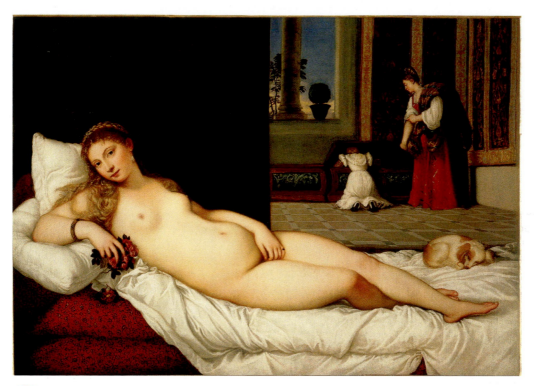

14/23 TITIAN, *Venus of Urbino*, 1536–1538. Oil on canvas, approximately 48" × 66". Galleria degli Uffizi, Florence, Italy.

Those who lived at the peak of the Renaissance believed the power of the mind made anything possible. The world seemed good and understandable. Raphael, one of the greatest masters of the Renaissance, managed to achieve its highest goals: *beauty, proportion, grace*, and a *sense of human virtue*.

THE RENAISSANCE IN VENICE

In the medieval period, bright colors were used for decorative and symbolic purposes; artists were not concerned with reproducing actual colors or even realistic forms. Partly in reaction to that art, the Florentines of the Renaissance were most interested in drawing issues, such as the realistic depiction of forms. Perspective and composition were the things that fascinated them: color was a secondary interest.

However, color was not a mere adornment for the artists of Venice but central to their work, giving energy and movement to their pictures. The greatest colorist and painter of the Venetian Renaissance was Tiziano Vecellio, or Titian. Unlike the geniuses of Florence and Rome, Titian's sole interest was painting; he was not an architect or a scientist. He mastered the medium with a single-mindedness that was unique for his time.

He developed new techniques—for example, **impasto**, where thick layers of paint are built up for added richness (see Chapter 5). Titian would vary the texture of the paint itself, sometimes scratching into it with his fingers. His surfaces are full of energy.

Sensuality became a hallmark of Venetian painting, and the *Venus of Urbino* (**14-23**) probably epitomizes the Venetian love of sensual delight better than any other work. Here is Titian's ideal beauty, and she is very different from Raphael's or Leonardo's. She is an openly sexual woman, lying on cool sheets on a hot day. The purpose of this picture is not to give moral or religious instruction but to give pleasure. Notice how Titian uses color as a compositional element. The large red pillow (the hue is known as either Venetian or Titian red today) in the foreground is balanced by the red skirt in the background. The white shapes of the pillow and arm form triangles that lead back into the background. Titian had created a new type of image, one that would be borrowed by artists for centuries. Romantics, Classicists, Realists, and Impressionists would all choose to continue the *tradition of the reclining nude*.

PALLADIO AND ARCHITECTURE

While Leonardo, Michelangelo, and Raphael engaged in architectural projects, architecture never was a primary interest for them. The quintessential Renaissance architect was Andrea Palladio. His most influential building,

the *Villa Rotonda* (14-24), has been a model for architects in every century since it was built, in the mid-1500s. It is the essence of calm and harmony, a study of the purest geometric forms. The building is perfectly symmetrical, with four identical façades designed like a Roman temple on each side. A circular hall topped by a dome is the center of the building, making Palladio's design a circle within a square. This private retreat of a wealthy landowner rests on a hillside outside the city of Vicenza and provides four different views of the countryside from each of the entrances. Many classical-style statues on the pediments and stairways share the lovely views, which the occupants could choose from, depending on time of day, weather, or whim.

Palladio was a scholar of ancient architecture and, like his predecessor, Brunelleschi, made many trips to Rome to study the ruins there. His influential treatise, *The Four Books of Architecture*, was written to encourage the construction of buildings that would bring the world into an ideal state. With floorplans and drawings, the book systematically explained classical architecture. Palladio also included the designs for his buildings, thereby putting his own work on the same level as the greatest architecture of the past. His treatise became the primary source of information on the buildings of the Greeks and Romans and was widely circulated. The familiarity of the

Palladian style of architecture testifies to his treatise's acceptance as the authoritative guide to ideal architecture. Among many others, he would influence architects of the early American republic like Thomas Jefferson (see Chapter 10).

THE END OF THE HIGH RENAISSANCE IN ITALY

Unlike Raphael, who was only thirty-seven when he died, Michelangelo had a long, full life—he lived until the age of eighty-nine. Despite his immense talent, Michelangelo ended his life as a frustrated and angry old man. Many of the projects he began (like the tomb of Pope Julius II) were left unfinished. By the 1530s, he could see the age of the High Renaissance was ending, never to return.

In 1534, Michelangelo returned to the Sistine Chapel to paint an enormous fresco on the wall behind the altar. Thirty years had passed since he had completed the ceiling of the chapel. Since then, his beloved Italy had become a battleground, the victim of many invasions from the north. Even Rome had been sacked in 1527, leaving it in disarray. In Florence, the Medicis, once his patrons, had become tyrants who were propped up by the

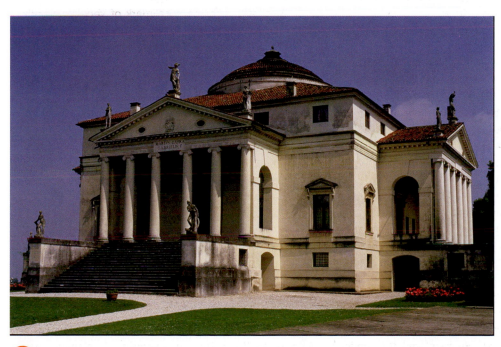

14/24 ANDREA PALLADIO, *Villa Rotonda* (formerly Villa Capra), near Vicenza, Italy, c. 1566–1570.

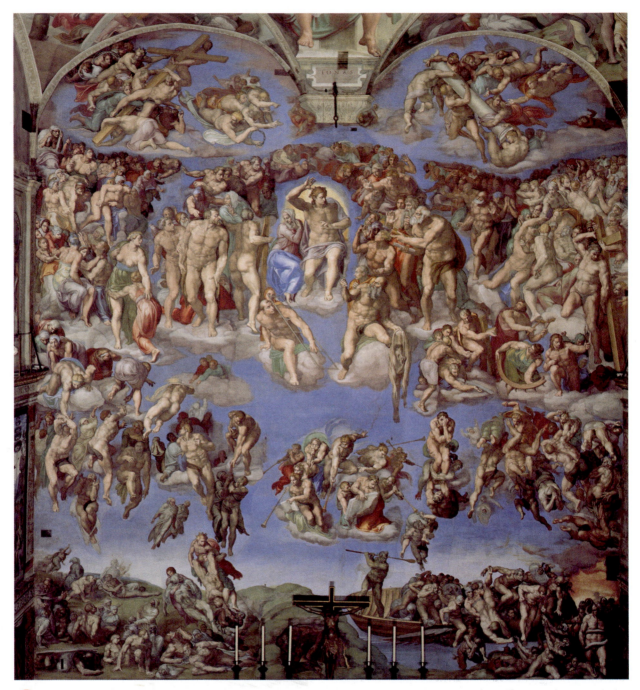

14/25 MICHELANGELO BUONARROTI, *The Last Judgment*, fresco on the Sistine Chapel, 1534–1541.

Spanish king. All across Europe, there was change. The Protestant Reformation (see following section) had split Christianity. Michelangelo became deeply concerned about the fate of humanity. He felt the world had gone mad, and he worried about the fate of his own soul.

Even though they share the same room and were done by the same artist, *The Last Judgment* (14-25) has a very different mood from that of the Sistine ceiling. On a dark and turbulent Judgment Day, Christ has come, but his arm is lifted in damnation as if he is destroying the world (14-26). Mary, his mother, turns her head away; she cannot bear to see his judgment. The heavens are in chaos. Ideal beauty and perfection no longer have a place in Michelangelo's painting. At the end of his life, using ugliness and terror for their expressive power, the greatest artist of the High Renaissance moved beyond its ideals.

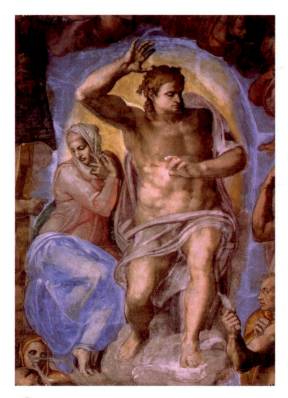

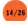

14/26 Detail of figure 14-25.

THE BEGINNING OF THE NORTHERN RENAISSANCE

The Renaissance did not take place only in Italy. In the early 1400s, a century after Giotto but long before the birth of Michelangelo, it had also begun in northern Europe. As in the Italian Peninsula, growing cities made more powerful by trade altered the structure of society. The new wealthy courts in the Netherlands, Germany, France, and England became centers for art. Unlike Italy, however, the cultures of northern Europe had flowered during the Middle Ages. The Medieval Era, for example, was the era of the great Gothic churches and stained-glass windows in France. Therefore, the difference between medieval art and that of the Early Renaissance in the north is not as clear-cut as it was in Italy. However, during the fifteenth and sixteenth centuries, with commerce on the rise between Northern and Southern Europe, the ideas of the Italian Renaissance began to be gradually assimilated in the north.

ART IN THE COURTS OF THE DUKE OF BURGUNDY

Based in both Dijon, France, and Flanders (now Belgium), the courts of the duke of Burgundy were two of the most significant artistic centers in the north by the end of the fourteenth century. This French duke had inherited the Netherlands, one of the most prosperous lands in northern Europe, from his father, the king. By the end of the Renaissance, the Netherlands would replace Florence as the center of European finance.

The French felt that the artists of the Netherlands were the best in Europe. Therefore, it is not surprising that in 1395, Philip the Bold, the duke of Burgundy, sent for the Flemish artist Claus Sluter to design a huge crucifixion for a church in his capital of Dijon. Originally twenty-five feet tall, the statue's base is all that remains intact. Today it is called *The Well of Moses* (14-27), because it was originally placed over a fountain. It is an extraordinarily naturalistic sculpture, with life-size portraits of individuals who seem only to be leaning against the backgrounds temporarily. The Old Testament prophets Moses, David, Jeremiah, Zechariah, Daniel, and Isaiah look as if they are about to leave the fountain, walk into

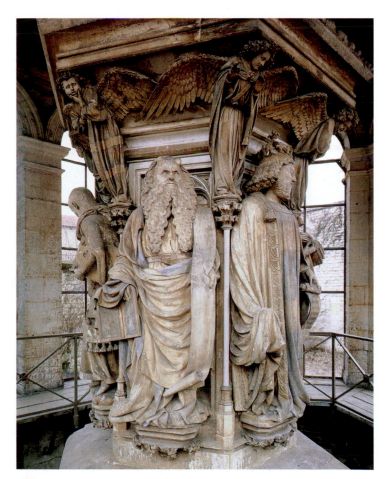

14/27 CLAUS SLUTER, *The Well of Moses*, 1395–1406. Limestone, painted and gilded by Jean Malouel, Moses 6' high. Dijon, France.

14/28 JAN VAN EYCK, *Giovanni Arnolfini and His Bride,* 1434. Tempera and oil on wood, 32" × 23½". National Gallery, London, United Kingdom.

the congregation, and begin to preach. Each is a unique character, and every part has been sculpted by Sluter with careful attention to realistic detail. Notice how the heavy cloth of Moses's robes is held to his waist by a precisely delineated belt. As realistic as the statues seem today, originally they were even more so, because they were not bare stone but painted. Moses wore a blue robe with golden lining. Jeremiah even had on a pair of metal spectacles.

JAN VAN EYCK

Another Flemish artist, Jan van Eyck, was the favorite artist of a later duke of Burgundy, Philip the Good. Although we do not know much about this artist's life, his sober, realistic style was most likely influenced by Sluter's. Like Sluter, he lived in Brussels but also traveled widely as a diplomat of the duke.

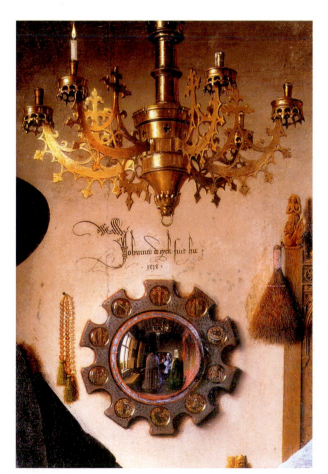

14/29 Detail of figure 14-28.

While the Italian Renaissance artists like Leonardo da Vinci were pursuing naturalism with the technique of *sfumato* light, van Eyck used a different approach to reach a similar goal. As seen in his *Virgin with the Canon van der Paele* (2-16), van Eyck used detail upon detail to carefully recreate nature. This obsession with detail is common in northern Renaissance painting and one of the clearest ways to differentiate it from the art of the south. If the painting is concerned with the beautiful surface of things, then it is most likely from the north.

Giovanni Arnolfini and His Bride (14-28) is van Eyck's most famous work and is evidence of the growing trade between Northern and Southern Europe. It depicts the marriage ceremony between an extremely wealthy Florentine banker who lived in Flanders and the daughter of a rich Flemish family. At this time, civil marriages (versus church ceremonies) were permitted as long as they were witnessed by a government official. Because the painter was an appointed official of the duke, the painting served as both portrait and official document. On the back wall, between the bride and groom, is his elaborate signature—"Jan van Eyck was here 1434."

Van Eyck's painting is a good example of **secondary symbolism**. Medieval artists loved to make symbolic puzzles out of pictures, and van Eyck continues the practice. It was part of a desire to give realism even greater meaning by making each detail meaningful. The dog, for example, symbolizes Fidelity (Fido). Peaches ripening on the desk and window sill suggest fertility, as do the ripe cherries on the tree outside the window. The chandelier has only one candle—the nuptial candle, carried during the ceremony and by tradition blown out right before going to bed on the wedding night. The ceremony is not totally secular. The main participants have removed their shoes because it is sacred ground. The mirror (with tiny scenes of the Stations of the Cross around its edge) probably represents the eye of God witnessing the ceremony (14-29). In it we can see the backs of the couple as well as van Eyck and his assistant. A rosary hangs to its side. The entire scene, while very naturalistic, symbolizes the holy sacrament of marriage.

ALBRECHT DÜRER

Van Eyck mastered detail, color, texture, and realistic portraiture, but knowledge of mathematical perspective had not yet come from Italy. Like his fellow northern Renaissance artists, he accepted what he saw but did

not search for underlying universal laws. One man took it upon himself to bring the ideas of the High Renaissance to northern Europe—the German artist, Albrecht Dürer, who became known as the "Leonardo of the North" because of the variety of his interests: writing treatises on painting, perspective, human proportions, fortifications, and many other topics. Like Leonardo, he did many sketches from nature, studying its most delicate details.

Dürer is probably the first artist to paint pictures devoted solely to a self-portrait. His *Self-Portrait* (14-30) in 1500 shows him at the age of twenty-eight, after his return from Italy, where he studied the great works of the Italian Renaissance and became determined to bring this knowledge north. The careful detailing of his fur collar is very typical of the northern style, but his interest in High Renaissance composition is revealed by the pyramid construction of the picture. If you look closely, you will discover, in fact, that the composition contains several triangles. The portrait's striking resemblance to European images of Christ is conscious but not blasphemous; Dürer is saying he is a creator, too (note his hand's position).

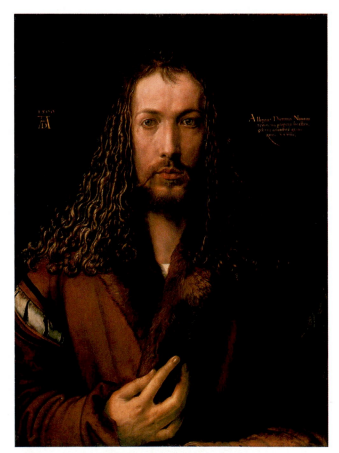

14/30 ALBRECHT DÜRER, *Self-Portrait*, 1500. Panel, 26½" × 19¼". Alte Pinakothek, Munich, Germany.

Despite the exceptional skill demonstrated in his self-portrait, Dürer's greatest talent was not as a painter but as a printmaker. His graphic work in metal engravings and woodcuts, such as the *Four Horsemen* from his *Apocalypse* series (6-2), made him rich and famous in his time and maintains his reputation even today. He inherited his skill from his father, a goldsmith, who trained him (see "Global View" box on *The Gold of the New World*). His technical mastery was combined with an inventive mind, a marvelous eye for detail, and the patience to render detail upon detail. A good businessman, too, he hired salesmen to sell his prints across Europe. He priced them so that they were affordable to middle-class collectors.

As an artist, Dürer demonstrated that effects once thought possible only in paint could be accomplished by a master printmaker and helped make the print the equal of any other fine art form. He was recognized as being among the greatest masters even in his own time. In a discussion with the Holy Roman Emperor Charles V, Michelangelo said of Dürer: "I esteem him so much that if I were not Michelangelo, I should prefer to be Albrecht Dürer than Emperor Charles V."

HANS HOLBEIN AND THE PROTESTANT REFORMATION

In one of his many treatises, Dürer included among a painter's most important responsibilities "to preserve the appearance of men after their death." A younger German, Hans Holbein, made that goal his main occupation and became one of the greatest portraitists who ever lived. He came from a family of painters and began his career after Dürer's mission to spread the influence of the Italian Renaissance had taken hold. Like Dürer, Holbein traveled to see the great Italian masterpieces firsthand, and by the time he was thirty years old, he had assimilated the learning of the Renaissance. Settling in Switzerland, he painted beautiful altarpieces and was on his way to becoming the leading painter of the German-speaking world when that world, and Europe, suddenly changed profoundly.

The Protestant **Reformation** led by Martin Luther turned Europe upside down and had deep and pervasive effects on the art world, too. The rebellion against the Roman Church was sparked by the church's practices, like the sale of indulgences (which Pope Julius II had zealously promoted to pay for his new Saint Peter's). Northern Europeans were outraged by the idea that Christians could buy their way into heaven. Luther and his followers preached that Christians needed only faith and knowledge of the Bible to reach salvation, but the rise of the Protestant

A GLOBAL VIEW

THE GOLD OF THE
NEW WORLD

In 1520, during a visit to the court of the Holy Roman Emperor Charles V in Brussels, the artist Albrecht Dürer saw objects from another culture that took his breath away. He wrote in his journal:

> Then I saw the things which were brought to the King from the new Land of Gold [Mexico]: an entire golden sun a full fathom wide, and likewise an entire silver moon equally as large, likewise two rooms full of armor of the people there, all kinds of wondrous weapons; most strange clothing, bedding and all sorts of marvelous objects for human use which are much more beautiful to behold than things spoken of in fairy tales.

> These things were all so precious that they were valued at 100,000 florins. In all the days of my life I have seen nothing which so filled my heart with joy as these things. For I saw among them wondrous works of art, and I marveled over the subtle genius of those men in strange countries. Truly, I cannot tell enough of the things which I saw there before me.

Dürer was writing about some of the first objects brought from the New World to Europe by the Spanish Conquistador Hernán Cortés, presents from the Aztec leader Montezuma. Only a year earlier, the Spanish ships had arrived on the shore of Mexico. Montezuma believed at first that they were mountains that divine beings sailed on the seas. Cortés, his body covered in gleaming metal, was thought to be a legendary god returning—Quetzalcoatl, one of the gods who created the world. Montezuma was wrong about the ships but terribly right in his belief that the arrival of these divinities would mean the destruction of his empire. The riches that Cortés presented to Charles V were given to the conquistador in a futile effort to convince this divine being to spare Montezuma's people. Hundreds of messengers were sent back and forth to deliver huge objects of gold and silver to Cortés. Among the gifts were the treasures that the Aztecs had revered as belonging to Quetzalcoatl.

During the European Renaissance, the royal families and the Catholic Church first began building great collections of art. Charles V, who ruled an empire that stretched from Spain to Austria, was not the only collector of what has since become known as *Pre-Columbian* art. The Medicis of Italy and the popes also added the treasures of the Americas to their collections. But, unfortunately, the primary goal for Cortés's patrons was not a love of art but simply of wealth. Cortés was sent to the Americas for silver, precious stones, and especially gold. By the mid-1500s, each year more gold was shipped to Europe from the New World than was mined in all of Europe.

Precious few of the golden artworks of the Aztecs like the ones that amazed Albrecht Dürer remain. A rare survivor depicts a great warrior (14-31). Beautifully crafted

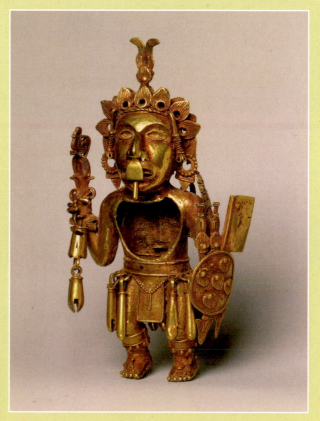

 Figure of a Warrior, fourteenth to sixteenth century, Central Mexico, Aztec. Cast gold-silver-copper alloy, 4⅜" × 2⅜". Cleveland Museum of Art, Cleveland, Ohio.

THE GOLD OF THE
NEW WORLD

with intricate details, he wears ear, nose, and lip jewelry, which were common among high-born Aztecs. He carries a spear with a serpent's head in one hand and a shield and darts in the other. At the time of Cortés's arrival, the Aztec capital in Tenochtitlan had a population of 200,000, but the civilization was doomed. Its Great Temple, the center of its rituals and the empire, was destroyed and buried beneath the ground. A new Mexico City was soon built on its ruins and the land renamed New Spain.

Two hundred feet tall, The Great Temple of the Aztecs remained lost and buried for centuries. It was discovered by accident in 1978 during the excavations for a new subway line in Mexico City. In 1987, the Templo Mayor (Great Temple) Museum opened and exhibited many of the artifacts found at the site. One of its saddest objects is in its last room. It tells the tale of what happened to almost all of the golden statues and jewelry of the Aztecs. It is a foot-long bar of gold—one of thousands made by the Spanish from melted cultural treasures.

Reformation came with a terrible cost for art and artists. There was a wave of *iconoclasm*—the destruction of religious imagery (though Luther, a close friend of a painter, was horrified by this development). Many Protestants associated imagery not only with the Roman Church but, like the early Christians, with idolatry. All over northern Europe, Protestant mobs swept into churches destroying altarpieces, decapitating statues, and burning crucifixes. The lack of decoration in most Protestant churches today is a result of this darker side of the Reformation.

While most of his religious paintings were being destroyed, Holbein desperately looked for a safe haven where he could continue his career. He sailed to England and was given refuge by Sir Thomas More, a world-famous writer, scholar, and political leader. His *Portrait of Sir Thomas More* (14-32) was painted soon after Holbein's arrival when More was Speaker to the House of Commons. With meticulous detail, it shows an intelligent, dignified, and successful man wearing the symbol of his high office. The picture provides sensual pleasures as well. Holbein masterfully reproduces a variety of textures: More's soft hands, the stubble of his beard, red velvet, black satin, gleaming gold, and fur. Underlying all of Holbein's work is his marvelous drawing ability. We believe every detail without question; we are convinced this is how Sir Thomas More looked.

When the Reformation came to England, even powerful friends like More could not prevent the end of Holbein's career as a painter of religious art, but More helped Holbein become Henry VIII's court portraitist (see his portrait of the king in Chapter 1). He was a prolific painter, so even though he died of the plague at the relatively young age of forty-six, we have an almost firsthand acquaintance with the many members of the Tudor court.

If we compare Holbein's portrait of Sir Thomas More to Leonardo da Vinci's *Mona Lisa* (1-1, painted less than twenty-five years earlier), we can see some of the characteristic differences between northern and Italian Renaissance painting. Northern artists accentuated detail and crispness of edges, while in the south, a soft diffuse light—*sfumato*—eliminated definite edges. Interest in delineating fabrics, textures, and patterns precisely was the common feature in northern Renaissance art.

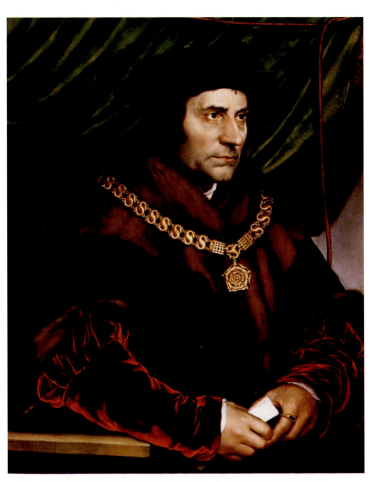

14/32 HANS HOLBEIN THE YOUNGER, *Portrait of Sir Thomas More*, 1527. Panel, 29½" × 23¾".

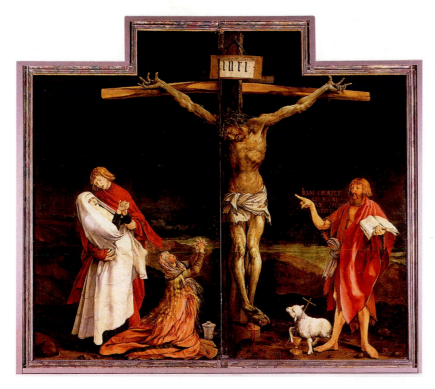

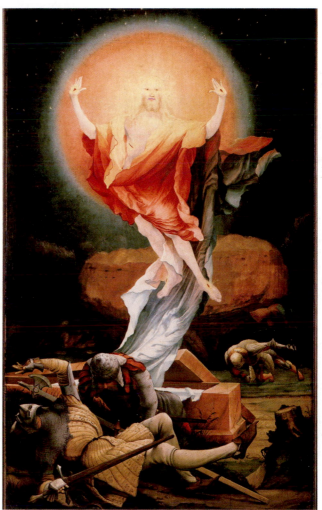

MATTHIAS GRÜNEWALD, *The Isenheim Altarpiece* (closed), Crucifixion, c. 1510–1515. Oil on wood, center panel 9' 9½" × 10' 9", Colmar, France.

NORTHERN RENAISSANCE: THE DARKER SIDE

There are other differences between the two European Renaissances. For example, nobility of gesture, perfect proportion, and harmony are notably absent from Matthias Grünewald's *Isenheim Altarpiece* (14-33), a set of paintings that would have horrified an artist like Raphael. But the Northern artist's goals were quite different. Because it was designed for a hospital, Grünewald painted a crucified Christ that the suffering patients could identify with and pray to, a figure who seemed to express all possible human torments in his sickly colored flesh and broken body. No matter what physical tortures the patients may have felt, this cruel masterpiece seems to say that Christ had already suffered the same. His body hangs heavily on the cross and his feet twist painfully; his expressive hands reach up in anguish. Grünewald portrays a massive crown of thorns upon Jesus's head and dried blood running down his sore-covered body.

Yet the crucifixion scene is only part of the altarpiece, which was made to unfold and open to reveal a series of images. Inside the picture of suffering and death is one of rebirth and resurrection (14-34). Here, Christ's

MATTHIAS GRÜNEWALD, *Resurrection*, detail of the inner right panel of the first opening of the Isenheim Altarpiece. Approximately 8' ³⁄₈" × 4' 6¾".

body—now glowing white rather than sickly green—rises dramatically out of the grave. He holds out his hands with their **stigmata** (bloody signs of the nails that held Christ to the cross), as if proving that he is ultimately unhurt by his ordeal. These wounds are no longer sources of pain but now sources of light. All of the torture of the first scene has been replaced with triumph. Christ's face glows like a rising sun. Here, in Grünewald's *Isenheim Altarpiece*, you have the essence of the Christian doctrine of God's suffering and rebirth, the victory of good over evil. For the hospital's patients, this altarpiece was meant to replace fear of illness and death with a vision that inspired faith and hope.

During this period, there lived another northern artist whose pictures are among the most fantastic, weird, bizarre, and visionary of any age—Heironymus Bosch. We know little of his life, except it was quite unlike the experiences of the educated city dwellers Dürer and Holbein. His was the world of northern villages before the Reformation, where alchemy was an accepted practice, superstitions were unquestioned, and the Roman Church had its hands full trying to control the widespread

use of magic. Preachers used pornographic images to make their points, and prostitutes could be seen at work in the churches.

Bosch cared little for the new ideals of Renaissance painting. He was interested in creating visions that taught moral lessons and used the achievements of the Renaissance only to help make his visions look more real. Most of Bosch's pictures are very symbolic and difficult to decipher. *The Garden of Earthly Delights* (14-35) is his greatest and most famous painting, but scholars are still trying to understand it. The left panel shows Christ introducing Adam and Eve in the garden of Eden before the Fall. The central panel gives the triptych its name, showing the world after the Fall and symbolizing Bosch's era. The setting seems to be a park where nude men and women are indulging in pleasure, enjoying free and open sexuality. But Bosch is not celebrating this scene. What he wants to show is a false paradise. Bizarre acts are rampant, as revelers engage in acts restricted only by the limits of Bosch's fertile imagination.

After an orgy of false pleasures comes the right panel—Hell (14-36), a nightmare from which sinners can

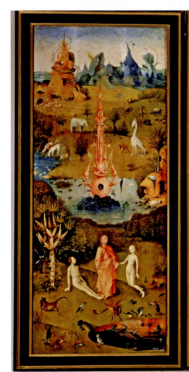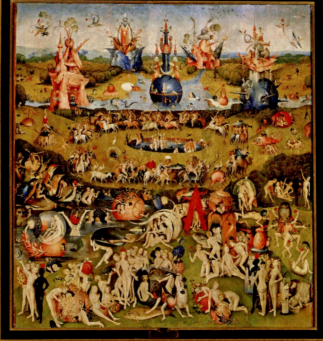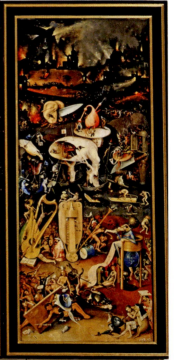

 HIERONYMUS BOSCH, triptych of *The Garden of Earthly Delights: Creation of Eve* (left wing), *The Garden of Earthly Delights* (center panel), *Hell* (right wing), 1505–1510. Oil on wood, center panel 86⅝" × 76¾". Museo de Prado, Madrid, Spain.

never wake. There is torture of all the senses and emotions. Buildings explode into flame in the background. In the foreground, a rabbit carries a victim on a pole, and blood spurts out of the victim's belly. A proud lady is forced to admire her reflection on the backside of a demon. Victims are crucified on a harp or stuck to a lute. A man tries to balance on a giant skate and heads straight for a hole in the ice. A pair of ears with a giant knife proceeds like a tank, slicing up the damned (14-37). The dreamlike reality of the scene is most apparent in the Treeman, who has sinners in his hollow chest and arms rooted in the foundation of Hell. Is he Hell's monarch or another victim?

Surprisingly, the *Garden of Earthly Delights* was an altarpiece for a church. It was a kind of Last Judgment in an age when the Apocalypse was thought to be near. Bosch showed the results of humanity lost to sin and warned that if people continued to live as they did, no one would be saved. Yet one can see little hope for humanity; lost in temporary pleasures, the people in the *Garden of Earthly Delights* give no thought to consequences or repentance. Michelangelo had a similar pessimistic vision thirty years later in his *Last Judgment* (14-25).

GENRE: SCENES FROM ORDINARY LIFE

Although Pieter Bruegel began his career with Bosch-inspired work, he eventually developed his own unique subject matter. Bruegel is best known for his paintings of country life. His *Landscape with the Fall of Icarus* (14-38) is an unusual retelling of the ancient Greek myth in a sixteenth-century Flemish setting. Icarus was the son of Daedalus, a clever artisan imprisoned by King Minos of Crete in a fabulous labyrinth (or maze) Daedalus had designed himself. To escape, the father fashioned wings of wax and feathers for his son and himself. He warned

14/36　Right panel of figure 14-35, *Hell*.

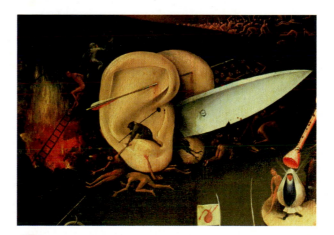

14/37　Detail of figure 14-36.

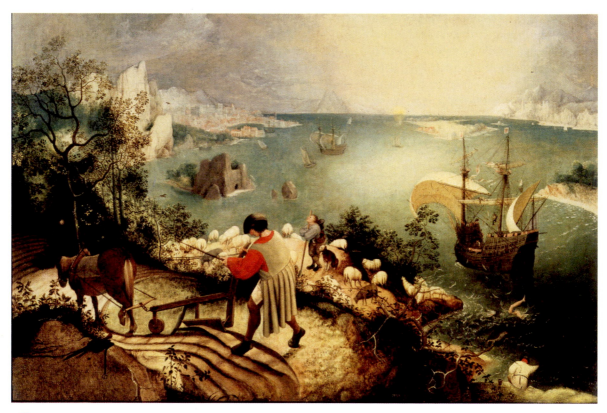

14/38 PIETER BRUEGEL THE ELDER, *Landscape with the Fall of Icarus*, c. 1554–1555. Oil transferred from wood to canvas. 29" × 44⅛". Musées royaux des Beaux-Arts de Belgique, Brussels, Belgium.

his son not to fly too close to the sun, but Icarus ignored him. When his wax wings melted, Icarus fell into the sea and was killed. Usually understood as a cautionary tale about blindly confident youth and reckless ambition, Bruegel presents the myth quite differently. Almost the entire picture is devoted to a scene of a typical day in the fields of Netherlands alongside the sea. The central figure is busy plowing; the plow is shown actually cutting and turning the heavy earth. This is far from the classically inspired mythological paintings of the Italian Renaissance, such as Botticelli's *The Birth of Venus* (14-9) or Raphael's *The School of Athens* (14-21). Imagine how an Italian artist would have portrayed the myth—a marvelous-looking boy filling the canvas as he tumbles through glorious sun-drenched skies. But here the plunge of Icarus to his death in the sea seems almost incidental to the picture. All we see of Icarus is two tiny legs making a small splash in the water. No one seems to notice the

cosmic event. One man looks up, but in the wrong direction; the rest are just busy living their lives.

Bruegel's work is one of the first to use **genre** (ordinary and commonplace) subject matter. His approach to his subject is a statement that not only is our world worth portraying, but it is much more significant than an ancient myth. For most people, cosmic events have less importance than their own everyday concerns.

In *Hunters in the Snow* (14-39), a variety of typical winter activities is depicted: hunting with dogs, cooking on outdoor fires, and skating on the frozen pond. Bruegel's painting exhibits an almost perfect balance between the depiction of a subject—in this case, winter as experienced by Flemish peasants—and the formal arrangement of lines, shapes, and colors into a totally satisfying visual experience. The dark silhouettes against the pale snow of hunters, dogs, and trees create a wonderful rhythmic pattern; the icy blue and white

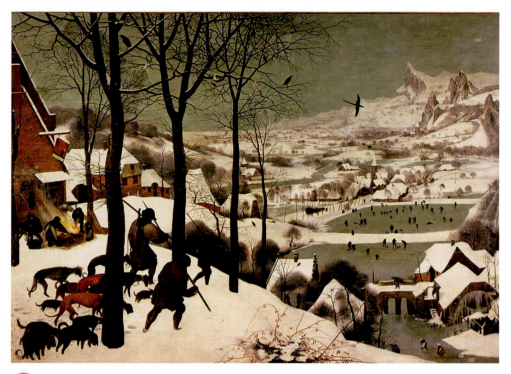

14/39 PIETER BRUEGEL THE ELDER, *Hunters in the Snow*, 1565. Oil on wood, 46" × 64". Kunsthistorisches Museum, Vienna, Austria.

of the landscape contrast with the glowing red fire. The line of the trees and the birds leads the viewer's eye irresistibly past the tired hunters and down the hill to the town below. We are able to share the temperature and tones of a winter day from four centuries ago because of Bruegel's mastery. He has allowed us to connect to the lives of people long gone and reminds us that we are all in a cycle of life. We feel that our experiences, like trudging along in the snow, were experienced by past generations and will be for generations to come.

Although it is very different from Leonardo's or Michelangelo's masterpieces, *Hunters in the Snow* is not too distant from the work of Giotto that began the Renaissance. More than two hundred fifty years later, as the Renaissance comes to an end in Europe, Bruegel's pictures bring to a profound realization the humanistic advances of the old Italian master. It would be difficult to find finer examples of realistic space, true emotion, and above all, honestly portrayed human beings.

CHAPTER 15

By the 1530s, with Raphael dead and Michelangelo returning to Florence, Rome was in the hands of a new generation of talented young artists. Yet it was a difficult time for them. The goals of the High Renaissance, already accomplished by Raphael and Michelangelo, did not seem to leave much room for other artists to become outstanding. The young men realized they could not repeat what had already been done, and even if they did, they would find it almost impossible to compete with those great masters. Italy was in a period of serious economic decline. Italian society had been disrupted by repeated invasions from northern Europe. Raphael's achievement of beauty, proportion, grace, and a sense of human virtue no longer seemed appropriate to the troubled times. The young artists decided to abandon the old goals and go beyond nature.

1530–1600

PERIOD

END OF THE RENAISSANCE
ITALIAN MANNERISM
THE COUNTER-REFORMATION
THE SCIENTIFIC REVOLUTION
COURT OF BENIN
MUGHAL PERIOD IN INDIA

HISTORICAL EVENTS

Council of Trent begins the Counter-Reformation **1545–1563**
Vasari publishes *Lives of the Artists* **1550**
Mercator publishes map of the world for navigators **1569**
Ottoman Turks win Cyprus from Venice **1573**
Buried Roman city of Pompeii discovered **1592**

ART

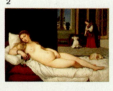
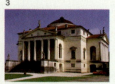

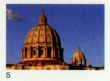

1. Parmigianino, *Madonna dal Collo Longo*, 1535
2. Titian, *Venus of Urbino*, 1538
3. Palladio, *Villa Rotunda*, 1566–1570
4. Plaque showing King mounted with attendants, Benin, sixteenth century
5. Michelangelo and della Porta, Dome of St. Peters, 1547–1592

DRAMA AND LIGHT: MANNERISM, THE BAROQUE, AND ROCOCO

1600–1715

FIRST ENGLISH SETTLEMENTS IN NORTH AMERICA
THE BAROQUE
THE ENLIGHTENMENT IN EUROPE
CLASSICISM

1715–1790

ROCOCO
NEOCLASSICISM

Shakespeare's *Hamlet* **1600**
Tokugawa period begins in Japan **1603**
African slaves brought to Virginia **1619**
Galileo condemned by Inquisition **1633**
Descartes, "I think therefore I am" **1637**
Reign of Louis XIV **1643–1715**
Isaac Newton presents the law of gravity
in *Principia* **1687**
Parthenon damaged during Venetian attack **1687**

J. S. Bach, *The Brandenburg Concertos* **1721**
Handel's *Messiah* **1741**
The American Revolution **1776–1783**
The French Revolution begins **1787**

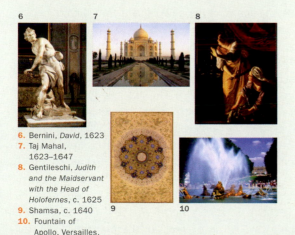

6
7
8
9
10

6. Bernini, *David*, 1623
7. Taj Mahal, 1623–1647
8. Gentileschi, *Judith and the Maidservant with the Head of Holofernes*, c. 1625
9. Shamsa, c. 1640
10. Fountain of Apollo, Versailles, 1672–1674

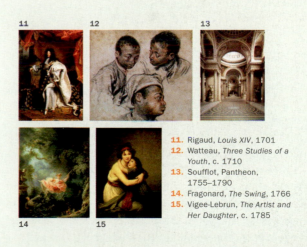

11
12
13
14
15

11. Rigaud, *Louis XIV*, 1701
12. Watteau, *Three Studies of a Youth*, c. 1710
13. Soufflot, Pantheon, 1755–1790
14. Fragonard, *The Swing*, 1766
15. Vigee-Lebrun, *The Artist and Her Daughter*, c. 1785

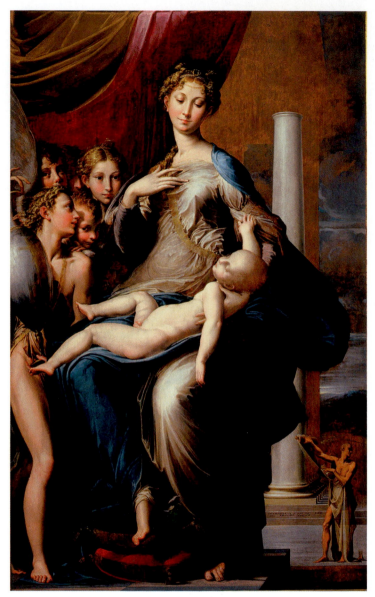

PARMIGIANINO, *Madonna dal Còllo Longo*, c. 1535. Oil on wood, approximately 7' 1" × 4' 4". Galleria degli Uffizi, Florence, Italy.

MANNERISM

In Parmigianino's *Madonna dal Collò Longo* (or *Madonna of the Long Neck*, 15-1), there is a great deal that would have shocked Leonardo. The space is nothing like the realistic and accurate space created by Renaissance artists. Many of the figures are distorted, and true proportion is seemingly abandoned at whim (notice the tiny prophet at the bottom right). An unfinished column supports nothing. Even more disturbing is the image of the Virgin Mary, an aristocratic figure who holds the infant Jesus at a cool distance. Warmth and love, traditional to this theme, are noticeably absent. The smooth-skinned angels seem like servants. The Christ child looks cadaverous and deformed.

Commissioned for a church in Bologna, but never actually presented to his patrons, Parmigianino's strange seven-foot-tall painting is characteristic of a new style called **Mannerism**. Instead of picturing inner and outer realism, Mannerist artists produced demonstrations of their inventiveness and refinement. Their highest goal, which Parmigianino exemplified, was elegance. In Mannerist works, the subject is rarely important and functions only as an excuse for a painting or sculpture. Emotions are ignored for the sake of elegance and what was called "style." The perfect balance of High Renaissance painting had been exchanged for unique, strange compositions, a kind of artful choreography.

One artist of the time wrote:

> in all your works you should introduce at least one figure that is all distorted, ambiguous and difficult, so that you shall thereby be noticed as outstanding by those who understand the finer points of art.

The Mannerists believed the body was most elegant when posed so the limbs and torso resembled the letter S. They called this pose the **serpentinata**, or the twisting of a live snake in motion. Many of the distortions in the *Madonna dal Collò Longo* are caused by the characters being forced to conform to S-like shapes.

Serpentine curves abound in another remarkable Mannerist painting, Jacopo Pontormo's *Deposition from the Cross* (15-2). Like Michelangelo, Pontormo was a Florentine who enjoyed the patronage of the Medici family. Yet here the Renaissance rules of perspective are ignored as the figures appear to be stacked on top of each other and pushed toward the surface of the picture within a shallow space. Surrounding the body of the dead Christ are figures dressed in a riot of bright blues and pink pastels. At the center of the painting is a confusion of hands and arms that don't always connect to any of the figures. Draperies swirl and the viewer's eye slides from Mary's head, along her outstretched arm, then down the slump of Christ's body to a strange, golden-headed figure beneath. Crouched below the corpse and weighted down by it is the most riveting person in the scene—an anonymous young man whose large, sad eyes look directly out at the viewer. The unsettling arrangement of distorted figures conveys the emotional confusion of the scene. Rather than elegance and refinement, Pontormo's work is a view into the emotional shock of the witnesses to the crucifixion.

Federico Zuccaro's portal of the *Palazetto Zuccari* in Rome (3-4) is an example of the Mannerist spirit in architecture. The wild conception of an entrance as a

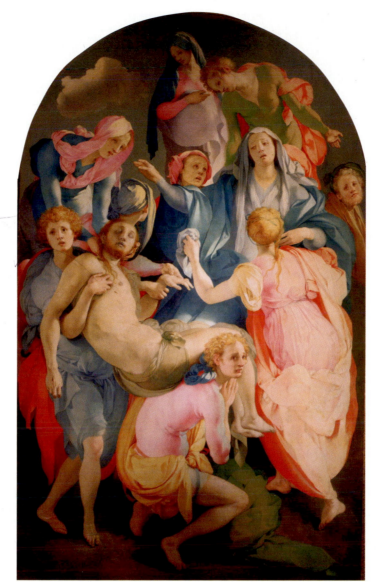

15/2 JACOPO PONTORMO, *Deposition from the Cross*, 1525–1528. Oil on wood, 10' 3" × 6' 4", Capponi Chapel, Santa Felicitá, Florence, Italy.

giant mouth leading into a long gullet of a hallway was the kind of idea that intellectuals of the time would call "the modern way."

THE COUNTER-REFORMATION AND TINTORETTO

The Mannerist period was relatively brief. It disappeared at the start of the Counter-Reformation, the Roman Catholic Church's attempt to combat the Protestant Reformation that had swept through much of Europe during the early sixteenth century. In 1545, Pope Paul III convened the *Council of Trent* to recommend changes in church policy and new initiatives. Abuses of the past, such as the sale of indulgences, were eliminated. Because the arts were considered one of the most important arenas for fighting against Protestantism, the Catholic Church encouraged a new vitality in Christian art and decoration. It proclaimed the need for art that would entertain and electrify the faithful.

Pictures like the *Madonna dal Collò Longo*, not surprisingly, were considered offensive and decadent by religious leaders who were concerned with the revival of Catholic values. Still, while short-lived, Mannerism served as an important link between the Renaissance and the next great period of art: the **Baroque**. The Venetian artist Jacopo Robusti, known as *Tintoretto*, also bridges this gap and reflects the dynamic spirit of the Counter-Reformation. Elegance and beauty were not enough for this painter; he wanted his pictures to be exciting, to make the biblical stories live. His goal was to combine Titian's rich color with the vigorous drawing and design of Michelangelo.

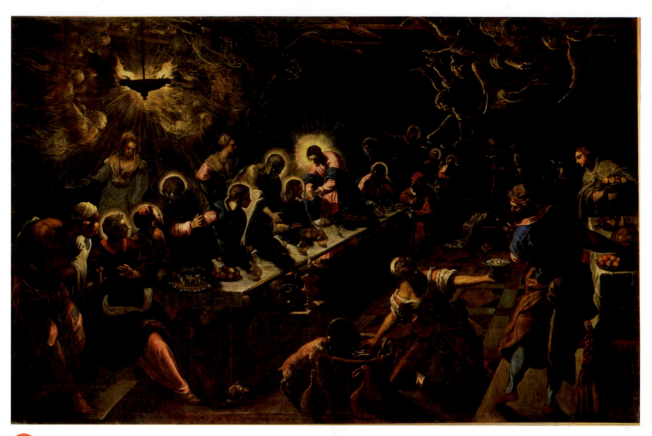

15/3 TINTORETTO, *The Last Supper*, 1594. Oil on canvas, 144" × 244". San Giorgio Maggiore, Venice, Italy.

Tintoretto's pictures *are* dramatic. His *The Last Supper* (15-3) is far from a mannerist composition like the *Madonna dal Collò Longo*, with effete, elongated figures arranged in limp poses. Instead, it is full of energy, opposing motions, and swirling lines. Tintoretto was known as *il furioso* for his speed as a painter; this nickname is appropriate to the spirit of his works, too. If we compare Tintoretto's *Last Supper* to Leonardo's (14-14), we clearly see the difference between an early Baroque and a Renaissance interpretation of the same subject. Leonardo's fresco, painted almost one hundred years before, is harmonious and balanced. The light is natural. The geometry of the room is stressed, and the composition arranged so Christ is at its perfect center. The table on which the story of the last supper is being acted out is a simple horizontal band; the focus of the picture is on the poses of the characters, which seem frozen in time. Leonardo chose to illustrate the human side of the story, the moment when Christ predicts his betrayal by one of his apostles.

Tintoretto's version is totally different. The first visual element we notice is the energetic diagonal of the table, plunging back into space. Christ is not a static, stationary figure, nor is he the clear center of the composition. He stands about halfway down the table, handing out bread. We can distinguish him because his halo bursts forth from his head like a sun (Leonardo's Christ has no painted halo). The heads of disciples also glow against the rich, smoky darkness of the room. The only natural, rather than supernatural, light source is a hanging lamp that emits twisted tongues of flame and coils of smoke. This smoke is transformed into angels, outlined only in white paint, as if drawn on a chalkboard. In the foreground of the picture, Tintoretto has added everyday events, like the servants clearing away food and a cat looking into a basket. This normal scene makes the rest of the picture seem even more miraculous by contrast.

In his painting, Tintoretto has chosen to focus not on the human drama of the betrayal of Judas but on the supernatural meaning of the Last Supper. As he passed out the bread at his last meal with the disciples, Jesus said: "This is my body which is given for you; do this in remembrance of me." This theme was particularly important at the time of the Reformation, because the Protestants claimed that during the Mass (communion service), bread and wine only symbolized Christ's body and blood and were not miraculously changed into his actual body and blood, as the Catholic Church taught.

We can see in the work of Tintoretto many of the attributes that were new to the Baroque movement: its dramatic use of light and dark, its preference for dynamic movement and theatrical effects, and the inclusion of elements of ordinary life in religious scenes.

THE BAROQUE PERIOD

The period of the Baroque (generally defined as spanning the years 1575 to 1750) was one of great confusion. Everything from the place of the earth in the universe to the place of the individual in society was being reconsidered. People questioned authority in religion, in government, in science, and in thought. One of the great thinkers of the time was the Frenchman René Descartes, who began his philosophical inquiry by doubting the existence of anything, including himself. The scientist Galileo used a telescope to study the heavens and declared in 1632 that the earth was not the center of the universe. The Catholic Church was so upset by his discoveries, which appeared to contradict the wisdom of the ages and the Bible itself, that he was forced to renounce them on pain of possible torture and death. England, a Protestant country, was more open to scientific discoveries. There, Sir Isaac Newton began a new era in science when he published his *Principia* in 1687, which announced, among other important physical laws, his discovery of the laws of gravity.

The great age of European exploration and discovery was coming to a close, but an active period of colonization and world trade followed. Borders were changing. Great conflicts were taking place in Europe: bloody wars, rebellions, intense religious disputes, and persecutions.

EL GRECO

When Domenikos Theotokopoulos, known as *El Greco*, arrived in Spain around 1576, the Spanish Empire was at its very height as a great military and colonial power, but its art was backward and provincial. There had been no great Spanish artists during the Renaissance. Born on the Greek island of Crete, this young man had been trained as an apprentice to make icons, or religious images, in the centuries-old Byzantine style. At the age of twenty, Domenikos Theotokopoulos went to Venice, where he absorbed the lessons of the great Venetian masters Titian and Tintoretto: their light, color, and energy. He then visited Rome and fell under the influence of Mannerism, especially its elongated, distorted figures. Like Tintoretto, El Greco is sometimes categorized as a Mannerist and, like Parmigianino, he had certainly learned to use the tool of distortion. But his work is not cool and refined; it is intensely emotional and wholeheartedly committed to the goals of the Counter-Reformation.

The *Purification of the Temple* (15-4) is a good example of El Greco's mature style. Christ comes thundering in

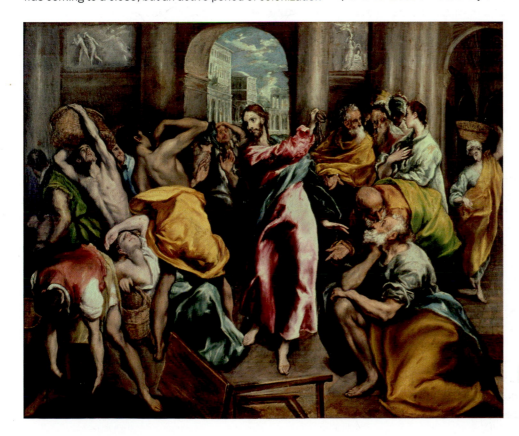

 EL GRECO, *Purification of the Temple*, 1600. Oil on panel, 3' 6" × 4' 3". National Gallery, London, United Kingdom.

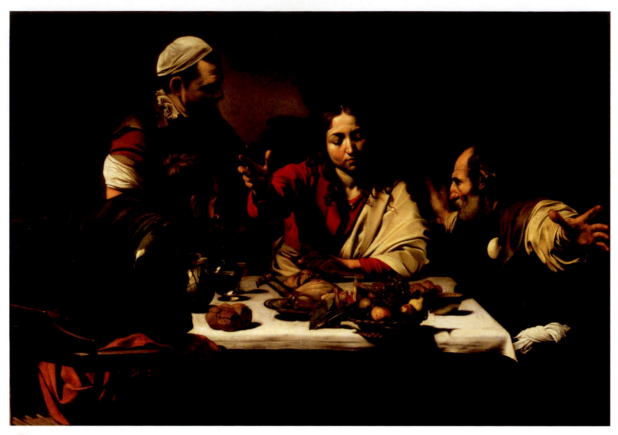

to purify the temple in Jerusalem. The figures on either side pull away and are distorted, as if by the shock waves of Christ's anger. On the left are the lower-class peddlers who react physically to Christ, cringing and trying to protect themselves. Their limbs are arranged in sharp angles; they take strange and twisted poses. On the right are the Jewish elders, who react mentally rather than physically, intensely discussing Jesus's actions. The entire picture stresses dynamic diagonal lines rather than the calmer verticals and horizontals favored by Renaissance artists. Even the folds of the costume's drapery are angular and sharp. El Greco's brushstrokes are bolder than those of his contemporaries, giving his paintings a rough, active—rather than smooth and calm—surface. The Renaissance is now far behind us.

CARAVAGGIO AND NATURALISM

As Mannerism declined in Rome, a new artist emerged who would become a brilliant innovator. This painter came from northern Italy, where painting traditions were less influenced by the Renaissance desire for perfection and harmony, and a style of greater realism prevailed. Michelangelo de Merisi, called *Caravaggio* after the small town where he grew up, became the greatest Italian painter of the seventeenth century and one of the most influential of the entire Baroque period.

Caravaggio was orphaned at the age of eleven and came to Rome when he was seventeen. This exceptionally talented artist was also an outsider and soon considered a violent, unpredictable rebel. In *The Supper at Emmaus* (15-5), Christ and his attendants are depicted as real working-class people, with torn clothing and worn faces. This New Testament story takes place after Christ's resurrection, but before his followers realize that he has truly risen from the dead. Two of the disciples were on the road to Emmaus, a small town outside Jerusalem, and were joined by a stranger whom they did not realize was Jesus because "their eyes were kept from recognizing him." Stopping in the village, they urged their fellow traveler to stay with them overnight. As they sat down to eat, Christ "took bread, and blessed it, and broke it, and gave it to them" in a reenactment of the Last Supper. At this point "their eyes were opened, and they knew him." It is this very moment of illumination that Caravaggio chose to illustrate.

The architecture of the room, so important in Renaissance paintings, has been eliminated here in favor of the flat backdrop of a wall. The viewer is quite close to the figures, who make dramatic gestures that almost seem to leap out of the picture into real space. For instance, the man on the left, whom we see from the rear (a favorite visual device of Carravagio's, allowing us the illusion of

peeking into a real scene), is about to push his chair backward, and his elbows jut toward us as if they might break through the canvas. On the right, an elderly apostle thrusts out his hand in a dramatic gesture, like an actor on the stage. But the most theatrical effects are provided by the stark lighting—illuminating the face of Jesus, accentuating the wrinkles of the careworn faces, focusing our attention on the most important gestures, and casting dark shadows on the wall behind Christ's head in a "reverse" halo.

Consider how different this painting is from the work that preceded it, even the work of Tintoretto and El Greco. Here, although a miraculous event is taking place, there are no supernatural halos or angels, no distortions, just ordinary people painstakingly observed. Caravaggio shares with Titian and El Greco, however, his taste for dramatic and theatrical effects, a taste that is typically Baroque. In *The Conversion of Saint Paul* (15-6), he topples the figure of the saint directly toward the

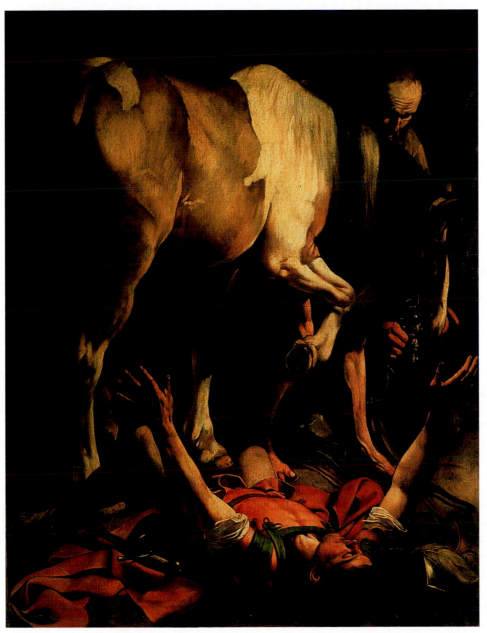

15/6 CARAVAGGIO, *The Conversion of Saint Paul,* c. 1601. Oil on canvas, approximately 7' 6" × 5' 9". Chapel Santa Maria del Popolo, Rome, Italy.

TUMULTUOUS AND TORTURED LIVES:
CARAVAGGIO AND GENTILESCHI

Caravaggio's *David with the Head of Goliath* (2-11) is much more than a memorable depiction of one of the best-known Bible stories. At the time he was painting this great picture, the sea of darkness that surrounds the characters had begun to surround the artist, too. For four years, Caravaggio had been running for his life across Italy. Known for both his talent and his terrible temper, he had been banished from Rome on pain of death by the pope after an argument over the score in a handball match. Caravaggio had killed his opponent by stabbing him in the groin.

For years, the naturalism of his paintings had shocked the clergy and many sophisticated Romans, yet he was never short of commissions. Even as a young man, Caravaggio was known for his quarrels and recklessness. He once attacked a waiter because he didn't like the way that his artichokes had been seasoned. Despite this he retained many loyal supporters who believed in his genius, but the murder was the beginning of the end for Caravaggio. Since his flight from Rome, he had little peace. Still respected for his art, he would be welcomed in towns, where he was offered and even completed important commissions. Nevertheless, he ultimately would be forced to flee. Why he outstayed his welcome in each town is not always known. However, after being made a Knight of Malta, he was soon expelled as a "foul and rotten member" after seriously wounding a fellow knight. Convinced he was being pursued by enemies, he slept at night with a dagger close at hand. This was not just paranoia. One night in a bar he was attacked by a gang and stabbed in the face.

His painting of David and Goliath was sent as a gift to Cardinal Scipione Borghese, the man in charge of Vatican pardons. The two heads in the painting are both believed to be self-portraits: one the youthful, indiscrete Caravaggio and the second, the older and wiser man. In essence, Caravaggio is saying he is a changed person and offering the pope's representative his head to gain forgiveness. It is also ironic, because at the time, there literally was a price on his head—a reward offered for anyone who brought his head back to Rome.

In Naples, he finally received word that his pardon was coming. While the end of his tale is not clear, unfortunately, the pardon would be too late. The most accepted story is that, thrilled by the news, Caravaggio booked passage and loaded all his possessions, including paintings and art supplies, on a ship bound for Rome. However, when he boarded the ship, he was put off by the captain and immediately jailed. By the time he had succeeded in regaining his freedom, the ship had sailed. He was also ill; most art historians believe Caravaggio died of the fever from either malaria or typhus at the age of thirty-eight. There are competing theories that he died of lead poisoning from his paint or that he was murdered in revenge by the Knights of Malta. In any case, he would never return to his beloved Rome.

After his death, his style of painting, *tenebrism*, became an international movement and one of the most influential styles in Western art. An old friend, Orazio Gentileschi, was one of the followers known as *Caravaggisti*, and he helped spread the new style. Like many painters of the time, he trained his daughter, Artemesia, to be his assistant. Her success would far outstrip her father's, and she became the first woman in Western art to be among the most famous artists of her time. While in Florence painting for the Medicis, she created an unusually brutal version of *Judith Slaying Holofernes* (15-7). The decapitation of the Assyrian general is realistically and gruesomely depicted. Judith and her assistant struggle with the sword, positioned like a cross, as they saw through his neck. Streams of blood spurt up, hitting the women, and blood also runs down the bedsheets, where it pools below his shoulder.

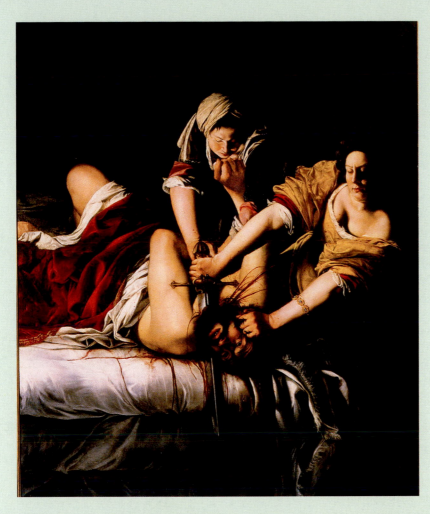

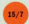 ARTEMISIA GENTILESCHI, *Judith Slaying Holofernes*, 1614–1620. Oil on canvas, 6' 6" × 5' 4", Galleria degli Uffizi, Florence, Italy.

As disturbing as the picture is, it is nearly impossible to turn your eyes away from the grisly act. Gentileschi used chiaroscuro masterfully to light the many arms, making them diagonals that draw your attention irresistibly to the spot where the sword is slicing head from body.

Some critics speculate that Gentileschi's attraction to this theme of feminine revenge was the result of a painful and traumatic experience early in her career. When she was a young woman, her father arranged for her to be tutored in perspective by another painter, Agostino Tassi, who raped her several times, and then promised to marry her. Her father took this man to court, not only for raping his daughter, but also for stealing some of his pictures (Tassi had already been convicted of raping other women and was suspected in the murder of his own wife). Caravaggio, still in Rome at the time, was one of the witnesses against Tassi. During the trial, Artemisia was tortured on the witness stand with thumbscrews—a primitive type of lie detector and particularly dangerous

for a painter. Tassi testified that Artemisia (who was a virgin) had slept with five other men, including her father. Tassi also claimed her father sold her as a whore. He also said her sisters, aunts, and dead mother were whores, too. To add to her humiliation, the rapist was jailed for only a few months, and then eventually pardoned. After the trial, Gentileschi married a man from Florence and left Rome for many years. Sadly, because of this unfortunate episode, in her time she had the reputation of a wanton woman.

Some art critics dismiss the importance of her early traumatic experience and point out that the subject of Judith and Holofernes was a common one of the period for both male and female painters. Caravaggio was among the many artists to portray the subject. No one can deny, however, that Gentileschi brought an unusual passion and realism to her versions of the theme. She painted at least six variations of this theme in her lifetime.

viewer, his head almost touching the bottom edge of the canvas. The dramatic action of the scene seems to be frozen by a flash of light—the horse's hoof is shown in midair.

Saul was a Roman citizen who delighted in persecuting the early Christians. On the road to Damascus—a city in Syria where he was headed to continue his persecutions—he experienced a vision. In his own words: "Suddenly there shown from heaven a great light all about me, and I fell to the ground." Then Saul heard the voice of Jesus asking, "Why do you persecute me?" and directing him to go to Damascus. Blinded by his experience, Saul had to be led into the city, where he met a devout Christian and was converted and baptized. He took the name of Paul and became the greatest leader, writer, and theologian of the early Christian church.

Here we see a mystical moment portrayed with high realism. Saul has just hit the hard ground and lies as if in a trance, listening to the voice of Jesus. The New Testament account states that although they saw the light, the men who accompanied Saul could not hear this miraculous voice. True to the story, Caravaggio pictures a horse and servant drawing back in surprise, unsure of what is going on. Miraculous light is a perfect subject for Caravaggio, who, as we saw in *The Supper at Emmaus*, had been using the power of light symbolically in his paintings to indicate supernatural happenings. Caravaggio's use of **chiaroscuro**, the dramatic contrast of light and dark, would influence many artists and would be copied throughout Europe.

Caravaggio was condemned by the art critics of his time as a "naturalist," while his religious paintings were condemned by the clergy. Some said that his way of painting meant the end of painting. They felt that his use of working-class people to portray the apostles and Christ himself was offensive, even sacrilegious, despite the fact that Christ and his followers had actually been poor, simple men and women. The controversy over Caravaggio's pictures reflects a difference of opinion about what the correct style for Counter-Reformation painting should be. Although some admired his revolutionary honesty and directness, other critics felt that Caravaggio's work did not serve to promote the Catholic faith. The most powerful members of the Roman establishment—the papal court, for example—preferred artists who simply glorified the church and its saints.

Caravaggio lived only thirty-eight years (he died of malaria after being banished from Rome by the pope; see "Lives of the Artists" box), but he left behind a great

body of work that influenced artists during the entire Baroque period. His revolutionary naturalism and dramatic use of chiaroscuro light would prove to be one of the strongest legacies in the history of art. Among the many great artists who learned from his work were Velázquez in Spain, Rubens in Flanders, and Rembrandt in Holland, but first we will discuss his direct influence on another Italian painter, Artemisia Gentileschi, who also suffered from the prejudices of Roman society, although for different reasons.

ARTEMISIA GENTILESCHI: THE SPREAD OF *TENEBROSO*

Most women artists of the Baroque period were the daughters of painters; for example, Tintoretto had a favorite daughter who acted as an assistant on many of his huge canvases. Artemisia Gentileschi's father, Orazio, was a talented follower of Caravaggio and taught her many of his techniques. Most of Gentileschi's pictures show women as biblical or mythological heroines.

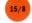 ARTEMISIA GENTILESCHI, *Judith and Maidservant with the Head of Holofernes*, c. 1625. Oil on canvas, approximately 6' × 4' 8". Detroit Institute of the Arts, Michigan (gift of Leslie H. Green).

One reason Gentileschi specialized in the female figure was that she was easily able to find models and to study female anatomy in great detail. It would have been considered improper for her to study the nude male figure; this limitation hampered female artists until the twentieth century.

The Biblical story of Judith and Holofernes was one that Gentileschi painted several times. Holofernes was an Assyrian general who laid siege to an Israelite city. To save her town from the attacking general, Judith dressed in her most beautiful clothes, then crept with her maid behind enemy lines. They were soon captured and taken to the tent of the general. He was attracted to Judith and invited her to dine. She drank with him until he was unconscious, and when he passed out, she took his sword and, with the help of her maid, chopped his head off. Judith and the maid then escaped, and the next morning displayed the head of Holofernes on the city walls, sending his invading army into panic and retreat.

In an early version (15-7), Gentileschi chose the gruesome moment of the actual decapitation. In the later picture, considered her masterpiece, *Judith and Maidservant with the Head of Holofernes* (15-8), the artist chose instead to imagine the time after the general has been murdered, when Judith and her maid are waiting to escape from the enemy stronghold. It is a huge work, more than six feet tall, so the figures are larger than life-size. Gentileschi has used a single light source—a candle flame—then interrupted it with Judith's raised hand, so it throws weird shadows on her figure. The mood is suspenseful. We glimpse the figures as they pause in the midst of their secret crime, perhaps hearing a sound and fearing discovery. Judith covers the candlelight calmly, holding her sword in readiness, while the maid tries to cover the head.

This is a painting in the **tenebroso**, or dark manner. The followers of Caravaggio who specialized in such night scenes were known at the time as *Caravaggisti*. Gentileschi was not only one of the Caravaggisti, but she also spread the style throughout Italy as she moved from Rome to Florence, back to Rome, and on to Naples, visiting Genoa and Venice as well. Through the influence of Caravaggio and followers like Gentileschi, the Baroque style became truly an international art movement.

BERNINI

In contrast to the unfortunate Caravaggio, Gianlorenzo Bernini was a highly successful and internationally famous architect and sculptor. Only Michelangelo was ever held in as high esteem by popes, the powerful, wealthy art patrons, and other artists. Like Michelangelo, Bernini was a brilliant sculptor in marble, but he was also a painter, architect, and poet. Unlike Michelangelo, Bernini was known for his great charm and wit; he was fond of people and a good husband and father.

Bernini was only twenty-five or so when he sculpted *David* (15-9), one of his masterpieces. Just as the contrast between Tintoretto's *Last Supper* and Leonardo's can be used to illustrate the differences between

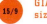 GIANLORENZO BERNINI, *David*, 1623. Marble, life-size. Galleria Borghese, Rome, Italy.

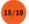 GIANLORENZO BERNINI, *The Ecstasy of Saint Theresa*, 1645–1652. Marble, group 11' 6" high. Cornaro Chapel, Santa Maria della Vittoria, Rome, Italy.

Renaissance and Baroque painting, one can see the changes in sculpture by comparing Bernini's *David* with Michelangelo's (14-16). Both sculptures were tours de force, carved when the artists were in their twenties. Unlike Bernini, Michelangelo strove for harmony and the ideal beauty of a perfect young man. His enormous statue (more than fourteen feet tall) is in elegant proportion; the figure stands motionless, self-contained. But Bernini's *David* is captured at a specific moment—the split second before he releases his slingshot at the giant Goliath. There is great dynamic energy in this figure, the first version of David to show the subject in motion. Bernini's *David* is a mature man who contorts his less-than-ideal features into a grimace of concentration as he puts total effort into his coming shot. The statue's gaze is so intense that the unseen Goliath becomes part of the sculpture. In this way Bernini breaks down the barrier between art and the real world. Realistic details also make the biblical event convincing. As in his *Apollo and Daphne* (9-5), Bernini skillfully creates a variety

of textures in stone (flesh, drapery, leaves, and hair), as well as incredibly minute work like the taut rope of the sling. The differences between the two Davids are reminiscent of the contrast between calm and balanced Classical sculpture, such as the *Doryphoros* (12-17), and the writhing motion typical of later Hellenistic sculpture like the *Laocoön* (12-21).

The type of work for which Bernini became most famous was not the sculpting of individual statues, however powerful, but the creation of total artistic environments. *The Ecstasy of Saint Theresa* (15-10, 15-11), which combines sculpture with architecture and painting, was designed for a chapel in the small Roman church of Santa Maria della Vittoria. The materials include white marble, colored marble, gilded bronze, stucco, fresco, and stained glass. Here, the effect of the whole is far greater than the sum of the parts. The ceiling of the chapel is decorated with a fresco of angels frolicking on billowing clouds. To the sides, statues of the Cornaro family members observe the scene from boxes, as if at the opera. At center stage is Bernini's marble statue of Saint Theresa in ecstasy.

Saint Theresa of Avila was a sixteenth-century Spanish nun and mystic who lived about the time that El Greco was painting in Spain. Through her widely circulated writings, she became an important saint of the Counter-Reformation. Many of these writings describe her personal, mystic visions. For this chapel, Bernini illustrated a spectacular vision of a visit from an angel, about which Saint Theresa wrote:

> In his hands I saw a great golden spear and at the iron tip there appeared to be a point of fire. This he plunged into my heart . . . again and again and left me utterly consumed by the great love of God. The pain was so acute that I groaned aloud several times; yet the pain was so sweet that no one would wish to have it go away.

Bernini mixes realism and illusion here just as he mixes media. He shows Saint Theresa's spiritual passion as physical: Her head lolls to one side in rapture, her body falls back limp, her bare foot escapes from beneath her voluminous habit. Even her clothing writhes in excitement. The intensity of this realism rivets our attention, but Bernini is also a great master of light and illusion. By flooding his statue in a stream of "heavenly" light from above (through a hidden window of yellow stained glass),

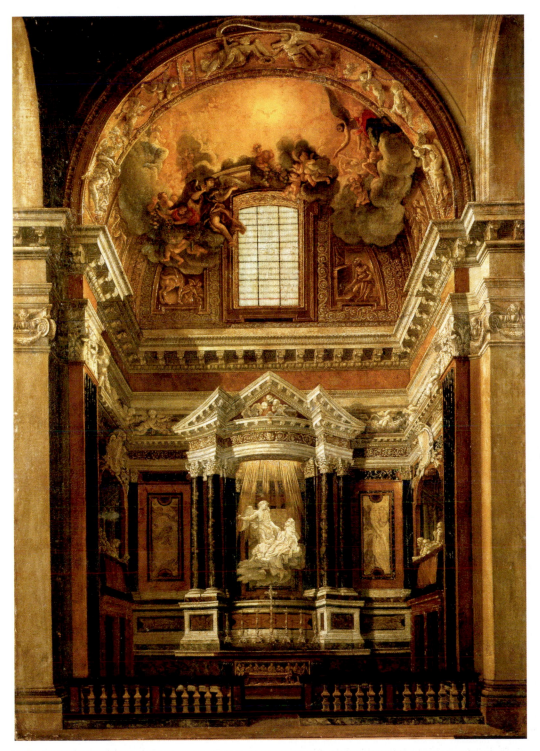

15/11 GIANLORENZO BERNINI, interior of the Cornaro Chapel, 1645–1652, Santa Maria della Vittoria, Rome. Eighteenth-century painting, Staatliches Museum, Schwerin, Germany.

he sets the statue of saint and angel off in a special space—a miraculous, visionary dream world.

Bernini's greatest impact was on Saint Peter's Basilica, seat of the popes. As we learned in Chapter 10, Bernini designed the enormous courtyard or **piazza** (10-36) in front of the basilica that set Saint Peter's off from the surrounding confusion and created a courtyard that is calm, orderly, and logical. While Bernini's design altered the effect of Saint Peter's exterior considerably, his influence inside Saint Peter's was even greater.

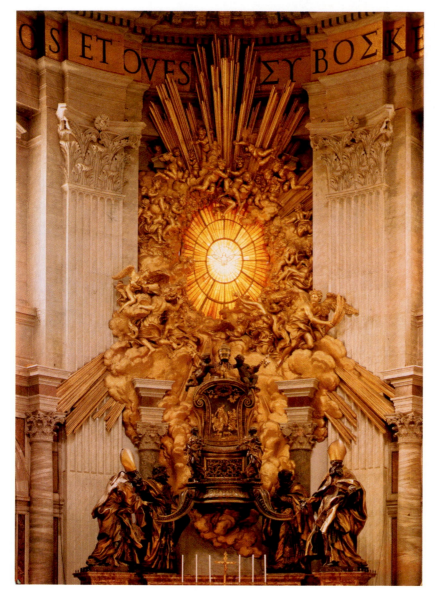

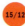 GIANLORENZO BERNINI, *Throne of Saint Peter*, 1656–1666. Gilded bronze, marble, stucco, and stained glass. Saint Peter's, Rome, Italy.

For example, the *Throne of Saint Peter* (15-12) brings a heavenly host of angels and cherubs down into the church. Constructed of gilded bronze, marble, stucco, and stained glass, it is the visual climax of Saint Peter's. The throne is a reliquary, enshrining what was supposed to be the actual throne of Peter. As in Bernini's vision of Saint Theresa, light streams onto the sculpture through a stained-glass window, which shows the dove of the Holy Ghost. Saint Augustine and Saint Ambrose, the two fathers of the Catholic Church, support the front of the throne, while two fathers of the Greek Orthodox Church are relegated to the back. Because of the immense size of Saint Peter's, Bernini's colossal work actually manages to make the scale of Saint Peter's more human.

The theatricality and energy of Bernini and his dramatic use of light and space are attributes we have seen in the paintings of El Greco, Tintoretto, and Caravaggio.

There was a love of illusion, gorgeous materials, and exuberant effects in the Baroque period. Artists of the Baroque era used architecture, sculpture, and painting together to give reality to the visions they were trying to create. Through these works, they allowed the faithful to see heaven, not just imagine it, and actually attempted to bring heaven down to earth.

BAROQUE NATURALISM IN SPAIN: VELÁZQUEZ

The greatest master of Spanish painting and one of the greatest painters of the Baroque was Diego Velázquez. Inspired by the simple, realistic paintings of Caravaggio, his approach to art flew in the face of the flamboyant trends popular in his day and went even further in the direction of naturalism. Surprisingly, when he was twenty-four, the honest realist was appointed as court painter to

MEXICAN BAROQUE

While the Baroque style of painting spread throughout Europe, the Baroque style of architecture and architectural decoration spread throughout the world, becoming the first truly international style of architecture. This was a result of the global Spanish Empire, where militant colonialism combined with intense missionary efforts to convert native populations to Roman Catholicism. The energy and building programs of the Counter-Reformation were brought by the missionaries, who followed the Spanish conquistadors to Mexico, Central and South America, as well as the Philippines in Asia. In the seventeenth and eighteenth centuries, magnificent cathedrals, churches, and chapels in the Baroque manner were built across New Spain. They eventually exceeded European models in the exuberance of their decoration.

The Metropolitan Cathedral in Mexico City is the largest cathedral in the Western Hemisphere. Attached to its side is the Sagrario Metropolitano (15-13), whose

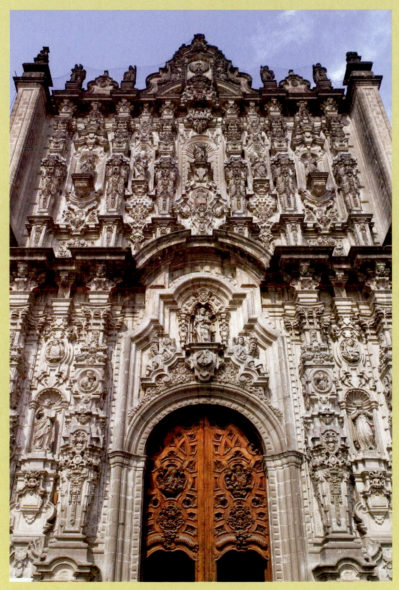

15/13 Metropolitan Cathedral in Mexico City, Mexico.

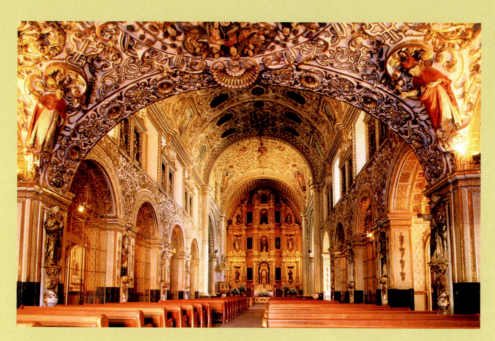

façade represents an outstanding example of the Mexican *Churrigueresque* architecture. The name comes from a Spanish Baroque architect, José Benito Churriguera, who developed and popularized the lavish style, filling all available space with a variety of ornament. In Latin America, architects like Lorenzo Rodriguez (who designed the Sagrario) adapted the Spanish Baroque to local materials and tastes, and the talents of local artists.

The interiors of such ultra-Baroque churches can be even more fabulous. The church of Santo Domingo in the southern Mexican state of Oaxaca, for example, is encrusted with decoration in stucco, painted in bright colors, and gilded with gold leaf (15-14). The statues and other carvings seen here are not cut out of stone like those on medieval cathedrals, but modeled out of damp plaster.

The ceiling is decorated with an elaborate family tree of Domingo de Guzmán, the founder of the Dominican order. Its Chapel of the Rosary (15-15) glitters with twisted golden columns and a magnificent gilded *retalbo* (the shelf behind the altar) for the figure of the Virgin.

The church's main altar is covered with more than sixty thousand sheets of gold leaf and devoted to the Virgin of Guadalupe, the patron saint of Mexico. Each sunset, during the late afternoon mass, light pours in through the choir window, so that the entire church glows with a heavenly light and no space seems to remain unadorned. No wonder the British writer Aldous Huxley described it as "one of the most extravagantly gorgeous churches in the world." Here the Baroque reached its furthest extreme.

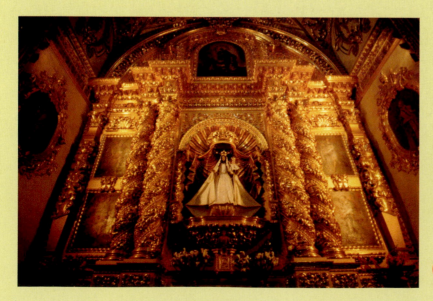

15/15 Chapel of the Rosary, Church
of Santo Domingo de Guzman,
Oaxaca, Mexico.

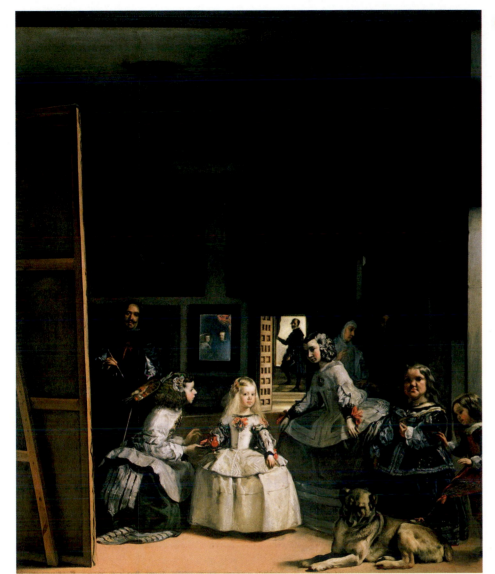

DIEGO VELÁZQUEZ, *Las Meninas*, 1656. Oil on canvas, approximately 10' 5" × 9'. Museo del Prado, Madrid, Spain.

the king. More surprisingly, Velázquez succeeded in his new role without changing his approach. Even though he never flattered the royal family, he was made a court chamberlain and given the rare honor of a home attached to the palace with its own studio. For thirty years, he painted King Philip IV, his family, and members of the court.

Las Meninas (15-16) is Velázquez's great masterpiece, a huge work, ten and one-half by nine feet tall. It demonstrates a mastery of realism that has seldom been surpassed. Here he shows a moment in the life of the court. Because Velázquez is an important member of that court, he shows himself painting a picture. But what is he painting? There are two possible answers. It might be a portrait of the princess, who is in the center of the picture (and therefore the painting we are looking at), or it is the king and queen, whose reflections we can see in the mirror at the back of the room. In either case, it is a life-size portrait of the royal family and their attendants. At the center are the Infanta Margarita with her maids of honor, a dog, a dwarf, and a midget. The Spanish royal family had a tradition of keeping dwarves and midgets around them, almost as toys, for entertainment. Velázquez always portrayed them with sympathy and respect, rather than as victims or clowns. Perhaps he felt that his situation was not so different from their own. In the background, a court official pauses to glance back through the doorway. Notice how the painter honors the viewer by giving us the same viewpoint as the king and queen.

Velázquez, unlike the northern Renaissance artists van Eyck and Holbein, did not attain realism by observing and copying minute details. Instead, he captures the impression of realism through suggestive brushstrokes, a method that would influence not only other Baroque painters but also the Impressionists of the nineteenth century. The hair and corsage of the princess, for instance, are painted loosely rather than reproduced line

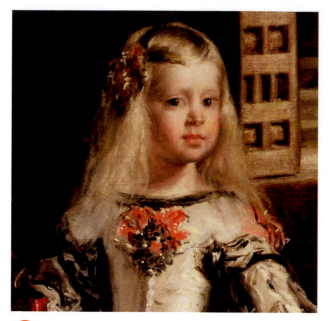

15/17 Detail of figure 15-16.

by line (detail, 15-17). Up close, much of the painting appears out of focus. Yet, if one steps back to view the entire scene, it is as if the strokes come together to produce an extremely convincing impression of reality. To use a second example, Velázquez's dog looks much more real than the dog in van Eyck's *Giovanni Arnolfini and His Bride* (14-28), even though the artist has not taken the trouble to paint it hair by hair. He paints what he sees rather than what he knows intellectually is there (we do not see every hair on a dog from across the room). In this way, he can create an illusion of reality that is actually more vivid than an enormously detailed work.

THE BAROQUE PERIOD IN THE NORTH

The fortunes of Spain and its territory, the Netherlands, were linked during the Baroque period. The Netherlands was particularly important to the Spanish Empire because it had many important centers of trade. But the Protestant cities of the Netherlands longed for political independence and religious freedom from their devout Catholic rulers. In the 1620s, the Netherlands was plunged into civil war. The rebellion ultimately succeeded in driving the Spanish from the northern half of the Netherlands, which became the *Dutch Republic*, an independent Protestant state. The south, *Flanders*, whose people were predominantly Roman Catholic, remained a territory of Spain. This division of the Netherlands

is approximately the division of Holland and Belgium of today (see Map 15-1).

RUBENS

During this period, an artist from Flanders, Peter Paul Rubens, spent months in the Spanish court as a diplomat and befriended the younger painter Velázquez. They studied the Spanish royal art collection together. Velázquez felt honored to accompany the man he thought of as the model of a learned painter. Besides being the most learned, Rubens was also the most popular, most successful, and most internationally famous artist of the Baroque age.

Like many northern painters, Rubens gloried in the textures of real things and portrayed in fine detail leaves, flesh, and clothing. But he was profoundly influenced by a trip to Italy when he was twenty-three. Remaining eight years, he filled his notebooks, many of which have survived, with studies of the great masters. *The Elevation of the Cross* (15-18) was painted soon after Rubens returned to Flanders. We can recognize the rich color of the Venetians

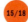

15/18 PETER PAUL RUBENS, *The Elevation of the Cross*, 1610. Oil on canvas, 15' 2" × 11' 2". Antwerp Cathedral, Belgium.

Map 15/1 Europe in the Age of Kings

and the active, muscular figures of Michelangelo, as well as the dramatic lighting of Caravaggio—a potent combination. As the men strain and pull, they exhibit extraordinary muscular vitality. The strong diagonal of the cross and the many directions of activity are brought to a dynamic equilibrium by the young master.

Rubens completed Albrecht Dürer's mission of a century earlier and created a synthesis of the northern and southern European painting styles. Before Rubens, painters in the north had mostly painted on a small scale. *The Elevation of the Cross*, like much of his work, is enormous, more than fifteen feet tall. Rubens's grand, powerful religious pictures suited the Catholic Church's desire to regain its past strength during the Counter-Reformation.

Rubens's art has a buoyant energy, a love of splendor that also made it perfect for the rich and aristocratic courts of Europe. He received commissions from all of the Catholic monarchs in Europe and was even knighted in England. The *Arrival of Marie de' Medici at Marseilles* (15-19) shows why his work was so popular with the powerful. The arrival of a young Italian princess to marry King Henry IV of France is extravagantly pictured. Rubens makes it a mythic, exciting event. The swirling figures and the decoration give the picture great vitality. There are no Christian symbols, even though it celebrates the union of Henry and the Catholic princess Marie de' Medici. Instead, pagan gods and goddesses surround the scene as if they arranged the union. Fame flies above trumpeting the great and important news

15/19 PETER PAUL RUBENS, *Arrival of Marie de' Medici at Marseilles*, 1622–1625. Oil on canvas, 61" × 45²⁄₃". Louvre, Paris, France.

for all of Europe. Their marriage resulted in France's return to Catholicism. Henry IV renounced his Protestant faith in order to marry Marie. This large picture was one of twenty-four commissioned by the new Queen of France after Henry's subsequent murder. The *Marie de' Medici Cycle* was part of a campaign to solidify her power and establish her eight-year-old son's right to be next in line to the throne.

Rubens was a painter who loved not only the souls of women but also their flesh. In terms of today's standards of athletic slimness, his females may appear unattractively pudgy, but in the world of the seventeenth century, starvation was more to be feared than excess weight. Plumpness was a sign of wealth and upper-class status. For Rubens, it was also a glory of nature. Today, these proportions are often described as *Rubenesque*. In the *Garden of Love* (**15-20**), his pink-cheeked, double-chinned, dimpled females seem to promise all the delights of the flesh to their devoted swains. Some even glance provocatively at the viewer, almost enticing one to enter the world where they recline languorously on the grass or stroll with their arms about each other's waists. There is nothing pornographic or openly erotic in this scene, yet it is clearly a celebration of physical rather than spiritual love.

Rubens was also a loving husband and father who recorded his family in many pictures, beginning with his first marriage as a young man and continuing through his second marriage (after the death of his first wife) later in life. At the time he painted the *Garden of Love*, the widower

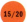 PETER PAUL RUBENS, *Garden of Love*, c. 1632–1634. Oil on canvas, 6' 6" × 9' 3¹⁄₂". Museo del Prado, Madrid, Spain.

Rubens (in his fifties) had just married his second wife, a lovely girl of sixteen. You can see them at the left of the picture, where a cupid pushes her into his arms.

Rubens lived like no painter before him. He had an excellent education and spoke many languages fluently. When he traveled from country to country in Catholic Europe, besides painting portraits, he acted as an official diplomat for Flanders and the Spanish king on matters of the highest importance. Respected and successful, he was a very rich and happy man who dominated the Catholic art world. Rubens's home in Antwerp (pictured in the *Garden of Love* and still standing) could easily be mistaken for a palace. Attached to it was a huge workshop with many assistants, functioning like a painting factory in Rubens's time. He charged clients by the size of each painting and how much he had worked on it. Because the quantity of commissions he was offered could never have been accomplished by a single man in one lifetime (or even three), most of the talented artists of Flanders worked in the Rubens workshop.

THE DUTCH REPUBLIC

The art world of the Dutch Republic was very different from the one Rubens dominated. The art of the Protestants of northern Netherlands was entirely different, as was their art market. The Protestant Church did not patronize artists, and there was no large wealthy aristocracy. Holland was governed by a bourgeois, middle-class society of merchants. In this atmosphere, an art reflecting middle-class life began to flourish. Dutch painting became concerned with the everyday life of the towns, and with portraits. In Holland, the humanistic development of art that began in the fourteenth century with Giotto reached its climax in a profound naturalism. One of the most accomplished masters of the beauty of simple scenes was Jan Vermeer.

In Vermeer's work, as in that of his fellow countryman's, the Renaissance painter Bruegel, we see an everyday event raised to a high artistic plane. *Young Woman with a Water Jug* (15-21) is an extraordinary work of art. The subject of a woman standing at a window holding a

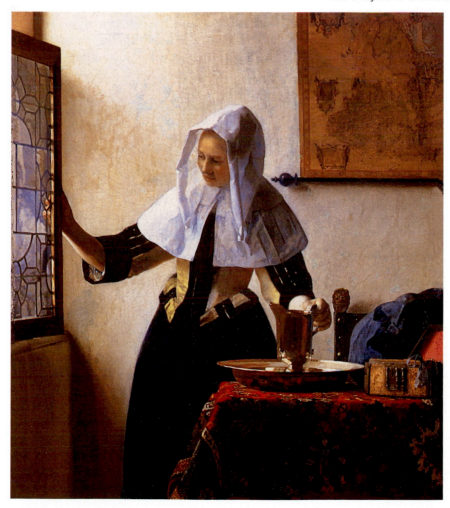

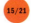 JAN VERMEER, *Young Woman with a Water Jug*, c. 1655. Oil on canvas, 18" × 16". Metropolitan Museum of Art, New York.

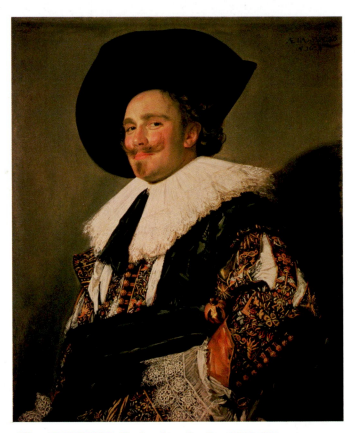

15/22 FRANS HALS, *The Laughing Cavalier*, 1624. Oil on canvas, 33¾" × 27". Wallace Collection, London, United Kingdom.

Portraits were Frans Hals's specialty. Although he was one of the most prominent of the first generation of artists in the new Dutch Republic, we know very little about him. Most of the surviving documents mentioning his name are records of debts and loans to repay debts. He must have been a very careless manager of money, because he had an excellent reputation and many commissions. His *The Laughing Cavalier* (**15-22**) engages us as few pictures do. It looks much more casual than most posed portraits. It seems as if the dashing man posed only for an instant and was impatient to move again. The energetic brushstrokes in the hair, in the mustache, and in the collar add to the liveliness of the scene.

Hals was painting in Holland at the same time Rubens was working in Flanders. They share a lively, optimistic approach, but Hals's subjects are very far from the aristocrats and goddesses of Rubens. The ordinary, even lower-class characters he portrayed against simple backgrounds identify Hals as a follower of Caravaggio. In a later portrait, *Malle Babbe* (**15-23**), Hals demonstrated an even more spontaneous and looser style. There is more expression in his brushwork, which is filled with feeling and is almost electric. There is also the illusion of great speed, as if Hals could dash off a painting in a few

pitcher in her hand is utterly simple, and one Vermeer used more than once. What is unique about this painting is the combination of vivid realism and idealism. The realism is seen in the artist's ability to depict textures flawlessly. The rug appears thick and shaggy; the design is clearly woven into the fabric rather than drawn on top. The silver of the pitcher and bowl reflect the rug exactly as they would in real life. The woman's plain headdress is absolutely readable as stiff, wrinkled linen. Still, the face and costume of the figure seem to have been simplified. The pale blue light from the window bathes the picture in a beautiful cool radiance. The simple geometric volumes of her head, along with the repeated curves of the bell-shaped collar and skirt, create a quiet, harmonious, almost spiritual, image.

In the Dutch Republic, artists, like other merchants, sold their wares independently, and success was ruled by the marketplace. Many Dutch artists, to be more easily identifiable in the marketplace, specialized in one kind of painting. Vermeer's specialty was interiors. Others specialized in still lifes, animals, or the new, popular subject of landscapes.

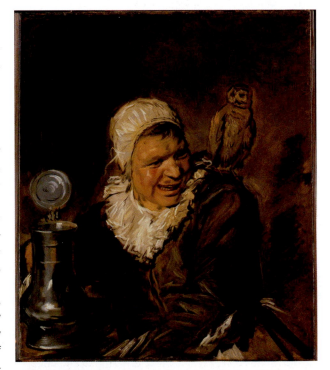

15/23 FRANS HALS, *Malle Babbe (Mad Babbe)*, c. 1650. Approximately 30" × 25". Staatliche Museen Preussischer Kulterbesitz Gemäldegalerie, Berlin, Germany.

JUDITH LEYSTER

REDISCOVERED

For three hundred years, *The Jolly Toper* (15-24) was thought to be a masterpiece by Frans Hals. This was not an unreasonable assumption, since the painting does resemble his subject matter and style. Yet when the picture was cleaned by a twentieth-century restorer, an important discovery was made—two initials had been painted over. They were not "F.H." but "J.L." While *The Jolly Toper* may look superficially like the work of Hals, it is actually the work of a woman named Judith Leyster. It is not unusual for a woman artist's work to be attributed to a more famous male artist. Sometimes this has been done unintentionally or out of ignorance, or because of wishful thinking, but often it has been done so pictures could sell for a higher price. In this case, the signature may well have been hidden by a dishonest dealer.

Hals and Leyster shared an interest in portraying happy drunkards, so the confusion might have been natural. Because Leyster was listed as a witness at the baptism of one of Hals's children, we can assume they were friends. If we compare her picture to his *Laughing Cavalier* or *Malle Babbe*, we notice other similarities. The figures are cut off below the chest, there are plain flat backgrounds, and both works share an immediate, snapshot quality. Leyster, however, does not use loose, active brushwork. The texture of the paint is not meant to be noticed. What is important to her is creating a clear, honest portrait.

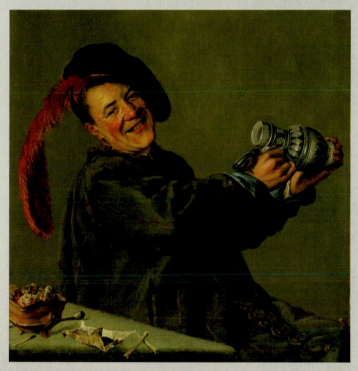

15/24 JUDITH LEYSTER, *The Jolly Toper*, 1629. Oil on canvas, 35" × 33½". Rijksmuseum, Amsterdam, Netherlands.

minutes. With a series of rapid spontaneous marks, Hals captures the wild drunkenness of a mad woman, probably an object of ridicule in her town. This style of painting is called **alla prima**. Previously, oil paintings were built up layer by layer over a long period of time with a series of glazes. Instead, Hals's picture is done quickly and at one sitting, *alla prima*, meaning "at the first." This daring and spontaneous way of painting would have a great influence on the Impressionists of the nineteenth century.

Judith Leyster was a friend of Hals whose pictures were similar in several ways (see the "Art News" box), but *The Proposition* (15-25) has a seriousness and understanding that is noticeably absent in Hals's work. The bold lighting and the lack of glamour in the scene show the influence of Caravaggio more profoundly. In the painting, a man is hanging over a seated woman and offering her money in an effort to convince her to become a prostitute. The woman seems modest and embarrassed, uninterested in the proposition. She is trying to ignore the leering "gentleman," pretending not to hear, as if she were too absorbed in her sewing to notice.

The theme of a proposition is a common one of the period, but Leyster's picture is untraditional. Generally, when men had portrayed this theme, the woman would be dressed provocatively and smiling in a drunken, lusty way. The woman in *The Proposition* is dressed modestly and is clearly uncomfortable. Leyster counters male fantasies with realism.

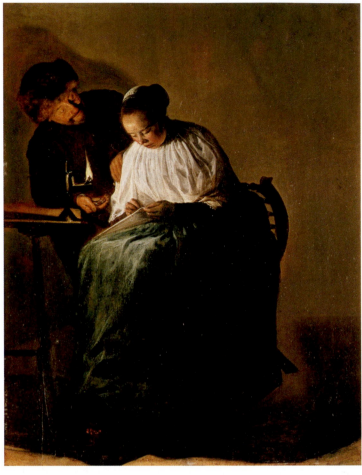

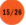
JUDITH LEYSTER, *The Proposition*, 1631. Oil on canvas, 11⅞" × 9½". The Mauritshuis, The Hague, Netherlands.

REMBRANDT

In the Protestant regions of Europe like the Dutch Republic, portrait painting gained importance as commissions for religious works declined. Spiritual messages, previously conveyed in biblical scenes, now had to be expressed through the eyes and expressions of individuals. While Hals seems to effortlessly capture the personality of the sitter and go no further, Leyster brings depth to her approach. Rembrandt van Rijn also attempted something more profound—to reveal the sitter's soul. Like the Renaissance painter Albrecht Dürer, Rembrandt did many self-portraits during his lifetime (at least eighty), but Rembrandt never represented himself as Christ (14-30). He portrayed people, even himself, with great honesty and no intent to flatter. In this very small early self-portrait (15-26)—the artist was

only 23—Rembrandt seems almost caught off-guard, as if he had just turned his head in response to a sudden sound. With his messy hair and open mouth, he hardly seems to be posing at all, but, like many people, mesmerized by his reflection in a mirror. Rembrandt's devotion to Caravaggio's naturalism, as well as his understanding of chiaroscuro, is apparent in this early self-portrait. These remained his principal means of expression throughout his career.

Rembrandt, the son of a miller, was born in a small Dutch village. At an early age, he was recognized as an artistic genius. A painting done when he was only twenty-four was said to be "a work that could be compared with anything in Italy and with any of the beauties and marvels that have survived from the remotest antiquity." Underlying his talent was his remarkable skill as a draftsman, which can be seen in both his drawings and prints. His *Sleeping Woman* (4-10) is a drawing that captures a pose in only a few strokes. His *Christ with the Sick around Him* (6-10) is an etching of great complexity and imagination, a masterly orchestration of light and shadow. In contrast to the work of most artists (Picasso is one exception), Rembrandt's drawings and prints are held in the same high regard as his paintings.

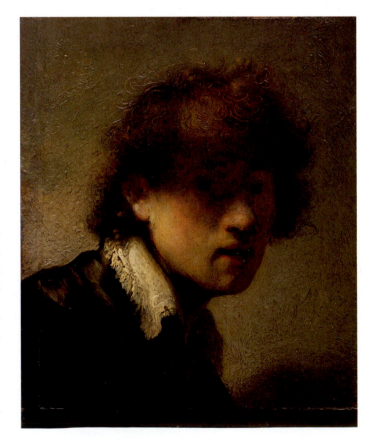

REMBRANDT VAN RIJN, *Self-Portrait as a Young Man*, 1629. Oil on canvas, 6" × 5". Bayerische Staatsgemäldesammlungen—Alte Pinakothek, Munich, Germany.

In the 1640s, the ambitious Rembrandt was Holland's most popular portrait painter, and had become quite wealthy. Yet his dream was to be a painter, like Rubens, of impressive historical and biblical scenes. The *Sortie of Captain Banning Cocq's Company of the Civic Guard* (15-27), known traditionally as the *Night Watch*, marks a turning point in his career. The large painting (it is more than fourteen feet long) was commissioned by a company of officers under the command of Captain Frans Banning Cocq. The artist knew them and had probably watched them leave for patrol many times, because he lived on the same street as their headquarters. Each of the eighteen men depicted paid one hundred guilders and expected, in return, a traditional portrait. Rather than show everyone equally, however, Rembrandt decided to have a more imaginative composition. Some figures, like the captain, are featured, but others are almost hidden. For example, one soldier, at the right, had the bad luck to have his face blocked by an arm pointing to the center. Some individuals are also concealed by heavy shadows because, rather than using a dull, even light, Rembrandt used dramatic chiaroscuro. The final result was impressive, but, not surprisingly, many of his subjects were unhappy. After the portrait was unveiled, Rembrandt's commissions began to decrease.

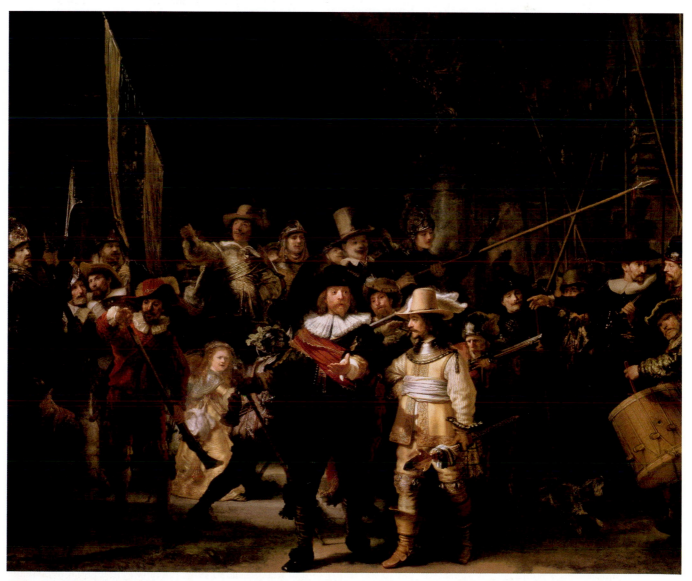

15/27 REMBRANDT VAN RIJN, *Sortie of Captain Banning Cocq's Company of the Civic Guard (Night Watch)*, 1642. Oil on canvas, 12' 2" × 14' 7". Rijksmuseum, Amsterdam, Netherlands.

15/28 REMBRANDT VAN RIJN, *Self-Portrait*, 1659. Oil on canvas, 33¼" × 26". National Gallery of Art, Washington, D.C.

The year 1642 marked another sad turning point in his fortunes: His beloved wife and model, Saskia, died after giving birth to their son, Titus. In the *Sortie*, she appears as a small ghostly presence just to the left of center. The loss of Saskia also meant the loss of her trust fund, on which he had become dependent despite his success. Unfortunately, Rembrandt had developed a taste for the finer things in life. He also liked to drink and eat well. As his fortunes declined, he found it impossible to restrain his free-spending ways.

Rembrandt's art came under attack in the 1650s. As the Dutch Republic aged, it became richer and more conservative, less concerned with honesty and realism. Patrons wanted a more classical-looking art, reminiscent of Raphael and ancient Greek statues. This new taste was developing, not only in Holland, but also all over Europe. Like Caravaggio before him, Rembrandt was criticized for his naturalism. It was said his pictures were too dark; they contained too many ugly and vulgar types, but Rembrandt refused to change.

Rembrandt's biography is told in his many self-portraits. The man seen in the self-portrait of 1660 (15-28) is much changed from the energetic young man of thirty years earlier. In the intervening decades, his self-portraits had shown a tattered but defiant, almost confident Rembrandt. By 1659, he had been forced to declare bankruptcy and sell off his personal art collection. Here we see the artist as a tired, worried old man who seems to see little hope in the future. Although he would live another seven years, before his death he would lose both his son Titus and his beloved mistress Hendrickje, and finally become dependent on their daughter, Cornelia.

Rembrandt's dedication to his principles and resistance to Classicism cost him dearly, but his contribution to art was immense. If the Renaissance can be seen as the beginning of the rise in the importance of the individual, then Rembrandt's work can be seen as an important new development of that idea. In his pictures, *his* own unique impressions and thoughts became even more important than realistic depiction of his subjects. This is the beginning of an important part of the modern approach to art, where the sensibility of the artist is now a crucial element of the subject matter. In other words, not only imitation but also expression was to be valued.

THE BAROQUE IN FRANCE

In Chapter 11, France was discussed as the birthplace of Gothic art, but it would not be an important art center again until the Baroque period. In the seventeenth century, France's power increased rapidly until it became the most powerful nation in Europe and the virtual capital of Western art, a position it would hold for nearly three centuries, until World War II.

Classicism, the same movement that ruined Rembrandt's career, was centered in France. Nicolas Poussin was the emperor of Classicism; his ideas and career helped formulate the basic doctrines of the new international movement. He lived for many years in Rome, the Mecca of the Classicists. There he made copies of the works of his heroes, the Renaissance masters, along with drawings of ancient Greek and Roman sculptures. His approach to learning would form the basis of the traditional course of study in the French Royal Academy of Painting and Sculpture founded in the seventeenth century. It became the model for academies of art all over Europe, where students were taught the following doctrines of **Classicism**: (1) reject Naturalism, especially the portrayal of authentic emotions; (2) the highest aim of a work of art is to represent noble and serious thoughts; (3) an artist should make images with logic and order—not as things really are but as they should be; (4) true art should depict great themes and raise viewers up by appealing to their reason, not their base emotions. These doctrines were inscribed in a treatise by Poussin and became the bylaws of the movement, a major force in Western art for centuries.

Poussin's paintings reflect his belief in an art based on ideals, not naturalism. The shepherds in *Et in Arcadia Ego* (15-29), for example, are not portrayed as peasants

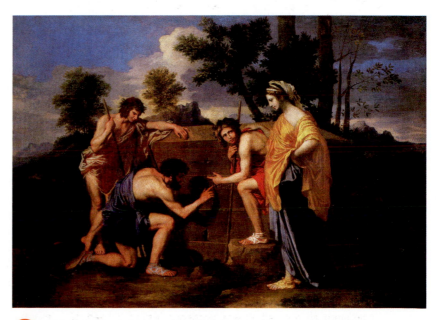

15/29 NICOLAS POUSSIN, *Et in Arcadia Ego*, c. 1655. Oil on canvas, 34" × 48". Louvre, Paris, France.

but are closer to the statues of archaic gods. This scene is in fact set in an ideal ancient past, as are all of his works. The light and color are not dramatic but calm, as in the Madonnas of Raphael. The shepherds are reading and reflecting on the words carved into a tomb, "Et in arcadia ego," or "even in Arcadia I am." Arcadia was an ancient mythical land, a rustic paradise that symbolizes perfect earthly life. "I" refers to death. The inscription therefore means that even in an ideal pastoral land-scape, death rules supreme. The spirit of death is at the right, in the form of a goddess. She calmly puts her hand on one of the shepherds, perhaps announcing the end of his life. All elements of the picture are carefully staged to create a sense of Classical serenity, a dignified world ruled by logic and understanding.

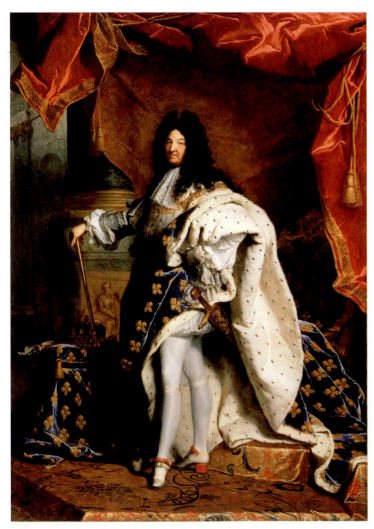

HYACINTHE RIGAUD, *Louis XIV,* **1701. Oil on canvas, 9' 2" × 6' 3". Louvre, Paris, France.**

LOUIS XIV AND VERSAILLES

The dominance of France during the seventeenth and eighteenth centuries was not just artistic but military and political, too. Its preeminence was centered around its king, Louis XIV, the most important figure of the Baroque period. After a childhood made insecure by civil war and factional strife, he created a new kind of nation-state based on his absolute rule, sustained by his claim to divine authority. Louis's most famous quote, "L'état, c'est moi" ("The state, it is myself"), characterizes per-fectly his attitude toward governance. Known as the Sun King, he was the most powerful monarch in Europe and ruled for seventy-two years.

In his official portrait by Hyacinthe Rigaud (15-30), the sixty-three-year-old Louis is surrounded by sumptu-ous fabrics and classically inspired architecture. As was characteristic of almost everything associated with Louis XIV, his portrait is gigantic and larger than life, more than nine feet tall. It looms over the viewer and is meant to impress one with its absolute power. The pride with which he reveals his slim legs may seem silly to us today, but simply reflects a change in cultural values: men of this period were as interested in fashion and vain about their personal appearance as women. The large, jeweled sword hilt seen just above his stockings reminds us that he was a man of immense power.

In the mid-1600s, the king grew dissatisfied with his major palace, the Louvre, and decided to make a new one away from the crowds of Paris (whose population had doubled in eighty years), which reminded him of the politi-cal strife of his youth. Hundreds of architects, decora-tors, sculptors, painters, and landscape designers were sent into the countryside to convert a royal hunting lodge into a palace so grand that it would be capable of glorify-ing the most powerful ruler in Europe. Because of the astounding size of Louis XIV's *Palace of Versailles*, no one photograph can capture it, even one taken from the air. A city was created, attached to its grounds, to house all of the court and government officials, the military, clergy, and thousands of servants. Under Louis, Versailles became a world all to itself, cut off from the distractions of city life. Its famous gardens literally extend for miles (see 11-30).

The palace is a combination of both Classical and Baroque elements. Among the hundreds of rooms inside, the king's bedroom, decorated in gold-and-silver brocade, was the center of activity in the palace. All roads in Versailles led to it, and most of the important official business was conducted there. The great event

of each day was the rising or *levee*, of the Sun. As the sun would appear above the horizon, the Sun King would rise from his bed. Once dressed, he would push open his elaborately carved bedroom door. It opened into the *Hall of Mirrors* (15-31), which would reflect bright sunlight around Louis XIV as he progressed down the hall with his courtiers by his side.

The hall extends the entire width of the central wing's second floor, and the windows provide a fine view of the marvelous gardens. In daytime, the seventeen grand mirrors reflect the light of the large windows across from them, making the hall bright without any artificial lights. Besides mirrors, the walls are covered with marble of many colors, and the ceiling tells of the magnificent accomplishments of the king. As beautiful and elaborate as it is today, compared to Louis's time it is rather bare. It was once filled with gold-and-silver chairs and trees

covered with jewels. This and other halls were open to the public to impress visitors with the majesty of Louis XIV. Versailles was the center of many festivals that took place in this hall: comedies, balls, music, fireworks, and suppers by torchlight. The mirrors would reflect and magnify the magnificence of the great *fêtes* or parties, some lasting for days.

Louis XIV's era was a bloody one in Europe, and he bears a large responsibility for this. He loved war and owed much of his power to it. Attached at one end of the Hall of Mirrors is the *Salon de la Guerre* (War Room, 15-32), where he made his plans to crush France's neighbors. The central feature of the room is a marble relief that shows him on horseback trampling his enemies in triumph. Around the room are such pictures as "Germany on her knees" and "Denmark surrendering." At the other end of the hall, his queen built a "Salon de

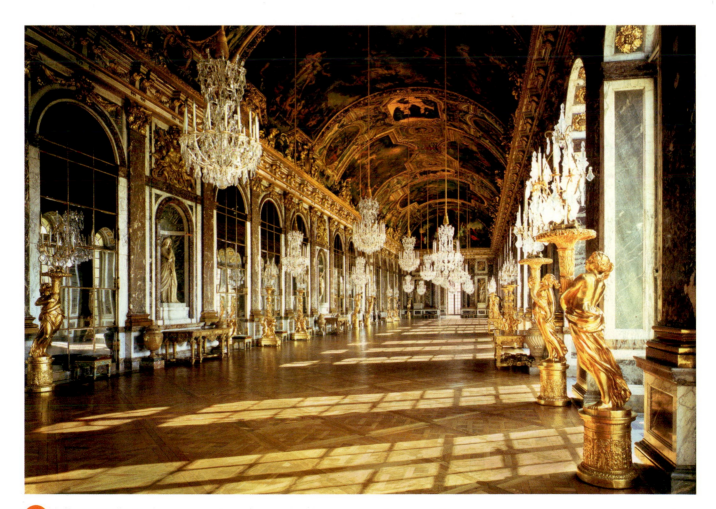

15/31 JULES HARDOUIN-MANSART, *Hall of Mirrors*, Palace of Versailles, France, 1680.

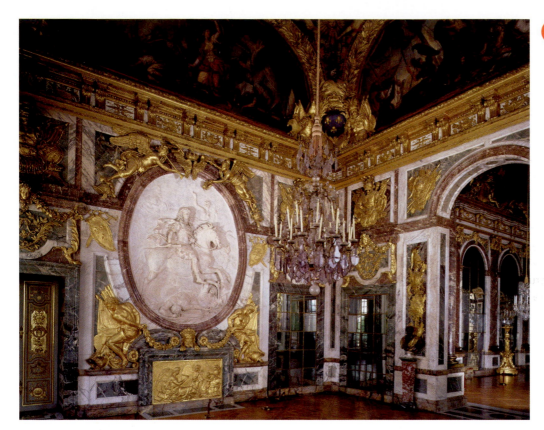

Paix" (Peace Room) to balance her husband's ferocity. Sadly, it never seemed to have its intended effect. Still, Versailles captured the imagination of Europe, and soon there was building everywhere. It was as if every member of the European nobility had to build his own little Versailles.

THE ROCOCO IN FRANCE: THE ARISTOCRACY AT PLAY

Much to the relief of Europe (and France, which was almost bankrupt after more than fifty years of extravagance and wars), Louis XIV finally died in his glorious bedroom in 1715, after ruling for seven decades. When he died, a new period of art began. Its characteristics were not formality and grandeur but lighthearted, playful decoration, as if artists along with the rest of Europe heaved a deep sigh, relaxed, and began to enjoy themselves.

This new period in art is called the **Rococo**, and Antoine Watteau was its preeminent painter. Born in Flanders (a nation Louis XIV had conquered), he only lived to be thirty-seven, but in his short life he painted many scenes—of parties, picnics, and love—that typify the Rococo spirit. His style was influenced by his countryman, Rubens. Notice the similarities between Rubens's *Garden of Love* and Watteau's masterpiece *Return from Cythera* (15-33). Curving S shapes and the theme of love reign in both. Each show a variety of actions. The differences, however, illustrate a distinction between

the Baroque and the Rococo. Because it is set in the midst of a large landscape, the *Return* seems much more peaceful than the *Garden of Love*. The characters are distant, rather than pushed close to the viewer. The lighting is soft and gentle. Watteau's picture is therefore not nearly as intensely energetic as Rubens's. Although Rubens made many paintings on a grand scale, most Rococo pictures are more modest. One of Watteau's largest works, the *Return from Cythera* is a bit more than six feet long; many of Rubens's are twice that.

In Watteau's painting, a group of lovers are about to leave Aphrodite's isle of Cythera, a mythical island where love never dies and one never grows old. We can see that the lovers find it difficult to leave this idyllic island; many look back sadly. Every figure is paired in a couple, some almost swooning in rapture. As in many of Watteau's pictures, a classical sculpture of a bust of Aphrodite, the goddess of love, keeps a watchful eye over lovers, protecting them. Cupid, her son, has left his arrows at its base, because they are unnecessary here. He tugs at one woman's dress, trying to get her attention and tell her that it is time to leave. Swarms of cupids tumbling in the air surround the gondolas at the right, preparing to lead them back to the real world beyond the hazy blue mountains.

As romantic and lovely as it is, there is a sadness in this and many of Watteau's paintings, as if the wonderful days of youth and love are passing too fast. He may have

known he was dying of tuberculosis (what was then called consumption) when he painted this picture. Perhaps he is telling us he does not want to leave just yet. Ten years after his death, the Rococo style had swept Europe; even the clothing worn by his characters in the *Return* had become *the* style for the aristocracy.

The visual idea of love in a garden was especially popular in the France of Louis XV, where the court was dominated by the king's mistresses and intellectual life flourished in the salons of famous female hostesses. French aristocrats of the eighteenth century seemed to be bound by no moral scruples; extramarital affairs and illegitimate children were common. Romantic love was the theme of many works of art, especially those painted to decorate the rooms of wealthy ladies. One of the most famous is *The Swing* by Jean-Honoré Fragonard (15-34). The mood of this picture is light and playful; love is a game, courtship an art. We see a tastefully dressed

young woman swinging above her would-be lover, who is hiding in the bushes. The young man has paid an elderly bishop (seen in the shadows) to bring his beloved to this spot and swing her higher and higher so he can peek up her skirt. The young lady is well aware of her admirer's trick and plays along with it, going so far as to kick off one of her shoes. Even the statues of cupid partake of the intrigue; one holds his fingers to his lips as if to say, "Sssh! It's a secret."

The French aristocracy turned to Fragonard for images to hang in their boudoirs but to Marie Louise Élisabeth Vigée-Lebrun for their portraits. A child prodigy, she supported her widowed mother and brother from the age of fifteen. By the time she was twenty, Vigée-Lebrun commanded the highest portrait prices in France. Her success was enhanced by the patronage of the queen of France, Marie Antoinette, whom she painted more than twenty times. Vigée-Lebrun's *The Artist and Her Daughter*

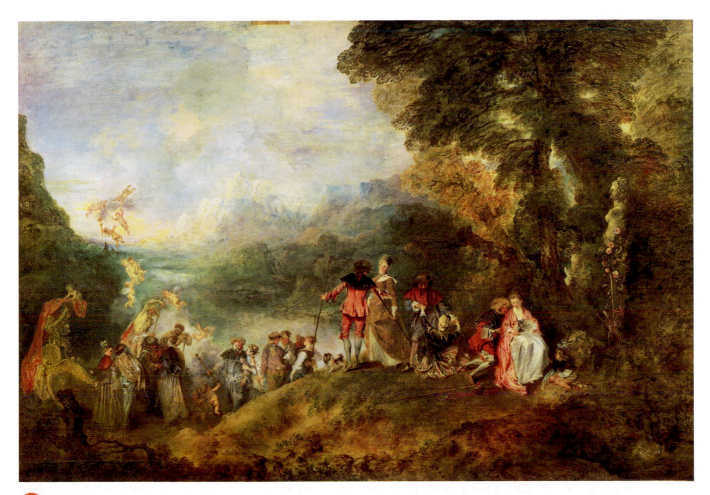

15/33 **ANTOINE WATTEAU,** *Return from Cythera,* 1717–1719. Oil on canvas, 4' 3" × 6' 4". Louvre, Paris, France.

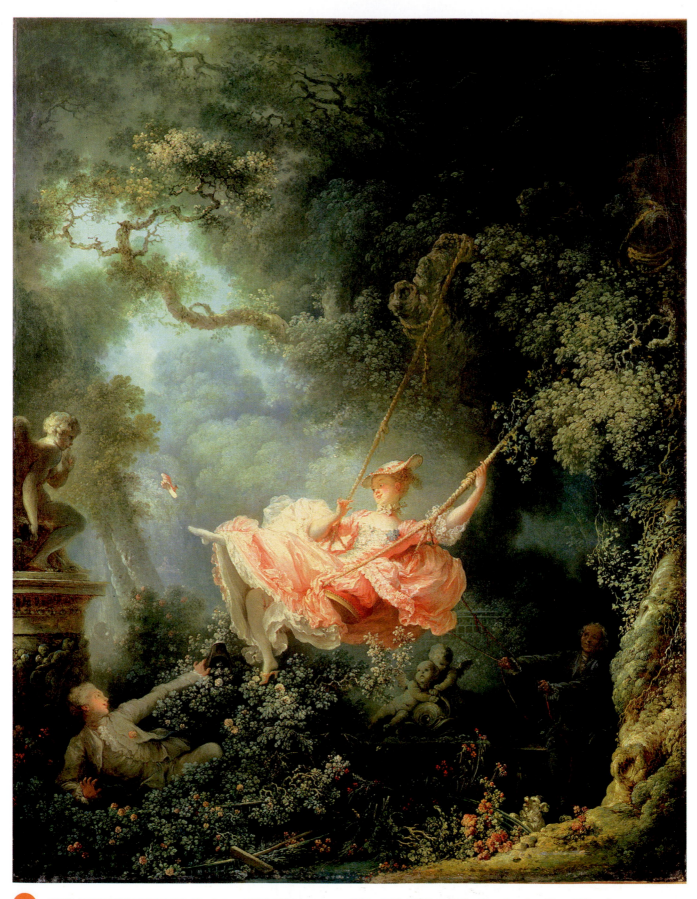

15/34 JEAN-HONORÉ FRAGONARD, *The Swing*, 1766. Oil on canvas, 35" × 32". Wallace Collection, London, United Kingdom.

(15-35), painted on the eve of the French Revolution, illustrates how the new Classicism even had begun to influence the work of a painter devoted to portraying the aristocracy. In the next chapter, we see how this style was a factor in the coming upheaval.

The successes of Watteau, Vigée-Lebrun, and Fragonard were partly a result of the desire of the aristocracy to be cut off from the cares of everyday life and ordinary people. Their pictures, devoted to the elegant lifestyles of upper-class pleasure, simply ignore the existence of any other classes. As the eighteenth century came to an end, however, social and political changes would make it impossible for the aristocracy to ignore the outside world. Because of her close association with the royal family, Vigée-Lebrun was forced to flee during the French Revolution and spent her most productive years visiting the capitals of Europe, a figure of international stature patronized by the crowned heads of Europe. As for Fragonard, he stayed in France. After the Revolution, grace and charm were no longer considered admirable qualities, and his career would sink along with his clients, the nobility.

15/35 MARIE LOUISE ÉLISABETH VIGÉE-LEBRUN, *The Artist and Her Daughter*, c. 1785. Oil on canvas, 51" × 37". Louvre, Paris, France.

CHAPTER 16

The birth of Modern Art was a slow one, with many parents over the centuries. From the Middle Ages through most of the seventeenth century, artistic styles had evolved slowly over time, one following another. The Romanesque led to the Gothic, Gothic art was replaced by the Renaissance, the Renaissance by Mannerism, Mannerism by the Baroque. The word *modern* was first used to describe art that was wild and imaginative during the Mannerist period. The Renaissance conception of genius and Rembrandt's emphasis on the artist's personal expression also played parts in defining modernity. In the eighteenth and nineteenth centuries,

the last elements were introduced. First, the Baroque was replaced by two distinct styles—the Classical and the Rococo. Proponents of these movements called themselves the *Rubenistes*—after the flamboyant painter Peter Paul Rubens—and the *Poussinistes*—after the Classical master Nicholas Poussin. These eighteenth-century styles were then challenged in the nineteenth century by a series of almost simultaneous movements jockeying for patronage and prestige. All ending in the suffix "ism," the competing movements of Neoclassicism, Romanticism, and Realism each declared that it was the best expression of the spirit of the age.

1650–1776

PERIOD

THE ENLIGHTENMENT
CLASSICISM
GEORGIAN AGE IN ENGLAND
FORMATION OF ACADEMIES AND SOCIETIES FOR ARTS AND SCIENCES

HISTORICAL EVENTS

Great Fire of London 1666
Milton, *Paradise Lost* 1667
Locke, *Essay Concerning Human Understanding* 1690
Diderot, *Encyclopedia* 1751
Voltaire, *Candide* 1759

ART

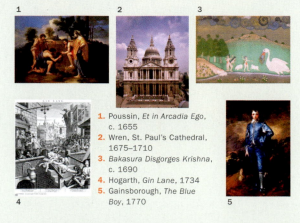

1. Poussin, *Et in Arcadia Ego*, c. 1655
2. Wren, St. Paul's Cathedral, 1675–1710
3. *Bakasura Disgorges Krishna*, c. 1690
4. Hogarth, *Gin Lane*, 1734
5. Gainsborough, *The Blue Boy*, 1770

THE BATTLE OF THE ISMS:

NEOCLASSICISM,

ROMANTICISM,

AND REALISM

1776–1815

NEOCLASSICISM
THE AGE OF REVOLUTIONS
INDUSTRIAL AND TRANSPORTATION REVOLUTIONS
ROMANTICISM IN ART AND LITERATURE
NAPOLEONIC AGE

Jefferson, *The Declaration of Independence* 1776
The French Revolution 1789–1799
Wollstonecraft, *Vindication of the Rights of Woman* 1792
Napoleon becomes Emperor 1804
Beethoven, *Eroica* 1804

1815–1860

SOUTH AMERICAN REPUBLICS BREAK AWAY FROM
 SPAIN
THE VICTORIAN PERIOD IN ENGLAND
THE HUDSON RIVER SCHOOL: FIRST SCHOOL OF
 AMERICAN PAINTING
REALISM IN ART AND LITERATURE

Scott, *Ivanhoe* creates taste for historical novels 1819
Invention of photography 1839
Marx and Engels, *The Communist Manifesto* 1848
Mexican Independence from Spain 1821
Slavery banned in British Empire 1833
Irish Potato Famine 1845–1849

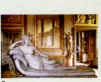

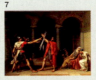

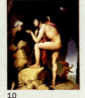

6. Jefferson, Monticello, 1770–1806
7. David, *Oath of the Horatii*, 1784
8. Kauffmann, *Cornelia Pointing to her Children*, c. 1785
9. Canova, *Paulina Borghese as Venus*, 1804–1808
10. Ingres, *Oedipus and the Sphinx*, 1809

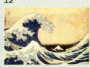

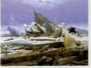
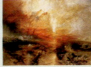
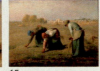

11. Nash, The Royal Pavillion at Brighton, 1815–1823
12. Hokusai, *The Great Wave*, c. 1822
13. Friedrich, *The Wreck of the Hope*, 1823–1825
14. Turner, *Slave Ship*, 1840
15. Millet, *The Gleaners*, 1857

THE ENLIGHTENMENT

The **Age of Reason** or the **Enlightenment** stressed the value of rationality over faith, senses, and emotions. The Enlightenment was an age of great scientists and mathematicians who attempted to unlock the secrets of the universe using the powers of the human intellect. The foremost thinkers of the time embraced the idea of progress—that the world was getting better and that humans were capable of improving their own lives. These ideas would become core beliefs of modernism.

Beginning in England, this intellectual movement spread to France, which in turn spread its influence throughout Europe by the end of the eighteenth century. An important catalyst was the rebuilding of London after the great fire of 1666, which destroyed more than three-quarters of the old city. Christopher Wren's *Saint Paul's Cathedral* (16-1) put a new face on the London skyline, one that reflected the best of the Classical, Renaissance, and Baroque traditions. A brilliant mathematician and astronomer rather than a trained architect (Isaac Newton considered him one of the great minds of his time), Wren lived in a period when science and the arts were not considered incompatible. As the royal architect, he devised a new city plan less than two weeks after the fire and personally directed the construction of fifty-two new city churches. It was the start of an era that would see for the first time the emergence of an influential native British art.

ENGLISH ART BECOMES RESPECTABLE: REYNOLDS

A career in art in England during the eighteenth century became respectable because of Sir Joshua Reynolds, who became known as an intellectual figure as well as an artist. Through the interest of wealthy patrons, he was able to study in Italy, an experience that profoundly influenced his views of art and culture. When he returned to London, he immediately became a great success in polite society and the city's most fashionable portrait painter. When the Royal Academy was founded by King George III in 1768, Reynolds became its first president and was knighted the following year. From this post he was able to dominate "official" art and disseminate his views on aesthetics and the proper training for young painters.

Reynolds taught that all artists should base their work on the Old Masters. He dedicated the Royal Academy to preserving the traditions of the past and believed that an artistic education should begin with technical training, progress to a study of great works of art, and only then attempt to imitate the natural world. Like the French academic and classical artist Poussin, Reynolds believed that great art should concern itself with the ideal rather than the real to express "great and noble ideals." His views were thus directly opposed to those of his countryman and contemporary, William Hogarth (6-7), who believed in useful art that reflected reality.

In his portrayal of the greatest English actress of the period, *Mrs. Siddons as the Tragic Muse* (16-2), Reynolds painted a symbolic **allegory** (a form of art in which human characters personify certain qualities or ideals). Because Sarah Siddons was famous for her brilliant acting of tragic roles, particularly Lady Macbeth, Reynolds shows her as the classical muse of tragedy. The artist pays homage not just to the actress but also to the Old Masters in his choices of both style and subject. The actress's pose is copied from that of one of the prophets Michelangelo had painted on the Sistine ceiling, while the dramatic lighting and theatrical contrasts are reminiscent of Rembrandt and Gentileschi. Reynolds's color scheme has a typically reddish brown "old masters" tone that contrasts with the fresher and more natural colors of his rival, Thomas Gainsborough.

16/1 CHRISTOPHER WREN, *Saint Paul's Cathedral*, London, United Kingdom, 1675–1710.

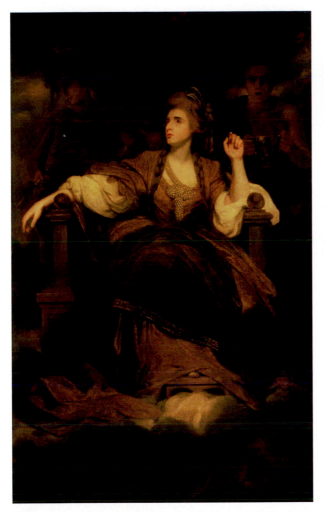

 SIR JOSHUA REYNOLDS, *Mrs. Siddons as the Tragic Muse*, 1784. Oil on canvas, 93" × 51½". Dulwich Picture Gallery, London, United Kingdom.

 THOMAS GAINSBOROUGH, *The Blue Boy*, 1770. Oil on canvas, 70" × 48". Henry E. Huntington Library and Art Gallery, San Marino, California.

THOMAS GAINSBOROUGH

The Blue Boy (16-3) is not only Gainsborough's most famous painting, but for many years probably the best-loved picture in English art. Rather than a mythic figure, the boy in the picture is Jonathan Buttall, the son of a wealthy hardware merchant and a friend of the artist. However, the true subject of *The Blue Boy* is a love of painting and perhaps even a bit of Gainsborough's friendly rivalry with Reynolds, who had once painted a boy in a similar brown costume. A popular legend states that it was painted just to disprove one of Reynolds's many aesthetic theories: that it would be impossible to make a great painting using blue as the dominant color.

Despite his fancy dress costume, Jonathan Buttall looks boldly at the viewer and appears vigorously alert and alive. The design is simple and striking. The blues of the costume contrast dramatically with the warm reddish-brown tones of the background. Gainsborough's handling of paint varies from the crisp impasto used to detail the suit to the wispy, feathery lines in the trees and sky.

The two most important English painters of the eighteenth century represented different approaches to art. Reynolds, looking to the artistic models of the past and attempting to portray the ideal rather than the real, was a typical Classicist. Gainsborough, however, introduced many of the attitudes of the movement that later became known as **Romanticism**—a deep love for nature and the landscape and an emphasis on his own personal viewpoint rather than adherence to Classical rules. The contrast between these artists is representative of the conflict between two art movements that would dominate the next one hundred years in Western art: Romanticism and Neoclassicism.

NEOCLASSICISM

The **Neoclassical** style was a visual expression of the ideals of the Enlightenment. Enlightenment thinkers, both scientists and philosophers, valued order and rationality above all. Similarly, Neoclassical painters rejected

both the high drama and murky atmosphere of Baroque art and the misty sentimentality of the Rococo. They searched for clarity of line, color, and form, admiring the simplicity of Greek art.

The supreme object of the Neoclassical artist was to paint a moral lesson that would educate and improve the viewer—what were called "history paintings," generally scenes from the ancient past. They dreamed of creating large works of art that could be used to educate the public about civic virtues, much as stained-glass windows educated peasants in the Middle Ages. In the words of Denis Diderot, an eighteenth-century French philosopher and art critic, "To make virtue attractive, vice odious, ridicule forceful: That is the aim of every honest man who takes up the pen, the brush, or the chisel."

An excellent illustration of this moralizing style of art can be seen in the work of an artist of international reputation, Angelica Kauffman. Like Artemisia Gentileschi, she had been trained by her artist father; like Bernini, she was considered a prodigy. As a young woman Kauffman traveled to Florence and Rome, where she met other Neoclassical artists; she eventually settled in Rome. A good friend of Sir Joshua Reynolds, she was one of only two women who became founding members of the British Royal Academy.

Cornelia Pointing to Her Children as Her Treasures (16-4), created in 1785, is a typical Neoclassical painting that both tells a story and points to a moral. Cornelia, a Roman widow, is being visited by a friend who shows off her jewelry. When she asks her hostess to display her own

ANGELICA KAUFFMAN, *Cornelia Pointing to Her Children as Her Treasures*, 1785. Oil on canvas, 40" × 50". Virginia Museum of Fine Arts, Richmond, Virginia.

jewels, the proud mother points to her children—two boys on the left and her daughter on the right. Thus the picture demonstrates several values prized by Neoclassicists— modesty, frugality, and pure maternal love. The content and feeling of this painting contrast dramatically with Rococo works about aristocratic sexuality, such as Fragonard's *The Swing* (15-34). Responsibility has replaced frivolity.

The style of the painting reinforces the ideas it expresses. Kauffman's figures are crisp and clean, their outlines set against a plain backdrop. Like other Neoclassical artists, Kauffman prefers clear, bright colors to murky or suggestive shades. Because this is a painted lesson, there is no place for mood, emotion, or atmosphere.

DAVID AND THE FRENCH REVOLUTION

During the eighteenth century, France had lost some of the glory and preeminence she had enjoyed under Louis XIV. Rococo art, patronized by the mistresses of Louis XV, was a style of the boudoir, not the halls of government. Toward the end of the century, the frivolous and playful Rococo was criticized as an art of decadence. French Neoclassical art, modeled more directly on Greek and Roman art than on the work of either Poussin or Reynolds, emerged as a powerful force that seemed to express a new, more serious moral purpose. Discoveries at the recent excavations at Pompeii and Herculaneum also inspired a Classical revival in art and fashion in the Western world.

Although Neoclassicism appealed to many artists throughout Europe and the United States, it found its most perfect expression in the work of the French artist Jacques-Louis David. David took Neoclassical ideals and followed them to their logical conclusions, concentrating their power. His style of painting appeared absolutely brutal when it first appeared. All the fluidity and elegance of the Rococo, echoes of which had remained in the work of Kauffman, were replaced by a new icy-hard surface. In their crystalline purity, David's figures seem to be carved rather than painted. In his enthusiasm for the new Neoclassical style, he revolutionized academic painting.

Success did not come easily to David. When he was denied the prestigious Prix de Rome (a prize of a year's study in Rome given to the most promising student in the French Academy), he even attempted suicide. Happily (and somewhat surprisingly), the Rococo artist Fragonard took pity on him and transferred an important commission to the young artist. Eventually, David did win the prize to study in Rome, which is where his first great masterpiece, *Oath of the Horatii* (16-5), was painted.

As in other Neoclassical history paintings, David's painting tells a moral story and seeks to teach proper

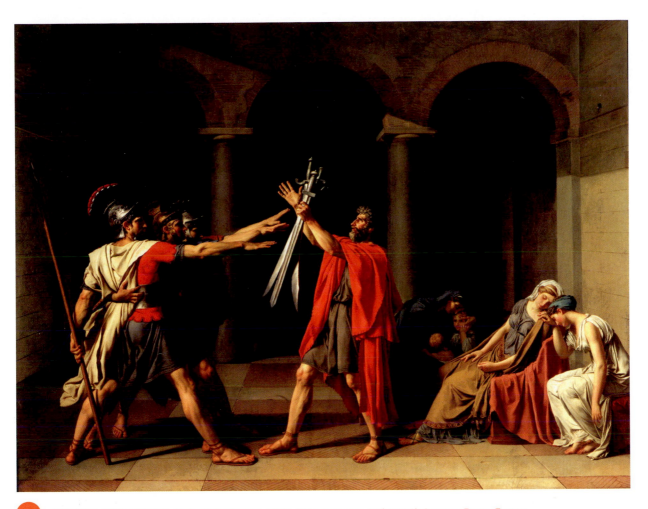

16/5 JACQUES-LOUIS DAVID, *Oath of the Horatii*, 1784. Oil on canvas, 11' × 14'. Louvre, Paris, France.

values. It is based on a legend about the early years of the Roman Republic, when the Romans were about to go to war with the Albans. On the eve of battle, it was decided that the outcome would be determined by single combat in three individual contests. The three brothers of the Horatii family swore to defend the Roman state against three brothers of another family, one of whom was engaged to their sister. David chose to depict the moment when the father calls on his sons to swear to sacrifice their lives, if necessary, for the good of the country. Two brothers would die; so would their sister's fiancé. Thus the virtues David emphasized were patriotism, self-sacrifice, and fidelity to a higher purpose.

The *Oath of the Horatii* shows David's mastery of composition. The geometry of the design is clear: The space is divided by three arches, in front of which are arranged three distinct figure groupings—the sons, the father, and the women. Silhouetted against the simple, darkened background, three arms reaching toward three swords catch the light. David sets up a powerful rhythm of legs, arms, and swords by repeating each form with slight variations. The outlines of the male figures are rigid and strong, in contrast to the soft, melting outlines of the females.

Although the *Oath of the Horatii* was painted before the French Revolution, its style and content put David at the forefront of art and convinced the revolutionaries that he was one of them in spirit. His utter rejection of the Rococo style was seen as an equally strong condemnation of the old regime. David became not only a firm supporter of the Revolution but also one of its leaders, its artist, spokesman, and historian. He organized revolutionary holidays and celebrations. He abolished the Royal Academy and replaced it with what was called the Commune of Art. David also transformed the Louvre, the newly vacant royal palace, into a public art museum. He named his former benefactor, Fragonard—who might otherwise have been in danger because of his past association with aristocrats—curator of what was then called the Musée Napoleon.

Now David painted contemporary events with the same reverence he had used for historical pictures. Like the ancient Roman Republic, the new French state had heroes and martyrs. What was different was that David knew these men and women; they were his associates and friends. For this reason, *Death of Marat* (16-6) has a great immediate impact. Marat was a revolutionary leader who was forced to spend hours in the bath because of

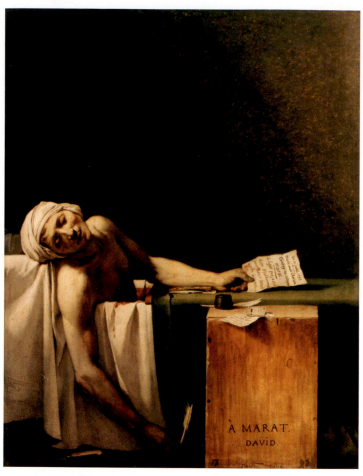

16/6 JACQUES-LOUIS DAVID, *Death of Marat*, 1793. Oil on canvas, approximately 63" × 49". Musées Royaux des Beaux-Arts de Belgique, Brussels, Belgium.

a painful skin disease. Because he spent so much time soaking, Marat was accustomed to working and even receiving visitors while in his therapeutic tub. One visitor was a young woman named Charlotte Corday. A revolutionary who disagreed with Marat's policies, she stabbed him while he was at work. The stark painting combines David's emotional intensity with the simplicity of the Neoclassical style. Like a religious painting by Caravaggio, nothing in the background distracts from the pale corpse of the martyr Marat. With his white, marble-like flesh, Marat is shown as a mythic hero, not a suffering human.

Before Marat's death, revolutionary leaders had inaugurated a series of public executions, in which forty thousand people were put to death in ten months. This period, known as the Reign of Terror, was part of a long chain of events that would lead to the collapse of the Revolution. David was imprisoned as a traitor, but his life was spared. Then, with the rise of Napoleon Bonaparte, David found a new patron. For him, Napoleon became the hero who would bring France back to glory, and he painted his new hero many times.

But Napoleon was a very different kind of leader from Marat. He was a military man. In a dozen years he had

not only fought off France's enemies but also conquered much of Europe. This difference in models is obvious when we compare *Bonaparte Crossing the Great Saint Bernard Pass* (16-7) with *Death of Marat* and *Oath of the Horatii*. Rather than exhibiting Classical restraint and purity, David fills his canvas with the dynamic form of a rearing horse. Horizontals and verticals, which create a feeling of stasis, have been replaced by strong diagonals, suggesting movement. Cool harmony and balance were now supplanted by theatricality more reminiscent of Baroque art—foreshadowing the coming Romantic movement.

CANOVA AND NEOCLASSICAL SCULPTURE

As they ascended the thrones of Europe and married into royal families, Napoleon's relatives also became important patrons of Neoclassical art. The greatest sculptor of the period was Antonio Canova, a Venetian who gained international fame at a young age. Like David, Canova studied in Rome and was directly inspired by Classical art. Napoleon's sister, Paulina, had married an Italian Prince of the Borghese family, a Roman dynasty noted for their fabulous art collection and elegant gardens in the heart of the city. It was natural that Paulina would turn to Canova to immortalize her, as he did when he portrayed her as Venus Victorious (Venus after she had been declared the most beautiful of the Greek goddesses in a mythological contest). With nudity echoing that of the *Venus de Milo* (*Aphrodite of Melos*, 12-19), the statue of Paulina lounges on a classical divan (16-8). It may seem shocking that a princess asked to have herself shown as the goddess of love in what appears to be a provocative pose—she seems to be either waiting for or relaxing after lovemaking—but Napoleon's sister was known for both her beauty and her scandalous lifestyle. Canova's statue exhibits skill similar to that of Bernini (the Borghese collection still houses both this sculpture and many of Bernini's greatest works), but the effect is far more cool, elegant, and restrained—more Neoclassical. By employing the talents of exceptional artists, the upstart Bonapartes were attempting to catapult their family into the highest society culturally as well as politically.

Soon after working on this statue, Canova was commissioned by Napoleon himself to portray the French leader as Mars, the god of war, although the statue was actually titled *Mars, the Peacemaker*. For this project, the sculptor carved a massive—larger than life-size—naked heroic figure in marble. Unlike his sister, however, Napoleon was embarrassed by a vision of himself as a Classical nude. Never publicly exhibited, the statue was purchased by the British government after Napoleon's defeat at Waterloo

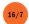

JACQUES LOUIS-DAVID, *Bonaparte Crossing the Great Saint Bernard Pass*, 1801. Oil on canvas, 8' 6" × 7' 3". Chateaux de Malmaison et Bois-Rueil-Malmaison, France.

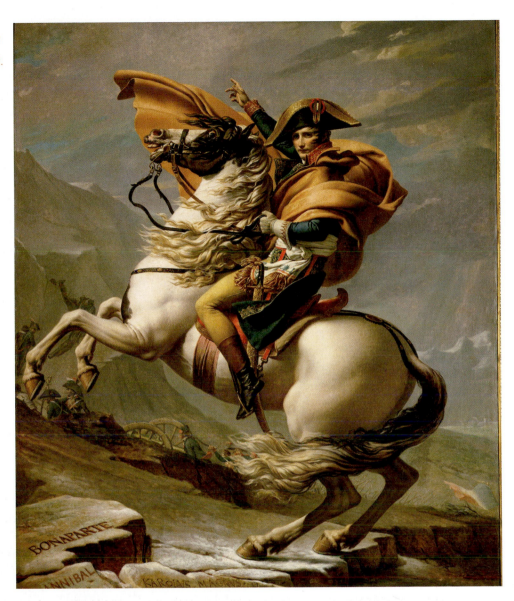

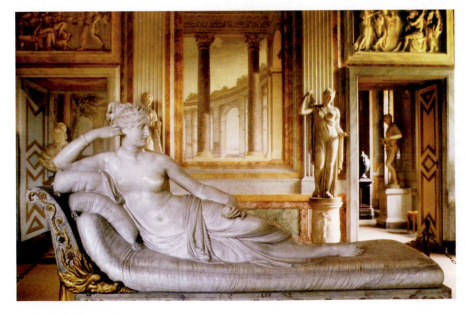

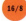 ANTONIO CANOVA, *Portrait of Paulina Borghese as Venus Victorious*, 1804–1808. Marble, height 5' 3", width 6' 7". Galleria Borghese, Rome, Italy.

and was given to the Duke of Wellington as a reward for his great victory. Today it remains in Wellington's London townhouse as a symbol of fallen pride.

ROMANTICISM

GOYA AND THE ROMANTIC REACTION

The careers of David and Canova contrast sharply with that of the first great Romantic artist we will consider, the Spaniard Francisco Goya. Goya's ambition always was to become a painter to the court. His road to success took many years; he was not elected to the Royal Academy of Spain until the age of thirty-four. He was forty-three when he was finally elected to the coveted post of president of the Royal Academy and First Painter to the King, the same position his idol, Velázquez, had held approximately one

hundred fifty years earlier. Unfortunately, Spain no longer enjoyed the same power and prestige she had known under Philip IV.

Shortly after reaching his goal of becoming the premier painter in Spain, Goya experienced a personal crisis. For a year he became so ill that he could not paint, and when he recovered he was completely deaf. Yet, as his work became more bitter and critical, he became a far greater artist. Goya's personal problems were echoed by Spain's political disasters. In 1804, Napoleon took advantage of Spain's weak rulers and installed his tyrannical brother on the Spanish throne.

In the war that followed, Goya saw many real events that confirmed his new, morbid view of humanity. One of the most infamous was a massacre of innocent, unarmed Spanish civilians by French soldiers, a scene that the painter immortalized in *The Third of May, 1808* (16-9). A faceless firing squad is shown in the midst of

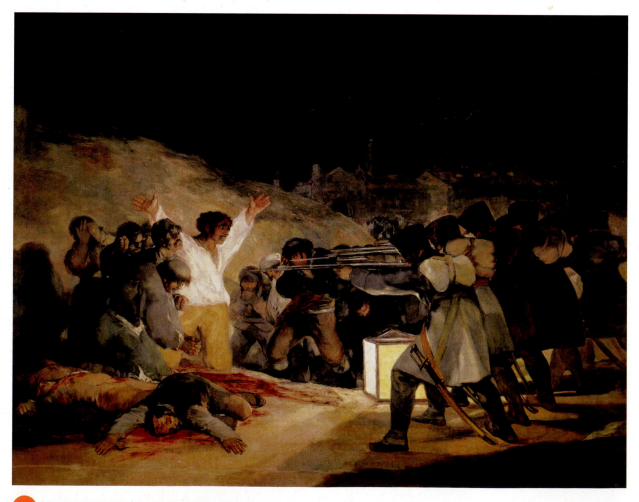

16/9 FRANCISCO GOYA, *The Third of May, 1808*, 1814. Oil on canvas, approximately 8' 8" × 11' 3". Museo del Prado, Madrid, Spain.

its butchery; one victim lies in a pool of blood on the ground, while others wait their turn in terror. The central figure is illuminated as if by a harsh spotlight, his arms spread wide in a crucifixion-like pose.

Goya's masterpiece is a mixture of both brutal realism and passionate Romanticism. It appeals not to measured reason but to the viewer's emotions. For David, Napoleon's army was heroic; for Goya, it was made up of inhuman creatures who followed orders blindly. *The Third of May, 1808* is one of the most convincing, powerful, and influential portraits of suffering ever painted. The timeless image reminds us of similar acts of political repression and cruelty in our own time.

Goya's style of painting is as far from David's as were his politics and subject matter. David's technique was flawlessly controlled; the surfaces of his paintings were smooth as glass, revealing no touch of the human hand or brush. Goya's technique was deliberately rough and coarse. Emotion has infused the artist's brushwork—the strokes could be described as wild. This conscious abandonment of control, as well as his fascination with horrifying subject matter, marks Goya's work as Romantic.

Even more gruesome are images from a series of prints known as *The Disasters of War* (16-10). They record what Goya saw as he walked the countryside, and to this day, the images are unbelievable and horrible to contemplate. Before the war, the enlightened thinkers of Spain, Goya among them, had always looked to France for inspiration. France had been the home of a revolution for liberty and justice, but the French did not bring grand ideals to Spain. The butchered remains of Spanish patriots tied to a tree in *Great deeds—against the dead!* serve as a reminder that humanity is just as capable of vicious cruelty as of reason and compassion.

After the return of the Spanish monarchy, Goya, old and in poor health, retreated to his country home outside of Madrid. In private, he decorated the walls of his home with a series of pictures known as "The Black Paintings." Among these dark, forbidding images, *Saturn Devouring his Son* (16-11) stands out for its gruesome imagery. In this mythic tale, Saturn ate his children because one was prophesized to overthrow him. Goya paints Saturn's eyes as wide and glazed, caught up in a mindless passion to eat greedily. The picture could be a comment on the senseless wars that had exhausted Spain during

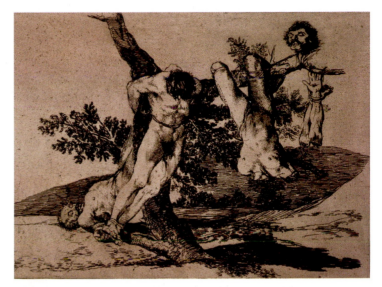

16/10 FRANCISCO GOYA, *Great deeds—against the dead! The Disasters of War*, 1863. Etching, 5½" × 6⅞". British Museum, London, United Kingdom.

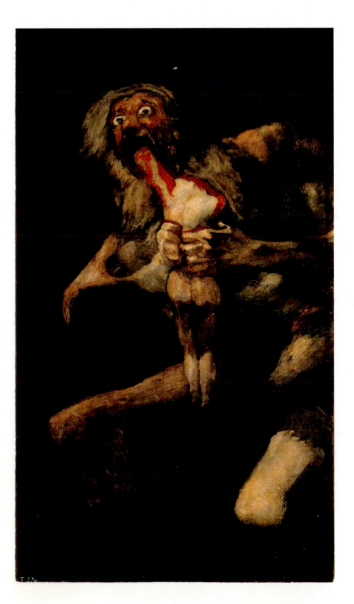

16/11 FRANCISCO GOYA, *Saturn Devouring his Son*, c. 1819–1823. Oil on plaster transferred to canvas, approximately 57½" × 32¾". Museo del Prado, Madrid, Spain.

Goya's lifetime. Another explanation connects to Saturn's other name, Chronos or Time. Perhaps the artist meant us to see how time inevitably devours us all without remorse. But even if he was ill and disillusioned, Goya still retained a sly sense of humor. When guests came to his home, this painting was what they saw in his dining room.

THE BIRTH OF ROMANTICISM

It is not surprising that the movement of Neoclassicism gave birth to an opposing artistic style. Neoclassicism had appeared as a reaction to the playful Rococo; the Rococo had developed in contrast to the formal Classicism of the Age of Louis XIV. What is surprising is that almost from its conception Neoclassicism was challenged by what might be described as an equal and opposite force—that of Romanticism. Both movements shared certain characteristics, such as a strong sense of moral purpose and a passionate adherence on the part of their supporters. But they differed utterly on what values they idealized.

Romanticism rejected much of the logic and order of Neoclassicism. Instead of searching in past models for universal values, Romantic artists looked inside themselves to discover truth. When the German painter Caspar David Friedrich (see 2-20) stated, "The artist should paint not only what he sees before him but also what he sees within him," he expressed one of the seminal ideas of Romanticism. This idea continues to influence the art world up to the present day. When Romantic artists discovered their own tumultuous nature, it also opened their eyes to nature's own power.

Nature, for a Neoclassicist, was an unthinking force that could and should be controlled by humans. The Romantics sensed that nature could never be controlled. Where Neoclassicists set their pictures in classical temples or peaceful landscapes, the Romantics were attracted by the savage, untamed aspect of the natural world. Neoclassicists prized civilization above all; Romantics often chafed under the regulations of society.

The subjects of Friedrich's work could not have been more different from the subjects preferred by Neoclassicists. In place of historical or mythological scenes, Friedrich painted seascapes, forests, and mountains. These wild scenes were often entirely devoid of

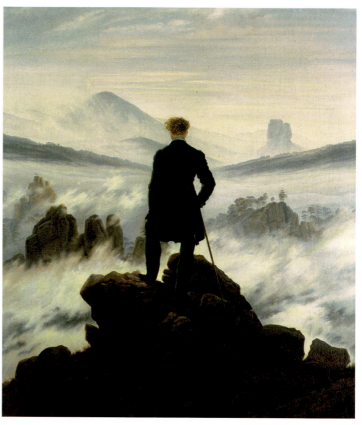

16/12 CASPAR DAVID FRIEDRICH, *Wanderer über dem Nebelmeer (Wanderer above a Sea of Fog)*, 1818. Oil on canvas, 37" × 29". Kunsthalle Hamburg, Germany.

human figures. At other times, Friedrich showed a solitary traveler silently contemplating the infinity of nature, as in *Wanderer above a Sea of Fog* (16-12). A feeling of delicious melancholy pervades many of his evocative images, a sense of yearning and the quest for life's meaning.

THE ENGLISH LANDSCAPE AND ROMANTICISM

England produced great Romantic poets and painters. The works of both groups were centered around nature and the English landscape. J. M. W. Turner's vision of nature was similar to that expressed by Caspar David Friedrich, who gloried in the grandeur and power of the natural world—what was known in the early nineteenth century as the *sublime*. Turner's brilliant career began early. By the age of seventeen, Turner was able to support himself by painting, and he was elected to the British Royal Academy of Art when he was only twenty-four. Turner's favorite themes were dramatic views of storms, fires, sea battles, and sunrises and sunsets over the sea. In *Slave Ship* (16-13), Turner exhibits Romanticism of both subject and style. The picture's complete title is *Slave Ship (Slave Throwing Overboard the Dead and Dying, Typhoon Coming On)*. Turner has chosen to show

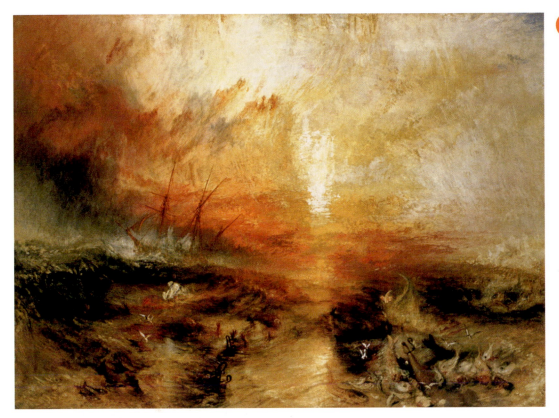

a disaster caused not simply by the destructive power of nature but also by the cruelty of greed. The painting was based on a notorious event off the coast of Jamaica sixty years earlier. As a typhoon approached, the captain ordered the many sick and dying slaves thrown overboard—not to save the ship, but so his employers could collect insurance money. In their policy, only slaves who were "lost at sea" were covered, not ones who died of illness or malnutrition. The helpless captives sink in the churning waters; on the lower right a chained ankle is visible on a single leg surrounded by swarming, hungry fish. *Slave Ship* is the ultimate Romantic scene of wild beauty mixed with horror. At the same time, Turner conveys a strong antislavery message that appealed to English patrons of the period; England was the center of a strong antislavery movement.

By the end of his career, Turner focused entirely on the raw power of nature and the primal elements of earth, wind, fire (see "Art News" box), and water. In works like *Snow Storm* (5-6), he created startling imaginative images, almost totally abstract compositions of color, rich layers of paint, and vigorous brushstrokes that today cannot fail to remind us of the work of the Abstract Expressionists more than a century later.

ROMANTICISM AND POLITICS IN FRANCE

Théodore Géricault was a young French artist who adopted the Romantic lifestyle. Like the English Romantic Lord Byron, whose poetry he admired, Géricault embraced excess—passionate political convictions, passionate opinions about art, and a passionate taste for adventure. Trained in the academic, Neoclassical style of painting, Géricault traveled to Rome at the age of twenty-five. What caught his attention there were the late works of Michelangelo, especially his *The Last Judgment* (14-25), and the paintings of Caravaggio.

The year Géricault visited Rome, 1816, was also the year of a dramatic historical disaster that caught his imagination and made his reputation. In July, *La Meduse*, a French ship bound for Senegal, was wrecked off the West African coast. The captain and officers boarded the only seaworthy lifeboat and began towing the rest of the one hundred fifty passengers and crew on a raft built from the ship's timbers. After a couple of days, those on the lifeboat cut loose from the raft and abandoned it. By the thirteenth day after the wreck, when the survivors were finally rescued, only fifteen remained alive. The others had died of hunger, thirst, and exposure from the blazing sun as the raft became a living hell where desperate men sickened, became insane, and even ate human flesh.

Géricault threw himself into the immense project of capturing the shocking horror of this event on canvas with enormous energy. In the interest of realism, he had a duplicate raft built in his studio. He interviewed survivors and learned all he could about the disaster. Then

TURNER, THE
FIRE KING

According to the October 17, 1834, issue of the *Times of London*:

> *Shortly before 7 o'clock last night the inhabitants of Westminster . . . were thrown into the utmost confusion and alarm by the sudden breaking out of one of the most terrific conflaglarations that has been witnessed for many years past. . . . The Houses of the Lords and Commons and the adjacent buildings were on fire.*

J. M. W. Turner was one of the tens of thousands of Londoners who lined the south bank or crowded onto bridges across the Thames River to witness the burning of the Houses of Parliament. Unlike them, he filled two sketchbooks. He made drawings and watercolors from several positions, even hiring a boat to take him down the river. He would complete two oil paintings in his studio (16-14) based on the national tragedy, causing critics to call him "the fire King."

One can easily see why the scene so captivated Turner, a man who believed in nature's sublime and terrible magnificence. What a subject for a Romantic artist! The brilliant fire's golden light illuminates the night, sending sparks across the canvas, reflecting in the water below, framed by a vortex of billowing clouds of smoke. What better symbol of the awesome power of nature, one that makes the hordes of people who line the edges look quite small and insignificant? The sturdy and impressive Westminster Bridge on the right appears to disappear near the hellish blaze. The Houses of Parliament, a symbol of Western civilization and government, is no match for nature's fury and seems puny in contrast to the flames. These grand gothic buildings that had housed the British governing body for centuries (and English kings before them), the center of the great British Empire, were quickly swept away.

The inferno was a result of an ordinary human error—overloading a furnace with too much wood. Rebuilding took thirty years (Turner, as well as the architects, would not live to see it completed) and millions of pounds. In a strange irony, the terrible fire resulted in the creation of London's most famous symbol, the new Parliament's clock tower, known around the world as Big Ben.

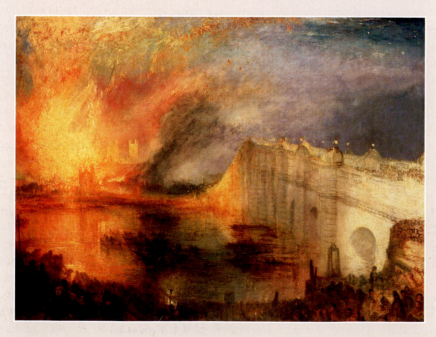

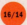 J. M. W. Turner, *Burning of the Houses of Parliament, October 16, 1834*, 1834 or 1835. Oil on canvas, 36¼" × 48½". Philadelphia Museum of Art, Pennsylvania.

16/15 THÉODORE GÉRICAULT, *Raft of the Medusa*, 1818–1819. Approximately 16' × 23'. Louvre, Paris, France.

16/16 EUGÈNE DELACROIX, *Liberty Leading the People*, 1830. Oil on canvas, 8' 6" × 10' 8". Louvre, Paris, France.

he visited hospitals to observe the sick and dying. Yet the final result, the *Raft of the Medusa* (16-15), has a unity that overrides incidental details and transforms the picture into an epic statement of the beauty and danger found in humanity and nature.

Searching for the most dramatic moment in the story, Géricault decided to illustrate the instant when the pitiful remnant of survivors finally caught sight of the ship that would rescue them. The dramatic impact of his canvas is the result of a strong, dynamic composition. The figures are arranged in a pyramid that thrusts from the lower left- and right-hand corners to the figure of a black man waving a flag. Thus the climax of the story is conveyed visually as the viewer's eye is swept swiftly to the peak of the pyramid.

When Géricault died at the age of thirty-four as the result of a fall from a horse, the leadership of the Romantic movement passed to Eugène Delacroix. (Delacroix had not only studied in the same studio as Géricault, but he had also posed for the central figure lying face-down in *Raft of the Medusa*.) Like the *Raft of the Medusa*, Delacroix's *Liberty Leading the People* (16-16) is an epic

painting based on an important contemporary event. In 1830, Paris rose in a three-day revolt against a repressive regime that was attempting to reinstate pre-revolutionary abuses, such as strict censorship of the press. Though he was not in the streets himself, Delacroix felt a great sympathy for this popular movement.

Like Géricault, Delacroix based his composition on a strong pyramid, but instead of receding into the background, the figures march out of the picture, into our space. This is a visual translation of the idea of progress, of victory. It is almost as if *Raft of the Medusa* had been turned around; a bare-breasted female (the allegorical representation of liberty) replaces the barebacked black man at the center of Géricault's earlier picture. Instead of looking at the action from the outside, we seem to be in the midst of the battle, with smoke swirling around us and bodies under our feet. In both pictures, triumph is juxtaposed directly with suffering and death.

In later years, Delacroix developed a freer style of painting that suited his dramatic subject matter. His *The Abduction of Rebecca* (16-17) is based on a story from Sir Walter Scott's romantic novel *Ivanhoe*, set in medieval England during the reign of Richard the Lionhearted. The beautiful Rebecca loves the hero

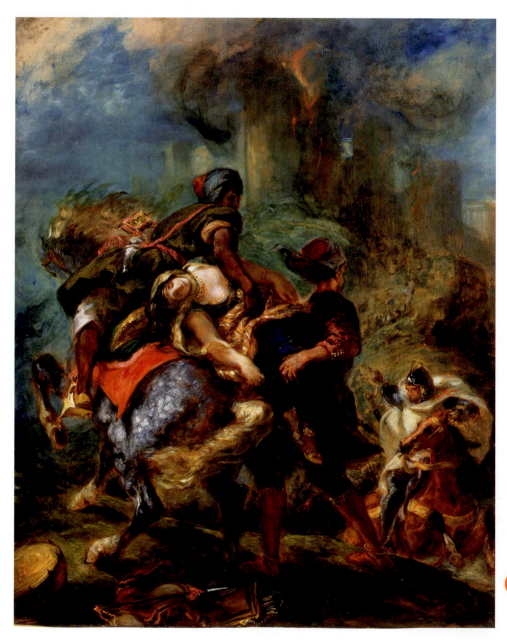

16/17 EUGÈNE DELACROIX, *The Abduction of Rebecca*, 1846. Oil on canvas, 39½" × 32¼". Metropolitan Museum of Art, New York.

Ivanhoe but can never be married to him because she is Jewish. Her persecutions make up a large part of the plot; in Delacroix's painting she is shown being thrown over a horse and carried away by the slaves of an evil knight who desires her.

The tempestuous subject and lively composition are well matched. The design is made up of many swirling curves, reminiscent of the work of Rubens, whom Delacroix greatly admired. But Delacroix's colors are more intense, his drawing and brushwork looser. Notice the variation of brushstrokes, the sense of urgency expressed in the flame-like mane of the rearing horse versus the evocative background of a burning castle billowing smoke and fire. Delacroix liberates color from old restraints. Notice how a color like turquoise will appear in many places—not just the sky but also a turban, the ground, and even the horse's rump. Delacroix's free and brilliant use of color would be an important influence on the Impressionists.

INGRES AND LATE NEOCLASSICISM

Popular as it was, Romanticism did not replace Neoclassicism. In France, the Neoclassical tradition of David continued in the work of his student Jean Auguste Dominique Ingres, who consciously opposed the Romantic style of his artistic rival Delacroix. The Romantic Delacroix was a colorist; Ingres insisted that beautiful line was more important than dramatic sweeps of color and tone. We have already seen his mastery of line in the drawing of a young woman in Chapter 4.

Ingres had been one of David's students, and won the Prix de Rome at the age of twenty-one in 1801. He would ultimately remain in Italy for eighteen years, first in Rome, then in Florence. During his early years in Italy, Ingres painted *Oedipus and the Sphinx* (**16-18**), based on a Greek myth about the tragic hero Oedipus (whose fate was to unknowingly murder his father and marry his own mother). The Sphinx was a monster with the body of a lion, the wings of a bird, and the face of a human woman. If Oedipus had failed to answer her riddle, she would have eaten him. (Notice the skeleton at the bottom left of the painting.) However, according to legend, Oedipus did guess the answer, and the Sphinx committed suicide in her fury at being outwitted.

Like the English Classicist Reynolds, Ingres hoped to make his reputation by mythological and historical paintings such as *Oedipus and the Sphinx*, but he actually gained greater fame from the portrait commissions he accepted to support himself. One of the most beautiful of these is his portrait of Louise, the Countess of Haussonville (**16-19**), the wife of a diplomat and a

16/18 JEAN AUGUSTE DOMINIQUE INGRES, *Oedipus and the Sphinx*, 1808. Oil on canvas, 74³⁄₈" × 56⁵⁄₈". Louvre, Paris, France.

16/19 JEAN AUGUSTE DOMINIQUE INGRES, *Comtesse d'Haussonville*, 1845. Oil on canvas, 4' 5¹⁄₂" × 3' ¹⁄₄". Frick Collection, New York.

brilliant society hostess, as well as a writer and ama-
teur artist.

Ingres pictures his subject in her own home, an
elegant and fashionable setting. The painting of the
still-life objects (such as the vases and flowers) and
the costume reveal Ingres's brilliant ability to recre-
ate realistic details of texture and pattern. Despite
the collection of precious art objects and rich furnish-
ings, however, the focus of the painting remains on the
countess, who stands at its center in a graceful pose.
Her expression and the touch of her finger to her chin
suggest that she is intelligent and thoughtful as well
as beautiful. Ingres was not just a master of detail,
but also of harmonious composition. The oval of the
countess's face is echoed in the oval formed by her
shoulder and forearm; all of the lines that describe her
figure are gently curved. This is far from accidental;
Ingres made about eighty preparatory studies before
he chose this pose and setting (4-2). Everything about
her is refined, delicate, and aristocratic—even slightly
cool. Compare this portrait to Raphael's *Madonna della
Sedia* (14-22), which Ingres admired above all other pic-
tures. Although Ingres has studied Raphael's line and

composition, his view of womanhood is far less sen-
sual and far more typical of nineteenth-century, upper-
middle-class morality.

THE FRENCH ART WORLD DIVIDED

Ironically, the French artists who most admired Ingres's
early work were Delacroix and the Romantics. But when
Ingres returned to France from his studies in Italy in
1824, he took up the fight against Romanticism with
great fervor. The French art world divided into two camps.
While Ingres led the new Classicists, who celebrated the
Renaissance artists like Raphael, the Romanticists were
headed by Delacroix, who revered the Baroque painter
Rubens. Ingres was particularly bitter in his condemna-
tion of the Romantic Rubenistes and all they stood for.
He would not even allow his students to *look* at Rubens's
paintings in the Louvre. He called Rubens "that Flemish
meat merchant." Ingres felt called on to preserve what
he saw as the timeless and true values represented
by Neoclassicism. The rivalry between Delacroix and
Ingres was fought not only in the salons but also in the
press. Each style had its supporters, patrons, critics, and
students.

A cartoon of the time (16-20) shows
the artists jousting in front of the Academy,
the older Ingres wielding a pen and
Delacroix hoisting a brush. While the car-
toon mocks both artists, it also grasps one
of the major differences between Ingres's
Classicism and Delacroix's Romanticism—
the distinction between what are called
painterly and **linear styles** of painting. A
linear artist like Ingres (or David, Raphael,
or Poussin) draws with sharp outlines,
clearly defined forms, and relatively solid
areas of color. A painterly artist like
Delacroix (or Turner or Rembrandt) paints
with broader strokes, without distinct out-
lines between shapes, with gradual grada-
tions of light to dark tones, and with colors
blended into each other. The clarity of the
linear style clearly has many attractions
for the Neoclassical painter, who wishes
to portray universal truths and appeal to
the intellect of the viewer. The painterly
style is more suitable for conveying mys-
tery and mood and thus appealed to many
Romantic artists, who hoped to reach their
viewers' emotions as well as their minds.

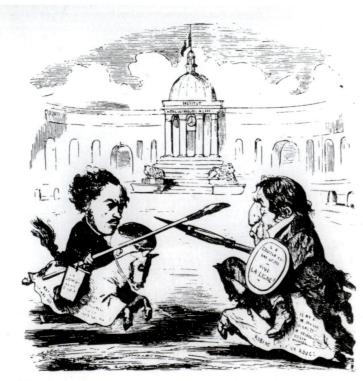

16/20 Caricature of Delacroix and Ingres jousting in front of the Institut de
France. Delacroix: "Line is color!" Ingres: "Color is Utopia. Long live
line!" Engraving.

ORIENTALISM

In the vicious battle between Neoclassicism and Romanticism, there was one mutual interest—a fascination with exotic foreign lands. **Orientalism**, or the study of Asian art and culture, swept Europe and the United States throughout the nineteenth century. While Americans were most interested in East Asia (China and Japan), Europeans were more attracted to subjects from the Middle East (today's Egypt, Arabia, Turkey, Iraq, and Iran), or in the case of the British, India. What these Orientalists had in common was a view of the peoples, history, and culture of Asia as "other"—the mysterious opposite of Western civilization. Oriental subjects and designs entered Western art at the same time that Europeans were attempting to dominate Asia both economically and politically.

Orientalism influenced all of the fine arts—painting, sculpture, architecture, photography, and design—as well as European literature, music, and philosophy. In some cases, the borrowing was overt, as in the Royal Pavilion at Brighton (16-21), built for the Prince Regent (the heir to the British throne and acting king after his father, George III, was declared insane). Known for his active social life and flamboyant taste, the Prince had architect John Nash design a seaside palace that echoes many oriental styles—note the multiple domes, minarets, and Islamic arches—particularly the famous Taj Mahal in India, which was then a recently acquired British colony. Nash's interpretation stands as a tribute to all of these influences, yet although the exterior and interior of the building have been inspired by the "look" of the Orient, they reflect no real understanding of Asian culture or architecture. The mixing of visual elements from very different societies, separate from their original function and meaning, reflects the European habit of appropriating exotic forms rather than respecting them. Collecting design elements, like trophies, from foreign lands and their imagination of the romantic past, nineteenth-century Europeans remixed periods and civilizations to create a fantasy vision. If Jefferson's Monticello (10-37) is the quintessential Neoclassical ideal, based on Greek and Roman models, Nash's palace is a purely Romantic confection. In Monticello, Jefferson lived the life of the mind; in the Royal Pavilion, the Prince Regent entertained on a lavish scale.

The building that inspired The Royal Pavilion was the Taj Mahal of Agra, India (16-22), recently selected

16/21 JOHN NASH, The Royal Pavilion at Brighton, 1815–1823.

as one of the new Seven Wonders of the World. The Taj served a very different purpose than Nash's palace. Rather than a personal residence, it was a royal tomb constructed in memory of Mumtaz Mahal, a beloved wife of the Mughal Emperor Shah Jahan (son of Jahangir, pictured in 1-19). The famous white marble edifice and its setting took twenty thousand workers seventeen years to complete; one thousand elephants were used on the

16/22 Taj Mahal, Agra, India. 1623–1647.

project. The structure was the result of a collaboration of architects and artists from throughout the Islamic world. No one knows exactly who developed the original concept, but the crown-shaped dome was designed by the Turkish architect Ismail Afandi, while inlaid mosaic designs were supervised by Chiranji Lal, an Indian jewelry artist from Delhi. Persian master Amanat Khan, who decorated the walls with calligraphy, was considered so important that he had a status equal to that of an architect.

The symmetrical structure is made up of precisely balanced shapes: The central block is surmounted by a dome of equal height, while the width of the block and its wings is exactly equal to the height of the block plus the dome. Minarets stand at each corner, their caps miniature versions of the side domes that flank the gently swelling central dome. The whole arrangement is placed on a high platform, reflected in a pool of water set within a garden. This pool is one of four long, narrow pools that criss-crossed the four symmetrical gardens each divided into four sections on the approach to the tomb (four being a holy number in Islam), and the whole is approached through a massive gate indicating that this is a place set apart from daily life, and symbolizing the gate to Paradise.

Despite its Western association with romance, the edifice's symbolism is religious. The entire complex of buildings, waterways, and gardens (which originally included beautiful beds of flowers) was meant to suggest Paradise as described in the Qur'an. Calligraphic inscriptions on the tomb refer to the Day of Judgment, when unbelievers will be punished and the faithful rewarded. The building is designed to evoke the Throne of God, beneath which only the most worthy Moslems will rest. The Shah himself decided to be buried with his beloved wife after his death.

Neoclassical artists were entranced with visions of the exotic East, and used Oriental themes in their artwork. For example, Ingres painted several versions of the *odalisque*, or harem slave—as did his Romantic rival Delacroix. The best known of these works is the earliest—Ingres's *Grand Odalisque* of 1814 (16-23), painted for Napoleon's sister Caroline, then Queen of Naples. Here the Neoclassicist Ingres aggressively asserts the primacy of line in the sinuous curves of the central figure, silhouetted against a black background. The reclining nude had been a staple of European painters since Titian's *Venus of Urbino* (see 14-23), but Ingres's elongated torso seems to owe more to a Mannerist influence than to the Renaissance attempt to revive ideal Classical forms. (Critics at the time complained that the odalisque's back was far too long and that her arms lacked bones.) Certainly, Ingres was not influenced by Islamic art, which did not depict the naked

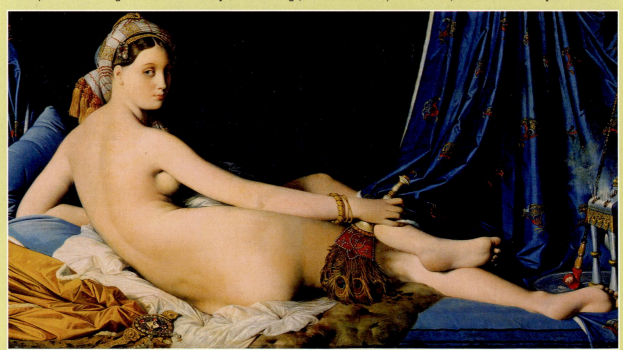

16/23 JEAN AUGUSTE DOMINIQUE INGRES, *Grande Odalisque*, 1814. Oil on canvas, 35⅞" × 63". Louvre, Paris, France.

body, male or female. Nor had he (obviously) ever visited a Turkish harem, where research suggests that women delighted in elaborate costumes rather than naked lounging. Instead, this is a Western beauty set among symbolic Eastern objects—a hashish pipe, a peacock-feathered fan, and an elaborate turban, borrowed from the collections of other artists to add a touch of exotic realism. Harem slaves or odalisques provided fascinating subjects for European painters throughout the nineteenth century, offering both a critique of the Eastern custom of keeping women enslaved for the sexual pleasure of a ruler and a titillating glimpse into a forbidden world of erotic pleasure.

AMERICAN ROMANTICISM: THE HUDSON RIVER SCHOOL

As Romantic art swept Europe in the nineteenth century, the winds of change reached the new nation of the United States, where the Romantic spirit created the first authentically American school of painting. (The term "school," when used in art, refers not to a real art school but to a group of painters working in a similar style.) Founded by Thomas Cole, this movement was named the **Hudson River School** after the wide and beautiful river that runs through New York State. The Romantic Hudson River artists saw in America a new, unspoiled land of great promise. They translated their vision into art by depicting many views of the Hudson Valley—an area already experiencing industrialization, although artists chose to show it as unspoiled—and other wilderness areas in the Northeast. The strong horizontal of the horizon line in Cole's *View on the Catskill, Early Autumn* (16-24), for instance, creates a calm, reflective mood. The winding river seems to meander slowly through a sunny world, fertile with possibilities.

Cole considered the landscape of Europe "long since destroyed or modified" and wanted to inspire our country to appreciate its exceptional "birthright." He wrote that "American Scenery . . . is a subject that to every American ought to be of surpassing interest . . . it is his own land:

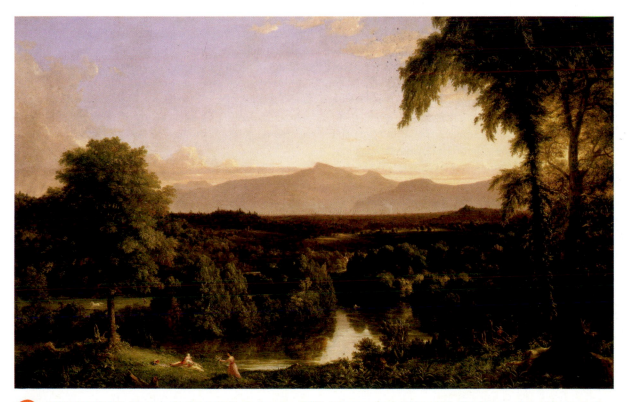

16/24 THOMAS COLE, *View on the Catskill, Early Autumn*, 1837. Oil on canvas, 39" × 63". The Metropolitan Museum of Art, New York (gift in memory of Jonathan Sturges by his children, 1895).

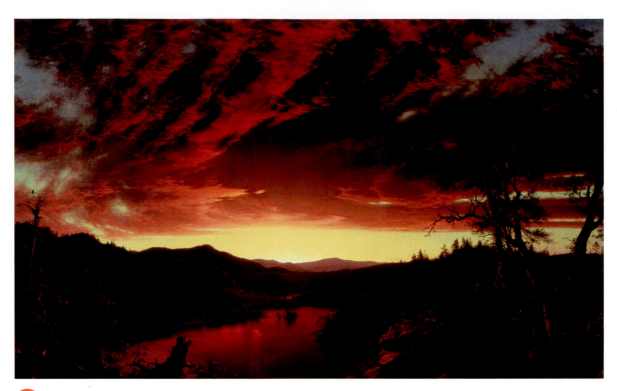

16/25 FREDERICK EDWIN CHURCH, *Twilight in the Wilderness*, 1860. Oil on canvas, 40" × 64". Cleveland Museum of Art, Cleveland, Ohio.

its beauty, its magnificence, its sublimity—are all his." While he had many admirers and followers, Cole had only two pupils. One of these, Frederick Edwin Church, went on to become the most famous and successful American painter of his period. Born to a wealthy Connecticut family, Church surprised his parents by his desire to become an artist. They were eventually won over by his success, which allowed him to live a comfortable, even luxurious life and finally to build Olana, a kind of dream castle of his own design on a hillside overlooking the Hudson. In a sense, Church was the greatest example of a Hudson Valley painter; in another sense, he went beyond Cole and the other members of the school. He traveled throughout the world searching for romantic landscapes. Church was even able to transform the symbol of Classicism into a Romantic ruin in his painting of the Parthenon (12-9). Church specialized in views of breathtaking grandeur, magnificent sunsets and sunrises, majestic mountains, waterfalls, volcanoes, and icebergs.

In works like *Twilight in the Wilderness* (16-25), he reveals his continuing interest in the symbolic power of landscape painting to excite human imagination and yearning for the infinite—as in the works of Friedrich and Turner. The dramatic, sweeping clouds that dominate the picture were painted with the new cadmium pigments: brilliant reds, oranges, and yellows then available for the first time. Contrasted against the green of the mountains and reflected in the mirror-like blue lake, these luminous magentas and pinks convey the majesty of the American

wilderness through their spectacular visual impact. At the same time, the vast sky with its glowing light seems to translate the idea of America as God's country—a land under special divine protection—into visual terms. Yet in 1860, the American wilderness was already disappearing. Viewers who flocked to see Church's work at special exhibitions in New York City (where his paintings were displayed surrounded by curtains, like windows into another world) appreciated not only the grandeur of the American landscape but also the nostalgic sense that such an unspoiled wilderness was already disappearing. The late nineteenth century was, indeed, *Twilight in the Wilderness*.

REALISM: ART AND POLITICS

In the early nineteenth century, a third -ism arose to challenge the movements of Neoclassicism and Romanticism—a style that became known as Realism. Realist artists focused on the world around them, particularly problems like poverty and political repression. Romantic artists like Goya, Géricault, and Delacroix had tackled such subjects, but Realists went a step further in exposing the gritty details of contemporary life. Led by writers like Flaubert, Balzac, and Zola, French literature moved in the same direction.

French Realist Honoré Daumier began his career as an illustrator, but he soon became a political cartoonist

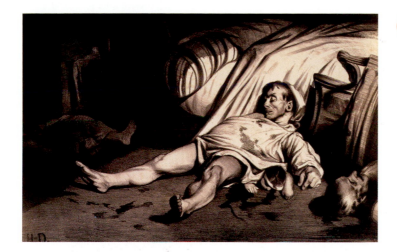

whose work was published in several satirical journals. In the 1830s, caricatures showing King Louis Philippe as a greedy giant swallowing up the people's earnings and another picturing his face as a fat pear landed the artist in jail for six months.

Although Daumier shared liberal political views with Romantic artists like Delacroix, his work is far more direct and realistic. In *Rue Transnonain* (16-26), like Delacroix, Daumier was recording a battle between the people in Paris and the government. In this case, workers joined in a weeklong protest against a new law that prohibited unions. One night, a lone sniper in a working-class apartment shot and killed a soldier. The remaining soldiers stormed the residential building and massacred the families they found inside.

In Daumier's lithographic print, it dawns on the viewer only slowly that a terrible tragedy has occurred: An entire family has been murdered. Unlike Delacroix, the Romantic, who chose the tone of an enthusiastic supporter to show

a revolt's heroic elements, Daumier, the Realist, honestly depicts the tragic aftermath of unjust violence. Rather than viewing the tragedy as heroic, Daumier stresses the bloody, messy, and also almost ordinary aspect of death.

Despite his challenges to governmental authority, Daumier was not the most controversial of the French Realists. The most famous of the French Realists was Gustave Courbet, an artist who was not content simply to caricature society but who actively set out to offend it. As a result of his radical political views, Courbet began exhibiting pictures that shocked the conservative art world, particularly the Salon (see Chapter 17). On huge canvases, he painted ordinary working and working-class people, as in *Burial at Ornans* (16-27). Here, on a grandiose scale (the painting is twenty-two feet wide), ordinary people stand clustered around an open grave in a rather desolate countryside. Neither Neoclassical (this is no death of a great figure, and in fact the person being buried is not even named) nor Romantic (there

16/27 GUSTAVE COURBET, *A Burial at Ornans*, 1849–1850. Oil on canvas, 10' 4" × 21' 11". Musée d'Orsay, Paris, France.

ROSA BONHEUR
WEARS PANTS!

The most famous woman painter of the nineteenth century was Rosa Bonheur, an eccentric individual who often wore male attire and kept a menagerie of animals in her household. Bonheur's training was Neoclassical; her father was an artist who rejected Romanticism, organized an art school, and brought up all of his children—male and female—to be artists. Her interest in nature and studying from real life, however, tied Rosa Bonheur to the Romantics and Realists. Claiming to have had no teacher but her father, however, she went her own way in both life and art.

The household in which the Bonheurs grew up was unconventional. At one point, their father left the family to enter a community of radical utopian socialists who believed in female equality, and whose approved costume for women was a long tunic over a pair of pants. This outfit was similar to what Bonheur wore to work and ride in for the rest of her life. As a child, Rosa (the oldest of four children) was considered a tomboy; educated along with her brothers, she delighted in physical games, and was eventually thrown out of a girls' school where she was

sent to be "polished." In her early twenties, Bonheur began studying animal anatomy by visiting slaughterhouses, where she was harassed by men. Dressing as a boy, she discovered, was the best way to remain unnoticed and free to go about her research.

Bonheur's most famous painting, *The Horse Fair* **(16-28)**, was inspired by the horse market in Paris, which reminded the neoclassically trained artist of the horses on the Parthenon frieze. In her multiple studies of animals and figures, Bonheur employed the method Géricault had used for *The Raft of the Medusa*. The final canvas is huge, dramatic, and full of life. The muscular, masculine subject could not be further from the typical work of most female painters of the time, who tended to specialize in flower paintings, still lives, portraits, and family scenes. Bonheur's father had promised her that she would surpass Vigée-Lebrun (15-35), and although that claim would be difficult to prove, her work was equally admired by royalty, including Emperor Napoleon III of France and Queen Victoria of England. After traveling through Europe and the United States, *The Horse Fair* was purchased

16/28 ROSA BONHEUR, *The Horse Fair*, 1853–1855. Oil on canvas, 8' ¼" × 16' ½".
The Metropolitan Museum of Art, New York.

by an American collector, which is why it now hangs in the Metropolitan Museum of Art in New York. Bonheur's dealer arranged for her to sell the copyright to reproductions separately from the painting itself, and her royalties from prints made her a wealthy and independent woman. She was the first woman to receive the Cross of the Legion of Honor. When Empress Eugenie of France awarded it, she declared, "genius has no sex."

Bonheur wore her hair cut short, smoked cigarettes, and usually wore trousers. In order to wear male dress on her travels, Bonheur even received official permission from the French government—supposedly for "reasons of health." Unlike George Sand, a contemporary French female writer who wore men's clothes as a sign of rebellion, Bonheur always said that her choice of pants and a smock was practical rather than political (16-29). Whereas Sand had a series of lovers, Bonheur spent most of her adult life living with a female friend and her family in a large Château with extensive grounds. There they kept a collection of farmyard and exotic animals, including sheep, cows, horses, and chickens, as well as lions, elk, and a yak—and many others. Rosa Bonheur's lifelong success—artistic and financial—proves that despite Victorian conventions, nineteenth-century women were able to express themselves creatively and through an unconventional lifestyle.

16/29 *Rosa Bonheur.* Collection of Gérard Lévy, Paris, France.

is no adventure among these somber figures), the composition is rather boring, and the painting feels almost pointless. Courbet attained the realism he desired by faithfully copying individuals from his native village, dressed in their ordinary clothes, not idealized or beautified in any way. This is similar to his accurate depiction of real people in his *Studio of a Painter* (1-42). For one of his most controversial paintings, *The Stonebreakers* (lost or destroyed during World War II), the socialist artist focused on the backs of two laborers breaking rocks for a road. Courbet's critics recognized the antibourgeois and anticapitalist message of this new art and considered his annual entries to the Salon insults to its traditions and values.

The Realist painter Jean François Millet's inspiration came from rural life rather than the town or city. Like Courbet, Millet had grown up among farming people. After a decade of living in Paris, where he received artistic training, he returned to the countryside. From the first, Millet was attracted to the theme of work and workers. In the past, artists had often shown peasants as humorous or picturesque subjects, but Millet made

them monumental. With bent backs, his workers (male or female) seem to have been shaped from the earth they tend. In *The Gleaners* (16-30), which was displayed at the Salon of 1857 (see Chapter 17), Millet shows three women gathering the "gleanings," or leftover grains, from a field that has already been harvested. These are the poorest of the poor—landless peasants who must toil all day in what was literally backbreaking labor just to collect a few grains.

To translate this reality into pictorial terms, the artist shaped the women almost like lumps of clay and echoed the placement of their figures in the haystacks at the edge of the field. Millet's method of handling paint seemed as rough as his subjects. Instead of creating the smooth, glazed surface favored by popular artists, Millet practically piled his paint onto the canvas. Areas of colored pigment became dense and heavy. His colors were most often earth tones or grayed neutrals. According to critics, his pictures were socialistic and ugly; one even said they had the odor of those who did not change their linen. Millet probably did not consider this an insult.

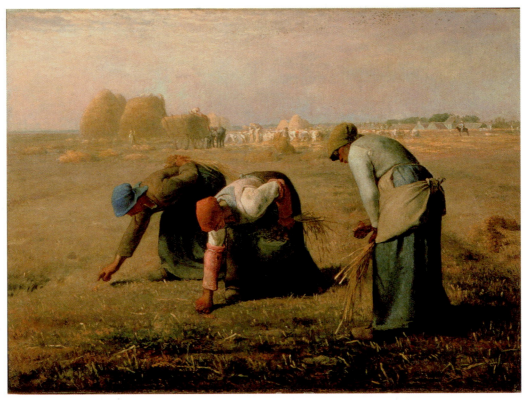

16/30 JEAN FRANÇOIS MILLET, *The Gleaners*, 1857. Oil on canvas, 33" × 44". Musée d'Orsay, Paris, France.

NEOCLASSICISM AND ROMANTICISM MERGE IN ACADEMIC ART

In the mid-nineteenth century, a style of painting emerged that integrated aspects of Neoclassicism and Romanticism into a highly acceptable, and popular, formula. This style was approved by the French Royal Academy of Painting and Sculpture, which organized annual exhibits, known as *Salons*, accepting or rejecting submitted works and handing out prizes. The works that won critical praise and patronage (which became known as *academic art*) were extremely detailed and colorful scenes from history, literature, mythology, or exotic lands. Purchasing such works suggested that the patrons—including newly rich and upwardly mobile industrialists from Europe and the United States—were genteel, tasteful, and educated.

One of the most successful of these academic artists was Jean-Léon Gérôme. His *Death of Caesar* **(16-31)**

is a Classical subject, a historical scene familiar to the educated public of the day. It is the Ides of March. At the rear, the conspirators rush out to the streets moments after assassinating the leader of Rome. Caesar lies in the foreground, his throne toppled over. The painter admired Ingres and imitates his precise ideal forms and command of structure. He also believed in history paintings with the drama of Romantic art, to bring important and instructive events of the past to life for a modern audience. The result is a "you are there" scene with a glassy, smooth surface. As one critic of his time commented, "If photography had existed in Caesar's day, one could believe that the picture was painted from a photograph taken on the spot at the very moment of the catastrophe."

Rejecting the new, grittier approach of Realism, Gérôme and other academic artists continued to produce works in the same style for decades. Gérôme became a well-respected teacher at the French national art school, the Ecole des Beaux-Arts. By the time he died in 1904,

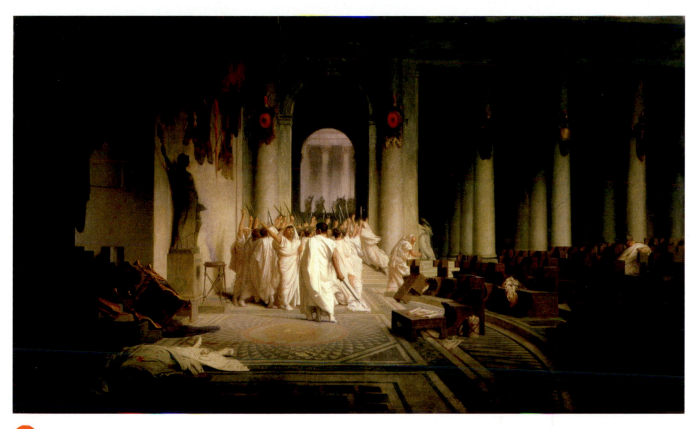

16/31 JEAN-LÉON GÉRÔME, *Death of Caesar*, 1859. Oil on canvas, 33⅝" × 57¼". Walters Art Gallery, Baltimore, Maryland.

European art had moved far beyond the battle between Neoclassicism, Romanticism, and Realism, and stood on the verge of the abstract and nonrepresentational revolution. In resisting Impressionism and Post-Impressionism, the movements that flowed from and supplanted Realism, Gérôme stood with the majority of his class, country, and profession. Not only did his own work remain the same, but in 1893, he argued that France should refuse a gift of Impressionist works. By that time, however, art history had clearly passed him by. Ironically, once Modern Art took hold, works like those of Gérôme and Bonheur were condemned as "academic" and devalued by museums and collectors. Only in the past few decades have art historians rediscovered and revived an interest in academic painting, and then largely as a reflection of its historical context and social meaning. No experts believe that the work of academic painters, however polished, can compare to the masterpieces of the Neoclassicists, Romanticists, and Realists who preceded them, or with the Impressionists who followed.

Thus, the battle of the -isms produced its own competing movements: an academic school that attempted to merge the best of Neoclassicism and Romanticism, versus an attempt by Realists to make art more modern and reflective of contemporary life. However, influenced by both the flat, abstract line of Neoclassicism and the vibrant colors, loose brushwork, and individualism of Romanticism, a revolutionary generation of artists was about to emerge. These radical individuals broke through artistic conventions that had been in place since the Renaissance. The Impressionists and Post-Impressionists transformed Western art from a cycle of competing styles into a whole new way of understanding—and making—the visual arts.

CHAPTER 17

The nineteenth century witnessed the creation of the modern city. Cities like Paris, London, and New York grew into huge metropolises. In the past, the royal court or the church had most often been the center of art patronage, but with the growth of the middle class in towns and cities, a new audience for art began to emerge. Newspapers and magazines commented on art and artists and reported on public opinion about the arts. The relationship between artists and the public changed too, and the modern art market was born. No longer were most paintings done "to order" for wealthy collectors. Instead, artists created artworks in their studios and then attempted to sell their wares in galleries. Some became incredibly successful and wealthy; most struggled to make a living. But most artists shared one thing: they lived in urban centers, where they could interact with each other and be part of an art world that included gallery owners and critics, as well as artists and collectors. The life of the city had a vital impact on these mid-nineteenth-century artists.

1850–1870

PERIOD

THE VICTORIAN PERIOD IN ENGLAND
REALISM IN ART AND LITERATURE
THE SALON AND ACADEMIC ART
THE SECOND EMPIRE IN FRANCE

HISTORICAL EVENTS

Japan opens trade with the West **1854**
Transatlantic cable completed **1858**
Darwin publishes *Origins of Species* **1859**
Serfs freed in Russia **1865**
American Civil War **1861–1865**
Slaves freed in United States **1865**
Suez Canal opened **1869**
Meiji Revolution in Japan **1866–1869**

ART

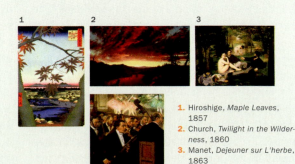

1. Hiroshige, *Maple Leaves*, 1857
2. Church, *Twilight in the Wilderness*, 1860
3. Manet, *Dejeuner sur L'herbe*, 1863
4. Degas, *Orchestra of the Paris Opera*, 1868–1869

OUT OF THE STUDIO AND INTO THE LIGHT:

IMPRESSIONISM AND POSTIMPRESSIONISM

1870–1885

IMPRESSIONISM
THE GILDED AGE IN THE UNITED STATES
UNIFICATION OF ITALY

1885–1900

POSTIMPRESSIONISM
FIN-DE-SIÈCLE IN EUROPE

Conquest of Western Plains in United States 1865–1880
Italy annexes Rome 1870
Unification of Germany 1871
Dominion of Canada stretches from Atlantic to Pacific 1871
Bell invents telephone 1876
Edison invents the light bulb 1879

European Imperialism, The Scramble for Africa 1880–1914
Indian National Congress established 1885
Meiji Constitution in Japan 1889
Spanish American War 1898
Boer War in South Africa 1899–1901

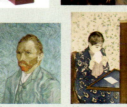
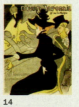

5. Monet, *Impression: Sunrise*, 1872
6. Renoir, *La Loge*, 1874
7. Morisot, *Woman at her Toilette*, 1879
8. Rodin, *The Thinker*, 1880
9. Germantown "eye-dazzler" rug, Navajo, 1880–1890

10. Oath-Taking Figure, Congo, 1880–1890
11. Cezanne, *Boy in a Red Waistcoat*, 1888–1890
12. Van Gogh, *Self-Portrait*, 1889
13. Cassatt, *The Letter*, 1891
14. Toulouse-Lautrec, *Divan Japonaise*, 1893

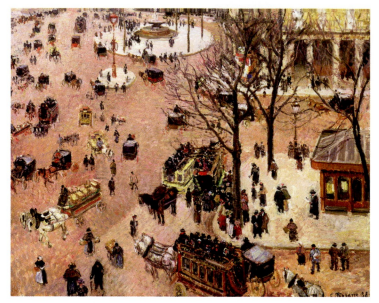

Nowhere was this more true than in Paris. The capital of France, once deserted by Louis XIV for the artificial city of Versailles, was now again the hub of French government and culture. Rich, middle-class, working-class, and poor rubbed elbows—in the narrow medieval streets, in the formal squares that formerly displayed the power of absolute monarchs, on the wide boulevards recently designed by Baron Haussmann, and in the new public parks. Camille Pissarro's *La Place du Théâtre* (17-1) is one of many street scenes that convey the bustle of Paris's busy thoroughfares and the daily activities of ordinary people in the modern city. Paris was an exciting place to be.

17/1 CAMILLE PISSARRO, *La Place du Théâtre*, 1895. Oil on canvas, 28½" × 36½". Los Angeles County Museum of Art, California.

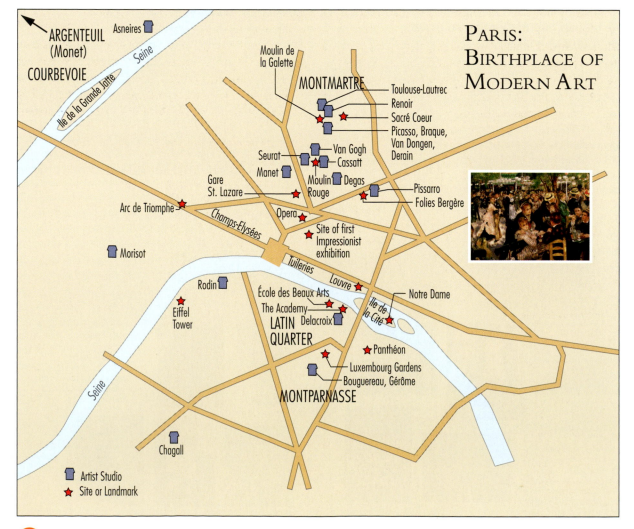

PARIS: BIRTHPLACE OF MODERN ART

ARGENTEUIL (Monet)
COURBEVOIE
Asnieres
Seine
Île de la Grande Jatte

Moulin de la Galette
MONTMARTRE
Toulouse-Lautrec
Renoir
Sacré Coeur
Picasso, Braque, Van Dongen, Derain

Seurat
Van Gogh
Cassatt
Manet
Moulin Rouge
Degas
Pissarro
Folies Bergère

Gare St. Lazare
Arc de Triomphe
Champs-Elysées
Opera
Site of first Impressionist exhibition

Morisot
Tuileries
Louvre
Notre Dame

Rodin
École des Beaux Arts
The Academy
Delacroix
Île de la Cité

Eiffel Tower
LATIN QUARTER
Panthéon
Luxembourg Gardens
Bouguereau, Gérôme

Seine
MONTPARNASSE

Chagall

🏠 Artist Studio
⭐ Site or Landmark

Map 17/1 Paris: The Birthplace of Modern Art

THE SALONS AND ACADEMIC ART

Yet, in a very important way, the art market in France had not changed. Begun in 1737, the annual **Salon** exhibitions in Paris, which were chosen by members of the French Academy and officially sanctioned contemporary art, remained the only important public exhibition available to artists. Although generally competently drawn and composed, academic paintings had become largely a repetition of historical, mythological, literary, and exotic subjects, all presented in a similar style. Large canvases on epic historical, literary, and biblical themes, such as Jean-Léon Gérôme's *Death of Caesar* (16-31), were praised by the Academy as contemporary masterpieces.

But not all artists were satisfied with repeating the formulas of the past. Once again, a new generation rose up to challenge old doctrines and propose new solutions. What was unusual was not so much the challenge itself; we have seen others before: the Mannerists versus the High Renaissance, or the Neoclassicists versus the Rococo. But the bitterness of the earlier battles was nothing compared to the hostility inspired by the

radical art movements of Realism, Impressionism, and Postimpressionism. In part, this happened because, as these styles evolved, they began to challenge the most important premises of Western art. It was in the nineteenth century that the ideals of Renaissance artists were overthrown and a new world of possibilities opened up for what would be known as Modern Art.

Gustave Courbet was a Realist (see Chapter 16) who was not content simply to caricature society but who actively set out to offend it. As a result of his radical political views, Courbet began exhibiting pictures that shocked the conservative Salon. On huge canvases, he painted ordinary working people—not just working-class people but people actually doing work. Critics recognized the antibourgeois and anticapitalist message of this new art and considered his annual entries to the Salon insults to its traditions and values. For example, in 1857, Courbet presented the Salon with a picture of two young women openly lounging on the banks of the Seine (17-2). The girl in the foreground has taken off her dress and is lying openly in her underwear, a corset, and petticoat. Whether they were prostitutes or simply young working women, they were clearly not respectable. Courbet had taken a real scene from Paris life—a scene from which

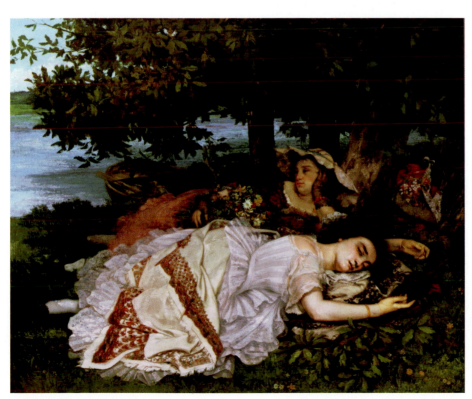

17/2 GUSTAVE COURBET, *Two Girls on the Banks of the Seine*, 1856. Oil on canvas, 5' 6½" × 6' 9⅛". Musée d'Orsay, Paris, France.

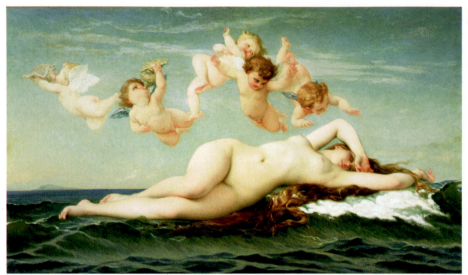

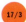 ALEXANDRE CABANEL, *The Birth of Venus*, 1875. Oil on canvas, 41¾" × 71⅞". The Metropolitan Museum of Art, New York (Gift of John Wolfe, 1893).

proper middle- and upper-class people would have turned their eyes—and glorified it by immortalizing it on a large canvas. Now these same people could no longer pretend "not to see" the seamy side of Parisian life. Visitors coming into the Salon to contemplate uplifting historical and mythological subjects would discover a slice of life they would rather ignore.

A picture such as this appeared graceless and ugly to most mid-nineteenth-century viewers, who either did not understand or did not agree with what Courbet wanted to accomplish. Popular taste called for women to be shown as goddesses, as in *The Birth of Venus* **(17-3)**, or at least as pure and unattainable, like the *Comtesse d'Haussonville* by Ingres (16-19). As a Realist, Courbet struggled against this kind of idealization. Interestingly, Cabanel's *Venus* from the Salon of 1863 is completely nude, while Courbet's young women are still half-dressed. Yet Courbet's vision of contemporary society shocked viewers, while Cabanel's idealized female body (which looks as if it were made of marble rather than human flesh) proved immensely popular with the upper classes. The French Emperor, Napoleon III, purchased the original, and Cabanel was commissioned to paint copies for many other wealthy collectors. This version was ordered by an American banker in 1875, more than a decade after the first was the celebrated hit of the Salon.

IMPRESSIONISM

THE SALON DES REFUSÉS AND MANET

In 1863 (the same year that Cabanel's *Venus* was first exhibited), four thousand artists were refused by the official Salon. The rejections became such a scandal that Napoleon III sponsored an alternative exhibit—known to history as "The Salon des Refusés." For the first time, the state had sponsored a show not approved by academic juries. Artistic freedom of speech was now officially supported. Of all the pictures on display, one in particular excited the liveliest debate and most bitter condemnation. Painted by a young artist named Édouard Manet, it showed a naked woman picnicking with a group of well-dressed, middle-class gentlemen in a park. Both the subject and the way it was painted were criticized at great length in the press. The art public experienced *Le Déjeuner sur l'herbe* (*Luncheon on the grass*; **17-4**) as a slap in the face. Many art historians have called it the first example of Modern Art.

Manet was a wealthy member of the Parisian *bourgeoisie* (upper middle class) and had not deliberately set out to be the same kind of radical artist as Courbet. However, as an art student, he had shown little interest in the academic tradition. He said that when he went to class, it was like entering a tomb. *Le Déjeuner sur l'herbe* was meant by Manet to be seen as a painting in the academic tradition—a nude reclining in a landscape, a theme that had been popular since the Renaissance—but reinterpreted in a modern, realist fashion. However, because Manet clothed his gentlemen in contemporary dress, Parisians found that the scene had many of the same shocking sexual overtones they had objected to in Courbet's *Two Girls on the Banks of the Seine*. Manet's woman appeared not to be a classical goddess, but simply a prostitute. To show such a naked, shameless creature in the midst of dallying with young men scandalized the bourgeoisie. Some wondered if he were joking.

The way Manet painted was considered just as offensive as his choice of subject. To many viewers, this immense canvas seemed like an unfinished sketch. The

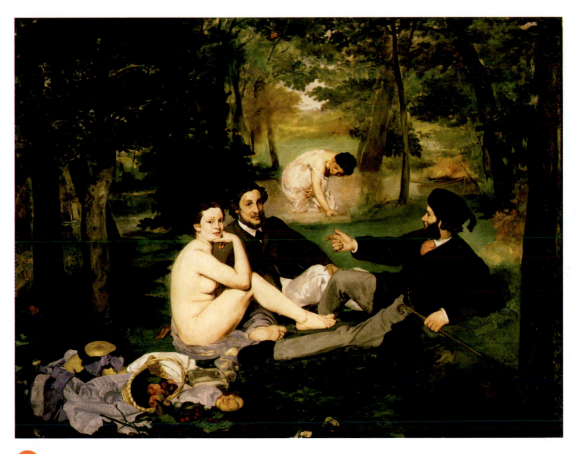

17/4 ÉDOUARD MANET, *Le Déjeuner sur l'herbe*, 1863. Oil on canvas, 7' × 8' 10". Musée d'Orsay, Paris, France.

nude was particularly criticized for lacking beauty. She had been painted boldly, in high contrast without transitional tones or shades. The stark contrast between her pale body and the dark background also appeared crude and awkward, as if the artist did not know how to do any better. The figure, however, does not reveal incompetence but Manet's fascination with the new media of photography. Early photographs showed Manet that extremely realistic images could be made even if one eliminated most detail and subtle shades.

Manet's style also owed something to past masters. The Baroque master Velázquez was a lifelong influence. Velázquez (see detail of *Las Meninas*, 15-17) had created his realism by suggestion, not with precise details but by capturing the way light hit surfaces. Under his influence, Manet began to paint in strong and defining strokes, creating bold and flat shapes. As Manet developed as an artist, the very arrangement of these strokes of paint, their placement on the canvas, was becoming an important part of the painting itself. That is, the *way* in which Manet used paint was becoming as important to him as his subject matter—it actually was becoming the subject of his work. This would become one of the central ideas of Modern Art.

OUT OF THE STUDIO AND INTO THE LIGHT

Manet became a symbol for the young painters of Paris. Although Manet never took part in the exhibits arranged by these radical young artists—who would soon be known as the **Impressionists**—he came to be seen as the "father" of the new movement. The younger painters were interested in working outdoors, directly from nature. They were assisted by a new invention of the 1840s—the packaging of oil paints in metal tubes—which made oil paint portable for the first time. Previously, artists had mixed hand-ground pigments with oils in the studio—a painstaking, time-consuming procedure. For this reason, outdoor sketches were done in pencil, chalk, or watercolor and only later transferred to oil on canvas, an indirect method of portraying reality.

This new generation of artists drew from their experiences around Paris. They shared the goal of the Realists to show ordinary contemporary life, but their palette was much brighter. As Manet began to work alongside these younger painters, particularly Claude Monet (see the next section), his colors also became brighter and lighter. Inspired more by Japanese prints (see "Global View" box) and the life of the city around him and less

17/5 ÉDOUARD MANET, *Boating*, 1874. Oil on canvas, 38¼" × 51¼". The Metropolitan Museum of Art, New York.

by past masterpieces, Manet's work began to resemble that of his Impressionist followers. Air, color, and light entered his work.

In 1874, a little more than a decade after he electrified the art world with *Le Déjeuner sur l'herbe*, Manet painted a Parisian couple boating on the Seine (17-5). Here we can see the influence of the younger Impressionists on his style, especially in the choice of lighter, brighter

colors, broken brushstrokes (as in the woman's dress and the water), and the immediate, split-second view. In comparison, Manet's earlier painting seems dark and old-fashioned, with its small figures set in the midst of a traditional landscape. Retaining his strong sense of design and bold handling of paint, by the mid-1870s, Manet expressed himself confidently in the new Impressionist style.

MONET, THE PURE IMPRESSIONIST

To truly understand the essence of the Impressionist movement, one must examine the work of Claude Monet. Monet not only painted the picture that gave Impressionism its name, but he also represents the purest example of the Impressionist method, subject matter, and spirit. In the 1860s, there was a fresh breeze in the air. The word for it was *modern*. To be modern was to be alive, youthful, and optimistic. The most modern city was Paris, and young artists flocked to it filled with enthusiasm. They painted the outdoor life of the city, its suburbs, and popular resorts. At the floating restaurant and dancing pavilion known as *La Grenouillère* (17-6), artists, writers, musicians, and dancers—male and female—came from Paris (the trip took less than an hour) to fish, row, swim, eat, drink, dance, and relax.

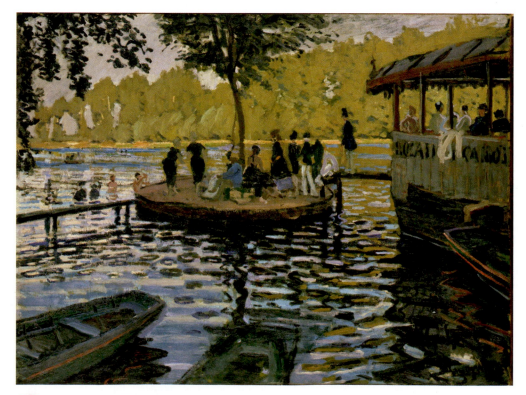

17/6 CLAUDE MONET, *La Grenouillère*, 1869. Oil on canvas, 29⅜" × 39¼". The Metropolitan Museum of Art, New York.

17/7 Detail of figure 17-6.

In his view of the restaurant, Monet achieved heightened color effects by placing colors side by side rather than mixing them. The water in the foreground, for instance, is made up of rough, overlapping, unblended strokes of sky blue, white, and black, with dabs of gold ochre added to suggest the reflection of the floating pavilion on the ripples of the river (17-7).

In 1872, Monet completed a painting that was destined to give an ironic title to the whole new movement that he and other painters had begun. *Impression: Sunrise* (17-8) was a view of the French port of Le Havre with the sun just visible over the horizon. Its vivid colors and lack of detail or outline convey an immediate impression of a place and time of day. This painting was part of the first independent exhibit organized in 1874 by Monet and his friends. They called themselves the *Société Anonyme* (or Incorporated Society) of artists, painters, sculptors,

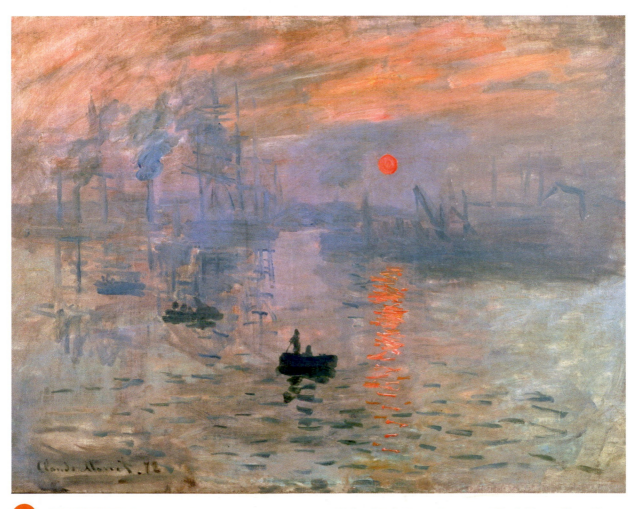

17/8 CLAUDE MONET, *Impression: Sunrise*, 1872. Oil on canvas, 19⅝" × 25½". Musée Marmottan–Claude Monet, Paris, France.

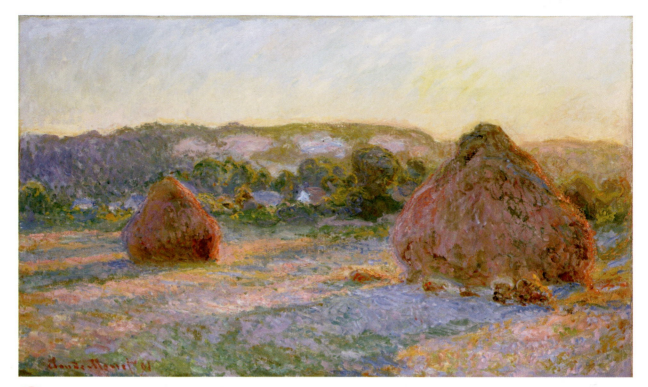

17/9 CLAUDE MONET, *Grainstacks (End of Summer)*, 1891. Oil on canvas, 23½" × 39". The Art Institute of Chicago, Illinois (Arthur M. Wood in memory of Pauline Palmer Wood). Photograph © 1993, The Art Institute of Chicago. All rights reserved.

engravers, and so on. The exhibit was not well received. The paintings lacked the "finish" that the public associated with great art, were "too freshly painted," and seemed to resemble sketches rather than completed works of art. "Wallpaper in its embryonic state is more finished than this seascape," wrote one critic of *Impression: Sunrise*. Noting the title of the work, he titled his review, "Exhibition of the Impressionists"; they became known by that name to their contemporaries and to history.

MONET IN GIVERNY

Several more Impressionist exhibitions occurred, all receiving negative reviews. Most of the artists lived a hand-to-mouth existence. But by 1883, Monet had managed to sell some of his work. He rented a farmhouse in Giverny, a small village on a river outside Paris. Now living in the French countryside, he began to explore new visual themes—rivers, trees, and fields. As the years passed, Giverny became increasingly central to Monet's work. Eventually he purchased the property, which became not only a family home and studio but also the setting for his famous gardens and the subject of much of his later work.

In 1888, he began the first of his famous series of paintings with several views of the muffin-shaped stacks of wheat in a neighbor's field. Repeating the same subject, popularly known as "haystacks," over and over, Monet painted dozens of views in different conditions of weather and different times of the day. As he worked,

Monet became sensitive to minute and subtle differences in his subject over short periods of time—in as little as twenty minutes or half an hour, he discovered that the light had changed. Thus he set up a series of canvases and worked on each one only as long as the view remained the same. Eventually twenty-five paintings were completed.

In *Grainstacks (End of Summer)* (17-9), Monet shows the long shadows and golden light of late afternoon. In comparison with his earlier work, the colors are richer and the brushstrokes heavier, laden with thick paint. Monet uses paint to create a purely pictorial texture, which boldly states that we are looking at paint on canvas, not a photograph of reality. Yet, Monet is also attempting to convey something about the natural world—a quality of light and atmosphere—through his color. The setting sun has turned the grainstacks orange and pink, warm against the bluish shadows. The Impressionist use of such vibrant colors reflects nature and the way we see. Lights are not made up of white alone, nor darks of black and gray; in reality, lights and shadows vibrate with color. This had always been part of the Impressionist technique; now Monet pushed further, exaggerating natural colors for a heightened effect.

With the money he made from his new work, Monet created his own natural paradise at Giverny. He designed and planted a lush garden where water reflected beautiful and exotic flowers. In addition to landscaping the

grounds and designing the plantings, Monet added touches such as a Japanese footbridge (17-10). All of this became the subject of his late work.

During the last twenty years of his life, Monet created his most radical work—paintings that appeared dramatically new even when compared to works by the much younger Picasso and Matisse (see Chapter 18). His final project was a series of panels of the water lilies that bloomed in his gardens (17-11). He called them decorations and planned that each would be 6 1/2 feet high by 14 feet long. The resulting paintings remain his most famous and popular works. Although the subject—water lilies in a pool that also reflects the sky and gardens around it—can be recognized, it seems almost incidental to the beauty and power of the densely painted image. Three-dimensional form has finally dissolved into pure color, texture, and paint. Vibrant purples and greens float across the canvas; the visual play of color and painted line, the variations of painted texture, the creation of a purely pictorial space built up from individual strokes of color—the Impressionist style had evolved into something dramatically modern, unprecedented in the history of Western art.

RENOIR

Another artist whose pictures infuriated the critics, although they seem quite beautiful to modern eyes, was Monet's friend, Pierre-Auguste Renoir. They had met as students, and abandoning their formal training, often painted side by side. They shared bread and the insults of critics. In 1876, a well-known journalist wrote that the second Impressionist exhibit was made up of "five or six lunatics" attempting "the negation of all that has made art what it is." Another critic compared the

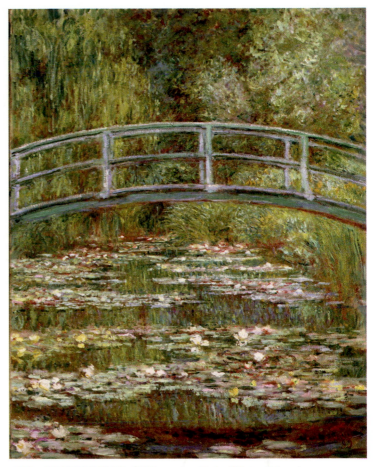

17/10 CLAUDE MONET, *Bridge over a Pool of Water Lilies*, 1869. Oil on canvas, 36½" × 29". The Metropolitan Museum of Art, New York (H. O. Havemeyer Collection, Bequest of Mrs. H. O. Havemeyer, 1929).

flesh of Renoir's nudes to "a mass of decomposing flesh with those purplish green stains which denote a state of complete putrefaction in a corpse." Yet, more than one hundred years later, Renoir's portraits of women are tremendously admired as representations of female beauty (see *La Loge*, 1-36).

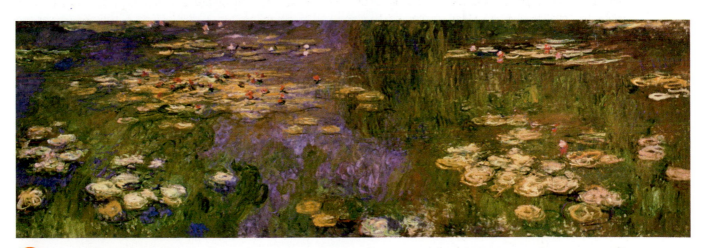

17/11 CLAUDE MONET, *Nympheas* (Water Lilies), 1915–1926. Oil on canvas, 77¹⁵⁄₁₆" × 234⁷⁄₈". Carnegie Museum of Art, Pittsburgh, Pennsylvania.

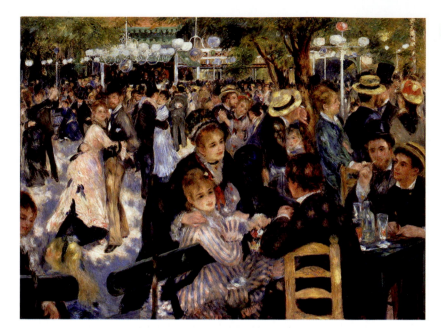

 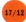 PIERRE-AUGUSTE RENOIR, *Le Moulin de la Galette*, 1876. Oil on canvas, 51" × 68". Musée d'Orsay, Paris, France.

Like all of the Impressionists, Renoir wanted to show the life he saw around him in Paris. But even more than the others, he was concerned with human interactions and moods. While Monet retreated from Paris to the fields and gardens of Giverny, Renoir always remained (in his own words) "a painter of figures." One of his most successful figure compositions, and one that seems to express all of the lighthearted gaiety of Parisian life, was *Le Moulin de la Galette* (17-12). The subject was a popular outdoor café where young middle-class couples could eat, drink, and dance. Renoir used several of his friends as models for the figures sitting at the tables or whirling around the dance floor.

The dappled light, broken brushstrokes, and bright colors are typical of Renoir's Impressionist style. Pinks are often contrasted with cool blues, yellows set against darks, but the darks themselves are vibrating with strokes of different colors. Somehow Renoir evokes not only the light of a late spring afternoon as it filters through the trees but also the movement of the dancers, the flutter of the breeze, the murmur of the crowd, the music and conversation, the taste of the wine—the pleasures of this particular place and time.

MORISOT

If the press was outraged by radical male artists, it found a female working in the bold new style even more appalling. Wrote one critic of Berthe Morisot: "There is also a woman in this group, as there nearly always is in any gang . . . and she makes an interesting spectacle. With her, feminine grace is retained amidst the outpourings of a mind in delirium." Morisot was most strongly influenced by Manet, whose brother she married in 1874. In *Woman at her Toilette* (17-13), Morisot portrays an

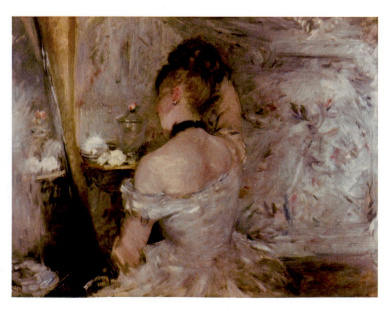

BERTHE MORISOT, *Woman at her Toilette*, c. 1879. Oil on canvas, 23¾" × 31⅝". The Art Institute of Chicago, Illinois.

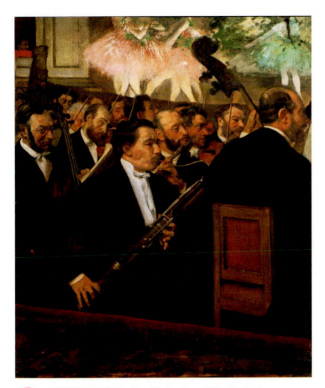

17/14 EDGAR DEGAS, *The Orchestra of the Paris Opera*, 1868–1869. Oil on canvas, 22" × 18". Louvre, Paris, France.

Like Renoir, Degas recorded the everyday life of the Parisian capital. His outdoor scenes were done not in wheat fields or gardens but at the racetrack. He was particularly fascinated by the pictorial opportunities he found in the world of the theater and ballet—at rehearsals, performances, or backstage. Despite his preparation of many preliminary drawings, his pictures do not appear formalized and stiff but like candid snapshots. In fact, he was an avid photographer, and photography added an important element to Degas's masterful and innovative compositions. For instance, in *The Orchestra of the Paris Opera* (17-14), Degas shows the opera ballet on stage but arbitrarily cuts their heads out of the picture. The cropping gives a quality of immediacy to his observations. Such novel arrangements made the impact of his images seem more alive.

In his late years, pastel became Degas's favorite medium. Where his oil paintings are often darker than those of the rest of the Impressionists, the colors he used in his pastels, like *After the Bath* (17-15), were vibrant, applied to the paper unmixed. At the same time, Degas combined these bold colors with his taste for

intimate interior with an elegant lady arranging her hair in front of a mirror. The viewer seems to stand behind her, peeking over her bare shoulder. The figure is sketched rather than defined, and the face of the subject is hidden. Much of the image is covered with loose, almost abstract brushstrokes that merely suggest a pattern on the wall behind the figure. The rich surface texture does not attempt to imitate flesh, satin, or a silvery mirror, as in Ingres's portrait of the *Comtesse d'Haussonville* (16-19), but instead offers the creamy impasto of oil paint. As her style developed, Morisot painted more freely and used a lighter palette. The basic ideas behind Impressionism were in harmony with her own: "to set down something as it passes, oh, something, the least of things!"

DEGAS AND CASSATT

If Monet, Renoir, and Morisot were the most typical of the Impressionists, Degas would seem to be the least. Most of his paintings are far from the open-air bustle of happy middle-class Parisian life that the public identifies as Impressionism. First, Edgar Degas was not a member of the bourgeoisie but a wealthy, rather snobbish young man from an aristocratic family. Second, while most of the Impressionists consciously rejected academic drawing, Degas truly admired the Neoclassicist Ingres (see Figure 4-2). The beauty of Degas's line remained one constant throughout his career.

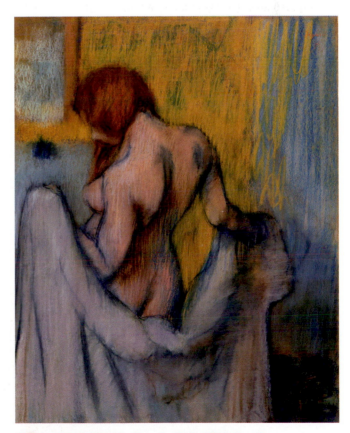

17/15 EDGAR DEGAS, *After the Bath*, 1894. Pastel on paper, 37¾" × 30". The Metropolitan Museum of Art, New York.

ARTIST vs. CRITIC

The relationship between the artist and the art critic has historically been an uneasy one. With the rise of Modern Art, however, the clash between artists and art critics often broke into open warfare. As we have seen, the Impressionists in France were often treated as laughing-stocks and the butt of particularly vicious comments. One reviewer wrote of their second exhibition that viewers will "roar in laughter in front of these works." Of Pissarro he wrote, "the things he paints are not to be seen in any country on earth, and no intelligent human being could countenance such aberrations." Most, but not all, artists suffered these reviews without retaliating—however, after reading a review by Edmond Duranty that described his painting as "a philosopher trampling oyster shells," Edouard Manet found the critic in a café and slapped him with a glove. The artist then challenged the critic to a duel with swords. They met a few days later in a nearby forest. After the critic received a minor sword wound, Manet agreed (at the urging of the seconds) that his honor had been satisfied.

One of the most famous battles of this period took place not in France, but in England. It was not held in a field of honor, but in a courtroom. In 1877, the American expatriate artist J. A. M. Whistler, best known today for the painting commonly called "Whistler's Mother," was exhibiting a new painting, *Nocturne in Black and Gold: The Falling Rocket* (17-16). The painting shows a fireworks display in London that Whistler, a prominent supporter of the Impressionists, had painted in the modern style. John Ruskin, one of the most famous critics of his day, described Whistler's picture as "cockney impudence" and "a pot of paint flung in the public's face." Whistler was outraged by the insults and decided to sue the critic for libel.

This was not the first time that Ruskin had criticized Whistler. A few years earlier, he had described another painting as "absolute rubbish, and which had taken about a quarter of an hour to scrawl or daub—it had no pretence to be called painting." Ruskin was an ardent believer in the academic historical painting that filled the Salons of both London and Paris. For him, great art was a time-consuming, painstaking process and had "morality." Whistler had studied in Paris and was friends with

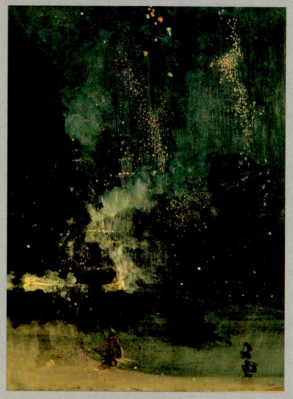

17/16 JAMES ABBOTT MCNEILL WHISTLER, *Nocturne in Black and Gold: The Falling Rocket*, 1875. Oil on canvas, 23¾" × 18½". The Detroit Institute of the Arts, Michigan.

Courbet, Degas, and Manet. The painter wrote, "Art should be independent of all clap-trap—should stand alone, and appeal to the artistic sense of eye or ear, without confounding this with emotions entirely foreign to it, as devotion, pity, love, patriotism, and the like."

Whistler asked for damages of one thousand pounds (and court costs) for the harm the review had done to his artistic reputation. Because of Ruskin's ill health, the trial did not begin for more than a year. When it began in the Old Bailey, the defense strategy was to criticize Whistler's painting technique. Artists were called as witnesses against Whistler. An old master painting by Titian (see 14-23) was brought into the courtroom and compared to Whistler's picture. Whistler was cross-examined and, in a famous exchange, was asked how long the painting had taken him. To the delight of the defense attorney, Whistler

calmly said only two days. When then asked if he could justify the high price he put on the painting for only two days' work, he said, "No. I ask it for the knowledge I have gained in the work of a lifetime."

The final result? There was really no winner. After a short but expensive trial, Whistler was declared the victor and awarded damages. Unfortunately, the damages were only one farthing (a coin worth less than a pound) and no court costs. The real result was that the trial bankrupted Whistler. While he proudly wore the farthing on his watch chain, he was soon forced to sell his home and would struggle financially for years.

As a younger man, Ruskin had been a proud defender of artists and had championed the proto-impressionist J. M. W. Turner (see Chapter 16). He also was a leader in calling for the preservation of medieval architecture in Europe, particularly Venice. After the trial, Ruskin's health continued to deteriorate. He became mentally ill and lived increasingly as a recluse and invalid at his home, publishing little, until his death in 1900.

strong design and beautiful lines. Notice how the composition is based on the complementary curving lines of the woman's shoulders and back contrasted to the U-shape of the towel. He allowed the strokes of the chalk to remain visible, clearly showing the viewer how he constructed his picture from lines of color. The color scheme places gold against turquoise, orange against green. The drawing has been greatly simplified, and the fussiness of detail is lacking. Degas's art draws its power from a fusion of Ingres's line, the solid form and composition of the great Renaissance masters, and the spontaneous realism of Impressionism.

Although Degas often used women, especially working-class women, for his subjects, he said more than once that he detested females. Despite this prejudice, Mary Cassatt won his respect and became a pupil and eventually a close friend. Born of a wealthy family from Pittsburgh, Cassatt had studied art in Philadelphia before coming to Europe and eventually settling in Paris. Although her father supposedly said that he would rather see her dead when she first proposed going abroad to study art, her family (like Degas's) provided enough money to be sure that she would never suffer the privations of most of the other Impressionists.

Also like Degas, Cassatt was more interested in line than the other Impressionists, and her work was also strongly influenced by Japanese prints (see 6-3 and "Global View" box, *Japonisme*). Her favorite subjects were women and children shown in unguarded moments. Most nineteenth-century artists would have sentimentalized this theme of a mother and her sleepy child on a boat ride in *The Boating Party* (17-17). Instead, Cassatt uses the

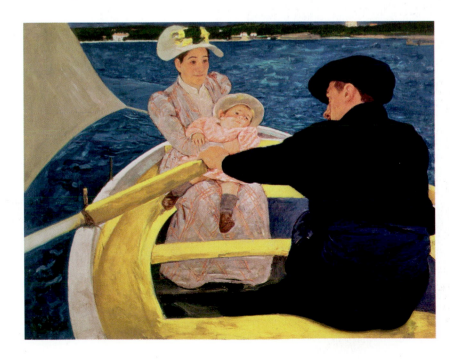

 MARY CASSATT, *The Boating Party*, 1893–1894. Oil on canvas, 35½" × 46⅛". National Gallery of Art, Washington, D.C.

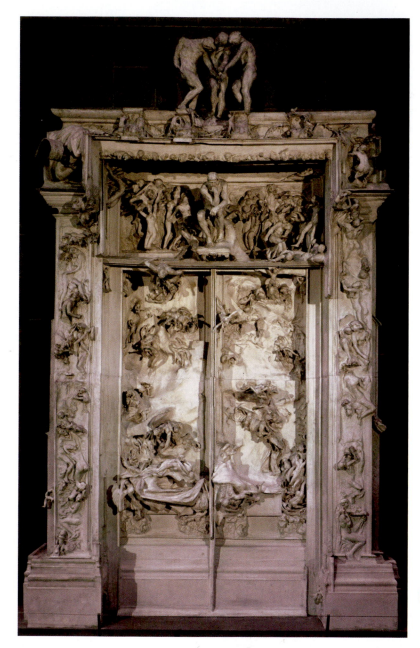

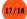 AUGUSTE RODIN, *The Gates of Hell*, 1880–1917. Intended to be cast in bronze, fully assembled in plaster, 21' high × 13' wide × 3' deep. Musée d'Orsay, Paris, France.

everyday incident as the basis of a dynamic composition. The strong horizontal seats of the rowboat, the thrusting diagonal of the oar, the broad expanse of the sail contrasted with the flat surface of the water, the opposing curves of the boat's gunnel, and the back of the rower all create an almost abstract composition of flat shapes and lines balanced against each other. The boldness of her shapes and colors—an acid lime-green against bright blue—are another reminder, as in the works of Monet, Degas, and Renoir, that the Impressionists never stopped developing. For most of these revolutionary artists, the Impressionist period of 1872 to 1886 was followed by an era of searching for new discoveries, new solutions to artistic problems.

RODIN'S TOUCH

The prolific nineteenth-century genius Auguste Rodin combined a love of past forms with an Impressionist sensitivity to artistic materials, along with a Romantic sensibility. In his hands, marble became as sensuous as flesh, and cast-bronze figures like his *Walking Man* (9-16) showed the rough thumbprints of their original clay models. In this sense, much of his work (like that of the Impressionists) appeared unfinished to viewers who expected flawless, almost mechanical smoothness in their statues.

However, Rodin's work was generally well received, and he won important commissions. *The Gates of Hell* (17-18), for instance, were originally designed as

a doorway to be cast in bronze for a new Museum of Decorative Arts in Paris. With this immense door, Rodin hoped to rival the greatest sculptures of the past, such as Ghiberti's bronze doors for the baptistery in Florence (14-3). Rodin took his inspiration from Dante's poem "Inferno" (the first book of *The Divine Comedy*). In a sense, the long shadow of Michelangelo (the artist Rodin most admired) also falls over *The Gates of Hell*. The huge door is a kind of sculptural equivalent of *The Last Judgment* (14-25). Yet, despite all references to the past, Rodin's interpretation of the subject was completely modern. Out of a pulsating surface are drawn twisted, tortured, isolated figures who must pay for their sins in circles of Hell, ever buffeted by the winds. Rodin envisions humanity as both eternally damned and forever lonely—the bodies that emerge out of darkness are imprisoned in their own pain. Above it all, the famous figure of *The Thinker* (17-19) sits, pondering the scene.

Rodin used his commission for *The Gates of Hell*—a project he never actually finished—as an opportunity to experiment with many sculptural ideas. It became the inspiration for his two most popular works: *The Thinker* and *The Kiss* (17-20), each later reproduced as statues in both marble and bronze. (The original gates were executed in plaster.) Although Rodin retained *The Thinker* as part of the *Gates*, he eventually rejected the figures of a naked man and woman embracing as too sensual for his conception of Hell. Instead he exhibited the figures as an independent sculpture in 1887. The public named this piece *The Kiss*, and its popularity was so great that the French government asked him to make a larger version in marble. Rodin referred to this statue as a "huge knick-knack" and seemed uninterested in completing it (the process took him almost a decade). However, like *The Thinker*, Rodin's lovers in *The Kiss* have attained an iconic status, recognized around the world. The young lovers, their smooth flesh emerging from a rough marble base, remain eternally entwined and symbolize the universal of human passion. Rodin remains one of the few modern sculptors whose work can be compared to that of Michelangelo and Bernini.

THE POSTIMPRESSIONISTS

Almost all of the artists who came to be known as the **Postimpressionists** began working in the avant-garde style of their time, Impressionism. However, each became dissatisfied with Impressionism and developed a new

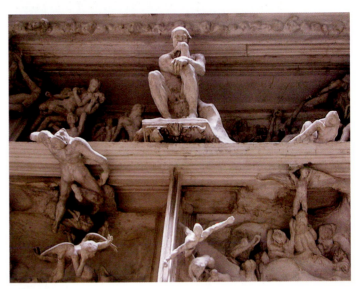

17/19 AUGUSTE RODIN, Detail of *The Gates of Hell*, *The Thinker*, 1880. Musée d'Orsay, Paris, France.

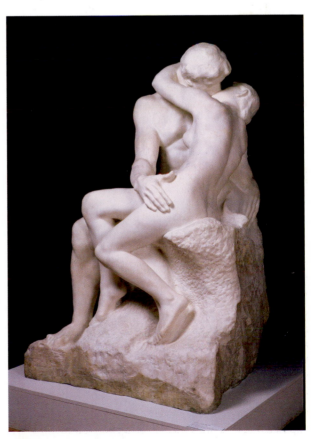

17/20 AUGUSTE RODIN, *The Kiss*, c. 1882. Marble, 71½" × 44⅓" × 46". Musée Rodin, Paris, France.

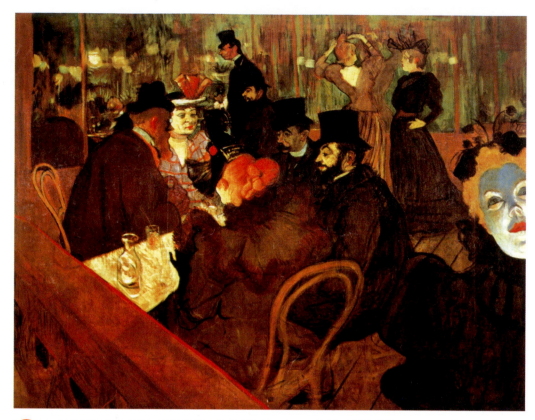

17/21 HENRI DE TOULOUSE-LAUTREC, *At the Moulin Rouge*, 1892–1895. Oil on canvas, 4' × 4' 7".
The Art Institute of Chicago, Illinois.

approach. The most important figures of this new generation of artists were Toulouse-Lautrec, Georges Seurat, Paul Gauguin, Vincent van Gogh, and Paul Cézanne.

TOULOUSE-LAUTREC

Henri de Toulouse-Lautrec was an aristocrat of distinguished lineage and an adoring admirer of Edgar Degas. However, the older artist refused to associate with him. This was because Toulouse-Lautrec was a peculiar aristocrat who enjoyed the seamier side of French nightlife, the houses of prostitution, and the "can-cans" (theatres where a risqué dance took place). He lived in an artificially lit world devoted to sordid pleasures. He came to live such a life because he suffered from dwarfism. Seen as deformed by his proper (and callous) father, he was treated as a humiliation to his family. Toulouse-Lautrec left his home as a young man and found acceptance among the prostitutes and cabaret artists of Paris. His childhood talent for drawing led him to his career.

A comparison between Renoir's *Le Moulin de la Galette* (17-12) and Toulouse-Lautrec's *At the Moulin Rouge* (17-21) can help us understand the striking contrast between the Impressionist point of view and Lautrec's. In Renoir's café, the people are young and happy, celebrating the innocent pleasures of city life.

In Toulouse-Lautrec's, the people are tired and ugly; we can almost smell the stale odors of cigarette butts and spilled liquor. One café is outdoors and filled with sunlight and color; the other is indoors and claustrophobic. In the friendly Impressionist painting, a pair of dancers looks toward the viewers as if to invite us in. In contrast, the horrifying green-faced woman at the right of *At the Moulin Rouge* pushes directly toward the viewer, as if to say, "Do you belong here?" It should not be surprising then that Toulouse-Lautrec was never accepted into the Impressionist group and that Degas said that "all his work stinks of syphilis."

SEURAT AND POINTILLISM

A painter of the highest ambition, Georges Seurat wanted to use Impressionism to recreate the timeless, classical feel of Millet and achieve the modern equivalent of Greek art. Seurat worked for two years on his *A Sunday on La Grande Jatte* (17-22). Its size, seven feet by ten feet, puts it on the scale of the grand canvases of David and Géricault, but his subject is entirely different. There is no pomp, suffering, or tragedy. He shows us the pleasures of a warm Sunday afternoon.

The subject, the colors, and the light could have been painted by most of the Impressionists. However, *La Grande Jatte* is unlike a typical Impressionist picture

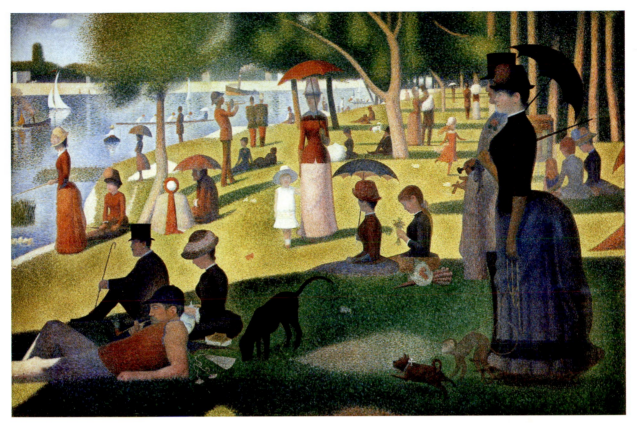

GEORGES SEURAT, *A Sunday on La Grande Jatte*, 1884–1886. Oil on canvas, 6' 9" × 10'. The Art Institute of Chicago, Illinois.

Detail of figure 17-22.

in that it is the result of many drawings and oil sketches. For months, Seurat went daily to the island of La Grande Jatte to make studies. His concentration was so fierce that he did not respond to friends who tried to get his attention. Seurat was assembling a composition of perfect stillness with figures as solid as statues.

La Grande Jatte is Seurat's most famous picture and justifiably so. Its nearly seventy square feet of canvas is completely covered with tiny dots of color (see detail, 17-23), a method that was the result of years of experimentation. Seurat had noticed that, paradoxically, the smaller his brushstrokes, the more solid the form and the greater the intensity of the colors. His new method of painting, called **Pointillism**, helped him achieve what he had been searching for—more brilliance and light, as well as a sense of permanence.

The final form of the painting was created by a three-stage process. First, Seurat simplified the forms (people, trees, animals) until they were almost silhouettes and their basic geometric shapes could be seen (his drawing, *L'écho*, 2-12, is a good example). Second, he arranged the forms into a satisfying composition, altering them when necessary to help them integrate with one another. Third, he painted the design in a Pointillist manner.

Pointillism was based on new scientific studies of seeing. Artists had always known that mixing colors

in paint reduced their colors' intensity. These studies revealed that, by using colors only in their purest state and letting the viewer's eye *optically* mix them, an artist could increase the luminosity of the colors. This principle of color theory had been understood intuitively by Delacroix and Monet. They all had painted passages in their pictures where pure colors were set side-by-side rather than mixed to form a smooth blend. But Seurat was the first to utilize dots so the colors could optically mix more easily. The dots become virtually invisible when a viewer steps away from *La Grande Jatte*.

But it is not just a scientific method that makes this a great painting; there is also its subject. Seurat shows modern people living in the modern world. Despite the crowds of people and the many activities, there is very little interaction. They are all together yet all apart. This kind of privacy and loneliness is unique to the modern city.

GAUGUIN AND THE SEARCH FOR PARADISE

Paul Gauguin's life story brought him fame before his art did. He had been a successful stockbroker and banker who drew and painted for relaxation. He collected the work of the Impressionists and was friendly with them. The Impressionists liked his work well enough to ask him to show with them. As a result, what began as a hobby began to take over his life. In 1883, he suddenly quit his job and decided to make a living as a painter. He abandoned his wife and children for a life of adventure, self-indulgence, and art. His story was what made him a celebrity in his own time.

Gauguin's ideas about art became as radical as his change in lifestyle. He felt that European art needed new life; its old vitality was gone. The Europeans had become too civilized; modern life was corrupted by cynicism. What was missing, he decided, was the energy of primitive art. To recapture the great powers of the universe that had been lost to intellectualism, he decided to become a primitive man himself. In essence, Gauguin was looking to return to the Garden of Eden. If he could find an unspoiled primitive paradise and enter it, it would rejuvenate him, and then he would be able to rejuvenate European painting.

At the World's Fair of 1889 in Paris, Gauguin saw beautiful dancers from Java. He became convinced that the paradise he was looking for was in the tropics of the South Seas. In 1891, he went to Tahiti to escape from the decadence of Europe. There he lived among the natives and painted their world. He lived in a shack, took a native girl as a wife, and eventually had a son.

Spirit of the Dead Watching (**17-24**) shows Gauguin's native wife lying on her bed, terrified of the

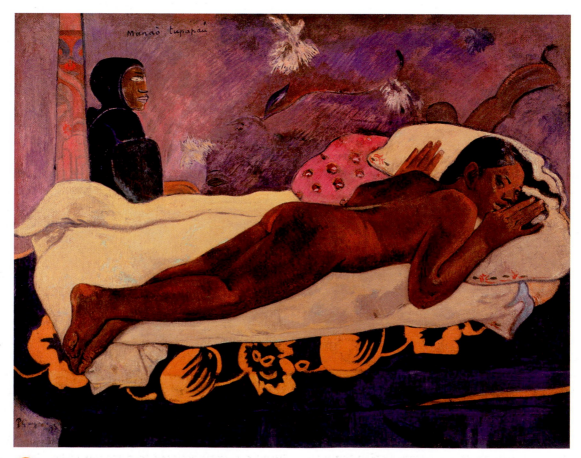

17/24 PAUL GAUGUIN, *Spirit of the Dead Watching*, 1892. Oil on burlap mounted on canvas, 28½" × 36⅜". Albright Knox Art Gallery, Buffalo, New York.

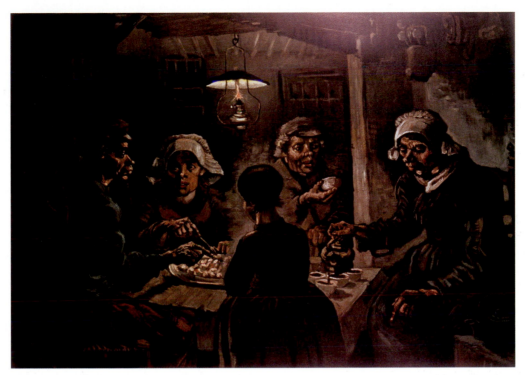

17/25 VINCENT VAN GOGH, *The Potato Eaters*, 1885. Oil on canvas, 32¼" × 44⅞". Stedelijk Museum, Amsterdam, Netherlands.

dark. It is based on a conversation he had with his wife after he had left her alone for a night. The next morning she told him that in the darkness she had seen a dead spirit watching her. To capture the mood, he painted a solid young woman surrounded by an imaginary world. The space is confusing, the colors mysterious. Still, Gauguin could not entirely escape Western culture. The format is in the old tradition of the reclining nude established centuries before by Titian (see his *Venus of Urbino*, 14-23).

While Gauguin's life made him a celebrity among the general public, his art was what interested other artists. His idea of using primitive art to invigorate European art influenced many artists. So did his use of bright, powerful colors to present an inner, emotional truth. He freed color from the bonds of reproducing visual reality.

VAN GOGH: FATHER OF EXPRESSIONISM

Before he left for Tahiti, Gauguin shared a house for a short period of time with a quiet man, one who would ultimately become much more famous—Vincent van Gogh. As a young man, van Gogh left his native Holland and worked as a preacher among miners. While there, he gave all of his clothes, his money, and even his bed to the impoverished. The authorities were frightened by his zealousness and forbade him to preach anymore. It was not until van Gogh worked in an art gallery owned by his uncle that he found his true mission. Seeing the work of Millet (16-30) there, he suddenly decided to become

a painter at the age of twenty-seven. In Millet, van Gogh found a sympathetic soul because he, too, wanted to portray the innate goodness in the hardworking lower class. Van Gogh was not a promising artist at first. He was a poor draftsman; his pictures were crude and clumsy. But he was stubbornly devoted to his mission and worked very hard, religiously, and made slow improvement. His *The Potato Eaters* (17-25) show people who keep God in their hearts. They have little else. The dark, depressing blacks and browns make this a gloomy scene. Yet light falls on their faces, revealing the simple goodness of this family. Despite the obvious clumsiness in van Gogh's early technique, we can already see his ability to transmit strong feelings. This will always be an important strength in his work.

Van Gogh went to Paris to study art, but life there proved difficult. Exposed to all of the most dramatic advances in art, he began to feel the strain. Van Gogh left for the south of France, where he hoped that the warmth of the sun would rejuvenate him. When he got on the train, he did not have a plan for where he would get off. He finally stopped in Arles, which he later called "the country of the sun." There he would have the most productive period of his life. The bright colors of the south would fill his work. He wrote, "I think that after all the future of the new art lies in the south."

In the space of three years, van Gogh went from being a clumsy amateur to a master of line (see 4-8). After ceaseless practice, his drawing had become sure,

JAPONISME: PICTURES OF THE FLOATING WORLD

Twentieth-century art owes much to the dissatisfaction and desire for change felt by French artists of the late nineteenth century. Academic art, living on the vestiges of the Renaissance tradition, seemed tired and worn-out to artists like Manet, Degas, and Monet. They and others were looking for a new way of making pictures.

It was at the same time that a fresh source, uncontaminated by Western culture, made its first appearance in Paris—Japanese prints. It was a propitious coincidence. These prints were to be crucial to the creation of Modern Art. To understand them, it is necessary to get a sense of the history and the culture that created them.

Japan in the 1500s was a land of rigid structures and rules. An official class system included (in rank order) the emperor and his family, the military dictators or shoguns, the samurai warriors, scholars, farmers, and tradespeople. In their rigidly structured society, the rich merchants had very little freedom. Because they were unable to buy power or influence, they could only spend their money on luxuries and pleasure. A hidden culture therefore developed, where the powerless could spend their yen. This underworld, located in Edo (now Tokyo), was known as Ukiyo, "the floating world," a place obsessed with rapidly changing fads, pleasure, and little thought for tomorrow. The art made for the floating world was known as **Ukiyo-e** or "pictures of the floating world." This art would later have a powerful impact on European artists and set off a wave of **Japonisme**, or the love of all things Japanese, in Western culture.

A whole section of Edo was filled with brothels and was known as the pleasure quarter. It was the only place in Japan where there were no class barriers. Kitagawa Utamaro's print (17-26) shows men strolling by the display window of a "house of pleasure." The casual, ordinary quality of Utamaro's scene was one of the most important reasons why Japanese prints were so admired by Europeans. The battle between the Impressionists and the French Academy was not just a matter of new techniques and composition but also a debate over what subject matter was appropriate for art. After hundreds of years of the Academy prescribing lofty subject matter, images of everyday life seemed like a breath of fresh air. Degas's interest in documenting the seemingly trivial events of life, like *Woman with a Towel*, can then be traced to the influence of Japonisme. One of the most important types of Ukiyo-e were scenes of life at home.

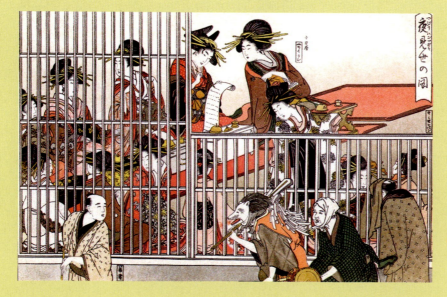

 KITAGAWA UTAMARO, *Scene in Yoshivara,* c. 1803. Woodblock print, ink and color on paper. Mary Evans Picture Library/The Image Works.

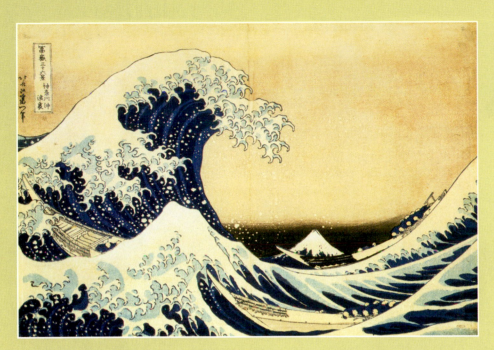

KATSUSHIKA HOKUSAI, "The Great Wave" from *Thirty-Six Views of Mount Fuji*, c. 1822. Woodblock print, 10" × 14¾". Musée des Arts Asiatiques-Guimet, Paris, France.

The composition of Japanese prints also inspired Western artists. Hiroshige's *Maple Leaves at the Tekona Shrine* (3-22) is an excellent example of how elements are cropped and arranged to design the empty space in a structure that ignores perspective. In essence, in Japanese prints everything is arranged for a decorative effect. Edgar Degas's use of cropping and unusual views in pictures like *The Orchestra at the Paris Opera* (17-14) and Mary Cassatt's print *The Letter* (6-11) are more easily understood when one is familiar with Japanese prints.

The most famous and influential of the Japanese print designers on Europeans was a man named Hokusai, whose drawing we saw in Chapter 2. *The Great Wave* (17-27) is the most famous Japanese print in the West. The print is from *Thirty-Six Views of Mount Fuji*, a travel series that portrays Mount Fuji, a religious shrine, from different vantage points and seasons and in all kinds of weather. Hokusai is known for the power of his simple, almost abstract designs. All inessentials are removed. His drawing is strong and clear, with boldly defined outlines and strong, flat colors.

A final reason the Japanese prints remained so popular is because they were so cheap. Even a poor artist like van Gogh was able to amass a fine print collection. In fact, he stated that all his work was "founded on Japanese art," and he went to the south of France under the impression that because of the warm sun there, the people were like the Japanese. He later wrote to Gauguin about his train ride, "I kept watching to see if I had already reached Japan!" While van Gogh tended to overstate his enthusiasms, it is quite clear when one looks at Impressionist and Postimpressionist art that the striking characteristics of Japanese prints—strong contour lines, flat color shapes, unusual cropping, and decorative patterns—had a major impact on the development of Modern Art.

his lines rhythmic. Some of his advances were a result of his study of Japanese art, which he had discovered in Paris (see "Global View" box). In the house that he rented in Arles, the walls were covered with Japanese prints. Working feverishly, van Gogh would paint for hours and then collapse and sleep for days.

Van Gogh dreamt of a "school of the south" that he would create in Arles. In June 1888, he invited the living artist he most respected, Paul Gauguin, to come live there with him. Gauguin arrived in October, planning to stay a year, but the visit lasted only nine weeks. At first the men worked well together; they would work all day, and in the evening, exhausted, go off to a café. But Gauguin was not an easy man to get along with, and neither was van Gogh. Tension soon developed between them, and they began to argue. A darker world now entered van Gogh's

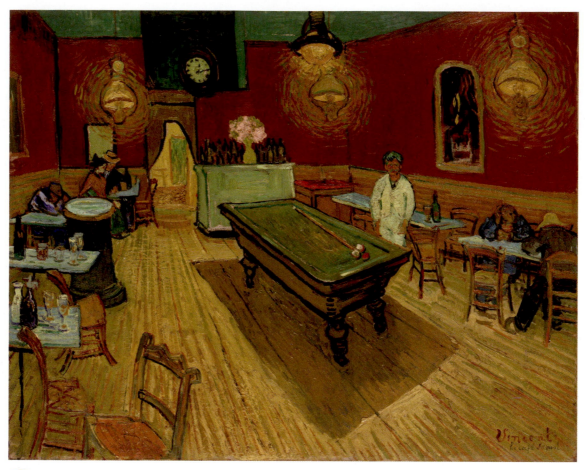

17/28 VINCENT VAN GOGH, *The Night Café*, 1888. Oil on canvas, 28½" × 36". Yale University Art Gallery, New Haven, Connecticut.

work. He wrote: "In my painting of *The Night Café* (17-28), I have tried to express the idea that the café is a place where one can ruin oneself, go mad, or commit a crime." Van Gogh stayed up three nights to paint this picture, sleeping only during the day. The contrast with his earlier interior, *The Potato Eaters*, is considerable. Dark browns and blacks have been replaced by intense colors. The red walls clash against the green ceiling. The floor is a sickly yellow; the lamps cast a dim light that hovers around them like moths.

One night, after a particularly violent argument, Gauguin stormed out of the house. Later that night, van Gogh—a little drunk, a little mad perhaps—went into a local house of prostitution and handed his favorite girl a box. Attached to it was a note: "Keep this object carefully." Inside was part of his ear. He almost bled to death; he had severed an artery and was discovered in his bed unconscious. He lay in a coma for three days. Van Gogh had gone mad. From then on, he would paint only in his occasional lucid moments. His *Self-Portrait* of 1889 (17-29) is a courageous representation of a man trying to be strong while fighting mental illness. It was

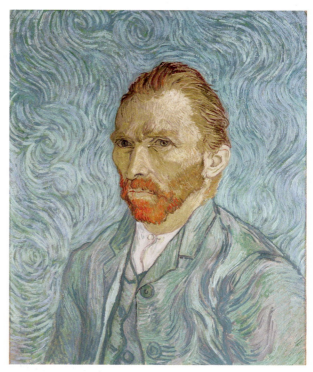

17/29 VINCENT VAN GOGH, *Self-Portrait*, 1889. Oil on canvas, 25½" × 21½". Musée d'Orsay, Paris, France.

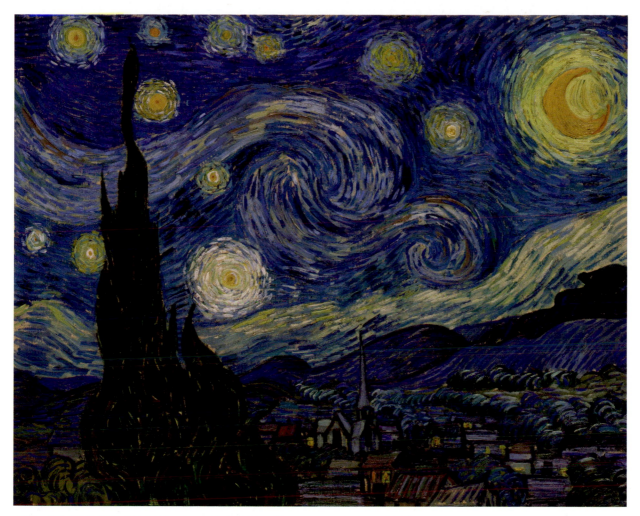

17/30 VINCENT VAN GOGH, *The Starry Night*, 1889. Oil on canvas, 29" × 36¼". The Museum of Modern Art, New York (acquired through the Lillie P. Bliss Bequest).

painted in the asylum; the world is a confusing mass of blue-green swirls.

In another lucid moment at the asylum, van Gogh painted his greatest picture, *The Starry Night* (17-30). We are on a hill, looking below to a small town whose tallest feature is the steeple of a little church. In the distance are mountains. The stars have come out—with a vengeance. Large swirling balls of fire fill the sky. The ground the town rests on is unstable; it rolls as if in an earthquake. A large, dark cypress tree rises from the foreground like a brown tongue of fire. All of the spiraling shapes are painted by van Gogh with thick lines of paint, sometimes squeezed directly out of a tube. *Starry Night* is a vision, a picture of his mental state. Van Gogh was

not satisfied with an imitation of the world but wanted an intense recreation of feeling.

Just two months after he had been discharged from an insane asylum, van Gogh completed his last painting. It has always been thought that he killed himself, but a recent investigation suggests that he might actually have been shot by someone else. In any case, it appears he had lost the will to live. He was thirty-seven years old. It had been less than five years since he had painted *The Potato Eaters*. His best work was done in little more than two years. Yet his popularity, fame, and influence would be greater than all but a few artists. When van Gogh declared that artists should "paint things not as they are, but as they feel them," he articulated what

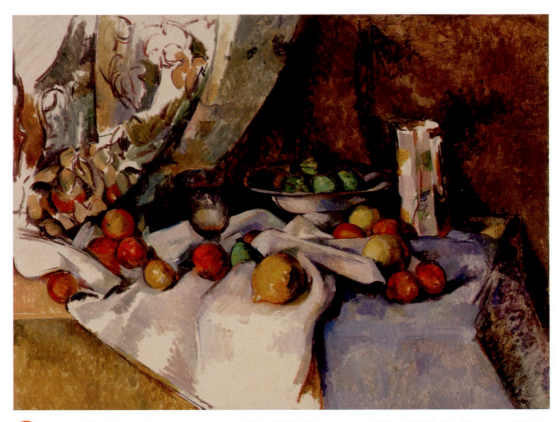

17/31 PAUL CÉZANNE, *Still Life with Apples*, 1895–1898. Oil on canvas, 27" × 36½". The Museum of Modern Art, New York (Lillie P. Bliss Collection).

would become one of the most important doctrines in twentieth-century art.

CÉZANNE'S REVOLUTION

Still, the Postimpressionist who would have the biggest impact on twentieth-century art was Paul Cézanne. Of all the Postimpressionists, Cézanne's work may be the most difficult to appreciate. This is because he *redid the way pictures were made*—a method developed slowly with years of painstaking work. His subject matter was far from revolutionary; he used three of the most ordinary types of painting: still lifes, portraits, and, the favorite of the Impressionists, landscapes. However, if we examine *Still Life with Apples* (17-31) closely, what appears at first to be a pleasant still life with some awkward passages proves to be more imaginative. Notice the distortion in the fruit bowl. Its back is tilted forward unnaturally. What you are seeing is not simply a clumsily drawn object. It is a sign that Cézanne is no longer obeying what artists had followed since the beginning of the Renaissance—the mathematical rules of perspective (see Chapter 3).

Cézanne was scrupulously honest. He believed that what the eye saw was the truth, and he realized that perspective was a lie. We do not really see in perspective. None of us is a one-eyed Cyclops, looking in one direction and one direction only. Cameras "see" like that, but people do not. People move their heads and their eyes when they are looking at something.

Perspective, however, had been a very useful lie. It had helped organize paintings and given them the illusion of reality. What could replace it? Cézanne had the courage to try to find out, to go beyond perspective and try to recreate the way we actually see. This is what gives his pictures their fragmented look. His eyes were looking not at the whole scene but at each part separately. That is how we all see; we look from part to part, never really taking in the scene as a whole. Eventually we accumulate a sense of the scene. In fact, the world we know is a carefully constructed web of relationships—approximations of what is there. For example, look at the white of the tablecloth. It appears thick and three dimensional, but the white areas are actually just empty canvas. The darker marks around the white areas make

the tablecloth appear to be solid. Cézanne, through his study of color relationships, noticed that we see objects only when they contrast with what is around them.

It is impossible to look at Cézanne's pictures and not be aware of the painter himself. That is part of Cézanne's honesty—he does not conceal his brushstrokes; he reveals how all of the parts of his picture were made. Cézanne used color, not lines, to create forms. He shared with the Impressionists a distaste for conventional drawing, which they associated with the antiquated French Academy. So Cézanne's shapes are constructed by little planes of solid color lying next to each other. In *Boy in a Red Waistcoat* (17-32), you can see how Cézanne would narrow his focus to study a specific relationship without paying attention to what could be seen elsewhere. Notice how the arm on the right is much longer than the one on the left. Cézanne never thought of the whole arm; he examined the relationship of each part of the vest to the adjacent part of sleeve. After he worked his way down

and reached the end of the vest, he probably noticed that the boy's arm was unnaturally long. Most artists would at that point make corrections and make sure that the arm was in proportion to the rest of the body. But to Cézanne that would be dishonest. It was more important to record what he had seen than to have a "logical" picture.

Cézanne's pictures mark the end of the naturalistic approach that Giotto began in the 1300s. By rejecting perspective, the cornerstone of art since the Renaissance, Cézanne opened up a Pandora's box in the twentieth century. Artists became free to pursue their own vision and ignore the fundamental rules of academic art. His influence on the painters of the next generation is profound. The work of the two most important painters of the twentieth century, Henri Matisse and Pablo Picasso (see next chapter), would not be possible if Cézanne had not led the way. His relatively small pictures with the most ordinary of subject matter changed the course of art history.

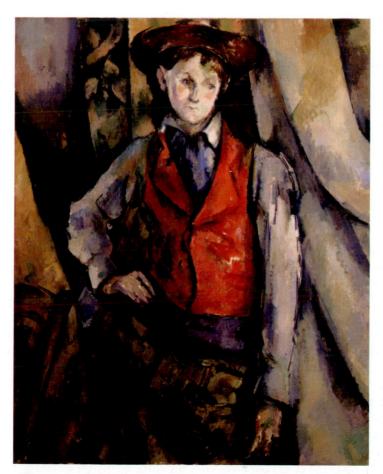

17/32 PAUL CÉZANNE, *Boy in a Red Waistcoat*, 1888–1890. Oil on canvas, 35¼" × 28½". Collection of Mr. and Mrs. Paul Mellon, National Gallery of Art, Washington, D.C.

CHAPTER 18

1880–1900

PERIOD

EXPRESSIONISM
ART NOUVEAU
JAPONISME

HISTORICAL EVENTS

First Kodak camera **1888**
San Francisco earthquake **1892**
Wireless invented by Marconi **1895**
Tchaikovsky, *Swan Lake* **1895**
Spanish-American War **1898**
Pierre and Marie Curie discover radium **1898**
Freud, *The Interpretation of Dreams* **1900**
Boxer Rebellion in China **1900**

1900–1914

PERIOD

DIE BRUCKE (GERMAN EXPRESSIONISM)
FAUVISM
PICASSO'S BLUE PERIOD
ANALYTICAL CUBISM
FUTURISM
PHOTO-SECESSION

HISTORICAL EVENTS

Death of Queen Victoria **1901**
Wright Brother's first powered flight **1903**
Einstein, *Special Theory of Relativity* **1905**
Henry Ford's Model T **1908**
Marinetti's *Futurist Manifesto* **1909**
Sun Yat-Sen founds Chinese Republic **1911**
Mona Lisa stolen from Louvre **1911**
Stravinsky's *Rite of Spring* causes riot in Paris **1913**
The Armory Show in New York City **1913**

ART

1. Eiffel Tower, 1887–1889
2. Victor Horta, Staircase for Tassel House, 1893–1894
3. Munch, *The Cry*, 1895
4. Harriet Powers, *Bible Quilt*, 1895–1898

5. Picasso, *Les Demoiselles d'Avignon*, 1907
6. Olowe of Ise, Veranda Post, 1910–1914
7. Stieglitz, *The Steerage*, 1911
8. Chagall, *I and the Village*, 1911
9. Boccioni, *Unique Forms of Continuity in Space*, 1913

THE REAL WORLD ON TRIAL: THE EARLY TWENTIETH CENTURY

1914–1920	1920–1940
DADA THE NEW OBJECTIVITY	SYNTHETIC CUBISM SURREALISM MEXICAN MURAL MOVEMENT

1914–1920

World War I 1914–1918
Russian Revolution 1917
Balfour Declaration on Palestine 1917
Treaty of Versailles 1919
Black Sox scandal in baseball 1919
Women's suffrage in United States 1920
End of the Mexican Revolution 1920

1920–1940

Fall of the Ottoman Empire 1922
T.S. Eliot, *The Waste Land* 1922
Robert Goddard ignites first liquid fuel rocket 1926
U.S. stock market crash 1929
Depression in Europe and the United States 1929–1940
Stalin becomes dictator of Soviet Union 1929
Japan invades Manchuria 1931
Rise of Adolph Hitler in Germany 1933
Spanish Civil War 1936–1939
Beginning of World War II 1939

10

14

15

14. Kollwitz, *Bread!*, 1924
15. O'Keeffe, *Two Calla Lillies on Pink*, 1928
16. Dali, *Persistence of Memory*, 1931
17. Bertelli, *Head of Mussolini*, 1933
18. Picasso, *Guernica*, 1937

11

12

13

10. de Chirico, *Mystery and Melancholy of a Street*, 1914
11. Kirchner, *Self-Portrait as a Soldier*, 1915
12. Duchamp, *Fountain*, 1917
13. Hoch, *Cut with a Kitchen Knife*, 1919

16

17

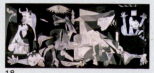
18

THE BIRTH OF A NEW CENTURY

The end of the nineteenth century ushered in a wave of optimism in Western civilization. A new and better modern world was coming in the new century, an era of progress on all fronts. The emblem of modernism had just been constructed at Western culture's center: the *Eiffel Tower in Paris* (18-1). It was like a beacon, attracting forward-looking young people, the vanguard or **avant-garde** of Europe, North America, and even Asia. Remnants of the old way of life were being torn down, not just by artists and writers but also by scientists like Marie Curie and Albert Einstein. Sigmund Freud was even changing our view of the human mind.

The tower was built as the main attraction for the International Exhibition of 1889, celebrating the one-hundredth anniversary of the French Revolution. Gustave Eiffel proposed to build the tallest edifice in the world as

GUSTAVE EIFFEL, Eiffel Tower, 1887–1889. Cast iron, 985' high. Paris, France.

a "dazzling demonstration of France's industrial power." When it opened, visitors lined up every day, waiting an hour or more to take the long elevator ride to the top. Once there, they were greeted by a godlike view—the pan-orama of Paris, with electricity, now truly the City of Light. Before the tower was built, only a few balloonists had ever seen such a view. It would not be an overstatement to say that the Eiffel Tower changed the way people perceived reality. Celebrated in paintings, prints, sculptures, and photographs, it articulated the spirit of the times.

MUNCH: "INNER PICTURES OF THE SOUL"

This exciting atmosphere attracted a young man, Edvard Munch, from Norway to Paris in 1889. Dissatisfied with his native land's pleasant, superficial art, Munch was search-ing for the means to create pictures that explored what lay beneath the strict social conventions of Norwegian society. He wanted Norwegians to abandon their cold for-mality and puritanical attitudes, to open their eyes and face life. Like van Gogh a decade before him, Munch left Paris skilled in new techniques and dedicated to reveal-ing the underlying emotions of life.

Munch confronted straitlaced Victorian attitudes toward sexuality with works of startling honesty. In his painting *Puberty* (18-2), he explored the mysterious oncoming of sexual impulses in a child. In it, a young girl sits alone, naked, with her arms folded protectively over her thighs. The look on her face is frightened, and she seems completely vulnerable. Her shadow can be seen in two ways: It is a ghostly presence and herself as a long-haired, grown woman.

Munch's most famous image depicts a state of high anxiety. It is usually called *The Scream* or *The Cry* (18-3) in English, but a better translation would be "the shriek." This woodcut recreates the psychological terror Munch experienced himself one day when walking across a bridge. He wrote about the event:

I walked along the road with two friends. The sun went down—the sky was blood red—and I felt a breath of sadness. I stood still tired unto death—over the blue-black fjord and city lay blood and tongues of fire. My friends continued on—I remained—trembling with fright, and I felt a loud unending scream piercing nature.

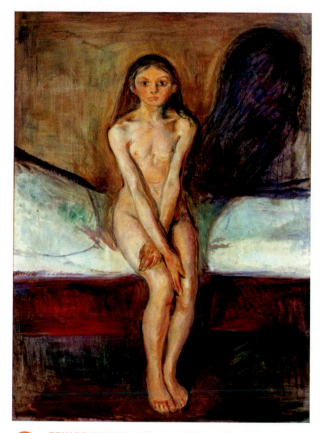

 EDVARD MUNCH, *Puberty,* **1894–1895. Oil on canvas, 59⅝" × 43¼". © 2012 The Munch Museum/The Munch-Ellingsen Group/Artists Rights Society (ARS), NY.**

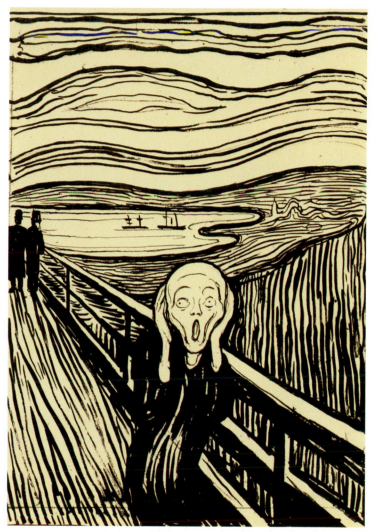

EDVARD MUNCH, *The Cry,* **1895. Lithograph, 20" × 15³⁄₁₆". © 2012 The Munch Museum/The Munch-Ellingsen Group/Artists Rights Society (ARS), NY.**

The swirling of the curving lines that fill the work do not create a sense of pleasant harmony with nature but quite the opposite. Packed tightly and crowding the central figure, they become ripples of tension. Nature is threatening; life is unbearable. *The Cry* depicts not only a shattering sound wave, but it is also a representation of the inner life. Munch's statement, "Nature is not only that which is visible to the eye—it also includes the inner pictures of the soul," echoes the ideas of the nineteenth-century artists Caspar David Friedrich and van Gogh. Making inner feelings (as dark and deep as they may be) visible would be the aim of many artists in the new century and would be known as **Expressionism**.

GERMAN EXPRESSIONISM

By 1905, followers of van Gogh and Munch in Germany produced paintings that generated an intense emotional effect by their use of powerful colors and vivid contrasts of light and dark. Emil Nolde, for example, pursued the goal of a native German art, pictures that

would be "so sharp and genuine that they never could be hung in scented drawing rooms." He acknowledged that the influences of van Gogh and Munch had led him to his method—the use of the direct expressive power of color and form. Fellow German artists paid tribute to his "tempests of color." When Nolde went to study in Paris and saw Impressionist works for the first time, the sunlit landscapes of Monet and Renoir did not appeal to him. He was irritated by their "sweetness" and "sugariness," disgusted that Impressionism was "the elected darling of the world." Nolde's preoccupation was not capturing momentary effects of light but "an irresistible desire for a representation of the deepest spirituality, religion, and fervor." Color was the gateway to our inner nature because "every color harbors its own soul."

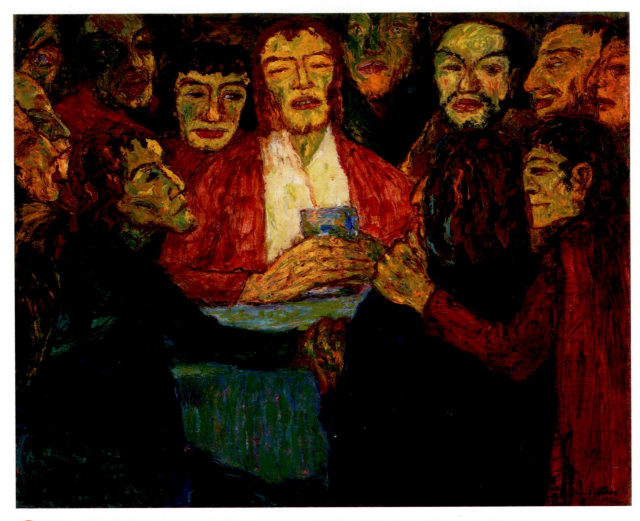

18/4 **EMILE NOLDE,** *The Last Supper,* 1909. Oil on canvas, 33⅞" × 42⅛". Statens Museum for Kunst, Copenhagen, Denmark.

Nolde's *The Last Supper* (18-4) was the first of a series of religious pictures. It is quite different from da Vinci's version. Rather than a carefully composed Renaissance scene, we witness a tribal rite. Paint was applied in thick, textured layers. The drawing is raw, the colors unmixed and intense. Jesus is performing the eucharist (the sacred transformation of wine and bread into Christ's blood and body) as if he is in a trance. Nolde accentuates the magical nature of the rite, and Christ's followers huddle around him as if they were a loving clan of cave dwellers. Powerful religious emotion fills the painting. Like Caravaggio three centuries before him, Nolde reread New Testament stories, rejected stereotypical images, and presented them in original and powerful ways. Like Paul Gauguin, he wanted to return to a purer, more primal experience of life—to paint like a primitive man. In Nolde's own words, he wanted "to render sensations with the intensity of nature at its most powerful," uncontaminated by logical thought.

FAUVISM

Artists have loved and known the power of color since the time of cave painting; its exploration is far from a twentieth-century phenomenon. But in the early twentieth century, newly invented synthetic pigments enabled artists to use brighter, more intense colors than ever before. Just as the invention of paint tubes was essential for the Impressionists and their work outdoors, the invention of brighter artificial pigments by chemists turned out to be an important catalyst for early twentieth-century artists.

France had a long tradition of innovation in color: from the Romantic painter Delacroix to the Impressionists, then Gauguin and van Gogh. In 1900, Henri Matisse and André Derain met while taking art classes in Paris. After studying the adventurous pictures of the Postimpressionists, these young painters began a dialogue that would ultimately have a lasting effect on

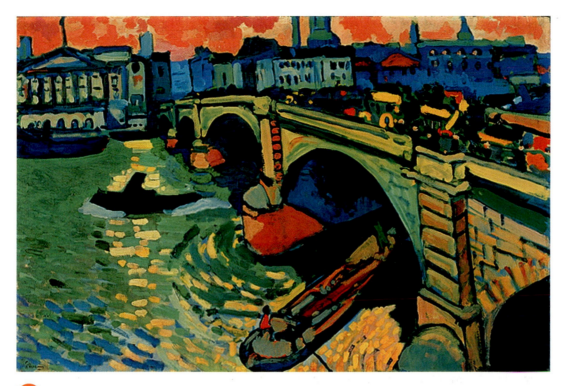

18/5 ANDRÉ DERAIN, *London Bridge*, 1906. Oil on canvas. 26" × 39". Museum of Modern Art, New York.
© 2012 Artists Rights Society (ARS), New York/ADAGP, Paris.

twentieth-century art. Painting side by side in the countryside, each goaded the other into more radical experiments with color. Enlisting fellow students and friends on their return, the **Fauves** (or the "wild beasts") were born. Like the German Expressionists, they rejected the need to copy color from the natural world. But for the Fauves, using pure color was not a doorway to exploring dark, primal passions but an exhilarating experience, a source of pleasure. Their ultimate concern was with what takes place on the canvas itself. This is what makes their pictures seem surprisingly fresh and modern even today.

In *London Bridge* (18-5), Derain selected a subject that had been painted previously by Impressionist Claude Monet, but his approach was quite different. Instead of exploring the effects of light at different times of day, Derain filled his picture with unique color combinations, exploiting the potential of uninhibited colors. Rather than using light and dark shading to model forms, as Monet had, Derain's hues are even more vivid, his brushstrokes rougher and thicker. The blue tugboat in the center left of the picture is a flat silhouette with no modeling at all. While real, momentary light (as in Monet's *Grainstacks*, 17-9) is ignored, nevertheless, *London Bridge* is filled with light because of its brilliant colors. Visual excitement is produced by the intensity of strongly contrasting, even clashing hues: blue against orange or yellow, red against green. Because of their almost uniform brightness, each colored area moves forward and flattens

the space. Fauvist pictures, therefore, were one more modern assault on traditional Renaissance perspective. In such unorthodox pictures, equilibrium was achieved through design, balancing the raw hues by their arrangement in the picture.

MATISSE

French critics were not sympathetic to the Fauves, describing their pictures as "the uncouth and naïve games of a child playing with a box of colors." Yet, the original ideas of Fauvism, manifested in many forms, would occupy the strong-willed Henri Matisse his entire life. He would ultimately become one of the most influential artists of the twentieth century.

Matisse had trained to be a lawyer as a young man. While he was in the hospital recuperating from appendicitis, his mother gave him a box of watercolors. She may have regretted it, because soon afterward he abandoned the legal profession. Matisse wrote of his change of heart:

> In everyday life I was usually bored and vexed by the things that people were always telling me I must do. . . . When I started to paint I felt transported into a kind of paradise.

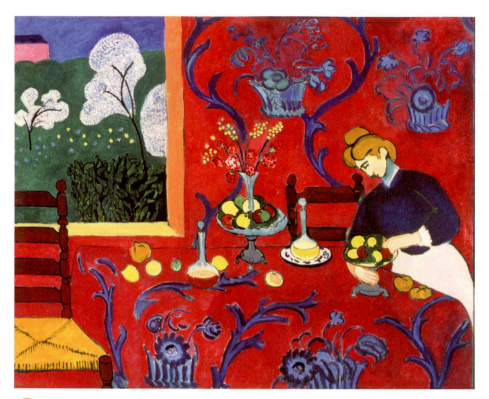

18/6 MATISSE, *Red Room (Harmony in Red)*, 1908–1909. Approximately 5' 11" × 8'1". State Hermitage Museum, St. Petersburg, Russia. © 2012 Succession H. Matisse/Artists Rights Society (ARS), New York.

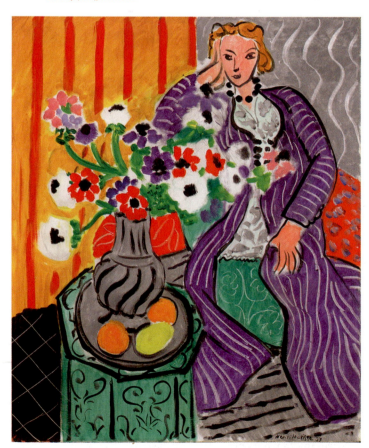

18/7 HENRI MATISSE, *Purple Robe and Anemones*, 1937. Oil on canvas, 28¾" × 23⅝". Baltimore Art Museum. © 2012 Succession H. Matisse/Artists Rights Society (ARS), New York.

In *Red Room (Harmony in Red)* (18-6), Matisse reinterpreted an interior through the free use of color and design. Using color at its maximum strength, he let the need to balance pattern and colors determine his design. He found that areas of color could balance a composition, just as the Baroque artist Rubens had used dramatic diagonals and limbs pulling in different directions. So the field of red that dominates three-quarters of his canvas holds the picture together. As in a tapestry, the strength of that large color field allows him to place many lively decorative elements within it without creating a chaotic scene.

Matisse had discovered that colors and shapes, once liberated from their obligation to literally recreate objective reality, could imbue paintings with extraordinary energy and life. By escaping the requirements of realistic drawing and using his fertile imagination simply to respond to the natural world, he was able to explore the extraordinary beauty of what he called "a living harmony of colors, a harmony analogous to a musical composition."

In Matisse's art there is no struggle, no shock, no tension. As his work developed over the decades, he continued to use color and pattern to create pleasing compositions of pleasant subjects—beautiful women, peaceful interiors, still lives of fruit and flowers. All of these can be seen in *Purple Robe and Anemones* (18-7), where warm colors and flowing lines create a serene mood very far from the anxieties of Munch's Expressionist masterpiece *The Cry* or the intensity of Emil Nolde's *Last Supper*. This picture, painted in 1937—the same year as Picasso's famous *Guernica* (18-15)—is not designed to challenge or upset the viewer like so much of modern art. Open and friendly, it is the twentieth-century version of **grazia** (see Chapter 14). The simplicity—the free and easy feeling—in Matisse's pictures was actually hard won; he labored on version after version of each subject on a canvas. Day after day, unsatisfactory work was scraped and wiped off so a new attempt could be made. The process might take months, but Matisse wanted to ensure that each picture would look like it was done at one sitting with the greatest ease. Matisse said that he struggled to reach "an art of balance, of purity and serenity . . . something that calms the mind."

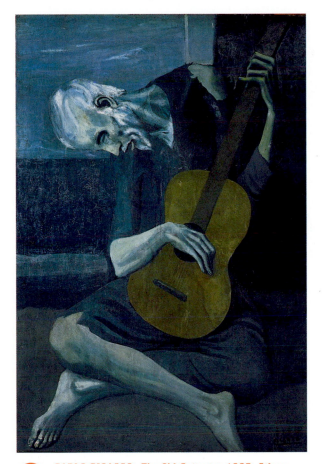

PABLO PICASSO, *The Old Guitarist*, 1903. Oil on canvas, 47¾" × 32¼". Art Institute of Chicago, Illinois. © 2012 Estate of Pablo Picasso/Artists Rights Society (ARS), New York

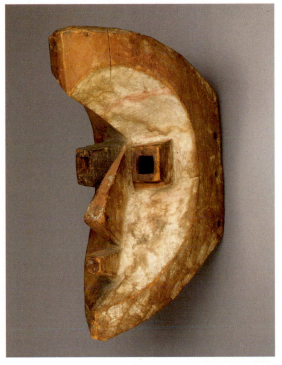

Mahongwe mask, Gabon, Africa, nineteenth century. Wood and pigments, 39" high × 14" wide. The Brooklyn Museum, New York.

PICASSO AND CUBISM

Pablo Picasso is, without question, the most famous and celebrated artist of the twentieth century. A child prodigy, Picasso told a story about how he surpassed his father, a respected art instructor at the School of Fine Arts in Barcelona, before he was ten years old. According to this legend, the young Picasso was already working as an assistant to his father when he was asked to paint a small bird on a large canvas his father was working on. When his father saw what his son had done, he was stunned. He gave Picasso his brushes and said, "You take them; you already are better than me." Whether the story is actually true or not, it reflects the absolute confidence and talent Picasso already had as a young man. By 1900, at the age of nineteen, having mastered academic technique, he went to Paris in search of greater challenges. Always a quick study, Picasso assimilated the most advanced early styles of Modern Art in just a couple of years. His early work from Paris includes pictures in the manner of Toulouse-Lautrec, Seurat, and Gauguin.

The Old Guitarist (18-8) was done in Picasso's first original style, known today as his *Blue Period*. The world of the urban poor, the depressed, and those weak from hunger were painted in somber hues of blue, brown, and black. The old guitarist is emaciated; the length and thinness of his arms accentuate his frailty. He is blind, but his blindness is like the Greek poet Homer's; it symbolizes wisdom. Like many artists and writers who had come to Paris, Picasso was young and struggling, not sure where his next meal was coming from. However, these pictures of the Blue Period established Picasso as an artist to be watched. In 1906, when the famous art dealer Ambroise Vollard (who represented Degas, Renoir, and Cézanne) visited the young artist's studio, he purchased every painting. Success would now follow the young Spaniard for his entire life.

Just as Gauguin became fascinated with primitive art in the previous generation, a taste for magical artifacts was developing among the young avant-garde. Introduced by Derain to African masks (18-9), Picasso felt the visual and psychological power in their simple, oversized geometrical forms. Although Derain could never successfully

THE LIVING ART OF AFRICA

In the early twentieth century, Picasso and other modern artists were inspired by African art that was being exhibited in museums and privately collected in Europe for the first time. Picasso said:

> *I have felt my strongest artistic emotions, when suddenly confronted with the sublime beauty of sculptures executed by the anonymous artists of Africa. These works of a religious passionate and rigorously logical art are the most powerful and most beautiful things the human imagination has ever produced.*

For European artists, African art was thrilling because it provided a new direction that could revitalize Western art through more "primitive" geometric forms. Yet, unfortunately, it was the understanding of the Europeans that was primitive. The African art was the product of sometimes thousands of years of tradition. But Picasso, like others, showed little if any interest in learning about the cultures that produced this exciting art. Their limited interest mirrored their worldview during an age of colonialism. For them, Africa was meant to serve the needs of Europe, whether that meant raw materials for industry or artists.

What Picasso and the others were missing was the vibrant living tradition of Africa. One of the great African artists alive at the time was Olowe of Ise. Far from an anonymous tribesman, Olowe was a Yoruban known throughout his nation. The Yoruba have a

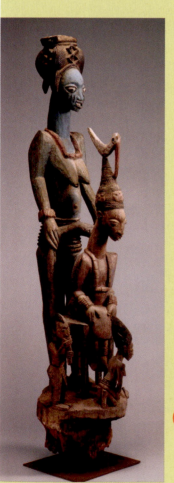

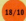
OLOWE OF ISE, Veranda Post of Enthroned King and Senior Wife (Opo Ogoga), 1910–1914. Nigeria, Ekiti, Ikere. Wood, pigment, 60" high × 12½" wide × 16" deep. Art Institute of Chicago, Illinois.

thousand-year-old culture and remain one of the largest groups in Africa. There are today about eighteen million Yoruba who live primarily in Nigeria, but they can be found from Senegal to Egypt.

Olowe was first a sculptor to the King of Ise, but during his career he was summoned for work by the rulers of Ilese, Akure, Idanre, and Ogbaki. His *Veranda Post of Enthroned King and Senior Wife* (18-10) was a commission for the *Ogoga,* or King, of Ikere. The post was one of four for the palace of the Ogoga and was originally painted in bright red, white, and indigo. It depicts the king, his senior wife, a junior wife, and the god Esu. As is traditional in African art, it utilizes hierarchical scaling—the size of the figures conveys the status of the individuals. What is surprising to Western eyes is the relative size of the senior wife compared to the king. While the king is certainly the central figure, his wife towers over him. The role of the senior wife was very important to a Yoruban king. She crowned him during his coronation. She also functioned as an important political advisor and was respected for her knowledge and connection to the spiritual world. Choosing a wife as the subject for the veranda post of a palace made sense to a Yoruban, because they believed that the strong shoulders of women supported their community.

As important as his wife is, the king's crown, the source of his authority, is meant to be the center of our attention. His wife's eyes focus on it, and the bird's beak on top also draws our eyes there. The bird represents the female ancestors and deities who support the kingdom and are known to the Yoruba as "our mothers."

Olowe was well-versed in traditional art but was also an innovator in style. His work increased the depth of the open spaces within Yoruban art, while his figures are elongated rather than traditionally short. He trained many apprentices in his large workshop. He died in 1938 at the age of seventy-eight, but his legend lives on in one of the *oriki,* or praise songs of the Yoruba. The song tells of the many palaces where his work can be found and describes him as "One who carves the hard wood of the iroku tree as though it was soft as calabash, One who achieves fame with the proceeds of his carving." It ends with the story of one of Olowe's carvings being exhibited in London in 1924 and now in the collection of the British Museum. "There was a carved lion, That was taken to England, With his hands he made it."

18/11 PABLO PICASSO, *Les Demoiselles d'Avignon*, Paris, June–July 1907. Oil on canvas, 8' × 7' 8". Museum of Modern Art, New York. © 2012 Estate of Pablo Picasso/Artists Rights Society (ARS), New York.

incorporate their influence into his art, Picasso would do so in a way no one else could ever have imagined (see "Global View" box).

Only a year after his success with Vollard, Picasso made a picture that shocked not only his new dealer and the older artists of Paris but also the avant-garde. It was a product of his study of African masks and the then-legendary but rarely seen work of Paul Cézanne. In 1907, there had been a Cézanne retrospective in Paris that opened the eyes of the younger generation. In later years, Picasso would say of the Postimpressionist master: "Cézanne is my father; he was the father of us all." The imaginative combination of these two influences resulted in the most revolutionary picture of our century, *Les Demoiselles d'Avignon* (*The Women of Avignon*) **(18-11)**. Picasso had leapt into the unknown with this

picture, making a more radical break with Renaissance art than any previous artist. His women are prostitutes who display themselves to the viewer as if to a customer, but they are hardly enticing. Their bodies have been broken up into geometrical fragments and flattened. The fragments are reminiscent of the small panes of color Cézanne had used, but now Picasso has made them bold and geometric like the shapes of African masks. The composition of *Les Demoiselles d'Avignon* creates a new kind of space—everything, including the background, seems to press forward. There is no conventional negative space. All is foreground. The placement and design of shapes and space seem to be determined merely by the whim of the artist. In the same way that the Fauves declared color could be arbitrary, now Picasso was declaring shapes and space could be as

well. In his *Les Demoiselles d'Avignon*, a melon becomes flat with points as sharp as a knife, or a breast becomes a shaded square.

The painting is brimming with ideas and a variety of styles. There are even four different methods for the heads. Two seem clearly influenced by African masks, but the most bizarre is the head at bottom right. The parts of her face have been redesigned and reassembled as if she is being viewed from several angles at once. Picasso is deliberately ignoring one of the oldest design principles: A picture must be consistent to be successful. "Is life coherent?" he might ask. The fragmentation of this painting has been said to reflect the fragmentation of modern life, making *Les Demoiselles d'Avignon* a very twentieth-century picture.

Picasso's friends and supporters were stunned and hated the painting. "A horrible mess," said one. Matisse said it was "repulsive." Many thought Picasso had gone insane. Derain said it would not be long before Pablo would be "found hanging behind his canvas." The youngest of the Fauves, Georges Braque, had also been among those who were initially horrified by the "monstrous" painting. Later, Braque began to see that because *Les Demoiselles d'Avignon* blew apart many of the old conventions, it was rich with possibilities. Braque soon abandoned Fauvism and joined Picasso in one of the most famous collaborations in the history of art. Together they explored the consequences of this landmark picture, the first example of **Cubism** (see Chapter 3).

Both artists had studios in the same building in an artist quarter in Paris. Soon their pictures were so similar that, without signatures, it would be nearly impossible to distinguish who had done which. To study their new structure, Picasso and Braque initially limited color in their work, a style called **Analytical Cubism**. The first Analytical Cubist pictures are a collection of views from different angles fused into a balanced design. Like Cézanne, they wanted to present a truer picture of the way we see, with eyes moving from one part to another. But as Picasso and Braque further explored Cubism, their work became more and more abstract; the arrangement of shapes became less like the source objects (see Braque's *Violin and Palette*, 3-26), and the design of the many shapes in the picture became more important than any representational function.

Picasso and Braque had created a new reality, one that existed only in the painting. Picasso declared that a picture should "live its own life." The Cubists were posing once more the crucial question of Modern Art: Should art be chained to visual appearances? Their answer, as seen in their works, is a loud "no!" Art can give us experiences that reality cannot, they would say. It is time for the artist to be liberated from the old requirement of recreating what anyone can see. While much of the public remained horrified by Cubist pictures, Cubism spread like wildfire in the next few years through the avant-garde in Europe and beyond.

Yet by 1912, Picasso wanted to find a way to bring the real world more directly into Cubist pictures. He did it by literally attaching bits and pieces from everyday life—inventing **collage** (see Chapter 5). The first was *Still Life with Chair-Caning* (18-12), where Cubist painting is mixed with a printed pattern of chair caning on it. Picasso used collage to play fast and loose with visual reality, to question its nature. In the picture, some letters from the French paper *Le Journal* appear as simulated collage, but they were actually painted on the canvas. This kind of deception forced viewers to examine his art closely, because one cannot always be sure what is paint and what is collage. Sometimes he and Braque might carefully recreate wood grain in paint, but in other pictures they would attach some actual wood. In later collage-paintings, Picasso openly used real materials that had little to do with what is portrayed—a glass made of newspaper, for example. These tricks keep the viewer in doubt, but they also allow the viewer to enjoy surprises, to share in something like the artists' joy of invention. Picasso is constantly reminding us that art is by nature deceptive: an illusion constructed from materials, whether paint, stone, or wallpaper.

The same year, Picasso began translating Cubist space into three dimensions with Cubist **assemblages** (three-dimensional collages). Because one curving side

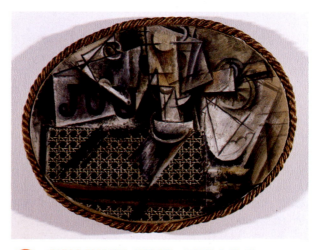

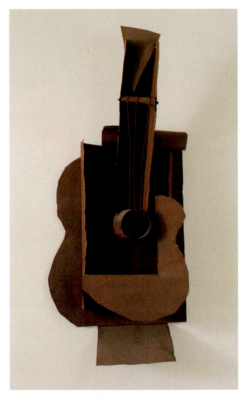

 PABLO PICASSO, *Guitar*, Paris, winter 1912–1913. Construction of sheet metal and wire, 30½" × 13⅛" × 7⅝". Museum of Modern Art, New York. © 2012 Estate of Pablo Picasso/Artists Rights Society (ARS), New York.

of his *Guitar* of 1912–1913 (18-13) is larger than the other, we get the sense of Picasso moving back and forth as he looked at different parts of the guitar. We also get a sense of Picasso's perception and thought processes: The top of the guitar reminded him of a triangle; the center hole, a cylinder. Like so many Cubist works, *Guitar* is a report from the artist about what he saw and what he thought as he looked closely at an object.

Although no one would be fooled into believing this collection of sheet metal and wire was an actual guitar, it is easy to identify. By 1912, the visual symbols Picasso made for the things he saw were becoming more playful, imaginative, and easily understood, and marked the opening of a new phase called **Synthetic Cubism**. Less than a decade after its creation, the painstaking investigation of the possibilities of *Les Demoiselles d'Avignon* was over, replaced with the more open, even comical approach of the *Three Musicians* (18-14). In Synthetic Cubism, lively color reentered Picasso's pictures and expression, too. In the years to come, Cubism proved to be a very flexible style. Picasso would use it to create a variety of moods. His *Three Musicians* is playful and light, his *Girl before a Mirror* (2-8) loving and erotic. Yet

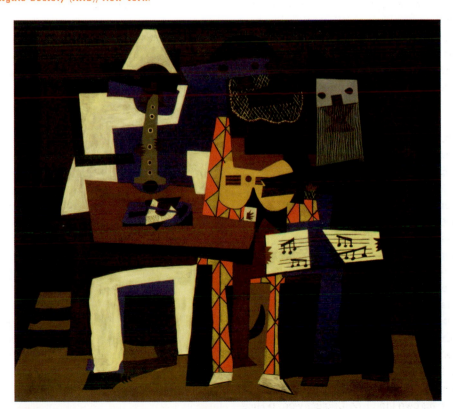

PABLO PICASSO, *Three Musicians*, Fontainebleau, summer 1921. Oil on canvas, 6' 7" × 7' 3¾". Museum of Modern Art, New York. © 2012 Estate of Pablo Picasso/Artists Rights Society (ARS), New York.

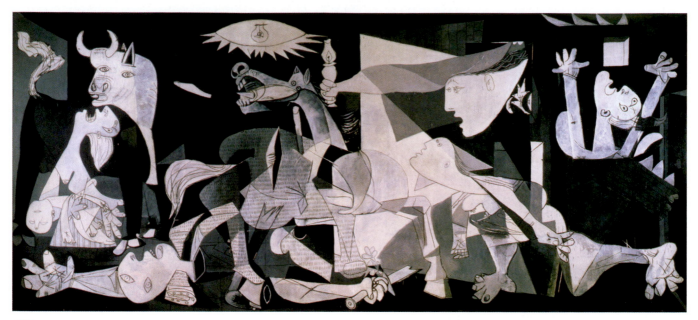

18/15 **PABLO PICASSO,** *Guernica*, **1937. Mural, 11' 6" × 25' 8". Centro de Arte Reina Sofia, Madrid, Spain.** © 2012 Estate of Pablo Picasso/Artists Rights Society (ARS), New York.

Pablo Picasso's monumental *Guernica* **(18-15)** is universally acknowledged as one of the most forceful protests against war ever created.

While the painting's message is timeless, its catalyst was a single event. On April 26, 1937, during the Spanish Civil War, the small town of Guernica was attacked by German bombers supporting the Fascist armies of Generalissimo Franco. The town was still controlled by the republican government of Spain but had little military significance. Adolf Hitler's Luftwaffe used the attack as a test of the effects of saturation bombing—in preparation for World War II. The effects were catastrophic. Much of the town was leveled, and thousands died. Newspapers reported that those who ran from the town were machine-gunned by planes.

Living in France, but emotionally tied to his native Spain, Picasso responded to the atrocities with the largest canvas he had ever painted, more than twenty-five feet long and eleven feet high. Picasso's *Guernica* is not a recreation of a specific event but a universal message about the suffering of the innocent in war. Women, children, and animals are the main subjects, their bodies twisted and distorted by Cubist structure. Many look to the sky (toward God or bombers?), screaming. The space is confused; we seem to be both indoors and outdoors. Figures bump into one another. The Cubist style actually seems, in the hands of its master, to be peculiarly suited to express the victims' anguish, confusion, and panic. Only one soldier is present, a broken Roman sculpture symbolizing the end of the ancient heroic ideals of war. During the German occupation of France, some Nazi officers came to inspect Picasso's studio. One pointed to a postcard of the *Guernica* on the artist's wall and

asked him, "Did you do this?" Picasso is reputed to have answered, "No, you did."

Throughout the first half of the twentieth century, Matisse and Picasso were rivals for the leadership of the modern movement. Matisse's genius was in his groundbreaking use of color, while Picasso's was his revolutionary use of form. Both had devoted, sometimes fanatical, followers. There was even a period early in the century when gangs of Picasso-istes roamed the streets of Paris and wrote graffiti on walls claiming "Matisse causes madness! Matisse has done more damage than war!" They also threw darts (thankfully rubber-tipped) at Matisse canvases in exhibitions. But the rivalry of the two artists inspired them as they rewrote the history of art. Many times one was motivated to paint an even more radical picture after seeing the latest work of the other. Throughout their lives they traded canvases, which became prized possessions. As they aged, both agreed that the other artist was the only one who could truly understand his own work. When the older Matisse died in 1954, Picasso, one of the most prolific artists who ever lived, stopped painting for two weeks. Some time later, a friend asked him about Matisse. Picasso only looked out the window and quietly said, "Matisse is dead, Matisse is dead."

Today, most art critics identify Picasso as the dominant artist of the twentieth century. His productivity, imagination, and range of interests redefined what being an artist meant. Up to the day he died in 1973, he was producing a stream of paintings, drawings, sculptures, etchings, woodcuts, lithographs, and ceramics (see photograph 1-40). He became the most famous and richest artist who ever lived. More important, Cubism became the bridge to most of the radical art of the twentieth

THE DIARY OF AN AFFAIR: PICASSO AND MARIE-THÉRÈSE

As the sun was setting in Paris, on January 8, 1927, Pablo Picasso was walking past a fashionable department store when his eyes fell upon a young woman shopping. Immediately infatuated, the artist (then unhappily married and in his mid-forties) took Marie-Thérèse Walter by the arm and, according to her, said, "I'm Picasso! You and I are going to do great things together!" She was confused by the man and unaware of who he might be. Picasso introduced himself by dragging her into a bookshop and showing her a book filled with reproductions of his paintings. Thus began a passionate affair and an enormously productive period for Picasso.

Seventeen at the time, Marie-Thérèse lived with her family and, like other teenagers before and after, told them she was going to a girlfriend's house while actually leaving for a rendezvous. But in her case her trysts were with the world's most famous artist. By spring, they were meeting every day, and Marie-Thérèse invented an imaginary job to explain her absences.

Picasso once said that "Painting is just another way of keeping a diary," and one way to understand his work, as abstract as it may appear, is to follow its stages through the women he loved. Picasso's paintings initially referred to Marie-Thérèse in a kind of visual code. In the first pictures, she is depicted as fruit in a bowl or as a guitar. It is a change in his style that is the clue to her identity. His new lover was not a skinny flapper or dancer like his wife, but a sturdy athletic young woman, with a Grecian nose, large breasts, and strong legs. The hard-edged, angular shapes of Cubism make way for rounded, sensual lines. Soon, he abandoned the subterfuge and portrayed Marie-Thérèse directly—in sketchbooks full of drawings, etchings, sculptures, and paintings. Their passion made them reckless and daring. Even while vacationing with his wife and child on the French coast, Picasso found a small hotel for Marie-Thérèse nearby. They met secretly in a cabana while his wife played with his son on the beach.

In the year before they met, Picasso had experienced a lull in his creativity that was very unusual and painful for him. Now, there was a flood of pictures. It was, as he told Marie-Thérèse, because he never tired of looking at her. He particularly loved to paint her when she was asleep.

The Dreamer from 1932 (18-16) is a good example of how Picasso's approach to painting changed. Cubism was no longer a drab, strict, analytical study of forms but a doorway to freedom and creativity. The artist explores his passionate feelings with curving, voluptuous forms and colorful, luscious, thick paint. The sleeping Marie-Thérèse appears as a lovely, sexual being in harmony with nature. In the summer of 1936, Picasso wrote to her,

I love you more than the taste of your mouth, more than your look, more than your hands, more than your whole body, more and more and more and more than all my love for you will ever be able to love and I sign Picasso.

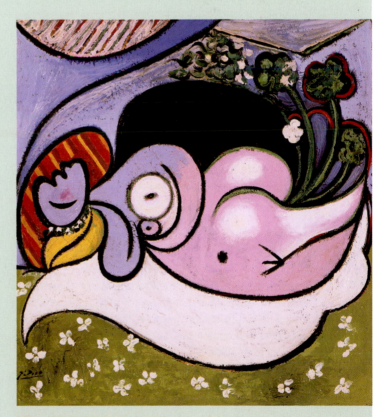

 PABLO PICASSO, *The Dreamer*, 1932. Oil on canvas, 39⅞" × 36¾". The Mr. and Mrs. Klaus G. Perls Collection, 1997. (1997.149.4). Metropolitan Museum of Art, New York. © 2010 Estate of Pablo Picasso/Artists Rights Society (ARS), New York.

THE DIARY OF AN AFFAIR: PICASSO AND MARIE-THÉRÈSE

In this period before World War II, Marie-Thérèse appeared in many guises: model, muse to the gods, and even a Madonna in *Girl Before a Mirror* (2-8). In 1935, their daughter Maya was born and she, too, became a favorite subject. But sometime around 1936, Picasso met Dora Maar, a well-known photographer and artist, in a Paris café, and she began to compete with Marie-Thérèse for his affections. Maar would become his next muse, portrayed in many pictures of the late 1930s and early 1940s, as well as serving as the model for the grieving mother in *Guernica*. He later said that for him, Dora was always the weeping woman.

After their affair ended, Picasso continued to support Marie-Thérèse and their daughter. He provided an apartment in Paris and a home in the South of France. Even as Picasso moved on to other mistresses over the next forty years, Marie-Thérèse remained devoted to the memory of their love and always hoped he would return to her. They continued to write to each other. Picasso had once told her that she had saved his life, and his art of the 1930s documents their great passion. Sadly, life in a world without Picasso was too much for Marie-Thérèse. Four years after the artist's death in 1973, and fifty years after they had first met, she hung herself in the garage of her home in the South of France.

century. His innovations of mixing media and exploring the artistic value of everyday objects would be exploited by Dadaists, Surrealists, and Pop Artists, among others. Yet, as revolutionary as Picasso's career may have been, it was never completely removed from the visual legacy he inherited. In his seventies and eighties, he revisited the great masters of the past, painting Cubist versions of pictures by Delacroix, Manet, and even Rembrandt. It seems symbolic that he chose to live his old age and to be buried at the base of Mount Sainte Victoire—a mountain near the home of Paul Cézanne—as if to reaffirm his debt to the man Picasso called his father and to place himself firmly in the Western tradition.

ABSTRACTING SCULPTURE: BRANCUSI

Like painting, much of the sculpture in the twentieth century went in the direction of abstraction. We have seen this already in the Cubist sculpture of Picasso. One aspect of abstraction—refining form to achieve purity and clarity—was the driving force in the seminal sculptural abstractions of the Romanian artist, Constantin Brancusi (see photo 9-2).

Brancusi was born in a tiny peasant village in Romania, where as a young boy he was a shepherd. When the villagers saw his skill in carving (he had made a violin out of a crate), they raised the money necessary to send him to a school of crafts. After he graduated, Brancusi left for Paris, the magnet of his generation. However, he made his way more slowly than most, walking from Munich after his funds ran out. He later described this

walk as one of the happiest experiences of his life. Fed by peasants in the villages, he sang all the way. Brancusi said that he learned on this walk how good it was to be alive and to be able to see the wonders of nature.

Brancusi arrived in Paris in 1904 at the age of twenty-eight and lived virtually the rest of his life there. For a short time, he worked as an assistant to Rodin, but soon left to work on his own, saying "nothing grows under the shade of great trees." Like many other modern artists, Brancusi was interested in the art of non-Western people, not just African but Egyptian, Buddhist, and Cycladic art as well. Their art showed him that simple, abstract forms had great visual and psychological power. He decided that:

> What is real is not the external form, but the essence of things. Starting from this truth it is impossible for anyone to express anything essentially real by imitating its exterior.

Or, put even more succinctly, "The sculptor is a thinker, not a photographer." He set out to create sculptures that were universal and stripped to the essentials.

Perhaps the greatest example of Brancusi's desire for purity can be found in his *Bird in Space* (18-17). Brancusi once wrote: "All my life I have been working to capture the essence of flight." *Bird in Space* is the last in a series of sculptures Brancusi made on this theme. The series was begun in 1910; early versions were called "Maiastra," after the beautiful golden bird in Romanian folktales. As this series evolved, each bird in succession was more abstract, more refined; in each, Brancusi came closer to showing the essence of flight. In the final version, we can see only the desire to move upward, to escape the

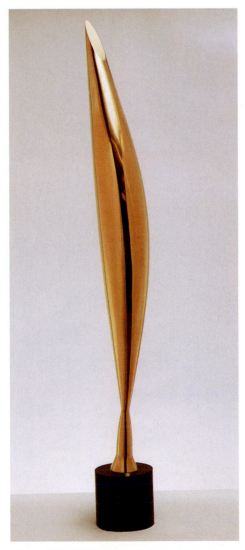

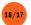 **CONSTANTIN BRANCUSI,** *Bird in Space,* c. 1928. Bronze (unique cast), 54" high. Philadelphia Museum of Art, Pennsylvania. © 2012 Artists Rights Society (ARS), New York/ADAGP, Paris.

force of gravity. Here he used bronze with a high degree of polish, so it seems machined rather than handmade. In fact, when *Bird in Space* was sent to the United States to be shown in a museum, customs officials confiscated it because they suspected it was military hardware.

Brancusi's clear, streamlined design inspired not only sculptors but also the industrial designers of the Bauhaus (see Chapters 11 and 19) and the pure, metallic symmetry used by International Style architects.

"ALL THINGS ARE RAPIDLY CHANGING": FUTURISM AND SPEED

The idea of a modern age was celebrated not only by visual artists but also by philosophers and writers.

The high priest of international modernism was Filipo Tomasso Marinetti, an Italian poet, playwright, and professional agitator, known as "the caffeine of Europe." Independently wealthy, he preached the virtues of the new world created by technology. In 1909, he wrote the "Manifesto of **Futurism**," coining a new term that was instantly in the mouths of avant-garde artists throughout Europe. Futurism was the credo of those who did not look back, who celebrated the age of the machine. Among the declarations in his manifesto were:

> We affirm that the world's magnificence has been enriched by a new beauty: the beauty of speed. . . . A roaring car . . . is more beautiful than the *Victory of Samothrace.*

Marinetti and his followers were nationalists and felt Italy's devotion to ancient greatness left it no more than a tourist mecca, preventing it from rising to new greatness:

> For too long has Italy been a dealer in secondhand clothes. We mean to free her from the numberless museums that cover her like so many graveyards.

The solution Marinetti called for was brutal: Italians should flood the museums and burn the libraries:

> We will destroy the museums, libraries, academies of every kind. . . . Come on, set fire to the library shelves! . . . Oh the joy of seeing the glorious old canvasses bobbing adrift on these waters, discolored and shredded! . . . We want no part of it, the past, we the young and strong Futurists!

Marinetti was a master publicist, and his ideas spread like wildfire throughout Italy. He traveled from city to city, organizing "evenings" in theaters designed to provoke violent responses from the conservative members of the audience. Crowds were drawn by posters advertising "opening nights." What they found instead was a mixture of art and politics, a series of challenges to their "mediocre bourgeois" values. An evening was considered successful when it ended in shouted insults, fistfights, flung rotten vegetables, and police intervention.

Umberto Boccioni was one of many young Italian artists who joined the new movement. His *The City*

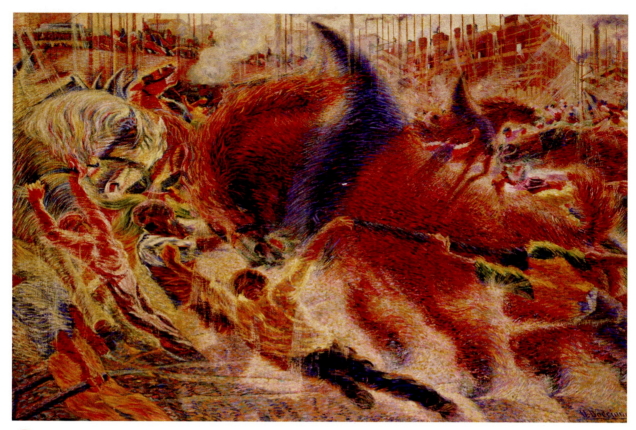

18/18 UMBERTO BOCCIONI, *The City Rises*, 1910–1911. Oil on canvas, 6' 6" × 9' 10". Museum of Modern Art, New York (Mrs. Simon Guggenheim Fund).

Rises (18-18), finished in 1911, shows how the Futurist painters adapted Cubism to create waves of muscular energy, each motion a series of steps reminiscent of multiple-exposure photography. The sweeping surges of movements make the whole picture a dynamic dance celebrating the building of the urban utopia. Man and animal pull the great enterprise into being.

Often, the ideology of the Futurists was ahead of their actual works of art. Marinetti's manifesto of 1909 declared a speeding car to be more beautiful than the Victory (or Nike) of Samothrace. No Futurist sculpture, however, had been made yet that could even challenge that masterpiece of the Greeks until Boccioni created his *Unique Forms of Continuity in Space* (18-19) four years later. Here the complexity and variety of movements seen in *The City Rises* were translated into three dimensions. Inner and outer forces pull at the solid figure, shaping it. Moving like a twentieth-century gladiator, this machinelike man is built of bronze; his head is a helmet and his arm a shield. His stride is confident, surging forward, but the memory of his past movements linger on, drag on him. Here is the Futurist hero for the technological age, shedding past remnants and moving to battle and victory.

18/19 UMBERTO BOCCIONI, *Unique Forms of Continuity in Space*, 1913. Bronze (cast 1931), 43⅞" × 34⅞" × 15¾". Museum of Modern Art, New York.

Calling for war was also part of the Futurist manifesto. Marinetti declared in 1909: "We will glorify war—the world's only hygiene—militarism, patriotism . . . beautiful ideas worth dying for." When war came in 1914, the Futurists joined eagerly, plunging into what would become a European holocaust, with the same speed they plunged into all of their actions. Like European culture as a whole, Futurism was never the same afterward. Still, the Futurist spirit left a lasting legacy for twentieth-century art; their call for "courage, audacity, and revolt" replaced the nineteenth century's "liberty, equality, and fraternity" as bywords for the Modern Art movement.

MODERN WARFARE FOR A MODERN WORLD: WORLD WAR I

Clearly, a widespread desire for change charged the air at the turn of the last century. After a leisurely progression of art movements that lasted centuries, suddenly an explosion of many art movements occurred in a very short period. These reflected the thrill of progress as the world entered a new technological era and the shared excitement of young people (exemplified by the Futurists) over a future that seemed limitless in potential. The confident and enthusiastic mood was shaken profoundly by the events that followed June 28, 1914.

On that day, Archduke Francis Ferdinand, heir to the Austro-Hungarian Empire, was assassinated. His murder precipitated, through a complex series of political alliances, the drawing of the entire Western world into the bloodiest conflict ever seen, now called the *First World War*. In this conflict, the glorious modern machinery beloved by the avant-garde was transformed into awesome modern weapons of destruction. Submarines, poison gas, and air, tank, and trench warfare all made their first appearance in World War I. Battleships, barbed wire, machine guns, and heavy artillery were used on an unprecedented scale.

Few sensed the horrors to come at the war's outset. After nearly forty-five years of peace, the declarations of war filled the young and old of Europe with eagerness. Nationalism seemed to swell the hearts of all; heroic thoughts were in the soldiers' minds. When the brave warriors got to the front lines, they entered a labyrinth 450 miles long, known as the "western front." There, the horrifying conditions of the grim trenches shattered their naïve illusions. Soldiers were stuck below ground for months on end, knee deep in mud and water, listening to regular bombardments and the screams of the wounded, waiting for the murderous poison gas. Above them was a landscape covered with barbed wire and craters. According to Robert Graves, a novelist and British soldier:

> The Western Front was known among its imbittered inhabitants as the Sausage Machine because it was fed with live men, churned out corpses, and remained firmly screwed in place.

The final cost of this miserable "Great War" was sixteen million dead and twenty million more wounded, maimed, or missing. The Allied victory, according to Winston Churchill, was "bought so dear as to be almost indistinguishable from defeat." The young (better described as "once young") who survived became known as the "lost generation." The dream of progress was dead by the war's end.

DADA: TO ONE MADNESS WE OPPOSE ANOTHER

Idealism could be said to have been one of the earliest casualties of the war. By 1915, Zurich, Switzerland, had already become a sort of refugee camp for intellectuals, artists, Communists, and anarchists who had seen the uselessness of the war and had lost faith with their political leaders. The small, proper provincial town in a neutral country had been transformed into a hotbed of avant-garde activity and the birthplace of an international movement called **Dada**.

Convinced that the war was "horrible and stupid," the Dadaists wanted to launch their own war—a war on the conventional way of thinking that had guided Europe into the conflict. They believed that the Great War demonstrated that old beliefs and ideals were worthless and could only lead to disaster. It was time for the world to begin again; all traditional ways of thinking had to be shattered by poetry and painting. Or, as the chronicler of the movement and artist, Hans Arp, said: "Losing interest in the slaughterhouses of the world war, we turned to the fine arts."

Why the name *Dada*? According to Arp: "It means nothing, aims to mean nothing, and was adopted precisely because it means nothing." A Dada handout offered a reward "to the person who finds the best way to

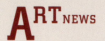

MODERN ART INVADES AMERICA:
THE ARMORY SHOW

In 1913, the most important exhibition in the history of the United States took place. Called The International Exhibition of Modern Art, the show had been conceived initially as a large exhibition of a group of advanced (for America) artists who lived in New York City. Later, the organizers decided to make the show a complete survey of Modern Art by showing Europeans. They accumulated so much artwork that a National Guard Armory in Manhattan was chosen as the only place large enough to accommodate them. More than thirteen hundred works by three hundred artists were exhibited in what would come to be known as the Armory Show. Even though only one-quarter of the exhibition was devoted to European artists, to the chagrin of the Americans, the foreigners stole the show. Their work outraged America and became front-page news. More than half a million people came to see the show, many as curiosity seekers, of course. But for the first time, Modern Art gained the attention of the New World.

In an exhibition that introduced Gauguin, Cézanne, van Gogh, Munch, Monet, Picasso, and Braque, there was much to shock the public. The *New York Times* said the whole show was "pathological." But it was Marcel Duchamp's *Nude Descending a Staircase (No. 2)* (18-20) that became the scandal of the show. To anyone familiar with Futurism (which few Americans were), the picture does not seem so radical. Duchamp was using a Cubist approach to explore motion. He also was influenced by the then-new multiple-exposure photographs that revealed the many aspects of movement. Most viewers were genuinely puzzled by Duchamp's work (at least those who could get close enough to see it once it became notorious and surrounded by crowds). The American magazine *ArtNews*, tongue-in-cheek, offered a prize for the best explanation of it. One critic described it as an "explosion in a shingle factory." Ridicule was common; the *Evening Star* mocked the painting in its *The Rude Descending a Staircase* (18-21), but at least the editorial cartoonist had understood what Duchamp was trying to portray.

It became almost a patriotic cause to attack these foreign intruders. Offended artists and critics, high school teachers, and ministers called the art immoral and indecent. Even former president Theodore Roosevelt felt obliged to comment on the exhibition. Like most, he criticized almost all of the exhibited work, but he also showed some understanding:

There was one note missing . . . and that was the note of the commonplace. . . . There was no stunting or dwarfing, no requirement that a man whose gifts lay in new directions should measure up or down to stereotyped and fossilized standards.

 MARCEL DUCHAMP, *Nude Descending a Staircase (No. 2)*, 1912. Oil on canvas, 4' 10" × 2' 11". Philadelphia Museum of Art, Pennsylvania. © 2012 Artists Rights Society (ARS), New York/ADAGP, Paris/Succession Marcel Duchamp.

He seemed to suggest that perhaps Modern Art contained something close to the American ideal.

The show, despite or because of its notoriety, turned out to be a financial success in terms of sales, but to the American artists' lasting humiliation, most of the sales were made by the scandalous Europeans. The most innovative American work now appeared cautious and old-fashioned. For the next three decades, forward-thinking American artists would turn their eyes toward Europe.

 The Rude Descending a Staircase (Rush Hour at the Subway), a cartoon that appeared in the New York *Evening Sun* on March 20, 1913. Museum of Modern Art Archives, New York: Armory Show Scrapbook (1913), compiled by Harriet S. Palmer.

explain Dada to us." Dada art was anarchic and humorous but also deadly serious. Following the Futurist model, performances were organized and designed to frustrate and confuse audiences. One of the more notorious performances came after running an ad in a local newspaper that Charlie Chaplin was appearing for three dollars at a theatre. Once the large audience had become impatient for the famous actor's arrival, the Dada artists came on stage and chanted:

> No more aristocrats, no more armies, no more police, no more countries, enough of these imbecilities, no more nothing, nothing, nothing.

Dada manifestos called for the destruction of all values—the end of art, morality, and society. This "anti-art" was an effort to evolve a new way of thinking, feeling, and seeing. Their pictures, writing, and performances were an invitation to utter confusion, a series of blows against accepted values. Dadaists were not interested in intellectual responses; they preferred violent ones. Dada performances typically ended with yelling insults from the stage at the disappointed listeners, who often responded in kind. Fistfights were deliberately instigated, because the Dadaists equated anarchy and chaos with true freedom.

MARCEL DUCHAMP AND INTERNATIONAL DADA

When Marcel Duchamp arrived in New York City in 1915, he was already a notorious figure in the United States because of his contribution to the Armory Show (see

"Art News" box). However, Duchamp's early controversial painting, *Nude Descending a Staircase (No. 2)* (18-20), would seem rather conventional when compared to his next scandalous work, one of the seminal objects of Dada. In 1917, Duchamp was one of the organizers of an exhibit at the Society of Independent Artists in New York City. Secretly, Duchamp submitted *Fountain* (18-22), a porcelain urinal signed "R. Mutt 1917." The work was literally thrown out of the show. Pretending to be appalled

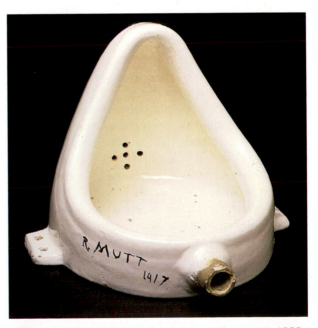

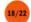 MARCEL DUCHAMP, *Fountain* (second version), 1950 (original version 1917). Glazed sanitary china, black paint, 1' high. Philadelphia Museum of Art, Pennsylvania. © 2012 Artists Rights Society (ARS), New York/ADAGP, Paris/ Succession Marcel Duchamp.

by the conservatism of his supposedly avant-garde fellow artists, Duchamp immediately resigned from the society and published a spirited defense of the work, entitled "The Richard Mutt Case." In his essay, he responded to their charges of plagiarism and immorality:

> whether Mr. Mutt [actually the name of a plumbing fixture manufacturer] with his own hands made the fountain or not has no importance. He CHOSE it. He took an ordinary article of life, placed it so that its useful significance disappeared under the new title and point of view—he created a new thought for that object. . . . Mr. Mutt's fountain is not immoral, that is absurd, no more than a bathtub is immoral. It is a fixture that you see every day in plumbers' show windows.

Fountain was what Duchamp called a "ready-made," art that asserted a new right for the artist: Anything an artist says is art is art. Because of this, Duchamp opened up the possibility that countless everyday items could be art. The genre art of Bruegel, where ordinary life was declared a new subject for great artists, had now evolved into an art of household objects. Duchamp's exhibited ready-mades ran the gamut from bottle-drying racks to snow shovels (called *In Advance of a Broken Arm*).

Perhaps the quintessential Dada work was Duchamp's *L.H.O.O.Q.* of 1919 (1-21). By scribbling a moustache and goatee on a cheap postcard of the *Mona Lisa*, Duchamp defiled and ridiculed what the cultured public generally acknowledged as the greatest artwork ever made. That simple act was intended to dynamite the pillars of culture, declaring the urban renewal of the entire Western tradition. Like Futurism, Dada pronounced the icons of the past (exemplified by Leonardo da Vinci's masterpiece) worthless rubbish to be discarded.

The Dada aesthetic motto was "beautiful as the chance encounter on an operating table of a sewing machine and an umbrella." *Gift* (**18-23**) is an example of the motto put into practice. By creating an unusual combination of everyday items, tacks and an iron, Man Ray, an American friend of Duchamp's, produced a visually powerful creation. His use of juxtaposition—a technique where unrelated objects are taken out of their normal context and joined together, producing a new unique object—opened a new area for artistic exploration. Man Ray called such objects either "indestructible objects" or "objects to be destroyed" and often did smash them.

This was the ultimate Dada act, subverting the old notion of art being permanent and deriding the value of immortality. It made the guards in the museums and the notion of masterpieces ridiculous. Other Dadaists caught the iconoclastic mood. One German artist even attached an ax to one of his sculptures with a note encouraging viewers to take a swing at his artwork.

By 1922, there were active centers of Dada activity in Berlin (see Hannah Höch, 7-14), Paris, Zurich, and New York City. The movement, however, had already crested. The ensuing rapid disintegration of Dada might be seen as the natural culmination of its own manifesto. If anarchy was one's supreme goal, then how could one belong to a movement? Some Dadaists even took actions to encourage its dissolution (for example, sending unsigned insulting letters to their colleagues). By 1923, there were only a few scattered members left in Europe and the United States. The Dada moment had passed.

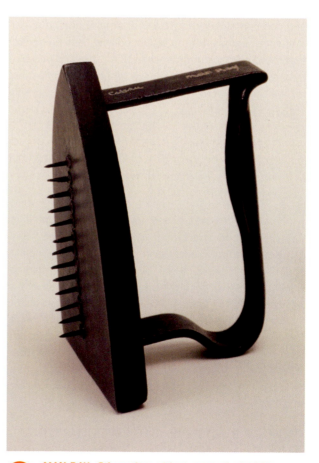

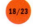 MAN RAY, *Gift*, replica of lost original of 1921. Painted flatiron with nails, 6½" high. Museum of Modern Art, New York. © 2012 Man Ray Trust/Artists Rights Society (ARS), NY/ADAGP, Paris.

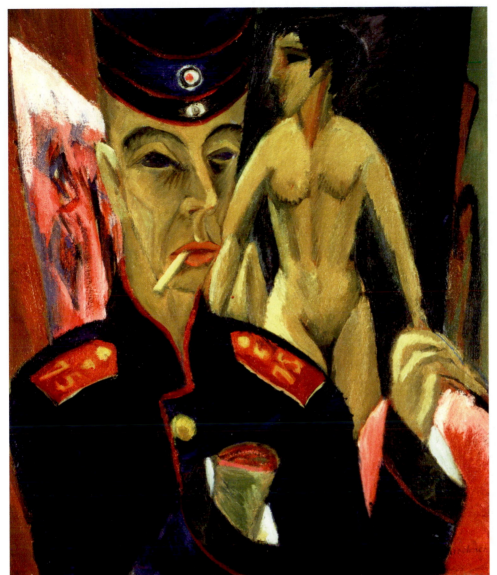

THE NEW OBJECTIVITY

Embittered by the shattering ordeal of World War I, German Expressionism's very nature changed. Ernst Ludwig Kirchner, one its leaders, suffered a mental breakdown during the war and was hospitalized. His *Self-Portrait as Soldier* (18-24) shows the toll taken by war on both his body and spirit. We see an unhealthy, sallow-faced, sunken-cheeked soldier with dark circles under his eyes and a cigarette butt hanging from his lips. His eyes are empty, his look cynical. He holds his painting arm, whose end is a cleanly cut bloody stump, up to the viewer. The only sign of humanity is the model who stands shamelessly naked, but looking away from the symbolically emasculated artist. While he was never actually injured physically, Kirchner's painting reminds us

that the wounds he and many others suffered were both physical and spiritual.

In 1914, Otto Dix had been an "enthusiastic volunteer" of twenty-three. Trained as a machine gunner, he served four years in the front lines. There, Dix was able to see firsthand the results of modern weaponry as the enemy died in his spray of bullets. Like many other veterans who returned from the war, Dix was shocked to see that his homeland seemed unaware of what he had experienced. His countrymen were all too eager to return to the illusions of the previous happier age. In response, Dix became a leading member of a recast Expressionism called The New Objectivity. Their goals, he said, were to "show human being in all its grandeur, but also in all its depravity, indeed its brutishness." These Expressionists would have "the courage to portray ugliness, life as it comes."

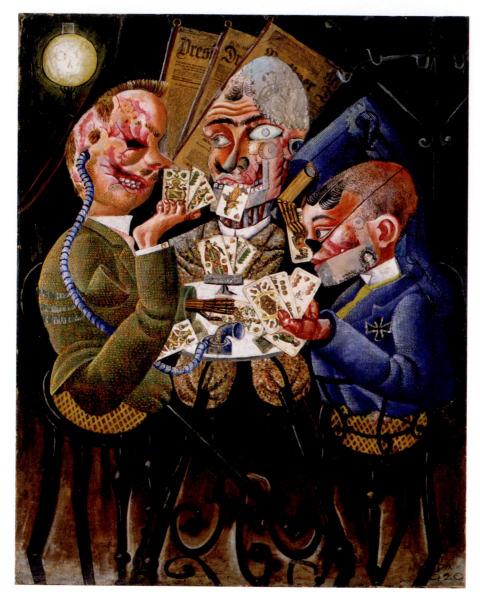

 OTTO DIX, *Cardplaying War-Cripples*, 1920. Oil on canvas with collage, 43¼" × 34¼". Nationalgalerie, Staatliche Museen zu Berlin, Germany. © 2012 Artists Rights Society (ARS), New York/VG Bild-Kunst, Bonn.

With *Cardplaying War-Cripples* (18-25), Dix confronted his fellow Germans with the real consequences of the Great War and cruelly mocked modern science's pathetic attempts to rebuild the maimed young survivors. The card players in this picture are alive but less human than before. Little more than repulsive half-robots, with clumsily sewn eye sockets and tubes stuck in their faces, they are the useless refuse of war; their lives are over. Dix's grotesque images were meant to cut through the atmosphere of self-delusion and denial among the German populace that he felt was suffocating him.

Käthe Kollwitz (see *Self-Portrait*, 4-4), unlike Dix, was an artist who engaged in the struggles of her time as an outspoken advocate, not as a bitter outsider. She wrote:

> I believe that there must be an understanding between the artist and the people. In the best ages of art that has always been the case. . . . I want to have an effect on my time, in which human beings are so confused and in need of help.

Many of Kollwitz's drawings were designs for posters to be used by humanitarian and socialist organizations. Like Dix, Kollwitz illustrated the suffering that the German government tried to ignore. This did not go without notice. When she won a prestigious prize, a government official canceled it, declaring her work "gutter art."

In the 1920s, Germany had its great depression. Devastated financially by the First World War, Germany experienced overwhelming inflation that forced a large part of the population into poverty. There were food riots and starvation. In *Bread!* (18-26), Kollwitz shows a mother whose children are hungry but who has little to

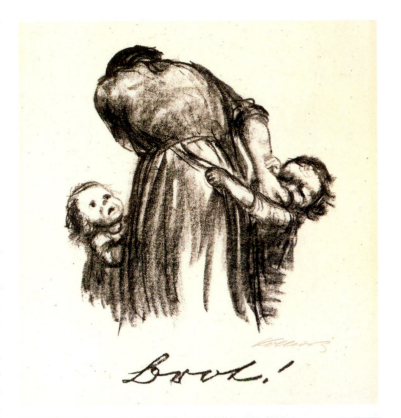

offer them. With only a crust, she must decide between them, pushing it into the mouth of an older boy behind her back while looking into the face of the little girl whom she cannot feed. Kollwitz was unique in her ability to translate abstract social problems into the real burdens that human beings were facing. These problems, unfortunately, remain widespread, which accounts for the enduring power of her art.

SURREALISM

With the disintegration of the Dada movement, many former Dadaists reorganized under a different flag. Once again they searched for an alternative to a conventional view of reality. They found inspiration in the work of the Viennese psychiatrist Sigmund Freud, whose discovery of the unconscious and the meaningfulness of dreams had changed the twentieth-century picture of the human mind. This new movement was called **Surrealism**, a word meaning "more real than reality," an art of dreams and the irrational unconscious.

Freud contended that beneath our veneer of rationality, in the unconscious portion of our minds, there lies a world of intense, barely suppressed desires (especially sexual urges). Our dreams, however, give us ways to express feelings that ordinarily have to be suppressed in a symbolic way. So rather than being simply confusing and irrational, dreams are rich in meaning once their symbols are analyzed. In dreams and irrationality, the Surrealists found a fertile world of fantasy and imagination. The unconscious, according to Freud, was also the key to our creativity and emotions. By giving our unconscious a "voice," the Surrealists intended to complete our picture of the world and gain access to the source of imagination. They were therefore confronted with a challenge: How to visualize the irrational unconscious, the unexplainable? How could they make an art of dreams?

The Surrealists of the 1920s found a forerunner of their movement in a relatively unknown Italian painter, Giorgio de Chirico. Without access to the works of Sigmund Freud, he had intuitively created what he called "Metaphysical Pictures" even before World War I. By setting his paintings in landscapes that did not follow the rules of perspective but were painted in a recognizable manner, he was able to evoke the seemingly real but ultimately confusing nature of the dream state. In *Mystery and Melancholy of a Street* (18-27), the

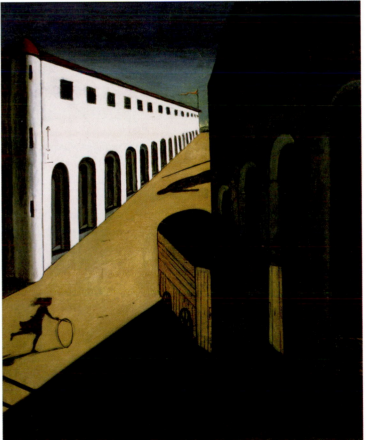

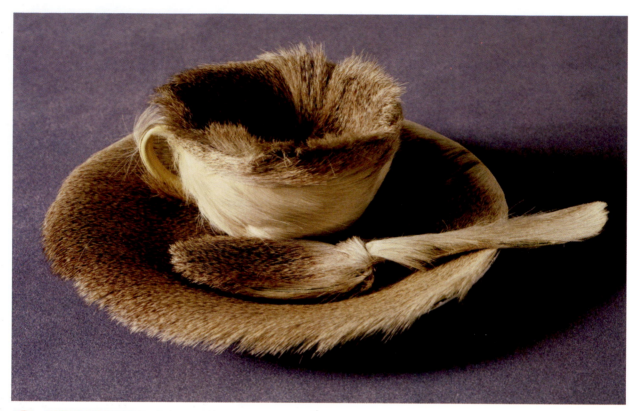

18/28 MERET OPPENHEIM, *Object (Le Déjeuner en fourrure)*, 1936. Fur-covered cup, saucer, and spoon; cup 4⅜" diameter; saucer, 9⅜" diameter; spoon, 8" long; overall, 2⅞" high. Museum of Modern Art, New York. © 2012 Artists Rights Society (ARS), New York/ProLitteris, Zurich.

mathematical certainty of the Renaissance arcade on the left becomes uncertainty when compared to the one on the right. These arcades lead to two irreconcilable vanishing points (see "Linear Perspective," Chapter 3). An empty boxcar sits in the foreground, enhancing the eerie loneliness of the scene. The frightening quality of a dream is evoked by the interplay between the small girl at play and the long, dark shadow of a figure with a spear above her.

SURREALIST JUXTAPOSITION

The Surrealists were committed to the liberation of sexual impulses as the first step in building a better world. Employing the Dadaist technique of illogical juxtaposition, Meret Oppenheim created an unforgettable and oddly sexual Surrealist sculpture—*Object (Le Déjeuner en fourrure)*, often known as *Luncheon in Fur* (18-28).

By covering a common cup, saucer, and spoon with gazelle fur, she altered them profoundly and released many troubling associations. Think of using the fur cup in a conventional way. The connection of two primal urges

(thirst and sex) underlies what at first seems only a humorous object but is actually much more disturbing.

DALÍ

One of the eerie qualities of dreams is that they look so real while we are asleep. To show dreams in vivid reality, some Surrealists ignored the revolutionary techniques of modern times and returned to the precise techniques of the Baroque masters of Holland and Spain. Salvador Dalí was the greatest master of this style of Surrealism. By bringing a superb realistic technique to Surrealism, he could make bizarre images seem believable.

The setting of Dalí's *The Persistence of Memory* (18-29), as in most of his pictures, is a lovely and timeless Mediterranean. In this pleasant landscape reside several strange objects. From left to right, we see a pocket watch with ants crawling on it; a flaccid watch, melted as if made of wax; and another watch hanging limply from a dead tree. An even more disquieting object is placed in the center of this vision—another melted watch hangs over what seems

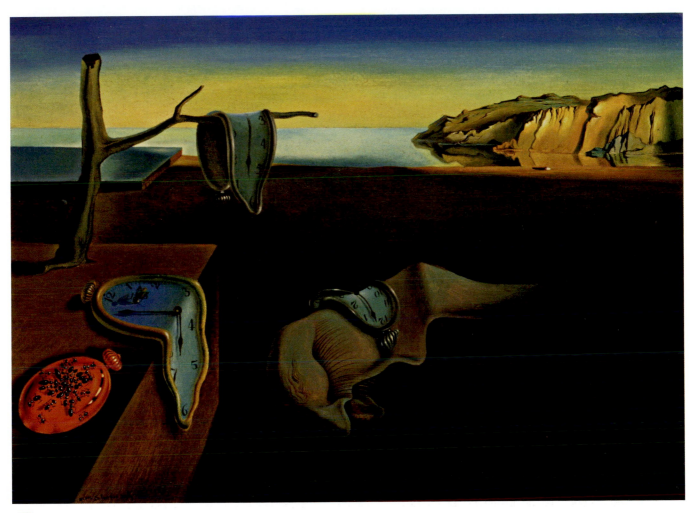

18/29 SALVADOR DALÍ, *The Persistence of Memory*, 1931. Oil on canvas, 9½" × 13". Museum of Modern Art, New York. © Salvador Dali, Fundació Gala-Salvador Dali, Artists Rights Society (ARS), New York 2012.

to be a piece of flesh. Complete with eyelashes, it looks as if someone has torn off the side of his or her face and left it on the sand, like a dead fish. In addition to the irrational juxtaposition of these strange objects, their size and scale are confusing, as things often are in dreams.

What does Dalí's picture mean? The artist did not offer much assistance:

> My enemies, my friends and the general public allegedly do not understand the meaning of the images that arise and that I transcribe into my paintings. How can anyone expect them to understand when I myself, the "maker," don't understand my paintings either. The fact that I myself, at the moment of painting, do not understand their meaning doesn't imply that they are meaningless: On the contrary, their meaning is so deep, complex, coherent, and involuntary that it eludes simple analysis of logical intuition.

In other words, one should not be surprised that successfully irrational pictures should be incomprehensible. Otherwise, they would not be "images of concrete irrationality."

One of Freud's discoveries in dream analysis was that events and objects could have several meanings at once. Dalí was able to create the visual equivalent of this idea in his *Apparition of Face and Fruit-Dish on*

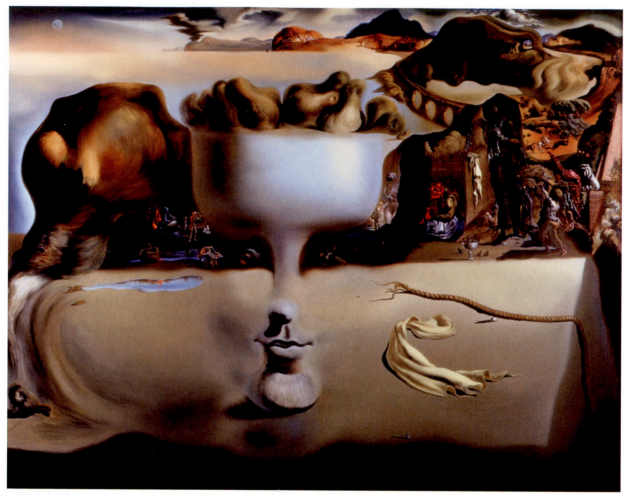

18/30 SALVADOR DALÍ, *Apparition of Face and Fruit-Dish on a Beach*, 1938. Oil on canvas, 45" × 56⅞". Wadsworth Ath- eneum, Hartford, Connecticut. © Salvador Dali, Fundació Gala-Salvador Dali, Artists Rights Society (ARS), New York 2012.

18/31 Detail of figure 18-30.

a *Beach* (18-30). Although it may not be initially per- ceptible, the entire picture is filled with a giant dog. His eye is also a cave (18-31), his body also a fruit bowl. The fruit bowl is also a face. Once we understand Dalí's method, this entertaining puzzle manages to lift us out of ordinary existence. We are able to look at the picture with fresh, searching eyes and do not take any part of the image at face value. That is the liberation of Surrealism.

MAGRITTE: THE REAL WORLD ON TRIAL

René Magritte offered liberation to his viewers by under- mining their confidence in the most ordinary things. *The Treachery (or Perfidy) of Images* (18-32) borrows the format of a typical children's book. Written below the simple image of a pipe is the sentence *Ceci n'est pas une pipe*, which translated reads, "This is not a pipe." Magritte explained that his titles "were chosen to inspire a justifiable mistrust of any tendency the spectator

might have to over-ready self-assurance." Magritte wanted to make the viewer conscious of the limitations of signs, labeling, and language. For example, snow has various qualities, so the Eskimos have many names for its different types. Yet in English we lump them all under the word *snow*. What do we miss when we generalize? What have we, by habit, become blind to when we say the word *snow* or *pipe* and stop looking? Simple identification is a prison that prevents us from seeing our world fully.

Magritte felt that our sense of what is normal constrains us. True freedom cannot exist until the fabric of normalcy is destroyed. Like Dalí, Magritte also pictured the impossible realistically. But unlike Dalí's, Magritte's scenes are set not in a distant ideal landscape but in a familiar, almost banal world. In 1939, Magritte explained his approach:

> I painted pictures in which objects were represented with the appearance they have in reality, in a style objective enough to ensure their upsetting effect.

In *L'Empire des lumières* (The Empire of Light) (18-33), for example, it is nighttime at street level, but above the trees it is day. Both parts of the picture are absolutely convincing, and the transition between the times of day even seems completely natural. What is portrayed looks normal but cannot be. In this surreal world, nothing is for certain, and things cannot be explained logically. Like ours, perhaps.

When René Magritte undermined language, signs, and conventional perceptions, he undermined all that makes us feel secure. Like many artists of the early twentieth century, he felt obligated to question what was once unquestionable, or, in his words, he was "putting the real world on trial." Along with the other artists in this chapter, he did this not simply to disturb us but to open our eyes to "an infinity of possibilities now unknown in life." His challenge to all of us is to see with fresh eyes, without prejudice. His aim was to return to us the full power of seeing.

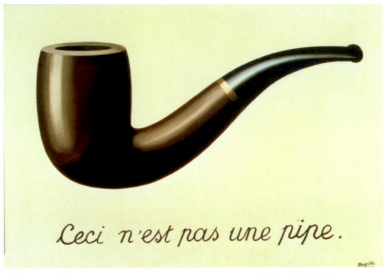

RENÉ MAGRITTE, *The Treachery of Images*, 1928–1929. Oil on canvas, 25½" × 37". Los Angeles County Museum of Art, California. © 2012 C. Herscovici, London/Artists Rights Society (ARS), New York.

RENÉ MAGRITTE, *L'Empire des lumières*, 1954. Oil on canvas, 4' 11½" × 3' 8⅞". Musée d'Art Moderne, Brussels, Belgium. © 2012 C. Herscovici, London/Artists Rights Society (ARS), New York.

CHAPTER 19

CROSSING THE FRONTIER

Art lovers who followed the avant-garde art movements of the early twentieth century witnessed some shocking changes. Traditional manners of representation that had been considered the essence of art for centuries—beauty, logic, realistic space, literal color, solid objects—were discarded enthusiastically. While many artists broke fresh ground, few were more revolutionary than Pablo Picasso. His treatment of color and form demolished barriers that had seemed impregnable only a few years before. Yet even he respected one ultimate barrier.

While some of his Analytical Cubist compositions were very abstract, Picasso never made a completely non-representational picture. All his art referred to the real, visible world in some way. It was his primary source of inspiration. As a young man, Picasso had seen that Paul Cézanne's work was pointing toward a new, more radical direction for painting—the style of Cubism. Beginning around 1912, other artists began to see that Cubist pictures were pointing toward an even more revolutionary type of art—one that would be completely liberated from the visible world, that could be created only out of pure colors, lines, and shapes. What appeared to be the last frontier for artists was about to be explored.

1910–1930

PERIOD

NONREPRESENTATIONAL ART
DE STIJL
THE BAUHAUS
THE INTERNATIONAL STYLE

HISTORICAL EVENTS

World War I **1914–1918**
League of Nations founded **1920**
Regular radio broadcasts begin **1920**
Mahatma Gandhi emerges as leader of independence movement in India **1921**
James Joyce, *Ulysses* **1922**
Louis Armstrong joins King Oliver's band **1922**
Gershwin, *Rhapsody in Blue* **1923**
Kafka, *The Trial* **1925**

ART

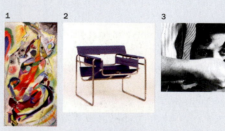

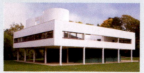

1. Kandinsky, Panel for Edwin R. Campbell No. 1, 1914
2. Breuer, Club Chair, 1925
3. Bunuel and Dali, *Un Chien Andalou*, 1928
4. Le Corbusier, Villa Savoye, 1929–1931

THE INVISIBLE MADE VISIBLE:

ABSTRACT AND

NONREPRESENTATIONAL ART

1930–1945	1945–1965
THE INTERNATIONAL STYLE	ABSTRACT EXPRESSIONISM
STRAIGHT PHOTOGRAPHY	THE NEW YORK SCHOOL
DOCUMENTARY PHOTOGRAPHY	COLOR FIELD PAINTING
SURREALIST PHOTOGRAPHY	THE INTERNATIONAL STYLE
EXODUS OF ARTISTS AND INTELLECTUALS TO THE UNITED STATES FROM EUROPE	

1930–1945

The Great Depression in United States 1930–1939
Steinbeck, *The Grapes of Wrath* 1939
World War II 1939–1945
Attack on Pearl Harbor 1941
Penicillin discovered 1943
Nuclear bombs exploded over Hiroshima and Nagasaki 1945

1945–1965

United Nations founded 1945
Beginning of Cold War 1946–1949
Independence movements in Europe's African and Asian colonies 1940s–1960s
Mao Zedong unites China under Communism 1949
Samuel Beckett, *Waiting for Godot* 1952
Discovery of DNA 1950s
Television supplants radio in United States 1953
New York becomes center of world art 1950s
Building of Berlin Wall 1961

5
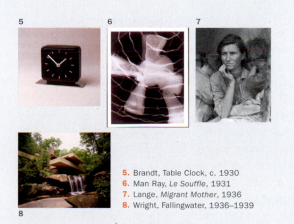
6
7

8

9

10

11
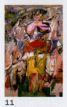
12
13

5. Brandt, Table Clock, c. 1930
6. Man Ray, *Le Souffle*, 1931
7. Lange, *Migrant Mother*, 1936
8. Wright, Fallingwater, 1936–1939

9. Kahlo, *The Little Deer*, 1946
10. Jackson Pollock at Work, 1951
11. de Kooning, *Woman and Bicycle*, 1952–1953
12. Johnson and van der Rohe, Seagram Building, 1956–1958
13. Smith, *Cubi XII*, 1963

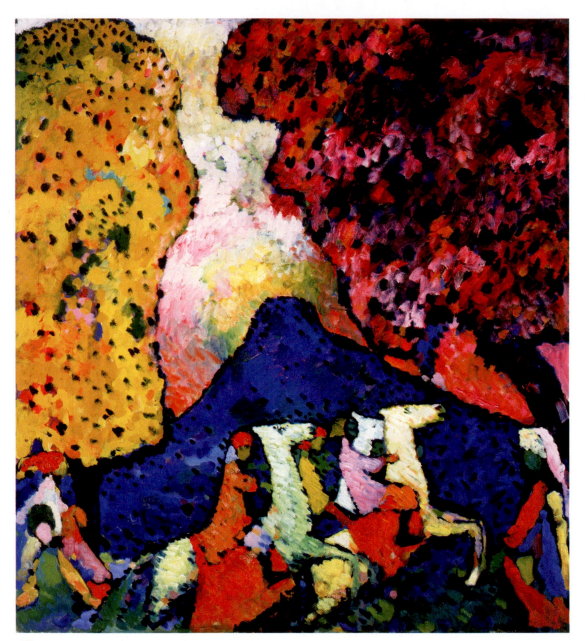

19/1 VASILY KANDINSKY, *Blue Mountain*, 1908. Oil on canvas, 41¼" × 37¾". Solomon R. Guggenheim Museum, New York. © 2012 Artists Rights Society (ARS), New York/ADAGP, Paris.

No one can deny that nonrepresentational art is challenging to the viewer. However, by looking at some of its first practitioners closely, we will be able to understand the natural progression that led to its creation.

THE SPIRITUAL PATH TO NONREPRESENTATION

Even early in life, Vasily Kandinsky had extraordinary sensitivity to color. When he heard music that moved him, he would close his eyes and see the music in colors. When the young Kandinsky saw a show of Claude Monet's paintings for the first time, he noticed only the colors and did not realize that the pictures were landscapes until he read the catalog. It was one of his first hints that a subject from the visible world would not be necessary for all art.

Kandinsky wanted to show the "inner mystical construction of the world." The latest discoveries in physics seemed to support his own intuition that an underlying invisible force holds our universe together—something called "energy" by physicists. Kandinsky felt

that color could show this energy. In paintings like *Blue Mountain* (19-1), Kandinsky simplified his drawing to open up wider areas for bright colors. Life's intensity was evoked by using unmixed, brilliant hues of yellow and red in the trees against the blues of the mountain itself. These colors vibrate vividly together. Despite the obvious power in colorful canvases like *Blue Mountain*, Kandinsky remained dissatisfied. He realized, little by little, that to show the spiritual nature of the cosmos, he needed to abandon all reference to the physical world.

Between 1909 and 1913, elements of the visual world were slowly transformed into increasingly abstract symbols. During 1913, Kandinsky painted the first *nonrepresentational* paintings, in which lines, shapes, and colors are independent elements and no longer refer to the real world (19-2). Each appears to have a life of its own; lines and shapes move in many directions and almost shove each other aside in an attempt to be noticed. Our eyes are pulled in many directions, and it is difficult to focus on any part of the composition for very long. We are witnessing Kandinsky's own struggle to organize his pictures, to orchestrate energy. His first abstract pictures seem chaotic, because he is painting in a new world where none of the old rules seem to apply. Now, the issue was no longer how to obtain absolute freedom, but how to control it.

Pink Accent (2-28) demonstrates how Kandinsky found ways to organize nonrepresentational painting. He used two large color fields of magenta and gold as a background to unify the picture. To make sure the fields remained in control, he kept the other pictorial elements relatively small in relation to them. By using lively colors and varying the sizes of the circles and squares, Kandinsky was able to achieve a balance that is dynamic but not chaotic. Although *Pink Accent* is a totally nonrepresentational picture, it does have a "natural" feeling to it. The geometric shapes shift like colorful planets in space. They exude animation and energy.

At the end of his life, Kandinsky was in complete command of a totally abstract art. Pictures like *Dominant Curve (Courbe dominante)* (19-3) are celebrations. Overflowing with creativity, Kandinsky is now uninhibited by earlier fears of chaos. Each line, color, and shape has its own mood, its own personality. These pictorial elements dance around, floating freely, like many characters joined together in harmony.

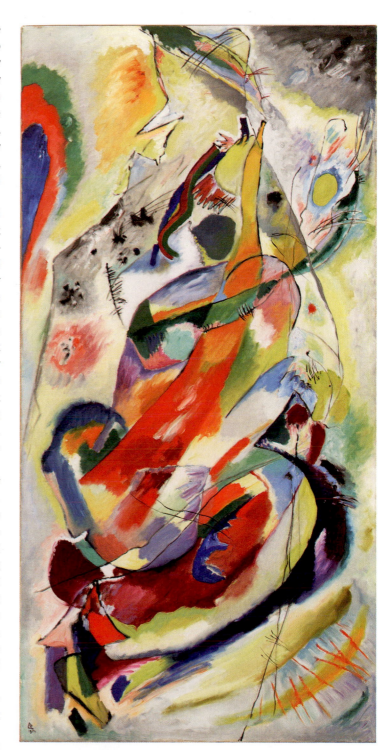

19/2 VASILY KANDINSKY, *Panel for Edwin R. Campbell No. 1*, 1914. Oil on canvas, 64" × 31½". The Museum of Modern Art, New York. © 2012 Artists Rights Society (ARS), New York/ADAGP, Paris.

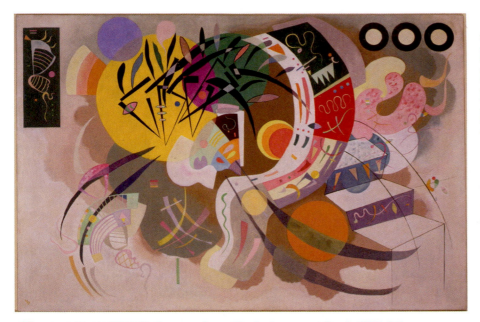

19/3 VASILY KANDINSKY, *Dominant Curve (Courbe dominante)*, April 1936. Oil on canvas, 50⅞" × 76½". Solomon R. Guggenheim Museum, New York. © 2012 Artists Rights Society (ARS), New York/ADAGP, Paris.

MALEVICH AND EL LISSITZKY: A MANIFESTO FOR NONREPRESENTATION

The variety in Kandinsky's paintings demonstrates that he had discovered a fertile field for exploration. Other artists were also moving in this new direction; among them, his countryman Kazimir Malevich. As a young man, he tried his hand at many of the modern movements like Impressionism, then with a more primitive style inspired by Russian folk art. By 1909, like other European artists, he was swept up in the enthusiasm for Cubism. He began to simplify landscapes into tubular and spherical geometrical shapes. However, in 1915, Malevich broke away from Cubism. He felt artists needed to be liberated from the constraints of representing reality and declared it was time for a new, purer art—what he called Suprematism. In his book *The Non-Objective World,* he wrote, art "can exist, in and for itself, without 'things.'" According to Malevich, "To the Suprematist, the visual phenomena of the objective world are, in themselves, meaningless; the significant thing is feeling."

His first Suprematist pictures were far simpler and more radical than Kandinsky's. One, *Black Square*, was simply a black square centered on a white background. *Suprematist Composition: Airplane Flying* (19-4), while ultimately nonrepresentational, demonstrates that Malevich was still inspired by things in the real world. In this case, it was an exciting new perspective made possible by a ground-breaking technology of the Modern Age—the moving landscape seen from above in an early airplane. Rather than recording aerial perspective, Malevich translates the invigorating sensation of flying into a dynamic arrangement of flat rectangles and lines. To better understand the painting, one should consider how different arrangements of these simple elements could have created different feelings. What if the rectangles were not placed on a diagonal, for example, or the black forms spread across the canvas? While Malevich had reduced art to its pure basics, for him the weight and length of each line and the width, area, and position of every color had its effect on the whole mood of the painting.

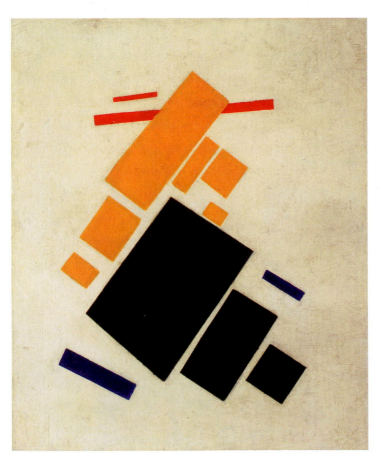

19/4 KAZIMIR MALEVICH, *Suprematist Composition: Airplane Flying,* 1915. Oil on canvas, 22⅞" × 19". Museum of Modern Art, New York.

Modern Art was not the only momentous change in the early twentieth century. In 1917, Russia was transformed by the Bolshevik Revolution that overthrew the Czar and established the world's first communist government. Malevich was among the many enthusiastic avant-garde artists who embraced the new Socialist philosophy and used their talents to support the emerging Soviet state. They believed that this was their chance to help build a Modern utopia. Malevich worked at the People's Commissariat for Enlightenment, creating Suprematist posters and banners for events, as well as stage sets for revolutionary plays. He was appointed a studio head at a State art school and was determined to educate students in a new art for a new society.

He was joined there by El Lissitzky, another Russian artist, who soon embraced the principles of Suprematism. Nonobjective art meets political propaganda in El Lissitzky's poster from the turbulent early years of the Revolution, *Beat the Whites with the Red Wedge* (19-5). At the time, Russia had been plunged into a civil war between the radical Red Army of the young Bolshevik government and the Whites, made up of conservative elements of the old Russia (former land owners, capitalists, monarchists, army officers, and devout Christians) attempting to regain power. With totally abstract forms, El

Lissitzky calls on the Reds, the aggressive triangle on the left, to pierce the Whites, the open white circle. The split in society is symbolized by the picture's division into white and black areas. The Russian words on the left translate as "With Red Wedge" and on the right "Beat Whites." Both El Lissitzky and Malevich believed that nonobjective art could be universally understood and was ideal for reaching the masses of uneducated Russian peasants.

In the early days of the Soviet regime, Russian Modern artists were given a high rank. The purity of Suprematism was considered free from the stain of old bourgeois values and ideal for building a new society. But as the Soviets consolidated their power, their tastes became more conservative. Avant-garde art was considered too preoccupied with self-expression. Social Realism, realistic art more easily understood by the people, became the official style, and many abstract artists were labeled counter-revolutionary. El Lissitzky managed to survive because he used graphic design with photomontage and imaginative typography for propaganda purposes. Malevich did not fare as well. In the 1930s, Suprematist art was banned, and Malevich was ordered to change his style. His earlier paintings were confiscated. The dream of a union between nonobjective art and a socialist utopia in Russia had ended.

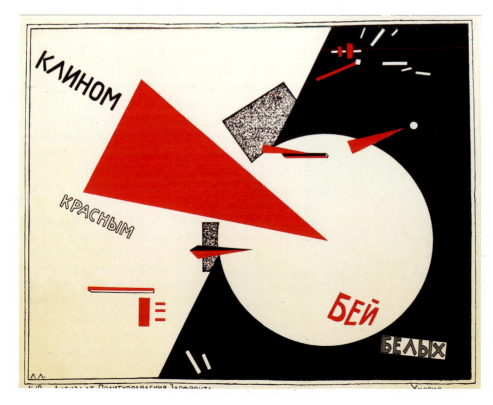

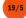 **EL LISSITZKY**, *Beat the Whites with the Red Wedge*, 1919–1920. Lithograph, 19½" × 28". Van Abbemuseum, Eindhoven, Netherlands. © 2012 Artists Rights Society (ARS), New York.

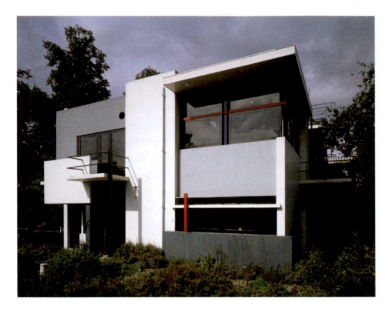

19/6 GERRIT RIETVELDT, Schröder House, Utrecht, Netherlands, 1924. © 2012 Artists Rights Society (ARS), New York.

of the best examples of De Stijl architecture, a three-dimensional equivalent of a Suprematist picture. Built in 1924 in Utrecht, Holland, it follows the strict vertical and horizontal orientation common in avant-garde Dutch art of the time, but Rietveldt's design manages to avoid rigidity. The rectangular panels seem to float in front of equally rectangular dark windows. All forms are balanced asymmetrically, and a portion of the flat roof seems to move out from the building toward the street. As we look at it, the building seems almost to be in the process of arranging itself. In fact, the interior spaces were designed to be flexible; sliding panels could be moved to accommodate the needs of the occupants. While it seems very modern even today, to really understand its impact in 1924, however, imagine the shocking contrast made by this building painted in white, gray, and primary colors in a neighborhood of nineteenth-century homes.

DE STIJL

In Holland during World War I, a movement called *De Stijl* ("the style") emerged whose ideas and approach to art were very similar to Russian Suprematism. The Dutch artists believed a pure universal style in art and architecture could be the solution to humanity's misery. They declared that "art and life are no longer two separate domains. . . . We demand the construction of our surroundings according to creative laws." De Stijl artists designed furniture and buildings using flat geometric areas filled with pure and simple colors, like Malevich's paintings. Gerrit Rietveldt's *Schröder House* (19-6) is one

THE INTERNATIONAL STYLE

The Schröder House and De Stijl would eventually be included in a worldwide movement called the **International Style**. Other architects in Europe and the United States shared the Dutch artists' desire for a pure modern counterpart for the Machine Age—constructions that utilized a new language for the arts.

The **Bauhaus**, founded by Walter Gropius (see Chapter 11), was designed to be a home for this new language. Gropius's dictum that "the complete building is the final aim of the visual arts" was one of the central tenets of the movement, and his influential design for the new *Dessau Bauhaus* (19-7) epitomizes many of the qualities that would characterize the International Style for decades to come. Finished in 1926, it was the new home for the school after political changes made it impossible for the Bauhaus to remain in its first location.

The building was the antithesis of the heavily ornamented style taught in traditional architectural academies. Flat-roofed and made of modern materials (concrete, steel, and glass), it was free of any superfluous decoration. Boxlike and practical, all spaces were designed for efficient organization. It

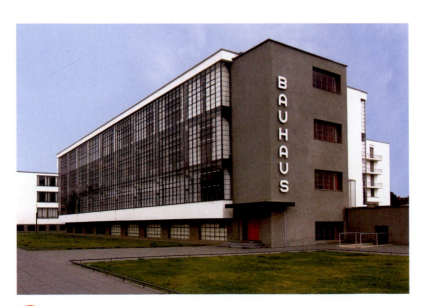

19/7 WALTER GROPIUS, Bauhaus, Dessau, Germany, 1925–1926.

followed Gropius's directives for the new architecture in 1923:

> We want a clear, organic architecture, whose inner logic will be radiant and naked, unencumbered by lying facades and trickeries; we want an architecture adapted to our world of machines . . . whose function is clearly recognizable in the relation to its form.

The building was supported by an outer skin of glass and steel, what would be known as a **glass curtain**. Notice Gropius's handling of the corners of the building. Instead of the typical heavy stone piers, there was only a sharp edge formed by the meeting of transparent panes of glass. Light poured into the large, open classrooms. The glass-curtain walls also allowed those on the outside to see the activities inside, breaking the age-old tradition of separation between interior and exterior spaces. All aspects of the building were designed and built by instructors and students, from the lamps to the furniture in the dining rooms (11-24, 11-26). Its integration of interior and exterior design became the new tradition for modern architects.

After the Bauhaus was finally closed by the Nazis (see "Art News" box), Gropius and many of his instructors came to the United States and continued teaching and designing. Their influence on the training of young American artists and architects helped make Modern architecture and design the dominant style for the rest of the twentieth century. One measure of their influence is that the Bauhaus building at Dessau seems like an ordinary building today.

LE CORBUSIER: MASTER OF THE "NEW SPIRIT" IN ARCHITECTURE

Le Corbusier's *Villa Savoye* (19-8), however, still seems radical more than 75 years after its construction. Built in 1931 as a weekend house in the suburbs of Paris, it has long since been seen as the embodiment of the International Style. Resting at the top of a hill supported by concrete columns, with horizontal windows providing views in all directions, it is the twentieth century's *Villa Rotonda* (14-24) or *Monticello* (10-37). Unlike Palladio or Jefferson, however, Le Corbusier utilized no Classical

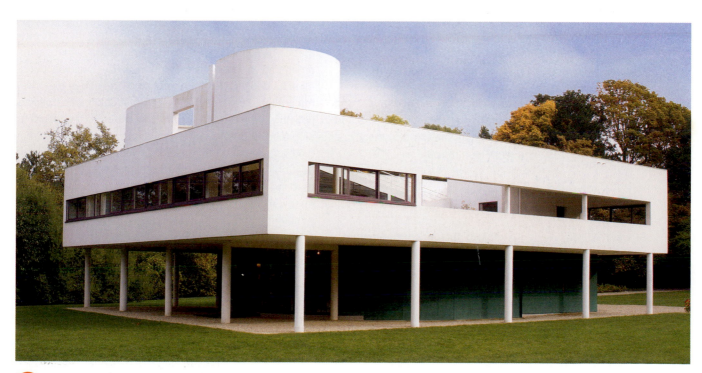

19/8 LE CORBUSIER, Villa Savoye, Poissy, Ile-De-France, France, 1929–1931.

elements or historical references. An architectural purist, he believed that Modern buildings should be more rational and scientific than previous styles. According to him, a house was "a machine to be lived in."

In the Villa Savoye, the columns that support the building not only provide a fine view inside and on top but also a convenient place to park one's car. A pure, undecorated skin of windows and smooth stucco surround its inner frame. Inside, ramps lead through large, open, and well-lit rooms and up to a secluded roof garden—a pleasant idiosyncrasy of his buildings. Along with most of the buildings in the International Style, Le Corbusier's buildings have come to be seen as dehumanizing, but that was not their original intention. Like Gropius, Le Corbusier dreamed of an architecture that could create a better world. By utilizing and preaching a new international style, what he called the New Spirit, Le Corbusier hoped that old nationalist boundaries could be broken down, and a new world order devoted to humanitarian goals could be achieved. His "Plan for a Contemporary City for 3 Million Inhabitants" (10-40) was one of a lifetime's worth of projects designed to resolve the intransigent social problems of poverty, homelessness, and class divisions. Le Corbusier imagined such reforms could be achieved through an orderly and perfected architecture. Despite his extraordinarily creative mind (Gropius once said it would take an entire generation of architects to explore all of Le Corbusier's ideas), most of his projects were never built. In the twentieth century, however, this was no longer a hindrance to fame. Because he lived in an age of easily made reproductions, Le Corbusier's blueprints were circulated worldwide, and a younger generation of architects spread his plans and the International Style throughout the world by modifying his ideas and making them less radical.

FRANK LLOYD WRIGHT

Frank Lloyd Wright epitomized the American approach to modern architecture before World War II. Wright, who became the most famous American architect, designed modern buildings that have many similarities to the Bauhaus model but are based on profoundly different ideas. His motto—"Form follows function"—learned in his apprenticeship from the architect Louis Sullivan, remains a slogan of the Modern Art movement.

Wright was born in the beautiful hills of rural Wisconsin just after the end of the Civil War. He learned the lessons of nature, which he called "a wonderful teacher," on his uncle's farm. As a young architect in Chicago, the messages of his childhood were translated into an ideal he would later call "organic architecture": functional buildings designed to work with nature, built from the creative arrangement of simple forms.

For his entire life, Wright refused to be associated with what he felt was the essentially European International Style. In 1932, Wright said of Le Corbusier: "I believe Le Corbusier [is] extremely valuable, especially as an enemy." Wright's *Kaufman House (Fallingwater)* (10-32), built in 1936, makes a striking comparison with the Villa Savoye. Both homes are designed as country retreats, but their underlying attitudes are quite different. The utter logic and machinelike quality of Le Corbusier's design is opposed by the free forms and natural materials favored by Wright. Wright's building is designed to blend into nature; in fact, it sits on a ledge where a waterfall actually passes under the house. Le Corbusier's villa stands on columns that distance it from nature; its boxlike form has nothing to do with its surroundings. Although both architects used concrete to shape simple, geometric forms, Wright's open slabs reach out to nature, while Le Corbusier's box resembles a fortress.

However, both architects shared the modern aesthetic. They believed in the elimination of unnecessary ornament, in letting the function of the building determine its design. Neither approved of the use of historical references. Both believed interiors should be as open as possible. Above all, they were committed to the idea that architects should design every aspect of a building, from the overall plan to the furnishings within. One of the most beautiful results of this aesthetic is Wright's exploration of round shapes at his *Solomon R. Guggenheim Museum* in New York City (**19-9, 19-10**). In a building that is almost a modern sculpture itself, art lovers move smoothly and gradually along a spiral ramp from the top to the ground level without interruption.

Wright was the first American architect to have a truly international influence. While he probably never achieved his intention of being "not only . . . the greatest architect who has ever lived, but the greatest who will ever live," during the middle decades of the twentieth century, there were many in his field who believed he had.

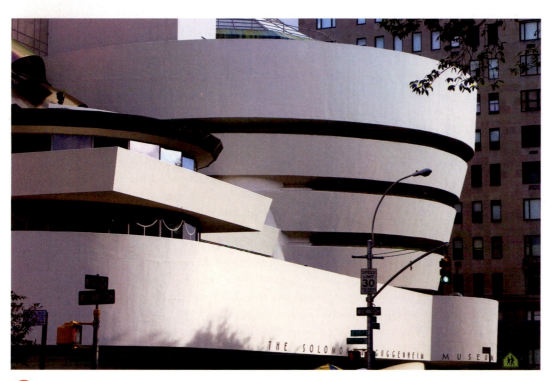

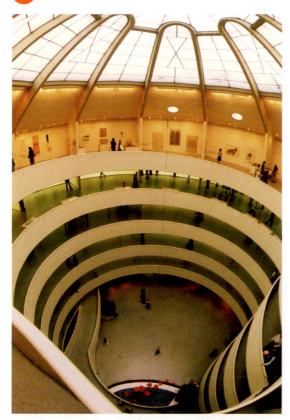

ABSTRACT ART IN AMERICA: O'KEEFFE

Georgia O'Keeffe was another American original. Like Wright, O'Keeffe was born in rural Wisconsin and first attracted attention in the early years of the twentieth century. In her old age, she also became a larger-than-life figure in the art world. She said she knew as a child that she wanted to be an artist, even though she had very little idea what that meant. In the early 1900s, however, most American women who wanted a career in art were expected to become teachers; higher ambitions were not considered practical or proper. After years devoted to the study of art, followed by teaching in public schools and colleges, she felt rather discouraged. As she wrote many years later,

> One day I found myself saying to myself, "I can't live where I want to. I can't even say what I want to." I decided I was a very stupid fool not to at least paint as I want to.

She discovered a deep well of inspiration in the abstraction of nature, its creations, and its forces—her most dominant theme during a career that lasted nearly seven decades. *Two Calla Lilies on Pink* (see 3-12) is a

good example of her sensuous style of synthesizing natural forms.

Radiator Building—Night, New York (19-11) was painted in 1927, when she was living in New York City. O'Keeffe focused on the unique experience of artificial light at night in the modern city—a manufactured world filled with unnatural experiences. The home of the American Radiator Company rises like a beacon at the center of the picture; the skyscraper's windows form a grid of whites and grays. Searchlights illuminate an undulating cloud of steam that rises from a rooftop; streetlights glow like stars and float mysteriously.

Throughout her career, O'Keeffe followed a pattern that she established at its beginning: taking inspiration from the world around her and reworking it into a personal statement. Sometimes her pictures were quite literal; at other times they would become totally abstract. The simple purity of O'Keeffe at her most nonrepresentational is seen clearly in *Abstraction Blue* of 1927 (19-12). What once may have been the interior of a flower is now a series of rounded forms. Arranged symmetrically, they are all brought together in a quiet balance that gives an impression of monumentality. With *Abstraction Blue*'s sharp edges and blue palette, one might have expected it to seem harsh and cool, but O'Keeffe mitigates this sharpness with soft gradations of blue and pink. Such gradual blendings of color combined with crisp edges are hallmarks of her style. Her pictures are accessible to the general public in a way that is rare among the nonrepresentational artists of the twentieth century. Shortly after her death at the age of ninety-eight in 1985, a retrospective of her art in Manhattan drew enormous crowds and solidified O'Keeffe's reputation as one of the most important American artists of the century. As she predicted, when explaining why she made her flowers so big, "I will make even busy New Yorkers take the time to see what I see of flowers."

 GEORGIA O'KEEFFE, *Radiator Building—Night, New York,* 1927. Oil on canvas, 48" × 30". The Carl van Vechten Gallery of Fine Arts, Fisk University, Nashville, Tennessee. © 2012 Georgia O'Keeffe Museum/Artists Rights Society (ARS), New York.

GEORGIA O'KEEFFE, *Abstraction Blue,* 1927. Oil on canvas, 40¼" × 30". © ARS, NY. Museum of Modern Art, New York © 2012 Georgia O'Keeffe Museum/Artists Rights Society (ARS), New York.

 IMOGEN CUNNINGHAM, *Leaf Pattern*, before 1929. Gelatin silver print. © 1978 The Imogen Cunningham Trust.

STRAIGHT PHOTOGRAPHY

Photographic art also has the power to concentrate our vision, to focus on reality in a new way. When comparing the work of the painter O'Keeffe and the photographer Imogen Cunningham, it seems surprising that they were not close friends (though they did meet in New York in the 1930s). Cunningham was a West Coast photographer who spent much of her career exploring the abstract patterns created by natural forms such as plants. In her *Leaf Pattern*, Cunningham focuses on a close-up detail of her subject (19-13). By presenting just a leaf or a flower in sharp focus, her pictures almost seem to increase our vision, to enable us to see their subjects with a kind of superrealism. In this way, her pictures appear to stop time.

Many of the photographs of Edward Weston also have a similar quality. His closely studied vegetables (7-13), sculptural and almost abstract, cannot fail to remind one of similar pictures by Cunningham and O'Keeffe. He also shared with O'Keeffe a love for the wide-open spaces of the American West. Born in Chicago, he visited California for the first time at the age of twenty and stayed virtually for his entire life.

Like many other artists discussed in this chapter, Weston attempted to capture the eternal, but he insisted on doing this "honestly." Disturbed by photographers who tried to imitate painters by using soft focus and other "trickery," he resolved in the 1920s "to present clearly my feeling for life with photographic beauty . . . without subterfuge or evasion." He thus became one of the fathers of *straight photography* (see Chapter 7). With Cunningham, Ansel Adams (1-24), and other West Coast photographers, he founded *Group f/64*, named for the small aperture setting (see Chapter 7) that results in a wide depth of field and highly detailed images.

Dismissing interesting accidents produced by rapid shooting, Weston believed photographers should decide on each image they took. Using a large-format camera that allowed him to see exactly what was in the lens, he "previsualized" each image before pressing the shutter release. A time-consuming process, Weston would wait all day if necessary to reveal the "deepest moment of perception." His camera made negatives that were eight by ten inches, and all of his prints were *contact* prints, made directly from a negative without enlargement or reduction. This provided images of the utmost clarity and purity. These prints were also *uncropped* (printed "full-frame"), a tradition established by Weston and followed to this day by many photographers. For him, the need for any alteration to his images implied that he had failed.

Drift Stump, Crescent Beach (19-14) is ample proof that Weston's patience paid off handsomely. Point Lobos

EDWARD WESTON, *Drift Stump, Crescent Beach,* 1937. Gelatin silver print, 9½" × 7¾". Center for Creative Photography, University of Arizona.

THE WAR AGAINST MODERN ART:
DEGENERATE ART

As a young man, Adolf Hitler wanted a career as an artist. His student work was far from controversial or threatening. Most of his pictures were architectural drawings and pleasant, sentimental landscapes in watercolor. Unfortunately, when he applied for admission to an art academy in Austria, he was rejected and forced to abandon his dream.

As he rose to power in Germany, Hitler never forgot the insult. He would take his revenge on the art world and decide what was acceptable in art. The Bauhaus was one of the first schools affected by the rise of Nazism. A new Fascist city government appointed a new director, whose view of Bauhaus style was that it was "cosmopolitan rubbish." The school was closed by the government in 1933.

Hitler believed in an art that was elevated and classical, one that anyone could understand. According to him, Modern art was the expression of sick minds, and so was modern music like jazz. Modern art was removed from the museums, and private collections were confiscated by the government. Some of these pictures were destroyed in bonfires, but many would be sold to raise funds for the Nazi war machine. Artists like the Expressionists, who did not share his views, first lost their teaching positions and later were forbidden to even make any art. Some artists, like Ernst Kirchner, committed suicide. Many were forced into exile. Outside of Germany, the Emergency Rescue Committee was created in Europe to assist fleeing artists, musicians, and writers.

To show the German people his vision of art, in 1937 Hitler opened The House of German Art in Berlin, a museum designed to replace modern art with "a 'German' art and an eternal art." Hitler's chief spokesman declared that the new museum was proof that "the Führer loves art." Along with German masters like Dürer and Holbein, the museum exhibited new works created to glorify the Aryan empire, all part of "a new and vigorous flowering of art."

Across the street, another exhibition opened at the Führer's direction—"Entarte Kunst" (Degenerate Art) **(19-15)**. Its goal was to educate the people and to cleanse the nation of degenerate influences. More than six hundred works were in the show, which included some of the most important names in the history of Modern art. Among the 112 artists on exhibit were Kandinsky, El Lissitzky, Klee, Chagall, Ernst, Kollwitz, Nolde, and Kirchner. The works were hung all over the walls at many angles, with slurs like "Bolshevik" and "Jew" scrawled next to the pictures. Modern landscapes were described as "Nature as seen by sick minds."

Hitler declared that there were only two possible explanations for these modern artists. He said:

Either these "artists" really do see things in this way and believe in what they represent. Then one has only to ask how the defect in vision arose, and if it is hereditary, the Minister for the Interior will have to see to it that so ghastly a defect of vision shall not be allowed to perpetuate itself. Or if they do not believe in the reality of such impressions but seek on other grounds to burden the nation with this humbug, then it is a matter for a criminal court.

The Degenerate Art show toured Germany and Austria for four years and would be seen by more than three million people, probably more than any exhibition before it. Most visitors laughed at the works. Artists and art students went to see these masterpieces of twentieth-century art for what they believed was the last time and suffered in silence.

19/15 Degenerate Art Show poster, 1938, Hamburg, Germany.

is a state park on the coast of California near Weston's home and one of his favorite sites. The vivid description of the textures on a piece of weathered wood could not be seen so clearly with any other photographic method. It fulfills Weston's ambition to show "the greater mystery of things revealed more clearly than the eyes can see." Photographed against a clear sky, the aged wood seems like an ancient monolith.

THE CENTER OF WESTERN ART SHIFTS

In the 1930s, storm clouds were gathering in Europe that were harbingers of its coming decline. The closing of the Bauhaus by Adolf Hitler's government in Germany was just one small part of his organized plan of censorship, repression, and terror (see "Art News" box). After Hitler's armies began their attempt at world domination in the 1940s, Europe was no longer capable of providing a nurturing ground for advanced artists. While Picasso and Matisse would stay in France, many artists fled from Europe, looking for a place where they could pursue their art in freedom. Marc Chagall and Salvador Dalí were among the many artists who left Europe for America. They joined other important European artists like Marcel Duchamp, who had already emigrated to the United States before the war.

Their combined presence had a profound effect on American art, especially in New York City, where most of them found a home. New York City became the world capital of art in the 1940s and 1950s, replacing Paris, which had been the center of Western art since the age of Louis XIV. The land of Norman Rockwell had been invaded by Modern art.

ABSTRACT EXPRESSIONISM: MODERN ART CREATED IN AMERICA

Willem de Kooning, born in Holland, came to this country as a young man. De Kooning's early paintings were portraits, influenced by Picasso but already with a dramatic command of line. Then, in the late 1940s, de Kooning began a series of black-and-white paintings that were totally original (**19-16**). Loose, expressive lines described

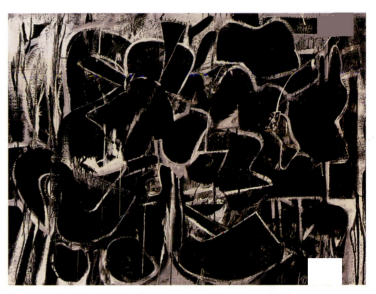

 WILLEM DE KOONING, *Painting*, 1948. Enamel and oil on canvas, 42⅝" × 56⅛". Museum of Modern Art, New York. © 2012 The Willem de Kooning Foundation/Artists Rights Society (ARS), New York.

very complicated and interlocked abstract spaces. Drips go up and down. It is not clear which shapes are coming forward and which are behind. This was intentional; like the Cubists, de Kooning did not want these pictures to have a conventional background and foreground. His mastery of a gestural, calligraphic line creates powerful rhythms all by itself.

These nonrepresentational, energetic pictures were some of the first of a new kind of painting that would become known as **Abstract Expressionism**. Like many art historical labels, it is a loosely defined one, describing art that combines the potent psychological content of Expressionism with an abandonment of any clear reference to the visual world.

Throughout his career, de Kooning would paint both pictures that referred to the visible world (like *Woman and Bicycle*, 1-37) and those that were more or less completely abstract. He, along with his fellow Abstract Expressionists, believed it was more important to be an honest painter than to stick to a single-minded theory of art. If, while painting, his picture began to look like a woman, then why should he deny it? If it reminded him of looking out a door toward a river, then why shouldn't he have the freedom to recognize it? Paintings like *Door to the River* (**19-17**) can be admired either as an imaginative interpretation of a scene or understood on a totally abstract level. The confident, wide, thick brushstrokes and harmony of the colors communicate on a direct emotional plane. The sense of a landscape is intuitive and not compulsory.

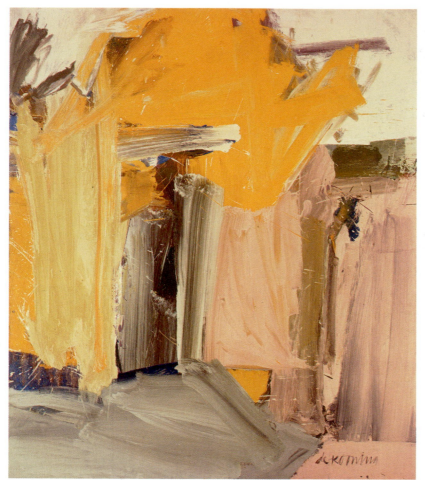

POLLOCK'S ACTION PAINTING

There were two fathers of this new movement: de Kooning and an American painter, born in Wyoming, Jackson Pollock. Pollock was influenced by the Surrealist artists who came to New York during World War II. He was particularly inspired by the way they gained access to their unconscious through a method called "automatic picturemaking," where all marks were made instinctually, without planning or thought.

Pollock transformed this approach into a revolutionary and nonrepresentational way of painting that would be called his "drip technique" (see photo, **19-18**). On a length of canvas rolled onto the floor of his studio, Pollock would instinctually drip long lines of paint with brushes and sticks. He would hover over his canvas, sometimes stepping into it, moving constantly. While he was working, his picture would not really have a top or bottom. Not until he was finished would he determine the picture's final size (by cutting the canvas) or where its bottom was (by signing it). His lines were unique not only because of his technique, but also because they did not do what lines had always done in art—describe spaces or shapes. His lines were independent and active, each a lively experience.

The design of a drip painting was also original—an "all-over" picture. This meant that, unlike all previous paintings, in Pollock's work no one part or section dominated the others. No part could be called the subject. All over the canvas, everything was equal in impact. By looking at *Number 1, 1950 (Lavender Mist)* and a detail of it **(19-19, 19-20)**, we can see that, whether it is seen at a distance or close up, Pollock's approach created an entirely new kind of space. Nets of lines laid one over another produce a sense of infinity. Looking at a huge Pollock painting is like looking up at a sky full of stars on a clear night.

Pollock is the artist most identified with the term *action painting* because of the energy in his new technique. His action paintings, according to witnesses, were done in fits of intense and often violent activity. He was known to spit at and burn parts of his pictures. Their great size was not a result of any artistic theory but rather Pollock's sense that he needed room to work in. Wall-sized, heroic pictures would become one of the identifying characteristics of Abstract Expressionism.

Jackson Pollock's unusual method of painting and lifestyle transformed him from an unknown into a celebrity. An art critic described Pollock as Picasso's heir, saying he

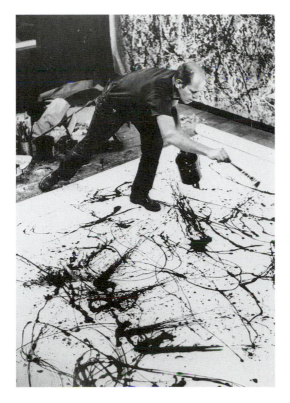

19/18 Jackson Pollock at work, 1951.
Photograph by Hans Namuth.

19/20 Detail of figure 19-18.

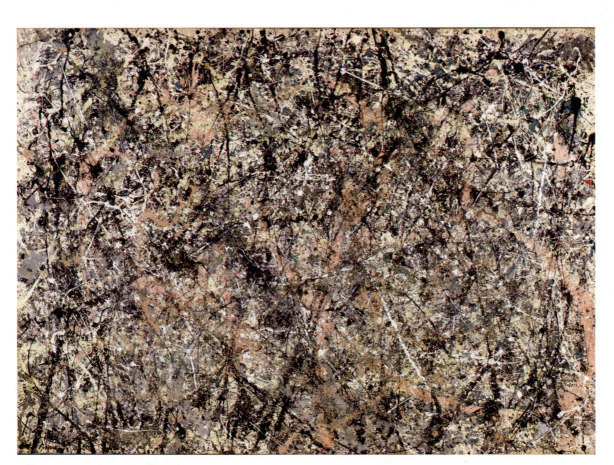

19/19 JACKSON POLLOCK, *Number 1, 1950 (Lavender Mist)*, 1950. Oil, enamel, and aluminum on canvas, 88" × 119" × 1½". The National Gallery of Art, Washington, D.C. © 2012 The Pollock-Krasner Foundation/ Artists Rights Society (ARS), New York.

had taken the old master's ideas and made them "speak with an eloquence and emphasis that Picasso himself never dreamed of." For the first time, Pollock was able to survive solely on the sale of his paintings. The paintings of de Kooning and other Abstract Expressionists began to sell, too. Before Pollock's acclaim in the 1950s, the Abstract Expressionists were largely a group of unknown artists living in low-rent apartments in lower Manhattan, barely surviving. De Kooning painted his black-and-white pictures in enamel because that was the cheapest paint he could find in hardware stores. As part of a conscious effort to recreate the exciting atmosphere of café life in Paris, these artists would meet in bars after painting all day and discuss art. Between drinks, they would offer each other consolation and camaraderie—so necessary for the essentially lonely act of making art. Sales were few and far between, but the news media got excited about Jackson Pollock. He was known as a wild man, a real cowboy; when he got drunk, he was often violent. With the attention of the art world and the media, Abstract Expressionism became the dominant style of art worldwide by the late 1950s.

Although de Kooning and Pollock were the most influential of the Abstract Expressionists, other members of this group developed their own individual styles. The Abstract Expressionists did not have an all-encompassing style like earlier movements in art history. What they shared was a belief in individual freedom. This individualism is often said to be uniquely American. It may also be seen as a reaction to the totalitarian forces in Europe that led to the horrors of World War II. These artists did not want to share a manifesto, because they believed artists should operate freely.

COLOR-FIELD PAINTING

Mark Rothko was another member of the original group of Abstract Expressionists. Like Pollock, he explored automatic picture-making early in his career; his paintings contained totemic or symbolic shapes produced from the unconscious. In the late 1940s, he generated a new kind of picture, where large areas of color were more dominant than any particular shape. This new way of painting would become known as **Color-Field Painting**.

Rothko had not abandoned his earlier interest in the unconscious. He was simply approaching it from a different direction, by exploring the psychological and spiritual effects of color. In his paintings **(19-21)**, Rothko creates a living, breathing color field. He applied his colors in thin, transparent layers, one over another. The edges between the rectangular areas are not hard but soft, and they seem to shift, producing a sense of gentle movement.

Many of Rothko's pictures are more than eight feet tall. He wanted viewers to be surrounded by his pictures. It was only on this scale, he felt, that his Color-Field paintings would come alive and affect the spirit of the viewer. He wrote: "I paint large pictures because I want to create a state of intimacy. A large picture is an immediate transaction: It takes you into it."

TEACHER TO THE NEXT GENERATION

Hans Hofmann is known primarily as the teacher of the next generation of American Abstract Expressionists. His career in teaching began in his native Germany, and he also lived in Paris, where he witnessed the birth of Fauvism and Cubism. In 1932, he arrived in New York and began teaching. His reputation as a great teacher

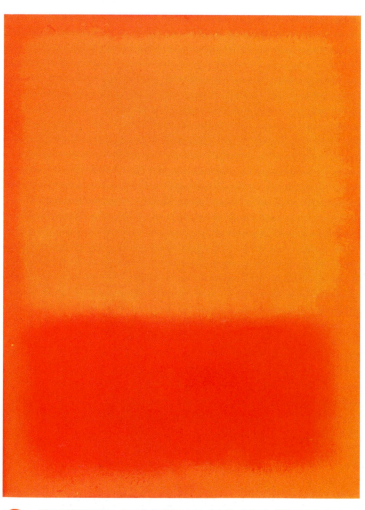

19/21 MARK ROTHKO, *Untitled (Painting)*, 1953–1954. Oil on canvas, 8' 8⅝" × 9' 9⅜". Art Institute of Chicago, Illinois. © 1998 Kate Rothko Prizel & Christopher Rothko/Artists Rights Society (ARS), New York.

brought him many students who would become important artists and teachers themselves.

Hofmann believed in what he called "pure painting," which according to him was the only honest painting, "the true realism." What he meant by pure painting was art that would have no reference to the visible world. According to Hofmann, there was more to nature than visual reality. In the Modern era, painting had moved beyond illusionism, which was only a cheap trick. The activity and excitement on the surface of the painting were enough of a subject for any artist. He talked about "push, pull": how the addition of, say, a rectangle of color creates a whole new dynamic in a picture. It would push the other elements around, necessitating a balancing pull to bring the other parts of the picture into a sense of equilibrium. For example, in *The Golden Wall* (19-22), we can see how Hofmann placed the thin tall blue rectangle at the right on top of a yellow area to keep it from pushing forward. He then added a tall orange area just to its left to diminish the strength of the blue rectangle. This push-pull balancing act was what artists, according to Hofmann, had been doing for centuries. It was only with a totally abstract art that the essence of painting could be revealed honestly.

Most of the second generation of Abstract Expressionists were fervent believers in Hofmann's ideas. They believed representational art was dead as fine art, and it should be left to the commercial illustrators. Abstract Expressionism, by the mid-1950s, was the

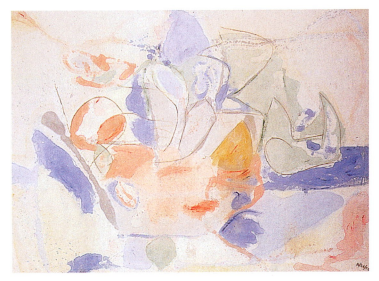

 HELEN FRANKENTHALER, *Mountains and Sea*, 1952. Oil on canvas, 7' 2⅝" × 9' 9¼". © National Gallery of Art, Washington, D.C. © 2012 Estate of Helen Frankenthaler/Artists Rights Society (ARS), New York.

most powerful force in Western art. Its next generation would build on the foundation its creators had built.

THE NEW YORK SCHOOL

Helen Frankenthaler was a student of Hans Hofmann and one of the leaders of the next generation (sometimes called *The New York School*). The turning point in her career came during a visit to Jackson Pollock's studio. She watched him at work, spreading his canvas on the floor, circling his picture, painting from every side. She later said, "It was as if I suddenly went to a foreign country but didn't know the language, . . . [I] was eager to live there . . . and master the language."

In 1952, she began to paint in a new way. She spread raw canvas on the floor and began pouring paint from coffee cans, letting it soak into the unprimed canvas. (Most painters *prime* their canvases, which means applying a coat of a special white paint, *gesso*, that seals the fabric.) Her colors stained the canvas, creating unusual effects. The result she called *Mountains and Sea* (19-23), a painting more than ten feet tall. Its title came from the colors that reminded her of the Nova Scotia coast she had just visited. Despite its title and great size, there is a sense of intimacy. Because of its soft, gradual transitions, it seems more like watercolor than an oil painting. Unlike "normal" oil paintings, where the paint is clearly on top of the surface, in Frankenthaler's the paint seeped into the canvas, becoming an integral part of it. While she remembers that many who saw her first canvas thought it looked like a "large paint rag," she was convinced she had discovered a new way of working that was rich in possibilities.

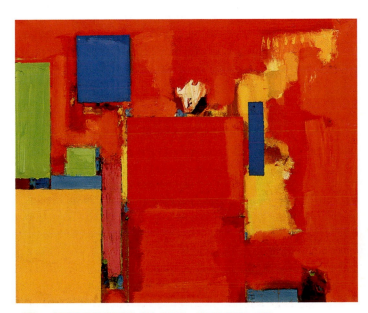

HANS HOFMANN, *The Golden Wall*, 1961. Oil on canvas, 60" × 72½". Art Institute of Chicago, Illinois.

She observed that accidents were bound to happen in both her and Pollock's method. Rather than trying to avoid them, she found them to be an important creative stimulus that opened up important new questions for artists. Is all life planned? Doesn't it take true creativity to deal with accidental circumstances, in life and in art? Perhaps an accident would lead her to ideas she would have never thought of on her own. This concept, called *happy accidents*, continues to be popular among contemporary artists. One should not think, however, that Frankenthaler made no attempt to control her paintings. On the contrary, she spent a great deal of time working with her poured paint. She would manipulate the wet areas with brushes, or by blotting. Sometimes she would pour enough paint to create puddles of color—all to create a variety of textures. These different textures gave her work an unusual sense of space, a space that was neither Renaissance nor Cubist.

As mentioned in Chapter 5, Frankenthaler later shifted from oils to the new acrylic polymer paint (see 5-9). This eliminated a faint oily stain that had surrounded each color area in her early work. It also permitted her to experiment with flatter and purer color fields versus the relatively gestural *Mountains and Sea*. These simpler fields would be very influential on later Color-Field painters and the Minimalists of the 1960s and 1970s (see Chapter 20). No matter the medium, her work has a calm, sensuous beauty that sets it apart from the generally anxious works of Abstract Expressionism.

NONREPRESENTATIONAL SCULPTURE

Few artists have created a whole new form of art. Most have made their contributions by innovating in traditional forms. In the twentieth century, however, two new forms were invented by artists: Picasso's invention was **collage**, and Alexander Calder's was **kinetic sculpture**, or the *mobile*.

Sculpting was a family tradition for the Calders. Alexander's father and grandfather were both successful in the field, his grandfather being best known for the statue of William Penn that stands atop Philadelphia's City Hall. Alexander's first sculptures were not much more than drawings with wire (2-5), but they have a sense of fun and playfulness that was endearing and helped make him one of the most popular artists in the United States and Europe. His miniature circus "performances," with figures made of wire and corks that swallowed knives and walked a tightrope, were the talk of Paris.

His **mobiles**, discussed in Chapter 9, are the sculptures with which he is usually identified. Although the mobiles were quite small initially, Calder later in his career built mobiles on an enormous scale in response to public commissions. For example, his mobile designed in the 1970s for the central court of the National Gallery of Art in Washington, D.C. (9-7), spans more than six feet and weighs more than nine hundred pounds, but its gentle movements are able to bring life to the stark, empty space it floats in. Calder's mobile, like Picasso's collage, has become one of the standard art forms. Today, both are even practiced by children in their arts and crafts classes.

He also made larger sculptures he called stabiles, like *La Grande vitesse* **(19-23)**, which can be seen in public spaces all over the United States. Despite its huge size (fifty-five feet tall) and weight (forty-two tons), *vitesse* does not appear heavy but cheerful and light. Calder's pleasure in making such works is contagious. Because of the prevalence of his public work, Calder probably did more to make nonrepresentational art acceptable to the general public than any other artist. In fact, *La Grande vitesse* was the first public sculpture commissioned by the National Endowment for the Arts after the organization's creation.

The Abstract Expressionist movement in American art during the late 1940s and early 1950s would find its expression in sculpture in the work of David Smith. He began his artistic career as a painter and was friendly with all of the leading Abstract Expressionists in New York. He shared many of their concerns, especially those of eliminating artificial constraints to artistic freedom and the necessity for an artwork to evolve as it is being made. Smith eventually developed a totally abstract art based on manipulating large geometric solids (see 9-24). One of the wonders of Smith's work is how tons of metal are treated lyrically rather than ponderously. His skill as a welder helped him create sculptures that demonstrated that steel can be as flexible a material as the more traditional bronze, stone, and wood.

Mark di Suvero is another sculptor who was inspired by the Abstract Expressionist movement and the energy of living in New York City. In *The A Train* **(19-25)**, Di Suvero hangs heavy wooden forms but allows them to move freely, making them seem more gestural and alive. With the help of gravity and air currents, they rotate and activate the space, making the sculpture a constantly changing "painting in three dimensions," as Di Suvero describes his approach. Like Louise Nevelson (see Chapter 9), the sculptor used found materials, but in his case they were an old ladder and some abandoned beams. Di Suvero, who prefers working with ordinary items rather than marble or bronze, left them rough and

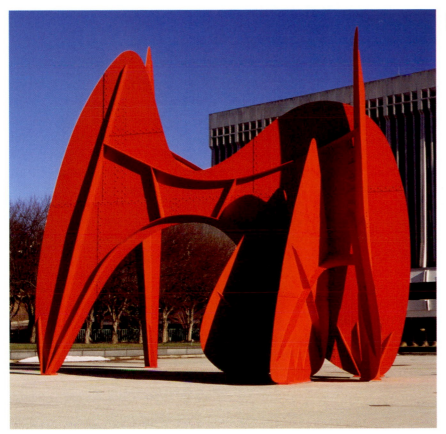

 ALEXANDER CALDER, *La Grande vitesse*, 1969. Painted steel plate, 55' high. Calder Plaza, Vandenberg Center, Grand Rapids, Michigan. © 2012 Calder Foundation, New York/Artists Rights Society (ARS), New York

 MARK DI SUVERO, *The A Train*, 1963–1964. Wood and painted steel. Hirshhorn Museum and Sculpture Garden, Washington, D.C.

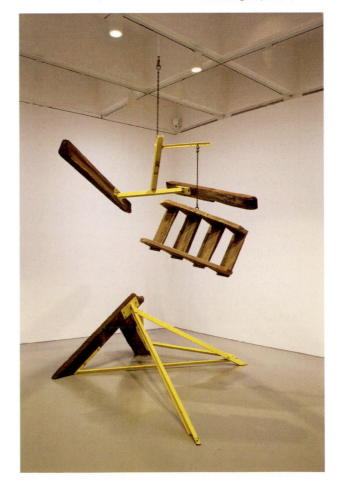

unpolished and attached them with thick bolts to brightly colored steel girders and supports.

In 1960, five years before constructing this sculpture, di Suvero was paralyzed when he was pinned under an elevator in a work-related accident. He was told he might be confined to a wheelchair for the rest of his life. Rather than learning to be satisfied with making small sculptures at a table, he became skilled at handling welding torches, a crane, and a cherry-picker. With these tools, he was able not only to move huge pieces of steel into place, but to bend them as well. This allowed him to make work on an even larger scale than before his accident. He also learned how to walk again in just two years. Today, he works on a monumental scale (often thirty feet tall). His outdoor sculptures can be found all around the world, and he is a member of the crane operator's union.

ARCHITECTURE: THE GLASS BOX

In the twentieth century, modern architects explored the use of glass in ways that would have stunned architects of the past. As a building material, glass has quite different aesthetic possibilities than the traditional media of stone, earth, and metal. Because glass is both transparent and reflective, the standard division between inside and outside

is challenged by a building with glass walls. This quality was explored by the American architect Philip Johnson when he built himself an all-glass house in the late 1940s (19-26). Except for a central brick core that houses the bathroom, the whole interior space is open, without walls or room dividers. All of the exterior walls are made of glass (although there are built-in shades to be used if desired), so the experience is one of living in the midst of nature, weather, and the trees that surround the site.

The experience within the glass house is far from sleeping under the stars. It retains a building's traditional role of shelter, and its design puts considerable psychological distance between the dweller and nature. Because of Johnson's strict adherence to the tenets of International Style, every aspect of its interior and exterior is integrated, logical, and civilized. The building's purity of design and use of modern materials provide a formal, intellectual vantage point from which to contemplate nature.

For obvious reasons of privacy, as well as expense, solid walls of glass have been more popular for commercial rather than domestic architecture. We associate glass walls with modern office buildings, towers where glass covers a skeleton of steel. Philip Johnson, during his long and distinguished career, has designed many fine examples of these goliaths of the International Style, perhaps none better than the *Seagram Building* (10-29),

a collaboration with his mentor, Mies van der Rohe (a former director of the Bauhaus). In the 1950s, 1960s, and 1970s, the International Style of architecture dominated large-scale public and corporate architecture around the world, putting an enduring stamp on urban life. Its orderly, disciplined forms are no longer seen as controversial but, in fact, as neutral and nonpartisan. A glass box lacks political or social overtones. Its absence of ornament was also a plus because, as even Johnson admitted in later years, it made building a skyscraper much cheaper.

ORGANIC ABSTRACTION

Nonrepresentation has been pursued in two general directions: the geometric and the organic (see Chapter 2). Johnson's Glass House is a collection of pure right angles, while Buckminster Fuller's geodesic dome (2-9) is a hemisphere, and David Smith's sculptures juggle cubes and cylinders. Those who make geometric works are often interested in evoking pure, transcendent existence, a kind of refined Neoclassical abstraction. Organic abstraction, as in Henry Moore's *Sheep Piece* (2-14), tends to be less cerebral and more spiritual, evocative of natural forces or living things. It could be called a kind of Romantic abstraction.

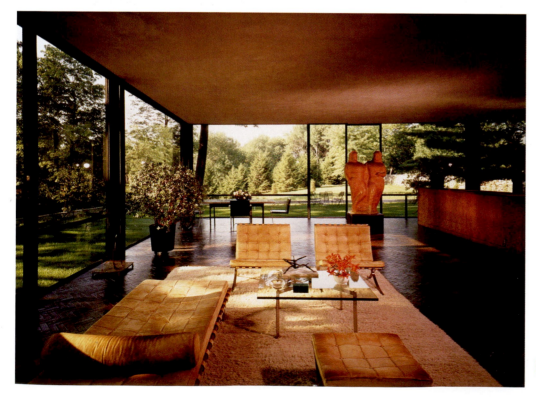

19/26 **PHILIP JOHNSON**, Glass House, New Canaan, Connecticut, 1949.

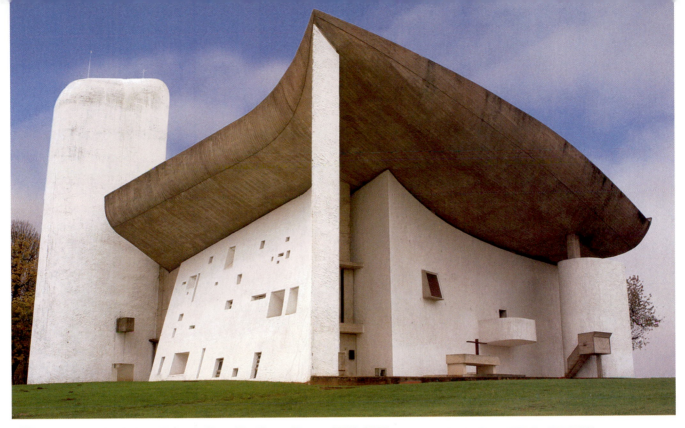

In the first half of the twentieth century, the highly geometric buildings of Le Corbusier epitomized the beliefs of the International Style and the glorification of the machine. No wonder that the architectural community was stunned by what appeared to be a startling reversal by one of the founding fathers of the International Style in 1950. Le Corbusier's *Notre Dame du Haut* (19-27), a small chapel in Ronchamp, France, seems the polar opposite of his earlier buildings, meant to foster a marriage of art and technology and nearer to Moore's sensual sculpture. In the organic, flowing Notre Dame du Haut, right angles have been replaced by soft curves, rational order with intuitive placement. There is no clear glass curtain filling an interior with even light; instead, small windows with colored glass are placed in deep cuts in the heavy concrete walls (interior, 19-28).

Le Corbusier had actually given an earlier warning of his change of heart. In 1936, disappointed with the lack of imagination among fellow architects whom he believed were eager only to refine his ideas rather than to go beyond them, he wrote to a group of young architectural students:

> How are we to enrich our creative powers? Not by subscribing to architectural reviews, but by undertaking voyages of discovery into the inexhaustible domain of Nature!

Le Corbusier's chapel is more like a sculpture than a building. It is placed on a hill that looks out onto a river, a site with a long religious history, from the early

Christians to pre-Roman pagans. As if challenging less daring followers of the International Style, Le Corbusier exploits the flexibility of concrete with great imagination. The walls are curving, tilted forms that lean toward the center. The roof, shaped like the headdress of a French nun's habit, floats above the outer walls, perched on small columns. It is a building of many original spaces, with a dark, bare inner chapel, as well as an open-air one. An absolutely unique work of architecture, it is extraordinarily free of historical references. Concrete has rarely seemed so sensual or unfettered. Le Corbusier's lesson is that in the hands of creative people, abstract and nonrepresentational art has no boundaries.

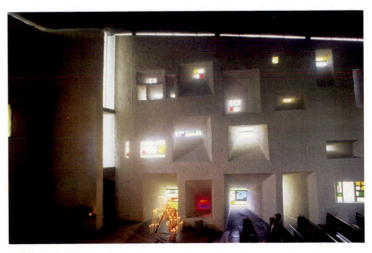

THE CHALLENGE OF NONREPRESENTATIONAL ART

Nonrepresentational art, the logical development of changes in art throughout the 1800s, has been in existence for almost a century. Many of the first totally abstract canvases are now antiques; their paint is cracking from the passage of time. Yet abstract art is still often viewed as weird or strange.

Most viewers feel more comfortable with artworks that refer to the world they know; many prefer art that tells a story. Nonrepresentational art can do these things, but not in a conventional way. Each work is an expression of the ideals, personality, and mood of the artist. The world they refer to is an inner one. We have seen many artists, all working abstractly, create very different artworks. Some seem passionate and violent, some absolutely logical and calm. If you look closely, there are significant differences even between two emotional Abstract Expressionist artists.

GETTING THE REAL WORLD BACK INTO ART: RAUSCHENBERG AND JOHNS

Born as a movement to open up new territories and freedom for artists (and much to the horror of many of its creators), Abstract Expressionism was all too soon turned into a doctrine. Trumpeted by critics as the only way to make serious art, it was also embraced by academics who codified the movement. For the next twenty years, art schools and universities trained students to work abstractly. Drawing realistically was dismissed as only for beginners, considered no more than an illustration skill and merely a step toward more important concerns. As might be expected, younger artists soon began to feel straitjacketed by the new dogma of Abstract Expressionism.

In 1954, Robert Rauschenberg came to New York and met a shy, young artist from rural South Carolina, Jasper Johns. Rauschenberg had grown up in Texas, in a bustling port surrounded by oil refineries, far from the intellectual centers of Paris or New York City. He and Johns became close friends and rented studios in the same building in downtown Manhattan. Like Picasso and Braque during their Analytical Cubist period, for the next few years the two young men worked feverishly and

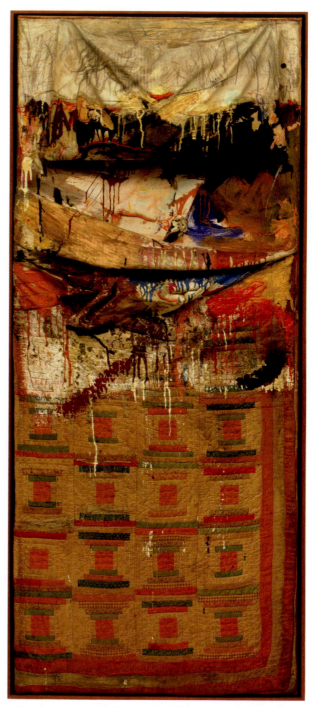

 ROBERT RAUSCHENBERG, *Bed*, 1955, Combine painting: oil and pencil on pillow, quilt, and sheet on wood supports, 6' 3¼" × 31½" × 8". Museum of Modern Art, New York. Art © Robert Rauschenberg Foundation/ Licensed by VAGA, New York, NY.

saw each other every day, engaging in an intense dialogue on the nature of art and life. In New York City, the young artists joined in the camaraderie of Pollock, de Kooning, and others. Rauschenberg later said he learned

more from drinking with these artists in the taverns of Manhattan than from any of the art schools he attended. But Rauschenberg also witnessed the chilling effect Abstract Expressionism was having on younger artists. He thought that the complete exclusion of our daily visual experience of the real world was too high a price to pay for what was supposed to be a purer, more honest art. He wondered how to get the real world back into painting without totally abandoning the power or achievement of Abstract Expressionism.

Rauschenberg proposed that "a picture is more like the real world when it's made out of the real world" and began the reintroduction of everyday objects as Picasso had, by using the medium of collage, or what Rauschenberg called **combines**. In *Bed* (19-29), he pulled art and life together by using a bed as his canvas. Across the pillow and sheets and onto the nice quilt, he applied the great colorful gestures and dripping paint of Abstract Expressionism. Despite his use of ordinary materials, the result is a shocking combination for anyone raised to keep one's bed clean and crisply made. It is also an unforgettable and powerful image.

Two years earlier, Rauschenberg had gone to de Kooning's studio on a symbolic mission to separate himself from his hero and the now all-powerful art movement. He asked the artist for a drawing with the intention of erasing it. Although Rauschenberg never explained why he wanted the drawing, de Kooning intuitively knew and, to his credit, took his time to select one that he would miss. He also picked one so rich and complicated that it took Rauschenberg two months to finish erasing. It would later be exhibited in a gold frame as simply *Erased de Kooning Drawing*, Robert Rauschenberg, 1953.

Jasper Johns's work, like his personality, was more restrained than Rauschenberg's, but it also challenged the basic premises of Abstract Expressionism. What interested Johns were "things the mind already knows," subjects that were instantly recognizable. For example, his *Flag* (19-30) was part of a series of more than twenty-five paintings and many drawings and prints using the same subject. Johns would vary size, number, color, and materials, but the essentially flat flag would be the same in each. Most flags were built by painting thickly over a collage of newspapers, resulting in a richly textured surface. The flag paintings seemed to follow the rules of Abstract Expressionism and to slyly undermine them at the same time. Like a typical Abstract Expressionist picture, Johns's images were absolutely flat and nonillusionistic

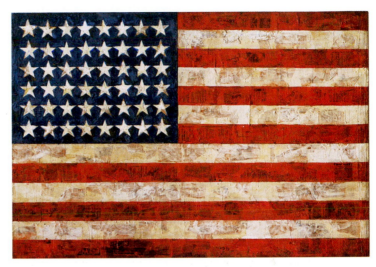

 JASPER JOHNS, *Flag*, 1954–1955. Encaustic, oil, and collage on fabric mounted on plywood, 42¼" × 60⅝". Museum of Modern Art, New York. Art © Jasper Johns/Licensed by VAGA, New York, NY.

and covered with lively, gestural brushstrokes. But they also had subjects; they were unquestionably, instantly recognizable as flags.

In direct opposition to the romantic search for inner truth found in the action paintings of Pollock and de Kooning, Johns's flag paintings were impersonal. He explains that he chose flags precisely because they are "things which are seen and not looked at, not examined." By using them in atypical ways, Johns is encouraging the viewer to go beyond the conventional reading of flags to see them freshly. He warns of the tendency we all have of thinking we know at one glance what we see. One should be open to new ways of understanding or new uses of ordinary things. His message is reminiscent of René Magritte's *The Treachery of Images* (18-32), a surrealist work in which the illustration of a pipe is subtitled with a message that it is not a pipe.

Done at the peak of Abstract Expressionism's dominance in the late 1950s and early 1960s, Rauschenberg's and Johns's work shocked many artists and critics. Rauschenberg had pushed the limits of the definition of art by erasing a fellow artist's work. By repeating familiar symbols in lengthy series, Johns had discarded one of the oldest tests of an artwork's value, one particularly important to the Abstract Expressionists—originality or uniqueness. They reopened the visual world and legitimized borrowing objects and symbols from popular culture, an approach that is used by artists to this day. Their rejection of limits in materials or subjects for artists opened the door to what we will explore in the final chapter: the diverse, rich art world of contemporary art.

CHAPTER 20

By the 1960s, New York City was the magnet that drew young, ambitious artists from all over the world, just as Paris had a century before. At the same time that the United States became the foremost power in world affairs after World War II, America's artists and cultural institutions came to dominate the art world. For the following half-century, artists of every nationality could be found living and working in New York.

Robert Rauschenberg from Texas and Jasper Johns from South Carolina (Chapter 19) were just two of the many young artists who headed to New York City in the late 1950s. They discovered that in the new capital of the art world, Abstract Expressionism reigned supreme (its style and approach was actually called The New York School). Having their own ideas about art, Rauschenberg and Johns painted in an Abstract Expressionist style but applied it to objects and symbols from popular culture, working as Rauschenberg said "in the gap between art and life." Their transgressions against the prevailing dogma and especially the cool tone of Johns's paintings and sculptures appealed to a considerable group of artists who would focus more directly on common household objects and the products of the booming postwar American economy. Their works have become known as **Pop Art**.

1960–1980

PERIOD

POP ART AND HAPPENINGS
MINIMALISM
EARTH ART
PERFORMANCE ART

VIDEO ART
SUPERREALISM
FEMINIST ART

HISTORICAL EVENTS

Space race between U.S.S.R. and the United States 1950s–1960s
Civil Rights March on Washington 1963
Assassination of President John F. Kennedy 1963
United States fights Vietnam War 1964–1973
First Earth Day 1970
Watergate, President Nixon's resignation 1974
Second-wave feminism in the United States 1960s–1970s

ART

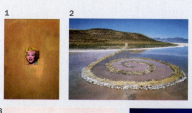

1. Warhol, *Gold Marilyn Monroe*, 1962
2. Smithson, *Spiral Jetty*, 1970
3. Paik, *TV Buddha*, 1974
4. SITE, *Best Products Showroom*, 1975
5. Chicago, *Dinner Party*, 1979

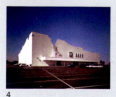

A STORM OF IMAGES: ART IN THE CONTEMPORARY WORLD

1980–PRESENT

NEW IMAGE
NEO-EXPRESSIONISM
POST-MODERN ART AND ARCHITECTURE

INSTALLATION ART
DIGITAL ART

Last remaining European colonies in Africa receive
 independence 1980s
Rise of Islamic fundamentalism 1980s
Iran-Iraq war 1980–1990
AIDS first identified 1981
First personal computers 1981
Collapse of Soviet Empire 1991
Nelson Mandela becomes President of South Africa 1994
World Wide Web 1994

Facebook launched 2004
Fourth World Conference on Women, Beijing 1995
Introduction of Euro currency 1999
Attacks on World Trade Center and Pentagon
 September 11, 2001
Growing concern about Global Warming 2000s
United States war with Iraq begins 2003
The Great Recession begins 2008
Arab Spring 2011

6. Skogland, *Radioactive Cats*, 1980
7. Lin, Vietnam Veterans Memorial, 1981–1983
8. Lasseter, et. al, *Luxo Jr.*, 1986
9. Gehry, Guggenheim Museum, Bilbao, 1997
10. Shonibare, *The Swing*, 2001
11. Murakami, Kaikai and Kiki Balloons, 2010

POP ART

The most famous and influential of the Pop artists was Andy Warhol. His early paintings of Campbell's soup cans and cardboard sculptures of Brillo boxes announced that no kind of subject matter was more important than any other. A six-foot canvas devoted to a can of soup seemed to mock the central precepts of Abstract Expressionism, still the dominant force in the art world. When Pollock and Rothko had worked on a large scale, they were announcing that their inner searches and new approaches were important. Few could question the powerful and heroic impact they had. Warhol reminded viewers that anything made large will have a dramatic effect, even a soup can.

Following the success of his first works, Warhol began producing images of celebrities that implied their connection to his images of packaged products. Multiple images of Elvis Presley, Jacqueline Kennedy, and Marilyn Monroe (20-1) were given the same treatment as Brillo and Coca-Cola. Even the *Mona Lisa* has become a glamorous commercial product according to Warhol (see

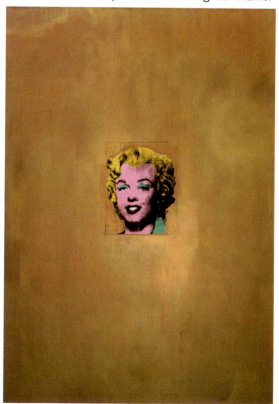

ANDY WARHOL, *Gold Marilyn Monroe,* **1962.**
Synthetic polymer paint, silkscreened, and oil
on canvas, 6' 11½" × 57". © 2012 The Andy Warhol
Foundation for the Visual Arts, Inc./Artists Rights Society (ARS),
New York. The Museum of Modern Art, New York.

Chapter 1). While Jasper Johns's cool attitude seemed revolutionary just a few years earlier, Johns had still applied gestural brushstrokes almost lovingly to his flags and targets. Warhol's approach was more than cool, even neutral. Warhol used photographically created silkscreens of his subjects and printed them directly onto his canvases in order to achieve a more mechanical look. He later said: "I want to be a machine. . . . I think everybody should be a machine." His large studio in New York City came to be known, appropriately, as The Factory. Assistants were reported to be producing his pictures.

Warhol became a celebrity. The Factory was filled every night with famous people and those seeking fame. The artist generally remained silent but listened to conversations and drew inspiration from them. After being shown a dramatic headline and gruesome front-page photograph of a horrible airplane crash, Warhol began his *Disasters* series. Gory automobile wrecks and racist beatings were reproduced several times on single-color canvases. The *Disasters* series illustrates the numbing effect that the daily storm of images has on us. When seen over and over again, even the most shocking pictures lose their impact. The Warhol canvases of the 1960s that treat celebrities, tragedies, famous paintings, and products as the same thing recreate the daily experience of watching television news. All are equivalent in importance, each given its few minutes of air time.

By focusing on the things we see every day, Pop Art was following the mandate of Robert Rauschenberg and closing the gap between art and our everyday experience of life. Claes Oldenburg went one step further and called for an art "that does something else than sit on its ass in a museum." He was a founder of *Happenings*, an attempt to use "real" materials and locations as art—theatrical events intended to break down the distance between art and audience, to become, as one artist said, an "all-encompassing art experience." In *Store Days*, for example, Oldenburg rented an abandoned storefront in New York City and filled it with life-size plaster reproductions of hamburgers, cakes, dresses, hardware, and other standard merchandise. Each object was loosely painted in bright colors with drips running over them, a parody of action painting. When the audience entered, they were encouraged to behave like customers. When a sculpture was purchased, in contrast with the custom in fine art galleries, the buyer was permitted to take the object home immediately. Oldenburg replaced sold items from his studio in the back, which served as a storeroom.

Store Days was an examination of the relationship between art and money, an increasing concern among

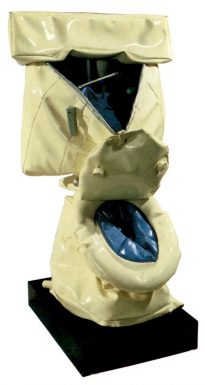

CLAES OLDENBURG, *Soft Toilet*, 1966. Vinyl, Plexiglass, and kapok, on painted wood base, 57¹⁄₁₆" × 27⁵⁄₈" × 28¹⁄₁₆". Whitney Museum of American Art, New York.

20/2

many American artists after World War II. As the American art market gained prominence, art seemed to be becoming more and more a commodity like stocks or precious metals. For the artists who achieved success in the 1950s, the struggle for acceptance, the years spent trying to make ends meet, was part of what gave an artist integrity. They felt that money and early success endangered the honesty and independence of any artist. Not surprisingly, Andy Warhol did not share the older artists' views. He did not find financial rewards disturbing and said "being good in business is the most fascinating kind of art."

Shortly after *Store Days*, Oldenburg's objects began to grow larger in scale. In his one-man exhibition of 1962, the small plaster hamburgers had expanded to soft-cloth ones four feet tall. The gallery was filled with enormous ice cream cones and slices of cakes. Viewers were treated to an *Alice in Wonderland* experience, as if they had shrunk to miniature size. By enlarging the things we see every day to gigantic dimensions, Oldenburg altered their reality and made them strangers to us. This allowed the viewer to examine them freshly, as if seeing them for the first time. Another way to shatter conventional seeing was by changing the materials of commonplace objects. In *Soft Toilet* (20-2), the artist substitutes stuffed vinyl for porcelain, and now the familiar bathroom item collapses as if it is fatigued. By making it soft, the toilet is humanized—one can even move its parts around and reshape it.

By 1965, Oldenburg had increased the scale of his projects to monumental. At first these were simply sketches of fantasies, but eventually he prepared formal architectural proposals and submitted them to various public and private institutions. In 1967, for example, he proposed to replace the Washington Monument with mammoth scissors that would open and close. Oldenburg has even been successful in realizing some of his monumental dreams. A forty-five-foot clothespin now graces a city square in Philadelphia, and a nearly one-hundred-foot-tall baseball bat is in Chicago.

Roy Lichtenstein used a change of scale and a picture frame to draw our attention to the comics and show how popular culture literally caricatures our deepest feelings. His *Drowning Girl* from 1963 (20-3) has the emotional turmoil and large scale so important to Abstract Expressionism, but in an absurd, clichéd way. While the melodrama of her situation is easily laughed at, the painting is more than a joke. It is probably no coincidence that Lichtenstein painted it as his first marriage was coming apart.

Based on the illustration on the first page of a romance comic book, Lichtenstein recreates the Ben-Day dot pattern used by comics (bright colors that optically

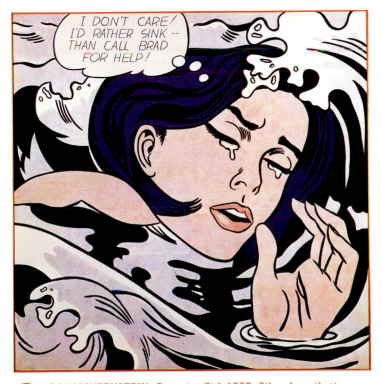

ROY LICHTENSTEIN, *Drowning Girl*, 1963. Oil and synthetic polymer paint on canvas, 67⁵⁄₈" × 66³⁄₄". Museum of Modern Art, New York.

20/3

mix, much like today's pixels), but makes important compositional changes to maximize the impact. The picture is cropped (in the original the boyfriend is in the background hanging on to a boat), elements are rearranged, and the text is edited, strategies he used in all his borrowed subjects. The waves on the left are references to Hokusai's *Great Wave* (see Chapter 17).

Over a long career, Lichtenstein borrowed freely from high and low culture, from Walt Disney, Picasso, children's books, and Monet and converted them to his comic book style. He found it difficult to tolerate egotistical, self-important artists and deliberately punctured the seriousness and pomposity behind many earlier art movements. He said his work was "anti- all of those brilliant ideas of preceding movements which everyone understands so thoroughly." Along with his fellow Pop Artists, Lichtenstein opened the door wider to artists making use of any imagery from our past or present, masterpieces or the most ordinary items. By filtering our civilization's artifacts into bright colors and dots, he also returned irony, fun, and a sense of humor back into the artist's palette.

VENTURI: POP ARCHITECTURE

Just as Abstract Expressionism became the standard form of painting and sculpture in the postwar years, the **International Style** dominated architecture. The buildings and theories of Gropius, Le Corbusier, and Philip Johnson (see Chapter 19), which called for pure, logical designs and prohibited unnecessary ornament or decoration, were the preeminent models for most serious architects around the world. Mies van der Rohe, chief architect of the *Seagram Building* (10-29) and a director of the Bauhaus, spoke for his generation of architects when he said, "Less is more."

Robert Venturi's response, however, was, "Less is a bore." The ideology of the International Style, according to Venturi, was a failure because it ignored the local culture of the locations where its buildings stood. No building could be successful that ignored the interests of the clients and the surrounding architecture. Buildings like the *Villa Savoye* (19-8) were more like alien structures than homes. They spoke a language that no one except sophisticated architectural scholars could understand and had a destructive effect on their environments.

Like the Pop Artists, Venturi felt architects should embrace popular styles of architecture, finding ways to utilize what he called "honky-tonk elements" that spoke in a language anyone could understand. Venturi put his ideas into practice in a design for a firehouse in Columbus, Indiana (20-4). Although the simplicity of its form is certainly more reminiscent of the International Style than a Gothic cathedral, several aspects of the building were considered a kind of heresy at the time. Venturi used a variety of windows with different sizes and designs, depending on the needs of the occupants rather than any geometric rules. A loud contrast between glossy white and red brick creates an irregular, not uniform, design. At the top of a seemingly functionless tower (it actually is used for drying hoses), he placed an equally

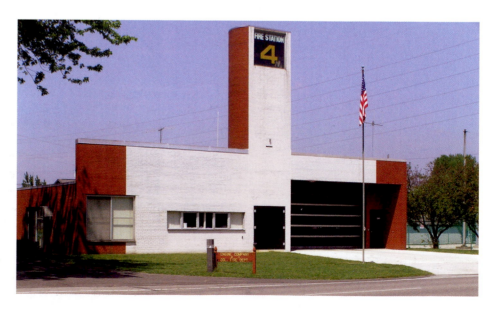

20/4 ROBERT VENTURI (Venturi and Rauch), *Fire Station #4*, Columbus, Indiana, 1965–1967.

loud sign that announced in bold graphics "FIRE STATION 4" to the public.

Venturi felt strongly that the International Style made a mistake when it rejected the past. The public service nature of his *Fire Station #4* is easily understood because its tower is connected to clock towers and church steeples of the past. It fits into its neighborhood because it is a brick building with a flat front and ordinary glass-windowed garage doors. The front is really a thin façade, an approach Venturi called "the decorated shed . . . a modest building with a big sign," used by supermarkets, department stores, and other commercial buildings all over the country. So unlike the metal-and-glass skyscraper, the Seagram Building, *Fire Station #4* is a truly American building designed to hold its own and live with the billboards and gas stations found along any main street or highway. It has what Venturi called the "messy vitality" that the International Style had attempted to eliminate.

THE END OF ART: MINIMALISM

Pop Art was not the only alternative to Abstract Expressionism advanced in the 1960s. A group of serious, intellectual artists who were disgusted with the emotional outpourings of the Abstract Expressionists and the vulgarity of Pop Art began to make high-minded and refined art known as **Minimalism**. Minimalist art is stripped down to the essentials, or as one artist said: "What you see is what you see." It is paintings and sculptures that are self-sufficient and have no subject matter, content, or meaning beyond their presence as objects in space. Lauded by some as a return to purity and high ideals, others called Minimalism the end of art. What was occurring was a replay of a battle that we have seen before: the battle among Romanticism, Realism, and Classicism, now in the arena of nonrepresentational and Pop Art. On one side, once again, were the defenders of emotions and expressiveness, on another, ordinary life, and on the third, purity and logic.

Donald Judd was one of the foremost creators and theorists of Minimalism. As an art critic in New York City, the Missouri-born Judd became concerned that art made it difficult to perceive reality. It bothered him that, while contemplating works of art, viewers are inevitably drawn into illusions, emotions not their own, and references to the past. The only way to reconnect the viewer with reality, Judd felt, was to produce works of art with no expressive techniques, free of associations, that could be seen to be simply what they were—plain and honest "matters of fact":

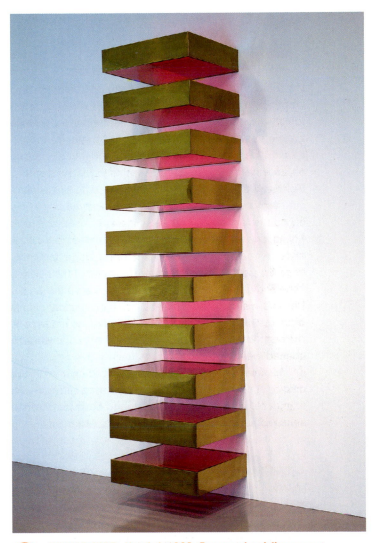

20/5 DONALD JUDD, *Untitled*, 1969. Brass and red fluorescent Plexiglas, 10 units 6⅛" × 24" × 7" each, with 6" intervals. Hirschhorn Museum and Sculpture Garden, Washington, D.C.
Art © Judd Foundation. Licensed by VAGA, New York, NY.

I wanted work that didn't involve incredible assumptions about everything. I couldn't begin to think about the order of the universe, or, the nature of American society.

Beginning in 1962, Judd made sculptures that were controlled and completely logical, designed to cleanse viewers of whatever concerns or preconceptions they brought into the gallery and allowing them to focus on the situation the artist had created there.

Untitled (20-5) is a good example of how Judd resolved his interest in a direct, honest work of art. It is made of ten virtually identical boxes constructed from brass and Plexiglas attached to a wall with even spacing. Because it is internally logical, it is relatively unaffected by what surrounds it. To eliminate any sign of the human hand (which might evoke emotions), Judd had

his sculptures manufactured in factories, based on his drawings. Industrial fabrication ensured that his sculptures were also well constructed and as perfect a recreation of his concepts as possible. His boxes were open at two sides, with Plexiglas permitting light to enter so no aspect of their structure was hidden or mysterious. Because *Untitled* contains no allusions or illusions, viewers can focus on what they are truly experiencing. They become aware of being in a unique kind of situation—what Judd would call "art space," an isolated place separated from the commotion of their everyday experience. In such a space, viewers realize the limits of their vision. Although you know logically that each box is the same, as you slowly pass by the work in the gallery, your changing spatial relationships alter its appearance moment by moment. This is what Judd would call a true, unadulterated art experience.

Minimalism appeared to be the final chapter in the refining of purity and truth in the visual arts, a search with a long history, from Ancient Greece to Malevich. Art had been reduced to one simple, essential experience—the relationship between object and viewer. Yet in Modern Art's long history of radical changes, probably no other movement opened such a wide chasm between the artist and the ordinary viewer. Shell-shocked observers were further startled when one Minimalist artist, Carl Andre, exhibited a pile of 120 bricks called *Equivalent VIII*. The ordinary, mass-produced bricks were neatly arranged, two high, in a rectangle on the gallery floor. In such artwork the conceptual background—the artist's ideas about what art should be—was far more important than any visual attribute. But where would artists go from here, if anywhere?

Although Minimalist artists like Judd and Andre continued working within their narrowly devised confines, since the 1970s the term *Minimalist* has been expanded to include a much wider variety of art forms than Judd and Andre would have accepted. Today the word is used to refer to any work of art that is refined, simple, and abstract with no references to any subject.

RETURN OF REPRESENTATION: SUPERREALISM

Until Pop Art, for a century the predominant trend in Western art had been away from literal representation and toward abstraction. In a related development in the late 1960s, many artists trained as Abstract Expressionists betrayed their teachers with a 180-degree turn toward realism. **Superrealism** (or **photorealism**) was a movement that recreated in two dimensions the look of photographs and in three dimensions used casting to achieve the utmost fidelity to reality. Like the Realists of the nineteenth century, most of the Superrealists avoided drama and concentrated on ordinary life.

At first look, Superrealism appears to be the polar opposite of Minimalism. Richard Estes's *Central Savings* **(20-6)** is an impressive demonstration of the painter's technical skill. Rather than a flat, nonillusionistic canvas, one sees depicted in oil paint a bewildering number of layers of depth, reflection upon reflection of the world behind and within a city restaurant's plate-glass window. However, *Central Savings* does share some qualities with Minimalist art. Although Estes's picture is very representational, notice that he is not expressing his feelings about this scene. In a methodical way, he is imitating the way a camera records reality, utilizing the harsh contrasts and precise focus of mechanical vision. Like Minimalist pictures, Superrealist pictures are cool and calculated performances.

Precise images like *Central Savings* are not just technical achievements but compositional ones as well. Estes's design of dense, layered spaces is imaginative: complex but balanced. His subjects are always drawn from the world he lives in, typical American metropolitan scenes, but he never imposes his personal viewpoint or glorifies his cityscapes. As with the Pop artist Warhol and the Minimalist Judd, for Estes "cool" is better than emotional. It is probably no coincidence that in the 1960s "cool" first came to mean "good."

Duane Hanson, however, was a Superrealist artist who was interested in breaking down the barriers between artist and viewers and engaging them. Born in rural Minnesota, he wanted to make an honest art that could communicate with anyone who saw it and not "something that looks nice to hang on a wall." He said, "If art can't reflect life and tell us more about life, I don't think it's an art that will be very lasting." By pouring polyester resin into casts made directly from his models and adding real hair, glass eyes, and clothing, Hanson managed to develop perhaps the most naturalistic sculptures ever created. Museum visitors are usually startled when they encounter one of Hanson's realistic figures.

Hanson generally chose to portray one or two subjects in the midst of an ordinary day. He said, "You can't

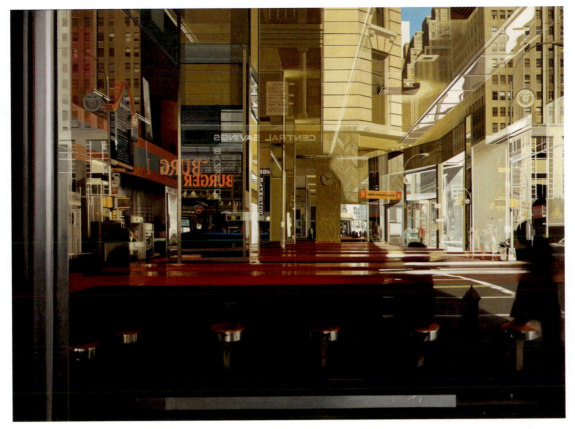

RICHARD ESTES, *Central Savings*, 1975. Oil on canvas, 36" × 48". The Nelson-Atkins Museum of Art, Kansas City, Missouri, F75-13. © The Nelson Gallery Foundation. All reproduction rights reserved.

always scream and holler ... sometimes a whisper is more powerful." *Janitor* (20-7) is typical of his mature works that speak about the emptiness and loneliness of modern life. The janitor's pose reflects exhaustion and dissatisfaction; he is dressed in soiled clothing. When seen in a museum from as little as a few feet away, *Janitor* appears to be just another employee. As one approaches it, one senses that the figure has a natural territory like any living being. However, because it is a sculpture, we are permitted to enter his personal space and stare at him in a way no polite person would ever do. The power of Hanson's sculpture is not limited to his craftsmanship or the verisimilitude of his figures or even his messages. His work taps into the voyeuristic nature of art, the fascination of carefully studying another person and gaining access to his or her private world.

 DUANE HANSON, *Janitor*, 1973. Polyester, fiberglass, polychromed in oil, 65½" × 28" × 22". © Estate of Duane Hanson/Licensed by VAGA, New York, NY. Milwaukee Art Museum, Wisconsin.

ARCHITECTURE: BREAKING DOWN BARRIERS

In the late 1960s, a sculpture instructor at New York University, James Wines, became dissatisfied with the direction Modern Art was taking, especially the isolation of artists from the general public. After discovering that he was not alone with this disenchantment, he began meeting regularly with like-minded artists and architects. In 1970, *SITE* (Sculpture in the Environment) was formed to establish a new relationship between art, architecture, and the public. Their goal was to search for a "more . . . socially significant content, a new public imagery drawn from a more integrated fusion of the arts."

SITE members were determined not to use references to the past but to "search for sources of content in the present." Their challenge was to "identify an appropriate iconography for a society with no universal symbols." Their first important commissions were showrooms all across the United States for one of the nation's largest catalog merchandisers, Best Products. Few successful architects would have been enthusiastic about this kind of job—a renovation of a typical box-shaped building in a

shopping center along a highway—but the earnest SITE artists went to work analyzing the problem. The challenge would be to find a way to attract the attention of motorists who were speeding down the highway. Wines and his associates realized that drivers only pay attention to things that are out of the ordinary, that break the pattern of normal life.

Built in 1975, the *Best Products Indeterminate Façade Showroom* (20-8) in Houston, Texas, is one of their most famous works. By building a white brick façade higher than the structure's actual roof line (like Venturi's firehouse), the designers gave themselves room for imagination. The startling result was a new building that looks as if it is crumbling into ruin. In the tradition of disaster movies, the edges of the façade have become ragged and broken. Bricks tumble down onto the canopy in front, threatening imminent collapse. The doomsday look of the showroom was hard to ignore; it attracted customers even as it gave notice that American consumer culture was in the process of decay. By looking freshly at architectural problems with an artist's eyes, by ignoring academic approaches but not customer needs, James Wines and SITE continue to create a people-oriented architecture that is stimulating, engaging, and artful.

20/8 SITE, Best Products Indeterminate Façade Showroom, Houston, Texas, 1975.

THE MUD ANGELS of Florence

Disaster struck Florence, Italy, on November 4, 1966. At 4 a.m., the Arno River rose over its banks without warning and a wave of mud, oil, and water swept through the birthplace of the Italian Renaissance. In some locations, it reached up to fifteen feet high and plunged into many of the most treasured sites in the world. Streets were suddenly turned into canals, and billions of gallons of water poured into churches, libraries, museums, and other buildings. When the flood began, the director of the History of Science Museum had managed to rush to the roof with Galileo's telescope, but little else. Tens of thousands were left homeless and many died.

When the waters receded the next day, the assessment of the damage to the city and its priceless heritage began. Stunned Florentines walked from street to street and saw once-beautiful piazzas now fouled with huge piles of mud-clogged debris, sprinkled with automobiles, tossed like discarded toys. Across Florence at least ten thousand artworks were either damaged or destroyed. More than a million volumes in the national library had been soaked. Books from a Renaissance palace's collection were now stuck to the ceiling of its library. In front of Brunelleschi's Duomo, the flood had swept away pieces of Ghiberti's famous bronze doors, the *Gates of Paradise* (see Chapter 14), which were luckily later found in the mud. Funneled by the narrow streets, the rushing water came across the square in front of the Church of Santa Croce (20-9), home of important frescoes by Giotto and where Michelangelo, Machiavelli, and Galileo are entombed, at a height of twenty-two feet. The floodwaters burst through the huge doors, leaving five feet of mud in its wake. Santa Croce's giant crucifix painted in the thirteenth century by Cimabue, Giotto's teacher, was all but destroyed. Christ's damaged figure became the symbol of the catastrophe and was called by the Pope "the most illustrious victim."

In response to the deluge, a flood of volunteers from all over the world poured into Florence to help the overwhelmed population and sweep the monuments clear of the mud. They were from all walks of life—an international community of students, politicians, priests, celebrities, and many ordinary people inspired by the thought of saving the world's heritage. Wearing rubber boots and pushing rakes, other times up to their waists in water,

the Florentines dubbed them *gli angeli del fango*, or the "Mud Angels." The Angels washed off books, delivered food with ropes and baskets to people who where still trapped in the upper floors of their homes, and often worked late into the night by candlelight.

The catastrophe also changed the world of art restoration. In the past, it had been the province of a small cadre of professionals with years of training in art and chemistry. Special techniques were jealously guarded by teachers and their pupils. Given the scale

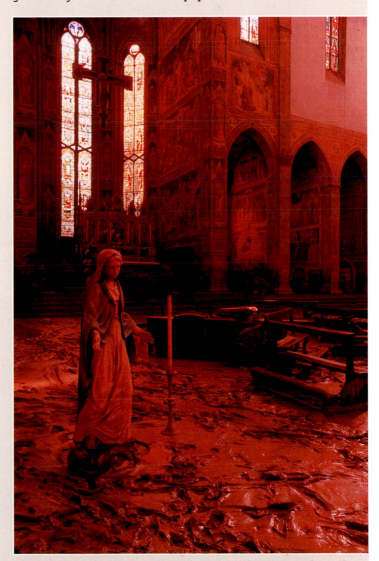

 (Mud Angels) DAVID LEES, *Interior of the Basilica of Santa Croce, 6 Nov 1966,* Time/Life Pictures.

of the disaster, emergency measures were required. The volunteers were put to work on the many thousands of objects that needed to be cleaned. Squads transported drawings, paintings, and sculptures to designated restoration areas like the greenhouses of the Pitti Palace's Boboli Gardens. While much of the work was done in the wet and cold of late autumn, a great camaraderie developed between experts and the Mud Angels (helped a bit by generous donations of Chianti). Another important change was the establishment of the Italian equivalent of the space race, opening up many training programs for the hundreds of new restoration experts that would be needed for the decades of work ahead. As a result, today, Florence is one of the most important centers of restoration in the world, and their experts have helped restore churches in India and preserve the monoliths on Easter Island.

In 2006, on the fortieth anniversary of the flood, a reunion was held in Florence with two thousand of the Mud Angels in attendance. As one Florentine official explained, "We want to thank all those who showed real solidarity by coming here from all over the world, saving not only the city, covered in mud and slime, but also a priceless cultural heritage."

Renzo Piano of Italy and Richard Rogers of England turned architecture inside out with their design for the *Georges Pompidou National Arts and Cultural Center* (20-10). When the city of Paris first gave the commission for a new museum of Modern Art to the architects, it was very controversial. First, the architects were not French, a tacit acknowledgement that artistic imagination was no longer solely a French commodity. Second, the construction would require the tearing down of many buildings that were centuries old. But probably most disturbing to French critics was the proposed design itself. It had no visible connection to the Modern movement, whose capital had been Paris and whose masterpieces would be housed there. Instead, the architects provided a new, contemporary approach to architecture. They envisioned an ultramodern cultural center, a reflection of an age of new media and scientific advances.

Unlike typical buildings, the "Beauborg" (nicknamed after its Parisian neighborhood) exposes its inner workings—nothing is hidden. The glass walls are surrounded with a network of white columns and scaffolding. The tubular main escalator is attached to this metal grid, rising up the outside like a mechanical glass worm. The Beauborg's life-support system of pipes and ducts (for plumbing, electricity, air circulation, and heat) is not only visible but also boldly announced, painted in bright colors. The walls are all movable; even the floors can be adjusted. Large video screens and banners can be attached to the grid of pipes anywhere on the building.

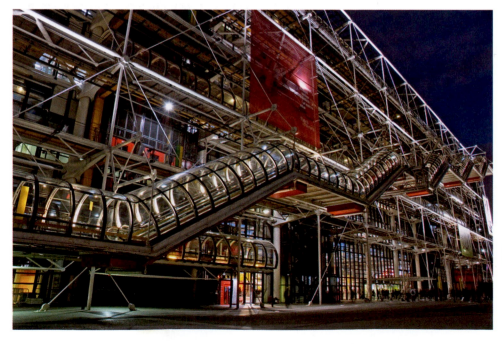

 RENZO PIANO and RICHARD ROGERS, Georges Pompidou National Arts and Cultural Center, Paris, France, 1971–1977.

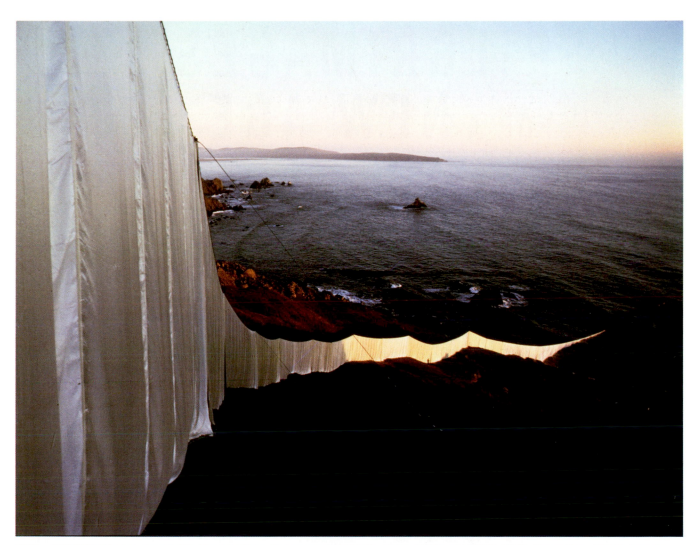

20/11 CHRISTO (Christo Javacheff), *Running Fence*, Sonoma and Marin Counties, California, 1972–1976. Two million square feet of woven nylon fabric and 90 miles of steel cable, 2,050 steel poles, 18' high and 24½ miles long.

GOING BEYOND THE ART WORLD

While the sites used by most Earth artists have been situated in isolated locations (see "Art Issues" box), the environmental art of the artists Christo and Jeanne-Claude did not shy away from populated areas. They built their works "NEVER in deserted places, and always sites already prepared and used by people, managed by human beings for human beings." Perhaps that is why they achieved more widespread fame than either Robert Smithson or Nancy Holt (see Chapter 9).

Christo's earliest efforts were concerned with wrapping objects like cans and oil barrels in cloth and seeing how they were changed by the process. He and Jeanne-Claude became international celebrities when their work grew to a monumental scale—wrapping the Museum of Contemporary Art in Chicago and then a mile-long section of the Australian coast in 1969. When the work began to be made outdoors, Jeanne-Claude and Christo became

partners on every project. However, for many years, their partnership was kept private. Christo was the public face of the team.

For Christo and Jeanne-Claude, *Wrapped Coast, Little Bay, Australia* was a success because it allowed viewers to see nature more clearly by drawing a human-made contrast to it. Their even more ambitious *Running Fence, Sonoma and Marin Counties, California, 1972–1976* (20-11) was planned to draw attention to the glories of the California landscape. Four years in preparation, the final result was an eighteen-foot-high white nylon barrier that extended for twenty-four and one-half miles across pastures and roads and into the Pacific Ocean. This monumental undertaking cost the artist $3 million, which paid for materials, a team of lawyers, environmental consultants, engineers, workers, and a building contractor.

As with all of Christo and Jeanne-Claude's environmental works, the funds were entirely their own, raised mostly from the sale of Christo's preparatory collages and drawings describing the project. Because the fence

PILGRIMAGES FOR A NEW AGE

Many of the most important sites in Earth Art are in remote locations that are difficult to reach. While this is not surprising, given the large scale of the works and the cost of land, it does demand a great deal from anyone interested in seeing them in person. In essence, a visitor must make a modern pilgrimage. Like a religious one, it requires time, commitment, and dedication.

To reach Walter De Maria's *Lightning Field* (20-12), one has to travel many miles through the desert of New Mexico. The closest town is about 150 miles outside of Albuquerque. Once you arrive there, it is another forty-minute drive to the site. The work is four hundred stainless-steel poles spread evenly in a grid over an area of one mile by one kilometer. Each of the poles are about twenty and one-half feet high and two inches in diameter. The organization that maintains the site, the Dia Art Foundation, recommends spending an extended period of time with the work and offers overnight reservations in nearby cabins. While July and August are the best times to see lightning strike the poles, there is no guarantee for any of the pilgrims.

The Dia Art Foundation also maintains Robert Smithson's *Spiral Jetty* (see 9-13). Constructed in 1970, it remains the most famous and archetypal earthwork. This enormous fifteen-hundred-feet-long spiral ramp extends out into an obscure spot of the Great Salt Lake in Utah.

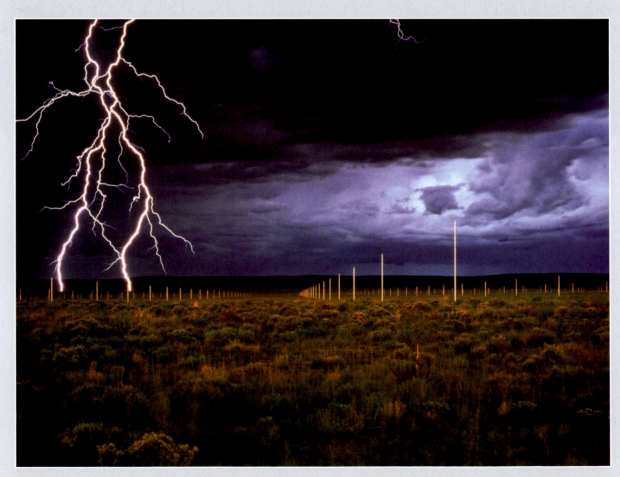

20/12 WALTER DE MARIA, *Lightning Field*, 1977. Four hundred polished stainless steel poles (2" diameter and 20' 7½" tall) in a grid of 1 mile by 1 kilometer. Southwestern New Mexico.

In the midst of a state park about ninety miles from Salt Lake City, it can only be reached by driving fifteen miles on rough, dirt roads in an all-terrain vehicle. At the shore, there's a sign that reads, "Spiral Jetty, End of Road." Even after making the long trip, one is not guaranteed a view of it. Because of the water level, it is not always visible, but the chances of glimpsing it are much better than they have been in decades. Two years after its construction in 1972, it disappeared beneath the waters and was assumed gone forever. However, in 2002, much to the surprise and delight of the art world, it reappeared when the water levels of the Salt Lake dropped. The location is not far from another important earthwork. Nancy Holt's *Sun Tunnels* (9-14) can be found in a high-terrain Utah desert two hours' driving time to the west.

James Turrell's best-known works like *Night Passage* (2-13) use illumination to create a sense of mystery and wonder in a gallery. But for more than thirty years, he's been working on a project that uses lighting on a cosmic scale. For his largest work, he says, "the sky is my big studio." The *Roden Crater* is housed in an extinct volcano on the western edge of the Painted Desert of Arizona. Since the 1970s, Turrell has been reshaping the crater into a bowl whose lighting will change based on the movements of the sun, the moon, and the stars. For the viewer, the sky will also become a huge bowl, attached to the rim of the volcano. Nothing else will be visible; it will be a pure experience of light and nature from a 360-degree panorama, what Turrell calls "celestial vaulting." Built twenty-five miles from the nearest electricity, Turrell uses windmills to generate power. Initially intended to be finished in two to three years, it has become his life's work and is only recently nearing completion. When it finally opens, a maximum of fourteen viewers per day will be permitted, eight of whom will stay overnight in rooms inside the crater designed by Turrell. He believes that the pilgrimage to *Roden Crater* will be part of the spiritual experience. "The main thing is to make a journey, so that you actually go to something purposely and have time to settle down and empty out the noise and distractions of daily life."

was hung on steel poles with cables for only two weeks, many questioned the high cost of such a temporary artwork. Much of the four years were taken up convincing environmental groups that their plan was safe. Why would they be willing to go to all this trouble? Christo said:

> Just as religion was important [in the Renaissance] so are economics, social problems, and politics today. . . . Knowledge of these areas should be an important part of one's work.

The final result *was* breathtaking. Nature cooperated with art by providing innumerable gorgeous settings—sunlight and wind, rolling hills and rocky shore, grazing sheep and grasslands made *Running Fence* a spectacle to behold.

Since then, Christo and Jeanne-Claude created other environmental works like the *Surrounded Islands*, in Biscayne Bay, Florida, *Umbrellas* in Japan and California, and 2005's *Gates* in New York's Central Park, a project that took more than a quarter century to complete. Every project was paid for by the artists. They did not accept grants or use volunteers. For them, "Financing is aesthetic." Every member of the teams that constructed the projects was paid. Disposal of the materials used in the projects was also handled by the artists and recycled industrially.

The fact that for decades Jeanne-Claude's artistic partnership with her husband Christo was not made public reflects both the prejudice found in the art world and the difficulty any artist has in achieving success. As they explained it, "The decision to use only the name Christo was made deliberately when we were young because it is difficult for one artist to get established and we wanted to put all the chances on our side." Christo was presented as the artist and Jeanne-Claude as the business manager. It wasn't until 1994 that they revealed that they had been artistic partners on every project since 1961. The ideas for their projects always came from either or both of them. According to them, however, there were two clear divisions of labor: "Jeanne-Claude does not make drawings, she was not trained for that. Christo puts their ideas on paper, [and] . . . Christo never had the pleasure of talking to their tax accountant." Sadly, Jeanne-Claude passed away in 2009, but their collaboration goes on with at least two future projects they planned together, one over a river in Arkansas and another in Abu Dhabi,

which is currently underway. These works are listed as by Christo and Jeanne-Claude on their website, which also continues to bear their names together.

MAKING ROOM FOR WOMEN: JUDY CHICAGO

In 1970, an art instructor at Fresno State College in California placed a statement at her solo exhibition that read:

> Judy Gerowitz hereby divests herself of all names imposed upon her through male social dominance and freely chooses her own name, *Judy Chicago.*

In the same year, she offered a feminist art class that excluded men, in a studio away from her college. The young women not only made works of art but also learned how to use tools. It was the beginning of a career devoted to forcing the inclusion of women in the art world.

The young Judy Cohen grew up in Chicago and was raised in a family that taught equality, so it was a shock for her to learn that America in the 1950s did not share her family's values. Early in her art career, she worked in a Minimalist style (she described this as trying to be "one of the boys") while living in Los Angeles. It was not until 1970 that Chicago made a clean break with the male art world and began making symbolic works using imagery based on female genitalia. During the 1970s, Chicago was a key figure in the birth of the women's movement, organizing Womanspace, a gallery, and the Women's Building, a center for women's culture in Los Angeles. The building housed a multidisciplinary program, called the Feminist Studio Workshop (FSW), where Chicago taught. The FSW encouraged women to explore what it meant to be female and to translate their experiences as women into subjects for artworks. The curriculum included traditional studio classes in art, writing, and video, along with consciousness-raising groups. While the traditional art world was slow to accept the work being done there, Los Angeles became a magnet for talented women from all across the United States and was known as one of the leading centers of the growing feminist movement, and eventually as a world art center.

Chicago's participation in the creation of collaborative artworks that dealt with feminist issues culminated in her most famous work, a room-sized installation called *The Dinner Party* (20-13) that was four years in the making. The artist led a team of more than one hundred women in the creation of a triangular table, forty-eight feet on each side. On it were thirty-nine place settings that symbolized the contributions of great women of the past, from prehistoric times to Georgia O'Keeffe. The table rested on a tiled platform on which the names of 999 women were written in gold. *The Dinner Party* utilized crafts media that in the past had been denied consideration as fine art. Each porcelain plate was a symbolic portrait of the woman honored, and her era was evoked in the design of an embroidered runner. Weaving and needlepoint were also employed. The plates all contain Chicago's characteristic vaginal imagery that aims to "make the feminine holy" (20-14). A companion book was written to tell about the women represented and to explain the symbols used.

In 1978, *The Dinner Party* was exhibited at the San Francisco Museum (it broke all previous attendance records) and then traveled across the country. At the Brooklyn Museum in 1980, more than seventy-five thousand visitors saw it. Chicago explained the purpose of her work as:

> A people's history—the history of women in Western civilization. . . . This information, however, was . . . certainly unknown to most people. And as long as women's achievements were excluded from our understanding of the past, we would continue to feel as if we had never done anything worthwhile. This absence of any sense of our tradition as women seemed to cripple us psychologically. I wanted to change that, and I wanted to do that through art.

The face of the art world has been changed by the works of Judy Chicago and many other women artists. Not only have the numbers of women artists grown, but the kinds of art and strategies they pursued in the 1970s have become important ones for all artists. Political art, collaborative art, performance art, photographing constructed environments, art that deals with the self and fantasy, and appropriation were all unconventional paths originally taken by creative women artists (see "Art Issues" box).

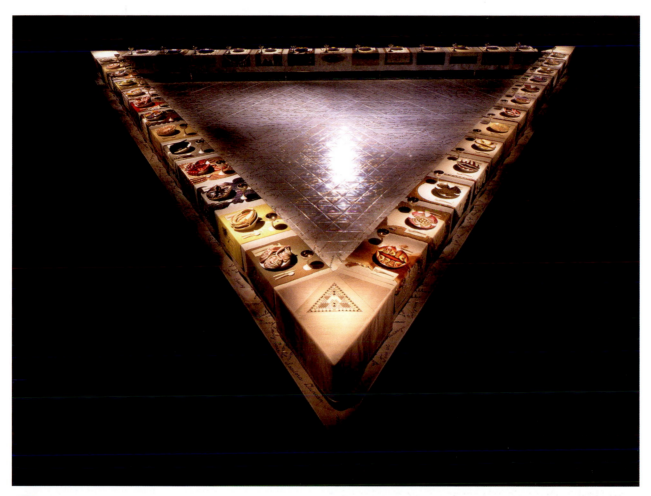

CHANGING THE NATURE OF THE GALLERY SPACE: PERFORMANCE ART

Performance art (see Chapter 9) is another way twenti-eth-century avant-garde artists tried to provoke viewers into a reappraisal of art and life. The Futurists, Dadaists, and the Pop Artists all performed art. Some performance art has been very successful in reaching the general public, like the multimedia concerts of Laurie Anderson (9-10), who began performing on streets wearing ice skates embedded in a block of ice while playing cowboy songs on a violin. Joseph Beuys even became a political force in Germany (9-9) as a leader in European environ-mental and peace movements. Performance artists are interested in producing unexpected repercussions, even dangerous ones.

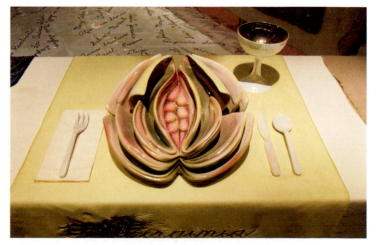

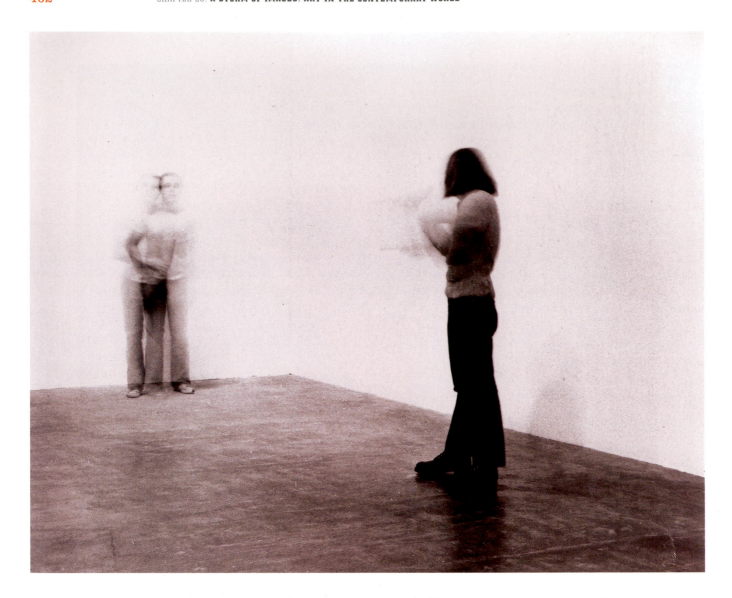

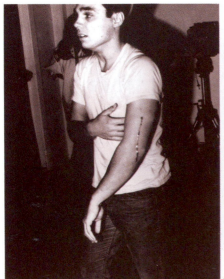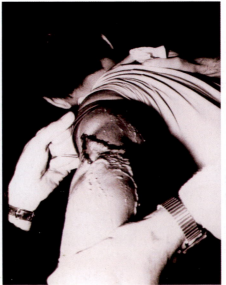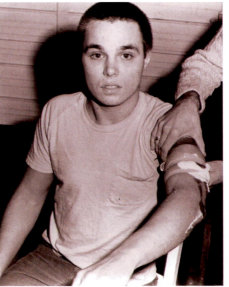

20/15 CHRIS BURDEN, *Shoot,* performed at F Space on November 19, 1971. "At 7:45 p.m. I was shot in the left arm by a friend. The bullet was a copper jacket .22 long rifle. My friend was standing about 15 feet from me." Courtesy of the artist.

The Los Angeles artist Chris Burden drew attention to his concepts with works that deliberately tested his own psychological and physical limits. His most famous (or infamous) work was *Shoot* (20-15) in 1971. Because Burden believes we live in a culture that is deadened by seeing violent acts portrayed every day on television and in films, he decided to explore and reveal the reality of violence. With inconceivable calm, Burden stood against a wall while a friend standing only twelve feet away shot him in the arm with a rifle. While the plan called for the bullet to simply graze him, the bullet punctured the center of his arm just above the elbow. This did not faze Burden because the performance was about:

> Being shot at to be hit . . . it's something to experience. How can you know what it feels like to be shot if you don't get shot? It seems interesting enough to be worth doing. . . . It was horrible but it was interesting.

Two years later, Burden reenacted the ancient legend of Icarus in a modern way (see Bruegel's *Fall of Icarus*, 14-38, for an explanation of the myth). In front of invited spectators, he lay on the floor of his studio naked with a long piece of plate glass balanced on each of his shoulders. Two assistants poured gasoline across the glass and then threw matches at the end of the glass until the gasoline was ignited. In seconds, Burden leapt up and the pieces of fiery glass crashed to the floor.

Burden's horrifying performances are meant to set up an energy between him and his audience. They bring a vividness to danger and violence that he feels our culture has lost. Like many of the artists in this chapter, he is concerned with reestablishing art as a vital, living presence in people's lives. He does this by creating memorable events that challenge our basic assumptions about what an artist is supposed to do and what is art.

Ana Mendieta's artworks also combine performance and photography, but with a strong sense of the earth and our place in it. Concerned that the colossal gestures of male artists involved with Earth Art (see "Art Issues" box on *Pilgrimages for a New Age*) seemed without true feeling for nature and also disappointed in the neglect of women in the art world (see "Art Issues" box on *Why Isn't a Woman's Place in the Museum?*), her work focuses on the relationship between women and nature and is on a smaller, more intimate scale.

Born in Havana, Cuba, as a young child she was sent away by her parents after the Communist revolution to Iowa, where she lived in a series of foster homes and orphanages. Feeling the pain of dislocation in an unfamiliar environment, she finally was able to return to Cuba when she was twenty-one. For the rest of her brief life, she made several trips there to study its culture and religion, particularly Santiría rituals, which combine African, Catholic, and Caribbean beliefs. Mendieta's work has the quality of ritual acts, momentary events that survive only because they were recorded in photographs or films. In the *Tree of Life* (20-16), she joins with nature by covering her body in mud. In this, like many of her other works, her body or silhouette connect her to the landscape. As she said, "my art is the way I reestablish the bonds that unite me to the universe." In another work recorded on film, she dug the outline of her body into the ground and filled it with gunpowder, which was then lit on fire. Her shadowy form, her *silueta*, was used by Mendieta in hundreds of works. Some were painted on caves, others built in sand or out of fireworks, not as a self-portrait, but as symbols of a vanished primal earth goddess that for thousands of years played an essential role in art and ritual. She called them "recreations of the lost female spirit."

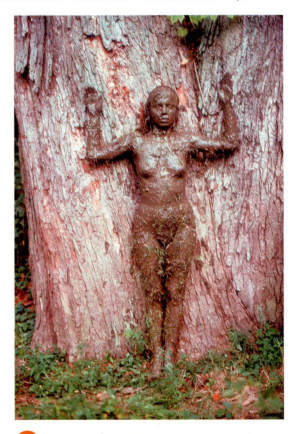

20/16 ANA MENDIETA, *Tree of Life*, 1976. Photograph.

WHY ISN'T A WOMAN'S PLACE
IN THE MUSEUM?

For the past five centuries, an unstated, unofficial, possibly unconscious, but apparent censorship of the artwork of more than half the population in the West has occurred. Although they have been making art as long as it has existed, until recently women have been systematically excluded from most museums and art histories. As women's status has risen in the last 150 years, so have the number of professional women artists. Yet, a visitor to U.S. museums or readers of art history texts from just thirty years ago would have seen the almost complete absence of any sign of art created by women. Recently, the censorship of women has begun to slowly subside, mostly as a result of the efforts of women themselves.

However, the traditional measures of success—solo shows in galleries, retrospectives in prominent museums, representation in scholarly works and texts—were slow in coming. For example, before 1987, the National Gallery of Art in Washington, D.C., had in its entire history only one retrospective of a woman artist, Mary Cassatt. Until 1986, the most successful college art survey text in the country did not include the work of a single woman, despite having more than one thousand illustrations. The author stated that unfortunately there had been no women "great enough to make the grade." After his death, his son included twenty-one women in the 1986 edition, out of more than a thousand artworks.

The Guerrilla Girls (20-17) are a coalition of artists whose goal is to keep continued pressure on the art establishment to eliminate bias against women. Formed in 1985, they describe themselves as "the conscience of the art world." They began by working secretly, under cover of darkness, plastering posters around Manhattan. Even today, their identities and overall number are unknown; all photographs show them wearing large gorilla masks. They receive mail at a post office box and conduct interviews by phone or email. With simple, well-designed posters (20-18), the Guerrilla Girls give status reports on the art world's acceptance (or lack of it) of women. Their first poster listed forty-two of the most well-known contemporary male artists and asked, "What do these artists have in common?" The answer was, "They all allow their work to be shown in galleries that show no more than 10 percent women or none at all." A press release warned of more posters ahead, "Simple facts will be spelled out; obvious conclusions can be drawn." The feminist activists were not going to allow male artists to escape responsibility for their galleries' exclusionary policies. Other posters pointed out that, in one year, the four major New York City museums had only one retrospective for a woman. Another reminded us that "Women in America earn only

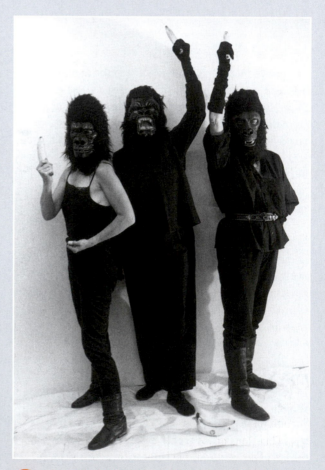

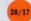 Guerrilla Girls poster, 1985. Courtesy Guerrilla Girls, West.

2/3 of what men do. Women artists earn only 2/3 of what men do." A 1989 poster directed to collectors asked:

When Racism & Sexism are no longer fashionable, what will your art collection be worth? The art market won't bestow megabuck prices on the work of a few white males forever. For the 17.7 million you just spent on a single Jasper Johns painting, you could have bought at least one work by all of these women and artists of color:

A list followed with the names of sixty-seven artists, most very well-known and respected, from the Renaissance to the present, including Artemisia Gentileschi, Judith Leyster, Élisabeth Vigée-Lebrun, Angelica Kauffman, and Georgia O'Keeffe.

While few would admit it, the posters seem to have had an effect on the prominent art institutions they have targeted. The Whitney Biennial, for example—the most important national survey of contemporary art—had only a 24 percent representation for women in 1987. Two years later, it was 40 percent. In 1999, in an effort to change the way art history is presented, they wrote their *Bedside Guide to the History of Western Art*. The first line is, "Forget the stale, male, Yale textbooks. This is Art Herstory 101!"

Still, equality and an end to sexual discrimination remain distant goals. Although women are having more exhibitions in both galleries and museums than ever before and textbooks are changing, a walk through the permanent collection of any major museum is still fundamentally a tour of the history of male artists. When the Guerrilla Girls revisited the Metropolitan Museum in New York, they found the number of women artists exhibited had actually gone down from 5 percent to 3 percent in the last fifteen years, but 83 percent of the women seen in the artworks were nudes. So they reposed the question from one of their first posters in 1989: "Do women have to be naked to get into the Met. Museum?"

20/19 JAMES LUNA, *The Artifact Piece* (detail), 1987. Mixed-media installation and performance at the Museum of Man, San Diego, California.

Mendiata's desire to bring the rituals and diverse cultures into the contemporary art world seems intended to reassert our original primeval relationship with the natural world. James Luna doesn't want us to forget that tribal peoples like Native Americans are not just linked to the land and the past but include real human beings who are living today. His *The Artifact Piece* (20-19) was exhibited among the collections of Native American artifacts in the Museum of Man of San Diego in 1987. Inside a glass case was the artist himself resting on sand with his name on one label and his scars from injuries listed on three others. Other cases contained ceremonial objects from his reservation. Viewers who had come to the museum to admire the beauty of American Indian culture could not leave without considering the life many contemporary Native Americans live.

THE ART WORLD BECOMES GLOBAL: POSTMODERN ART AND THE NEW IMAGE

In the 1970s, Western Europe had finished its recovery from the devastation of World War II, and new hubs of economic power had emerged. One of the most important was Germany, which returned to its prewar importance in art. The contemporary German artist Anselm Kiefer was a student of Joseph Beuys (9-9). Beuys had urged young artists to begin to meet "the task facing the nation," to confront the "terrible sins and indescribable darkness" and to "consummate a process of healing." Even though he was born just as the war was ending for Germany,

Kiefer knew the Nazi past was an inescapable part of his heritage. He vowed to deal with the "terror of history" so he would no longer be dislocated from the past and could regain the valuable parts of his culture as well. Kiefer's work is a search for identity, both personal and national.

Märkische Heide (20-20) of 1974 focuses on the German landscape. Landscape had been a traditional theme of great German painting since the Romantic Era (see Caspar David Friedrich in Chapter 16), but Kiefer's scene is a desolate panorama. March Heath, southeast of Berlin, has been the site of battles for centuries. Because "you cannot just paint a landscape after tanks have passed through it," Kiefer puts the viewer in the midst of a scorched and blackened land with bare trees. The vista is huge, as is the picture (nearly nine feet long). The sky is distant and gray; the road is broken. Kiefer painted his image on burlap, the roughest, lowest grade of canvas; the surface is as dense and complex as a work by Jackson Pollock. On top of the layers of acrylic and oil paint is thick black shellac that runs like blood over the clods of earth.

Because Kiefer combines vigorous brushstrokes with emotion-laden imagery, his pictures have been labeled **Neoexpressionist**, or a revival of Expressionism. However, unlike the emotionally direct German Expressionists of the early twentieth century (Chapter 18), Kiefer combines references to many eras of his country's history at once. At the time of its painting in 1974, the area known as March Heath was one of the lands that had been lost in the split of Germany into East and West. It was meant to remind viewers of the price of militarism. German viewers would also associate the title with a song of the same name that Hitler's armies had marched to.

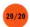 **ANSELM KIEFER**, *Märkische Heide*, 1974. Oil on canvas, 46½" × 100". Stedelijk Van Abbemuseum, Eindhoven, Netherlands.

It has been said that Anselm Kiefer's work is not really Modern at all, but what is called **Postmodern Art**. The dominant trends of Modern Art—a rejection of the past, a steady movement toward abstraction, and a disinterest in the average viewer—have been reversed by many vanguard artists since the 1970s. Postmodern artists like Kiefer are interested in rediscovering the past, not rejecting it. They aim to speak in clearer images and see history as a vast menu from which to select. They certainly draw on the Modern movement, but they see it as just one historical movement among many consecrated in museums and not the only choice or even the most important one. Kiefer, along with several other German artists, is also seen as a pioneer in what has been labeled *The New Image*—a return to imaginative and meaningful representational imagery, which many modern artists and critics had said was no longer possible in Western art.

The New Image movement led to a renewed interest in self-exploration and the self-portrait among contemporary artists. They were led by two older twentieth-century masters who had never abandoned representational art. Louise Bourgeois (see 2-10) met the French Surrealists (whom she describes as "father figures") as a young woman growing up in Paris in the 1930s. Bourgeois said that she used her art to help rid herself of fears and anger. Her sculptures were therapy of a kind, necessary because:

The unconscious is something which is volcanic in tone and yet you cannot do anything about it. You had better be its friend, and accept it or love it if you can, because it might get the better of you. You never know.

The Destruction of the Father (**20-21**) is a recreation of a violent fantasy and one of her most powerful works. Bourgeois described it as "a very murderous piece, an impulse that comes when one is under too much stress

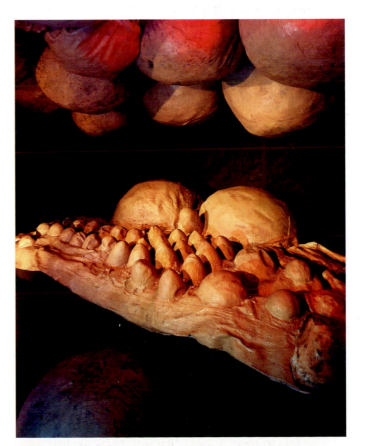

 LOUISE BOURGEOIS, detail of *The Destruction of the Father*, 1974. Latex, plaster, wood, fabric and red light. 93⅝" × 142⅝" × 97⅞"; 237.8 x 362.2 x 248.6 cm. Courtesy Cheim & Read and Hauser & Wirth. Photo: Peter Moore. Art © Louise Bourgeois Trust/Licensed by VAGA, New York, NY.

and one turns against those one loves the most." This seems to prove Sigmund Freud's theory that old conflicts never die if they are not brought out into the open and resolved. Completed when she was sixty-three, Bourgeois still remembered in anger her father's bullying ways and how he betrayed her mother with many mistresses. As a child she had fantasized one day at the dinner table when he was "going on and on, showing off" and forcing his family to listen, that she, her mother, sister, and brother suddenly grabbed her father, tore him limb from limb, and ate him. *The Destruction of the Father* is set in a frightening cave (inspired by a visit to Lascaux, site of the prehistoric cave paintings, 1-8, 1-9) with drooling alligator jaws and scattered organic shapes that look like

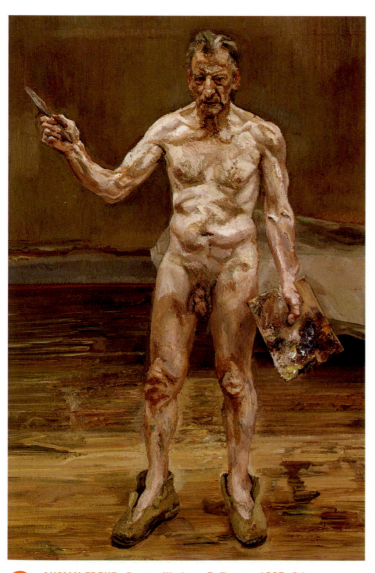

20/22 **LUCIAN FREUD**, *Painter Working, Reflection*, 1993. Oil on canvas, 40" × 32⅓". Private collection.

shredded body parts. Huge breastlike sacks loom overhead like a crowd of women exacting their revenge. In a corner of the installation is a round shape suggesting a man's head. To build this horrible environment, Bourgeois poured and shaped liquid latex over plaster and wood forms. After a half-century, Bourgeois exorcised her childhood anger, guilt, and fear with the creation of a scene of nightmarish retribution.

In a career lasting seventy years, Lucian Freud was known for his brutally honest portraits, and his self-portrait *Painter Working, Reflection* (20-22) is no exception. Freud, the grandson of the founder of psychoanalysis, described in oils not just the personality of his subjects but also the corporeal body that contains them with unpleasant specificity. Blood vessels seen through the skin, rolls of fat, blemishes, and every other flaw do not escape his eye. His application of paint was thick and almost flesh-like. Even when the subject was himself, he did not turn away from the effects of aging or the apparatus of sexuality. In his self-portrait, Freud stares down, his palette knife held up somewhat threateningly, his palette openly turned to us. The comic open boots on his feet only accentuate his nude body and the humiliating changes that are inevitable as one ages.

POSTMODERN ARCHITECTURE

With the easy access artists now have to both fine art and popular art images of every period and culture, artworks can assume a variety of guises, depending on their goals. In the mid-1960s, the buildings and theories of Robert Venturi gave architecture a head start on the Postmodern notion of exploiting rather than rejecting history. Since then, a more complete definition of Postmodernism in architecture, as well as the other media, has evolved. Postmodernism is a movement that prefers improvisation and spontaneity to perfection (ideas reminiscent of sixteenth-century Italian Mannerism). Instead of one style, the Postmodern artist combines several contradictory styles with wit. Sometimes called *neo-eclectic*, in this approach it is not considered important if the styles do or do not ultimately make a resolved whole. As we saw in the work of James Wines and SITE, a Postmodern building is not simply functional; it is also like a sculpture by the architect.

One of the iconic figures in Postmodern architecture is Frank Gehry. His most famous building is the Guggenheim Museum in Bilbao, Spain, which set the standard for contemporary museum design (10-3) and transformed a town that had lost its industries into an

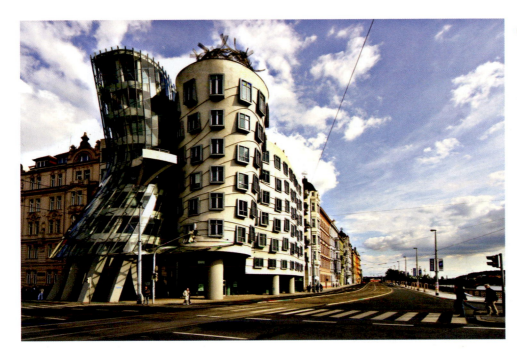

20/23 **FRANK GEHRY,** Nationale-Nederlanden building, Prague, 1992–1996.

international destination. However, Gehry has been an innovative architect since the 1970s. The remodeling of his home in Santa Monica (where he still lives) transformed a typical suburban house into an assemblage of industrial materials, composed asymmetrically. His *Nationale Nederlanden Building* in Prague (20-23) is an imaginative reflection of the elements in the traditional rowhouses that surround it. The two towers at the corner are known as "Fred and Ginger" because of the way one twists toward the other, like the famous dancers from Hollywood films. The pinched waist and twist of "Ginger" has a purpose besides decoration—it preserves the view of a castle for the apartment dwellers next door.

Frank Gehry has called Rem Koolhaas, "one of the great thinkers of our time." For many years, the Dutch architect was known more for his writings on architecture and theoretical drawings than for his buildings (much like his student, Zaha Hadid, see Chapter 10). Few projects ever got past the model stage. He has written that buildings should be "superradical and brutal" and exhibit stress from idiosyncratic combinations of forms and materials that appear unstable. But their final design should not be a result of any theory or style but determined by studying the conditions at their location. Identical projects in Chicago and Hong Kong should result in very different buildings. Enthusiastic about the rate of global change, he also believes that technology and social justice can be allies.

Koolhaas's *Seattle Public Library* (20-24) fits both his theories and the community it serves. Designed to honor the book and integrate new technologies, and based on studies of libraries all around the United States, the eleven-story building is divided into different layers,

20/24 **REM KOOLHAAS,** Seattle Public Library, Interior, Washington, 2004.

each with its own function, color scheme, and materials. Holding it all together visually is a net of steel diamond shapes whose design and structure is separate from the functional parts inside, making it easy to see from floor to floor. The enormous amount of glass in the building's skin makes it feel transparent. Books are found along a four-story ramp that spirals upward, a "continuous collection." Stairs and escalators are easy to find—they're a bright, glowing chartreuse. Contemporary art is found throughout the building. A wooden floor is carved with quotes from the foreign language collection. As you go up one escalator, you see embedded in the wall bizarre projected videos by Tony Oursler (9-27). The chief librarian calls it "the first library of the twenty-first century."

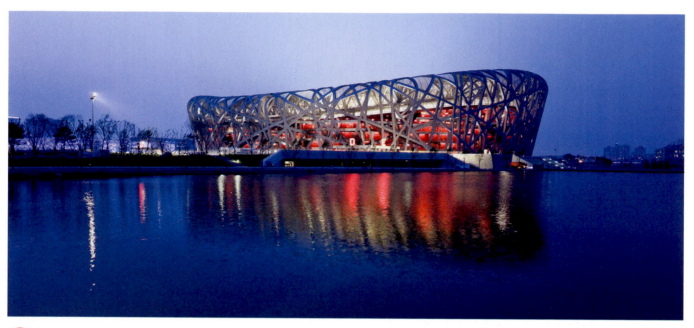

JACQUES HERZOG and PIERRE DE MEURON, *Bird's Nest Stadium (Beijing National Stadium),* China, 2008.

Public architecture in our century is expected to respond to many demands, including the requirement to be energy efficient. But how does one do that and also design an unforgettable contemporary sports arena for eighty thousand spectators and a worldwide television audience of four billion people? That was the challenge that faced the Swiss architects Herzog and de Meuron when they were commissioned to design the stadium that would be the centerpiece of the 2008 Beijing Olympics. Working with the Chinese artist Ai Weiwei, they developed a concept that reflected traditional Chinese culture, efficiency, and functionality for what is known popularly as the *Bird's Nest Stadium* **(20-25)**. The building rises atop a small hill, like a giant sculpture. The supporting beams and walkways of the building are not hidden but exposed, forming a mesh that shapes an enormous complex bowl. The models the architects and artist had in mind were the structure of nests and bamboo baskets. The exterior skeleton's wrapping of steel "twigs" seem to bend and bulge. A translucent membrane fills the spaces in the complex lattice, according to the architects, "just as birds stuff their nests with soft filler." The membrane lets light in but also is a natural insulator that keeps out wind and rain. In addition, it functions as a sound barrier that maintains the cheers and excitement of the crowd inside, but minimizes it outside. Geothermal pipes under the playing field collect heat. On the plaza outside the stadium, rainwater is collected and used to naturally cool the stadium and provide water for the facilities. Besides housing the arena and facilities for athletes, the Bird's Nest also includes restaurants, a hotel, and a shopping mall below ground. Now that the Olympics are over, it is home to sporting events, concerts, and is a popular tourist attraction, with thirty thousand visitors a day.

CONTEMPORARY NONREPRESENTATION

In our pluralistic, Postmodern era, there continues to be many serious practitioners of nonrepresentational art,

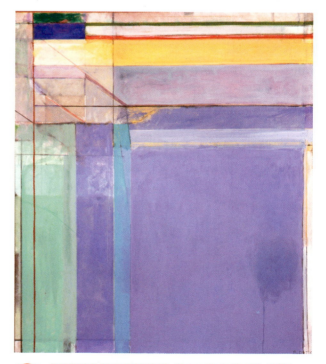

RICHARD DIEBENKORN, *Ocean Park No. 79,* 1975. Oil on canvas, 93" × 81". © The Philadelphia Museum of Art, Pennsylvania.

both young and old. Until his death in 1993, Richard Diebenkorn was the elder statesman of contemporary nonrepresentational painting. The *Ocean Park* series (20-26) was a nearly twenty-five-year exploration of the radiant Southern California light. While the series is certainly totally abstract, Diebenkorn admitted, "temperamentally, I have always been a landscape painter." In his pictures nothing is hidden; the viewer can follow the artist's struggle to resolve the composition through the thin, almost transparent layers of paint. His achievement is that he has managed to fuse the rigors of abstraction with the serene pleasures of the landscape.

In Julie Mehretu's dense, complex canvases (20-27), one can also see layers of drawing, previous ideas, the history of her artistic process. Born in Ethiopia, her family immigrated to Michigan when she was a child. Her enormous paintings resemble a dense and atmospheric map that cannot be read logically. Images are built up with pencil, pen, ink, and acrylic paint. Then she will wash away, erase, and sometimes sand certain areas of a layer before adding a new one on top. The active interplay of ruled lines, gestural paint strokes, and flat geometric colorful shapes can result in as many as twenty or more levels of movement.

While her paintings are ultimately totally abstract, Mehretu is inspired by architectural plans and maps, from ancient times to the satellite imagery of Google Maps. She often projects such pictures onto a canvas and traces parts of them—*sampling*, like the Hip-Hop musicians she grew up listening to. The layered history of her imagery, according to Mehretu, is meant to reflect the accumulated paths of travelers across the globe and the growth of our cities and culture over the centuries. She sees each painting as "a whole cosmos" made up of "the little minute detail marks [that] act more like characters, individual stories."

CONTEMPORARY INSTALLA-TIONS AND SCULPTURE

As we saw in the installations of Kenny Scharf (9-11), a more direct way to immerse viewers in a multifaceted world is by surrounding them. This art form continues to be an important one for contemporary artists, and many utilize a mix of old and new technologies in creating their environments. For example, the multimedia installations (20-28) by Assume Vivid Astro Focus

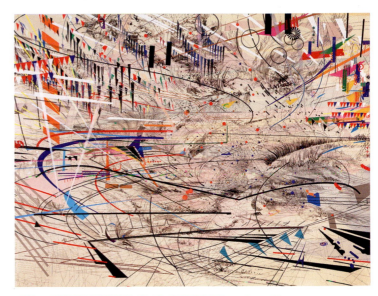

20/27 JULIE MEHRETU, *Stadia I*, 2004. Ink and acrylic on canvas, 107" × 140". San Francisco Museum of Modern Art, California.

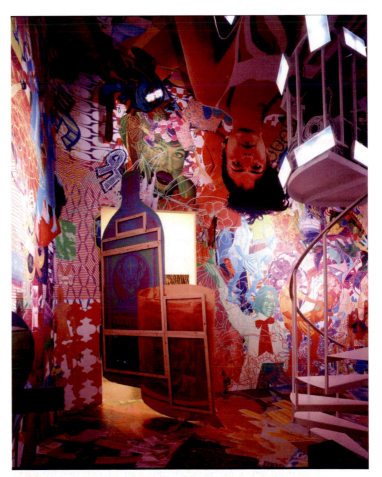

20/28 ASSUME VIVID FOCUS, *Assume Vivid Astro Focus 8*, 2004. Installation at 2004 Whitney Biennial.

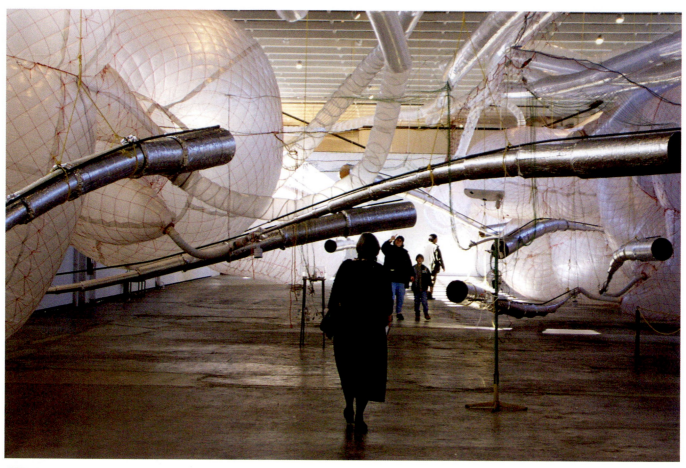

20/29 TIM HAWKINSON, *Überorgan*, 2000. Mixed-media installation at MassMOCA, North Adams, Massachusetts, approx. 300' × 28'.

blends light, sounds, and images. Born Eli Sudbrack, the Brazilian artist now makes his home in New York City. His installations (all of which he titles with his artistic name) are filled with images, music, and moving lights—more like a dance club than a gallery experience. At the center of the version he produced for the 2004 Whitney Biennial was a spiral staircase with colored projecting lights at the top. As each brilliant color changed, different parts of the decorated walls, floors, and ceilings were revealed. The images were a mix of past popular culture, cartoons, gossip, and fashion and girlie magazines. Reminiscent of both the psychedelic era and disco, the effect of all of his installations is high-energy sensory overload. Assume Vivid Astro Focus's goal is to "reach people in ways they don't even know they are being reached."

An image that moves beyond the sense of sight alone is Tim Hawkinson's *Überorgan* (20-29). This machine suggests many different structures and creatures. Hung from the ceiling, the massive mix of a bagpipe and a pipe organ perhaps resembles German blimps tethered together, a colossal invader with tentacles from a distant planet, the internal organs of a giant, or according to the artist, "kind of whales suspended in the air and hovering about you." It is constructed from enormous bladder-shaped balloons that undulate and expand as the air rushes through them. Long, rubbery pipes direct the air across the ceiling. The organ's deep sounds are controlled by a computer that reads a two-hundred-foot player piano scroll fed by a loom-like contraption. The sheer scale of *Überorgan*—it filled a room that was as long as a football field with a ceiling three stories tall—makes it difficult to categorize. Is it a huge sculpture, a performance, a sound work, or a room-size installation? For Hawkinson, like many contemporary artists, categories have really lost their meaning.

Damián Ortega's *Cosmic Thing* (20-30) is a good example of how something we see every day can be transformed and takes on new life when altered by an artist. The anatomy of a Volkswagen Beetle is revealed by suspending all of its parts from the ceiling. It is a fascinating mechanical diagram come to life. From the front, perhaps in a play on its nickname, it comes toward you like a flying bug. Ortega calls it "an exploded system with each piece has a molecular function, like a big system exploded and you can see the atoms."

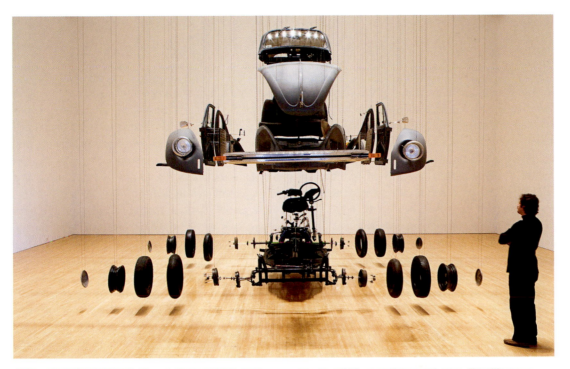

20/30 DAMIÁN ORTEGA, *Cosmic Thing*, 2002. Volkswagen Beetle 1989, stainless steel wire. The Museum of Contemporary Art, Los Angeles, California.

While reminiscent of his teacher Gabriel Orozco's *La D.S.* (3-14), this is not a luxurious Citroën but one of the most common Mexican automobiles. The first *Volkswagens* were originally designed as cheap, simple "people's vehicles" in Nazi Germany and ultimately became the most popular cars in history. The VW bug has a special meaning to Mexicans, because long after its production ended in other countries, the original Beetle continued to be manufactured there until 2003. While *Cosmic Thing* continues to travel today, it is no longer an ordinary taxi from the streets of Mexico City. It now journeys in crates to museums and galleries around the world and is reassembled in different arrangements wherever it goes.

With complex installations and sculptures, transportation and assembly can be quite a challenge for gallery and museum staffs today, even when artists are available to supervise. Petah Coyne's large sculptures and installations often include very fragile and delicate items, such as feathers, wax, silk flowers, sand, and hair. At less than five feet tall, *Buddha Boy*, constructed between 2001 and 2003 (20-31), is actually a relatively small work by Coyne, but it makes up for its short stature with complexity. Buried in a collection of materials one might find in a dressmaker's workroom, a statue of a saint is covered in dripping wax candles, ribbons, tree branches, chicken wire, feathers, tassels, and what appear to be long strands of fake pearls. Silk flowers and ribbons are scattered on the floor, while others are piled beneath the hidden figure like a long bridal train.

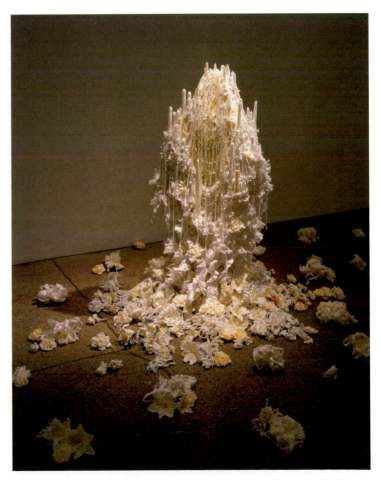

20/31 PETAH COYNE, *Untitled # 1093 (Buddha Boy)*, 2001–2003. Mixed media. © Petah Coyne. Courtesy Galerie LeLong.

Because it is so dense and elaborate, Coyne's work is often compared to Baroque altarpieces, particularly those by Bernini (see Chapters 9 and 15). According to her, this installation was made as a response to living in New York City during the 9/11 attacks and seeing the survivors walking the streets covered in white ash. At the time, she had been working on a series of photographs with white bridal dresses and flowers strewn on the floor. She was moved by how, all over the city, people were putting together makeshift outdoor shrines for those who were lost or missing. Although we in the West associate the color black with death, in Eastern religions, the color is white. Thus *Buddha Boy* is Coyne's personal expression of loss and mourning.

NEW ELECTRONIC MEDIA

In the last forty years, new electronic media have been added to the list of artists' materials, providing visual artists with tools that apparently have endless possibilities. Electronic media is a rapidly changing area of exploration that includes video art, animation, and digital art. These types of electronic art are often combined with each other and more traditional media.

Nam June Paik was the father of video art and a leader in its combination with new technologies. In his early *TV Buddha* (8-4), a traditional sculpture of the Buddha appears to be watching his own "live" image intently on a monitor. But Paik's video art was not limited to simple ("single channel") images of sculptures. Replace highlighted text with:

When visitors to the Smithsonian American Art Museum enter the room with his *Electronic Highway* (20-32) they are confronted with a fifteen foot tall map of the U.S.A. in neon lights constructed from over three hundred television sets. Meant to evoke Paik's first experience of the United States as a young immigrant, the barrage of rapidly changing pictures is a visual stream of iconic American images seen, according to Paik "as though from a passing car." Some of the

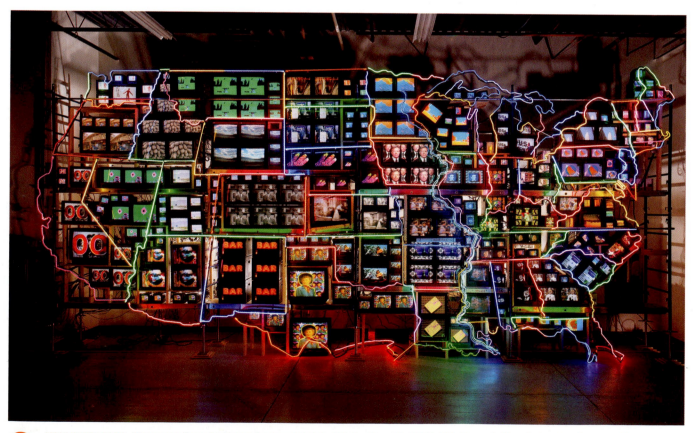

20/32 NAM JUNE PAIK, *Electronic Superhighway: Continental U.S., Alaska, Hawaii,* 1995. 49-channel closed circuit video installation, neon, steel and electronic components, 15' × 40' × 4'. Smithsonian American Art Museum, Washington, D.C.

video and soundtrack is connected to specific states: horses race in Kentucky, Martin Luther King gives a speech in Alabama, and Dorothy from the Wizard of Oz can be found in Kansas. There are also people dancing, abstract computer imagery, and more. A video camera captures images of the visitors and projects them on the screen that marks Washington, D.C. There is no beginning or end, just the endless bombardment of stimuli that seems to characterize our visual environment, a storm of images.

The medium of video art, like the other artists' media, can take many different forms and present a wide range of visions, depending on the artist's intentions. Matthew Barney's *Cremaster Cycle* is five feature-length films shot in digital video over six years. They are opulent productions filled with elaborate costumes, prosthetic makeup, mythic references, and symbolic and strange imagery. Illogical, like dreams, it is not the stories but the ideas and images that are memorable. *CREMASTER 3* (20-33) is three hours long and involves a myth of the construction of New York's Chrysler Building. The artist Richard Serra (see box in Chapter 3) appears as the ancient architect of the Temple of Solomon. Barney plays two roles: an apprentice and the notorious Utah murderer Gary Gilmore. At one point, the scene shifts to the Guggenheim Museum, and the artist is seen climbing up the outside of the circular ramps from level to level. He's dressed in a kilt and has a cloth stuck in his bloody mouth. At the museum's center, a group of Las Vegas showgirls gesture dramatically. Other characters include a half-leopard woman who has glass legs. In another scene at the Saratoga racetrack, the muscles of trotting horses tear off their bodies as they run a race. Throughout the surrealistic film there are many strange sculptures (which Barney also exhibits in galleries) in which Vaseline often plays an important role. He claims the films are simply elaborate vehicles for the sculptures. He prefers to exhibit his sculptures along with related drawings and photographs when screening his films.

A surprise awaits viewers of Eve Sussman's *89 Seconds at Alcázar* (20-34). As the film begins, it appears to be an elaborate costume drama. We are looking in on characters dressed in Spanish seventeenth-century costume. They move around the room talking quietly. The lighting is dark but beautiful. We can't quite hear what the characters are saying, but by observing their movements and body language, we begin to understand their relationships. Some are servants. There is a beautifully

dressed young girl whom everyone defers to. As the high-definition video nears the end after ten minutes, its subject suddenly becomes clear and the whole film takes on added depth. These are the people portrayed in Velázquez's *Las Meninas* (15-16), one of the greatest masterpieces of Baroque painting. They are taking their places for the grand portrait. The girl is the Infanta. We are in the role of the King and Queen of Spain, who are peeking into the court painter's studio and whose presence is revealed (as in the painting) by the mirror on the back wall. Finally, the very moment that Velázquez made immortal comes, and then the characters move back into their lives again.

History plays a different role in the work of Cory Arcangel. Videogames have been with us for more than fifty years (in 1951, MIT students created "Spacewar!" on a campus mainframe), and for many people the old games provoke the kind of nostalgia that their grandparents feel for the Golden Age of Hollywood. A former

 MATTHEW BARNEY, *CREMASTER 3*, 2002. Two silkscreened digital video disks, stainless steel, internally lubricated plastic, marble, and sterling silver in acrylic vitrine, with 35-mm print, color digital video transferred to film with Dolby Digital sound, 3:01:59, Edition 8/10, vitrine: 43½" × 47" × 40". Solomon R. Guggenheim Museum, New York.

20/34 EVE SUSSMAN, *Her Back to the Camera*, 2004. Screen grab from *89 Seconds at Alcázar*. Whitney Museum of American Art, New York.

classical music student who changed to electronic musical composition, Arcangel collects old videogame systems and reprograms them to make new works of art. As he says, "I like to get old stuff working again." He first achieved fame by hacking into a Super Mario Bros. game cartridge and erasing every character and set. He exhibited the resulting artwork at the 2004 Whitney Biennial as *Super Mario Clouds* (20-35)—a video of only the Mario clouds in motion and the famous background music of the game.

More recently, he used his music training and video-editing skills to string together YouTube clips of cute cats playing pianos so that they performed a modern classical composition. In 2011, Arcangel, who is committed to the preservation of video game history, returned to the Whitney Museum with an installation called "Various Self Playing Bowling Games." In what was also known as "Beat the Champ," the artist filled a gallery with ceiling-tall projections of six bowling video games that ranged from a 1970s simple square pixel design to a realistic 3D game from 2000. All were reprogrammed so that they play themselves endlessly but only throw gutter balls. Arcangel is also in the midst of a long-term project to construct an online archive of all his computer

codes so others can manipulate their past for creative purposes. *Super Mario Clouds* is already available for download.

20/35 CORY ARCANGEL, *Super Mario Clouds*, 2002. Modified video game.

FAME COMES TO TWO BRITISH BAD BOYS: HIRST AND BANKSY

It is common knowledge that Vincent van Gogh only sold one painting in his lifetime, which has given rise to the popular truism that an artist cannot be successful until he or she is dead. Although many contemporary artists' lives are full of struggles, since the beginning of the twentieth century there are many examples of artists enjoying spectacular success in their lifetime. Pablo Picasso and Andy Warhol, to pick just two, may have faced poverty as struggling young artists, but they were extremely wealthy for much of their lives.

In 2007, the British artist Damien Hirst opened his new show at London's White Cube Gallery. The centerpiece of the exhibition was *For the Love of God* (20-36), and its price was £50 million (or about $75 million in U.S. currency). Hirst had commissioned a jewelry firm to produce his artwork—a platinum skull covered in more than 8,500 diamonds. The skull was cast from a real one and made of thirty-two platinum plates. So many diamonds were used that it affected the worldwide price of diamonds. Hirst describes this work as "a brand produced in a factory," and has three studios where scores of assistants help produce his work. This is not without precedent, of course. The Baroque artist Peter Paul Rubens had a studio that ran like a factory (see Chapter 15), and closer to our time Andy Warhol had many assistants and actually called his studio The Factory. Hirst no longer feels the need to have a hands-on relationship with his art. "The real creative art is the conception . . . as the progenitor of the idea, I am the artist."

His ideas and approach have made Hirst one of the wealthiest artists in the world. He has several homes, including a property in the English countryside with three hundred rooms. His personal wealth is estimated at £200 million. With about two hundred twenty employees working as assistants, or in public relations, finance, investments, and marketing, Hirst is quite far from the popular image of the struggling artist. The center of his empire is a company he calls *Science* in London.

It was not always so. As a young, working-class lad, he was raised in Leeds by his mother after his father abandoned the family. Rebellious, he was often in trouble and was arrested twice. He did poorly in school in all subjects except in art. After first being rejected in art school, he gained admission and supported himself doing construction and by working in a mortuary. His first success came not as an artist but as an organizer. While at school in London, Hirst arranged for an exhibition of his schoolmates, which attracted the attention of several important members of the British art world. After he graduated, he organized more exhibitions of what became known as the *Young British Artists* (or YBAs), and he was expected to have a noteworthy career as gallery curator.

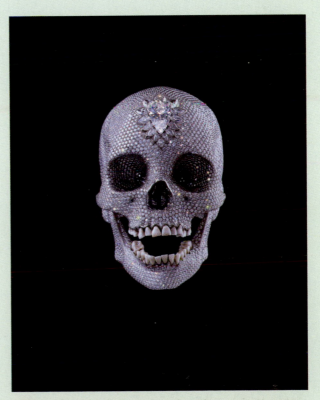

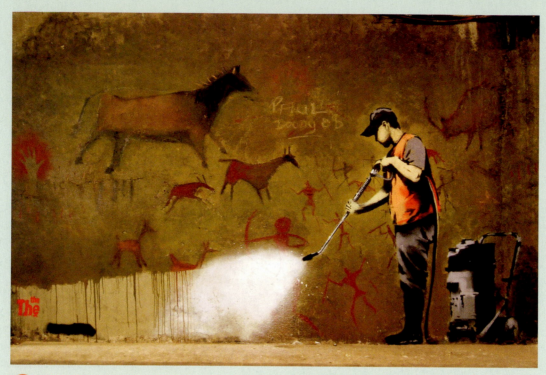

BANKSY, *Cans Buffer*, 2008. Street art (painting and stencils). Leake Street, Waterloo, South London, United Kingdom. Photograph by Martin Bull.

However, in one exhibition, he showed an artwork that would be his first step toward worldwide fame. *A Thousand Years* was a glass case containing a rotting cow's head covered in flies and maggots with an electric *bug-zapper* hanging above it. Gallery visitors were horrified, but the lurid newspaper accounts made him a celebrity. Reportedly, the esteemed artist Lucien Freud (20-22) said to him after seeing it, "I think you started with the final act, my dear." Later works by Hirst also focused on mortality and decay, for example, an open-jawed embalmed shark floating in formaldehyde *(The Physical Impossibility of Death in the Mind of Someone Living)* and a cow and calf sliced vertically in sections, each part in separate glass cases that you can walk around, titled *Mother and Child (Divided)*. Success, notoriety, and celebrity seemed to go to his head early in his career. He was often drunk and in incidents reported in the tabloids. But more recently, he has settled down to a life in London with his sons. He has opened award-winning restaurants, too.

The English street artist Banksy has taken a very different path to success. His real name is a secret to the public, and few biographical facts are known about him. When interviewed, the artist wears a hoodie that shields his face, and insists on his voice being electronically modified. Believed to be in his late thirties, he was raised in an industrial town like Hirst, where the economy was struggling. But Bristol also has a tradition of political activism, and Banksy's graffiti often is subversive in content. Many of his works show standing rats carrying things like signs, paintbrushes, or boomboxes. Other subjects are monkeys, policemen, and children. Banksy is knowledgeable about art history; a recent work known as *Cans Buffer* (20-37) has an elaborate recreation of a prehistoric cave painting being power-washed by a municipal employee. In 2005, he traveled to Palestine to see the controversial Israeli security wall that surrounds Palestinian territory in Jerusalem's West Bank. On his website, Banksy called the wall, "the ultimate activity holiday destination for graffiti writers." Despite some incidents with Israeli security forces, he was able to complete eight wall paintings. One depicts a young girl holding balloons and floating away to freedom. Another shows two boys playing in the sand with the illusion of a hole above them revealing a Caribbean beach scene. His trademark stencil of a rat was also left on another part of the wall, with the comment "We will return."

Banksy's graffiti is usually made with stencils because "it's very hard to mess up" and "you get to put something up quickly"—important when the police are hunting for you and you are trying not to be arrested. (As a young man, he was often caught before he could finish, which he found frustrating.) To make the stencils, Banksy hand-cuts

sheets of acetate or cardboard with box cutters and tapes the parts together.

Not limited to street art for his social commentary, Banksy has also "reverse shoplifted" Paris Hilton CDs by placing altered versions of the socialite's recordings in British music stores. Normal-looking labels were attached to the cover that said "Why Am I Famous? What Have I Done? What Am I For?" as if those were song titles. Inside was a message: "Every CD you buy puts me even further out of your league." The music was Hilton's but remixed by Danger Mouse. Many patrons bought these without realizing that they weren't the originals until they got home.

In addition to his street art and *drop-lifting*, Banksy also has made paintings in many historical styles that he secretly hangs in major museums along with matching labels. Designed to resemble the work exhibited nearby, it is only on closer look that their subversive message becomes apparent. One depicted a seventeenth-century French aristocrat in Classical style, but holding a can of spray paint. A fake rock carving of a caveman pushing a shopping cart was hung in the British Museum. Like Duchamp (1-21), Banksy has also modified the *Mona Lisa*, but he added a smiley face rather than a moustache. His avowed purpose is to challenge the role of museums in selecting and determining the value of works of art. "To actually go through the process of having a painting selected must be boring," according to Banksy. "It's a lot more fun to go and put up your own works." Some of these works have gone undetected for days. While his intention was to undermine the art world's power structure, because of Banksy's fame, some museums have simply decided to add the paintings to their permanent collections.

His work continues to gain popularity, and some government buildings with Banksy graffiti have announced they have no intention of removing the stencils (one town was polled and 97 percent wanted to keep the "vandalism"). In 2007, a home in Bristol with a Banksy mural on one of its walls was put up for sale. When it had difficulty attracting buyers, the owners contacted a gallery, who sold it as a Banksy artwork with house attached. They received more than they had listed it for with the real estate agent.

A GLOBAL ART WORLD WITH A RICH HISTORY

While New York remains the center of the art world today, important communities of artists can be found in many cities and on many continents. Takashi Murakami is one of the leading figures in Japanese contemporary art. His art bridges many media, both high and low. In Japan, these distinctions have never been important. Murakami makes paintings, inflatable sculptures, and also designs Louis Vuitton handbags, watches, and collectable figurines. Although his approach and attitude is very contemporary, his work draws from Japanese culture, with many references to Hokusai, anime, and manga (see Chapter 8) in his work.

Murakami is best known for his cheerful cartoon characters; his most popular one is Mr. DOB. DOB has been presented in many guises. Sometimes he is simply cute, at other times, as in 727, ferociously angry with razor-sharp teeth (20-38) and riding a Hokusai wave (see 17-27). According to the artist, "DOB is a self-portrait of the Japanese people. He is cute but has no meaning and promotes a sarcastic understanding of the truth."

Murakami has also animated a series of films with the characters of Kaikai, who wears a rabbit costume, and Kiki, who has three eyes and two fangs. In 2010, they became balloons at the 2010 Thanksgiving Parade in New York City (and can be seen on your textbook's cover). Murakami's success has led to studios and factories in both Tokyo and New York. Sometimes grouped with other Japanese artists as part of a Tokyo Pop movement, like Andy Warhol, he uses assistants to produce his work. He has a staff of around eighty people who regularly punch-in at work with timecards. His most recent pictures are drawn on a computer and then handpainted by his assistants. Murakami cheerfully sells his products. He knows that the owners of galleries are concerned that the production of too much work will lower his prices, but he says, "I don't think so. If there is demand, I will keep making them."

Shahzia Sikhander's approach is quite different. The Pakistani artist meticulously handpaints her pictures with a fine squirrel hair brush, mixing the traditional styles of

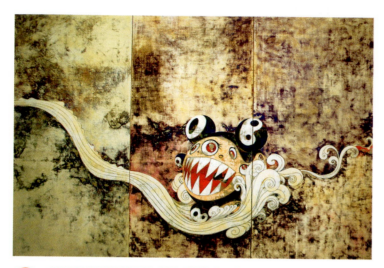

20/38 TAKASHI MURAKAMI, *727*, 1996. Acrylic on canvas board, three panels, 9'10" × 14'9". The Museum of Modern Art, New York.

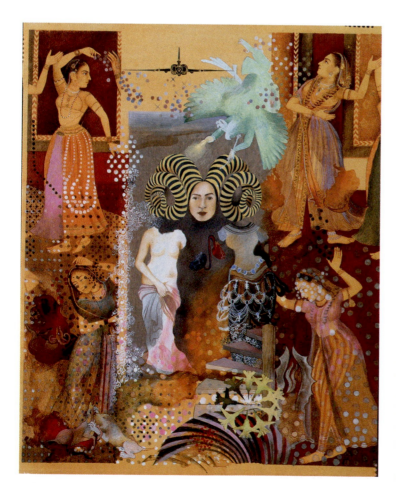

20/39 SHAZIA SIKANDER, *Pleasure Pillars*, 2001. Watercolor, dry pigment, vegetable color, tea, and ink on wasli paper.

Hindu and Persian painting. She was trained in Islamic court painting at the National College of Art in Lahore, but she uses these techniques to make images with personal imagery. "My whole purpose of taking on the subject was to break the tradition," Sikhander says, "to experiment with it, to find new ways of making meaning."

Many of her pictures, like *Pleasure Pillars* (20-39), explore issues of female identity. In the center, ideal images from ancient Western and Eastern cultures are compared. Between them, blue and red hearts are connected. The ancient women seem to be under attack by a flying white hawk-man. The dancing women at the top seem more shocked by the modern fighter plane that is just leaving the scene. By adding personal imagery and references to modern warfare, Sikhander is extending centuries-old artistic traditions and giving them fresh life in the twenty-first century.

Yinka Shonibare is another contemporary artist who also explores issues of identity and draws on cultural traditions—but in his case, the traditions of Africa and Europe. Born in London, he grew up mostly in Nigeria, then returned to England to attend art school. While there, he developed an illness that left him partially disabled. However, with the help of assistants, Shonibare has become one of the most celebrated British artists active today, winning major prizes and exhibiting his work around the world. His mediums include sculpture, painting, photography, film, and installation; his themes encompass colonialism and post-colonialism, disability, war, and African identity.

Shonibare's most recognized pieces are headless mannequins, dressed in brightly patterned materials, arranged in tableaux (scenes) that comment on African or European history, or famous works of art. For *The Swing (after Fragonard)* (20-40), Shonibare has recreated the central figure of that painting (15-34) in three dimensions. The decapitated mannequin is dressed in an historically accurate costume sewn from a type of colorful cloth called Dutch wax fabric. This material looks African, but was in fact originally designed in Indonesia (one can see the influence of batik printing), eventually manufactured in England, and then sold largely in Africa to Africans. In fact, it became so popular that today it *is* associated with African taste and identity. The fabric in itself, then, is a commentary on globalization and colonialism (Indonesia was once a Dutch colony, as were many parts of Africa, including Nigeria).

The headlessness of Shonibare's figures refers to the beheading of the upper classes during the French Revolution. The artist has said, "The idea of bringing back the guillotine was very funny to me," and his works are

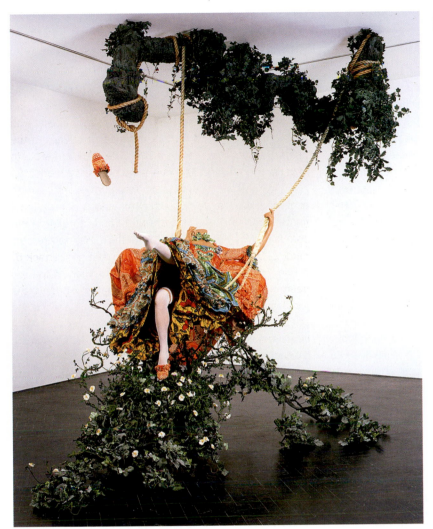

 YINKA SHONIBARE, *The Swing (after Fragonard)*, 2001. Life-size fiberglass mannequin, Dutch wax-printed cotton textile, swing, artificial foliage. Tate Gallery, London, United Kingdom.

fun as well as provocative. Shonibare stated that he was attracted to recreating *The Swing* because to him it represents "naughtiness"; that spirit is certainly captured in the same playful pose, with the tossed slipper hovering high in the air. The visual pleasure of the piece, however, is undercut by the messages conveyed by the decapitated body and the Dutch wax cloth. These remind us that the extravagance of the Rococo world pictured in *The Swing* would end in the bloody Reign of Terror, and that the wealth of eighteenth-century Europe was largely based on the exploitation of colonies and the slave trade. In bringing this scene to life, Shonibare seems to be drawing subtle parallels to today's world, where some frolic happily, unaware of the suffering around them or the threat of future reprisals.

Kente cloth is a truly traditional West African textile made of strips of fabric, usually on a very large scale. Considered sacred, it was originally only worn by African royalty. The Ghanian artist El Anatsui creates unique metallic versions of kente out of liquor bottle tops that he finds discarded in his small town. He flattens them out and stitches them together to form glimmering metal

tapestries. Over ten feet long, *Between Earth and Heaven* (20-41) from 2006 is a beautiful example of what results from his labor-intensive method. El Anatsui explains that it is alive because of its "indeterminate folds," meaning it can take many forms, since its shapes and lighting depends how it is hung and bent before it is hung. He chose bottle caps as his material not just for the visual beauty he saw in their gold, silver, black, red, and yellow metals but also their meaning. Of course, they did not exist in Africa until the arrival of Europeans. He weaves with these symbolic leftovers to link "the two histories together," old African kingdoms and the rich, powerful capitalist West. Of course, the influx of liquor was not entirely a blessing for the African people. El Anatsui's goal is to transform that painful history into something beautiful, but not to hide it. He is also putting to good use the waste of alcoholism, while employing many of his countrymen as assistants, sometimes twenty at a time to construct his textiles.

Giuseppe Penone has found his own unique way to reach back into the past and make a contemporary art form.

In 1999, a powerful wind storm knocked down thousands of the huge trees in the Gardens of Versailles (see Chapter 11), trees that had stood for centuries. This terrible loss to a masterpiece of landscape design was bemoaned by the arts community. Penone purchased one of the great fallen Atlas Cedars with the idea of making a sculpture from it. When he began carving into it, he discovered a miraculous thing: behind every knot on the bark, the original branches remain inside the trunk. Over the next two years, Penone dug into the massive eleven-thousand-pound tree and was able to reveal the original slender tree that the great cedar had grown from. His *Cedre de Versailles* (20-42) is now a window into a distant past. Inside, we can see one of the young trees that were planted in the seventeenth century, during the reign of Louis XIV.

Time and nature play important roles in teamLab's *Life Survives by the Power of Life* (20-43). Displayed on a flat wide-screen monitor turned vertically, so it can be exhibited like a traditional Japanese scroll, the video first appears to be a lovely animation of a Japanese ink painting in progress. It begins with calligraphy—the symbol for life—that is rotated in three dimensions. The virtual ink appears to be dripped into water and pools out. Over the next six and a half minutes, the symbol comes to life. Snow begins to fall and birds fly by as the calligraphic marks gradually turn into branches. The snow settles on the branches that are rotating in space slowly before our

20/42 GIUSEPPE PENONE, *Cedre de Versailles*, 2002.
© 2012 Artists Rights Society (ARS), New York/ADAGP, Paris.

20/41 EL ANATSUI, *Between Earth and Heaven*, 2006. Aluminum, copper wire, 91" × 126". Metropolitan Museum of Art, New York.

eyes. Winter changes to spring and pink plum blossoms appear, along with fluttering butterflies. As the leaves emerge, below we can see a river represented in the style of Japanese *sumi-e* painting. In a calm, beautiful, and natural fashion, the calligraphic shape becomes green and goes through the seasons. As winter approaches once more, the screen fades to black.

teamLab describes itself not as a group of talented artists, but as "an Ultra-technologist group made of specialists in the information society." *Life* is part of a series they worked on that they call Spatial Calligraphy, which reconstructs Japanese calligraphy in three-dimensional space while "expressing the power of the brush stroke." They believe that the Japanese people had a different understanding of space before Westerners arrived, and they are using new technologies to visualize that old traditional space. They also believe that part of the success of games like Super Mario (created in Kyoto, the ancient capital of Japan) is a result of their use of traditional Japanese space and how they scroll horizontally like traditional narrative scroll painting. Whether one shares their beliefs or not, they have given new meaning and a twenty-first-century twist to what is called *screen painting*.

It is also clear that advanced technologists like teamLab and many other contemporary artists continue to find new vitality in old sources. This is a worldwide phenomenon. In our time, the whole history of art is accessible and available to artists. The mine of the past is a rich and deep one, as are the wide range of media and techniques.

Today's storm of images began with a trickle when the printing press was invented in the fifteenth century. Television, computers, and the World Wide Web are just the most recent developments in a centuries-long history of more and more images becoming available to more and more people. The death of art announced in many obituaries written by artists and art critics during the heyday of Minimalism in the 1960s has come and gone. We are now in what is called a Postmodern and pluralistic era, a period of exploration of seemingly endless possibilities for every medium, new and old. Artists are now justifiably suspicious of anyone who announces that there is only one logical style or approach to making art. The history of the last hundred years—in fact, the whole history of art—is littered with the remains of generations of "true" art. To wait and see what the legions of artists will produce next is one of the most pleasurable parts of the power of art today.

20/43 TEAMLAB, *Life Survives by the Power of Life*, 2011. Original calligraphy by Sisyu, 3D animation, and concept by teamLab. 6 min. 23 seconds.

GLOSSARY

Abstract Expressionism: An American art movement that began in the 1950s. Large-scale art that combined Expressionism's potent psychological content and the gestural application of paint with an abandonment of any clear reference to the visual world.

abstract shapes: Representational organic or geometric shapes that have been simplified. Even when they have been reduced to their basic underlying forms, distorted or exaggerated, the original sources of abstract shapes remain recognizable.

academic art: Art officially sanctioned by the national academies (schools of art) in Europe. In the eighteenth and nineteenth centuries, the academies upheld traditional approaches, encouraging art in Classical or Renaissance styles with epic historical and literary themes. In the modern era, it has come to mean conservative and unimaginative art.

acrylic: A water soluble paint that dries quickly and can be applied to most surfaces. Originally made for industrial use in the 1950s, its medium is plastic polymer made from resins.

Action Painting: The energetic brushwork of Abstract Expressionism, apparently done in fits of intense and almost violent activity.

additive sculpture: As opposed to subtractive, sculpture that is *built up,* such as by modeling a flexible material like clay or plaster, or by building an installation.

adobe: A kind of sun-dried brick made of clay mixed with straw, used for building by native tribes of the Southwest and parts of South America.

Age of Reason: See Enlightenment.

airbrush: A spraying device that uses an air compressor to propel paint mist through a nozzle.

alla prima: Paintings done quickly and at one sitting, with little or no preparation. Means "at the first."

allegory: A form of art in which human characters personify certain qualities or ideals.

analogous colors: Hues adjacent on the color wheel; when placed together, they form pleasant harmonies because they are closely related. An example would be green, blue-green, and blue.

Analytical Cubism: The first phase of Cubism. A collection of views from different angles fused into a balanced design with limited color.

aperture (or diaphragm): An adjustable opening that controls the amount of light entering a camera.

applied arts: The useful media of the visual arts, such as architecture, design, and illustration.

applique: In quilting, fabric silhouettes cut out and stitched onto the background of another fabric.

appropriation: A twentieth-century method where imagery from other sources (photographs, past masterpieces) is taken and turned into a new work of art, sometimes with little or no alteration.

aquatint: An intaglio printmaking process that creates tonal areas. When powdered resin is applied to a metal plate and then heated, each particle becomes a dot that will resist acid. As with etched lines, the longer an area of aquatint is in the acid bath, the deeper the etch and the darker the tone in the print.

arbitrary colors: As opposed to naturalistic or realistic colors, colors that are the invention of the artist.

arcade: A covered walkway.

arch: A semicircular construction (usually of stone) that both supports the weight of a building and provides an opening. Used extensively during the Roman Empire, it allowed far wider spaces between columns than post-and-lintel construction. Also known as *rounded arch.*

art nouveau: A late nineteenth-century style utilized for furniture, architecture, interiors, and graphic design and characterized by elaborate, rhythmic, and organic decoration. It was the first modern international design style.

assemblage: Three-dimensional collages.

asymmetrical balance: An intuitive balance of visual weights that results in a more dynamic equilibrium than radial or symmetrical balance.

atmospheric perspective: A method of creating a sense of deep space in two-dimensional art based on the effect our atmosphere has on things seen at a distance. Distant forms are portrayed vaguer and closer to the color of the sky than near ones.

avant-garde: Literally the "advance guard"; the vanguard or leaders of new directions in the arts.

balance: Visually satisfying stability in a work of art. It is created by adjusting the placement of art elements in a field.

Baroque: The period in the seventeenth century that included art with dramatic use of light and dark and preferences for dynamic movement and theatrical effects, as well as intense naturalism and the inclusion of elements of ordinary life in religious scenes.

barrel vault: A rounded arch that when extended allowed for large and long public spaces in stone buildings, particularly cathedrals built during the Middle Ages.

Bauhaus: ("the house of building") A German school devoted to the cause of integrating the arts and modern technology and to transcending the boundaries among craft, design, and art. Founded in 1919 by the architect Walter Gropius, the school stressed a simple, modern, geometrical style.

bearing wall: An architectural construction using the walls themselves to support the weight of the roof and floors above.

binder: A glue-like substance that holds pigment together, the type of which determines the nature of the medium; for example, oil is the binder in oil paint. Used in all the colored media.

Buddhism: A religion founded by Siddhartha Gautama, a prince from Nepal who lived in the sixth century B.C. Through the revelation that all life is an illusion and that the only way to escape pain is to renounce all desires, he attained nirvana and became the Buddha.

Byzantine: The eastern Roman Empire founded by Constantine. Also an art style of the civilization centered in Constantinople (now Istanbul) during the Middle Ages that was less naturalistic and more symbolic, stylized, flat, and decorative than before the fall of the Empire.

cage construction: See steel frame construction.

camera obscura: Literally meaning "dark room," initially a room-sized camera. By preventing all light from entering a room and then cutting a small hole in a shade over a window, a person could project an inverted image of the outside onto the opposite wall. By the 1700s, a table model of the camera obscura with lens and mirror became available, providing a right-side-up projected image on a screen that artists could use for tracing.

capital: The crown of an architectural column.

cartoon: A preparatory drawing for larger work, such as tapestries or murals.

casting: A process that makes one or several lasting copies of sculpture. Often the casts are made of bronze, though other metals or plaster may be used.

ceramics: Objects made from clay fired in a kiln for lasting hardness and strength.

chiaroscuro: A technique in drawing and painting where a dramatic contrast between light and dark areas creates a convincing illusion of three-dimensional forms. The Italian Baroque painter Michelangelo da Caravaggio is noted for using this technique.

Classical Age: The flourishing of Greek culture during the fourth and fifth centuries B.C. Classical Greek art expressed ideals of clarity, order, balance, proportion, harmony, and unity.

Classicism: A seventeenth-century movement that, inspired by the Classical art of Greece and Rome, taught that the highest aim of a work of art is to represent noble and serious thoughts. It called for a logical, orderly art with great themes so as to raise viewers up by appealing to their reason, not to their base emotions.

collage: The combination of cut-and-pasted paper, photographs, and other materials on a two-dimensional surface.

colonnade: A row of columns, usually supporting a roof.

Color-Field Painting: A kind of Abstract Expressionism characterized by large areas of color that are more dominant than any particular shape.

color wheel: Primary and secondary colors arranged in a circle. The primaries are placed equidistant from each other, with their secondary mixtures between them.

complementary colors: Colors that are directly across from each other on the color wheel, such as red and green. When placed together, they accentuate each other's intensity. Considered opposites, or complements.

conté crayon: A versatile drawing crayon developed in the late 1700s. It comes in a variety of degrees of hardness and can be used to create both subtle tones and dense blacks.

contour lines: Lines that describe the edge of a form, sometimes emphasized by changes in weight or width.

cool colors: The family of colors based on blue, purple, and green; colors that are associated with calm, order, the sky, and the ocean. They tend to recede away from the viewer.

Counter-Reformation: The Roman Catholic church's attempt to combat the Protestant Reformation of the

sixteenth century. As part of this campaign, the church supported art that would entertain and rouse the faithful.

crayon: A colored drawing medium with a waxy or oily binder that adheres to paper; does not require fixative.

cross-hatching: A drawing technique used to make forms appear three-dimensional. A series of parallel lines cross in a net-like fashion, describing the contours of a surface.

Cubism: An alternative to linear perspective organization of space developed by Pablo Picasso and Georges Braque in the early twentieth century. Built from a collection of observations, objects are seen from several angles simultaneously. Each part is equal in importance—there is no conventional foreground and background. The result is a significantly shallower space compared to linear perspective, as well as a less naturalistic appearance.

Dada: A meaningless term for an international art movement that began during World War I. Dada manifestos called for the destruction of all values—the end of art, morality, and society. This "anti-art," which took the form of bizarre performances and exhibition of found objects, or "ready-mades," was an effort to evolve a new way of thinking, feeling, and seeing.

daguerreotype: The first permanent photographic image, invented by Louis-Jacques-Mande Daguerre in 1839, utilizing silver foil made light sensitive with chemicals. After the foil was exposed to light in a camera, the image was made permanent by bathing in a salt solution.

deductive reasoning: The medieval scientific approach to explaining natural phenomena using accepted general rules. Compare to inductive reasoning.

design: The organization of visual elements into a composition that is visually satisfying.

Die Brucke: Literally "the Bridge," a group of German Expressionist artists led by Ernst Kirchner in the early 1900s. By expressing emotions honestly and directly, they hoped to encourage others to abandon the stale hypocritical attitudes of their elders. Clashing hues, strong lines, and aggressive spirit typified their work.

digitize: To translate two-dimensional images (with scanners) and three-dimensional objects (with video cameras) into numbers that a computer can read so the images can appear on the computer's screen.

Earth Art: Large-scale environmental sculpture outside of a gallery or museum; interacts directly with nature.

edition: The limited number of prints made directly from an image created by an artist on a block, plate, stone, or screen. Once the last print of an edition is "pulled," the block, plate, or other source is destroyed.

egg tempera: See tempera.

elevation: An architectural drawing that shows front and side views of a planned structure on a vertical plane.

engraving: The oldest form of intaglio printmaking, developed in Europe during the 1400s. Cuts and scratches dug with tools into a metal plate are filled with ink and print directly onto paper as lines.

Enlightenment: An intellectual movement that began in England and spread to France, then spread throughout Europe by the end of the eighteenth century. Great scientists and mathematicians stressed the value of rationality over faith and embraced the idea of progress.

environment: See installation.

etching: An intaglio process using acids rather than tools to cut the metal plate. An acid-resistant wax coating, or ground, is applied to the plate. An image is made by cutting through the ground. Then the plate is put in a tray of acid that "bites" into the metal where the wax ground was removed. After the plate is washed with water, it is inked and printed just like an engraving. Lines can be made lighter or darker by the amount of time the plate is in acid.

Existentialism: A post-World War II philosophy that began in France. It declares that all people are essentially alone, that there is no God in the universe. Each one must face the ultimate meaninglessness of the universe and decide independently how to live one's own life.

Expressionism: A Modern Art movement that went beyond an imitation of the world toward an intense re-creation of feeling. Making inner feelings (as dark and deep as they may be) visible was generally achieved with powerful (often clashing) colors and vivid contrasts of light and dark.

façade: The outer side of an architectural structure; usually refers to the front of a building.

Fauves: Literally the "wild beasts," a group of French artists led by Henri Matisse in the early 1900s. They ignored perspective and used bright colors as a source of pleasure.

ferroconcrete: See reinforced concrete.

figure-ground ambiguity: A design whose positive and negative forms are so balanced that it is unclear which part should be called *figure* and which should be called *ground*.

488

figure triangle: Common in Renaissance compositions, a triangular arrangement of elements, often figures.

fine arts: The visual arts customarily considered in Western civilization a "high" form of artistic production (in other words, not useful like the applied arts). They have traditionally included drawing, painting, and sculpture, but in the last two hundred years have also included outstanding examples of printmaking, photography, design, decorative arts, and crafts.

fixative: A spray of shellac or plastic polymer used in charcoal and pastel drawings to ensure a permanent bond to the paper.

flutings: Scraped finger tracings that create grooves on soft stone ceilings in stone-age cave art. Also parallel vertical grooves in columns.

flying buttress: In a gothic church, an exterior support for stability.

flying logo: Via computer animation, a kind of logo seen on television that appears to spin in three dimensions and come toward the viewer.

foreshortening: In two-dimensional art, the apparent diminishing in size of forms as they seem to recede from the viewer.

forged: Metal shaped by heating.

frame or ballon-frame construction: A supporting skeleton made of vertical and horizontal wooden supports nailed together; used in architectural constructions.

freestanding sculpture: Sculpture in the round that the viewer must circle to see completely.

fresco: A permanent wall-painting technique in use since ancient times. Pigment and water is brushed directly into fresh, wet plaster (fresco means "fresh" in Italian). As the plaster dries, the pigment is bound into it and literally becomes part of the wall itself.

Futurism: An early twentieth-century Italian Modern Art movement led by the poet Filippo Marinetti. A celebration of the age of the machine, it called for a complete and utter rejection of the art of the past.

genre: Ordinary and commonplace subject matter; scenes from everyday life.

geometric shapes: Enclosed spaces formed by straight lines or curved ones that progress evenly. Squares, rectangles, triangles, and circles are all examples of this kind of two-dimensional shape. Three-dimensional examples are the cube, box, pyramid, and sphere. Sometimes called *hard-edged* shapes.

gesso: A thick paint applied to prepare surfaces like wood or canvas for painting. It produces bright white surface impermeable to liquids. Traditionally, a thick paste of gypsum and animal glue, although today many artists replace the glue with an acrylic medium.

glass blowing: A craft that transforms hot, molten glass into a finished art object. The glass is picked up in a small spherical blob at the end of a long metal pipe, then blown into bubbles of various shapes, shaped with tools or by rolling on a hard surface, and removed from the pipe to cool slowly.

glaze: 1. Paint diluted and made transparent. Often built up in layers on top of underpainting to create the illusion of three-dimensional forms. 2. In ceramics, a paint that melts into and fuses with clay while being baked in a kiln.

Gothic: Elaborately decorative medieval building style of the twelfth through fifteenth centuries, whose unique features were the pointed arch, the ribbed vault, exterior flying buttresses, high ceilings, and stained-glass windows.

gouache: An opaque watercolor made by adding chalk to pigment and gum arabic. Unlike watercolor, it can be applied more thickly, covers well, and permits changes.

graphic design: Once known as "commercial art," it is the manipulation of typography and images for advertisements, magazines, books, posters, packages, logos, and signs.

grazia: During the Renaissance period, art that was beautiful, graceful, and seemingly effortlessly achieved.

groin vault: The intersection of two barrel vaults at right angles.

ground: 1. The visual plane where art elements (or figures) are organized. When elements are added to the ground, it becomes, in itself, a shape (called the negative form), and must be consciously dealt with. 2. The surface of a two-dimensional work of art. 3. A wax coating that resists acid; used in etching.

Hellenistic Age: An age that began with the reign of Alexander the Great (356–323 B.C.) in Greece. During this time, Greek sculpture became more naturalistic and illusionistic, appealing less to the rational mind and more to the senses than the restrained works of the Classical period.

Hinduism: An ancient polytheistic religion native to India in which believers accept that humans experience an unending cycle of birth, life, death, and rebirth. *Karma*

determines one's fate; the deeds of one lifetime influence one's status in the next.

horizon line: The same as the viewer's eye level, it is where the sky and the earth appear to meet. In linear perspective, it is where parallel lines converge.

Hudson River School: A group of nineteenth-century American Romantic painters. These artists saw in America an unspoiled land of great promise and painted many views of the Hudson Valley and other wilderness areas in the Northeast.

hue: The name of a color on the color wheel or in the spectrum. For example, violet and green are two different hues.

Humanism: The predominant philosophy of the Renaissance and catalyst for the period's great achievements. Its two main ingredients were the study of the ancient cultural achievements of the Greeks and Romans and respect for the individual.

iconoclasm: The destruction of religious imagery.

impasto: Thick paint that reveals the action of brushstrokes.

Impressionism: A Modern Art movement that began around 1870 in France. Based on the idea of conveying an immediate impression of a place and time of day. Impressionist painters worked outdoors, directly studying the moment's light and color. Their typical style achieved heightened color effects by placing colors side by side rather than mixing them.

Impressionists: A group of artists who met in cafés and studios and exhibited together in Paris from the 1870s to the end of the nineteenth century. While some, like Claude Monet, worked in the characteristic Impressionist style, others simply joined a rebellion against the dominant academic style of their time.

inductive reasoning: A medieval scientific approach where one observes phenomena directly and then uses the gathered information to develop general rules. Compare to deductive reasoning.

industrial design: The design of manufactured objects such as telephones, typewriters, and automobiles.

installation: A room-sized multimedia sculpture constructed in a gallery, museum, or public space. It is meant to surround the viewer with a unique artistic experience. Also known as an *environment.*

intaglio: A printmaking method: lines cut into the surface of a metal plate become receptacles for ink after the plate is inked and its surface wiped off. Damp paper and plate are then run through a press; the heavy pressure forces the paper into the ink-filled grooves, and the image is transferred.

intensity: The vividness of a particular hue.

International Style: The dominant twentieth-century architectural approach in Europe and the United States. The antithesis of the heavily ornamental style taught in nineteenth-century architectural academies, its buildings were flat-roofed, made of modern materials (concrete, steel, and glass), and free of any superfluous decoration. Boxlike and practical, all spaces were designed for efficient organization.

Islam: Religion founded by the prophet Mohammed (A.D. 570–632). The teachings of Mohammed are recorded in The Koran, which tells of the revelations of God through the angel Gabriel. The name "Islam" means "submission to the will of God."

Japonisme: The love of all things Japanese, a wave that swept over cultured Western society in the late nineteenth century.

juxtaposition: A technique invented by the Dadaists where unrelated objects are taken out of their normal context and joined together, producing a new unique object.

kiln: An oven used for drying and baking clay sculptures or ceramics.

kinetic sculpture: Sculpture with moving parts.

lens: In cameras, the clear, rounded glass or plastic that focuses the light onto the film.

linear perspective: The principal means of creating the illusion of the third dimension or depth in Western two-dimensional art since the Renaissance. All parallel lines appear to converge at points in the distance, called vanishing points. Forms that seem closer appear larger than those meant to be farther from the viewer. See also one-point perspective, foreshortening.

linear style: A Neoclassicist approach; typically paintings drawn with sharp outlines, clearly defined forms, and relatively solid areas of color.

lithography: A printmaking process where images are drawn or painted directly in grease on a flat stone or metal plate. After the surface is chemically treated and moistened with water, ink will only adhere where there is grease. Wax crayons, soap, and black pigment with *tusche,* a greasy liquid that can be applied with a brush or sprayed on, are the most common materials used to make the images.

local color: The general color of anything we see, without considering the effect of lighting or adjacent colors.

logo: A symbol or trademark of an organization that is meant to be instantly recognizable.

loom: A machine for weaving fibers into cloth.

lost wax method: A method, in a series of steps, of using molds to cast hollow metal sculpture or jewelry.

mandala: In Buddhist art, an intricate, geometrical design of deities depicted in concentric circles that represent the cosmos.

Mannerism: A sixteenth-century Italian art movement that was a reaction to Renaissance ideals. Mannerist artists used distortion to demonstrate their inventiveness. Their highest aim was elegance.

maquette: A sculptural model in clay or wax of a planned larger work or cast work.

matte: A dull, nonreflective finish as opposed to a glossy finish.

media, medium: Artists' materials, such as oil paint or clay.

metalpoint: Drawings with pure, precise lines made by a thin metal wire in a holder; the wire is usually silver, but other metals including lead have been used.

mihrab: A niche for prayer in a mosque, oriented to face in the direction of Mecca.

minaret: A slender tower on the exterior of Islamic buildings.

Minimalism: An American art movement that began in the 1960s. Art is stripped down to the essentials; paintings and sculptures are self-sufficient and have no subject matter, content, or meaning beyond their presence as objects in space.

mixed media: A twentieth-century method that mixes materials (manufactured, natural "found objects," as well as conventional art media), often using them in unusual ways, without respect for the traditional borders between two- and three-dimensional media.

mobile: A hanging kinetic sculpture, originated by Alexander Calder in the twentieth century, whose parts are moved by air currents.

monotype: A one-of-a-kind print made by applying ink or paint directly to a metal plate and then running it through a press with paper. It can also be made without the press by rubbing the back of the paper.

morphing: A computer-aided transformation where one image gradually becomes another.

mosaic: Picture made of tiles of colored stone, ceramic, or glass.

mosque: An Islamic place of worship.

naturalistic: Art that is realistic. For example, animals are drawn as if they were alive.

nave: The large, central space in a medieval church.

negative form: The shape of the space or ground around art elements.

Neoclassicism: A reaction to Rococo art and the visual expression of the ideals of the Enlightenment of the eighteenth and nineteenth centuries. Its characteristics include clarity of line, color, and form. Its artists sought to create universal moral lessons that would educate and improve the viewer.

Neoexpressionism: An international revival of Expressionist methods that began in the 1970s. Combines vigorous paint strokes with emotion-laden figurative imagery.

neutral colors: White, black, and gray. Added to colors, they make tints and shades, changing the values but not the hue.

nirvana: In Buddhism, a state of eternal bliss.

nonobjective shapes: See nonrepresentational shapes.

nonrepresentational shapes: Shapes that are not meant to refer to anything we can see in the real world. They are sometimes called *nonobjective* or *abstract*. These shapes can be either organic (soft-edged) or geometrical (hard-edged).

oculus: "Eye"; round opening or window at the top of a dome.

one-point perspective: A system of linear perspective invented by the Renaissance artist Filippo Brunelleschi. All parallel lines appear to converge at one point in the distance, the *vanishing point,* which is exactly on

the horizon line. As in all linear perspective, the sizes of objects shrink as they increase in distance from the viewer.

Op Art: A nonrepresentational style, introduced in the 1960s, that explored optical illusions.

organic shapes: Enclosed spaces formed by uneven curves. They are sometimes called naturalistic, biomorphic, or soft-edged. Examples are shapes that look like amoebas or treetops.

painterly style: An approach to painting promoted by the nineteenth-century Romantics, utilizing broad strokes, indistinct outlines between shapes, and colors blended into each other. It is a style intended to reach viewers' emotions rather than their minds.

pastels: Colored chalks in sticks that are a combination of loose dry pigment and a binder of paste or methylcellulose.

patina: The green, brown, or black color caused by the oxidation of copper or bronze, either because of exposure to the elements or artificially induced by acids or other substances.

Pax Romanus: Roman peace during the reign of Augustus, when citizens could travel safely anywhere within the Roman Empire.

performance art: Twentieth-century events designed to be ephemeral, lasting only in memory.

perspective: An architectural drawing that gives a three-dimensional impression of a new building in its setting.

photomontage: The imaginative combination of more than one photographic image.

photorealism: See Superrealism.

piazza: Large courtyard.

picture plane: A flat two-dimensional surface within which art elements are organized.

plastic: Moldable material, like wet clay, rather than rigid.

pointed arch: A Gothic arch that allowed larger openings in the outer wall and higher ceilings in the interior than the Roman rounded arch.

pointillism: The Post impressionistic style developed by Georges Seurat. By placing small spots of pure color side by side, Seurat let the viewer's eye optically mix the colors and thereby increase their luminosity.

Pop Art: An American and English art movement of the 1960s that celebrated the commodities and celebrities of the time.

porcelain: Clay baked at a high temperature transformed into a material of glasslike hardness, sometimes known as "china."

positive form: The shape of an art element.

Postimpressionism: Separate expressions of dissatisfaction with Impressionism at the end of the nineteenth century by artists who had initially worked in that style. The most important figures of this new movement were Georges Seurat, Paul Gauguin, Vincent van Gogh, and Paul Cezanne.

post-and-lintel: A form of architectural construction in which posts or columns support horizontal lintels (cross beams).

Post-Modern Art: A contemporary movement that began in the 1980s. The dominant trends of Modern Art—a rejection of the past and of decorative elements and a steady movement towards nonrepresentational images—are reversed. Post-Modern Artists are interested in rediscovering the past, not rejecting it, and see history as a vast menu from which to select.

primary colors: Red, yellow, and blue, the three colors that cannot be made from any others, and that are the sources for all other colors.

proportion: The relative sizes of the parts of an object to each other.

quill: Pens made from bird feathers, most commonly goose. Variation in the pressure applied to the pen will smoothly change a line's width. Popular since the medieval period.

radial balance: All elements revolve around a central point.

raku: Hand-shaped Japanese ceramics associated with the tea ceremony. Irregular and asymmetrical, with glazes thick and rough, their imperfection is prized as a mark of mastery.

Realism: A nineteenth-century movement that rejected the idealized historical and mythological subjects of academic Neoclassicism; instead it focused on unembellished ordinary contemporary life as the source of truth and meaning.

Reformation: A rebellion led by Martin Luther against the Roman Catholic church in the sixteenth century resulting in the creation of Protestantism.

registration: In color prints, the proper alignment of each color with the other inked colors.

reinforced concrete (or ferroconcrete): Concrete reinforced with thin iron rods to provide added strength. It enables architects to design structures with dramatic shapes.

relief printmaking: A method of printmaking where the negative spaces of a design are cut away, leaving the positive areas raised. The print's marks are made from inking what is left in "relief" on the block. Woodcuts, linoleum cuts, and rubber stamps fall into this category.

relief sculpture: A sculptural image that projects from a flat, two-dimensional background. The back of a relief sculpture is not meant to be seen; the entire design can be understood from a frontal view.

Renaissance: Meaning "rebirth," a period famous for art and architecture and generally considered to mark the beginning of the modern world. Spanning the fourteenth to sixteenth centuries in Europe, it was marked by renewed interest in Classical culture as well as the development of capitalism, the rise of the nation-state, scientific investigation, and individualism. Also known as the "Age of Exploration."

rhythm: Repetition of similar shapes, as in *patterns*.

Rococo: An eighteenth-century lighthearted and decorative style of art whose subject matter is typically about lovers. It was a reaction to the formality of Classicism.

Romanesque: Medieval building style of the ninth through twelfth centuries based on the Roman round arch. Heavy stone geometric buildings were supported by thick walls with few windows and dark interiors.

Romanticism: A nineteenth-century reaction to Neoclassicism, by rejecting logic and order and looking for the inner truth of intuition and passions. Romantic artists admired the untamed power of nature and used a painterly style.

rotunda: A completely round building or a circular interior with a dome.

Salon: An annual exhibition in Paris, begun in 1737, of art chosen by members of the French Academy. It was the only important public exhibition available to artists in the mid-nineteenth century.

saturated colors: Colors that have a high level of intensity.

scale: The relative size between an object and a constant, usually the size of the average person.

secondary colors: Orange, green, and purple, created by mixing two primary colors.

secondary symbolism: Common in Medieval and Northern Renaissance art, where details have additional meanings, such as a white lily in a vase representing the Virgin Mary.

serpentinata: In Mannerism, the most elegant pose for a body—when the limbs and torso resembled the letter "S." It refers to the twisting of a snake.

sfumato lighting: In Italian, "the soft mist of a fountain." Soft lighting in Renaissance paintings originally used by Leonardo da Vinci. It makes both edges and details unclear. The lack of definite edges forces viewers to use their imagination, making portraits like the *Mona Lisa* seem more lifelike.

shades: Hues that have been darkened by the neutral color black. Navy blue is a very dark shade of blue.

shutter: The part of the camera that is triggered by the photographer and controls the time of the exposure.

silkscreen (or serigraphy): An inexpensive method of producing very large editions of prints. A stencil is attached to silk tightly stretched over a wooden frame. Paper or cloth is placed underneath the screen and ink is spread across the screen with a rubber blade or squeegee. The areas of silk not covered with a stencil let the ink come through and print onto the medium.

simultaneous contrast: The effect of two colors meeting. Differences between them are accentuated; their similarities are not apparent.

steel frame (or cage construction): A form of architectural construction developed in the 1890s using a steel interior skeleton that resembles a bird cage. Used today for building skyscrapers. Its facade is often a simple "skin" of glass.

stigmata: Bloody signs of the nails that held Christ to the cross.

De Stijl ("the Style"): Early twentieth-century Dutch artists who believed a pure universal style in art and architecture could be the solution to humankind's misery. Followers of Piet Mondrian, they designed furniture and buildings using flat geometric areas filled with primary colors.

stoicism: A Greek philosophy that encouraged dignity, rational thought, and control over one's emotions.

stupa: A Buddhist religious shrine in the shape of a mound. Pilgrims walk around it, symbolizing the Path of Life around the World Mountain. The walking is a form of meditation and worship.

subtractive sculpture: As opposed to additive, sculpture carved out of materials such as wood or stone.

Superrealism (or photorealism): A movement that began in the 1970s that in two dimensions, re-creates the look of photographs. In three dimensions, casting is often used to achieve the utmost fidelity to reality.

Surrealism: An art movement begun in the 1920s that depicted dreams and visions of the irrational unconscious and was inspired by Sigmund Freud's theories.

symmetrical balance: Sometimes known as *bilateral symmetry*, a balance where there is general equivalence of shape and position on opposite sides of a central axis; if folded in half, the forms would match.

Synthetic Cubism: The second phase of Cubism, where more colorful and playful visual symbols replaced the limited colors and angular planes of analytical cubism.

tattoo: The marking of skin with designs. Originally from the Tahitian word *tatau*.

tempera: A painting medium in which pigments are mixed with egg yolks (sometimes called egg tempera).

tenebroso: Literally, the "dark manner." A technique of the followers of Michelangelo da Caravaggio.

terra-cotta: Clay baked in a kiln and hardened to a rich red-earth tone.

texture mapping: In computer art, the wrapping of a texture around a wire-grid form drawn by an artist to create a realistic or imaginative surface.

three-dimensional space: The kind of space we actually live in. It contains objects that can be viewed from all sides, objects that have height, width, and depth. Sculpture and architecture are examples of three-dimensional art forms.

throwing: The action of a potter using a wheel to build a round vessel. A lump of clay is lifted and shaped by hand as the wheel turns.

tints: Hues that have been lightened by the neutral color white. Pink is a pale tint of red.

transept: In a medieval church, the short rectangular space that ran perpendicular to the nave, forming the Latin-cross floor plan.

trompe l'oeil: Art that fools our eyes into believing that what we see is real.

trumeau: The central pillar of the main doorway of a church.

two-dimensional space: Flat space that can only be viewed from one side. Anything that exists in this space will have height and width but no depth. However, two-dimensional art forms often create the *illusion* of depth. Drawing and painting are examples of two-dimensional art forms.

typography: The manipulation and selection of styles and sizes of letters *(type)* in graphic design.

Ukiyo-e: Literally "pictures of the floating world"; Japanese woodcut prints that depicted brothels, the theater, and scenes of travelers and ordinary life among the middle class of Japan. The style and subjects of these prints influenced the development of Impressionism and Postimpressionism.

underpainting: Painting done as a foundation for subsequent transparent glazes. Usually establishes basic composition and tonal relationships.

unity: A sense of coherence or wholeness in a work of art. Unity alone is unlikely to sustain the interest of a viewer. It must be balanced with *variety*.

value: The relative lightness and darkness of a color.

vanishing point: In linear perspective, a point where parallel lines appear to converge on the horizon, like railroad tracks meeting at a point in the distance.

visual weight: The relative importance of an element in a picture plane. Visual weight is dependent on the position, color, size, shape, or texture of the element.

volume: A three-dimensional shape, although sometimes implied, such as a drawing of a vase.

volute: A decorative spiral on a column.

warm colors: The family of colors based on yellow, orange, and red; colors that are associated with extreme emotions, chaos, fire, and the sun. They tend to advance towards the viewer.

warp: In weaving, vertical parallel threads arranged in a loom.

wash: Diluted ink applied with a brush to add tonal values to a drawing.

watercolor: Transparent paint that is a quick-drying combination of pigment and gum arabic. Diluted with water, it is usually applied to paper.

weft (or woof): In weaving, horizontal parallel threads passed at right angles to the warp and interlaced with them in a loom.

wood engraving: A relief process similar to woodcut, but that uses the endgrain on blocks of hard wood. The endgrain's density permits very fine, precise lines to be created, and, compared to woodcuts, many more prints can be made before the block begins to deteriorate.

woodcut: A type of relief printmaking made by carving directly into a smooth piece of wood and removing any parts of the surface not meant to be part of the image.

wrought: Metal shaped by hammering.

PHOTO CREDITS

FRONTMATTER

p. vii Jonathan Poore/© 2014 Cengage Learning. All Rights Reserved.

p. viii Pékin Fine Arts Co.

p. viii Journal-Courier/Clayton Stalter/ The Image Works

p. ix Brooklyn Museum of Art, New York, USA/Gift of Anna Ferris/The Bridgeman Art Library

p. ix Digital image courtesy of Richard Lewis © 2012 Artists Rights Society (ARS), New York

p. ix Topham / The Image Works

p. x Boltin Picture Library/ The Bridgeman Art Library

p. xi Jonathan Poore/ © 2014 Cengage Learning. All Rights Reserved.

p. xii Jonathan Poore/ © 2014 Cengage Learning. All Rights Reserved.

p. xiii Jonathan Poore/ © 2014 Cengage Learning. All Rights Reserved.

p. xv Photo by Ezra Shaw/Getty Images

p. xvi Photograph by Fabrizio Bensch, Reuters

CHAPTER ONE

1/1 Réunion des Musées Nationaux/Art Resource, NY

1/2 Roger-Viollet Paris/Private Collection/Bridgeman Art Library

1/3 Réunion des Musées Nationaux/Art Resource, NY

1/4 Réunion des Musées Nationaux / Art Resource, NY

1/5 © Sakamoto Photo Research Laboratory/Corbis

1/6 Haga Library/Lebrecht Music & Arts

1/7 Erich Lessing/Art Resource, NY

1/8 Sisse Brimberg/National Geographic/Getty Images

1/9 Art Resource, NY

1/10 © Yale University Art Gallery/Art Resource, NY

1/11 Angelo Tondini/CuboImages srl/Alamy Limited

1/12 Werner Forman/Topham/The Image Works

1/13 © George Steinmetz/Corbis

1/14 © Dennis Cox / Alamy

1/15 Jonathan Poore/ © 2014 Cengage Learning. All Rights Reserved.

1/16 Erich Lessing/Art Resource, NY

1/17 © Scala/Art Resource, NY

1/18 © INTERFOTO / Alamy

1/19 Freer Gallery of Art, Smithsonian Institution, Washington, D.C., Purchase, F1942.15a

1/20 Collection of University of California, Berkeley Art Museum; purchased with the aid of funds from the National Endowment for the Arts (selected by The Committee for the Acquisition of Afro-American Art). Courtesy of Michael Rosenfeld Gallery, LLC, New York, NY.

1/21 DACS / The Bridgeman Art Library. © 2012 Artists Rights Society (ARS), New York / ADAGP, Paris / Succession Marcel Duchamp

1/22 Rob Crandall/The Image Works

1/23 Bill Helsel/Alamy Limited

1/24 Ansel Adams/Corbis

1/25 Pékin Fine Arts Co.

1/26 akg-images

1/27 Courtesy Paula Cooper Gallery, New York. © 2012 The Murray-Holman Family Trust / Artists Rights Society (ARS), New York

1/28 The Museum of Modern Art/Scala /Art Resource, NY. © 2012 Artists Rights Society (ARS), New York / ADAGP, Paris

1/29 The Metropolitan Museum of Art. Image source: Art Resource, NY

1/30 Grandma Moses Properties/The Phillips Collection

1/31 MCT via Getty Images

1/32 James Prinz Photography, Chicago. Courtesy of Nick Cave and Jack Shainman Gallery, NY

1/33 Museum of Northern Arizona

1/34 AKG images

1/35 Reserve Bank of New Zealand/Herb Kawainui Kane

1/36 Scala/Art Resource, NY

1/37 Whitney Museum of American Art, New York. © 2012 The Willem de Kooning Foundation / Artists Rights Society (ARS), New York

1/38 Scala/Art Resource, NY

1/39 Whitney Museum of American Art, New York. © 2012 The Willem de Kooning Foundation / Artists Rights Society (ARS), New York

1/40 Gjon Mili/Time Life Pictures/Getty Images

1/41 © 2012 The Andy Warhol Foundation for the Visual Arts, Inc. / Artists Rights Society (ARS), New York

1/42 Réunion des Musées Nationaux/Art Resource, NY

1/43 Scala/Art Resource, NY

1/44 © Pipilotti Rist Courtesy the artist, Hauser & Wirth and Luhring Augustine/Installation view at MoMA PS1, 2011. Photo © Richard Wilson

CHAPTER TWO

2/1 Photograph © 2013 Museum of Fine Arts, Boston, Zoe Oliver Sherman Collection given in memory of Lillie Oliver Poor, 38.1838.

2/2 Berlin/Bpk/Art Resource, NY

CHAPTER THREE

CHAPTER FOUR

7/18 Matthew Marks Gallery New York

7/19 The Artist and Metro Pictures

7/20 © Lalla Essaydi, New York / Courtesy Edwynn Houk Gallery, New York

7/21 Levi van Veluw, Landscape I, 2008

CHAPTER EIGHT

8/1 Image Select/Art Resource, NY

8/2 DACS /The Bridgeman Art Library. © 2012 Artists Rights Society (ARS), New York/SIAE, Rome.

8/3 ArenaPal/Topham/The Image Works. © Salvador Dalí, Fundació Gala-Salvador Dalí, Artists Rights Society (ARS), New York 2012

8/4 The Museum of Modern Art/Licensed by SCALA/Art Resource, NY

8/5 Performer: Phil Esposito. Photo: Kira Perov

8/6 Performer: Phil Esposito. Photo: Kira Perov

8/7 Courtesy the artist and Lehmann Maupin Gallery, New York and Mizuma Art Gallery, Tokyo

8/8 © Pipilotti Rist Courtesy the artist, Hauser & Wirth and Luhring Augustine

8/9 Used with permission of MIT Lincoln Laboratory, Lexington, Massachusetts

8/10 Image Courtesy of The Advertising Archives

8/11 Maggie Taylor

8/12 Courtesy of Catharine Clark Gallery, San Francisco

8/13 House Industries

8/14 The artist and The Project, New York.

8/15 Copyright 1986 Pixar

8/16 Nina Paley

8/17 © Touhoku Shinsha/The Kobal Collection

8/18 Peter Edmunds, Unclaimed Baggage, 5/12/2005, online collaborative drawing from swarmsketch.com.

8/19 bitforms gallery nyc

8/20 Courtesy of Francois Poury

CHAPTER NINE

9/1 Danny Lehman/Terra/Corbis

9/2 Private Collection / The Stapleton Collection / The Bridgeman Art Library

9/3 The Trustees of the British Museum / Art Resource, NY

9/4 Metropolitan Museum of Art, Michael C. Rockefeller Memorial Collection, Gift of Nelson A. Rockefeller, 1965. (1987.412.309) Photograph © 1983 The Metropolitan Museum of Art

9/5 Alinari / Art Resource, NY

9/6 Alinari / Art Resource, NY

9/7 Gift of the Collectors Committee, Photograph © 2001 Board of Trustees, National Gallery of Art, Washington. © 2012 Calder Foundation, New York / Artists Rights Society (ARS), New York

9/8 Museum Jean Tinguely, Estate of David Gahr

9/9 © 2012 Artists Rights Society (ARS), New York / VG Bild-Kunst, Bonn

9/10 Cornelia Wyngaarden

9/11 Scharf Studio, photography by Tseng Kwong Chi. © 2012 Kenny Scharf / Artists Rights Society (ARS), New York

9/12 Tanya Bonakdar Gallery, New York

9/13 Art © Estate of Robert Smithson/Licensed by VAGA, New York, NY

9/14 Scott T. Smith/Documentary/Corbis. Art © Nancy Holt/Licensed by VAGA, New York, NY

9/15 Robert Preston Photography / Alamy

9/16 Réunion des Musées Nationaux/Art Resource, NY

9/17 Cengage Learning, 2014

9/18 The Metropolitan Museum of Art. Image source: Art Resource, NY

9/19 The Metropolitan Museum of Art. Image source: Art Resource, NY

9/20 Haga Library/Lebrecht Music & Arts

9/21 The Nelson-Atkins Museum of Art, Kansas City, Missouri. Purchase: the Renee C. Crowell Trust, F95-16 A-C. Photograph by Robert Newcombe.

9/22 Nimatallah / Art Resource, NY

9/23 Scala / Art Resource, NY

9/24 Hirshhorn Museum and Sculpture Garden, Smithsonian Institution. Photo: Lee Stalsworth. Art , Estate of David Smith/Licensed by VAGA, New York, NY

9/25 © 2012 Estate of Louise Nevelson/Artists Rights Society (ARS), NY. Photo © CNAC/MNAM/Dist. Réunion des Musées Nationaux/Art Resource, NY

9/26 Solomon R. Guggenheim Museum, New York. Purchased by exchange with funds contributed by Dakis Joannou and with a special International Director's Council fund in honor of Dakis Joannou, 2003. Accession #2003.79. Photograph by David Heald © The Solomon R. Guggenheim Foundation, New York

9/27 The Artist and Metro Pictures

9/28 Courtesy of Claire Oliver Gallery, New York.

9/29 "A Cappella" by Patrick Dougherty, Villa Montalvo, Saratoga, CA, Photo by Rod Johnson

CHAPTER TEN

10/1 Gehry Partners, LLP

10/2 Gehry Partners, LLP

10/3 David Burton / Alamy

10/4 Yoram Lehmann/Peter Arnold/Getty Images

10/5 Erich Lessing / Art Resource, NY

10/6 Mauritius / SuperStock

10/7　© Wolfgang Kaehler/Corbis

10/8　Brian Brake/Photo Researchers

10/9　Georg Gerster / Photo Researchers, Inc

10/10　Vanni/Art Resource, NY

10/11　© Jon Arnold Images Ltd / Alamy

10/12　Cengage Learning, 2014

10/13　© The Art Archive / Alamy

10/14　Cengage Learning, 2014

10/15　Cengage Learning, 2014

10/16　© Cosmo Condina North America / Alamy

10/17　Cengage Learning, 2014

10/18　Cengage Learning, 2014

10/19　© Peter Noyce / Alamy

10/20　Cengage Learning, 2014

10/21　JP Collection/Cengage Learning

10/22　Jonathan Poore/ © 2014 Cengage Learning. All Rights Reserved.

10/23　Cengage Learning, 2014

10/24　Cengage Learning, 2014

10/25　© John Warburton-Lee Photography / Alamy

10/26　© Alex Vertikoff

10/27　Réunion des Musées Nationaux / Art Resource, NY

10/28　Cengage Learning, 2014

10/29　Rob Kavanagh / Alamy

10/30　Ezra Stoller/Esto

10/31　VIEW Pictures Ltd/Alamy

10/32　age fotostock / SuperStock

10/33　Vincenzo Lombardo/Taxi/Getty Images

10/34　Cengage Learning

10/35　DEA PICTURE LIBRARY/De Agostini Picture Library/Getty Images

10/36　Alinari/Art Resource, NY

10/37　Robert Llewellyn / SuperStock

10/38　Robert C. Lautman Photography Collection/ Courtesy of the National Building Museum

10/39　William S Helsel/Stone/Getty Images

10/40　© 2012 Artists Rights Society (ARS), New York / ADAGP, Paris / F.L.C.

10/41　Zaha Hadid Architects

10/42　Diller & Scofi dio

10/43　© VIEW Pictures Ltd / Alamy

CHAPTER ELEVEN

11/1　Réunion des Musées Nationaux / Art Resource, NY

11/2　Museum of Fine Arts, Houston, Texas, USA / Gift of Miss Ima Hogg / The Bridgeman Art Library

11/3　Scala/Art Resource, NY

11/4　The British Musem/Art Resource, Inc.

11/5　Topham / The Image Works

11/6　The Charles Hosmer Morse Museum of American Art, Winter Park, FL © The Charles Hosmer Morse Foundation, Inc.

11/7　Digital Image © The Museum of Modern Art/Licensed by SCALA / Art Resource, NY

11/8　bpk, Berlin/Art Resource, NY

11/9　Victoria & Albert Museum, London / Art Resource, NY

11/10　2008 Museum of Fine Arts, Boston

11/11　The Metropolitan Museum of Art. Image source: Art Resource, NY

11/12　Photo: © schoppleinstudio.com. Courtesy of the Voulkos & Co. Catalogue Project, www.voulkos.com

11/13　San Francisco Museum of Modern Art (gift of the Modern Art Council). Art © Estate of Robert Arneson/Licensed by VAGA, New York, NY

11/14　Indianapolis Museum of Art, USA, Gift of Marilyn and Eugene Glick /The Bridgeman Art Library

11/15　Magdalena Abakanowicz. Courtesy of the Marlborough Gallery, New York.

11/16　Smithsonian American Art Museum, Washington, DC / Art Resource, NY

11/17　Smithsonian American Art Museum, Washington, DC / Art Resource, NY

11/18　Private Collection. Courtesy Tibor de Nagy Gallery, New York

11/19　Joslyn Art Museum

11/20　Rotasa Collection Trust

11/21　Tai Gallery

11/22　Marian Bantjes

11/23　Designed by Milton Glaser

11/24　Private Collection / The Bridgeman Art Library

11/25　Image copyright © The Metropolitan Museum of Art. Image source: Art Resource, NY

11/26　Digital Image © The Museum of Modern Art/Licensed by SCALA / Art Resource, NY. © 2012 Artists Rights Society (ARS), New York

11/27　© Mark Fiennes/The Gamble House.

11/28　Our Place World Heritage

11/29　Knoll

11/30　Glyn Thomas / Alamy

11/31　Art Kowalsky / Alamy

11/32　© 2012 The Isamu Noguchi Foundation and Garden Museum, New York / Artists Rights Society (ARS), New York

CHAPTER TWELVE

12/1　Gary Cook/Alamy

12/2　Erich Lessing/Art Resource, NY

12/3 Bildarchiv Preussischer Kulturbesitz / Art Resource, NY

12/4 Boltin Picture Library/ The Bridgeman Art Library

12/5 Carmen Redondo/Corbis

12/6 Bridgeman-Giraudon / Art Resource, NY

12/7 akg-images/Laurent Lecat

12/8 © View Stock/ Alamy

12/9 The Metropolitan Museum of Art. Image source: Art Resource, NY

12/10 The Parthenon Project www.debevec.org/Parthenon © 2004 University of Southern California

12/11 Cengage Learning, 2014

12/12 Julian Worker/World Religions Photo Library / Alamy

12/13 Christophe Loviny/Corbis

12/14 R Sheridan/Ancient Art & Architecture Collection Ltd

12/15 © Hercules Milas / Alamy

12/16 Araldo de Luca/Corbis

12/17 Scala/Art Resource, NY

12/18 Richard Ashworth/Robert Harding Picture Library Ltd / Alamy

12/19 Erich Lessing / Art Resource, NY

12/20 Réunion des Musées Nationaux / Art Resource, NY

12/21 Araldo de Luca/Corbis Museum/Corbis

12/22 © Corbis

12/23 Scala/Art Resource, NY

12/24 John Ross/ Robert Harding Picture Library Ltd / Alamy

12/25 UPPA / Topham / The Image Works

12/26 Canali Photobank

12/27 Roman, (2nd century AD)/The Art Gallery Collection / Alamy

12/28 Wendy Kay / Alamy

12/29 John Miller/Robert Harding Picture Library Ltd / Alamy

12/30 Vanni / Art Resource, NY

12/31 Scala / Art Resource, NY

12/32 Araldo de Luca/Corbis art/Corbis

12/33 Richard Lewis

CHAPTER THIRTEEN

13/1 Scala / Art Resource, NY

13/2 The Metropolitan Museum of Art/Art Resource, NY

13/3 Erich Lessing / Art Resource, NY

13/4 Canali Photobank

13/5 Canali Photobank

13/6 Adam Eastland Italy/Alamy

13/7 Rolf Richardson/Alamy

13/8 Cengage Learning, 2014

13/9 De Agostini/Getty Images

13/10 Erich Lessing/Art Resource, NY

13/11 HIP/Art Resource, NY

13/12 Steve Taylor ARPS/Alamy

13/13 Westend61 GmbH / Alamy

13/14 Werner Forman / Art Resource, NY

13/15 © Chris North/ Sylvia Cordaiy Photo Library LTD / Alamy

13/16 © Paul Almasy/Corbis

13/17 Adam Woolfit/Robert Harding Picture Library

13/18 Tetra Images/Getty Images

13/19 Copyright: Photo Henri Stierlin, Genève

13/20 The Huntington Library chech this in Fichner

13/21 Robert L. Brown

13/22 © Pacific Press Service

13/23 Erich Lessing / Art Resource, NY

13/24 David Crossland / Alamy

13/25 Erich Lessing/Art Resource, NY

13/26 Jonathan Poore/ © 2014 Cengage Learning. All Rights Reserved.

13/27 Jonathan Poore/ © 2014 Cengage Learning. All Rights Reserved.

13/28 Jonathan Poore/ © 2014 Cengage Learning. All Rights Reserved.

13/29 Cengage Learning, 2014

13/30 Bildarchiv Monheim GmbH / Alamy

13/31 Doug Pearson/Getty Images

13/32 Erich Lessing / Art Resource, NY

13/33 Jonathan Poore/ © 2014 Cengage Learning. All Rights Reserved.

13/34 Richard Lewis

13/35 Jonathan Poore/ © 2014 Cengage Learning. All Rights Reserved.

13/36 Scala / Art Resource, NY

13/37 Scala / Art Resource, NY

CHAPTER FOURTEEN

14/1 Scala / Art Resource, NY

14/2 Arte & Immagini srl/Corbis

14/3 Arte & Immagini srl/Corbis

14/4 JP Collection/ Cengage Learning

14/5 Jonathan Poore/ © 2014 Cengage Learning. All Rights Reserved.

14/6 Erich Lessing/Art Resource

14/7 Erich Lessing / Art Resource, NY

14/8 Canali Photobank, Italy

14/9 The Gallery Collection/Corbis

14/10 Bodleian Library

14/11 Friedrich Saurer/imagebroker/Alamy

14/12 Fratelli Fabbri/Bridgeman Art Library

14/13 Scala / Art Resource, NY

14/14 Alinari/Art Resource, NY

14/15 Araldo de Luca/Fine Art Premium/Corbis

14/16 Scala/Art Resource

14/17 © Jim Zuckerman/Corbis

14/18 Vittoriano Rastelli/Documentary/Corbis

14/19 Vittoriano Rastelli/Documentary Value/Corbis

14/20 © Bracchietti-Zigrosi/Vatican Museums

14/21 © M. Sarri 1983/Photo Vatican Museums

14/22 Alinari/Art Resource

14/23 Scala/Ministero per i Beni e le Attività culturali / Art Resource, NY

14/24 Merilyn Thorold/Bridgeman Art Library

14/25 akg-images / Electa

14/26 Art Resource

14/27 Erich Lessing / Art Resource, NY

14/28 Erich Lessing/Art Resource, NY

14/29 Erich Lessing/Art Resource, NY

14/30 akg-images

14/31 © Cleveland Museum of Art, Leonard C. Hanna, Jr. Fund. 1984.37

14/32 Superstock

14/33 © Musée Unterlinden, Colmar Musée Unterlinden, Colmar Inv. 88.RP.139

14/34 Bridgeman Art Library

14/35 The Art Archive at Art Resource, NY

14/36 The Art Archive at Art Resource, NY

14/37 The Art Archive at Art Resource, NY

14/38 Scala/Art Resource

14/39 Erich Lessing/Art Resource

CHAPTER FIFTEEN

15/1 Scala/Art Resource, NY

15/2 Scala/Art Resource, NY

15/3 Scala/Art Resource, Inc.

15/4 © National Gallery, London / Art Resource, NY

15/5 © National Gallery, London / Art Resource, NY

15/6 Scala/Art Resource, Inc.

15/7 Alinari / Art Resource, NY

15/8 Detroit Institute of Arts USA/Gift of Mr Leslie H. Green/ The Bridgeman Art Library

15/9 Scala/Art Resource, Inc.

15/10 Scala/Art Resource, Inc.

15/11 Erich Lessing/Art Resource ,Inc.

15/12 Scala/Art Resource, Inc.

15/13 Lightworks Media/Alamy

15/14 Hemis(Bertrand Gardel)/Alamy

15/15 Riccardo Lombardo/CuboImages srl/Alamy

15/16 Erich Lessing/Art Resource

15/17 The Bridgeman Art Library

15/18 Peter Willi/The Bridgeman Art Library

15/19 Erich Lessing/Art Resource

15/20 Scala/Art Resource, Inc.

15/21 Metropolitan Museum Of Art

15/22 The Bridgeman Art Library

15/23 Joerg. P. Anders/Art Resource, Inc.

15/24 Rijksmuseum, Amsterdam

15/25 Scala/Art Resource, Inc.

15/26 bpk, Berlin/ Art Resource, NY

15/27 © Corbis

15/28 Andrew W. Mellon Collection, 1937.1.72. Image courtesy of the Board of Trustees, National Gallery of Art, Washington, DC.

15/29 Réunion des Musées Nationaux/Art Resource, Inc.

15/30 Réunion des Musées Nationaux/Art Resource, Inc.

15/31 Réunion des Musées Nationaux/Art Resource, Inc.

15/32 Réunion des Musées Nationaux/Art Resource, Inc.

15/33 Réunion des Musées Nationaux/Art Resource, Inc.

15/34 © Wallace Collection, London, UK/The Bridgeman Art Library

15/35 Giraudon/The Bridgeman Art Library

CHAPTER SIXTEEN

16/1 Angelo Hornak/Corbis

16/2 © Dulwich Picture Gallery, London, UK /The Bridgeman Art Library

16/3 Francis G. Mayer/Fine Art/Corbis

16/4 Photo: Katherine Wetzel © Virginia Museum of Fine Arts

16/5 Réunion des Musées Nationaux/Art Resource, Inc.

16/6 Scala / Art Resource, NY

16/7 Erich Lessing/Art Resource, Inc.

16/8 Art Kowalsky/Alamy

16/9 Erich Lessing / Art Resource, NY

16/10 British Museum/Art Resource, Inc.

16/11 Erich Lessing / Art Resource, NY

16/12 Friedrich, Caspar David (1774–1840), Der Wanderer über dem Nebelmeer, ca. 1817. Oil on canvas. Bildarchiv Preussischer Kulturbesitz / Art Resource, NY

16/13 Barney Burstein/Fine Art/Corbis

16/14 The Philadelphia Museum of Art / Art Resource, NY

16/15 Erich Lessing / Art Resource, NY

16/16 Réunion des Musées Nationaux/Art Resource, NY

16/17 The Metropolitan Museum of Art/Art Resource, Inc.

16/18 Pierre Barbier/Roger Viollet/The Image Works

16/19 Geoffrey Clements/Fine Art/Corbis

16/20 Private Collection/The Bridgeman Art Library

16/21 Roger Antrobus/Alamy

16/22 Canabi Hugo/Iconotec/Alamy

16/23 Réunion des Musées Nationaux / Art Resource, NY

16/24 Metropolitan Museum of Art, New York. Gift in memory of Jonathan Sturges by his children, 1895 (95.13.3). Photograph © 2001 The Metropolitan Museum of Art

16/25 Bridgeman Art Library,London/SuperStock

16/26 The British Museum

16/27 Erich Lessing/Art Resource ,Inc.

16/28 Image copyright © The Metropolitan Museum of Art / Art Resource, NY

16/29 Adoc photos/Art Resource, Inc.

16/30 Erich Lessing/Art Resource ,Inc.

16/31 © Walters Art Museum, Baltimore, USA / The Bridgeman Art Library

CHAPTER SEVENTEEN

17/1 Los Angeles County Museum of Art, CA, USA / Giraudon / The Bridgeman Art Library

17/2 Erich Lessing/Art Resource, NY

17/3 © Dahesh Museum of Art, New York, USA / The Bridgeman Art Library

17/4 Erich Lessing/Art Resource, NY

17/5 Image copyright © The Metropolitan Museum of Art. Image source: Art Resource, NY

17/6 Image copyright © The Metropolitan Museum of Art. Image source: Art Resource, NY

17/7 Image copyright © The Metropolitan Museum of Art. Image source: Art Resource, NY

17/8 © Réunion des Musées Nationaux/Art Resource, NY

17/9 The Art Institute of Chicago, Gift of Arthur M. Wood in memory of Pauline Palmer Wood, 1985.1103. Photography © The Art Institute of Chicago.

17/10 Image copyright © The Metropolitan Museum of Art. Image source: Art Resource, NY

17/11 Claude Monet/Burstein Collection/Corbis

17/12 Réunion des Musées Nationaux / Art Resource, NY

17/13 © Francis G. Mayer/Corbis

17/14 Erich Lessing / Art Resource, NY

17/15 Image copyright © The Metropolitan Museum of Art. Image source: Art Resource, NY

17/16 Erich Lessing / Art Resource, NY

17/17 National Gallery of Art, Washington DC, USA / Index / The Bridgeman Art Library

17/18 © Erich Lessing/Art Resource, NY

17/19 Courtesy of the author.

17/20 Musee Rodin, Paris, France / Philippe Galard / The Bridgeman Art Library

17/21 © SuperStock/SuperStock

17/22 Erich Lessing/Art Resource, NY

17/23 Erich Lessing/Art Resource, NY

17/24 Albright Knox Art Gallery, Buffalo, New York, USA / The Bridgeman Art Library

17/25 Photo Credit : Art Resource, NY

17/26 © Mary Evans Picture Library/The Image Works

17/27 Réunion des Musées Nationaux / Art Resource, NY

17/28 Yale University Art Gallery / Art Resource, NY

17/29 © Erich Lessing/Art Resource, NY

17/30 The Museum of Modern Art/Licensed by SCALA / Art Resource, NY

17/31 Digital Image © The Museum of Modern Art/Licensed by SCALA/Art Resource, NY

17/32 Collection of Mr. and Mrs. Paul Mellon, in Honor of the 50th Anniversary of the National Gallery of Art. 1995.47.5. Image courtesy of the Board of Trustees, National Gallery of Art, Washington, DC.

CHAPTER EIGHTEEN

18/1 © JLImages / Alamy

18/2 Erich Lessing / Art Resource, NY. © 2012 Artists Rights Society (ARS), New York / VBK, Vienna

18/3 Digital Image © The Museum of Modern Art/Licensed by SCALA/Art Resource, NY. © 2012 The Munch Museum/The Munch-Ellingsen Group/Artists Rights Society (ARS), New York.

18/4 Statens Museum for Kunst, Copenhagen. © Nolde Stiftung Seebüll

18/5 Digital Image © The Museum of Modern Art/Licensed by SCALA / Art Resource, NY. © 2012 Artists Rights Society (ARS), New York / ADAGP, Paris

18/6 Digital Image © Archives Matisse, France. © 2012 Succession H. Matisse, Paris/Artists Rights Society (ARS), New York.

18/7 Photography By: Mitro Hood. The Baltimore Museum of Art: The Cone Collection, formed by Dr. Claribel Cone and Miss Etta Cone of Baltimore, Maryland, BMA 1950.261 © 2012 Succession H. Matisse / Artists Rights Society (ARS), New York

18/8 Helen Birth Bartlett Memorial Collection. 1926.253. Photography © The Art Institute of Chicago. © 2012 Estate of Pablo Picasso / Artists Rights Society (ARS), New York

18/9 The Brooklyn Museum New York Frank L. Babbott Fund

18/10 Photography © The Art Institute of Chicago.

18/11 The Museum of Modern Art/Scala/Art Resource, NY © 2012 Estate of Pablo Picasso / Artists Rights Society (ARS), New York

18/12 Réunion des Musées Nationaux / Art Resource, NY. © 2012 Estate of Pablo Picasso / Artists Rights Society (ARS), New York

18/13 Digital Image © The Museum of Modern Art/Licensed by SCALA / Art Resource, NY. © 2012 Estate of Pablo Picasso / Artists Rights Society (ARS), New York

18/14 Digital Image © The Museum of Modern Art/Licensed by SCALA / Art Resource, NY. © 2012 Estate of Pablo Picasso / Artists Rights Society (ARS), New York

18/15 Art Resource, NY/ © 2012 Estate of Pablo Picasso / Artists Rights Society (ARS), New York

18/16 Image copyright © The Metropolitan Museum of Art. Image source: Art Resource, NY/ © 2012 Estate of Pablo Picasso / Artists Rights Society (ARS), New York

18/17 © 2012 Artists Rights Society (ARS), NY/ADAGP, Paris. © Philadelphia Museum of Art/Corbis, 1950-134-14, 15.

18/18 Digital Image © The Museum of Modern Art/Licensed by SCALA / Art Resource, NY

18/19 The Museum of Modern Art/Licensed by SCALA/Art Resource, NY

18/20 Purchased with assistance from the Friends of the Tate Gallery 1999. Photo © Tate, London/Art Resource, NY. © 2012 Artists Rights Society (ARS), New York / ADAGP, Paris / Succession Marcel Duchamp

18/21 © The Philadelphia Museum of Art. The Louise and Walter Arensberg Collection, 1950/Art Resource, NY. Art © 2012 Artists Rights Society (ARS), New York/ ADAGP, Paris/Succession Marcel Duchamp

18/22 Digital Image © The Museum of Modern Art/Licensed by SCALA / Art Resource, NY

18/23 © 2012 Man Ray Trust / Artists Rights Society (ARS), NY / ADAGP, Paris. Digital Image © The Museum of Modern Art/Licensed by SCALA / Art Resource, NY

18/24 © SuperStock/SuperStock © Ingeborg & Dr. Wolfgang Henze-Ketterer, Wichtrach/Bern

18/25 © Bildarchiv Preussischer Kulturbesitz (Joerg P. Anders)/ Art Resource, NY. © 2012 Artists Rights Society (ARS), New York/VG Bild-Kunst, Bonn.

18/26 Fine Arts Museums of San Francisco, Achenbach Foundation for Graphic Arts, #1963.30.874. © 2012 Artists Rights Society (ARS), New York/VG Bild-Kunst, Bonn.

18/27 The Bridgeman Art Library. © 2012 Artists Rights Society (ARS), New York / SIAE, Rome

18/28 Digital Image © The Museum of Modern Art/Licensed by SCALA / Art Resource, NY © 2012 Artists Rights Society (ARS), New York/ProLitteris, Zurich.

18/29 © 2012 Salvador Dali, Gala-Salvador Dali Foundation/ Artists Rights Society (ARS), NY. Digital Image © The Museum of Modern Art/Licensed by Scala/Art Resource, NY, 162.1934.

18/30 © Francis G. Mayer/Corbis © Salvador Dalí, Fundació Gala-Salvador Dalí, Artists Rights Society (ARS), New York 2012

18/31 © Francis G. Mayer/Corbis © Salvador Dalí, Fundació Gala-Salvador Dalí, Artists Rights Society (ARS), New York 2012

18/32 Banque d'Images, ADAGP / Art Resource, NY © 2012 C. Herscovici, London / Artists Rights Society (ARS), New York

18/33 Banque d'Images, ADAGP / Art Resource, NY © 2012 C. Herscovici, London / Artists Rights Society (ARS), New York

CHAPTER NINETEEN

19/1 The Solomon R. Guggenheim Museum, New York. Solomon R. Guggenheim Founding Collection, Gift 41.505. © 20012 Artists Rights Society (ARS), New York/ADAGP, Paris.

19/2 © The Museum of Modern Art/Licensed by SCALA / Art Resource, NY. © 2012 Artists Rights Society (ARS), New York / ADAGP, Paris

19/3 Solomon R. Guggenheim Museum, New York. Solomon R. Guggenheim Founding Collection, Gift, Solomon R. Guggenheim. 45.989. © 2012 Artists Rights Society (ARS), New York/ADAGP, Paris.

19/4 Digital Image © The Museum of Modern Art/Licensed by SCALA / Art Resource, NY

19/5 Snark / Art Resource, NY/ © 2012 Artists Rights Society (ARS), New York

19/6 © VIEW Pictures Ltd (Nathan Willock)/ Alamy. © 2012 Artists Rights Society (ARS), New York

19/7 Jonathan Poore/ © 2014 Cengage Learning. All Rights Reserved.

19/8 Jonathan Poore/ © 2014 Cengage Learning. All Rights Reserved.

19/9 Jonathan Poore/ © 2014 Cengage Learning. All Rights Reserved.

19/10 © Paolo Koch/Photo Researchers, Inc. © 2012 Frank Lloyd Wright Foundation, Scottsdale, AZ/Artists Rights Society (ARS), New York.

19/11 Fisk University Galleries, Nashville, Tennessee. © 2012 Georgia O'Keeffe Museum/Artists Rights Society (ARS), New York.

19/12 Digital Image © The Museum of Modern Art/Licensed by SCALA/Art Resource, NY. © 2012 Georgia O'Keeffe Museum/Artists Rights Society (ARS), New York.

19/13 © 1978 The Imogen Cunningham Trust

19/14 Collection, Center for Creative Photography, University of Arizona, Tucson. © 1981 Arizona Board of Regents

19/15 © The Granger Collection, New York

19/16 © The Museum of Modern Art/Licensed by SCALA / Art Resource, NY. © 2012 The Willem de Kooning Foundation / Artists Rights Society (ARS), New York

19/17 Private Collection / The Bridgeman Art Library. © 2012 The Willem de Kooning Foundation / Artists Rights Society (ARS), New York

19/18 © 1991 Hans Namuth Estate, Courtesy, Center for Creative Photography, The University of Arizona, Tucson.

19/19 National Gallery of Art, Washington DC, USA / The Bridgeman Art Library /© 2012 The Pollock-Krasner Foundation / Artists Rights Society (ARS), New York

19/20 National Gallery of Art, Washington DC, USA / The Bridgeman Art Library /© 2012 The Pollock-Krasner Foundation / Artists Rights Society (ARS), New York

19/21 Art Resource/Gift of The Mark Rothko Foundation, Inc. © Kate Rothko Prizel & Christopher Rothko / Artists Rights Society (ARS), New York

19/22 The Art Institute of Chicago

19/23 SuperStock, Inc./SuperStock. © 2012 Estate of Helen Frankenthaler / Artists Rights Society (ARS), New York

19/24 © Panoramic Images/ Getty Inc. © 2012 Calder Foundation, New York/Artists Rights Society (ARS), New York.

19/25 Hirshhorn Museum and Sculpture Garden Washington D.C.

19/26 © Bill Maris/Arcaid/Corbis

19/27 © 2012 Artists Rights Society (ARS), New York / ADAGP, Paris / F.L.C./Photo by Jonathan Poore/ © 2014 Cengage Learning. All Rights Reserved.

19/28 © 2012 Artists Rights Society (ARS), New York / ADAGP, Paris / F.L.C. Photo: © Francis G. Mayer/Corbis

19/29 Digital Image © The Museum of Modern Art/Licensed by SCALA/Art Resource, NY. Art © Estate of Robert Rauschenberg/Licensed by VAGA, New York, NY

19/30 Digital Image © The Museum of Modern Art/Licensed by SCALA/Art Resource, NY. Art © Jasper Johns/ Licensed by VAGA, New York, NY

CHAPTER TWENTY

20/1 Digital Image © The Museum of Modern Art/Licensed by SCALA/Art Resource, NY. Art © 2012 The Andy Warhol Foundation for the Visual Arts, Inc. / Artists Rights Society (ARS), New York

20/2 Whitney Museum of American Art, New York. 50th Anniversary Gift of Mr. and Mrs. Victor W. Ganz 79.83a-b. Photograph by Jerry L. Thompson. Courtesy Oldenburg van Bruggen Foundation.

20/3 © DeAgostini / SuperStock

20/4 © Don DiBernardo/ Artifice Images

20/5 Art © Judd Foundation/Licensed by VAGA, NY Hirshhorn Museum and Sculpture Garden, Smithsonian Institution, photo Lee Stalsworth, 72.154

20/6 The Nelson-Atkins Museum of Art, Kansas City, Missouri . Gift of the Friends of Art, F75-13. Photograph by Jamison Miller.

20/7 Milwaukee Art Museum, Gift of Friends of Art, M1973.91. Photo by Ephraim Le-ver. Art © Duane Hanson/ Licensed by VAGA, New York, NY

20/8 Courtesy of SITE, New York

20/9 Photo by David Lees/Time & Life Pictures/Getty Images

20/10 © Idealink Photography / Alamy

20/11 Photo: Wolfgang Volz. COPYRIGHT © CHRISTO 1976.

20/12 Photo: John Cliett. © DIA Art Foundation

20/13 © Donald Woodman. © 2012 Judy Chicago/Artists Rights Society (ARS), New York.

20/14 © James Luciana. © 2012 Judy Chicago/Artists Rights Society (ARS), New York.

20/15 © Chris Burden. Courtesy Gagosian Gallery

20/16 © Whitney Museum of Art/epa/Corbis

20/17 Copyright © Guerrilla Girls. Courtesy www.guerrillagirls.com.

20/18 Copyright © Guerrilla Girls. Courtesy www.guerrillagirls.com.

20/19 Courtesy of James Luna, Luiseno Tribe

20/20 Collection Van Abbemuseum, Eindhoven, Netherlands. Photograph: Peter Cox, Eindhoven, The Netherlands. Copyright © Anselm Kiefer.

20/21 Collection of the Artist, courtesy Cheim & Read, New York. Photo © by Peter Moore. Art © Louise Bourgeois/ Licensed by VAGA, New York, NY

20/22 Courtesy of Acquavella Galleries, Inc. and the artist.

20/23 © Dave Jepson/ Alamy

20/24 © Art on File/ Corbis

20/25 Photo by Iwan Baan. Vanity Fair August 2010

20/26 © The Philadelphia Museum of Art /Art Resource, NY. © Estate of Richard Diebenkorn

20/27 Collection SFMOMA Fractional gift of Dominique Levy and purchase through the Accessions Committee Fund with the additional support of Gay-Lynn and Robert Blanding, Jean and James E. Douglas, Jr., Ann and Robert S. Fisher, and Pat and Bill Wilson © Julie Mehretu

20/28 Courtesy of Peres Projects, Los Angeles and John Connelly Presents, New York

20/29 Photo courtesy of the author/MassMOCA, North Adams.

20/30 Damián Ortega/The Museum of Contemporary Art, Los Angeles

20/31 © Petah Coyne. Courtesy Galerie LeLong

20/32 Smithsonian American Art Museum, Washington, DC / Art Resource, NY/Nam June Paik Studios, Inc.

20/33 © 2002 Matthew Barney. Photo: Chris Winget. Courtesy Gladstone Gallery

20/34 Whitney Museum of American Art, New York. Partial and promised gift of Jeanne L. and Michael L. Klein 2005.86. Courtesy Eve Sussman & The Rufus Corporation.

20/35 Courtesy of the artist and Team Gallery, New York

20/36 Photographed by Prudence Cuming Associates © Damien Hirst and Science Ltd. All rights reserved. © 2012 Damien Hirst and Science Ltd. All rights reserved / DACS, London / ARS, NY

20/37 © Loop Images / SuperStock

20/38 © Peter Horree / Alamy

20/39 Image courtesy of Sikkema Jenkins & Co.

20/40 Yinka Shonibare/Tate Gallery, London

20/41 Image copyright © The Metropolitan Museum of Art. Image source: Art Resource, NY

20/42 Courtesy of the author. © 2012 Artists Rights Society (ARS), New York/ADAGP, Paris

20/43 Courtesy teamLab.com

INDEX

NOTE: Page references in *italics* indicate artwork, illustration, or photos.

A

Abakanowicz, Magdalena, 203, *203*
Abduction of Rebecca, The (Delacroix), *356,* 356–357
Abstract art
 Abstract Expressionism, 36, 435–441
 Hitler and, 434–435
 O'Keeffe, 431–423
 photographic art, 433–435
 time line, 422–423
Abstraction Blue (O'Keeffe), 432, *432*
abstract shapes, 37
Achilles and Ajax Playing a Dice Game (Exekias), 194, *195*
Acropolis, *175,* 175–176, 219
Acropolis Museum, 230–231, *231*
acrylic painting, 91–92, 135
Action Photo 1 (Muniz), 95, *95*
Adam and Eve Reproached by the Lord, 264, *264*
Adams, Ansel, 17–18, *18*
additive sculptural methods, 158
adobe, 176
Aesthetic Movement, 200–201
African art
 Early Twentieth Century, 402
 mixed media, 94–95
 power of art for tribal peoples and, 9
 wood carving, 160
After the Bath (Degas), *379,* 379–381
Age of Reason (Enlightenment), 344–345
airbrush device, 92
Akhenaton, 221
Alba Madonna, The (Raphael), *88,* 88–89
Aldus, 139
Alexander the Great, 234
alla prima, 331
allegory, 344
Always Finding Another Cage (Romero), 110, *111*
American Studio Craft Movement, 201–204
Amida Buddha (Jocho), 6, *6*
Amiens Cathedral (De Lazarches, De Cormont, De Cormont), 48, *48,* 179, *179*
amphora, 194
analogous colors, 45
Analytical Cubism, 404
anatomy, birth of modern drawings, 283–284
ancient empires, 216–245. *see also individual names of civilizations*
 China, 223–224
 Egypt, 219, 220–223
 first civilizations, 218
 Greece, 224–236
 India, 228
 preservation and, 219
 Rome, 236–245
 time line, 216–217
Ancient Ruins in the Cañon de Chelle (O'Sullivan), 115, *115*
Anderson, Laurie, 153, *153*
Andre, Carl, 452
Angkor Wat (Cambodia), 174, *174*
Angles, 252–254
animation, 135–137
Annunciation and the Nativity, The (Nicola Pisano), *271*
Anthemius of Tralles and Isidorus of Miletus, Hagia Sophia, *259,* 260
Anthropomorphic Chest of Drawers, The (Schiaparelli), 210
aperture, 114
Aphrodite of Melos, 234, *234*
Apocalypse (Dürer), 300
Apollo and Daphne (Bernini), 150, *151,* 163, *163*
Apollodorus, *239,* 239–241
Apollonius, 236
Apparition of Face and Fruit-Dish on a Beach (Dalí), 419–420, *420*
Apple
 Macintosh, 137, *137,* 139
 Pixar and, 142
applied arts, 21
appliqué, 200
appropriate imagery, 108
aquatints, 104
arbitrary colors, 50
arcades, 171
Arcangel, Cory, 475–476, *476*
architecture, 168–191. *see also* Baroque; faith; Rococo
 architects, 168–170
 art of, 168–176
 contemporary approaches to, 189–191
 Contemporary Art and breaking down barriers, 454–456
 Early Renaissance, 277–280
 industrial design and, 208
 interior design and, 210–213
 materials and methods, 176–185
 Nonrepresentational art and, 429–430, 441–442
 Pop architecture, 450–451
 Postmodern architecture, 468–470
 as product of its time, 185–189
 Renaissance, 294–295
 Roman, 238–239 (*see also* ancient empires)
 urban planning and, 189
 "Wonders of the World," 173–176
Arch of Constantine, 178, *178,* 244, 244–245
Ardabil Carpet, The, 199, *199*
Arneson, Robert, 202, *202*
Arrival of Marie de' Medici at Marseilles, The (Rubens), 327–328, *328*
art, defined, 21
Art and Technology (Los Angeles County Museum of Art), 136

art appreciation, 2–33
 art as power, 19–20, 32–33
 controversy and, 16–17
 defining art, 21–32
 faith and, 7–11
 generally, 2–4
 ideals represented by art, 11–19
 methods and materials, 5
 "seeing" art, 4–7
 theft and, 3
 understanding art, 28–29
art criticism, 380–381
art history, generally, 30–32
Artifact Piece, The (Luna), 466, *466*
artificial intelligence, 146
Artist and Her Daughter, The (Vigée-Lebrun), 339–341, *341*
Artist in His Studio, The (Rembrandt), *34*
artists. *see also individual names of artists*
 historical context and, 5
 memory of, 20
 power of art and, 29–30
Art Nouveau, 211
Ashmolean Codex, 283
assemblages, 404
Assume Vivid Astro Focus 8 (Assume Vivid Astro Focus), *471,* 471–472
Assyrian relief sculpture, 149–150
asymmetrical balance, 56
asymmetry, 55–56
Athena (Debevec), *227*
Atlan (Turrell), 41, *41*
Atlas Slave (Michelangelo), 163, *163*
At Last a Thousand! (Wayne, Funk), 102, *102*
atmospheric perspective, 67–68
Aton (Sun God), 221
A Train, The (Di Suvero), 441, *441*
At the Moulin Rouge (Toulouse-Lautrec), 384, *384*
Augustus of Prima Porta, 235–237, *237*
Augustus of Prima Porta (recreation), 47, *47*
Autumn (Tiffany), *197,* 198
avant-garde, 396
Aztec Calendar, 257

B

Backs in a Landscape (Abakanowicz), 203, *203*
Bakasura Disgorges Krishna, 91, *91*
balance, 54–55
Balla, Giacomo, 130, *130*
Bamboo in the Wind (Chen), 80, *81*
Banksy, 477–479, *478*
Bantjes, Marian, 207, *207*
Barney, Matthew, 475, *475*
Baroque
 Counter-Reformation and Tintoretto, 311–312
 defined, 311
 in France, 335–338
 generally, 313–322
 in Mexico, Central and South America, 323–324
 naturalism in Spain, 322–326
 in northern Europe, 326–335
 time line, 308–309
barrel vaults, 178, *178,* 267
Battle of Romans and Barbarians, Ludovisi Battle Sarcophagus, 244, *244*
Bauhaus, 208–210, *428,* 428–429
Bay, The (Frankenthaler), 91–92, *92*
Bearden, Romare, 94, *94*
bearing wall method, 176
Beat the White with the Red Wedges (El Lissitzky), 426–427, *427*
beauty, art as, 27–28
Bed (Rauschenberg), *444,* 445
Bedside Guide to the History of Western Art (Guerrilla Girls), 465
Beer Street and Gin Lane (Hogarth), 100, *101*
Behind the Gare Saint-Lazare (Cartier-Bresson), *116,* 116–117
Ben-Day dot pattern, 449–450
Berlinghieri, Bonaventura, *272,* 273, *273*
Bernini, Gianlorenzo, 150, *151,* 163, *163,* 185–187, *186, 187, 319,* 319–322, *320, 321, 322*
Bertelli, Renato, *13,* 13–14
Best Products Indeterminate Façade Showroom (SITE), 454, *454*
Between Earth and Heaven (El Anatsui), 481, *482*
Beuys, Joseph, *152,* 152–153, 466
Bible Quilt (Powers), 200, *200*
Bichitr, 14, *14*
bilateral symmetry, 55
binders, 77, 84
Bingham, George Caleb, 68, *68*
biomorphic shapes, 37
Bird in Space (Brancusi), 408–409, *409*
Bird's Nest Stadium (Herzog, De Meuron), 470, *470*
Birth of Venus, The (Botticelli), 282, *282*
bit.fall (Popp), 146–147, *147*
Blind Man's Buff (Bourgeois), 39, *40*
Blue Boy, The (Gainsborough), 345
Blue Crown (Littleton), 202, *202*
Blue Mountain (Kandinsky), *424,* 425–426
Blur Building (Diller, Scofidio), *190,* 190–191
Boating (Manet), *374*
Boating Party, The (Cassatt), 379–382, *381*
Boccioni, Umberto, 409–410
Bonaparte Crossing the Great Saint Bernard Pass (David), 348, *349*
Bonhear, Rosa, 364–365
Book of Lindisfarne, 254–255, *255*
Borghese, Paulina (Princess), 348, *349*
Borghese, Scipione (Cardinal), 315
Borobudur (Indonesia), 173, *173,* 228
Bosch, Hieronymus, *304,* 304–305, *305*
Botticelli, Sandro, 281–281, *282*
Bourgeois, Louise, 39, *40,* 467, *467*

bourgeoisie, 372
Boy in a Red Waistcoat (Cézanne), 393, *393*
Boy Playing Flute (Hokusai), 36, *36*
Boy who loves water (Taylor), *138,* 138–139
Brahma, 262–263
Bramante, Donato, 56, *56,* 185–187, *186*
Brancusi, Constantin, 148, *148,* 408–409, *409*
Brandt, Marianne, 210, *210*
Braque, Georges, 70, *71*
Bread! (Kollwitz), 416–417, *417*
Breuer, Marcel, 208, *208*
brick architecture, 176–177
Bridge over a Pool of Water Lilies (Monet), 377, *377*
bronze sculpture, lost was method and, 158–159
Bruegel, Pieter, the Elder, *306*
Brunelleschi, Filippo, 68–69, *277,* 277–278, *278,* 281
brush and ink drawing, 80
Buddhism
 ancient art and, 228–229
 architecture, 173–174
 art appreciation and, 6–7
 design, 62, *62*
 faith and art, 249, 260–262
 sculpture, 160–161
buildings. *see* architecture
Buñuel, Luis, 130–131, *131*
Burden, Chris, *461,* 463
Burgundy, Duke of (Philip the Bold), 297–299
Burgundy, Duke of (Philip the Good), 299
Burial at Ornans (Courbet), 363, *363*
Burial of Pierrot, The (Matisse), 53, *53*
Burning of the Houses of Parliament (Turner), 354, *354*
Butterfly, Kathy, 204, *204*
Byzantine art, 250–252

C

Cabinet (Pabst), 201, *201*
Caesar, Julius, 236
cage construction, 182, *182*
Calder, Alexander, 36, *36, 150, 151,* 440–441, *441*
California Artist (Arneson), 202, *202*
cameras
 camera body, 114
 camera obscura, 112, *112*
 film, *114,* 114–115
 for still photography, 114–115 (*see also* photography)
 used by digital artists, 138 (*see also* new media)
Camera Work, 118
Cameron, Julia Margaret, 114, *114*
Canova, Antonio, 348–350, *349*
Cans Buffer (Banksy), 478, *478*
cantilevered construction, 184–185
capitals, 176
Cappella, A (Dougherty), 167, *167*
Caravaggio, 40, *40,* 40–41

Caravaggisti, 316
Cardplaying War-Cripples (Dix), 416, *416*
carpets, 199–200
Cartier-Bresson, Henri, *116,* 116–117
Cassatt, Mary, 104, *104,* 379–382, *381*
casting, 158–159
Castle, Wendell, 203, *203*
Cathedral of Transfiguration, 180, *180*
Catholicism. *see* Christianity
Cave, Nick, *23,* 23–24
Cedre de Versailles (Penone), 482, *482*
celestial deities, Jagadambi Temple, *263*
Central America, faith and art of Mesoamerica, 256–257
Central Savings (Estes), 452, *453*
ceramics, 193–194, 196–197, 204
Ceremony in Dogon village of Tiogoï Republic, 9, *9*
Cézanne, Paul, *392,* 392–393, *393*
Chagall, Marc, 20, *20*
chalk drawing, 76–78
Chapel of the Rosary, Church of Santo Domingo de Guzman,
 324, *324*
charcoal drawing, 76
Charles V (Holy Roman Emperor), 301
Chartres Cathedral, *266,* 267, *267,* 269
Chen, Wu, 80, *81*
Chest of Tutankhamen with Hunting and War Scenes, 60, *61*
chiaroscuro, 40–41, 318
Chicago, Judy, 460
Chien Andalou, Un (Buñuel, Dalí), 130–131, *131*
Chihuly, Dale, 205, *205*
Chinese art
 brush and ink drawing, 80
 decorative arts, 196
chisel, 163
Christ as the Good Shepherd, 250
Christianity. *see also* Baroque; Renaissance; Rococo
 architecture, 187–189
 faith and art, early Christian and Byzantine art, 250–252
 faith and art, in early Middle Ages, 252–255
 faith and art, in Middle Ages, 264–273
 power of religious art and, 11, 249
 Protestant Reformation, 96, 300–302
Christina's World (Wyeth), 87, *88*
Christo, *457,* 457–460
Christ with the Sick around Him, Receiving the Children
 (Rembrandt), 103, *103*
Church, Frederick Edwin, *226,* 362, *362*
Churchill, Winston, 411
Church of Santo Domingo de Guzman, 324, *324*
Churrigueresque architecture, 324
circumambulation, 173
Clark, Kenneth, 3–4
Classical Age (Greece), 225–234
Classicism, 335–338
claw, 163
clay architecture, 176–177

clay craft art, 193–194
Clearing Winter Storm (Adams), 17–18, *18*
Closet, No. 7 (Scharf), 154, *154*
Club Chair B3 (Breuer), 208, *208*
Coca Cola, 25, *25*
coherence, 58
Cole, Thomas, *361*, 361–362
collage, 92, 404, 440
Collection of Fossils and Shells (Daguerre), 113, *113*
Collection of Gérard Lévy (Bonheur), *365*, *365*
colonial style architecture, 187–188
colonnade, 186–187, 227
color
 color wheel, 45, *45*
 as element of art, 43–51
 harmony and, 59
Color-Field Painting, 438
Colossal Buddha, 62, *62*
Colossal Head, Olmec, 148, *148*
Colosseum, *238*, 238–239
Column of Trajan (Apollodorus), *239*, 239–241, *240*
combines, 445
commercial art, 25
Comparative Morphologies LIII (Syjuco), 139, *139*
complementary colors, 45
computer-aided design (CAD), 169–170
computer animation. *see* digital media
Comtesse d'Haussonville (Ingres), *357*, 357–358
Constable, John, 50, *51*
Constantine the Great, 248
Conté crayons, 78
Contemporary Art, 446–483
 architecture and breaking down barriers, 454–456
 art world as global, 479–483
 contemporary installations and sculpture, 471–474
 contemporary nonrepresentation, 470–471
 Earth Art, 458–459
 environmental works by Christo, 457–459
 generally, 446–447
 Hirst and Bansky, 477–479
 Judy Chicago, 460
 Minimalism, 451–452
 Mud Angels (Lee), 455–456
 new electronic media, 474–476
 performance art, 461–466
 Pop architecture, 450–451
 Pop Art, 448–450
 Postmodern architecture, 468–470
 Postmodern Art, 466–468
 Superrealism, 452–453
 time line, 446–447
contemporary city plan (Le Corbusier), 189, *189*
contour lines, 36
Conversion of Saint Paul, The (Caravaggio), *315*, 315–316
Conway, Don, *142*
cool colors, 45

copyright issues, digital media and, 143
Corinthian columns, *176*, 239
Cornelia Pointing to Her Children as Her Treasures (Kauffman), 346, *346*
Corner Plot (Sze), 154, *155*
Cortés, Hernán, 301–302
Cosmic Thing (Ortega), 472–473, *473*
Counter-Reformation, 311–312
Courbet, Gustave, 29–30, *30*, 363, *363*, 365, *371*, 371–372
Court of Gayumars, The (Muhammad), *66*, 67
Court of the Lions, *171*, 171–172
couturier, 209
Coyne, Petah, 473–474, *474*
Crack House (House Industries), 140, *140*
craft art
 ceramics, 193–194
 fiber arts, 198–200, 206
 generally, 22–24
 glass, 195–198, 202, 204–205
 metalwork, 198, 206
 wood, 200–201
crayon drawing, 78
Creation of Adam, The (Michelangelo Buonarroti), *292*
creativity, art as, 28
Cremaster 3 (Barney), 475, *475*
cross-hatching, 78–79
Crossing, The (Viola), 131–132, *132*
Cruz, Andy, 140
Cubism
 Analytical Cubism, 404
 defined, 404
 generally, 69–71, 401–408
 Synthetic Cubism, 405
Cubi XII (Smith), 164, *164*
Cunningham, Imogen, 433, *433*
Cut with the Kitchen Knife (Höch), 119, *120*
Cycladic idol, 55, *55*

D

Dacians, 240
Dada, 411–414
Daguerre, Louis-Jacques-Mandé, 113, *113*
daguerreotype, 113
Dalí, Salvador, 130–131, *131*, 209, *209*, 418–420, *419*
Daumier, Honoré, 362–363, *363*
David, Jacques-Louis, 346–348, *347*, *348*
David (Bernini), *319*, 319–320
David (Donatello), *279*, 279–280
David (Michelangelo Buonarroti), *288*
David with the Head of Goliath (Caravaggio), *40*, 40–41, 316
Da Vinci, Leonardo, *2*, 2–5, *4*, *5*, 60, *60*, 282–287, *283*, *285*, *291*, 291–292
Dead Christ, The (Mantegna), *280*, 281
Death of Caesar (Gérôme), 366–367, *367*

Death of Marat (David), 347–348, *348*

Debevec, Paul, *227*

De Chirico, Giorgio, 417, *417*

decorative art, 192–215. *see also* design

American Studio Craft Movement, 201–204

contemporary approaches in crafts, 204–206

craft media, 193–201

defined, 192

design and, 206–215

generally, 22–24, 192–193

De Cormont, Renaud, 48, *48*, 179, *179*

De Cormont, Thomas, 48, *48*, 179, *179*

deductive reasoning, 284

Degas, Edgar, 109, *109, 379*, 379–382

Degenerate Art show (1938), *434*, 434–435

De Guzmán, Domingo, 324

Déjeuner sur l'herbe, Le (Manet), 372–373, *373*, 374

De Kooning, Willem, *27*, 27–28, 435, *435*, 436, *436*, 438

Delacroix, Eugène, *355*, 355–357, *356, 358*

Delage automobile (Lartigue), 116, *116*

De Lazarches, Robert, 48, *48*, 179, *179*

Del Giocondo, Lisa, 4, 5

Della Porta, Giacomo, *185*, 185–187, *186*

Demand, Thomas, 124, *125*

De Maria, Walter, 458, *458*

De Meuron, Pierre, 470, *470*

Demoiselles d'Avignon, Les (Picasso), 403, *403*

Deposition from the Cross (Pontormo), *311*

depth, 66–68

Derain, André, 398–399, *399*

design, 52–71. *see also* decorative art

defined, 51, 52

designing and organizing space with depth, 66–68

emphasis and, 57–66

fashion, 209–210

generally, 206–207

graphic, 25, 207–208

industrial, 208–210

interior, 210–213

landscape, 197, 213–215

linear perspective and, 68–71

placement and, 52–56

power of art and, 24–27

desktop publishing, 139

De Stijl, 428

Destruction of the Father, The (Bourgeois), 467, *467*

Detroit Industry (Rivera), 86, *87*

developing, for photography, 113

Dezsö, Andrea, 62, *62*

Dia Art Foundation, 458

Diebenkorn, Richard, 470, *471*

digital artists, 134–137

digital media

computer-aided design (CAD), 169–170

digital animation, 141–143

digital video, 140–141

graphic and type design, 139–140

image editing, 138–139

interactive, 145–147

Internet and, 145

Japanese *anime*, 144

new electronic media, 474–476

digital painting, 95

digital studios, 137–138

digitizing tablets, 138

Diller, Elizabeth, *190, 190*–191

DiNa (Leeson), 145–146

Dinner Party, The (Chicago), 460, *461*

Discobolos, 232, *232*

Disney, Roy, 141

Disney, Walt, 141

Di Suvero, Mark, 440–441, *441*

Divan Japonais (Toulouse-Lautrec), *106*, 107

Dix, Otto, 415–416, *416*

documentary photography, 117

Dogon village (Mali), 172, *172*, 177

Dome of the Florence Cathedral (Brunelleschi), 278, *278*

Dome of the Rock, *170*, 170–171, *171*

domestic architecture, 179–180

Dominant Curve (Kandinsky), 425, *426*

Donatello, 278–280, *279*

Donovan, Tara, 58, *58*

Door to the River (De Kooning), 436, *436*

Doré, Gustave, 99, *99*

Doric columns, 239

Doryphoros, 232, *232*

Doryphoros (Polykleitos), *232*, 234

Dougherty, Patrick, 167, *167*

drawing, 72–83

brush and ink, 80

chalk and pastel, 76–78

charcoal, 76

contemporary approaches to, 81–83

crayon, 78

"drawing with scissors," 81

generally, 72–73

graphite, 73–75

pen and ink, 78–79

wash, 80

Drawing for Transient Rainbow (Guo-Qiang), 82–83, *83*

Drawing of Flowers and Diagrams (Da Vinci), 5

Dreamer, The (Picasso), *407*, 407–408

Drepung Loseling Monastery, 93, *93*

Drift Stump, Crescent Beach (Weston), 433–435

Drowning Girl (Lichtenstein), *449*, 449–450

D.S., La (Orozco), 60, *61*

Duchamp, Marcel, 15, *15, 412, 413*, 413–414

Duranty, Edmond, 380

Dürer, Albrecht, 78, *79, 97*, 97–98, 299–300, *300*, 301

Dutch Republic, Baroque period and, 329–335

Dynamism of a Dog on a Leash (Balla), 130, *130*

E

Early Twentieth Century, 394–421
 African art, 402
 Brancusi, 408–409
 Dada, 411–414
 Duchamp, 413–414
 Fauvism, 398–399
 Futurism, 409–411
 generally, 396
 German Expressionism, 397–398
 The International Exhibition of Modern Art (National Guard Armory, Manhattan, 1913), 411
 Magritte, 420–421
 Matisse, 399–400
 Munch, 396–397
 objectivity and, 415–417
 Picasso and Cubism, 401–408
 Surrealism, 417–420
 time line, 394–395
 World War I and, 411
Earth Art, 154–157, 458–459
Eastman, George, 114–115
Écho, L' (Seurat), 41, *41*
Echo of a Scream (Siquieros), *63*, 63–65, 66
Ecole des Beaux-Arts, 366
Ecstasy of Saint Theresa, The (Bernini), 320, *320*
Edison, Thomas, 130
editions, of prints, 96
Edmunds, Peter, 145, *145*
egg tempera, 86–87
Egypt, ancient empire of, 219, 220–223
Eiffel, Gustav, 181, *182*
Eiffel Tower (Eiffel), 181, *182*, 396, *396*
89 Seconds at Alcázar (Sussman), 475, *475*
El Anatsui, 481, *482*
Electronic Highway (Paik), 474, *474*
elements of art, 34–51
 color, 43–51
 form, 39–40
 light, shadow, and value, 40–41
 line, 35–36
 shape, 37–39
 space, 34–35
 texture, 41–43
Elevation of the Cross, The (Rubens), *326*, 327
elevations, 169
Elgin, Earl of (Thomas Bruce), 230
Elgin Marbles, 229, 230–231
El Greco, *313*, 313–314
Eliasson, Olafur, *45*, 45–46
El Lissitzky, 426–427, *427*
embroidery, 200
emotional resonance, color and, 50–51
emphasis, design and, 57–66

Empire des lumières, L' (Magritte), 421, *421*
encaustic painting, 84–85
England, Romanticism in, 352–353
engraving
 metal, 100–101
 wood, 99
ENIAC (University of Pennsylvania), 135
Enlightenment, 344–345
environment sculpture, 153–154
Equivalent VIII (Andre), 452
Erased de Kooning Drawing (Rauschenberg), 445
erasing, drawing and, 81
Escher, M. C., 70–71, *71*
Eskimo people, power of art for tribal people and, 10, *10*
Essaydi, Lalla, 126, *126*
Estes, Richard, 452, *453*
etching, 103
Et in Arcadia Ego (Poussin), *335*, 335–336
Eugenie (Empress of France), 365
Exekias, 194, *195*
Ex Libris page, from album Shamsa, 55, *55*
expeditionary photography, 115
Experiments in Arts and Technology (EAT), 136
Expressionism
 Abstract Expressionism, 36, 435–441
 defined, 397
 German, 397–398
 Van Gogh and, 387–392
exterior buttresses, 268
"eye-dazzler" rugs, 24, *24*

F

Factory, The, 448
faith, 246–273
 Buddhism, 249, 260–262
 early Christian and Byzantine art, 249, 250–252
 in early Middle Ages, 252–255
 Hinduism, 262–263
 Islam, 249, 255–260
 in Mesoamerica, 256–257
 in Middle Ages, 264–273
 religious images *vs.* sacrilege, 249
 time line, 247
Fallingwater (Wright), *184*, 184–185, 430–431
fashion design, 209–210
Fauves/Fauvism, 398–399
Fauvism, 398–399
Federal period, of architecture, 177
Femmes du Maroc, La (Essaydi), 126, *126*
Ferdinand, Francis (Archduke of Austro-Hungarian Empire), 411
ferroconcrete, 183–184
fertility goddesses, 233
fiber arts, 198–200, 206

figure
 defined, 52
 figure-ground ambiguity, 54–55
 figure triangle, 285
Figure of a crowned God, 198, *199*
Figure of a Warrior (Aztec), *301*
film (moving pictures), 131
fine art photography, 118–119
fine arts, 21
Fire Station #4 (Venturi), *450*, 451
Fishing Boats at Sea (Van Gogh), *35*
fixative, 76
Flag (Johns), 445, *445*
floor plans, 169, 186
Florence Cathedral, dome of (Brunelleschi), 278, *278*
flutings, 8
focal point, 57
folk art, 22
fonts, 139
Ford Foundation, 102
forged metalwork, 198
form, as element of art, 39–40
For the Love of God (Hirst), 477, *477*
found objects, 14
Fountain (Duchamp), *413*, 414
Four Books of Architecture, The (Palladio), 295
Four Horseman, The (Dürer), *97*, 97–98, 300
Fragonard, Jean-Honoré, 339, *340*, 341
frame construction, 180, *180*
France
 Baroque art, 335–338
 Impressionism, 368–370, *370*
 Renaissance art, 297–299
 Rococo art, 338–341
 Romanticism, 353–357, 358–361
Francis I (king of France), 5
Frankenthaler, Helen, 91–92, *92, 439,* 439–440
freestanding sculpture, 149, 150
French, Daniel Chester, 54, *54*
French Royal Academy of Painting and Sculpture, 366
fresco painting, 86
Freud, Lucian, 468, *468*
Friedrich, Caspar David, 46, *46,* 352, *352*
Fuller, Buckminster, *39,* 39–40
Funerary portrait of a Roman couple, *237*
Funk, Joe, 102, *102*
Furness, Frank, 200–201
Futurism, 14, 409–411

G

Gainsborough, Thomas, 345
Galla Placidia (Empress), tomb of, 250, *250*
Galloping Horses (Muybridge), *129,* 129–130
Gamble House (Greene Brothers), 180–181, *181,* 211, *211*

games, video, 147, 153, 475–476
garage fonts, 140
Garden of Earthly Delights, The (Bosch), *304,* 304–305, *305*
Garden of Love (Rubens), 328, *328,* 329
Gardenscape, Villa of Prima Porta, *242*
Gardens for UNESCO (Noguchi), 214, *215*
gardens (generally)
 architecture and, 189
 landscape design and, 197, 213–215
Gardens of Versailles, *213,* 213–214, *214*
Gates of Hell, The (Rodin), *382,* 382–383
Gauguin, Paul, *386,* 386–387, 389–390
Gehry, Frank, *168,* 168–169, *169,* 468–469, *469*
General Services Administration (GSA), 64–65
genre, Renaissance and, 305–307
Gentileschi, Artemesia, 316–317, *317,* 318–319
Gentileschi, Orazio, 316–317
Gentle Beast Hiding Among Leaves (Dezsö), 62, *62*
geometric shapes, 37
Georges Pompidou National Arts and Cultural Center (Piano, Rogers), 456, *456*
Géricault, Théodore, 353–356, *355*
Germany, Expressionism in, 397–398
Gérôme, Jean-Léon, *366,* 366–367
gestural lines, 35
Ghilberti, Lorenzo, *277,* 277–278
Ghost Clock (Castle), 203, *203*
Gift (Ray), 414, *414*
Gin Lane (Hogarth), 100, *101*
Giotto, 274–276, *276*
Giovanni Arnolfini and His Bride (Van Eyck), *298,* 299, *299*
Girl before a Mirror (Picasso), 38, *38*
Gislebertus, 265
Glaser, Milton, 208, *208*
glass
 craft art, 195–198, 202, 204–205
 glassblowing, 197–198
 glass craft art, 195–198
 glass curtain, 429
 Nonrepresentational art, 441–442
 stained glass, 195–198, 269–270
Glass House (Johnson), 442, *442*
glazes, 88–89
glazing, 194
Gleaners, The (Millet), 365, *366*
gold
 metalwork, 198
 Renaissance art and, 301–302
Golden Buckle of Sutton Hoo, 254
Golden Mean, 60
Golden Proportion, 60
Golden Wall, The (Hofmann), 439, *439*
Gold Marilyn Monroe (Warhol), 448, *448*
Gold Mine, Serra Pelada, State of Para, Brazil (Salgado), 123, *123*

Gone (Walker), 82, *82*
Gothic style, 267–270
gouache painting, 90–91
Goya, Francisco, *350,* 350–352, *351*
Grainstacks (End of Summer) (Monet), 376, *376*
Grande Odalisque (Ingres), *360*
Grande vitesse, La (Calder), 440, *441*
Grandma Moses, 22, *22*
graphic design, 25, 139–140, 207–208
Graphic User Interface (GUI), 137
graphite drawing, 73–75
grazia, 281, 400
Great deeds—against the dead! The Disasters of War (Goya),
 351, *351*
Great Mosque (Cordoba, Spain), *258,* 258–259, *259*
Great Mosque (Samarra, Iraq), *258*
Great Sphinx, The, 219, *219,* 220
Great Stupa, The, 228, 233
Great Temple of the Aztecs, 302
Great Wave, The (Hokusai), 389, *389*
Greek art
 ancient Greek empire and, 224–236
 architecture, 174–176
 art as representation of ideals, 11–19
 decorative arts, 194
 elements of art and, 47, 48
 Golden Mean, 60
 sculpture, 148–149
Greene Brothers, 180–181, *181,* 211, *211*
Grenouillère, La (Monet), *374,* 374–375, *375*
groin vaults, 178, *178*
Gropius, Walter, *428,* 428–429
ground
 defined, 52
 etching and, 103
 figure-ground ambiguity, 54–55
 painting and, 84
Grünewald, Matthias, *303,* 303–304
grunge fonts, 140
Guernica (Picasso), 406, *406,* 408
Guerrilla Girls (poster), *464,* 464–466, *465*
Guggenheim Museum (Spain) (Gehry), *168,* 168–169, *169*
Guitar (Picasso), 405, *405*
gum arabic, 90
Guo-Qiang, Cai, 82–83, *83*

H

Hadid, Zaha, *190,* 190–191
Hagia Sophia, *259,* 259–260, *260*
Hall, Donald, 150
Hall of Mirrors (Mansart), 337, *337*
Hals, Frans, 330, *330*
Han Kan, 21, *21*
Hanson, Duane, 453, *453*
hardware, for new media, 137–138

harmony
 in architecture, 170–171
 as design principle, 59
Hart, Frederick, 16, *16*
Hathor, 221
Haussmann, Baron, 370
Hawkinson, Tim, 472, *472*
Haywain, The (Constable), 50, *51*
Head of Mussolini (Bertelli), *13,* 13–14
Head of the Virgin (Van Der Weyden), *72,* 73
Heatherwick, Thomas, 191, *191*
Hellenistic Age, 234–236
Henry VIII (Holbein the Younger), 13, *13*
Henry VIII (King of England), 13, *13,* 302
Herakles and Telephos, 86, *86*
Hermes with the Infant Dionysus (Praxiteles), 12, *13*
Herzog, Jacques, 470, *470*
High Flying (Kenichi), 207, *207*
high relief, 150
High Renaissance, 284–294, 295–296
Hill with the Ruins of Montmajour (Van Gogh), 79, *80*
Hinduism
 elements of art and, 43–44
 faith and art, 262–263
 Orientalism, 359–361
 sculpture, 157
Hiroshige, Utagawa, 67, *67*
Hirst, Damien, *477,* 477–479
historical context
 placing art and artist in, 5
 prehistoric art and magical powers, 7–9
Hitler, Adolf, 406, 434–435
Höch, Hannah, 119, *120*
Hofmann, Hans, 438–439, *439*
Hogarth, William, 100, *101*
Hokusai, Katsushika, 36, *36,* 389, *389*
Holbein, Hans, the Younger, 13, *13,* 300–302, *302*
Holi Festival (Jodhpur), 44, *44*
Holt, Nancy, 156, *156*
Homage to New York (Tinguely), 152, *152*
Hoosick Falls (Grandma Moses), 22, *22*
horizon line, 69
Horse Fair, The (Bonheur), 364–365
Horta, Victor, 211, *211*
House Industries, 140, *140*
House of German Art, 434
How to Explain Pictures to a Dead Hare (Beuys), *152,* 152–153
Hudson River School, 361–362
hue, 44
humanism, 278
Hunters in the Snow (Bruegel the Elder), 306–307, *307*

I

I and the Village (Chagall), 20, *20*
Ichinyû, Raku, 196, *196*

iconoclasm, 302
ideals, art as representation of, 11–19
I (Heart) NY More Than Ever (Glaser), 208, *208*
Iktinos, *175,* 175–176, *176,* 219, 226, *227,* 229, *229,* 230–231, *231*
image editing, 138–139
impasto, 89, 294
Important Cultural Properties (National Treasures, Japan), 6
Impression: Sunrise (Monet), *375,* 375–376
Impressionism
 art criticism and, 380–381
 defined, 373–374
 Degas and Cassatt, 379–382
 generally, 368–370
 Japonisme, 388–389
 Manet, 372–373, 380
 Monet, 374–377
 Morisot, 378–379
 Postimpressionists and, 383–393
 Renoir, 377–378
 Rodin, 382–383
 Salons and academic art, 371–372
 time line, 368–369
impressionists, 27
India, stupas of, 228
inductive reasoning, 284
industrial design, 24, 208–210
Ingres, Jean Auguste Dominique, 73, *73, 357,* 357–358, *358, 360*
Inside and Out (Chihuly), 205, *205*
installations, sculpture, 153–154
intaglio printmaking, 99–109, *100, 103*
intensity, 45
interactive digital media, 145–147
interior design, 210–213
Interior of the Cornaro Chapel (Bernini), *321*
International Exhibition of Modern Art (National Guard Armory, Manhattan, 1913), 411
International Style, 428–429, 450
Internet, digital media and, 145
Ionic, *176*
iron and glass architecture, 181
Isenheim Altarpiece, The (Grünewald), 303, *303*
Islam
 architecture, 170–171
 faith and art, 249, 255–260
 Orientalism, 360
Italy, Medieval art of, 270–273. *see also* faith

J

Jagadambi Temple, 263, *263*
Jahangir Preferring a Sufi Shaikh to Kings (Bichitr), 14, *14*
Janitor (Hanson), 453, *453*

Japanese art
 anime, 144
 brush and ink drawing, 80
 Japonisme, 107, 388–389
 sculpture, 160–161
Japanese Sand Garden, Ryoanji Zen Temple, 196, *196*
Jar with feathers and an avanyu (Martínez, Martínez), 194, *194*
Javacheff, Christo. *see* Christo
Jeanne-Claude, 457–460
Jefferson, Thomas, *187,* 187–189, *188*
Jobs, Steve, 142
John 3:16 (Pfeiffer), 140–141, *141*
Johns, Jasper, 84, *85,* 444–445, *445*
Johnson, Philip, 182–183, *183, 442, 442*
Jolly Toper, The (Leyster), 331, *331*
Josephine Baker (Calder), 36, *37*
Judd, Donald, *451,* 451–452, 451–452. 451
Judith and the Maidservant with the Head of Holofernes (Gentileschi), *318,* 319
Judith Slaying Holofernes (Carvaggio), 316–317, *317*
Julius II (Pope), 288
Junior Suite (Demand), 124, *125*
Justinian and Attendants, 250–252, *251, 253,* 272
Jutes, 252–254
juxtaposition, Surrealist, 418

K

Kahlo, Frida, 19, *19*
Kailasa Temple at Ellora, 157, *157*
Kallikrates, *175,* 175–176, *176,* 219, 226, *227,* 229, *229,* 230–231, *231*
Kandinsky, Vasily, 50–51, *51, 424, 425,* 425–426, *426,* 427
Kauffman, Angelica, 346, *346*
Kaufman House (Fallingwater) (Wright), *184,* 184–185, 430–431
Kelly, Ellsworth, 52–53, *53*
Kenichi, Nagakura, 207, *207*
Ken Moody and Robert Sherman (Mapplethorpe), 120–121, *121*
Kentridge, William, 81, *82*
Khan, Amanat, 360
Kiefer, Anselm, 466–467, *467*
kinetic sculpture, 150–152, 440
King mounted on horse with attendants (plaque), 150, *150*
Kirchner, Ernst Ludwig, 415, *415*
Kiss, The (Rodin), 382–383, *383*
Kiss of Death (Noble, Webster), *165,* 165–166
Kitchen Painting (Murray), 20, *20*
Kline, Franz, 36, *36*
Knoll, Florence, *212,* 212–213
Knoll International (Knoll), 212, *212*
Kodak camera, invention of, 114–115
Kollwitz, Käthe, 76, *76,* 416–417, *417*
Kongorikishi (Unkei), 160–161, *161*

Koolhaas, Rem, 469, *469*
Kosho, 261, *261*
Kruger, Barbara, *108*, 108–109
Kuya-Shonin, 261, 262

L

Lamentation (Giotto), 274, *276*
Landscape (Degas), 109, *109*
landscape design, 197, 213–215
landscape photography, 115
Landscape 1 (Van Veluw), 127, *127*
Landscape with the Fall of Icarus (Bruegel the Elder),
 305–306, *306*
Lange, Dorothea, *117*, 117–118
Laocoön group, 235, *235*
"larger than life," 61
Lartigue, Jacques-Henri, 116, *116*
Lasseter, John, 142, *142*
Last Judgment, The (Michelangelo Buonarroti), 296, *296*, *297*
Last Judgment (Gislebertus), 265, *266*
Last Supper, The (Da Vinci), 285, 285–287, *291*, 291–292
Last Supper, The (Nolde), 398, *398*
Last Supper, The (Tintoretto), 312, *312*
Late Neoclassicism, 357–358
Latin Cross Plan, Chartres Cathedral, *266*
Latrobe, Benjamin, *188*, 188–189
Laughing Cavalier, The (Hals), 330, *330*
Laurana, Luciano, 69, *69*
Leaf Pattern (Cunningham), 433, *433*
Le Corbusier, 189, *189*, *429*, 429–430, 443, *443*
Lee, David, *455*, 455–456
Leeson, Lynn Hershman, 145–146
Leffler, Sam, *142*
Legend of Saint Cherón, 269
Letter, The (Cassatt), 104, *104*
Leyster, Judith, 331, *331*, 332
L.H.O.O.Q. (Duchamp), 15, *15*, 414
Liberation of Aunt Jemima (Saar), 14–15, *15*
Liberty Leading the People (Delacroix), *355*, 355–357, *356*
Lichtenstein, Roy, 136, *449*, 449–450
Life Survives by the Power of Life (TeamLab), 482–483, *483*
light, as element of art, 40–41
Lightning Field (De Maria), 458, *458*
Lin, Maya Ying, 16–17, *17*
line
 defined, 35–36
 design and linear perspective, 68–71
 linear perspective, 68–71
 linear styles of painting, 358
 line of force, 57
Lippi, Fra' Filippo, 281, *281*
literary arts, defined, 21
lithography, 102, 104–105
Little Deer, The (Kahlo), 19, *19*
Littleton, Harvey, 202, *202*

Lives of the Artists (Vasari), 287
Livia (Empress of Rome), 237, 242
local colors, defined, 49
Loge, La (Renoir), *26*, 27–28
London Bridge (Derain), 399, *399*
looms, 199
Los Angeles County Museum of Art, 136
lost wax method, 158–159, *159*
Louis XIV (King of France), 218, *336*, 336–338, 346–347, 352
Louis XIV (Rigaud), 336, *336*
Louvre, *Mona Lisa* (Da Vinci) theft and, 3–4
Lucas, George, 141–142
Lucasfilm, 141–142
Ludovisi Battle Sarcophagus, 244, *244*
Luna, James, 466, *466*
Luther, Martin, 96, 300–302
Luxo Jr. (Lasseter, Reeves, Ostby, Leffler, Conway), 142, *142*

M

Maar, Dora, 408
Macintosh (Apple), 137, *137*, 139
Maclean, Bonnie, 107, *107*
Maderno, Carlo, *185*, 186
Madonna dal Còllo Longo (Parmigianino), 310, *310*
Madonna della Sedia (Raphael), 281, *293*
Madonna with Child and Angels (Lippi), *281*
Magritte, René, 420–421
Mahonga mask, 401, *401*
Malevich, Kazimir, *426*, 426–427
Malle Babbe (Hals), 330, *330*
Malwiyah Miaret, Great Mosque (Samarra, Iraq), 258, *258*
mandalas, 56
Manet, Édouard, 372–373, *373*, *374*, 380
manga, 144
Mannerism
 Counter-Reformation and, 311
 defined, 310–311
 time line, 308–309
Mansart, Jules Hardouin, 337, *337*
Mantegna, Andrea, *280*, 281
Maori art, power of art for tribal peoples and, 10–11
Maple Leaves at the Tekona Shrine (Hiroshige), 67, *67*
Mapplethorpe, Robert, 120–121, *121*
maps
 ancient empires of Mediterranean, *218*
 ancient Greece, *225*
 Europe in the Age of Kings, *327*
 medieval Europe, *262*
 Paris: Birthplace of Art, *370*
 Renaissance Europe, *286*
maquette, 158
Marie Antoinette, 339–340
Marie-Thérèse, *407*, 407–408
Marinetti, Tomasso, 409–411
Märkische Heide (Kiefer), 466–467, *467*

Mars, the Peacemaker (Canova), 348
Martínez, Julian, 194, *194*
Martínez, María Montoya, 194, *194*
Mask depicting spirit flight of shaman (Eskimo), 10, *10*
Mask (Kanaga), 9, *9*
masonry, 177–179
mass, 37
Massachusetts Institute of Technology (MIT), 135–136
mass production, decorative arts and, 192
Matisse, Henri, 53, *53*, 398–400, 399–400, *400*, 406
matte, 194
MAXXI Museum (Hadid), *190*, 190–191
Mayans, 256–257
medallion reliefs, *Arch of Constantine*, *244*, 244–245
Medici Crypt Drawing (Michelangelo), 74, *74*
Medici family, patronage of, 31–32, 74–75, 287
medium (media). *see also* architecture; drawing; painting; sculpture
 binders for painting, 84
 generally, 72–73
 mixed media, 94, 165–166
 unique materials for painting, 94–95
Mehretu, Julie, 470–471, *471*
Melting Candelabrum (Mimlitsch-Gray), 206, *206*
memory, of artists, 20
Mendieta, Ana, 463, *463*
Meninas, Las (Velásquez), *325*, 325–326, *326*
Mesoamerica
 Baroque period, 323–324
 faith and art in, 256–257
metal engraving, 100–101
metalpoint, 73
metalwork, 198–200, 206
Metropolitan Cathedral (Mexico City), *323*, 323–324
Mexican art
 Baroque period, 323–324
 faith and art of Mesoamerica, 256–257
 sculpture, 148
Michelangelo Buonarroti, *31*, 31–32, 74, *74*, 163, *163*, *185*, 185–187, *186*, *187*, 287, 287–292, *288*, *289*, *290*, *292*, 295–296, *296*, *297*
Middle Ages
 faith and art in, 264–273
 faith and art in early Middle Ages, 252–255
Migrant Mother, Nipomo Valley (Lange), *117*, 117–118
mihrab, 258, *259*
Mili, Gjon, 28, *29*
Millet, Jean François, 365
Mimlitsch-Gray, Myra, 206, *206*
minaret, 259
Minimalism, 64, 162, 451–452
Miss Loie Fuller (Toulouse-Lautrec), 105, *105*
mixed building materials, 184–185
mixed media, 94, 165–166
Miyazaki, Hayao, 144, *144*
mobiles, 440

mobile sculpture, 150–152
modeling, 158
Modern Art. *see* Nonrepresentational art
Modern movement, of architecture, 189
Modjesko, Soprano Singer (Van Dongen), 49, *50*
Mohammed (Prophet), 255
Moko Tattoo (traditional), 11, *11*
Mona Lisa (Da Vinci), *2*, 2–4, 2–5, *4*
Monet, Claude, *374*, 374–377, *375*, *376*, *377*
monotype, 109
Monticello (Jefferson), *187*, 187–188
Moore, Henry, 42, *42*
Moorman, Charlotte, 131
Morisot, Berthe, *378*, 378–379
mosaics, 242–243
Moses, Anna Mary Robertson. *see* Grandma Moses
Mother and Child (wood carving), 160, *160*
Moulin de la Galette, Le (Renoir), 378, *378*, 384
Mountains and Sea (Frankenthaler), *439*, 439–440
moving pictures, 130–131
Mrs. Siddons as the Tragic Muse (Reynolds), 344–345, *345*
Mud Angels (Lee), *455*, 455–456
Muhammad, Sultan, *66*, 67
Muhammad (Prophet), 170–171
multiples, 96
Munch, Edvard, 396–397, *397*
Muniz, Vik, 95, *95*
Murakami, Takashi, 479, *480*
Murray, Elizabeth, 20, *20*
muscle studies (Da Vinci), *283*, 283–284
"Muscle System, The" (Vesalius), *284*
Mussolini, Benito, *13*, 13–14
Mutu, Wangechi, *94*, 94–95
Muybridge, Eadweard, 129, *129*
Mycerinus and His Queen, Kha-Merer-Nebty II, *220*, 232
Myron, *232*, *232*
Mystery and Melancholy of a Street (De Chirico), 417, *417*

N

Napoleon Bonaparte (Emperor of France), 348, *349*
Napoleon III (Emperor of France), 372
Nash, John, 359, *359*
National Endowment for the Arts (NEA), 122
Nationale Nederlanden building (Gehry), 468–469, *469*
National Guard Armory (International Exhibition of Modern Art, Manhattan, 1913), 411
National Treasures (Japan), 6
Native American peoples, craft and decorative arts, 24
naturalism
 Baroque period in Spain, 322–326
 Carvaggio and, 318
naturalistic colors, 50
naturalistic sculpture, 231
naturalistic shapes, 37
nave, defined, 266–267

Nave of Sainte-Madeleine, 178–179, *179*
Nazism, Degenerate Art show and, 434–435
negative form/negative space, 52
negative-positive principle, 113
Neoclassicism
 defined, 345
 generally, 345–348
 Late, 357–358
 Orientalism and, 359–361
 Realism and, 362–367
 sculpture, 348–350
 time line, 342–343
Neoexpressionism, 466
Netherlands, Baroque and, 326–329
neutral colors, 44–45
Nevelson, Louise, 164, *165*
new media, 128–147
 digital artists, 134–137
 digital media, 138–147
 digital studios, 137–138
 generally, 128
 time as medium, 128–131
 video art, 131–134, 140–141
Newton, Sir Isaac, 313
New York, New York (Kline), 36, *36*
New York School, 439–440
New Zealand, $10 bill of, *25*, 25–27
Nguyen-Hatsushiba, Jun, 133, *133*
nibs, 79
Night Café, The (Van Gogh), 390, *390*
Night Shining White (Han Kan), 21, *21*
Night Watch (Rembrandt), 333, *333*
Nike of Samothrace, 235, *235*
nirvana, 260
Noble, Tim, *165*, 165–166
Nocturne in Black and Gold (Whistler), *380*, 380–381
Noguchi, Isamu, 214, *215*
Nolde, Emile, 398, *398*
Nonrepresentational art. *see also* Abstract art
 Abstract art and O'Keeffe, 431–423
 Abstract art and photographic art, 433–435
 Abstract Expressionism, 435–441
 architecture, 441–442
 challenge of, 444
 contemporary nonrepresentation, 470–471
 De Stijl, 428
 Hitler and, 434–435
 International Style, 428–429
 Le Corbusier, 429–430
 Malevich and El Lissitzky, 426–427
 organic abstraction, 442–443
 Rauschenberg and Johns, 444–445
 sculpture, 440–441
 spiritual path to, 424–425
 time line, 422–423
 Wright, 430–431

nonrepresentational shapes, 39
Northern Renaissance
 beginning of, 297–302
 dark side of, 303–305
Notre Dame Cathedral, 11, *11*, 12
Notre Dame du Haut (Le Corbusier), 443, *443*
Nude Descending a Staircase (Duchamp), 412, *412*
Nude Woman (Venus of Willendorf), 7, 7–8
Number 1, 1950 (Pollock), 437, *437*
Nympheas (Monet), 377, *377*

O

Oath of the Horatii (David), 347, *347*
Oath-Taking Figure, 42, *42*
Object (Oppenheim), 418, *418*
obscenity, photography and, 121–122
Ocean Park (Diebenkorn), 470, *470*
oculus, 241
Oedipus and the Sphinx (Ingres), 357, *357*
oil painting, 87–90
Okama, Tezuka, 144
O'Keeffe, Georgia, 59, *59*, 431–432, *432*
Oldenburg, Claes, 448–449, *449*
Old Guitarist, The (Picasso), 401, *401*
Olowe of Ise, 402, *402*
One Hundred Lavish Months of Bushwhack (Mutu), *94*, 94–95
one-point perspective, 69
Oppenheim, Meret, 418, *418*
Orchestra of the Paris Opera, The (Degas), 379, *379*
organic abstraction, 442–443
organic shapes, 37
Orientalism, 359–361
originality, art as, 28
Orozco, Gabriel, 60, *61*
Ortega, Damián, 472–473, *473*
Ostby, Eben, *142*
O'Sullivan, Timothy, 115, *115*
Oursler, Tony, 166, *166*

P

Pablo Picasso drawing a centaur with light (Mili), 28, *29*
Pabst, Daniel, 201, *201*
Paik, Nam June, 131, *132*, 474, *474*
painterly styles, 358
Painter Working, Reflection (Freud), 468, *468*
painting, 84–95. *see also individual names of periods*
 acrylic, 91–92
 contemporary approaches to, 92–94
 Early Renaissance, 281–284
 encaustic, 84–85
 fresco, 86
 generally, 84

oil, 87–90
 Romanticism and, 358
 tempera panel, 86–87
 unique materials for, 94–95
 watercolor and gouache, 90–91
Painting (De Kooning), 435, *435*
Palace of Versailles, 336–338, *337, 338*
Palazetto Zuccari, 54, *54*
Paleolithic cave art (Lascaux, France), *8*, 8–9
Paley, Albert, 204, *204*
Paley, Nina, 143, *143*
Palladio, Andrea, 294–295, *295*
Panel for Edwin R. Campbell (Kandinsky), *425*
Pantheon (Soufflot), 58, *58, 241*, 241–242
paper cutouts, drawing and, 81
Parmigianino, 310, *310*
Parthenon, The (Church), *226*
Parthenon (Iktinos, Kallikrates), 174–175, *175*, 175–176, *176*, 219, 226, *227*, 229, *229*, 230–231, *231*
pastel drawing, 76–78
patina, 159
Pax Romanus, 237
Peabody (Animal Drawings) (Smith), 110, *110*
Pear-shaped Vase for Alcohol, 193, *193*
pen and ink drawing, 78–79
Penone, Giuseppe, 481–482, *482*
pens, 78
Penseur, Le (Steichen), 118, *118*
Pepper 30 (Weston), 119, *119*
performance art, 152–153, 461–466
performing arts, defined, 21
Persistence of Memory, The (Dalí), 418–419, *419*
perspectives (architecture), 169
Peru, metalwork of, 198
Peruggia, Vincenzo, 3
Pfeiffer, Paul, 140–141, *141*
Photiadis, Michael, *231*
photography, 112–127
 cameras and, 114–115
 contemporary approaches to, 123–127
 defined, 115
 generally, 112
 new media and, 135
 obscenity and, 121–122
 styles of, 115–123
 technique and development, 112–114
photomontage, 119–123
photorealism, 452
Photo-Secession group, 118
Piano, Renso, 456, *456*
piazza, 186, 321
Picasso, Maya, 408
Picasso, Pablo, 28, *29*, 38, *38*, 69–70, *401*, 401–408, *403, 404, 405, 406, 407*
picture plane, 52
Pietá (Michelangelo Buonarroti), *287*

pigments, 84
Pink Accent (Kandinsky), 50–51, *51, 425*
Pisano, Nicola, *271*
Pissarro, Camille, 370, *370*
Pixar, 142
Pizarro, Francisco, 198
Place du Théâtre, La (Pissarro), 370, *370*
placement, design and, 52–56
planning, by architects, 168–170
plastic craft media, 193
Pleasure Pillars (Sikander), 480, *480*
Plenty's Boast (Puryear), 162, *162*
plotters, 135
point, 163
pointed arch, 179, *179*, 268
Pointillism, 384–386
Pollock, Jackson, 135, 436–438, *437*
polychromy, 47
Polykleitos, *232*, 234
Pomona (Cameron), 114, *114*
Pontormo, Jacopo, *311*
Pop architecture, 450–451
Pop Art, 448–450
Popp, Julius, 146–147, *147*
porcelain, 194–195
Portal Gates (Paley), 204, *204*
Portrait of Paulina Borghese as Venus Victorious (Canova), 349, *349*
Portrait of Sir Thomas More (Holbein the Younger), 302, *302*
Portrait statue of the priest Kuya preaching (Kosho), *261*
positive form, 52
post-and-lintel, 177, *177*
posters, prints *vs.*, 106–107
Postimpressionism, 383–393. *see also* Impressionism
 Cézanne, 392–393
 defined, 383–384
 Gauguin, 386–387
 Seurat and Pointillism, 384–386
 time line, 368–369
 Toulouse-Lautrec, 384
 Van Gogh, 387–392
Postmodern architecture, 468–470
Postmodern Art, 466–468
Potato Eaters, The (Van Gogh), 387, *387*
pottery, 193–194, 196–197
Poussin, Nicolas, *335*, 335–336
Powers, Harriet, 200, *200*
Praxiteles, 12, *13*
preservation
 of ancient art, 219
 of Renaissance art, 290–292
Prevalence of Ritual (Bearden), 94, *94*
primary colors, 45, *45*
Principia (Newton), 313
printing press, invention of, 96

printmaking, 96–110
 contemporary approaches to, 110
 generally, 96
 intaglio, 99–109
 prints *vs.* posters, 106–107
 relief, 97–99
 unique types of, 109
Pritzker Architecture Prize, 190
Prometheus Bound (Rubens), *57, 57*–58
proofs, 110
Prophet Jeremiah, The, 264
proportion, 59–66
Proposition, The (Leyster), 331, *332*
Protestant Reformation, 96, 300–302
Puberty (Munch), 396, *397*
Purification of the Temple (El Greco), *313,* 313–314
Purple Robe and Anemones (Matisse), 400, *400*
Puryear, Martin, 162, *162*
Pyramid of the Morning Star, 257
Pyramids of Giza, 220

Q

Qin Dynasty, China, 223–224
Qin Shi Huang (Emperor of China), 223–224
Queen Nefertari presenting offerings, 223, 223
Queen Nefertiti, 221, *221*
quill pens, 78
quilting, 200
Qur'an manuscript, *249*

R

radial balance, 55
Radiator Building—Night, New York (O'Keeffe), 432, *432*
Radioactive Cats (Skoglund), 123–124, *124*
Raft of the Medusa (Géricault), 355, *355*
Raftsmen Playing Cards (Bingham), 68, *68*
raku, 196–197
Raphael, *88,* 88–89, 289, 292–294, *293*
Ratio, 60
Rauschenberg, Robert, *444,* 444–445
Ray, Man, 119, *119,* 414, *414*
rayograph, 119
Reading Photographic Establishment (Talbot), 113, *113*
Realism, 342–343, 362–367
Red/Blue (Kelly), 52–53, *53*
Redon, Odilon, *78*
Red Room (Matisse), 400, *400*
Reeves, Bill, *142*
Reformation, 96, 300–302
registration, 99
Reims Cathedral, 268, *268*
reinforced concrete, 183–184
relative size, 57
relief printmaking, 97–99

relief sculpture, 149–150
Rembrandt van Rijn, *34,* 80, *81,* 103, *103, 332,* 332–335, *333, 334*
Renaissance, 274–307
 defined, 276
 Early Renaissance painting, 281–284
 Early Renaissance sculpture and architecture, 277–280
 end of High Renaissance, in Italy, 295–296
 genre and, 305–307
 High Renaissance, 284–294
 idea of, 276–277
 Northern Renaissance, beginning, 297–302
 Northern Renaissance, dark side of, 303–305
 restoration and, 290–291
 time line, 275
 in Venice, 294–295
Renoir, Pierre-Auguste, *26,* 27–28, 377–378, *378,* 384
repatriation, of art, 230–231
reproductions, 96
Resurrection (Grünewald), *303*
Return from Cythera (Watteau), 338–339, *339*
Reynolds, Sir Joshua, 344–345, *345*
rhythm, 58
ribbed vault, 268
"Richard Mutt Case, The" (Duchamp), 414
Rietvelot, Gerrit, 428, *428*
Rigaud, Hyacinthe, 336, *336*
Rime of the Ancient Mariner, The (Doré), 99, *99*
Rist, Pipilotti, 32, *33,* 134, *134*
Rivera, Diego, 86, *86*
Roat, Rich, 140
Robusti, Jacopo. *see* Tintoretto
rock art, 9
rock gardens, 197
Rococo
 in France, 338–341
 time line, 308–309
Rodin, Auguste, 118, 158, *158, 382,* 382–383, *383*
Rogers, Richard, 456, *456*
Roman Empire
 art and art history, 31–32
 elements of art and, 47
 generally, 236–245
Romanesque style, 265–267
Romanticism
 birth of, 352
 defined, 345
 in England, 352–353
 in France, 353–357, 358–361
 generally, 350–352
 Orientalism and, 359–361
 Realism and, 362–367
 time line, 342–343
 in U.S. (Hudson River School), 361–362
Romero, Betsabeé, 110, *111*
Rose window, north transept (Notre Dame Cathedral), 11, *12*

Rothko, Mark, 438, *438*
rotunda, 241
round arch, 178, *178*
Royal Pavilion at Brighton, The (Nash), 359, *359*
Rubens, Peter Paul, *57*, 57–58, *326*, 326–329, *328*
Rue Transnonain (Daumier), 363, *363*
Running Fence (Christo), 457, *457*
Ruskin, John, 90, 380–381
Russian Suprematism, 427
Ryoanji Zen Temple, 196, *196*

S

Saar, Betye, 14–15, *15*
Sacrifice of Isaac, The (Brunelleschi), *277*, 277–278
Sacrifice of Isaac, The (Ghilberti), *277*, 277–278
sacrilege, religious images *vs.*, 249
Sagrario Metropolitano, Metropolitan Cathedral (Mexco City),
 323, 323–324
Saint Anthony Tormented by Demons (Schongauer), 100, *100*
Saint Francis Altarpiece (Berlinghieri), *272*, 273
Saint Francis Preaching to the Birds (Bonaventura), *273*
Saint Mark (Donatello), 279, *279*
Saint Matthew, from *Book of Lindisfarne*, 254–255, *255*
Saint Michael (Germany), 264
Saint Paul's Cathedral (Wren), 344, *344*
Saint Peter's Basilica (Della Porta, Maderno, Michelangelo,
 Bernini, Bramante), *185*, 185–187, *186*, *187*, 321–322
Salgado, Sebastião, 123, *123*
Salon de la Guerre, Palace of Versailles, 337–338, *338*
Salons, 366, 371–372
sampling, 471
Sand Mandala (Drepung Loseling Monastery), 93, *93*
San Miniato al Monte, *270*, 270–271
San Vitale, *251*, *253*
São Paulo Bienal, 162
sarcophagus, 244
Sargent, John Singer, *90*, 90–91
saturated colors, 45
Saturn Devouring his Son (Goya), *351*, 351–352
Saxons, 252–254
scale, 59–66
Scene in Yoshivara (Utamaro), 388, *388*
Scene of the Hunt (Lascaux, France), *8*, 8–9
Scharf, Kenny, 154, *154*
Schiaparelli, Elsa, 209, *209*, 210
Schongauer, Martin, 100, *100*
School of Athens, The (Raphael), 292–294, *293*
Schröder House (Rietvelot), 428, *428*
Schwedagon Pagoda, 228–229, *229*
science, of color, 46–50
Scofidio, Ricardo, *190*, 190–191
Scream, The (Munch), 396–397, *397*
sculpture, 148–167. *see also* ancient empires
 contemporary approaches to, 164–167
 Contemporary Art installations and sculpture, 471–474

Early Renaissance, 277–280
Early Twentieth Century, 408–409
Earth Art, 154–157
elements of art and, 47
generally, 148–149
Greek, 231–234
installations, 153–154
kinetic, 150–152, 440
Michelangelo and, 288
modern methods for, 164
Neoclassicism, 348–350
performance art, 152–153
relief, 149–150
in the round, 149, 150
traditional methods for, 158–163
Seagram Building (Van Der Rohe, Johnson), 182–183, *183*, 442
Seasons: Summer, The (Johns), 84, *85*
Seated Boxer, The (Apollonius), 236, *236*
Seated Buddha Preaching the First Sermon, 260, *260*
Seated Male with a Lance (wood carving), 160, *160*
Seattle Public Library (Koolhaas), 469, *469*
secondary colors, 45, *45*
secondary symbolism, 299
Seed Cathedral (Heatherwick), 191, *191*
seeing, 4
self-expression, 19
Selfless in the Bath of Lava (Rist), 32, *33*
Self-Portrait as a Young Man (Rembrandt), 332, *332*
Self-Portrait as Soldier (Kirchner), 415, *415*
Self-Portrait (Dürer), 300
Self Portrait (Kollwitz), 76, *76*
Self-Portrait (Rembrandt), *334*, 335
Self-Portrait (Van Gogh), *390*, 390–391
serigraphy, 105–109
serpentinata, 310
Serra, Richard, 64, *64*
Serra, Roy, 136
Seurat, Georges-Pierre, 41, *41*, 384–386
sfumato lighting, 4
shadow, as element of art, 40–41
shape, as element of art, 37–39
Sheep Piece (Moore), 42, *42*
Sherman, Cindy, 125, *125*
Shiva Nataraja, Lord of the Dance, 263, *263*
Shoe Hat (Schiaparelli, Dalí), 209, *209*
Shonibare, Yinka, 480–481, *481*
Shoot (Burden), *462*, 463
shutters, 114
Siddhartha Gautama (prince), 228
Sikhander, Shahzia, 479–480, *480*
silkscreen printing, 105–109, *108*
simultaneous contrast, 49
Sip My Ocean (Rist), 134, *134*
Siqueiros, David, *63*, 63–65, 66
Sistine Chapel, ceiling (Michelangelo Buonarroti), 288–292,
 289, *290*, 295–296, *296*, *297*

Sita (Redon), *78*
Sita Sings the Blues (Paley), 143, *143*
SITE (Sculpture in the Environment), 454
site-specific art, 154
Six Pillows (Dürer), 78, *79*
Sketchpad (MIT), 136, *136*
Skoglund, Sandy, 123–124, *124*
Slave Ship (Turner), 352–353, *353*
Sleeping Woman (Rembrandt), 80, *81*
Sluter, Claus, *297*, 297–298
Smith, David, 164, *164*, 440
Smith, Kiki, 110, *110*
Smithson, Robert, *155*, 156, 458–459
Snow Storm (Turner), 89, *89*
Société Anonyme, 375
Society of Independent Artists (New York City, 1917), 413
Soft Toilet (Oldenburg), 448–449, *449*
software. *see* digital media
soldering, 164
Solomon R. Guggenheim Museum (Wright), 430, *431*
Sortie of Captain Banning Cocq's Company of the Civic Guard (Rembrandt), 333, *333*, 334
Souffle, Le (Ray), 119, *119*
Soufflot, Jacques Germain, 58, *58*
Soundsuit (Cave), *23*, 23–24
space
 designing and organizing space with depth, 66–68
 as element of art, 34–35
Spain
 Baroque naturalism, 322–326
 Spanish Civil War, 406
Spiral Jetty (Smithson), *155*, 156, 458–459
Spirited Away (Miyazaki), 144, *144*
Spirit of the Dead Watching (Gauguin), *386*, 386–387
Stadia I (Mehretu), 470–471, *471*
stained glass
 Gothic cathdrals, 269–270
 stained-glass artistry, 195–198
Starry Night, The (Van Gogh), 391, *391*
Statue for Vietnam Veterans Memorial (Hart), 16, *16*
steel and glass architecture, 181–183
steel frame construction, 182, *182*
Steerage, The (Stieglitz), 118, *118*
Steichen, Edward, 118, *118*, 148, *149*
Stieglitz, Alfred, 118, *118*
stigmata, 304
Still Life with Apples (Cézanne), 392, *392*
stoicism, 232
stone architecture, 177–179
Stonebreakers, The (Courbet), 365
stone carving, 163
stoneware, 194–195
Store Days (Oldenburg), 448–449
straight photography, 115–118
Studio Craft Movement, 201–204
Studio of a Painter (Courbet), 29–30, *30*

studios, digital, 137–138
Study for the Portrait of Louisa d'Haussonville (Ingres), 73, *73*
stupa, defined, 173, 228
subtractive sculptural methods, 158
Sunday on La Grande Jatte, A (Seurat), 384–386, *385*
Sun Tunnels (Holt), 156, *156*
Super Mario Clouds (Arcangel), 475–476, *476*
Superrealism, 452–453
Supper at Emmaus, The (Caravaggio), *314*, 314–318, *315*, *317*
Suprematist Composition (Malevich), 426, *426*
Surrealism, 130–131, 417–420
Sussman, Eve, 475, *475*
Sutherland, Ivan, 136
Swarm Sketch (Edmunds), 145, *145*
Swing, The (Fragonard), 339, *340*
Swing, The (Shonibare), 480–481, *481*
Swiss National Expo (2002), 190
Syjuco, Stephanie, 139, *139*
symmetrical balance, 55
symmetry, 55–56
sympathy of the forms, 59
Synthetic Cubism, 405
Synthia (Leeson), 145
Sze, Sarah, 154, *155*

T

Table Clock (Brandt), 210, *210*
tablet computers, 138
Taj Mahal, *359*, 359–360
Talbot, William Henry Fox, 113, *113*
Tamarind Lithography Woodshop, 102
Ta-Moko, 10–11
Taos Publos (New Mexico), 176–177, *177*
Tassel House (Horta), 211, *211*
Tassi, Agostino, 317
tattoo, 10
Taylor, Maggie, *138*, 138–139
tea ceremony, Chinese, 196
TeamLab, 482–483, *483*
television, video art and, 131
tempera, 86–87
Tempietto (Bramante), 56, *56*
Temple I (Mayan), *256*
Temple of Athena Nike (Kallikrates), 176, *176*
Temple of Ramses II, *222*, 222–223
tenebrism, 316
tenebroso, 318–319
Terra-cotta army of First Emperor of Qin, 223–224, *224*
Tetsuma Atomu (Okama), 144
texture, as element of art, 41–43
Theodora and Attendants, *251*, 272
Theotokopoulos, Domenikos. *see* El Greco
Therrien, Robert, 63, *63*
Thinker, The (Rodin), 382–383, *383*

Third of May, The (Goya), *350,* 350–351
30 Are Better Than One (Mona Lisa) (Warhol), 28, *29*
Thirty-Six Views of Mount Fuji, 389
three-dimensional animation, 142
three-dimensional shape, *37*
three-dimensional space, 35, 66–68
Three Goddesses, 229
Three Musicians (Picasso), 405, *405*
Three Studies of a Youth (Watteau), 77, *77*
Throne of Saint Peter (Bernini), 322, *322*
throwing, 194
Tide Table (drawing used in film) (Kentridge), 81, *82*
Tiffany, Louis Comfort, *197, 198,* 198
Tikal, pyramids of, 256, *256*
Tilted Arc (Serra), 64, *64*
time issues
 architecture as product of its time, 185–187
 time as medium, 128–131
Tinguely, Jean, 152, *152*
Tintoretto, 311–312, *312,* 318
Titian, 294, *294*
Toltec culture, 257
Tomb of Guiliano de'Medici with Figures of Night and Day
 (Michelangelo), *31,* 31–32
Toulouse-Lautrec, Henri de, 105, *105, 106,* 107, 384, *384*
Trajan, 239–241
transept, 266
Treachery (or Perfidy) of Images, The (Magritte), 420–421, *421*
Tree of Life (Mendieta), 463, *463*
tribal peoples, power of art for, 9–11
Tropical Garden II (Nevelson), 164, *165*
trumeau, 265
Tschumi, Bernard, *231*
tumi, 198
Turner, J. M. W., 89, *89,* 352–353, *353,* 354, *354*
Turrell, James, 41, *41*
Tutankhamen, second coffin of, 221–222, *222*
TV Bra (Paik), 131
TV Buddha (Paik), 131, *132*
Twilight in the Wilderness (Church), 362, *362*
Two Calla Lilies on Pink (O'Keeffe), 59, *59*
two-dimensional shape, *37*
two-dimensional space, 35
Two Girls on the Banks of the Seine (Courbet), *371,* 371–372
type design, 139–140

U

Überorgan (Hawkinson), 472, *472*
Ukiyo-e, 388
underpainting, 89
Under the Table (Therrien), 63, *63*
Unique Forms of Continuity in Space (Boccioni), 410, *410*
United Nations Educational, Scientific, and Cultural
 Organization (UNESCO), 173, 214, *215,* 219
United States (Anderson), 153, *153*

United States Capitol (Latrobe), *188,* 188–189
United States Pavilion, EXPO 67 (Fuller), *39,* 39–40
unity, 58–59
University of Pennsylvania, 135
Unkei, 160–161
Unswept Dining Room Floor (SOSUS), 243, *243*
Untitled # 1093 (Buddha Boy) (Coyne), *473,* 473–474
Untitled (Calder), 150, *151*
Untitled (Donovan), 58, *58*
Untitled Ice Bucket (Voulkos), 201, *201*
Untitled (Judd), *451,* 451–452
Untitled (Kruger), *108,* 108–109
Untitled Painting (Rothko), 438, *438*
Untitled (Sherman), 125, *125*
Urban Landscape (Wang), *18,* 18–19
urban planning, architecture and, 189
Utagawa, Kuniyoshi, 98, *98*
Utamaro, Kitagawa, 388, *388*

V

vaginal imagery, 460
Valentine (Bantjes), 207, *207*
value, as element of art, 40–41
Van Der Rohe, Ludwig Mies, 182–183, *183,* 442
Van Der Weyden, Rogier, *72,* 73
Van Dongen, Kees, 49, *50*
Van Eyck, Jan, 43, *43,* 87, *298,* 299, *299*
Van Gogh, Vincent, 35, 79, *80, 387,* 387–392, *390, 391,* 477
vanishing point, 69
Van Veluw, Levi, 127, *127*
variety, 58–59
Various Stages of Making a Color Print (Utagawa), 98, *98*
Vasari, Giorgio, 4, 287
Vase (Tiffany), 198, *198*
Velásquez, Diego, 322–326, *325, 326*
Venice (Sargent), *90,* 90–91
Venturi, Robert, *450,* 450–451
Venus de Milo, 233–234, *234*
Venus of Urbino (Titian), 294, *294*
Venus of Willendorf, 7, 7–8, 233
Veranda Post of Enthroned Kind and Senior Wife (Olowe of Ise),
 402, *402*
Vermeer, Jan, 329–330, *330*
vernacular architecture, 172–177
Versailles, Gardens of, *213,* 213–214, *214*
Vesalius, 284, *284*
video
 video art, 131–134, 140–141
 videogames, 147, 153, 475–476
Vietnam—A Memorial Work (Nguyen-Hatsushiba), 133, *133*
Vietnam Veterans Memorial Fund (VVMF), 16
Vietnam Veterans Memorial (Lin), 16–17, *17*
viewfinders, 114
View of an Ideal City (Laurana), 69, *69*
View on the Catskill, Early Autumn (Cole), *361,* 361–362

Vigée-Lebrun, Marie Louise Élisabeth, 339–341, *341*
Villa Rotonda (Palladio), 295, *295*
Villa Savoye (Le Corbusier), *429*, 429–430
Viola, Bill, 131–132, *132*
Violin and Palette (Braque), 70, *70*
Virgin of the Rocks, The (Da Vinci), 284–285, *285*
Virgin with the Canon van der Paele, The (Van Eyck), 43, *43*
Vishnu, 262–263
"visual truth," 49
visual weight, 55
"Vitruvian Man" (Da Vinci), 60, *60*
volume, 37
volutes, 176
Voulkos, Peter, 201, *201*

W

Walker, Kara, 82, *82*
Walking Buddha, 261
Walking Man (Rodin), 158, *158*
Walt Disney Company, 141, 142
Wanderer über dem Nebelmeer (Friedrich), 352, *352*
Wang, Zhan, *18,* 18–19
Warhol, Andy, 28, *29,* 448, *448*
warm colors, 45
warp, 199
Warrior Columns (Toltec), *257*
washes, 80
watercolor painting, 90–91
Waterfall (Escher), 70–71, *71*
Watteau, Antoine, 338–339, *339,* 341
Watteau, Jean Antoine, 77, *77*
Wayne, June, 102, *102*
Weather Project, The (Eliasson), *45,* 45–46
Webster, Sue, *165,* 165–166
weft, 199
Weiwei, Ai, 470

welding, 164
Well of Moses, The (Sluter), *297,* 297–298
Weston, Edward, 119, *119,* 433–435
wet into wet technique, 90
"Whirlwind" (MIT), 135–136
Whistler, J. A. M., *380,* 380–381
Wines, James, 454
wireframes, 142
Woman and Bicycle (De Kooning), *27,* 27–28, *28*
Woman at her Toilette (Morisot), *378,* 378–379
"Wonders of the World," 173–176
wood
 architecture, 179–180
 carving, 160–161
 craft art, 200–201
 engraving, 99
 woodcut prints, *96,* 97–99
Woo (Oursler), 166, *166*
World's Fair (1889, Paris), 386
World War I, Early Twentieth Century art and, 411
Wrapped Coast, Little Bay, Australia (Christo, Jeanne-Claude), 457–459
Wreck of the Hope, The (Friedrich), 46, *46*
Wren, Christopher, *344*
Wright, Frank Lloyd, *184,* 184–185, 430–431
wrought metalwork, 198
Wyeth, Andrew, 87, *88*
WYSIWYG (what you see is what you get), 139

Y

Yakshi, The Great Stupa, 233, *233*
Yardbirds, The (Maclean), 107, *107*
Yo (Butterfly), 204, *204*
Young British Artists (YBAs), 477
Young Woman with a Water Jug (Vermeer), *329,* 329–330